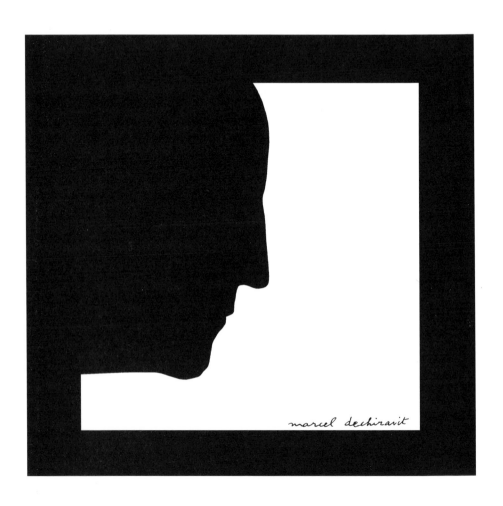

marcel dechirait

DUCHAMP

A Biography

CALVIN TOMKINS

A JOHN MACRAE BOOK HENRY HOLT AND COMPANY NEW YORK

Henry Holt and Company, Inc.
Publishers since 1866
115 West 18th Street
New York, New York 10011

Henry Holt® is a registered trademark of
Henry Holt and Company, Inc.

Library of Congress Cataloging-in-Publication Data
Tomkins, Calvin, 1925–
Duchamp / Calvin Tomkins.—1st ed.
p. cm.
"A John Macrae book."
Includes bibliographical references and index.
1. Duchamp, Marcel, 1887–1968. 2. Artists—France—Biography.
I. Title.
N6853.D8T58 1996 96-3080
709'.2—dc20 CIP

ISBN 0-8050-0823-3

Henry Holt books are available for special promotions
and premiums. For details contact: Director, Special Markets.

First Edition—1996

DESIGNED BY KATE NICHOLS

Printed in the United States of America
All first editions are printed on acid-free paper.∞

1 3 5 7 9 10 8 6 4 2

Frontispiece: *Self-Portrait in Profile,* 1958.

TO DODIE

Contents

DUCHAMP

The Bride Stripped Bare

Bride above—
bachelors below.

J ust under nine feet high and five and a half feet wide, freestanding
between aluminum supports, *The Large Glass* dominates the Duchamp
gallery in the Philadelphia Museum of Art. It is too big to take in at one
glance. Your eyes travel over it in random patterns, over it and through it,
to other viewers moving and stopping, and to the narrow window in back,
which overlooks an outdoor courtyard with its central fountain. Prey to dis-
tractions of all kinds, the sexual comedy of the *Glass* verges on farce. Marcel
Duchamp called it a "hilarious" picture.

He also insisted that it was not a picture. In one of the working notes that
he collected and published in *The Green Box,* Duchamp refers to it as a
"delay." *Use "delay" instead of picture or painting . . . It's merely a way of suc-*
ceeding in no longer thinking that the thing in question is a picture—to make a
delay of it in the most general way possible, not so much in the different meanings
in which delay can be taken, but rather in their indecisive reunion. Like so many
of the *Green Box* notes, this one has been chipped away at and drilled into
and bombarded by generations of Duchamp explainers, an international
tribe whose numbers increase each year. Laboring to unlock the mystery of
that little word, "delay," they have linked it, among other things, to Henri
Bergson's theory of duration, to the medieval practice of alchemy, and to a
subconscious fear of incest on Duchamp's part. One Duchampian has sug-
gested that it be read as an anagram for "lad[e]y," so that "delay in glass"
becomes glass lady. Duchamp adored puns and perpetrated a lot of them, but

his were never as heavy-footed as that. Generally overlooked in the ongoing analysis and microanalysis of Duchamp's wordplay is that it is *play*. He played with words, juggling a variety of senses and non-senses and taking pleasure in their "indecisive reunion." As he went on to say in that *Green Box* note, *a delay in glass as you would say a poem in prose or a spittoon in silver.*

The notes from *The Green Box* (italicized here) are essential to any understanding of *The Large Glass.* They constitute the verbal dimension of a work that is as much verbal as visual, by an artist who disdained words as a form of communication but who was fascinated by their other life, in poetry. It should be borne in mind, however, that nobody fully understands *The Large Glass.* The work stands in relation to painting as *Finnegans Wake* does to literature, isolated and inimitable; it has been called everything from a masterpiece to a hoax, and to this day there are no standards by which it can be judged. Duchamp invented a new physics to explain its "laws," and a new mathematics to fix the units of its measurement. Some of the notes are simply impossible to fathom. A good many of the ideas in them were never even carried out on the *Glass,* for that matter, either because the technical problems were too great or because, as Duchamp sometimes said, after eight years of work on the project he simply got bored and lost interest. He stopped working on the *Glass* in 1923, leaving it, in his own words, "definitively unfinished."

Its full title is *La Mariée mise à nu par ses célibataires, même,* or *The Bride Stripped Bare by Her Bachelors, Even.* Note the "Even." This sly adverb, thrown in to discourage literal readings, has also been subjected to endless analysis. One explanation is that it should be read as a pun on *"m'aime,"* meaning "loves me"—that is to say, the bride being stripped by these anonymous bachelors really loves Marcel Duchamp. The tribe can't resist looking for clues to the man in such discoveries, but Duchamp always maintained that his odd little adverb had no meaning whatsoever, that it was just "fun and poetry in my own way," that "the word *même* came to me without even looking for it." It was simply a humorous aside, something like the "already" in "enough, already."

Less attention has been paid to the word "her" in the title. There are nine bachelors, and the inference is that they belong to the bride—a male

Opposite: *The Bride Stripped Bare by Her Bachelors, Even (The Large Glass)*, 1915–23.

harem, servile and inferior in every respect to their peremptory mistress. *The bride has a life center—the bachelors do not. They live on coal or other raw material drawn not from them but from their not them.* Although she *must appear as an apotheosis of virginity, i.e. ignorant desire, blank desire (with a touch of malice)*, this bride clearly knows the facts of life. *Instead of being merely an asensual icicle,* she *warmly rejects (not chastely) the bachelors' brusque offer.* In fact, she does not reject it at all, but rather uses their lust to further *her own intense desire for the orgasm.* One note describes *The Bride Stripped Bare by Her Bachelors, Even* as an *agricultural machine,* an *instrument for farming;* this seems to suggest fertility, perhaps even birth, but as usual the terms are ambiguous. Other notes establish the bride as a thoroughgoing narcissist, intent on her own pleasure and nothing else.

The notes in *The Green Box* have a cryptic, absurd, self-mocking bite that is unique to Duchamp. Some are no more than a few scrawls on torn scraps of paper; others run on for pages, with precise pseudo-scientific diagrams and calculations in neat script. Most of them date from the years 1912 to 1915, when the ideas for *The Large Glass* were coming to Duchamp one after another, but they are in no particular order; he simply jotted them down and tossed them into a cardboard box that he kept for that purpose. At one time he thought of publishing the notes as a sort of brochure or catalog, to be consulted alongside the *Glass,* but not until 1934, eleven years after he had stopped working on the *Glass* itself, did he get around to reproducing them. The form he chose then was meticulously and enigmatically Duchampian—a limited edition of ninety-four notes, drawings, and photographs, printed in facsimile, using the same papers and the same inks or pencil leads, torn or snipped in precisely the same way as the originals, with the same crossings-out and corrections and abbreviations and unfinished thoughts, contained willy-nilly in a rectangular green box covered in green suede with the title, *La Mariée mise à nu par ses célibataires, même* (the same as the *Glass*), picked out in white dots on the front, like a sign on a theater marquee. A typographic rendering of the notes, translated into English by the artist Richard Hamilton and the art historian George Heard Hamilton, was published under the same title in 1960 and since then there have been other versions published in English, Spanish, Italian, German, Swedish, and Japanese, so that almost anyone who wants to can now approach the *Glass* the way Duchamp thought it should be approached, as an equal mixture of verbal and visual concepts. The *Glass,* he said, "is not meant to be

looked at (through esthetic eyes); it was to be accompanied by as amorphous a literary text as possible, which never took form; and the two features, glass for the eye and text for the ears and the understanding, were to complement each other and, above all, prevent the other from taking an esthetic-plastic or literary form." Eight years of work, in other words, on something that could be thought of as an attempt to answer the question he had asked himself, in a note dated 1913: *Can one make works which are not works of "art"?*

The *Glass* does have a subject, nevertheless, and a rather popular one at that. Sexual desire, or to be more precise, the machinery of sexual desire, is what we are dealing with here, although we might never suspect it just from looking at the *Glass*. Only by reading the notes can we follow the stages of the erotic encounter, which resembles no other in literature or in art. Before attempting that, however, a word of warning: as the French critic Jean Suquet points out, Duchamp's machinery only works when oiled by humor.

The Bride is basically a motor, Duchamp tells us. She is, in fact, an internal combustion engine, although her components do not conform to any known model. This bride runs on *love gasoline (a secretion of the bride's sexual glands),* which is ignited in a two-stroke cycle. The first stroke, or explosion, is generated by the bachelors through an *electrical stripping* whose action Duchamp compares to *the image of a motor car climbing a slope in low gear . . . while slowly accelerating, as if exhausted by hope, the motor of the car turns faster and faster, until it roars triumphantly.* The second stroke is brought about by sparks from her own *desire-magneto.* Although Duchamp suggests in two notes, confusingly, that the electrical stripping "controls" the bride's sexual arousal, he makes it clear in others that the bride herself is in full control. She *accepts this stripping by the bachelors, since she supplies the love gasoline to the sparks of the electrical stripping; moreover, she furthers her complete nudity by adding to the first focus of sparks (electrical stripping) the 2nd focus of the desire-magneto.* The notion of a mysterious female power that is both passive (permitting) and active (desiring) runs through many of the notes on *The Large Glass*. The bachelors, by contrast, are wholly passive. It is the bride's *blank desire (with a touch of malice)* that sets in motion the fantastic erotic machinery whose purpose is to bring about *the blossoming of this virgin who has reached the goal of her desire.*

The mechanico-erotic language of the notes on the bride has no visual counterpart in *The Large Glass* itself. In fact, the upper glass panel that is the

bride's domain shows nothing that even remotely suggests female anatomy, clothed or unclothed. What we see instead is a group of abstract, vaguely insectile shapes on the left-hand side, connected to a large cloudlike form that stretches all the way across the top. Each element on the left has a name, although even today, after seventy years of study and conjecture, it is hard to pin down exactly which is which. The large form at the top left is the *pendu femelle*, a decidedly unglamorous term meaning "hanging female object"; close examination shows that it does indeed hang from a painted hook at the top of the *Glass*. Underneath that is a *motor with quite feeble cylinders* and its reservoir of *love gasoline*, a sort of *timid-power*, or *automobi-line*, which, as you will recall, is secreted from the bride's sexual glands. Just to the right of these forms lies the *wasp*, or *sex cylinder*, a flask-shaped object that narrows at the top and is capped by a pair of snail-like antennae. Under that is the diagonal, sticklike shape of the *desire-magneto*—at least, I think it is the desire-magneto; others have located this vital organ elsewhere in the assembly. Just how all these elements combine to produce the two-stroke internal combustion cycle is not really clear to me nor, I believe, to anyone else, and I do not think that Duchamp meant it to be. The whole process, as he wrote, is *unanalyzable by logic,* and it would not hurt us at this point to suspend our disbelief by a few more notches.

The functioning of the large cloudlike shape at the top is stated fairly clearly. This element, which Duchamp identifies variously as the Halo of the Bride, the Top Inscription, the Milky Way, and the Cinematic Blossom-ing, is not something that emanates from the bride but is the bride herself, represented "cinematically" at the moment of her blossoming, which is also the moment of her being stripped bare. Three slightly irregular squares of clear (unpainted-on) glass are enclosed within the cloud; these are the Draft Pistons, a sort of telegraph system through which, using a special alphabet invented by Duchamp, the bride issues her *commands, orders, authorizations, etc.,* thus setting in motion the machinery of love-making. *This cinematic blossoming is the most important part of the painting,* Duchamp informs us in a surprisingly didactic note, forgetting his own interdiction against calling it a painting. *It is, in general, the halo of the bride, the sum total of her splendid vibrations: graphically, there is no question of symbolizing by a grandiose paint-ing this happy goal—the bride's desire; only more clearly, in all this blossoming the painting will be an inventory of the elements of this blossoming, elements of the sexual life of the bride-desiring.*

Moving to the lower half of the *Glass,* the domain of the bachelors, we come into a very different world. The forms here are precisely drawn and not a bit abstract, and their functions are spelled out in terms that often sound pitying or contemptuous. While the *principal forms* of the bride, according to Duchamp, *are more or less large or small,* the forms of the bachelor machine are *mensurable,* and their relative positions on the glass have been plotted according to old-fashioned vanishing-point perspective. Freedom of choice in the upper half is offset by a grim determinism in the lower half. The bride imagines and commands; the bachelors react and obey.

There are nine of them, ranged in a tight group at the far left of the *Glass,* and they are not even men but moulds of men—"malic" moulds, in Duchamp's coinage, reddish brown in color, looking something like eccentric chess pieces. What we are asked to believe is that if molten lead or some other substance were poured into them and allowed to harden, the result would be nine uniformed mannequins: priest, department-store delivery boy, gendarme, cuirassier, policeman, undertaker, flunky, busboy, stationmaster. Each of these figures has an occupation for which there was (in 1915, at least) no female equivalent, hence the Duchampian term "malic," which does not mean "masculine" (*mâle* in French) but rather "male-ish," with perhaps a touch of the bride's malice and an echo of phallic. Empty husks, then, inert and powerless, which wait stupidly for the signal to perform the basic male function that is required of them here.

Below them and slightly to the right stands the Glider, also referred to as the Chariot or Sleigh, a metallic construction on elliptical runners, with a Water Wheel built into it. Farther to the right, in about the middle of the lower glass panel, is the Chocolate Grinder, a thoroughly realistic rendering of a device that one used to be able to see (and the young Marcel Duchamp did see) in confectionery shop windows in France; it has three roller-drums that turn on a circular platform, supported by three Louis XV–style legs. Ascending vertically from the top of the Chocolate Grinder is a rod called the Bayonet, which supports the Scissors, a horizontal, X-shaped form whose handles connect with the Glider on the left and one of whose blades extends to the far right edge of the panel. Seven conelike shapes, the Sieves or Parasols, form a semicircular arc above the Chocolate Grinder and below the Scissors. At the far right are three Oculist Witnesses, circular diagrams used by oculists to test people's eyesight.

The erotic labors of the bachelors are fueled by falling water and natural gas—two resources whose availability in new apartment buildings in turn-of-the-century Paris was often announced by enamel wall plaques reading EAU & GAZ À TOUS LES ETAGES (WATER AND GAS ON EVERY FLOOR). Duchamp introduces these two elements in a note, entitled *Preface,* that would become a leitmotif in his life and work:

> *Given 1st the waterfall*
> *2nd the lighting gas . . .*

The waterfall is *A sort of waterspout coming from a distance in a half circle over the malic moulds* (*seen from the side*), except that we don't see it because it is one of the elements that Duchamp never got around to executing on the *Glass.* In its invisible state, however, it activates the Water Wheel, whose action moves the Glider. The lighting gas is the substance that animates the Malic Moulds. Where does it come from? Duchamp does not say: it is "given." All we know is that at a certain moment the gas, having filled the hollow moulds, escapes from openings at the top of each one and enters the Capillary Tubes, which run horizontally from each mould's summit to a point of convergence just underneath the first Sieve.

When the lighting gas enters the Capillary Tubes, it solidifies there *through the phenomenon of stretching in the unit of length.* (A Duchampian phenomenon.) As it emerges from the other end of the tubes, though, the now-solid gas breaks up into small needles of unequal length, which Duchamp calls *spangles of frosty gas.* These spangles tend to rise, since they are lighter than air; they are trapped by the first Sieve, although "trapped" may be the wrong term, for another note tells us that each spangle *strives* (*in a kind of spangle derby*) *to pass the holes of the sieve with élan.* The spangles are a lively lot. Each one retains *in its smallest part the malic tint.* But as they pass through the Sieves they become *dazed,* they *lose their designation of left, right, up, down etc. They no longer retain their individuality. In their progress through the sieves they change from spangles lighter than air . . . into: a liquid elemental scattering, seeking no direction.* And Duchamp's note on them concludes, *What a drip!*

While this spangle derby is going on, other elements of the bachelor machine are slipping and grinding and groaning into action. The Glider slides back and forth with a jerky motion. It is activated by the waterspout

Many other operations and pseudo-scientific processes are discussed in the notes, some of them far too complicated to summarize. What they all add up to is still an open question. To some dedicated Duchampians, the message of *The Large Glass* is anything but hilarious. It has been described as a deeply cynical and pessimistic work, in which the relationship between men and women is reduced to mechanical onanism for two. The Mexican poet and Nobel laureate Octavio Paz called it "a comic and infernal portrait of modern love." To others, though—this writer among them—pessimism doesn't stand a chance in *The Large Glass*. Running through the notes, in fact, is a high, clear vibration of something that sounds to me like epic joy. Duchamp said that he wanted to "put painting once again at the service of the mind." Since the time of Courbet, he felt, art had been exclusively "retinal," in that its appeal was primarily to the eye. Duchamp went beyond the retinal for the first time in 1912, when he painted his famous *Nude Descending a Staircase;* a year later, with his early notes and studies for what would become *The Large Glass,* he entered a new terrain where words and images fused and where the rules of tradition and logic and sensory impression gave way to a state of mind that can only be described as ecstatic. Again and again in Duchamp's notes, there is the joyous sense of a mind that has broken free of all restraints—a mind at play in a game of its own devising, whose resolution is infinitely delayed. The bride, who is queen of the game (as powerful and as mobile as the queen in the game of chess, to which Duchamp gave so much of his imaginative energy), will never achieve her ardently desired orgasm. Her "blossoming," Duchamp tells us, is merely *The last state of this nude bride before the orgasm which may (might) bring about her fall.* She is like Keats's maiden on the Grecian urn, forever in passage between desire and fulfillment, and it is precisely this state of erotic *passage* that Duchamp has chosen as the subject of his greatest work. Sexual fulfillment, with its overtones of disappointment, loss, and "fall" from grace, was never an option. The bride, the bachelors, and by implication the onlooker as well are suspended in a state of permanent desire.

Duchamp, who used to say that the artist never really knew what he was doing or why, declined to offer any such explanations for *The Large Glass.* One of his pet theories was that the artist performed only one part of the creative process and it was up to the viewer to complete that process by interpreting the work and assessing its permanent value. The viewer, in other words, is as important as the artist; only with the viewer's active

participation, after all, can Duchamp's bride be stripped bare. When he was close to seventy, though, Duchamp said something that cast doubt on his lifelong skepticism regarding the nature and purpose of art. "I believe that art is the only form of activity in which man shows himself to be a true individual," he said. "Only in art is he capable of going beyond the animal state, because art is an outlet toward regions which are not ruled by space and time." The strange thing is that after *The Large Glass,* Duchamp could not seem to find that outlet again. Although his influence on twentieth-century art continued to spread and deepen during the next four decades, he did not produce, until the very end of his life, another work that approximated the scale and ambition of *The Bride Stripped Bare by Her Bachelors, Even.*

The original in Philadelphia deteriorates a little more each year, and the museum's conservators say that because of the way it was made, it cannot be restored. Shattered in transit sometime after its first public exhibition, at the Brooklyn Museum in 1926, the *Glass* was painstakingly pieced together again in 1936 by Duchamp, who claimed afterward that he liked it better with its network of diagonal cracks. Because the original is too fragile ever to be moved from the Philadelphia Museum, four full-size replicas have been made—two with Duchamp's approval and two after his death, authorized by his widow; one is in England, two are in Sweden, one is in Japan.

Although very far from being the most famous art work of our century, *The Large Glass* may well be the most prophetic. The *Glass,* together with the "readymades" that were so closely associated with its development—a bottle-drying rack, a snow shovel, and other manufactured items that Duchamp promoted to the status of works of art simply by selecting and signing them—are primary sources for the conceptual approach that has come to dominate Western art in the second half of the twentieth century, an approach that defines art primarily as a mental act rather than a visual one. In the years since his death in 1968, Duchamp has come to be considered a forerunner of Conceptual art, as well as Pop art, Minimal art, Performance art, Process art, Kinetic art, Anti-form and Multimedia art, and virtually every postmodern tendency; the great anti-retinal thinker who supposedly abandoned art for chess has turned out, in fact, to have had a more lasting and far-reaching effect on the art of our time than either Picasso or Matisse. He never really did abandon painting, as the legend has it. Whenever someone asked him about this, he would explain that at a cer-

tain point in his career he had simply run out of ideas and that he did not care to repeat himself. In the meanwhile, however, the ideas set loose in the world by Duchamp were quietly spreading among younger artists, musicians, dancers, writers, and performers.

It has been argued that Duchamp's influence is almost entirely destructive. By opening the Pandora's box of his absolute iconoclasm and breaking down the barriers between art and life, his adversaries charge, Duchamp loosed the demons that have swept away every standard of esthetic quality and opened the door to unlimited self-indulgence, cynicism, and charlatanism in the visual arts. As with everything else that we tend to say about Duchamp, there is some truth in this. What could be more subversive than the readymades, which undermined every previous definition of art, the artist, and the creative process? To call Duchamp destructive, however, is to miss the point. What he was interested in above all was freedom—complete personal and intellectual and artistic freedom—and the manner in which he achieved all three was, in the opinion of his close friends, his most impressive and enduring work of art. Heavy-duty art critics who pounce on that claim as a cop-out, a tacit admission of his failure to become a great artist, don't have a clue to the new kind of artist that Duchamp became. Approach his work with a light heart, though, and the rewards are everywhere in sight. Duchamp's work sets the mind free to act on its own.

The Large Glass sheds relatively little light on the mystery of Marcel Duchamp, in spite of unending efforts to locate the man in the work. He was a bachelor for most of his life, to be sure, but there was nothing servile (or hostile) in his relationships with women. Duchamp even acquired a female identity at one point, the blithe and somewhat scandalous Rrose Sélavy, who signed a number of their joint works; it was as though, in his quest for complete freedom, Duchamp did not feel obliged to limit himself to the confines of a single sex. Was he sexually ambivalent in his private life, as some amateur Freudians would like us to believe? No, he was not. There is much evidence to suggest, however, that his enormous personal charm derived in no small part from an ability to reconcile, without apparent conflict, the male and female aspects of his complex personality—the MARiée with the CELibataire.

Duchamp is the ultimate escape artist. The *Glass* and *The Green Box* may offer an intriguing portrait of a mind that has been called the most

intelligent of our century, but the man himself eludes us and retains his mystery. "The *Glass* is not my autobiography," he said once, "nor is it self-expression." And what is this book, then, if we concede at the outset that the subject will never be stripped bare? What else but another link in the long chain of non-forgetting: a delay.

Blainville

All sorts of unsuccessful tries
marked by indecision.

S miling photographs of Duchamp are rare. His characteristic expression, in snapshots as well as in formal portraits, is rather somber—not self-conscious but guarded, watchful, unsurprised. A certain gravity must have been part of his nature even as a child, but this was not the part that most people noticed or remembered. What struck close friends and distant admirers alike was how easily he moved through the world. All his life Duchamp traveled light, carrying only enough baggage to sustain basic needs.

In later years, when it was commonly believed that he no longer made art, he liked to tell interviewers that he was simply a *"respirateur,"* a "breather," implying that this was occupation enough for anyone. The French expression *bien dans sa peau*—at home in his skin—fitted him perfectly, in the second half of his life, at any rate, after he had put *The Large Glass* behind him and embarked on his career as a chess player. It was as though the freedom that he had finally achieved in art carried over into his life, so that he could be free of art, too. Interviewers (and there were more and more of these during his last decade, when fame overtook him for the second time) marveled at how easy it was to talk with Duchamp. He replied to their questions in a relaxed, witty, highly quotable style, he never made anyone feel unintelligent, and as a result reporters rarely wrote unkind pieces about him. It was seductive, this lightness of spirit, but it also served to keep others from getting too close. The

corollary to lightness was detachment. He put a high value on what he called the "beauty of indifference."

Not long after his death in 1968, certain art critics and museum people undertook to re-establish Duchamp as a French artist, and not only French but Norman at that. This was understandable, inasmuch as the French had ignored him so thoroughly until then. Only one work by Duchamp had entered a French public collection at the time of his death, and as late as the 1960s, if you mentioned his name in Paris art circles, most people assumed you were referring to the sculptor Raymond Duchamp-Villon, his brother. It can certainly be argued that Duchamp, although he chose to live in New York after 1942 and became an American citizen in 1954, remained all his life, in most respects, a French artist and a Frenchman. The campaign to identify him as a Norman, however, has made little headway. "For my part I shall have to wait until I have met more Normans of this caliber before I decide that we have discovered one of those regional characteristics which Marcel Duchamp himself won't hear of," Robert Lebel, one of his closest friends, wrote in his 1959 monograph on Duchamp's life and work.

Although his mother was Norman-born, his father was not. Justin-Isidore Duchamp, who decided at an early age to jettison his given names and call himself Eugène, came from the Auvergne, near the geographical center of France. Eugène's parents were quintessential *petits-bourgeoises;* they owned a café in the small village of Massiac, not far from Clermont-Ferrand. Like many a thrifty, hard-working provincial couple in those optimistic decades of the 1850s and 1860s, however, the Duchamps expected their children to rise higher in the world than they had. Eugène, the youngest of their four sons (he was born in the revolutionary year 1848), was sent away to be educated at a seminary some thirty kilometers south of Massiac. After graduating, he went to work as a clerk in the registry (tax) office in Fontainebleau. With the outbreak of the Franco-Prussian War two years later, he was called into service and quickly rose to the rank of lieutenant with the Army of the Loire. He was captured by the Germans and spent time in a prison camp in Stettin. When the war ended, he returned to the French civil service, but his climb up the bureaucratic ladder was maddeningly slow. In 1874 Eugène was assigned to the tax office in the town of Damville, in Normandy's Eure valley. This was also the year his father died and the year he married Marie-Caroline-Lucie Nicolle, the daughter of a

well-to-do shipping agent in Rouen. The couple's first two children, both boys, were born in Damville: Gaston in 1875 and Raymond a year later. After five years in Damville the family moved to Cany-Barville, another small town in Normandy. Their daughter, Madeleine, was born there, just a few months before the family's move in 1884 to Blainville-sur-Crevon, a tiny village nineteen kilometers northeast of Rouen, where they would remain for the next twenty-two years. Blainville's notary had recently died, and Eugène, with the help of Lucie's substantial dowry, had been able to buy the notarial practice there and, by doing so, to ensure his own and his family's future.

For more than two centuries the notary has been an essential figure in French life—essential and unique, for there is nothing quite comparable in other cultures. In addition to drawing up deeds, wills, and contracts, notaries are civil servants; they collect taxes and arbitrate disputes. In Eugène Duchamp's day there were few small-town transactions of any kind that did not involve the notary, whose authority extended to giving advice about financial investments and whose intimate knowledge of local affairs allowed him to earn a good deal more from perfectly legal real estate and other dealings than from fees for services. The notary was often a French town's leading citizen and not infrequently its mayor as well.

Eugène Duchamp seemed born for the role. A small, energetic man with a nimble mind and the alert cheerfulness of a good listener, he possessed in greater or lesser degree most of the traits of a social class that was still dominant in France at that time, traits summed up by the French writer Michel Sanouillet as "discretion, prudence, honesty, rigor of judgement, concern for efficiency, subordination of passion to logic and down-to-earth good sense, controlled and sly humor, horror of spectacular excesses, resourcefulness, love of puttering, and, above all, methodical doubt." As a parent he was unusually tolerant, even indulgent; although he naturally hoped that his two older sons would continue the family's upward mobility by joining the ranks of the learned professions, he accepted without too much protest their decisions to become artists instead, and when the son and daughter who were next in line made the same decision, he accepted that, too. Eugène Duchamp, the self-made *bourgeois,* even agreed to help his artist-children while they struggled to establish themselves in their precarious calling, giving them monthly allowances that he meticulously recorded so he could deduct the total from each child's eventual inheritance.

For the amazing run of bad luck that led four of his six children to become artists rather than doctors or lawyers, Eugène Duchamp might well have blamed his father-in-law. Emile-Frédéric Nicolle, Lucie's father, had made a good deal of money as a shipping agent during the years when Rouen, thanks to ambitious dredging operations that enabled large ships to come up the Seine from the Atlantic, eighty-five kilometers to the west, was becoming France's fifth largest seaport. By 1875 he felt wealthy enough to retire from business and devote himself full-time to painting and engraving, his principal interests, which until then he had pursued on weekends and holidays. Nicolle was a first-rate academic draftsman who specialized in picturesque views of his native Rouen. His work sold well in that bustling, rapidly growing city, and his engravings were good enough to be accepted for showing in the Beaux-Arts section of the Universal Exposition of 1878 in Paris.

Emile Nicolle's daughter Lucie also had artistic inclinations, although in her case they were unaccompanied by talent. She painted amateurish street scenes of Rouen and Strasbourg, a city she had once visited, and after her marriage she spent endless hours painting designs on household china. The oldest of four daughters, Lucie took on adult responsibilities at the age of eleven, when her mother died. She looked after her three younger sisters until she married Eugène Duchamp (she was eighteen, he was thirty) and moved away. Born and raised in Rouen, Lucie may well have had difficulty adjusting to life in the small towns of rural Normandy. Although Blainville was only nineteen kilometers from Rouen, the trip took two days—one went by horse cart to the town of Morgny, spent the night, and caught the only train to the city early the next morning. A little less than five kilometers from Blainville lay the town of Ry, which Flaubert had used as the model for Yonville L'Abbaye in *Madame Bovary*. Many of the social attitudes and constrictions that Flaubert set down so indelibly in his novel still governed the lives of men and women thirty years later in the birthplace of Marcel Duchamp.

Henri-Robert-Marcel Duchamp was born at home in Blainville at two o'clock on a hot, dry midsummer afternoon. The date was July 28, 1887. Just a little more than six months earlier, Eugène and Lucie's three-year-old daughter, Madeleine, had died of croup, that merciless child-killer, and there are some indications that Lucie Duchamp was hoping to soften the pain of their loss by producing another baby girl. A photograph of Marcel at three

years shows him in a frilly white dress, his hair cut in bangs and worn long on the sides; although it was not unusual for very young French boys to be dressed that way at the time, three years is a little old for it, and in his case the look is more feminine than the norm.

Duchamp rarely talked about his childhood. When he did, he gave the impression that it had been a happy one, with little conflict and much shared affection, but he also made it clear that this affection did not extend to his mother. Lucie Nicolle suffered from a progressive hearing disorder that had made her almost completely deaf by the time Marcel was born, and she dealt with this by withdrawing more and more into a private world of her own. Duchamp described her as "placid and indifferent." He must have learned at an early age to

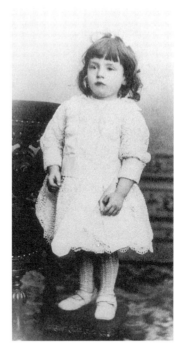

Marcel at age three.

internalize his feelings about her—indifference, after all, would become one of his guiding principles. Duchamp once said that he had "intensely disliked" his mother and that his two older brothers had felt the same way about her. For someone as reticent as Duchamp on the subject of personal relationships, this was a startling admission. He said virtually nothing else about her, though, and Lucie Duchamp, who left no diaries or memoirs, remains a mysterious and silent figure on the fringes of that happy childhood.

For the first two years of his life, Marcel was virtually an only child, both his older brothers having gone away to school in Rouen the year before he was born. If his mother was distant and withdrawn, he nevertheless found a warm ally in Clemence Lebourg, the sweet-tempered country woman who had come to work for the Duchamp family when they moved to her native village of Cany-Barville and who remained with them until Lucie and Eugène died, within a week of each other, in 1925. (A few months after they died, the inconsolable Clemence drowned herself in the Seine.) Marcel "adored" his brothers, who came home for occasional weekend visits in addition to their school vacations, and he often spoke of feeling love and

admiration for his father. The family member he was the closest to through-
out their childhood, however, was his sister Suzanne, born two years after
him in the fall of 1889. The two of them were natural allies. Suzanne, a
tomboy with a boisterous sense of fun, became a willing accomplice in the
games and activities that her brother's fertile imagination provided for them.
Later, when their mother began to devote her attention almost exclusively to
the two youngest children, Yvonne and Magdeleine (born in 1895 and 1898),
Marcel and Suzanne drew even closer together.

The handsome stone-and-brick house they grew up in was, and still
is, the finest in town. Built in 1825, it stands directly opposite the town's
fifteenth-century church; the land in back drops sharply to a broad and
lovely meadow, through which meanders a branch of the Crevon River. To
the left of the front entrance are the dining room and kitchen, to the right
the main *salon;* in the back are two more rooms, where Eugène Duchamp
maintained his notarial office. An impressive spiral staircase of polished oak
leads to the four bedrooms on the second floor (what the French call the *pre-
mière étage*), one of which, in Marcel's youth, could not be entered. This

The notary's house in Blainville.

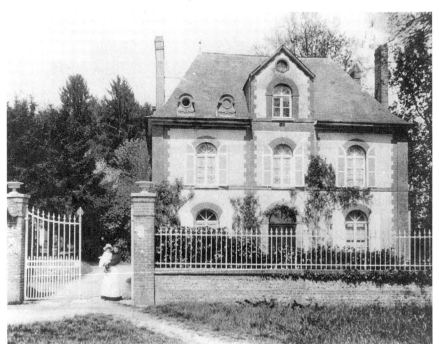

locked "green room," by an old tradition, was set aside for the occasional
short visits to Blainville of the Baron d'Hachet de Montgascon, who lived in
Paris and whose ancestral rights in this region included free lodging in the
town's best private residence. Up one more flight was the attic, where
Clemence slept.

Marcel and Suzanne went to the one-room school in Blainville. It was
in the same building as the *mairie,* where Eugène Duchamp attended meet-
ings of the municipal council—he had been elected to this body within
three months of his arrival. The town had fewer than a thousand inhabi-
tants then, most of whom lived within a few hundred meters of the church.
Today, although the center of town is virtually unchanged, rows of identi-
cal stucco villas on the outskirts have been built to accommodate com-
muters who work in Rouen, less than half an hour away by car. On the hill
behind the Duchamps' house, archeologists are slowly uncovering the ruins

Family gathering, 1895. Seated at the table, clockwise from front center: Gaston
Duchamp, Lucie Duchamp holding Yvonne, Clemence Lebourg, Eugène Duchamp,
Raymond Duchamp, Kettie Guilbert (aunt), Catherine Duchamp (grandmother).
Standing, from left: Marcel Duchamp, Fortuné Guilbert (uncle), Suzanne Duchamp.

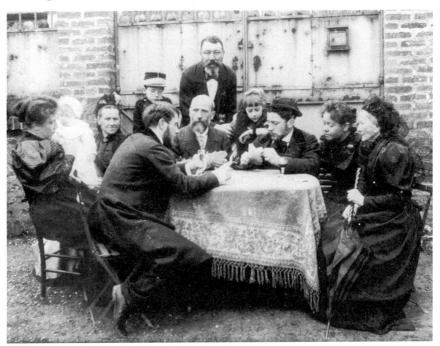

of a medieval *château fort,* elements of which date from the eleventh century. The area has been inhabited since prehistoric times. A settlement called Bleduinvilla on this site is documented in a deed signed in 1050 by William the Conqueror.

Among the early family photographs is one of Marcel at the age of eight or nine, dressed in a military uniform and visored *képi,* standing in front of a tent. He wears the same costume in a slightly later photograph of the whole family sitting around an outdoor table at which Gaston and Raymond are playing cards. The others include Lucie's married sister, Kettie, and her husband; Eugène's widowed mother, the café owner from Massiac, whose finely chiseled profile was inherited by Marcel; Clemence, the family servant, looking uncharacteristically grim; the nearly bald Duchamp *père* with his full but wispy beard; and Lucie, holding in her arms the latest addition to the family, Yvonne Duchamp, born in March 1895. This was also the year that Eugène Duchamp became Blainville's mayor. Named to serve out the term of the previous mayor, recently deceased, Duchamp was elected the following May for a five-year term, and he was re-elected in 1900.

Gaston Duchamp, dark-bearded and heavyset in that 1895 family photograph, was then a law student in Paris. After graduating from the Lycée Corneille in Rouen two years earlier, this quiet, gentle youth had demonstrated his filial piety by going to work first as a notary's clerk in Rouen. When Raymond graduated the next year, though, both sons moved to Paris, Gaston enrolling in the Sorbonne's Faculté de Droit and Raymond in its Ecole de Médecine. The liberating energies of the capital soon undermined Gaston's sense of filial duty. He started going to the Cormon art school on the boulevard de Clichy, taking an eight o'clock class that let out in time for him to get to his first law school lecture. By 1895 he was spending most of his free time sketching and drawing, and that Christmas, when he came home to Blainville for the holidays, he announced that he had decided to quit law school and become an artist. This amazing decision, coupled with Gaston's already well-developed facility for catching people and events in quick, fluid sketches, must have made a considerable impression on eight-year-old Marcel. In March, at any rate, Marcel produced the first art work by his own hand that has come down to us: a crude but extremely careful drawing of a uniformed cavalryman, dismounted, whose horse appears to be running away in the distance. At each corner of the drawing the artist has printed the words *La Cavalerie,* and at the bottom is

a legend reading: "NOTA: this image should go only into the hands of the Duchamp family."

Gaston's new career plan had to wait until he completed a year of military service. Young Frenchmen then were selected by lot for three years' conscription, but lawyers, doctors, and certain other professions were required to serve for only one year. By luck, Gaston was assigned to the 24th Infantry Regiment, which was stationed in Paris, and his military duties did not prevent him from producing a number of landscapes and portraits. Gaston's early paintings showed little originality. He had adopted the murky palette of the Rouen school of artists, who were just then catching up with Impressionism, and his early oils look derivative and overworked. In watercolors and in quick sketches from life, on the other hand, he had a fresh touch and a sure grasp of subject and mood. In 1897 he began selling some of his drawings to *Le Rire* and *Le Courrier Français,* two of the

Marcel and
Suzanne.

popular humorous newspapers of that period. Quite a few of these draw-ings, some published and others not, were inspired by Marcel and Suzanne's games: Marcel pushing Suzanne in a wheelbarrow (adapted from an 1896 photograph); Marcel at a drawing board, asking his scandalized sister to raise her doll's skirt so that he can draw it *"toute nue"*; Marcel reaching down to touch a glowworm, in spite of Suzanne's warning that "you'll burn yourself." The published drawings were signed "Jacques Villon," the name Gaston had chosen for his newborn artist self. The generally accepted explanation for this name change was that doing illustrations for humorous publications that satirized religion, the army, and other bastions of conven-tional morality was considered a risqué occupation at the time, and Gaston wanted to spare his father the embarrassment of seeing the family name appear in that dubious context. Marcel once said, however, that his brother felt the name Duchamp (meaning "of the field") was simply too prosaic for an artist. The name he chose reflected his admiration for the fifteenth-century French vagabond poet, François Villon; it suggests a rebellious spirit that never surfaced in Gaston's life or his work.

In September 1897, the same year that Gaston's drawings began appear-ing in the papers, ten-year-old Marcel left home to follow in his brothers' footsteps at the Lycée Corneille. He traveled alone, taking the horse-drawn coach to Morgny and the train to Rouen. Aunt Marie-Madeleine, his father's sister, met him at the station and took him to the Ecole Bossuet, a *pension* for students who were not boarders at the *lycée*. This is where he would eat and sleep and where he would meet the two boys who became his closest friends: Ferdinand Tribout, the son of a Rouen piano maker, and Raymond Dumouchel, whose father was a notary. For the next seven years these boys would be locked into an educational regime as demanding and as rigid as any yet invented but one that, unlike the corresponding English model, placed its major emphasis on intellectual development.

The Lycée Corneille was a grim stone fortress situated on the rue de Malevrier at the edge of the old center of medieval Rouen. It had been built as a Jesuit college in the seventeenth century, and among its alumni were such illustrious names as Pierre Corneille, whose statue stood in the central courtyard, Jean-Baptiste Camille Corot, Guy de Maupassant, and Gustave Flaubert. Marcel and his fellow sixth-form students were force-fed a heavy diet of Latin, Greek, English or German (Marcel chose German), philoso-phy, history, rhetoric, science, and mathematics. Although never an out-

standing student, Marcel got through these years without encountering any major academic or disciplinary problems. If he questioned the respect for authority that was drilled into every French *lycéean,* he did so only within the circle of his closest friends. He kept a low profile and worked no harder than necessary to get by. The immemorial schoolboy gap between ability and progress is summed up in his case by a school report for the year 1900–1901, which describes him as being "a long way from doing what he could." His best subject was math. He won the second-place math prize at the commencement ceremonies in 1900 and the first-place award in 1902.

Like his two brothers before him, Marcel took drawing lessons at the lycée from Philippe Zacharie, a veteran who also taught at Rouen's Ecole des Beaux-Arts. Zacharie's own work was exhibited annually at the official Salon des Beaux-Arts in Paris—it ran to large allegorical pictures with titles such as *The City of Rouen Protecting Its Schoolchildren Under the Shield of the Republic.* Although Zacharie did all he could to protect his own students from the viruses of Impressionism, Post-Impressionism, and other, more recent developments, he did not altogether succeed. Rouen's rather large artist community had developed, however belatedly, its own version of Impressionist painting, a version that emphasized expressive color while missing almost completely the great innovators' evocation of light and atmosphere. Two of Duchamp's classmates at the Lycée Corneille, Pierre Dumont and Robert Pinchon, eventually became adept practitioners of the style, especially Pinchon, a "baby Impressionist," as Marcel described him, who began having regular shows in Rouen before he was eighteen. Dumont and Pinchon, both day students who lived at home, soon joined Marcel's stable of intimate friends, along with a boy named Gustave Hervieu, nick-named "Poléon" because he supposedly looked like Napoleon. Marcel learned the fundamentals of academic drawing from Zacharie. His real mentor, though, was his brother Gaston, whose fluid and incisive drawing style he admired tremendously and tried hard to imitate.

After a year in the army, Gaston was living the life of an artist in Mont-martre. Marcel once said that his older brother was such a natural artist that if he wanted to describe a visual idea and did not have a pencil handy, he would simply outline it with his finger in the air. For many years, though, his painting took a back seat to the commercial work he did for a living. Posters signed Jacques Villon appeared on billboards throughout Paris at the turn of the century, alongside those of Jules Chéret, Alphonse Mucha,

Marcel at age thirteen.

and Henri de Toulouse-Lautrec. Villon also turned out engravings, aquatints, and lithographs of Paris genre scenes, and he continued to sell his drawings to *Le Rire, Le Courrier Français,* and several other humorous publications. None of his commercial activities brought in much money, and for years Gaston continued to receive a monthly allowance of 150 francs from his father. Eugène Duchamp used to come to Paris once a month on the train to pay his son's bill at Mme Coconnier's restaurant on the rue Lepic, where Gaston took all his meals; the gregarious notary would hardly have gone to the trouble if he had not enjoyed these brief glimpses of the *vie de bohème,* in which he could play a minor but benevolent role.

Raymond Duchamp quit medical school in 1900, having made his own decision to become an artist. A serious bout with rheumatoid arthritis had interrupted his last year of medical training. During a long convalescence he had done a lot of sketching and modeling in clay, and after that there was no turning back. His choice of sculpture as a medium, and the enormous strength and authority that he brought to it, indicates how different he was from his patient and contemplative older brother. The name he adopted for himself, Raymond Duchamp-Villon, nevertheless suggests a certain ambivalence—solidarity with his older sibling vying with family pride. To Marcel, Raymond was and would always be the wunderkind, the family's true genius, the hero whose early death cut short a career of unlimited promise. He had his first sculpture accepted by the Salon des Beaux-Arts in 1902. Raymond's early sculptures were highly realistic figure studies that showed the unavoidable influence of Rodin. Not until 1910 would his work take on the dynamic thrust and rhythm that paralleled the latest developments in modern painting.

Home from school for the Easter holidays in 1902, fourteen-year-old Marcel reacted to the artistic influences around him by producing a number

of drawings in various media that were his first serious attempts at art. Suzanne was his favorite subject—Suzanne in profile, seated in a red arm-chair (watercolor); Suzanne washing her hair (monotype in colored inks); Suzanne tying on a roller skate (wash drawing); Suzanne, full face, looking at us over the back of a chair (pencil and watercolor). Although they lack precocious facility, these early efforts have a confident air about them; they resemble Gaston's drawings, their obvious inspiration, in the ability to cap-ture a likeness or a gesture with a few lines. Marcel gave his sister the draw-ings he did of her, and she kept them all her life.

That summer he did his first paintings in oil. *Landscape at Blainville,* believed to be the earliest, is an Impressionist view of the meadow behind the family house, done mostly in shades of green. Trees reflected in a pool of water dominate the foreground; a small wooden bridge spans the river on the far right; and a row of tall poplars in the background suggests Monet, "my pet Impressionist at the time," as he said. (Although Monet had been living since 1883 at Giverny, less than fifty kilometers from Blainville, Mar-cel knew his paintings only through reproductions.) The picture also intro-duces a theme—landscape with water—that would occur again and again in Duchamp's work.

The two other oils he completed that summer show the Impressionist influence: *Church at Blainville,* a rendering of the village church seen in late-afternoon light, with dark shadows fall-ing diagonally across the foreground; and *Garden and Chapel at Blainville,* a more experimental composition in which splashy brushwork largely obscures the nominal subject. Ambition had clearly set in; a lot of work went into these paint-ings. It would be nearly two years, how-ever, before he tried oil on canvas again. Sometime during the fall or winter of 1902–3, at the Ecole Bossuet in Rouen, Marcel made a small charcoal drawing of a hanging gas lamp of the "Bec Auer" type, whose main feature was a vertical glass filament within a four-sided glass shade. Like the theme of landscape with

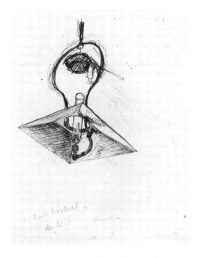

The "Bec Auer" gas lamp drawn by Duchamp in 1902 or 1903.

Church at Blainville, 1902.

water, this little lamp, so carefully rendered in the 1902 drawing, would turn up more than sixty years later in the astonishing *tableau vivant* that was Duchamp's last major work.

It is not easy to catch sight of Marcel during his seven years as a *lycéean*. Small for his age, with the reddish brown hair and lightly freckled, fair

complexion often seen in Normandy but virtually nowhere else in France, he left few distinguishing marks on the school records. In the first round of oral and written examinations for the all-important *baccalauréat,* which he took in the spring of his next-to-last year in 1903, Duchamp received a *"mention passable"*—barely passing. At the prize-giving ceremonies after the commencement address that July, he won a first prize for drawing, but the higher award, the Médaille d'Excellence given annually by the Rouen Société des Amis des Arts, went to his friend Robert Pinchon.

Marcel tested his approaching maturity that summer by going off alone on a fifteen-day trip to the island of Jersey. He stopped in Saint-Malo, Dinard, and Mont-Saint-Michel on the way home, taking in the sights, and afterward he managed to strike a world-weary note in a postcard to his schoolmate Ferdinand Tribout: "I am glad to be back because a trip like that is very tiring." The summer's main event, however, was Raymond's wedding. Raymond had fallen in love with a young widow named Yvonne Reverchon Bon, whose brother, Jacques Bon, was an artist. Raymond and Yvonne—she would be known in the family as *"la grande Yvonne"* to avoid being confused with Marcel and Suzanne's younger sister—were married in Paris that September.

Marcel passed the second part of the *baccalauréat* examinations in June 1904, without honors, and he graduated from the Lycée Corneille at the end of July. At the graduation ceremonies, a mayor of Rouen named M. Lebon delivered not one but two consecutive and lengthy speeches, but when the time for the annual award of prizes finally came around, the long wait turned out to have been worth while. In a reversal of the previous year's results, Pinchon received the first prize for drawing while Duchamp was awarded the medal of the Société des Amis des Arts. The award put an official seal of approval on his own recent decision to become an artist.

Marcel spent part of the long summer vacation visiting his grandmother in Massiac. She still presided over the Café de la Paix there, situated by the bridge over the Alagnon River—in Massiac, she and her late husband had always been known as "Duchamp du pont." Back home in Blainville, he continued to sketch his sisters and brothers, and it was probably during this summer that he painted his first portrait in oils. The subject was Marcel Lefrançois, Clemence's nephew, who used to visit his aunt from time to time and who was almost exactly the same age as Marcel. Many years later Duchamp would explain that this picture "was already a reaction

against the Impressionist influence . . . I wanted to try out a technique of the Renaissance painters consisting in painting first a very precise black and white oil and then, after it was thoroughly dry, adding thin layers of transparent colors." The result was not very impressive, and he abandoned the technique after that one effort and moved on, as he put it, "to direct my research towards all sorts of unsuccessful tries marked by indecision."

Duchamp was no wunderkind. He had the great advantage of knowing what he wanted to do, however, and he had the additional advantage—which was also to some extent an obstacle—of having the way prepared for him by his older brothers. In the fall of 1904, at any rate, with his father's blessing, Marcel left the family home for good and went to live with Gaston at 71, rue Caulaincourt, in the heart of the Montmartre artists' quarter.

Swimming Lessons

I understood at a certain
moment that it wasn't necessary
to encumber one's life with too
much weight . . . And I understood
that, fortunately, rather early.

Montmartre at the turn of the century was a sprawling village, largely untouched by Baron Haussmann's efforts to transform Paris into a modern city. A row of six-story apartment buildings had recently gone up on one side of the rue Caulaincourt, but across the street was a semi-rural landscape of scrub undergrowth and meandering footpaths between jerry-built shacks, many of which had kitchen gardens and pens for goats, chickens, donkeys, and other domestic animals. This undeveloped *maquis,* as it was called, ran all the way up the hill to the Basilique du Sacré Coeur, whose white dome (completed in 1910) could be seen from the front windows of Gaston's apartment.

For more than fifty years Montmartre, with its steep, narrow streets, cheap rents, and raffish nightlife, had been a magnet for artists. Henri de Toulouse-Lautrec moved there in 1885 and rarely left the quarter until his death in 1901. When Pablo Picasso came to Paris for the first time, in 1900, he and his friend Carles Casagemas went first to Montparnasse, where a Spanish friend of theirs had a studio on the rue Campagne-Première. They put down a deposit on a vacant studio in the same building, then hiked across Paris to visit another Spanish friend who lived in Montmartre; he persuaded them that they would be much better off living there instead—

he was leaving in a few days, so they could have his flat. Back they went to the rue Campagne-Première, where they persuaded the landlord to return part of their deposit, borrowed a cart to carry their belongings, and set off once again across Paris. Struggling wearily up the rue Lepic for the second time, Picasso and Casagemas passed Duchamp's older brother Jacques Villon, whom they had met earlier in the day and who assumed that the young Spaniards with their cartload of baggage were doing what penniless artists so often did—skipping out on the rent somewhere else. "Villon's mocking laughter made this misapprehension all too obvious," according to John Richardson, who tells the story in the first volume of his monumental *A Life of Picasso*. "Picasso's Spanish pride was wounded; years later he still held this laugh against Villon."

Villon was working mainly as a commercial artist, but he showed his paintings at the annual Salon des Indépendants, and he never wavered in his ambition to be a serious painter. Marcel's priorities were not that clear. He had realized very early, he said, "how different I was even from my brother [Villon]. He aimed at fame. I *had* no aim. I just wanted to be left alone to do what I liked." The freedom to do what he liked was certainly one of the central motives, if not *the* central motive, in Duchamp's life, but was art for him merely a means to this end? He said as much on several occasions, and he often expressed scorn for overinflated artistic egos and for the "religion of art." At the outset of his career, however, the seventeen-year-old Duchamp suffered a humiliating setback that may have had some bearing on his skeptical attitude. In the spring of 1905, a few months after moving to Paris, he took the examination for the Ecole des Beaux-Arts and failed it. The fact that he took the exam at all—something neither of his brothers had done—suggests that he may have been more ambitious than he let on. The Ecole des Beaux-Arts was still the principal gateway to recognition as an artist, and its two-year regimen was not something one embarked on lightly.

Duchamp, to be sure, had been fairly cavalier about his courses at the Académie Julian, the private art school in which he had enrolled the previous November. With studios in four different locations around Paris, the Académie Julian was a flourishing institution whose traditional teaching methods, supervised by the reigning *maître*, Alphonse Bouguereau, emphasized drawing from live models and from plaster casts. Duchamp paid in advance for morning classes at the branch at 5, rue Fromentin, a ten-minute

walk from where he lived, but he soon found that he preferred to spend the mornings playing billiards at his local café. His main artistic activity during this period was jotting down quick visual impressions in a pocket sketchbook. "That was the fashion among artists," as he recalled it. "You had to have a sketchbook in your pocket all the time, ready for action at any provocation from the physical world." One of the few surviving Duchamp sketchbooks shows quick pencil impressions of his brothers and sisters, of Jacques Villon's dog, and—interestingly, in the light of his future *Large Glass*—several pages of pencil-and-watercolor drawings of working-class Parisians in the distinctive uniforms or work clothes of their occupation: policeman, knife grinder, gas man, vegetable peddler, street sweeper, funeral coachman, undertaker.

For Duchamp, who valued his freedom so highly, the new conscription law passed by the legislature that spring came as an unpleasant surprise. Instead of three years' military service for a relatively few individuals who were selected by lot, the new law made all healthy young Frenchmen subject to a two-year enlistment—with the exception of doctors, lawyers, and some others who were engaged in what the inscrutable French state considered essential professions, and who could get off (as Gaston Duchamp had done because he was a law student) with serving only one year. One of these essential professions happened to be "art workers" (*ouvriers d'art*)—not artists, but printers, engravers, and other skilled technicians in what we would call the applied arts. Faced with the prospect of two years in uniform, Duchamp decided to become an *ouvrier d'art*. He cut short his paid-up classes at the Académie Julian and left Paris in May to go to work as an apprentice at the Imprimerie de la Vicomte, a well-established print shop in Rouen. Why Rouen? The main reason was that his parents had recently moved there. Eugène Duchamp, financially secure after twenty-two years as Blainville's notary and ten as its mayor, had retired early in 1905, sold the house and the notarial practice, and taken a comfortable two-floor apartment on the rue Jeanne d'Arc in his wife's beloved city of birth. Here Marcel settled once again into family life.

Five months later, having mastered the techniques of etching, engraving, and typesetting, he took an examination in his new trade. The examining board in Rouen "was composed of master craftsmen," he recalled, "who asked me a few things about Leonardo da Vinci. As to the written part, so to speak, you had to show what you could do by way of printed engravings."

Duchamp had procured for this purpose one of his grandfather Emile Nicolle's copper plates of *The Hundred Towers of Rouen,* a very popular series in its time, and he pulled from the press a print of this plate for every member of the jury. "They were enchanted," he said. "They gave me 49 out of a possible grade of 50." With his certificate as an *ouvrier d'art* in hand, Duchamp presented himself to the military authorities on October 3 and reported for duty the following day with the 39th Infantry Regiment in Rouen.

Very little is known about his military service other than that he was stationed not far from Rouen in the town of Eu, promoted to corporal in April, and discharged in October 1906. He headed straight back to Paris, where he rented a bachelor flat at 65, rue Caulaincourt, a few doors down the hill from Gaston's former lodgings. For the first time he was completely on his own, both his brothers having recently moved to the quiet rural sub- urb of Puteaux, just across the Seine from Neuilly on the city's western out- skirts. Jacques Bon, Raymond's artist brother-in-law, had discovered a group of inexpensive "pavilions with artist's studios," with a shared garden in back, at 7, rue Lemaître in Puteaux. Gaston took one of them, Raymond and Yvonne took another, and the Czech artist Frantisek Kupka, a former neighbor of Gaston's on the rue Caulaincourt, moved into a third, creating on the spot an artists' colony that would give Puteaux a place in art history. For Gaston—or Jacques Villon, as he wished to be known and will be known from now on in these pages—the move was a lifesaver. The Bohemian atmosphere of Montmartre had never agreed with his easily imposed-on good nature. "The worst thing for me was when my friends started to encroach on me," Villon told Pierre Cabanne. "They came over to smoke their pipes, brought along their women, and stopped me working. I had to make up at night for the time they wasted during the day." He lived in Puteaux for the rest of his life, virtually ignored by the art establishment until, in his seventies, the fame that he had long since stopped thinking about sought him out at last.

Duchamp's year in the army gave his recovered freedom a delicious savor. Instead of re-entering the Académie Julian, he slipped easily into the role of a *flâneur*—a detached observer of the passing scene, whose artistic leanings required no undue expenditure of effort. He saw a lot of his former classmate Pierre Dumont, who was also living the artist's life in Montmartre,

and he formed a lifelong bond with Gustave Candel, the son of a prosperous cheese merchant, who lived with his parents at 105, rue Caulaincourt. The elder Candels took a great fancy to Marcel and invited him to dinner at least once a week. Among the would-be artists flocking to Montmartre in ever-increasing numbers was a young Spaniard named Juan Gris, with whom Marcel often played billiards at the café on the corner of the rue Caulaincourt and the rue Lepic. Gris was already an acolyte of Picasso; he lived in the Bateau Lavoir, a dilapidated house in a seedy and rather dangerous neighborhood on the other side of Montmartre, where Picasso had settled in 1903. Picasso's reputation was spreading beyond Montmartre at this point—the German collector Wilhelm Uhde and the Americans Leo Stein and his sister Gertrude had started buying his work in 1905, and young artists in Paris spoke of him with a certain awe. Although Duchamp saw quite a lot of Gris, he steered clear of Picasso then and later, perhaps because he valued his own independence too highly.

He did not steer clear of his brothers—far from it. Nearly every Sunday Marcel went out to Puteaux, where in good weather the artists and their friends spent the day playing *spiroballe* (a racquet game with a ball on a long string attached to a post) and enjoying long, slow lunches at a table in the garden. Usually there would be a chess game in progress. Villon had taught Marcel to play chess when he was eleven, and all three brothers had a passion for the game.

At this point Duchamp seemed to have set his sights on becoming a humorist. A successful illustrator could make good money in those days, and Adolphe Willette, Lucien Metivet, Théophile-Alexandre Steinlen, Jean-Louis Forain, and other widely published satirists were minor celebrities. (As a young art student in Barcelona, Picasso had been so impressed by Steinlen and Forain that he imitated their signatures over and over in his sketchbook, an act that John Richardson interprets not as forgery but shamanism—an attempt to assimilate their powers.) The circle of Paris artist-humorists met regularly at Manière, a café-brasserie on the ground floor of Marcel's building at 65, rue Caulaincourt. Duchamp and Juan Gris, who both hoped to join their illustrious ranks someday, used to take their own drawings around to the offices of *Le Courrier Français, Le Rire,* and other papers, but it would be two years before either of them sold one. In the spring of 1907, however, Duchamp had five of his drawings accepted for

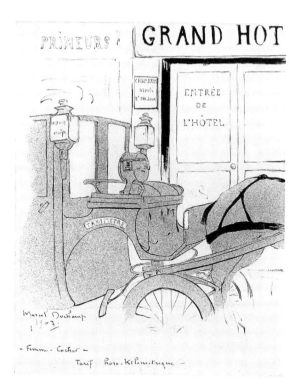

Femme-Cocher, 1907.

exhibition in the first Salon des Artistes Humoristes, organized by the editor of *Le Rire* and held in a popular ice-skating arena called the Palais de Glace. Only two of these drawings have survived. *Femme-Cocher* was a topical reference to the first women hack drivers in Paris; it shows a horse-drawn cab, sans driver, pulled up in front of a hotel, where the driver and her fare have presumably gone for activities unrelated to transportation. *Flirt,* the other surviving drawing, is more old-fashioned—it depends on an involved pun contained in several lines of dialogue between a stylish young woman playing the piano for her male admirer: *She—Would you like me to play "On the Blue Waters"? You'll see how well this piano gives the impression suggested by the title. He (witty)—Nothing strange about that, it's a watery piano.* (In French the words for grand piano, *piano à queue,* sound like *piano aqueux,* or "watery piano.")

Duchamp was living on the 150 francs a month (about seven dollars at the existing rate of exchange) that he received from his father. Duchamp *père,* in his affluent retirement, could easily afford the monthly subsidies

The summer group at Veules-les-Roses in 1911. Duchamp is at the far left.

that he still gave to all three of his sons. He could also afford to rent a seaside villa for family vacations. Starting in 1907 and for the next four summers, Duchamp spent most of the month of August with his parents and sisters at Les Peupliers, a red brick cottage in the village of Veules-les-Roses, on the Normandy coast between Dieppe and Le Havre. Less fashionable than Deauville and not as spectacular as nearby Etretat, whose high chalk cliffs and eroded rock formations appear in so many Impressionist paintings, Veules-les-Roses attracted summer visitors from Paris as well as from Rouen. Marcel and his sister Suzanne became part of a lively group of young people there who met regularly to play tennis, go on bicycle rides and picnics, and dance each evening at the local casino. Duchamp, who did not dance, gained a reputation for being charming, witty, and somewhat aloof.

He also started to paint again. Several *plein air* landscapes and a view of high chalk cliffs and sea, all done in the summer of 1907, show him dipping a tentative toe into Fauvism. Two years earlier Duchamp had visited the Salon d'Automne in which the violently colorful paintings by Henri Matisse, André Derain, and Maurice de Vlaminck had lead the critic Louis Vauxcelles to refer to these artists as "wild beasts [*fauves*]." It was an important event in his life. "[Matisse's] paintings at the 1905 Salon d'Automne

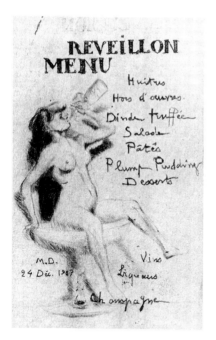

Duchamp's Christmas Eve
menu, 1907.

really moved me," he said, "particularly his big, flat-tinted red and blue figures ... it was at the Salon d'Automne that I decided I could paint." If so, he was in no hurry to act on the decision. Not until 1908, when Fauvism had been largely abandoned by its founders, did he experiment freely with the bold, unmodulated colors of the Fauves in paintings such as *Peonies in a Vase* and *Red House Among Apple Trees*—paintings that also showed the gentler influences of Pierre Bonnard's intimate late Impressionism.

Duchamp was making headway as an illustrator. Four of his drawings appeared in the second annual Salon des Artistes Humoristes, in March 1908, and in November he published his first drawing in *Le Courrier Français*. By this time, however, he was no longer living the life of an urban *flâneur*. He had been evicted from his new apartment (he had recently moved from number 65 to number 73, rue Caulaincourt) because of a wild Christmas party the previous December that went on for two days and infuriated the neighbors. Under French law, evicted tenants were given six months to find new lodgings. Instead of renting a new flat in Montmartre, Duchamp had moved to 9, rue Amiral-de-Joinville in Neuilly, a short walk from his brothers' place in Puteaux and only a few blocks from his godmother Julia Pillore's apartment on the avenue Victor Hugo. Family ties were still very important in Duchamp's life. But the main reason for his move to Neuilly was probably a desire to get away from the distractions of Montmartre so that he could concentrate on painting. Over the next five years, at any rate, living in Neuilly and spending a lot of time with his brothers, he would catch up with and assimilate most of the quickening currents and crosscurrents in modern art.

Jacques Villon was on the executive committee of the 1908 Salon d'Automne, the important annual exhibition that had been established in 1903

as a complement to the spring Salon des Indépendants, and Raymond Duchamp-Villon served on its sculpture jury. Unlike the increasingly derided Salon des Beaux-Arts, which was restricted to members of the official Académie des Beaux-Arts, the Indépendants and the Salon d'Automne were open to anyone whose work gained the approval of their annually elected painting and sculpture juries; after a third acceptance, an artist became a *sociétaire,* which meant that the jury's approval was no longer required. In 1908 the Salon d'Automne's painting jury, whose members were Henri Matisse, Albert Marquet, and Georges Rouault, voted to hang three paintings by Marcel Duchamp. The jurors who gave Duchamp his Paris debut as an artist rejected the paintings submitted that year by Georges Braque—paintings that Matisse described as being made of "little cubes." When these same pictures were shown at Daniel-Henri Kahnweiler's tiny gallery on the rue Vignon soon after the Salon d'Automne closed, the critic Louis Vauxcelles echoed Matisse by writing disdainfully in *Gil Blas* that "Braque reduces everything to geometrical forms, to cubes." Cubism had been born, but for the moment few people noticed.

The pictures that Duchamp showed at the 1908 Salon d'Automne—*Portrait, Flowering Cherry Tree,* and *Old Cemetery*—drew no comment from any critic. (*Flowering Cherry Tree* may have been the painting known today as *Red House Among Apple Trees;* the other two have not survived.) The critics also ignored two Duchamp canvases that were accepted by the Salon des Indépendants the following spring, although to Duchamp's great surprise, he found at the close of this exhibition that one of his submissions, a now-vanished townscape entitled *Saint-Cloud,* had been sold to an unknown buyer for one hundred francs. The price was insignificant—less than five dollars—but that was beside the point. In those years, when the Paris avant-garde was unaware of its own imminent triumph, only the despised artists of the academy entertained any ideas of earning a living through their art. Artists who looked for new paths were treated like pariahs, as Duchamp said, and "We were delighted to be pariahs." What counted was the opinion of other advanced artists—especially if they happened to be your brothers. In his paintings that summer at Veules-les-Roses, Duchamp experimented with a more restrained palette. Three of his new pictures were accepted by the jury for the 1909 Salon d'Automne, and one of them, a nude study described at the time as a "nude on a couch," was sold. The buyer this time turned out to be Isadora Duncan, then approaching the zenith of her fame, who let it be

known that she planned to give it to a friend for Christmas. The friend was never identified; the picture has disappeared.

Female nudes painted in the Fauve style, with heavy black outlines and arbitrary colors, occupied Duchamp for several months in 1910. This was his first serious attempt to deal with a subject that would soon become a primary interest for him, but the results were not impressive. In spite of the thick impastos of the paint handling and the voluptuous contours of the models, who are seen close-up in shallow space, there is a tentative, uncertain quality to these pictures. Areas of paint laid down with a palette knife alternate with roughly brushed passages and even some patches of bare canvas, in the manner of Cézanne, but the overall effect is clumsy rather than daring, and the paintings have very little erotic charge. Guillaume Apollinaire, who had recently emerged in Paris as the primary spokesman and promoter of the latest artistic developments, nevertheless took note of two Duchamp nudes at the 1910 Salon des Indépendants—he described them in L'Intransigeant as "très vilains" ("very ugly"), which may well have been a compliment. Duchamp and Apollinaire did not know each other at this point, but the poet-critic's enthusiasm for Fauvism and for the early Cubist dislocations of Picasso and Braque made him well disposed to work that lay outside traditional canons of beauty.

Duchamp exhibited four pictures at the Indépendants that year, which was also the year of the Boronali hoax. An artist named Joachim-Raphael Boronali, founder of the new school of "Excessivism," was revealed to be none other than Lola, a donkey belonging to the owner of the famous Montmartre café the Lapin Agile; photographs were circulated of Lola, with a brush tied to her tail, "painting" the large picture that hung in the salon, and thousands of visitors flocked in to enjoy the joke—a joke on the Salon that many took to be a joke on modern art.

Although Duchamp had abandoned Montmartre for Neuilly, he went to all the important exhibitions in Paris and often stayed to make a night of it with his artist friends or with Ferdinand Tribout and Raymond Dumouchel, his former schoolmates at the Lycée Corneille, both of whom had recently finished medical school and moved to Paris. Duchamp had a new friend that spring, a young German art student from Munich named Max Bergmann, who was visiting Paris for the first time. Bergmann's diary records more than a dozen meetings with Duchamp during March and April, including one all-night adventure that began

with a hearty supper at Mme Cocon-
nier's restaurant on the rue Lepic
(where Eugène Duchamp used to
pay for Villon's board), continued at
the Bal Tabarin and then the elegant
Taverna Olympia on the boulevard
des Capucines, and wound up after
midnight, back in Montmartre, at a
well-known, elaborately decorated
brothel on the rue Pigalle.

Three weeks later, at the Salon
des Beaux-Arts in the Grand Palais,
Duchamp introduced Bergmann to a
pretty young woman named Jeanne
Serre, who had recently moved into
an apartment just across the street
from Duchamp's in Neuilly. Twenty
years old, married but estranged
from her husband, she had decided to
escape her restricted background by
becoming an artist's model—perhaps
with Duchamp's help. Bergmann

Jeanne Serre, circa 1910.

was quite struck by his friend's dark-haired "new conquest," whom he met
again ten days later when the three of them spent an evening together on
the town. There was no hint, however, of anything binding or exclusive
about the liaison. Duchamp, at twenty-three, had already taken on the
wariness of a dedicated bachelor. His attitude toward marriage was sug-
gested by a grim drawing he did in 1909 called *Dimanches* (*Sundays*), which
shows a soberly dressed suburban couple, the husband pushing a baby car-
riage, the wife heavily pregnant, both looking terminally miserable. It was
an attitude he would never completely abandon. "The things life forces
men into," he said forty years later, "—wives, three children, a country
house, three cars! I avoid material commitments. I stop. I do whatever life
calls me for." If life called upon him to be an artist, he felt, then marriage
was to be avoided at all cost.

The influence of Cézanne appeared—somewhat belatedly—in
Duchamp's painting for the first time in 1910. The Cézanne retrospective at

Dimanches (Sundays), 1909.

the Salon d'Automne in 1907, one year after the artist's death, had come as a revelation to many painters in Paris. Picasso would soon call the reclusive Aix master "the father of us all," and countless others found in Cézanne's solid pictorial structure the necessary antidote to Impressionist looseness and sentimentality. Duchamp later made conflicting statements about Cézanne's influence on him. He told Pierre Cabanne that in the circle of humorist artists he frequented, "The conversation centered above all on Manet," not Cézanne, and he went on to say that his own discovery of Matisse had been much more of an event in his life than his discovery of Cézanne. At other times, however, Duchamp spoke of himself as being under the influence of Cézanne for two years or more, and he cited his 1910 portrait of his father as "a typical example of my cult of Cézanne mixed up with filial love." The *Portrait of the Artist's Father* that he referred to is clearly Cézannian in its balanced structure and its use of somber earth tones rather than Fauvist color; it is also the best painting of Duchamp's early career, a penetrating psychological study of a shrewd yet thoughtful man, who sits in his armchair, legs crossed, one hand supporting his head, his deep-set eyes gravely interrogating the viewer.

Duchamp painted several other portraits in 1910, including a very strange one of his friend Dumouchel. The young doctor is shown in three-quarter-length profile against a background of Fauve colors. The head, which is too large for his body, is surrounded by a shimmering violet aura, or halo, and so is the left hand, which Dumouchel holds in front of him with the fingers splayed. On the back of the canvas, which Duchamp gave to Dumouchel, he wrote: "*à propos de ta 'figure,' mon cher Dumouchel*" ("apropos your 'face,' my dear Dumouchel"). A number of theories have

Portrait of the Artist's Father, 1910.

been advanced regarding the halos, many of them centering on the wave of popular interest in extrasensory perceptions and "emanations" that was set off by Wilhelm Conrad Roentgen's discovery of X rays in 1895. It has been pointed out that when Raymond Duchamp-Villon was an intern at the Salpêtrière Hospital in Paris in 1898, he had been in contact there with

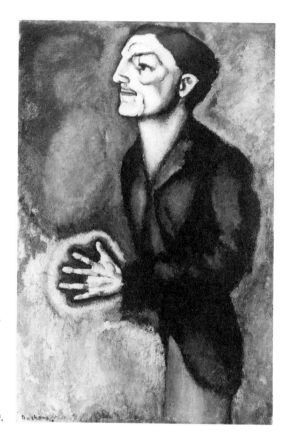

Portrait of Dr. Dumouchel, 1910.

Albert Londe, one of the pioneers in X-ray research; scholars have also noted that Marcel and Dumouchel's schoolmate Ferdinand Tribout would go on to become a major figure in the field of radiology. Duchamp never said anything to bear out such speculations. What he did say was that the picture, which has the look of a caricature, represented his first attempt to inject humor into his painting. Much later, when his friend and patron Walter Arensberg asked him specifically about the halo around Dumouchel's hand, Duchamp replied that it was "*not* expressly motivated by Dumouchel's hand" and that "it has no definite meaning or explanation except the satisfaction of a need for the 'miraculous.' " That "need for the miraculous" would find expression, as we will see, in several other paintings done in 1910 and 1911, paintings that remain—in the light of Duchamp's well-developed skepticism—as mystifying as the *Portrait of Dr. Dumouchel*.

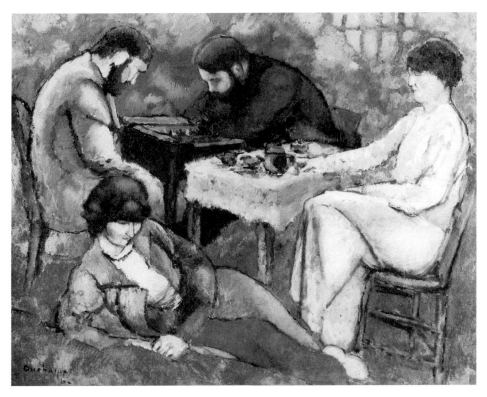

The Chess Game, 1910.

Duchamp's most ambitious painting in 1910—and his largest to date—was done that summer in the garden at Puteaux. Called *The Chess Game,* it shows his two older brothers hunched over a chess board at an outdoor table, and their wives in the foreground—Gaby Villon sits at a table laid for tea, Yvonne Duchamp-Villon reclines on the grass. There is no attempt at psychological portraiture here; the men are virtually featureless, the women locked away in their separate and isolated reveries. A memory of Cézanne's *Card Players* seems to hover over the scene, but the painting has none of Cézanne's monumental solidity. The figures inhabit the shallow space awkwardly; the composition is inert. Duchamp showed the picture and four other recent canvases at the Salon d'Automne in October; since this was his third consecutive appearance at the salon, it qualified him as a *sociétaire* who could show there in the future without having to submit to the jury's approval. There were no sales this time, and no critic mentioned Duchamp's entries.

Up to this point, the most perceptive art critic could have found little to write about in Marcel Duchamp's paintings. He was still in the phase of what he would later call his "swimming lessons," moving restlessly but tentatively from Post-Impressionist landscapes to Fauve nudes to Cézanne-influenced portraits and figure studies. He had shown evidence of originality and talent but no great dedication—compared to other artists, his output was meager. Nothing in Duchamp's work prior to 1911 prepares us for its meteoric trajectory over the next four years.

Puteaux Cubism

Bête comme un peintre was the saying in France all through the last half of the nineteenth century, and it was true, too. The kind of painter who just puts down what he sees *is* stupid.

Duchamp's swift transition from indecisive apprentice to radical innovator begins with *Sonata,* a painting he started to work on in January 1911, during the New Year's holiday at his parents' home in Rouen. The subject is a musical performance by his three sisters—a regular occurrence at Duchamp family reunions—but there is no sense of contact between any of the participants; like the wives in *The Chess Game,* each one looks away from the others. Yvonne is at the piano, Magdeleine plays the violin, Suzanne is seated in front of them, and their mother, presumably deaf to the sounds being made, stands like a totem in the background. "The pale and tender tonalities of this picture, in which the angular contours are bathed in an evanescent atmosphere, make it a definite turning point in my evolution," Duchamp said in 1964. The pale tonalities were borrowed from Jacques Villon, whose lyrical version of Cubism was the model for Marcel's first Cubist picture, but the rather mannered elegance of the figures, and their symmetrical placement in the shallow space of the painting, suggest that Duchamp had in mind a visual rendering of a musical theme or, perhaps, of the sonata form in poetry. "The theory of Cubism attracted me by its intellectual approach," as he explained it years later. In embracing

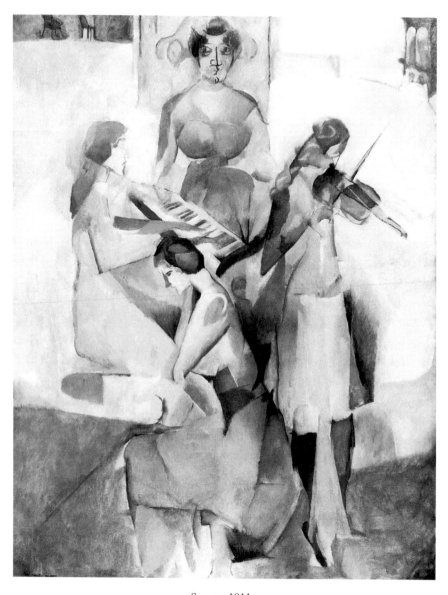

Sonata, 1911.

Cubism, however, Duchamp also said that he "wanted to invent or find my own way instead of being the plain interpreter of a theory."

One of the main differences between the Cubism of Picasso and Braque and that of their followers was the latter group's emphasis on theory. Working in virtual isolation from other artists, Picasso and Braque had created

the new pictorial language of Cubism without recourse to theories, manifestos, or verbal explanations of any sort. During the years of their most intensive collaboration, between 1908 and 1914, when they felt, as Braque put it, "like two mountaineers roped together," seeing one another's work every day was the main stimulus for the most complete and daring revolution in visual art since the Renaissance. Picasso refused to show in the big Paris salons, and Braque had stopped showing in them after the 1908 Salon d'Automne. Their latest paintings could be seen at the Galerie Kahnweiler, however, and the repercussions were swift and seismic.

A group of Cubist-influenced artists, most of whom had been painting until recently in the Fauve style, began to meet regularly in 1910 at one another's studios and at the Closerie des Lilas, the famous old Montparnasse café, where the Tuesday evening gatherings sponsored by Paul Fort's literary journal, *Vers et Prose,* brought together the older generation of Symbolist poets and writers and the rising generation of artists. The Cubist group—Robert Delaunay, Jean Metzinger, Albert Gleizes, Henri Le Fauconnier, Fernand Léger, and one or two others—felt the need to discuss and analyze the radical innovations of Picasso and Braque: the flattening out of pictorial space within the painting, so that a picture was no longer a window to look through but an object in itself; the fusion of image with background; the juxtaposition of representational and abstract elements; and, most strikingly, the shifting point of view that depicted objects within the painting from different angles simultaneously. These artists also believed that their work would have a greater impact if they exhibited together as a group, and with the support of the writers Guillaume Apollinaire and André Salmon, they prevailed on the hanging committee of the 1911 Salon des Indépendants to let them do just that. The result was a public sensation. Salle 41—the Cubist room at the Indépendants—was jammed to capacity on opening day, mainly by onlookers who were fully prepared to be outraged by the Cubists' well-publicized assault on pictorial conventions. The storm of derisive criticism that followed in the press was offset by Apollinaire's long review in *L'Intransigeant,* which established him as the movement's champion and leading spokesman. Cubism was suddenly catapulted into the public domain—without the participation of its founders. Picasso and Braque remained completely aloof from the newly formed Cubist group, whose theoretical discussions and idealist goals held no interest for them at all.

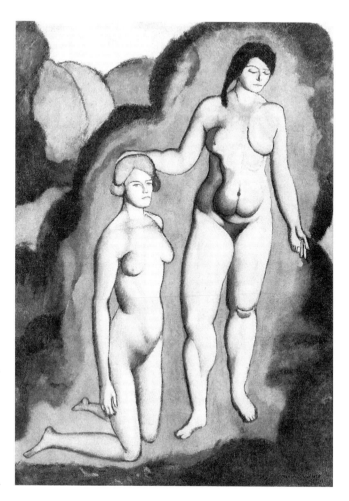

The Bush, 1910–11.

The Duchamp brothers were not represented in Salle 41. *Sonata,* Marcel's Cubist overture, was not finished at the time—he had put it aside and would not go back and complete it until the fall—and the three paintings that he did submit to the 1911 Indépendants showed no Cubist influences whatsoever. Two of them were Fauvist landscapes. The third, which he called *The Bush,* was one of the "allegorical" paintings that occupied him at this time.

In *The Bush* two fairly naturalistic female nudes seem to be enacting some sort of esoteric ritual. One of them is kneeling; the other stands, resting her right hand on the head of the kneeler, as though presenting her to an unseen authority. (According to Jennifer Gough-Cooper and Jacques Cau-

mont, who have dedicated many years to documenting Duchamp's life, the model for the kneeling figure was Jeanne Serre, Duchamp's mistress at the time.) Two similar figures appear in *Baptism,* painted soon after *The Bush,* although here they are depicted less naturalistically, and the hand of the more mature woman is extended in a protective gesture over the head of the initiate. *Draft on the Japanese Apple Tree,* also painted in the spring of 1911, shows a faceless and shapeless figure, presumably female, sitting on the grass under a spindly tree whose pink foliage has a semi-abstract, windblown shape. Did these three pictures have to do with the "need for the miraculous" that Duchamp recalled in his 1951 letter to Walter Arensberg? His offhand and possibly facetious remark has encouraged symbol hunters to comb the undergrowth in *The Bush* and its successors, and they have flushed out various clues to initiation rites and the attainment of spiritual enlightenment in various Eastern religions. Their speculations might carry more weight if applied to a lifelong spiritualist like Kupka, the Duchamp brothers' neighbor in Puteaux, but there is not the slightest evidence that Duchamp himself ever read about or took any interest in such arcana, and after 1910 his work shows no further concern with auras, symbolism, or "the miraculous." Duchamp did say that he was influenced around this time by the work of Odilon Redon (1840–1916), whose dreamlike lithographs and visionary oils would later be so prized by the Surrealists. He also described *The Bush* as "a turn toward another form of Fauvism not based on distortion alone," and in the same statement he went on to add, somewhat confusingly, that this was the first time he had used "a non-descriptive title" for a painting—a remark that would appear to undercut the symbol hunters' identification of the blue shape behind the two nudes as a bush. (Arturo Schwarz sees it as the "burning bush" of Indian and Judeo-Christian iconography.) The blue shape does look like a bush, nevertheless, and in fact Duchamp continued to give his paintings titles that could be called descriptive—although not in the literal sense. Starting with *The Bush,* Duchamp said, "I always gave an important role to the title, which I added and treated like an invisible color."

Young Man and Girl in Spring, the last of the allegorical pictures, is also the most perplexing. Duchamp painted two versions of it: a small one done in the spring of 1911, and a larger canvas, which he probably submitted to the Salon d'Automne that fall and which he later painted over. In both, two slender and androgynous figures are shown in profile, reaching upward into a tree whose lower branches are laden with fruit. Adam and Eve come

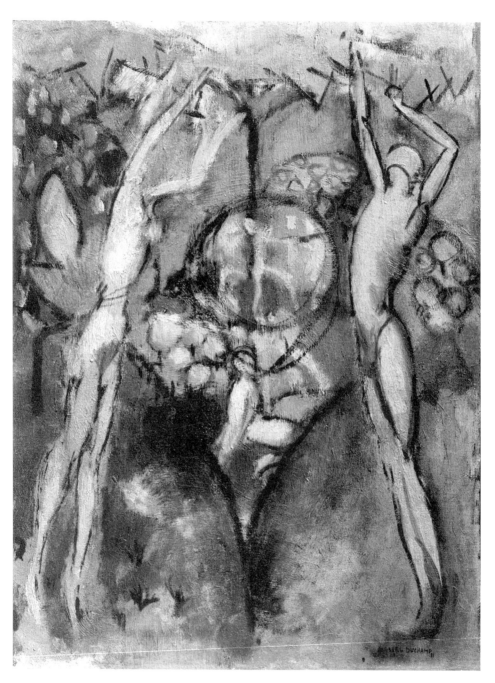

Young Man and Girl in Spring, 1911.

quickly to mind. Marcel had already broached this theme in a painting called *Paradise,* done the year before, which shows his friend Dumouchel as a nude Adam covering his genitals with both hands as he faces the seated nude figure of the Duchamp brothers' favorite model at the time, a woman known as "the Japanese"; there is no sign of the serpent in *Paradise,* however, and the lack of any apparent connection (physical or psychological) between the man and the woman makes me doubt that the scene has anything to do with postcoital "knowledge," as some analysts have assumed it does, or with any other aspect of the primordial garden event. No serpent is to be found in *Young Man and Girl in Spring,* either, but the smaller version has several elements that have given rise to no end of esoteric theorizing. Within a black circle centered between the two upward-reaching figures, a tiny nude makes an ambiguous gesture, while beneath this one, still another indistinct nude figure sits on the ground. Green, pink, yellow, and flesh tones predominate, and there are hints of lush foliage and blue sky. Painted in the spring of 1911, the first version of *Young Man and Girl in Spring* became Marcel's wedding gift to his sister Suzanne, who was married that summer to a Paris pharmacist named Charles Desmares. According to Arturo Schwarz, it is the key painting of Duchamp's early career, a work that anticipates the major themes of *The Large Glass* and unlocks the psychological and philosophical secrets of his life.

Like many of the leading authorities on Duchamp, Arturo Schwarz has very little sense of humor, and this sometimes makes his writings extremely funny. In *The Complete Works of Marcel Duchamp,* the vast monograph and catalogue raisonné that Schwarz brought out in 1969, fifteen pages are devoted to unearthing the hidden symbolic content of *Young Man and Girl in Spring.* With references to Egyptian hieroglyphics, Gnostic texts, the Hebrew cabala, Tantric yoga, Greek mythology, Plato, the Upanishads, Buddhism, alchemical texts dating from medieval times to the sixteenth century, and such relatively up-to-date authorities as Freud, Jung, and Mircea Eliade, Schwarz proves to his own satisfaction that Duchamp had an incestuous passion for his sister Suzanne and that his need to repress and sublimate this passion led him to the use of images drawn from the ancient theory and practice of alchemy. Schwarz protects his flanks by stating that Duchamp's illicit desire for Suzanne was entirely unconscious and that he was influenced by "forces and drives of which he was ignorant." Putting Duchamp on the couch, Schwarz finds great psychological significance in

the fact that he gave *Young Man and Girl in Spring* to Suzanne as a wedding present, and he goes on from there, at truly impressive length, to discuss the esoteric symbolism of the brother-sister duality, the incest taboo, and its eventual resolution in alchemical terms—the goal of alchemy being, Schwarz informs us, the reconciliation of philosophical opposites, for which the transmutation of base metals into gold is simply a metaphor. The argument takes on hilarious overtones in the light of Duchamp's tongue-in-cheek statement to Robert Lebel (which Schwarz gamely cites in a footnote): "If I have practised alchemy, it was in the only way it can be done now, that is to say without knowing it."

Alchemy and incest aside, *Young Man and Girl in Spring* can just as readily be seen as a lyrical ode to the joys of marriage, in the tradition of the Greek epithalamium. The Duchamp scholar Francis Naumann has pointed out that the little nude figure within the orb might then appear to be the future child of this upward-reaching couple; the pink and yellow tonalities would represent spring foliage (as indicated in the title); and the twin semicircular forms at the bottom, which Schwarz insists on seeing as buttocks (but only if the picture is turned upside down), could be seen to form a heart shape, the universal and by no means esoteric symbol of love. Duchamp inscribed it on the back, "*A toi ma chère Suzanne,*" and there is no indication that his sister's wedding, which took place in Rouen on the morning of August 14 and was followed by a festive breakfast for family and friends at the local Hôtel de France, was anything but a happy occasion for him as well as for the bride and groom.

That summer was the last one the Duchamp family would spend in Veules-les-Roses. There were the usual outings, tennis games, and evenings spent at the casino with his band of summer comrades, but Duchamp also found time during the summer to develop his own, still somewhat conservative version of Cubism. *Yvonne and Magdeleine Torn in Tatters* (a descriptive title if ever there was one) shows him trying out what he called "a very loose interpretation of Cubist theories." Rather than using the Cubist device of juxtaposing two or more points of view in a single image, Duchamp painted four separate profile views (two apiece) of his younger sisters, altering the scale, breaking up the elements with passages of abstraction, and even making Yvonne's features look like those of a much older woman in one of the images. "I so to speak tore up their profiles and placed them at random on the canvas," as he said. He did more or less the same thing in

Portrait (Dulcinea), 1911.

Portrait (Dulcinea), painted that October in Neuilly. Here, five images of a tall, severe-looking woman move sequentially across an abstract, subtly colored background. In three of them she is fully clothed; in the other two she is at least partially naked, although still wearing her irreproachable hat. She looks to be of a certain age, she is not at all beautiful, and Duchamp did not know her. (The reference in the title to Don Quixote's unattainable mistress ᵗhus acquires a self-mocking irony.) "*Dulcinea* is a woman I met on the

avenue de Neuilly, whom I saw from time to time, but to whom I never spoke," he told the art historian Pierre Cabanne, who published an extended series of interviews with Duchamp in 1967. "She walked her dog, and she lived in the neighborhood, that's all. I didn't even know her name." It would appear, at any rate, that his interest was not so much in the lady herself as in the themes of movement, change, and the imaginative stripping bare of a haughty woman—themes that would soon enough become major preoccupations.

In the same month that he did *Portrait (Dulcinea)*, Duchamp painted a delicately colored and appealing portrait of his youngest sister, red-haired Magdeleine. This picture had no title until 1936, when Duchamp was prevailed on to give it one and came up with *Apropos of Little Sister*. The inscription on the back of the canvas—*Une étude de femme/Merde*—has led some observers to decide that the subject is sitting on a toilet, but that seems unduly fanciful. Her knees are crossed, for one thing, and the central and most realistically rendered element in the picture is the ornamental arm post of her chair—the same family chair that appears in two earlier drawings by Duchamp. Her posture is sufficiently ambiguous to allow for different interpretations, at any rate.

Duchamp once said, with typical candor, that the surprising thing about *Portrait (Dulcinea)* was its "technical wishy-washiness." His Cubist experiments were far less radical, technically, than those of Picasso or Braque, whose latest canvases he saw regularly at Kahnweiler's gallery—"It was there that Cubism got me," he told Cabanne. Duchamp still made no effort to meet Picasso. He did go to see Braque at least once, in his studio in Montmartre, but it was from Jean Metzinger that Duchamp and the other aspiring Cubists got their verbal understanding of the new art. Metzinger had lived near the Bateau Lavoir for several years; he had spent many hours in Picasso's studio, and he had been one of the first to write about Picasso and Braque's ambition to make paintings that were the tangible equivalent of an idea. Metzinger "explained Cubism, while Picasso never explained anything," according to Duchamp. "It took a few years to see that not talking was better than talking too much."

The fact was that Metzinger, Gleizes, Delaunay, and their colleagues saw Cubism as a means to a much more socially conscious art than anything envisaged by Picasso or Braque. To the Salle 41 group, the new pictorial structure opened up painting to subjects and themes that had been off-

limits ever since the rise of Impressionism. While Picasso and Braque explored the ramifications of their discoveries in painting after painting whose subject matter was limited to a few familiar images—café table, cigarette pack, guitar, fruit in a bowl—Gleizes applied Cubist techniques to large figure compositions such as *The Football Players,* and Delaunay would soon embark on his series of paintings of the Eiffel Tower, which struck him and others as the most dramatic symbol of the modern era.

The continued refusal of Picasso and Braque to have anything to do with the other Cubists, whom Kahnweiler disparaged as second-rate imitators, did not keep the Salle 41 group from attracting new recruits. By the fall of 1911 their circle included Jacques Villon, Raymond Duchamp-Villon, and Marcel Duchamp. The Duchamp brothers had become friendly with the Salle 41 Cubists at that year's Salon d'Automne. Villon and Duchamp-Villon had persuaded the hanging committee to let Gleizes, Metzinger, Delaunay, Léger, and Le Fauconnier exhibit together in the same room, as they had done at the spring Indépendants, and after that the Cubists began coming out on Sunday afternoons to Jacques Villon's house in Puteaux. The rapidly expanding Puteaux circle also came to include Roger de la Fresnaye and several other artists belonging to the Société Normande de Peinture Moderne, a group organized two years earlier by Duchamp's old schoolmate Pierre Dumont. Made up originally of Rouen's late-blooming Post-Impressionist and Fauve painters, Dumont's society had attracted so many artists from Paris that it was no longer very Norman; Marcel Duchamp had designed a poster for its first exhibition, in 1909, and his work had been shown in that and the society's other group shows in Rouen and in Paris. The artists who came to Puteaux represented many different esthetic tendencies, but they all felt the magnetic force of the Cubist revolution.

Many of these artists, including the Duchamp brothers, attended the Monday evening meetings at Gleizes's studio in the suburb of Courbevoie, and they also went to the Tuesday night soirées at the Closerie des Lilas. Duchamp took a very minor part in the discussions and arguments at these meetings. A listener rather than a talker, he was still somewhat in the shadow of his older brothers, especially Raymond, whom he admired to the point of hero worship. Among the Cubists' favorite subjects of debate, though, at least two held special interest for Duchamp. One was the search for an art that would engage the mind as well as the eye; the other was the fourth dimension.

Again and again in later years, Duchamp would speak contemptuously of "retinal" art, by which he meant art whose appeal was solely to the visual sense. It was Gustave Courbet, he argued, who had turned art into a retinal affair; until Courbet, art had appealed to the intellect in many different ways, teaching moral or religious truths and leading the mind on imaginative journeys, but the powerful example of Courbet's realism had ruled all that out—with disastrous consequences. " '*Bête comme un peintre*' was the saying in France all through the last half of the nineteenth century," Duchamp complained, "and it was true, too. The kind of painter who just puts down what he sees *is* stupid." Exactly the same complaint can be found in Gleizes and Metzinger's book *Du Cubisme,* published in 1912, in which they castigate Impressionist art as an "absurdity" because "even more than with Courbet, the retina predominates over the brain." Duchamp's disdain for "retinal" art, in fact, was widely shared among modern artists. Wassily Kandinsky, Kasimir Malevich, Piet Mondrian, and other leading innovators were committed to the search for a spiritual art that would transcend the world of materialist sensations. The Cubism of Picasso and Braque, for all its tough-minded adherence to the real world, was above all a conceptual art in the classical sense, an attempt to paint, as Picasso once said, "not what you see but what you know is there." No other artist, however, would adhere to the anti-retinal bias as uncompromisingly as Duchamp did, or carry it to such unexpected lengths.

As a means of working toward the intellectually based art that was their goal, the Puteaux Cubists became interested—along with a great many people at that time—in the theoretical concept of the fourth dimension. Henri Poincaré in France, H. G. Wells in England, and several other popular writers had helped to spread the idea of a higher, "cosmic" dimension beyond space and time, and during the first decade of the twentieth century, the notion cropped up in hundreds of newspaper and magazine articles, novels, and cartoons. (When *Scientific American* sponsored an essay contest in 1909 for "the best popular explanation of the Fourth Dimension," entries came flooding in from all over the world.) This widespread obsession continued into the 1920s, when it was swept aside by the great wave of interest in Albert Einstein's theory of relativity. (The general theory of relativity, formulated in 1916, did not achieve widespread public recognition until 1919.) During the century's first decade, few laymen had more than a faint grasp of the non-Euclidian geometries whose development during the previ-

ous half century had given rise to abstruse notions about the space-time con-tinuum. The public seemed to sense, nevertheless, that enormous changes were taking place in man's understanding of the physical world. The phe-nomena of X rays and radioactivity, the wireless telegraph, electromagne-tism, and other recent discoveries had challenged long-held notions about the basic structure of things, and the growing recognition that chance played a significant role in nature's processes undermined the belief that those processes could ever be fully understood. In the nineteenth century science had come to be seen as virtually infallible; now, quite suddenly, the ability of empirical science to explain all things was being called into question, and this was both frightening and liberating. As science lost its infallible aura, a great many people found themselves yearning for evidence of phenomena that were beyond the reach of ordinary human sense perception.

The Puteaux artists made an effort to understand the mathematical concepts underlying the fourth dimension. Much of their information on the subject came from Maurice Princet, a young insurance actuary and amateur mathematician who had been hanging around Picasso's studio for several years. (He occasionally finagled a Picasso drawing to sell, and he was in love with one of Picasso's casual girlfriend-models; eventually he married her, but she left him a few months later for the painter André Derain.) Picasso paid no attention to this rather innocuous eccentric. Jean Metzinger thought that Princet "conceived mathematics as an artist," though, and it was Metzinger who started bringing him to the Sunday afternoons at Puteaux, where he found a receptive audience. To the Puteaux Cubists the fourth dimension came to stand for "a higher reality, a transcendental truth that was to be discovered by each artist." Apollinaire soon began referring to the fourth dimension in his writings and lectures. He devoted an entire article to it in the spring of 1912, claiming that the new freedom in art was a product of the artist's ability to express the fourth dimension and that "it is to the fourth dimension alone that we owe this new norm of the perfect." Duchamp tended to play down his own and his fellow artists' understand-ing of the fourth dimension. "The fourth dimension became a thing you talked about, without knowing what it meant," he told Pierre Cabanne. Duchamp would later deny that he had read the writings of Riemann or Lobachevsky, theoretical mathematicians whose work he was said to have been studying at the time—he insisted that he would not even have been capable of reading them. This was disingenuous, to say the least; the notes

he made, starting in 1913, on fourth-dimensional concepts relating to his work on *The Large Glass* refer to and apply some of Riemann's specific calculations. But if Duchamp was fascinated by the fourth dimension, it was for his own reasons, which were more poetic than mathematical. His line of reasoning was quite simple: since light falling on a three-dimensional object projected a two-dimensional shadow image, he reasoned, why couldn't our own, three-dimensional world be seen as the projection of another reality in four dimensions? That notion, filtered through the idiosyncratic apparatus of Duchamp's mind, led eventually to *The Large Glass.*

Sunday afternoons at Puteaux were not entirely given over to high-flown discourse. In warm weather the artists and their friends played *boules* in the garden, in the shade of a fine old chestnut tree whose lower branches brushed the ground, and the more athletic members of the group set up a target for archery contests. There was also the popular steeplechase game, which could be played either indoors or out. Duchamp had made the game himself by taking a large piece of canvas and dividing it up into painted squares whose layout roughly corresponded to the racetrack at Auteuil. Each player threw dice to advance a handmade wooden horse—Duchamp carved two of these, which he called *Gambit* and *Citron Pressé.* (Inevitably, they have been resurrected and stabled in the Duchampian catalogue raisonné.) Food and drink were plentiful, banter and flirtations enlivened the atmosphere, and everyone was on good terms with the Duchamp brothers' two Siamese cats and with Omnibus, the elderly, overweight collie whom Duchamp-Villon immortalized by sculpting his likeness in a bronze medallion. Duchamp never brought his own girlfriends to Puteaux. There had been quite a number of them in the last year, since the end of his liaison with Jeanne Serre. He was an extremely good-looking young man, with a thin, cleanly chiseled profile, high forehead, deep-set gray eyes, and fair skin. Unlike his brothers and many of the other artists of that time, he never grew a beard or a mustache, nor did he go in for the kind of posturing that young artists adopt to offset their own self-doubt. His manner was quiet and reserved. In this group he was still the younger brother; he had done nothing as yet to challenge that natural order. In the fall of 1911, however, Duchamp met an amazing individual named Francis Picabia, whose iconoclasm helped to ignite his own.

Picabia was rich, extravagant, self-indulgent, and opposed on principle to every received opinion. Nine years older than Duchamp, he was the only

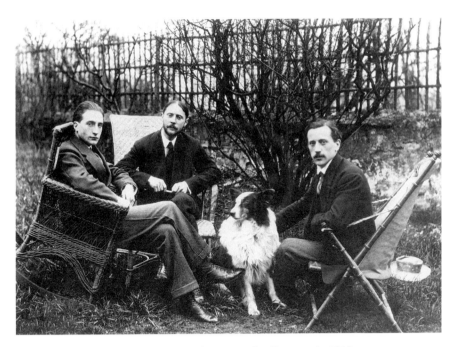

Marcel, Gaston, and Raymond at Puteaux in 1912.

child of a Cuban father and a French mother, both of whom were independently wealthy; his mother died when he was very young, and he grew up in a male-dominated Paris household where he was denied nothing and where his natural facility for art was encouraged by his maternal uncle Maurice Davanne, a highly sophisticated collector of art and rare books and the conservator of the Bibliothèque Sainte-Geneviève in Paris. Precocious sexually as well as artistically, at eighteen Picabia quit school and ran off to Switzerland with the mistress of a well-known Paris journalist. His amorous adventures and his passion for fast (and very expensive) automobiles were apparently looked on with indulgent approval by his father, himself a notorious roué and man-about-town. Picabia was not, however, as feckless and undisciplined as some of the tales told about him would suggest. He studied painting seriously for five or six years in the atelier of Fernand Cormon (Braque's teacher and also, briefly, Jacques Villon's), and in 1905, the year Duchamp was away doing his military service, Picabia made a name for himself in Paris with a sensationally successful show of *retardataire* but very skillful Impressionist pictures. According to William Camfield, the artist's most authoritative biographer, "Picabia seems to have come

along at the right time with a charming, conservative brand of Impressionism perfectly suited to the taste of many critics." He soon dropped Impressionism for Fauvism. By 1911 he had lost his self-confidence, however, and was shifting back and forth between imitations of Fauve, Post-Impressionist, and other current styles.

Gabrielle Buffet-Picabia, whom he married in 1909, sets the date of her husband's first meeting with Duchamp in 1910, which was the year that Picabia joined the Société Normande de Peinture Moderne. According to Duchamp, however, they were introduced to each other by Pierre Dumont at the 1911 Salon d'Automne, and "Our friendship began right there." Duchamp was immediately taken by Picabia's ebulliently negative spirit. "With him it was always, 'Yes, but . . .' and 'No, but . . .' Whatever you said, he contradicted. It was his game." In addition, Picabia "had entry into a world I knew nothing of. In 1911–1912, he went to smoke opium almost every night. It was a rare thing, even then." Although Duchamp never smoked opium and made little effort to keep up with Picabia's heavy drinking, his new companion's wild and flamboyant lifestyle made a powerful impression on the notary's son. "Obviously, it opened up new horizons for me," as he said. Meeting Duchamp seems to have opened up new horizons for Picabia as well. Picabia became interested in the nude as a subject soon afterward, and he painted a picture called *Adam and Eve* that was clearly influenced by Duchamp's allegorical canvases. During the next few years, moreover, he would follow the younger artist's lead in developing the machinelike imagery that took them both out of Cubism.

In the fall of 1911, Duchamp started work on a new painting that brought him much closer to his own personal Cubist vision. The theme, once again, was the game of chess, but instead of showing his brothers playing in the garden at Puteaux, as he had done in his rather conventional 1910 painting, Duchamp decided this time to show chess as a mental activity taking place within the minds of the two players. It is the first Duchamp painting for which preparatory studies have survived—six drawings and an oil sketch—but the drawings are not dated chronologically, and they do not show him proceeding step by step toward a final goal. The features of his brothers are still recognizable in two of the studies; in the others, masklike profiles or hooded, helmetlike heads are surrounded and invaded by shapes that resemble chess pieces, while other lines suggest the gridded squares of the board. The painting itself, called *Portrait of Chess Players,* was finished

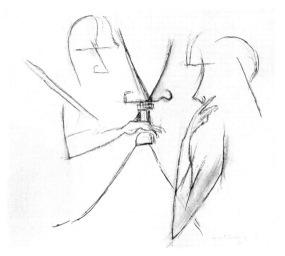

Study for Portrait of Chess Players,
1911.

Portrait of Chess Players, 1911.

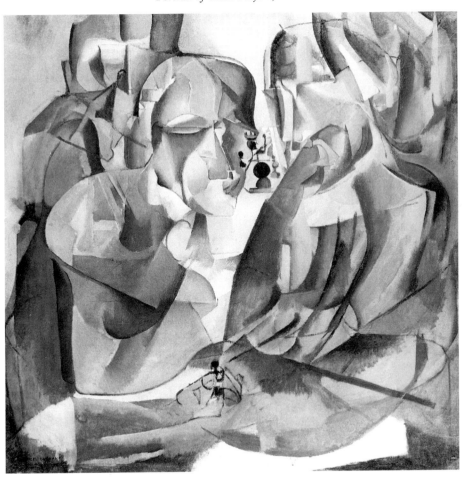

in December. In its use of overlapping planes and multiple perspective—
several profiles seen simultaneously from different angles—and with its
restricted palette of yellowish earth tones, it seems at first glance to be more
in line with established Cubist techniques than Duchamp's earlier experi-
ments had been. Duchamp had painted it at night, by the light of a gas
lamp, in order to get this muted color scheme. "When you paint in green
light and then, the next day, look at it in daylight, it's a lot more mauve,
gray, more like what the Cubists were painting at the time," he said. "It was
an easy way to get a lowering of tones." But in this picture Duchamp was
after something that no other Cubist—and certainly not Picasso or
Braque—had ever attempted. His chess players are not just playing chess
but *thinking* chess. An intensity of thought pervades the painting, taking
precedence over the mere "retinal" image. For the first time we catch a clear
glimpse of Duchamp's rapidly escalating ambition, which was to put paint-
ing "at the service of the mind."

The New Spirit

There is absolutely no chance for a word ever to express anything. As soon as we start putting our thoughts into words and sentences, everything goes wrong.

In the years immediately preceding the First World War, the energies of the modern movement seemed to gather fresh momentum. Picasso and Braque took the Cubist revolution into its second, "synthetic" phase in 1912 with their invention of collage, twentieth-century art's most significant and characteristic innovation. By gluing bits of paper, cloth, and other fragments of the real world to the surface of their canvases, they expanded the attack on art's imitative function and located "reality" all the more emphatically within the painting itself. In Cubism's earlier, "analytical" phase, Picasso and Braque had come very close to an art of complete abstraction. They had drawn back from it, unwilling to abandon all contact with the natural world, but for a number of other artists abstraction became the inevitable next step. Between 1910 and 1916, Wassily Kandinsky in Munich, Robert Delaunay and Frantisek Kupka in Paris, Kasimir Malevich in Russia, and Piet Mondrian in Holland—each working independently—took art into the realm of "pure," nonrepresentational form and color.

Slogans, polemics, and manifestos trumpeted the proliferation of rival avant-gardes. The Italian Futurists, whose opening salvo had been published in the Paris newspaper *Le Figaro* in 1909, attacked Cubism as an academic art that was irrelevant to the "dynamism" of modern life.

Simultanism and Orphism in Paris (the latter was Apollinaire's term for the abstract tendencies emerging out of Cubism); Cubo-Futurism, Rayonism, and Suprematism in Russia; Vorticism in England; and various offshoots and submovements sought to annex the latest developments and drive them forward in an increasingly frenetic climate of radical innovation in all the arts. As Europe plunged toward catastrophe, the "new spirit" that Apollinaire had proclaimed—a spirit of absolute freedom and radical experimentation—reached its highest pitch of intensity.

Although the spirit was new, the origins of all this intellectual and creative ferment went back half a century. Baudelaire had invoked the essential modernist creed when he described "pure art" as "containing at once the object and the subject, the world external to the artist and the artist himself." Only by giving free rein to subjective fantasies of the most extreme sort, he believed, could art convey the essential quality of modern life. Baudelaire was the great precursor of the Symbolist movement in French poetry, which, emerging in the 1880s as a second wave of the Romantic revolt half a century earlier, had helped to derail naturalism both in literature and in art. By elevating intuition, chance, and the "suggestive magic" of words to the highest position, Stéphane Mallarmé, Arthur Rimbaud, and their followers undermined the clarity and logic of the French classical tradition and challenged their fellow artists, in Mallarmé's famous phrase, "to paint not the thing itself, but the effect that it produces." This was exactly what the Cubists were trying to do. A portrait that showed the subject from several different viewpoints simultaneously—full face and profile appearing on the same plane—was intended to suggest the multiple impressions that we have of another person at any given moment. Photography had largely usurped art's traditional function as the mirror of nature; why should artists continue to paint what the camera could reproduce so accurately? Artists were required to look deeper, to leave imitation behind and find a new rationale for their ancient calling. In order to keep up with the accelerating changes in a world transformed by scientific and technological discoveries, art was literally being forced to become more intelligent.

Like many others, the artists of the Puteaux group found important elements of their esthetic rationale in the invigorating philosophy of Henri Bergson. Few thinkers have been as celebrated in their own time as Bergson, whose immense influence on twentieth-century thought and culture is rarely acknowledged today. His lectures at the Collège de France during

the early years of the century drew overflow audiences, and his book *Cre-
ative Evolution,* which appeared in 1912 and was widely translated, met
with virtually universal acclaim. Bergson's philosophy was based on the
perception that life means perpetual change. Science could never offer more
than a partial explanation of our existence, he argued, because its method
was to isolate and study particular aspects of an ever-evolving, ever-
changing reality. In order to deal with the reality of change, something
more than reason and intellect was called for, something that Bergson
defined as intuition—"the sympathy by which one transports oneself to the
interior of an object in order to coincide with its unique and therefore inef-
fable quality." Twenty years before Werner Heisenberg formulated the
uncertainty principle, Bergson argued that nature itself is indeterminate—
a process of continuous change and continuous creation that goes on forever
and is basically unpredictable. But he also brought the good news that
men and women, being part of nature, are part of the same process of cre-
ation and change. According to Bergson, the great engine driving human
evolution is not some dreary, mechanistic survival of the fittest, but a "vital
instinct" ("*élan vital*") that is indistinguishable from the creative urge. Life,
he maintained, "is essentially a current sent through matter."

Bergson's vitalist ideas appealed to an enormously wide audience.
George Bernard Shaw and H. G. Wells appropriated his notion of an *élan
vital* for their rationalist arguments, while theologians managed to find in it
sufficient room for God's purpose. Poets and artists rejoiced in his elevation
of intuition over intellect and in his critique of scientific "laws." "Everyone
rebelling against convention in conduct, chafing against formalism in art,
revolting against the fixed and stable in thought, found in him an enchant-
ing voice," as Irwin Edman wrote in his foreword to the Modern Library
edition of *Creative Evolution.* Several artists of the Puteaux group were par-
ticularly struck by Bergson's concept of "duration," which he called "the
persistence of the past in the present." They referred to it often in their dis-
cussions of the fourth dimension, but the one who applied it most effectively
in art was Raymond Duchamp-Villon. In the successive versions of his
sculptural masterpiece, *The Horse,* which he started to work on in 1913,
Duchamp-Villon achieved a fusion of multiple perspectives, of new form
flowing out of previous form, that made his image of a semi-abstract horse's
head appear to move through time as well as space and, going beyond that,
to function simultaneously as an animal and as a machine.

In a late interview Marcel Duchamp cheerfully conceded that "insofar as they recognize the primacy of change in life I am influenced by Bergson and Nietzsche. Change and life are synonymous . . . Change is what makes life interesting." The probable truth, however, is that Duchamp never read any books by Bergson or Nietzsche. In fact, except for the period in 1913–14 when he worked as a librarian at the Bibliothèque Sainte-Geneviève in Paris, he never read much of anything. Duchamp could always seem to pick the ideas that interested him out of the air, so to speak, and adapt them to his own purposes without troubling himself over details and fine print. As he grew older, he would occasionally say that he was "unable" to read the writings of heavy-duty thinkers like Nietzsche, implying that this was a matter of mental laziness on his part. Nobody who knew him could take that explanation very seriously. Duchamp was more convincing when he talked about his lifelong mistrust of language as a means of communication. "There is absolutely no chance for a word ever to express anything," he told this writer in 1964. "As soon as we start putting our thoughts into words and sentences, everything goes wrong."

There was one form of language for which Duchamp had the greatest respect, however, and that was poetry. "Words get their real meaning and their real place in poetry," he said. Duchamp often spoke of his liking for Mallarmé, and many parallels can be drawn between Mallarmé's achievement and his own. (As Octavio Paz has said, "One is the poet and the other the painter of the Idea.") Mallarmé, in his efforts to purify language of its utilitarian function and turn it into an instrument of exploration and discovery, had taken the daring step of enlisting the reader as a participant in the creative process. He believed in the absolute uniqueness of personal feelings and sensations and in the need to evoke these indirectly, by a special language of symbols that the reader must interpret in a creative act of his own. "The contemplation of objects, the image that rises out of the reverie that objects provoke—those are the song," he wrote. "But the Parnassians take the thing in its entirety and point to it: thereby they lack mystery. They deprive the reader of the delightful illusion that he is a creator. To name an object is to destroy three-quarters of our pleasure in a poem—the joy of guessing, step by step. The ideal is to suggest the object." By turning away from naturalistic or classical ("Parnassian") modes of expression and relying on private symbols that the reader is free to interpret in any number of different ways, Mallarmé and his followers ran the risk of being considered

deliberately obscure. Many readers balked at the creative effort that these poems required—just as many viewers balked at the visual complexity of a Cubist painting. One of the paradoxical ironies of early modern art was that, in trying to break down the traditional barriers between artist and viewer—and, by implication, between art and life—advanced artists alienated a large part of the public. These artists did not yearn to reach a mass audience—far from it. Most of them accepted with pride the role of aristocratic isolation that the public and the art establishment of that period were only too happy to assign them. Nevertheless, the desire to implicate and involve in the creative process the rare spectator who was capable of responding to such a challenge would become one of the strongest and most persistent strains in twentieth-century art, and it is an essential element in Duchamp's thinking from 1912 on.

Symbolism was never a clearly defined movement. Aside from the fact that a large number of the writers and artists who came to be associated with it were French, their ideas and sensibilities diverged so radically that it would be impossible to point to a set of principles that they held in common. What most of the early Symbolist figures did share, however, was a profound belief in the power of literature to influence and alter human life. Continuing the Romantic tradition of individual revolt against a repressive social and political order, Mallarmé and Rimbaud put their faith in the poet's ability to transcend ordinary human experience—to go beyond the mind's limits, whether self-imposed or dictated by society. Rimbaud stated this hugely ambitious proposition in a famous letter, written in 1871 but not published until long after his own death, that is known as the *Lettre du voyant*. In Rimbaud's incendiary words, the poet's duty was "to make oneself a seer" by means of a "long, immense, and deliberate *derangement of all the senses.*" Only through such a process (which included "all forms of love, suffering, and madness") could he break through the shell of reality and discover the unknown. The poet's true function was not to express an existing reality but to discover a new one and, in doing so, to change life.

Rimbaud's challenge echoes down the corridors of modernism. It can be heard in Surrealism's ardent cultivation of the "marvelous" in life and art and in the Abstract Expressionists' claim that painting, as Willem de Kooning put it, was "a way of living today, a style of living, so to speak." By the last decade of the nineteenth century, however, it was becoming more and more difficult to believe in spiritual salvation through art. For many of the French

writers and artists who came of age in the early years of the new century—Duchamp's generation—the most charismatic voyager into the unknown was neither Mallarmé nor Rimbaud but Alfred Jarry, a writer whose anarchistic trashing of every accepted value held out no hopes of redemption.

Jarry was an extremely odd character—odder than any of his fictional creations. Born into a middle-class family in the town of Laval (which also happened to have been the birthplace of Henri Rousseau), he made up for his small stature by being a precociously brilliant student. Proud, fiercely independent, shy, arrogant, sarcastic, witty, courageous, and underneath it all immensely good-natured, Jarry enthralled his schoolmates with his gift for pranks and troublemaking. At the lycée in Rennes, where his mother moved when he was fifteen, he became the ringleader of a gang of boys who devoted much time and energy to making sport of their well-meaning, obese, and hopelessly incompetent physics teacher, an unfortunate man named Hébert. Jarry and one of his schoolmates, Charles Morin, wrote a wildly fanciful play that they called *Les Polonais,* and performed it with marionettes in the house of one of their friends who lived in Rennes; the main character was "Père Heb," a brute blunderer whose physical characteristics were a huge belly, three teeth (one of stone, one of iron, and one of wood), a single, retractable ear, and a grotesquely misshapen body. M. Hébert, who was too befuddled to realize what was going on most of the time, would not live long enough to see his absurd alter ego develop into one of the most monstrous and astonishing characters in French literature.

When Jarry was seventeen, he passed his *baccalauréat* and moved to Paris, alone, to prepare for admission to the elite Ecole Normale Supérieure. Although he did not get admitted there, he soon gained attention in Paris literary circles for his startlingly original poems and prose-poems, and his first book, a collection of these brief bombshells, came out in 1893, when he was twenty. Both his parents died that year, leaving Jarry a tiny inheritance that he went through in no time. He had discovered the pleasures of alcohol, which he took to calling "my sacred herb." In one of his short texts he noted, "Antialcoholics are unfortunates in the grip of water, that terrible poison, so solvent and corrosive that out of all substances it has been chosen for washings and scourings, and a drop of water, added to a clear liquid like absinthe, muddies it." When he was drafted into the army in 1894, Jarry's deadpan gift for turning received notions upside down defeated all attempts to instill military discipline; the sight of him shoulder-

ing arms in his baggy uniform—he was under five feet tall, and nothing fit him—was so disruptively funny that he was excused from parades and marching drills. Eventually he was "reformed" out of the service with a medical discharge. He put the experience to good use, nevertheless, making it the basis for a novel called *Days and Nights.* Back in Paris, Jarry applied himself to drinking, writing (poems, novels, reviews), and the company of those few friends who could best appreciate his witty, sweet-tempered, and wholly unpredictable conversation.

In the spring of 1896, Paul Fort's review, *Le Livre d'art,* published the text of a new work by Alfred Jarry, a play in four acts called *Ubu Roi.* It was based on *Les Polonais,* the schoolboy jape that had never lost its obsessive hold on Jarry's imagination. Reworked, expanded, but by no means purged of its over-the-top outrageousness, *Ubu Roi* was unlike anything ever produced on a French stage, a work whose savage humor and monstrous absurdity seemed to rule out any possibility of its being performed. Jarry's growing reputation in Paris literary circles brought his play to the attention of an impetuous young theater director named Aurélien-Marie Lugné-Poe, however, and Lugné-Poe decided to take the huge risk of putting it on at his Théâtre de l'Oeuvre.

Advance publicity had attracted traditionalists and partisans of the new in approximately equal numbers, and many in the audience came primed for battle. When the curtain rose on opening night (December 11, 1896) and Firmin Gemier, the Comédie Française actor whom Lugné-Poe had persuaded to play the principal role of King Ubu, waddled toward the footlights and launched the slightly altered verbal obscenity that was the play's opening line—"*Merdre*" ("Shite")—pandemonium broke loose in the theater: outraged cries, booing, whistling, and fist shaking by the offended parties; frantic cheers and hand clapping by the avant-garde faction. It took fifteen minutes before the din died down and the actors could resume. "The interruptions continued for the rest of the evening," according to one account, "while Père Ubu murdered his way to the throne of Poland, pillaged the country, was defeated by the king's son and aided by the czar's army, and fled cravenly to France, where he promised to perpetrate further enormities on the population." Although the play received only one more performance at the time and was not revived until 1907, *Ubu Roi* made its twenty-three-year-old author famous.

Jarry, who had been closely involved with every detail of the production, appeared scarcely to notice the riotous goings-on or the violent attacks and counterattacks in the papers over the next few weeks. Instead of exploiting his success, he did something very strange. He began to submerge himself more and more in the fiction that he had created: Jarry became Ubuesque. In playing King Ubu, the actor Gemier had modeled his line readings on Jarry's own, highly peculiar manner of speaking—a staccato, nasal delivery with equal stress on every syllable, including the silent ones. From then on, Jarry never spoke any other way. He also adopted Ubu's pedantic and ridiculous figures of speech, employing the royal "we" in conversation and referring to the wind as "that which blows" and to his bicycle, which he rode everywhere, as "that which rolls." His living arrangements became increasingly eccentric. He moved into a cheap but drastically truncated flat at 7, rue Cassette—the landlord had made two apartments out of one by dividing them in half horizontally; Jarry could just manage to stand upright in the space, but his guests were obliged to bend or crouch. Jarry took to carrying a loaded pistol in his belt, a perfectly legal habit in Paris, where there were no laws against "arms openly displayed"; one dark night a pedestrian who stopped him in the street to ask for a light (un feu) had the unsettling experience of hearing a pistol shot, followed by Jarry's respectfully polite "Voilà." When a lady complained that Jarry's target practice in the adjoining garden was endangering her children—Jarry and some friends were renting a house in the Corbeil suburb that summer—Jarry sought to reassure her, in his jerky, Ubuesque manner, by saying, "If that should ever happen, Madame, we should ourselves be happy to get some new ones with you." It should be said that Jarry never hurt a living soul during his short life and that his sexual preferences, such as they were, did not extend toward the opposite sex.

Although he drank excessively, neglected his health, and lived under conditions of steadily worsening poverty, Jarry wrote several more highly original books. His novel *Le Surmâle* (*The Supermale*) can be read as a wicked satire on the Symbolist ideal of self-transcendence; its hero, a nondescript fellow named Marceuil, wins a ten-thousand-mile nonstop bicycle race against a five-man bicycle team *and* a steam locomotive, then establishes a different sort of record, for sexual intercourse—eighty-two orgasms within a twenty-four-hour period, clocked by a team of scientific observers and carried out, let us note, with the enthusiastic cooperation of a young

American woman who is fully capable of a Superfemale response. Jarry's best book, which was not published until after his death, defies all categories. Called *Gestes et opinions du Docteur Faustroll,* it describes the exploits and teachings of an antiphilosopher who was born at the age of sixty-three, travels the world in a sieve, and is the inventor of " 'pataphysics," a new science that deals with "the laws which govern exceptions and will explain the universe supplementary to this one." Science's so-called laws, according to Faustroll-Jarry, are simply exceptions that occur more frequently than others. Faustroll's supplementary universe is our own conscious, everyday world turned upside down, a place where hallucination is the norm and where everything can be its opposite. This was the world that Jarry himself chose to inhabit until his death in 1907, at the age of thirty-four, of tuberculosis aggravated by drugs and alcohol.

In his last years Jarry became a legendary and even heroic figure to some of the younger artists and writers in Paris. Apollinaire, André Salmon, and Max Jacob sought him out in his "second-and-a-half"-floor apartment in the rue Cassette. Picasso, who was fascinated by Jarry, acquired his pistol when he died and often carried it around Paris on nocturnal expeditions; later Picasso bought a number of Jarry's manuscripts. A contemporary American artist named William Anastasi has convinced himself that Jarry was *the* primary source both for Duchamp and for James Joyce; for example, he believes that Duchamp found something usable—an idea, a title, a pun—on every page but one of *Le Surmâle.* Duchamp, who freely acknowledged his debts to Mallarmé, Raymond Roussel, Jules Laforgue, and other literary figures, told the German art historian Serge Stauffer in 1965 that Jarry had "no direct influence" on him, "only an encouragement found in Jarry's general attitude toward what passed for literature in 1911." There can be no doubt, though, that in Duchamp's notes on "playful physics" and other mock-scientific notions, he was drawing on the rich legacy of Dr. Faustroll. "Rabelais and Jarry," he once said, "are my gods, evidently."

Roger Shattuck, who wrote about the origins of the European avant-garde in his book *The Banquet Years,* singled out four defining traits of the new art and literature in the extraordinarily fertile era from 1885 to the start of the First World War. The first was "the cult of childhood," which, although it went back to Jean-Jacques Rousseau and the English Romantic poets, reached a new plateau with Jarry and his contemporaries. In *Ubu Roi,* Jarry pushed his schoolboy prankishness to nightmarish extremes without

losing the sense of innocence and freshness that gave it life. Shattuck's three other traits—humor verging on the absurd; the cultivation of dreams and hallucinations at the expense of rational consciousness; and a pervading sense of ambiguity—were exemplified by the avant-gardists whose lives and careers he profiled in his brilliant book: Jarry, Erik Satie, Henri Rousseau, and Guillaume Apollinaire. If one trait could be said to subsume and illuminate all the others, though, it would be the cult of childhood.

Evidence of the rebellion could be seen in each of the arts. The spirit of playfulness in Satie's music and Apollinaire's poems; the Futurists' worship of speed and movement; the collage technique, with its juxtaposition of unrelated elements joined together without logic or connective; the delight in surprises and unexpected effects; the yearning to discover new ways and new materials and to go beyond what anyone else had thought was possible; and above all the accelerating attempts to break down barriers between life and art, as Jarry had done by turning himself into a fictitious character—all these suggest the unlimited inventiveness of a child's dreams and fantasies. Underneath it all, however, lay the awareness of a harsher reality. The world of the fathers was moving in a different direction, toward the suicidal carnage of the First World War. Jarry, more than anyone else, seemed to look that horror straight in the eye; Ubu's scatological wit anticipates the gallows humor of the trenches. For the most sensitive artists of the period, moreover, the effort to turn life into art might have seemed like the only hope of sanity in a world where Ubu had gained control.

William Butler Yeats was in the audience at the premiere of *Ubu Roi.* Understanding little French, the Irish poet clapped and cheered to show his support for "the most spirited party." Afterward, though, alone in his room at the Hôtel Corneille, he felt deeply sad. Yeats knew that his world and the kind of art he represented were dying, and Jarry's play had given him an idea of what would succeed them. Describing the evening later, in his autobiography, he wrote: "After us the Savage God."

Nude Descending

Reduce, reduce, reduce was my
thought—but at the same time I
was turning inward, rather than
toward externals.

By the end of 1911, Duchamp's work had begun to diverge from
the mainstream of modern art. After eight years of "swimming
lessons" in modernist waters—from Impressionism and Post-
Impressionism through Fauvism, Symbolism, and Cubism—he had arrived
at his own version of the Cubist idiom in *Portrait of Chess Players,* a painting
whose real subject is the process of thought. Many artists would have spent
the next few months or years exploring this new terrain, mapping its param-
eters in painting after painting, the way Braque and Picasso had done
in Cubism's first, "analytical" phase. After *Portrait of Chess Players,* however,
each new Duchamp painting is a step in a unique progression. He does not
repeat himself, and he does not pay much attention to what his contempo-
raries are doing. It is at this point that Duchamp, emerging from the shadow
of his older brothers, becomes a significant figure in modern art.

Duchamp's radical change of course suggests a self-confidence that was
not apparent to his friends. Gabrielle Buffet-Picabia, Picabia's perceptive
and musically gifted wife, described Duchamp during the early years of
their friendship as a young man at odds with himself:

Though very much detached from the conventions of his epoch, he
had not yet found his mode of expression, and this gave him a kind

of disgust with work and an ineptitude for life. Under an appear-
ance of almost romantic timidity, he possessed an exacting dialec-
tical mind, in love with philosophical speculations and absolute
conclusions . . . In that period Picabia led a rather sumptuous,
extravagant life, while Duchamp enclosed himself in the solitude of
his studio in Neuilly, keeping in touch with only a few friends,
among whom we were numbered. Sometimes he "took a trip" to
his room and vanished for two weeks from the circle of his friends.

The Picabias had two children by this time, but parenthood never inter-
fered with Picabia's zest for spontaneous pleasure seeking. He loved to shat-
ter Duchamp's solitude by roaring out to Neuilly in one of his expensive
cars and taking him off for a night of drinking and uproarious talk in the
Montmartre cafés. According to Gabrielle, the two of them "emulated one
another in their extraordinary adherence to paradoxical, destructive prin-
ciples, in their blasphemies and inhumanities which were directed not only
against the old myths of art, but against all the foundations of life in gen-
eral." Duchamp credited Picabia with detaching him from the overly seri-
ous atmosphere of Puteaux; no esthetic theories could stand up against
Picabia's derisive nihilism. But it was Duchamp who channeled this nega-
tive energy into new forms of art.

Duchamp had become interested in the problem of depicting movement:

I don't know how it came about. When I did that *portrait* of a
woman—five images of the same woman, in three of them she's
dressed and in the other two she's naked—there was already the
idea of movement, the movement of a woman walking her dog,
although maybe it was subconscious on my part. Then, in October
1911, came the *Sad Young Man in a Train*. It was on the occasion of
a train trip I took from Paris to see my family in Rouen, and of
course the sad young man on the train is myself. There isn't much
of the young man, there isn't much of sadness, there isn't much of
anything in that painting except a Cubist influence. My interpreta-
tion of Cubism this time was a repetition of schematic lines, with-
out any regard for anatomy or perspective—a parallelism of lines
describing movement through the different positions of a moving
person.

Sad Young Man in a Train, 1911.

Duchamp's description of the picture, which he actually painted in December, is unflattering but accurate. On the back of the canvas he wrote, "Marcel Duchamp nu (esquisse). Jeune homme triste dans un train," indicating that he considered it a sketch (*esquisse*) rather than a completely realized effort, and the successive images of a robotlike form, painted in dull yellow, brown, and black tones, do not add up to a very convincing suggestion of movement. Arturo Schwarz finds psychological overtones in the title; the young man is sad, Schwarz instructs us, because this is the first time he has been back to Rouen since his sister Suzanne's marriage in August. Duchamp's own explanation of the title was that he used the word "*triste*" solely because of its pleasing alliteration with the word "*train*"—puns, alliterations, and any kind of wordplay held great fascination for him even then. The painting, at any rate, is interesting today mainly because it is the first step in a new direction, using a technique that Duchamp called

"elementary parallelism." The technique was suggested to him by the time-lapse photographs of men, women, and animals in motion that French popular magazines had been publishing for nearly twenty years. Etienne-Jules Marey, a Parisian physiologist who knew most of the important painters and poets of his time, had invented a camera shutter in 1882 that could make multiple exposures of a moving figure on a single photographic plate. Duchamp was well aware of Marey's chronophotographs, which appeared in *La Nature* as early as 1893. He had also seen photographs by the American Eadweard Muybridge, who used a battery of cameras mounted side by side to catch fencers, galloping horses, and other moving figures in a series of separate views, which he then combined to show the movement's flow. Muybridge's book *The Human Figure in Motion,* published first in 1885, includes one sequence of twenty-four images of a nude woman descending a flight of stairs, trailing behind her a white chiffon scarf; it is tempting to think that Duchamp might have seen these, but he did not remember having done so. According to his own, rather vague recollection, it was Marey's photographs in the magazines *La Nature* and *L'Illustration* that gave him the idea of bringing movement into painting.

The Italian Futurists had had the same idea a year or so earlier, but they went about it quite differently. Futurism was in many ways the antithesis of Cubism. Literary, nationalistic, and aggressively political, it has been described as the first truly avant-garde movement because of its strident demands for a complete break with the traditions of Western art. Filippo Tommaso Marinetti, the movement's charismatic entrepreneur and chief polemicist, had announced in his 1909 manifesto that "the world's splendor has been enriched by a new beauty; the beauty of speed. A racing motor car, its frame adorned with great pipes, like snakes with explosive breath . . . a roaring motor car, which looks as though it runs on shrapnel, is more beautiful than the *Victory of Samothrace.*" Marinetti called for an art that would no longer concern itself with fixed moments, an art that would give visual expression to the "universal dynamism" of modern life. The Futurist artists responded to the challenge in various ways, which ranged from Giacomo Balla's charming *Dynamism of a Dog on a Leash,* in which the trotting dachshund appears to have twenty feet and eight tails, to Umberto Boccioni's huge, expressionistic *The City Rises,* with its giant stallions symbolizing industrial power and energy. Boccioni and Carlo Carrà visited Paris in the fall of 1911; they met Picasso and Apollinaire, and picked up many useful

ideas through direct exposure to Cubist painting and sculpture. Duchamp, however, had no contact with them. Living out in Neuilly and already somewhat removed from the group discussions in Puteaux, he did not become aware of the movement until an exhibition of forty-five Futurist paintings opened at the Galerie Bernheim-Jeune in Paris in February 1912. By then he had already worked out his own, very different conception of movement in painting.

The Futurists wanted to give the *impression* of movement on canvas. Duchamp would later refer to them as "urban Impressionists who make impressions of the city rather than the countryside," and he thought that by doing so they fell into the same old trap of "retinal" art from which he and others were trying to escape. Duchamp was after something else, a visual expression of the *idea* of movement. In a 1946 statement, an important but long-after-the-fact declaration of his principles, he explained:

> My aim was a static representation of movement, a static composition of indications of various positions taken by a form in movement—with no attempt to give cinema effects through painting. The reduction of a head in movement to a bare line seemed to me defensible. A form passing through space would traverse a line; and as the form moved the line it traversed would be replaced by another line—and another and another. Therefore I felt justified in reducing a figure in movement to a line rather than to a skeleton. Reduce, reduce, reduce was my thought—but at the same time my aim was turning inward, rather than toward externals. And later, following this view, I came to feel that an artist might use anything—a dot, a line, the most conventional or unconventional symbol—to say what he wanted to say.

This sounds very much like a rationale for complete abstraction. In the 1946 statement, though, Duchamp was really talking about the painting that immediately followed *Sad Young Man in a Train,* a work whose abstract qualities were immediately lost sight of in the cloud of controversy that surrounded it almost from the moment it appeared. The title of this one was *Nude Descending a Staircase.*

No painting in history has ever been so overshadowed by its title. If Duchamp's famous *Nude* had been called something more prosaic—*Study*

in Movement, say, or *Composition #2*—there would probably have been no furor at all. It is not a great picture; as the art historian William Rubin points out, Duchamp's "*Nude* hardly compares in adventurousness with the great analytic Cubist paintings of the same year." But the title was something else. For two thousand years the nude had functioned not just as a subject in art but as a form of art, and as such it had always followed certain conventions. Nudes, if male, posed heroically, performed feats of strength, expired in battle, and symbolized divine or secular authority; if female, they reclined, bathed, dispensed liquids from urns, and (as caryatids) held up roofs. They did not move, and they certainly did not come down flights of stairs. What sort of joke was Duchamp trying to pull?

Humor certainly had a hand in it. "The *Sad Young Man in a Train* already showed my intention of introducing humor into painting, or, in any case, the humor of wordplay: *triste, train,*" Duchamp told Cabanne. The new picture, which he started in December 1911, grew out of a small drawing that he had done a few weeks earlier, one of a series of eight or perhaps ten sketches that were conceived as illustrations for poems by Jules Laforgue. (Only three of them have survived.) This one was called *Encore à cet astre* (*Once More to This Star*), and it showed three rudimentary, barely legible figures, one of whom appears to be climbing a flight of stairs. "It was just a vague, simple pencil sketch of a nude climbing a staircase," Duchamp said, "and probably looking at it gave me the idea, why not make it descending instead? You know, in musical comedies, those enormous staircases."

Duchamp's nude would not just walk downstairs, then; she would saunter down majestically, like a showgirl at the Folies Bergère! But, of course, this is not what she did at all. In the first version, which is known as *Nude Descending a Staircase, No. 1,* we do see some indications of a human body, just as we can see a winding staircase that is almost certainly modeled on the one in Duchamp's childhood house in Blainville. When Duchamp painted the second, definitive version a month later, however, in January 1912, he eliminated all such naturalistic details. The nude in *Nude Descending a Staircase, No. 2* is an empty shell, a sort of hooded robot, whose twenty or more successive positions in a descending sequence make her look more mechanical than human—"a descending machine," as the critic Robert Lebel described her. Executed in the austere brown, gray, and greenish tones and overlapping planes of analytical Cubism, this nude is so nonerotic that some viewers have wondered about her sex. Was she really a man? Absolutely not,

Duchamp maintained—she was "definitely feminine." Eroticism asserted itself, nonetheless, in the painting's title, which Duchamp had painted in capital letters right on the canvas itself. The erotic charge, like the sense of movement, was located not in the retina but in the mind of the viewer. But a Cubist nude that is also a machine clanking down an abstract flight of stairs proved to be altogether too much for the Puteaux Cubists, in whose theoretical deliberations—as Duchamp must have known—there was not much room for eroticism or for humor.

Encore à cet astre (Once More to This Star), 1911.

Duchamp submitted his just-finished picture for exhibition in the 1912 Salon des Indépendants, which was scheduled to open on March 20. The Puteaux group had high hopes for this *salon,* where once again they were mounting a group show of their latest work in one big gallery. Gleizes and Metzinger, who had assumed leadership of the group, and who wanted to present their so-called "reasonable Cubism" in the strongest possible light, were taken aback by Duchamp's *Nude.* The picture struck them as a mockery of Cubist esthetics; they also thought it was much too close in spirit to some of the Futurist paintings that had gone on view at the Galerie Bernheim-Jeune just a month earlier, in February. (With their outspoken attacks on the Cubists as academic artists hamstrung by tradition, the Futurists were causing quite a stir in Paris; their appropriation of Cubist techniques added insult to the indignity.) Gleizes and Metzinger, at any rate, decided that the youngest Duchamp brother's picture would be detrimental to the cause of reasonable Cubism, and their arguments evidently convinced others in the group. Jacques Villon and Raymond Duchamp-Villon were delegated to break the news to their brother. Formally dressed in black suits, as though for a funeral, they called on him in his studio in Neuilly the day before the *salon*'s official opening. " 'The Cubists think it's a little off beam,' " Duchamp remembers them saying to him. " 'Couldn't you at least

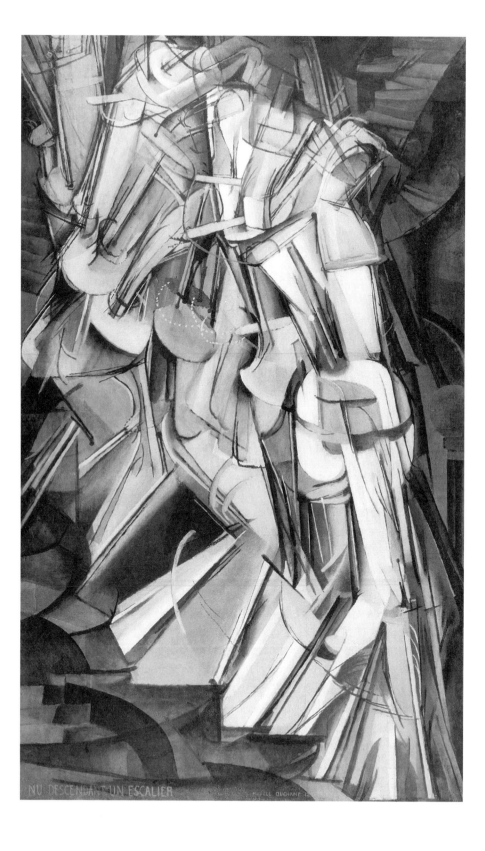

NU DESCENDANT UN ESCALIER

change the title?' They thought it was too much of a literary title, in a bad sense—in a caricatural way ... Even their little revolutionary temple couldn't understand that a nude could be *descending* the stairs.

"Anyway, the general idea was to have me change something to make it possible to show it, because they didn't want to reject it completely ... So I said nothing. I said all right, all right, and I took a taxi to the show and got my painting and took it away."

In the gentle irony of this account, spoken half a century later, we can catch only faint echoes of Duchamp's feelings

Joan Miró. *Nude Descending a Staircase*, 1924.

at the time. He said nothing to his brothers, who so evidently had failed to take his side in the dispute. No argument, but no compromise, either; he would not change the title. Although Duchamp suppressed whatever emotions were involved, the effects of the rebuff were deep and permanent. "It was a real turning point in my life," he once said. "I saw that I would never be much interested in groups after that."

Gleizes, Metzinger, and the others apparently got over their initial doubts regarding the picture. *Nude Descending a Staircase, No. 2* was shown a month later in the first important Cubist exhibition outside France, at the avant-garde Galerie Dalmau in Barcelona; although it excited no special attention there, it seems to have made an impression on a nineteen-year-old art student named Joan Miró—twelve years later Miró would make a drawing of a flight of steps and one long, meandering line and call it *Nude Descending a Staircase*. Duchamp's painting also appeared, without causing a scandal, in the important Section d'Or exhibition that the Puteaux group put on in Paris that fall. The question remains, did Duchamp intend to shock or provoke people with his troublesome *Nude*? Probably not—although, in the light of his later, highly subversive activities in the art worlds of Paris and New York, the element of mischief cannot be ruled out; stimulated and egged on by Picabia, he

Opposite: *Nude Descending a Staircase, No. 2*, 1912.

had grown increasingly derisive in his attitude toward the Puteaux artists and their "revolutionary temple." Whatever his intentions may have been, the incident strengthened and confirmed Duchamp's determination to go his own way, to find his own path without benefit of rules or theories, and to discover something that was entirely his own.

During the Christmas holidays in 1911, while he was still working on the first version of his *Nude,* Duchamp agreed to make a small painting for the kitchen of his brother Raymond's house in Puteaux. "It's normal today to have paintings in your kitchen, but at that time it was rather unusual," he said. "My brother asked Gleizes, he asked La Fresnaye, he asked Metzinger, five or six of us, and he gave us the size of the paintings because they were to go above the sink. I had the idea of making a coffee grinder. And as it turned out, instead of making an objective, figurative coffee grinding machine, I did a description of the mechanism. You see the cogwheel, and you see the turning handle at the top, with an arrow showing the direction in which it turned, so there was the idea of movement, plus the idea of composing the machine in two parts, which is the source of things that came later in my big *Glass.* You can also see the coffee after it has been ground."

Coffee Mill, 1911.

Although he did not realize it until later, this little painting, called simply *Coffee Mill,* would be far more important to his future development than *Nude Descending a Staircase.* It would show him the way to escape from traditional "pictorial" painting altogether—would offer, as he said, "a window onto something else." At the time, though, "I was just making a present for my brother."

Munich, 1912

In 1912 it was a decision for being
alone and not knowing where I was
going. The artist should be
alone . . . Everyone for himself, as in
a shipwreck.

In 1912 Duchamp completed four paintings that would assure his place
in art history and then moved beyond painting, into an area where no
artist had been before. The transition was swift—only five months sep-
arate *Nude Descending a Staircase* from the first pencil sketch for *The Bride
Stripped Bare by Her Bachelors, Even,* his masterpiece on glass. Working
alone, confiding in no one, he left almost no biographical clues, no letters or
statements, and only a few cryptic notes that hint at his state of mind during
this *annus mirabilis.* The paintings and drawings that Duchamp produced
in 1912 all have one element in common, however, and that is a subtle but
obsessive eroticism. It is his great theme, which he would pursue for the rest
of his life. He wanted, as he once said, "to grasp things with the mind the
way the penis is grasped by the vagina." For Duchamp, eros was more pow-
erful than sex and more liberating than love, and its true habitat was the
human mind.

Nudes, movement, and the game of chess come together in his next
painting, called *The King and Queen Surrounded by Swift Nudes.* Finished in
May, it was preceded by three pencil studies in which Duchamp plays with
images of machinelike yet recognizably male and female forms. In the first
sketch, *Two Nudes: One Strong and One Swift,* the male figure on the right

appears to be lunging violently toward the stationary female. This was followed by *The King and Queen Traversed by Nudes at High Speed,* in which the two figures have assumed shapes that vaguely resemble chess pieces; massive and unmoving, they are pierced by diagonal lines whose force and location suggest copulation. *The King and Queen Traversed by Swift Nudes,* the third preliminary study, shows the same two figures placed farther apart but still joined together by the moving diagonals. What is going on with these swift nudes? Since Duchamp never explained them, it is up to the viewer to decide whether they represent erotic thoughts and desires, or the movement of electrons, or something else—images of sheer velocity, perhaps, or a verbal dig at sober-sided Puteaux Cubism. (Forbidden to descend staircases, nudes might just start zipping around at high speed.)

The King and Queen Surrounded by Swift Nudes, 1912.

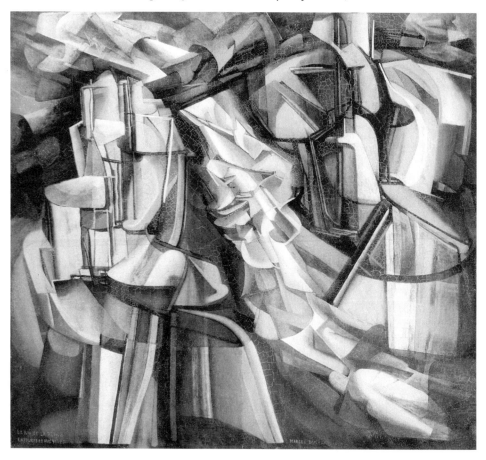

More and more now, Duchamp's work demands the onlooker's active participation.

The erotic action shifts gears rather dramatically in *The King and Queen Surrounded by Swift Nudes,* the oil painting that followed these studies. As its title indicates, the "swift nudes" no longer pierce or penetrate the two figures but flow between and around them in a sort of caressing movement, and the figures themselves, the king and the queen, have become much more clearly machinelike in their blocky contours and polished, metallic surfaces. Some critics have suggested that the forms in this painting show the influence of Léger, who was very much a part of the Puteaux circle at that time, but Duchamp's treatment of them seems closer to what the Futurist painter Umberto Boccioni was trying to achieve in his "States of Mind" pictures. Duchamp had visited the Futurist exhibition at the Galerie Bernheim-Jeune several times that spring, and in later years he said that his "King and Queen" series was perhaps "a bit Futurist." *The King and Queen Surrounded by Swift Nudes* is a highly original work nevertheless; beautifully composed and technically assured, its hieratic forms evoke a mysterious and somewhat ominous power.

In his influential 1959 monograph on Duchamp's work, Robert Lebel interpreted the king and queen as " 'father and mother' machines whose totemic stability is attacked by their turbulent offspring." It may be time to retire that theory—if only because Duchamp, throughout his life, seemed so happily immune to the Freudian miasma and because Eugène Duchamp's benign and tolerant acceptance of his children's decisions to become artists must have diffused any potential "turbulence" on that score. Some observers have found it significant that *The King and Queen Surrounded by Swift Nudes* is painted on the other side of an earlier canvas by Duchamp—the 1910 "allegorical" painting called *Paradise,* in which his friend Dumouchel impersonates the nude Adam (hands modestly shielding his genitals) and a pneumatic female model is Eve. Duchamp said he had decided to reuse this canvas simply because he didn't have enough money at the moment to buy another, but he placed the king and queen in the same relative positions as Adam and Eve, and that was enough to persuade several Duchampians that what we are dealing with here is original sin. Duchamp threw cold water on this sort of thinking. "*The King and Queen* never was to be interpreted otherwise than from an esthetic angle," he said in 1961. "The title and the introduction of themes like king, queen, nudes, speed without actually painting them were among my

artistic preoccupations, using the theme mostly in my apolitical, aromantic but humorous way. Don't forget that in that Fauve period following Impressionism a poetic title to a painting was anathema and despised as 'literature.' "

Duchamp's iconoclasm made him receptive to almost anything that was "despised" by the new academicians of art, of course, and at this point in his career he was more influenced by literature than by anything else. For several years his favorite poet had been Jules Laforgue, a late Symbolist who died at the age of twenty-seven in the same year Duchamp was born. Laforgue, whose experiments in free verse would have a significant influence on T. S. Eliot and Ezra Pound, was considered a fairly minor poet in France, but his nihilism, irony, and cynical humor held great appeal for Duchamp, and so did his frequent use of puns, alliterations, repetitions of sounds, and made-up word combinations such as *voluptial* (voluptuous and nuptial) and *éternullité* (eternal and nothing). Laforgue's poems ridiculed romantic love, marriage, family life, religion, logic, reason, beauty, and every other received idea or social convention. In "Encore à cet astre," one of the Laforgue poems that inspired Duchamp's drawings in 1911, he even attacked the sun, which he portrayed as diseased and drained of its warmth, "The laughing stock of the heartless stars." Many of the drawings that Duchamp did for *Le Rire* and other satirical journals reflect Laforguian themes; his 1909 *Dimanches* (*Sundays*), with its glum bourgeois husband pushing a baby carriage while his pregnant wife lumbers alongside, is a good example. No fewer than sixteen poems by Laforgue share the same title and the same derisive approach to marital misery. Duchamp said once that he was "less attracted by Laforgue's poetry than by his titles." He had a particular liking for the prose narratives that Laforgue called *Moralités légendaires* (*Moral Tales*), though, and his favorite of these, an ironic retelling of *Hamlet,* is worth examining as a reflection of its author and also, perhaps, of the young Duchamp.

Laforgue's Hamlet is cynical, self-mocking, witty, clownish, and despairing—the modern antihero. Early in the narrative we find him alone in his tower at Elsinore, waiting irritably for the traveling players to arrive. He amuses himself while he waits by tearing up a bunch of letters from Ophelia, "that silly little parvenue," who has been missing since the night before.

> Where can she be at this hour? Probably with her relations in the country. She'll get back all right, she knows the way. And besides

she would never have understood me. When I think of it! However lovely and mortally sensitive she may have seemed, all one had to do was scratch the surface to discover a little English girl imbued since birth with the egotistical philosophy of Hobbes . . . Ophelia, Ophelia, dear little gluey tart, come back, I implore you; I will never speak of these things again.—And besides, dear boy, Hamlet that we are, we can sometimes behave like a real son-of-a-bitch. Enough. Ah, here they come.

The two players he has sent for arrive, and as Hamlet instructs them regarding the scenes he has written for them to perform, he proceeds to fall in love with the beautiful ingenue, Kate, "who has been around quite a bit in her day." The actors go off to rehearse. Hamlet takes a walk and has his lengthy encounter with the gravediggers. When Ophelia's funeral procession approaches the cemetery, he conceals himself and then soliloquizes:

> Well, as I was saying, she had an angelic torso. But what can I do about all that now? Listen, God, I will give ten years of my life to bring her back to life. No answer. Going, going, gone! Either there is no God, or else I haven't got ten years left to give. The first hypothesis seems to me the more likely.

The players perform Hamlet's scene at the castle. Claudius and Gertrude betray their guilt, but by this time Hamlet has decided that instead of killing his father's slayer he would prefer to run off with Kate, the seductive ingenue.

> I don't give a damn about my throne either. It's too idiotic. Fortinbras of Norway would advise me to look at it that way. Well and good. The dead are dead. I'm off to see the world. And Paris! I am sure she acts like an angel, a terrific little angel. What a hit we'll be with our fantastic stage names!

Hamlet and the willing Kate slip out the back door of the castle, but as they pass the graveyard, Hamlet goes to take a last look at the tomb of Ophelia. He runs into her grieving brother, Laertes, who "plants a somewhat realistic dagger in his heart." Laforgue appends his jeering moral: "One Hamlet the less does not mean the end of the human race. Of that you can be sure."

The tone of ironic detachment that permeates everything Laforgue wrote is very close to Duchamp's attitude toward life at this point—much closer, for example, than Jarry's anarchic extravagance. Themes and titles used by Laforgue turn up over and over again in Duchamp's work, and not only in his humorous drawings; *Sad Young Man in a Train* was originally called *Pauvre Jeune Homme M,* which is the title of one of Laforgue's *complaintes,* and as we have seen, the little drawing that Duchamp did for Laforgue's "Encore à cet astre" gave him the idea for *Nude Descending a Staircase.* Why, then, has the Laforgue influence been largely overlooked by Duchamp's critical constabulary? One reason may be that Duchamp himself assigned so much greater importance to his encounter, in the spring of 1912, with the work of that sovereign eccentric, Raymond Roussel.

The youngest son of a wealthy French family, Raymond Roussel (1877–1933) showed remarkable gifts at an early age. As a youth he excelled at chess, won forty-five medals for pistol shooting, and played the piano so well that he was allowed to quit school at the age of thirteen to study with Alfred Cortot. Abandoning music for literature, he brought out his first book of poems when he was nineteen, and his second four years later—both were published at his own expense and totally ignored by the critics. Roussel's next effort, a novel called *Impressions d'Afrique* (*Impressions of Africa*), appeared serially in the ultra-conservative Paris journal *Gaulois du Dimanche,* where it must have greatly perplexed the regular subscribers; according to Robert Lebel, the weekly installments ran alongside such items as "the 'advice to the lovelorn,' the poetry of Stephen Liégeard, President of the Society for the Encouragement of Virtue, and the portrait of His Imperial Highness, the Tsarevich, saluting the colors." Roussel, who was addicted to the theater, decided next to seek a wider audience by adapting his novel for the stage. He financed the production himself, and the first version of *Impressions d'Afrique* opened at the Théâtre Femina in Paris in February 1911. It was withdrawn after three performances. The following year Roussel paid to have a revised version put on with a professional cast at the Théâtre Antoine, where it ran for four weeks. The reviews were dismissive, but before its run ended, the play gained a sort of cult following among the Paris avant-garde, and its final performances were well attended.

Duchamp probably saw *Impressions d'Afrique* during the second or third week in June. In all his later references to this major event in his life, however, he remembered having gone to it with the Picabias and Guillaume

Apollinaire, and this is where confusion sets in, because Duchamp also said, in separate statements to three different interviewers, that he met Apollinaire for the first time in October 1912, more than three months after the play had closed. It seems odd that Apollinaire and Duchamp would not have made contact earlier, either in Paris or at one of the Sunday afternoon gatherings in Puteaux that spring, but Duchamp's memory of their October meeting was very clear and specific.* On other occasions Duchamp said that he had read the text of *Impressions d'Afrique* sometime after he saw the play, and he spoke of Apollinaire's having "first showed Roussel's work to me"; perhaps this connection tricked his memory into recalling that Apollinaire had been present at the performance when, in fact, he had not. (Duchamp once wrote, in a letter to his friend Marcel Jean, that "it is curious to note how frail memory is, even for the important episodes of life.") In any event, Roussel's play made a tremendous impression on him. "It was fundamentally Roussel who was responsible for my glass, *La Mariée mise à nu par ses célibataires, même,*" he said in 1946. "From his *Impressions d'Afrique* I got the general approach. This play of his which I saw with Apollinaire helped me greatly on one side of my expression. I saw at once that I could use Roussel as an influence. I felt that as a painter it was much better to be influenced by a writer than by another painter. And Roussel showed me the way."

What Duchamp admired most about Roussel's play was that it bore so little resemblance to the work of any other writer, living or dead. Roussel's literary methods were based on elaborate, nonsensical word games. For example, he would select two words that sounded almost the same and use them in identical phrases, one of which he used to begin his story, and the other to end it; the shift in meaning between the two phrases would generate the plot of his story. An early tale called "Parmi les noirs" ("Among the Blacks") found its conceptual origin in the phrase "les lettres du blanc sur les bandes du vieux billard" ("the white letters on the sides of the old billiard table"), which became, when the word *pillard* was substituted for *billard* in the final sentence, "the white man's letters about the old pirate." Puns, homophones, and random phrases or slogans ran riot through his prose, each one giving way to all sorts of transformations and transubstantiations that led in turn to the most fantastic distortions of reality, but the prose style itself remained utterly deadpan, clear, and matter-of-fact. The effect was

* See Notes, p. 473.

extremely bizarre, to say the least. According to Pierre Janet, a well-known psychiatrist who treated Roussel and wrote him up in one of his published case histories, Roussel believed "that a work of literature must contain nothing real, no observation of the world, nothing but combinations of completely imaginary objects." In *Impressions d'Afrique* he achieved something very close to this ideal.

The plot is minimal. A ship bound for Buenos Aires founders off the coast of Africa, and a motley assortment of European passengers comes ashore. They are captured and held for ransom by the native tribesmen, whose king, Talou VII, conveniently speaks French. While the castaways wait for their emissary to return with the ransom, they prepare and eventually perform a series of utterly fantastic theatrical skits or feats of skill to amuse their captors, who join in the entertainment. Most of the play is taken up with these amazing goings-on, each of which derives from a play on words or a verbal distortion of some kind. One passenger invents a "wind-clock of the land of Cockaigne," whose origin is the word *empereur,* transposed into *hampe* (pole), *air* (wind), and *heure* (time). Another tells the story of a peg-leg Breton named Lelgoualch, who plays on a flute made from his own tibia—this came from Roussel's having seen an ad in a newspaper for a "Phonotypia" recording machine, which suggested to him *fausse* (wrong) *tibia* (shinbone). A passenger named Louise Montalescot demonstrates a "painting machine" to make art (fifty years later the Swiss artist Jean Tinguely would reinvent a similar device), and her brother, Norbert Montalescot, escapes death by fulfilling King Talou's demand that he build a life-size statue light enough to travel on rails made of calf's lungs. There is also a worm that plays a zither; an artificial orchestra made of "Bexium," a new metal whose thermal sensitivity enables it to produce sounds ranging from a harp to a hunting horn; and an epic recitation written by King Talou himself in a language that no one can understand. Machines that perform human functions, new metals that defy the laws of physics, puns and verbal distortions, absurdly illogical actions described in coolly logical terms—all these would figure prominently a few years later in Duchamp's *Large Glass.* Duchamp knew nothing about Roussel's literary methods at the time, because the book in which he described them, *Comment j'ai écrit certains des mes livres* (*How I Wrote Some of My Books*), was not published until 1935, two years after the author's death. But it was not the text of *Impressions d'Afrique* that made such a deep impression on Duchamp. As he recalled later, "One didn't really listen" to the dialogue on stage. What fasci-

nated him was "the madness of the unexpected," and the revelation that a work of art could be without influences—could come from nowhere but the artist's imagination.

A week or so after this exhilarating experience, Duchamp boarded a train for Munich. Traveling alone, he made overnight stops in the Swiss towns of Basel and Constance to visit the local museums and see the sights and arrived on the evening of June 21 in the Bavarian capital, where he was met at the station by Max Bergmann, the young German art student whom he had shepherded around Paris two years earlier. It was his first trip outside France. "I would have gone anywhere in those days," he explained many years later. "If I went to Munich it was because I had met a cow painter in Paris, I mean a German who painted cows, the very best cows, of course, an admirer of Lovis Corinth and all those people, and when this cow-painter said 'Go to Munich,' I got up and went there and lived for months in a little furnished room . . . Munich had a lot of style in those days. I never spoke to a soul, but I had a great time."

Duchamp was being somewhat evasive, as usual. For the rest of his life he never revealed any personal details about the two months that he spent in Munich—two months of solitary and (for him) prolific work, out of which came two important paintings and four drawings, including the first study for *The Large Glass.* We know next to nothing about how he lived or what he was thinking during this crucial summer—the defining point in his career—and Duchamp clearly wanted it that way. The impulse that made him travel to another city and lead a completely isolated existence, free of family ties or distractions of any kind, also seems to have made him want to preserve that experience, intact and inviolate, for himself alone. He hinted at this in a late filmed interview with the French documentary filmmaker Jean-Marie Drot. "In 1912 it was a decision for being alone and not knowing where I was going," Duchamp said. "The artist should be alone . . . Everyone for himself, as in a shipwreck."

He made no effort to meet any of the artists whose presence in Munich had established that comfortable bourgeois city as the most important center of advanced art in Europe, after Paris. Duchamp was certainly aware of Wassily Kandinsky, the great Russian painter and theoretician, who had returned to Munich in 1908 after extensive travels in North Africa and Europe and whose recently published book, *Über das Geistige in der Kunst* (*Concerning the Spiritual in Art*), was displayed in the window of almost every bookstore. Just a few

months before Duchamp's arrival, Kandinsky and his followers had split off from the Neue Künstlervereinigung, Munich's principal artist association, to form a loosely knit group called the Blaue Reiter (the Blue Rider, named after Kandinsky's near-abstract drawing of a mounted horseman that appeared on the cover of their exhibition catalog). The Blue Rider artists—Kandinsky, Alexei von Jawlensky, Franz Marc, August Macke, and a few others—had no specific program or esthetic philosophy. Strongly influenced by the work of Van Gogh and Gauguin and also by the coloristic freedom of the Fauves, they were in search of an art of "internal meaning" and "inner resonance"—a search that had brought Kandinsky, sometime in 1911 or 1912 (the exact date is uncertain), to take the step into total abstraction.

Duchamp shared none of the interests or ideals that were so dear to the Blue Rider artists and to German Expressionism in general—he had no affinity for social causes or for any view of art as a direct expression of personal emotions or communal yearnings. Even more significant, perhaps, was Duchamp's indifference toward the question of "pure" abstraction, which was about to become one of the defining issues in twentieth-century art. Duchamp did not find it necessary to make a decision for or against abstraction; for him it was just another tool to be used, and never exclusively. The images in the upper half of *The Large Glass* (the bride's domain) are more or less abstract; those in the lower (bachelors') half are not abstract at all.

Duchamp certainly had no interest in meeting Kandinsky in 1912, at any rate, although he may perhaps have read his book. A copy of it turned up years later among his brother Jacques Villon's effects, with penciled annotations in the margins that some scholars believe were made by Duchamp; but Alexina Duchamp, who married Marcel in 1954, has stated firmly that both the handwriting and the book were Villon's—Marcel, she added, would never have written notes in the margins of books.

Duchamp did not see much of his friend Max Bergmann. Shortly before he arrived, Bergmann had moved out to the little village of Haimhausen, twenty kilometers north of Munich, where he and another artist set up a teaching studio and offered open-air classes in landscape, figure, and animal painting. Duchamp took the train out to visit them at least once, and he made Bergmann a present of a small pencil drawing that he had done in 1910; the drawing shows a man embracing a woman whose hairstyle seems to identify her as Jeanne Serre, with whom Duchamp had been having a serious love affair at the time. Bergmann probably helped him find the furnished room

that he moved into ten days after he got to Munich. It was on the second floor at 65 Barerstrasse, in a section of town called Schwabing, which was popular with university students and artists. (Munich's large population of would-be artists was increased in 1913 by the arrival of Adolf Hitler, who moved there after failing the admission examination to the Vienna Academy of Arts.) The Alte Pinakothek, Munich's principal art museum, was within easy walking distance, and Duchamp went there nearly every day. It was at the Alte Pinakothek that he fell in love with the work of Lucas Cranach, the sixteenth-century Ger-

Duchamp in Munich, age twenty-five.

man artist whose paintings of nude figures in classical or biblical settings managed to look not so much nude as undressed and therefore slightly pornographic. Duchamp later credited Cranach with an assist on his Munich painting *The Bride*. "I love those Cranachs..." he said. "The tall nudes. That nature and substance of his nudes inspired me for the flesh color."

From the infrequent and laconic notes that Duchamp mailed to various members of his family that summer (five postcards and one letter are known), we learn only that he spent time in German beer halls, that he had difficulties with the language—he had studied German at the lycée, but, as he wrote to his godmother Julia Paulin-Bertrand in August, "it still remains for me to understand German better than I do"—and that occasionally he missed "the intimacy of Neuilly." A card to his grandmother Marie Nicolle wryly informs her that Munich's famed Schloss Nymphenburg, shown on the other side, "has the pretension to recall Versailles." In response to a letter from Apollinaire (whom he had not yet met), he went to a photographer's studio and had a picture taken of himself for the book that Apollinaire was writing entitled *The Cubist Painters*. Aside from that, silence. Not a word to anyone about the ideas and images that were germinating in the solitude of his furnished room.

The first Munich drawing was a small pencil-and-wash study of three abstract, machinelike personages, two of whom appear to be menacing or

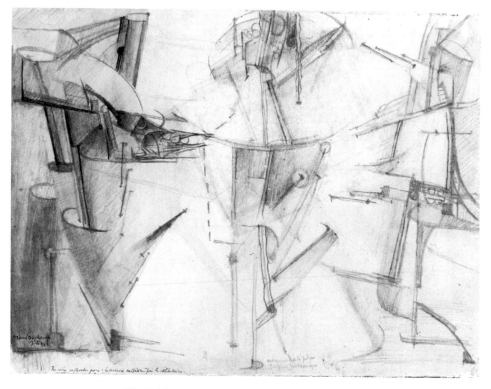

The Bride Stripped Bare by the Bachelors, 1912.

attacking the third. A penciled inscription at the bottom reads, *Mécanisme de la pudeur/Pudeur mécanique* (Mechanism of modesty/Mechanical modesty), but the true subject and significance of the drawing is made clear by another inscription, in ink, that Duchamp must have added sometime later: *Première recherche pour: La Mariée mise à nu par les célibataires* (First Research for the Bride Stripped Bare by the Bachelors). In this sketch the terms of the sexual encounter are very different from those in *The Large Glass*. Instead of lording it over the bachelors from her position on high, the bride stands between them on the same plane, helpless and vulnerable in her mechanical modesty, while the rapacious bachelors on either side attack with dartlike missiles or grappling hooks to pull away her clothes. The drawing itself is closer to the 1911 *Coffee Mill* than to the "King and Queen" studies he had done a few months earlier. Machine imagery was starting to influence the work of Picabia, Léger, Duchamp-Villon, and several other advanced artists around this time, but Duchamp's machine images

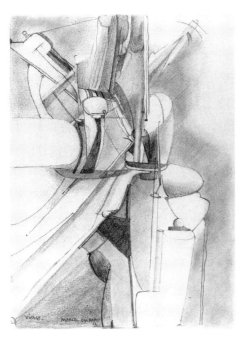

Virgin (No. 1), 1912.

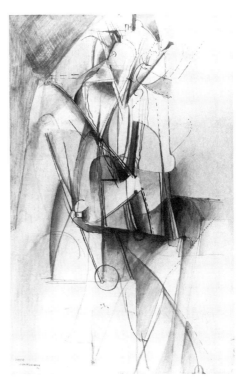

Virgin (No. 2), 1912.

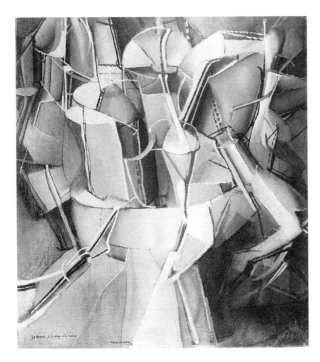

*The Passage from the
Virgin to the Bride*, 1912.

never looked "modern" in the way theirs did. His *Coffee Mill* was an old-fashioned mechanism turned by a hand crank. In the new little drawing the "machinery" looks almost medieval and there is an improvisational quality about it, a sense that Duchamp was not setting down preconceived ideas but rather giving his imagination free rein. This same quality of inspired doodling carries over into the next two drawings, both of which are dated July 1912 and titled *Virgin*.

The *Virgin* drawings take us inside the body-machine. Although elements in both of them suggest female breasts, a raised knee, or even a face shielded by a fall of hair, the forms press up against the surface of the paper in such extreme close-up that it is hard not to feel we are looking *into* a mental image of virginity. There is nothing particularly sexual or even sensual about these rather austere lines and shapes. Duchamp had the well-brought-up Frenchman's ingrained respect for the state of virginity—a respect that may even have verged on awe. In these two drawings he seems to have been investigating, perhaps with his own residue of *pudeur,* the nascent power of female eroticism, a power that would emerge triumphantly in the two paintings that followed.

The Passage from the Virgin to the Bride, which has been on permanent display since the 1950s in the Museum of Modern Art, demolishes once and for all the charge that Duchamp was an idea man who never quite mastered the art of painting. It is one of those pictures that gives back something new, a different insight or vibration, every time you see it. Once again the title—the verbal aspect—is an essential element. Duchamp painted it right on the canvas, at the lower left, as he had done with *Nude Descending a Staircase* and *The King and Queen Surrounded by Swift Nudes.* Although the word *passage* (it is the same word in French: *Le Passage de la vierge à la mariée*) suggests movement, in this case the movement is not through space but within the mind and the body—a transition from virginity to bridehood. And what, we might ask, is bridehood? The cultural historian Jerrold Seigel, in a recent book on Duchamp, suggests quite persuasively that "the reference is not to sexual initiation. A loss of virginity is expected to take place in a passage to womanhood or wifehood; the passage *to* bridehood is only a precondition for this second transformation." Duchamp's notes in *The Green Box* seem to bear this out. One of them calls the bride *an apotheosis of virginity;* another describes her "blossoming" as *the last state of this nude bride before the orgasm which may (might) bring about her fall.* Bridehood, in other

words, is a state of anticipation and delayed innocence—a brief, ecstatic moment prior to the uncertain blessings of carnal knowledge.

The painting itself is composed of interlocking Cubist planes done in a restrained palette of earth colors—brown, ocher, yellow, black. There are no recognizable images in it, although the shape at the far right has been interpreted as a menacing male figure, and impressionable observers have discovered all sorts of hidden visual references elsewhere in the composition. The most striking form is a thin, pinkish rectangle topped by a pair of antenna-like horns, which rises vertically from a funnel-shaped object near the center of the picture. The same form will reappear in Duchamp's next painting and also in *The Large Glass*. Arturo Schwarz identifies it as an "alembic—the classical androgynous symbol in alchemy," but it could also be seen as the upraised neck and head of a snail-like animal or insect. Its recurrence suggests that *Passage*, like the three drawings that preceded it, is itself a study—a stage in Duchamp's own approach to something far more ambitious. "My stay in Munich," he would say, "was the scene of my complete liberation, when I established the general plan of a large-size work which would occupy me for a long time."

Duchamp finished *The Passage from the Virgin to the Bride* toward the latter part of July and immediately started on his next painting, *The Bride,* which he completed in August. In addition to being one of the most mysteriously erotic paintings in twentieth-century art, Duchamp's *Bride* is his masterpiece as an oil painter, the culmination of a long series of works on canvas that really began with the 1910 *Young Man and Girl in Spring*. The picture is related to his earlier Munich works in its "juxtaposition of mechanical elements and visceral forms"—Lebel's phrase, which Duchamp must have liked, because he used it himself in a lecture some years later (perhaps Lebel got it from him in the first place)—but in all other respects this painting is a breakthrough into new and uncharted terrain. The Cubist structure that underlies *Passage* has been left behind in *The Bride,* and so has the attempt to depict motion. Here the sensuously painted forms exist in a completely new kind of space, shallow yet fully realized, luminous, tactile, and absolutely still. In the background of this painting, Duchamp once said, he had caught a glimpse, for the first time, of the fourth dimension. This suggests that he saw his Munich bride as a three-dimensional projection of an invisible four-dimensional being.

The color is extraordinary—a delicate interplay of rose, peach, and greenish-gray tones that were inspired, Duchamp said, by Lucas Cranach

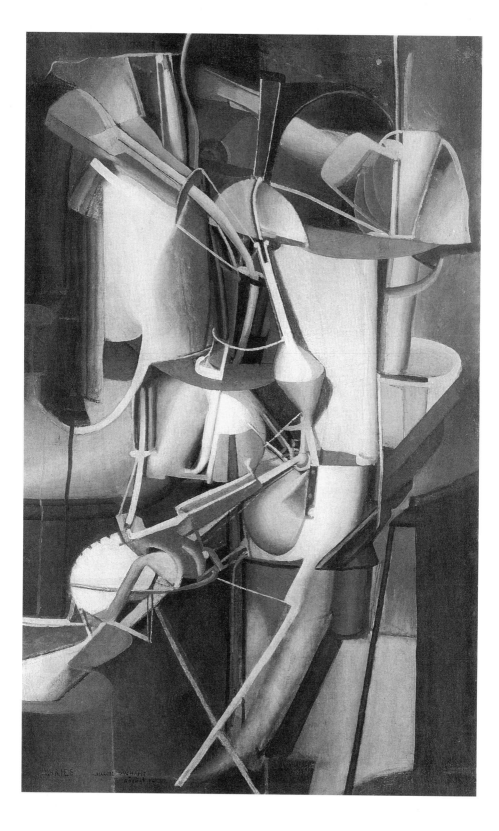

and also by Arnold Boecklin, whose mythological landscapes had caught his interest in the German museums he visited that summer. There is no doubt about the sexual implications of these delicately colored forms, with their suggestion of mucous membranes and moist internal tissues. The eye slides over and around them, the mind grasps them lubriciously—the same way the vagina (in Duchamp's phrase) grasps the penis. Duchamp had selected German Behrendt artist's colors, the best brand available; in some areas of the canvas he applied them with his fingers, kneading and smoothing the pigment to the silky consistency of a Vermeer. Never again would he exploit so sensuously the physical qualities of oil paint.

In Duchamp's mind, however, *The Bride* was not the culmination of a series of paintings. It was one more step toward the "large-scale work" that he had conceived at the beginning of his stay in Munich. So far he had concentrated his attention on the female side of things, ignoring for the time being the "bachelors" whose presence had been announced in that first Munich drawing. For two months the erotic theme of virgin-into-bride haunted his imagination with obsessive intensity—so much so that when he painted *The Bride* he had been, as he later recalled, "in a state of virtual anesthesia." One night, returning to his furnished room after drinking too much at a beer hall, he fell asleep and dreamed that his *Bride* "had become an enormous beetle-like insect which tortured him atrociously with its elytra." Aside from noting that "elytra" means "wing cases," I will leave the psychoanalytic implications of this nightmare to the ever-dwindling ranks of orthodox Freudians. The dream foreshadows, nonetheless, the superior and not entirely benign role that the bride would assume in *The Large Glass,* and the relative passivity of the bachelors.

Duchamp finished *The Bride* in late August, then took time out for a brief vacation. He left Munich and spent the next three weeks visiting Vienna, Prague, Leipzig, Dresden, and Berlin, going to the major museums in each city and seeing the Berlin Secession exhibition, which included works by Picasso and other Paris artists. Cubism had not taken hold in Germany. There were no German Cubists, and recent paintings by Picasso, Braque, and their followers were usually exhibited there under the banner of Expressionism, the catch-all term for any new art tendencies that were opposed to Impressionism. In a letter to his brothers from Berlin, Duchamp

Opposite: *The Bride*, 1912.

said that it had given him "great pleasure to find Cubism again, it was such a long time since I had seen it." In the same letter he wrote that his drawing *Virgin (No. 1),* which he had mailed back to Paris, had been accepted for showing at the upcoming Salon d'Automne. "I am writing to you from a so-called 'literary' café," he added. "There are, above all, lots of women who are not at all 'literary.' I hope that my friend [presumably he means Max Bergmann] will join me again here at the beginning of next week and will show me the 'night-life' in Berlin. It's a specialty." He told his brothers that he planned to be back in Paris around the tenth of October, stopping off in Cologne on the way. The letter concludes, "I am beginning to have a real need to see some friends' faces again."

The Jura-Paris Road

The whole trend of painting was
something I didn't care to continue.

Duchamp returned to Paris just in time for the opening of the Section d'Or, the largest and most important of the prewar Cubist group exhibitions. Jacques Villon was responsible for the show's title; it referred to a mathematical ratio of parts to the whole (the "golden section") that was used by artists in the Renaissance. Although the ratio did not really apply to the more than two hundred paintings on view at the Galerie de la Boetie, it had a nice ring, and it also served to indicate that the Puteaux artists and their allies in Pierre Dumont's Société Normande de Peinture Moderne were aiming beyond "retinal" painting. The absence of Picasso and Braque, neither of whom had the slightest interest in higher mathematics or philosophical and social ideals, went more or less unnoticed by the public. That spring Picasso and Braque had begun to glue to their canvases bits of paper, wood, and other evidence of the real world; a few of these early collage-paintings could be seen at Kahnweiler's gallery on the rue Vignon, but Kahnweiler did not want his artists to be associated in any way with the work of the rival Puteaux group, and the immense significance of the new collage technique was not immediately recognized. For the moment, the Section d'Or painters appeared to have taken over the Cubist revolution.

The catalog for the Section d'Or lists six works by Marcel Duchamp, only four of which can be positively identified: *Nude Descending a Staircase, No. 2,* whose first public showing in Paris set off no shock waves whatsoever;

Portrait of Chess Players; The King and Queen Surrounded by Swift Nudes; and the watercolor sketch *The King and Queen Traversed by Nudes at High Speed.* His other two contributions were listed simply as *Painting* and *Watercolor.* (In later years he said that the *Painting* might have been *Sad Young Man in a Train.*) Although Duchamp's first *Virgin* drawing was in the Salon d'Automne exhibition, which had opened on the last day of September, while he was still out of the country, he submitted none of his Munich work to the Section d'Or. Even *The Bride,* his most fully achieved painting to date, was in Duchamp's mind a study for the "large-scale work" that he had conceived at the beginning of the summer, and he was not yet ready to let it out of his hands. The paintings that he did show at the Salon d'Or excited very little attention, although Louis Vauxcelles, who scorned any sort of radical innovation, singled out *The King and Queen Surrounded by Swift Nudes* as an example of the worst and most outrageous tendencies in the new art.

There was one critic, however, who threw the full weight of his already famous name behind the Section d'Or artists. This was Guillaume Apollinaire. By the time the Section d'Or exhibition opened on October 9, Apollinaire had become the leading impresario of the Paris avant-garde. He was thirty-two years old, exuberant and disorganized, a prodigious reader, a nonstop talker and myth maker, and a gifted and dazzlingly original poet. Fernande Olivier, Picasso's mistress in those years, described him this way:

> He was pleasant-looking, distinguished, with sharp features, small eyes rather close together, a long, thin Roman nose, and eyebrows like commas. A little mouth, which he often seemed to make deliberately smaller when he spoke, as though to give more bite to what he was saying. He was a mixture of distinction and a certain vulgarity, the latter coming out in his loud, childish laugh. His hands and his unctuous gestures made you think of a priest. (In fact there were rumors that he was the son of a Vatican prelate. His mother was Russian or Polish.) What struck you above all was his evident good nature. He was calm and gentle, serious, affectionate, inspiring confidence the moment he spoke—and he spoke a great deal.

After years of struggle in a variety of ignominious jobs—tutor, bank clerk, hack journalist, pornographer—Apollinaire had established himself around 1910 as the champion of the most advanced art of his time. His fer-

vent support of Matisse, the Fauves, and the early Cubist experiments of Picasso and Braque had been an important counterforce to the reactions of the established critics, many of whom considered these new developments to be totally misguided, arbitrary, or even mad. Picasso and Apollinaire had been close friends since 1903—so close, in fact, that for a long time Apollinaire hesitated to go to the gatherings of the Puteaux artists because he feared, with good reason, that this would be considered an act of disloyalty. Apollinaire's friendship with Picasso had been severely strained, though, by a ludicrous incident in 1911 that became known as "the affair of the statuettes." A few years earlier, in 1907, a young Belgian drifter and petty thief named Géry Pieret, whom Apollinaire had taken under his wing and employed briefly as his secretary, had gone to the Louvre one day and come out with two small stone sculptures hidden under his coat. Pieret later put out the story that he had done it as a joke, but the Picasso biographer John Richardson suggests another reason: Picasso had recently been looking hard at a new installation in the Louvre of ancient Iberian stone sculptures of the fifth and sixth centuries B.C., and Pieret, when he lifted two of these same Iberian pieces, almost certainly had the artist in mind. Pieret showed them to Picasso, at any rate, and Picasso promptly bought them. Certain aspects of their crude, primitively carved features soon turned up, moreover, in the heads of the two central figures in Picasso's *Les Demoiselles d'Avignon,* the revolutionary 1907 canvas that is considered to be the beginning of Cubism.

Pieret spent the next four years in America. He reappeared in Paris in the spring of 1911, wearing an expensive suit and flourishing a great wad of cash, which he lost soon enough at the racetrack. Once again Apollinaire came to his rescue, lending him money and giving him a place to stay. Pieret showed his gratitude by making a return visit to the Louvre and stealing another Iberian stone head, which he installed over the mantelpiece at Apollinaire's apartment. Apollinaire's tolerance for this engaging and somewhat crazy Belgian was running out, however, and he succeeded in evicting him from his apartment on August 21, 1911, which happened to be the same day that every Paris newspaper ran big headlines announcing that the *Mona Lisa* had disappeared from the Louvre.

Pieret had had nothing to do with the most sensational art theft of all time. A temporary employee at the Louvre named Vincenzo Peruggia, finding the *Mona Lisa* unguarded one day, had simply removed it from the

wall, carried it to an interior staircase, taken it out of the frame, and walked out with the rolled-up canvas under his coat; the painting turned up two years later, miraculously undamaged, when Peruggia foolishly tried to sell it for 500,000 lire to an art dealer in Florence. In August 1911, however, with the *Paris-Journal* offering a huge reward for the *Mona Lisa*'s return, Pieret saw a chance to pull off a new scam. He sold his most recently acquired Iberian head (the one over Apollinaire's mantel) to the *Paris-Journal,* along with his own colorful account of how he had spirited it out of the Louvre—just to prove, he claimed, that the museum's security system was ineffectual. The *Paris-Journal* returned the sculpture to the Louvre without revealing Pieret's identity, but Picasso and Apollinaire now became very nervous about the other two Iberian heads. Terrified that their involvement with Pieret would become known, Apollinaire gave him 160 francs and put him on a train to Marseilles, the usual sanctuary for petty criminals on the lam. Picasso and Apollinaire spent that night lugging Picasso's two stolen heads around Paris in a suitcase, waiting for the right moment to drop them in the Seine; the moment never arrived, and Apollinaire subsequently took them to the offices of the *Paris-Journal,* under a pledge of secrecy, for restitution to the Louvre. Someone must have tipped off the authorities, though, because on September 7 the police raided Apollinaire's apartment, found some incriminating letters from Géry Pieret, and took Apollinaire off to the Santé, Paris's central prison, as a prime suspect in the *Mona Lisa* theft.

The police kept him there for six days and might have kept him longer if his many friends in the art and literary establishments had not brought pressure for his release. The worst moment came when Picasso, whose name had been wrung from the suspect during interrogation, was brought in and questioned. The presiding magistrate asked him whether he knew Apollinaire, who was also in the room, and the pale and trembling Picasso mumbled, to his lifelong shame, "I have never seen this man." (Curiously enough, Picasso was never charged with receiving stolen goods; if he had been, his status as a resident alien would certainly have led to his being deported.) Apollinaire bounced back quickly enough from the humiliating experience and soon regained his position as the most influential art critic in Paris. But his friendship with Picasso would never be the same. In fact, there is reason to believe that Apollinaire's emergence in 1912 as a champion of the Puteaux Cubists and as one of the main organizers—along with Picabia and the

Duchamp brothers—of the Section d'Or exhibition was motivated to some degree by anger over Picasso's cowardly betrayal at the Santé prison.

In a well-attended lecture at the Section d'Or exhibition, Apollinaire proceded to "dismember" Cubism into four component parts—scientific, physical, instinctive, and "orphic." He left no doubt that he considered "orphic Cubism," later shortened to "Orphism," the most promising new direction, and Robert Delaunay (not Picasso) its most brilliant interpreter. In his book *The Cubist Painters,* which he was working on at the time, Apollinaire described Orphism as "the art of painting new structures with elements which have not been borrowed from visual reality, but have been created entirely by the artist and have been endowed by him with a powerful reality . . . This is pure art." Since Picasso and Braque never would go all the way into the "pure art" of complete abstraction, Apollinaire was clearly voicing a shift of allegiance—a shift that was much resented. Picasso, Braque, and Kahnweiler made a point in later years of emphasizing Apollinaire's shortcomings as an art critic, although they all three conceded that he was a great poet. Apollinaire "never wrote penetratingly about our art, as did for example [Pierre] Reverdy," Braque said condescendingly. "I'm afraid we kept encouraging Apollinaire to write about us as he did so that our names would be kept before at least part of the public."

It is easy to make fun of the gaffes and absurdities that peppered Apollinaire's writings on art. His reference to Picasso's and Braque's use of numbers and printed letters in their paintings as something "new in art" showed his ignorance of the Islamic tradition (among others), which had made pictorial use of these same elements for centuries. His inclusion of Marie Laurencin in *The Cubist Painters* was an embarrassment; the enchanting Laurencin, whose lyrical paintings had nothing to do with Cubism, had recently left him after two years of being his somewhat less than faithful mistress, and Apollinaire was trying very hard to win her back. In the words of his biographer, Francis Steegmuller, Apollinaire was a promoter rather than a critic; his "erratic flair" for innovation in art was "like that of a hound who picks up too many scents, and he did a good deal of happy, excited barking about it." The fact remains that the artists Apollinaire promoted are the ones whom art history has singled out as the greatest of this century, and his excited barking was an important factor in their struggles for recognition. Some of his insights, moreover, were not only penetrating but prophetic.

Up to this point, Apollinaire had taken relatively little notice of the youngest Duchamp brother. He had mentioned Marcel's "very ugly" nudes in the 1910 Indépendants exhibition, and a few months later, in his review of a Société Normande exhibition in Paris, he had tossed in an unspecific reference to Duchamp as an artist who was "making great progress." More recently, just a week before the Section d'Or opening, he had noted "Marcel Duchamp's strange drawing" at the Salon d'Automne—the Munich *Virgin (No. 1).* By then Apollinaire must have decided to include Duchamp in *The Cubist Painters,* because he had written to him in Munich that summer to request a photograph. What had sparked his interest in Duchamp, who kept his distance from avant-garde art circles and whose relatively slim body of work to date had made only a modest impression on the critics and on his fellow artists? The catalyst in this case almost certainly was their mutual friend Francis Picabia.

Apollinaire, who needed cheering up after Marie Laurencin left him that June, had turned to Picabia for the kind of close, rollicking friendship that he had once enjoyed with Picasso. While Duchamp was away in Munich, Apollinaire spent most of his evenings with the Picabias, drinking, talking, smoking opium, and careening around Paris in one of Picabia's expensive cars. The combination of Picabia's flamboyant nihilism and Apollinaire's chameleon-like charm—according to his friend Jean Mollet, "Many who knew him slightly used to wonder, when they saw him a second time, whether he was the same man they had met before"—stimulated both of them to madcap adventures, such as painting neckties on their shirts, not showing up for lectures they had agreed to give, or dashing off to London on the spur of the moment. Although Picabia's wife, Gabrielle, once described their conversations as "forays of demoralization," the two men also had deep discussions about art, dialogues in which Picabia, who would paint his first completely abstract pictures in the fall of 1912, worked to overcome Apollinaire's initial opposition to abstraction. When Apollinaire embraced Orphism, or "pure art," he was responding in large part to Picabia's influence.

On October 20, Picabia, Apollinaire, and Duchamp left Paris together in one of Picabia's big cars. Their destination was the tiny village of Etival, high up in the Jura Mountains near the Swiss border. Gabrielle Buffet-Picabia's mother lived there, in an ancient stone farmhouse that had

Francis Picabia, Gabrielle Buffet-Picabia, and Guillaume Apollinaire in Paris, 1914.

belonged to her family for generations, and she and Gabrielle were on hand to greet the travelers when they arrived late at night, after a harrowing twelve-hour trip. While his chauffeur cowered in the back seat, Picabia had navigated the mountain passes on a night of torrential rainstorms, nearly going off the road several times.

Gabrielle describes in her memoirs the vivid impression that Apollinaire made on her mother during the week that they all spent together in

Etival. The pitchman for the avant-garde got on famously with Mme Buffet, an elegant, highly cultivated woman whose grandfather had been a famous botanist and a friend of Lamartine, Chateaubriand, and Madame Récamier. He wanted to know everything about the beautiful and remote region of France they were in, which was known locally as the Zone, and he loved to draw out Mme Buffet on the subject of her eighteenth-century ancestors; with his amazing erudition, Apollinaire told stories about the great intellects of that time as if he had known them intimately. Apollinaire could be tremendously winning, and on this occasion he seems to have been on his best behavior. It rained a lot, so they spent most of their time indoors, playing jackstraws or sitting by the enormous fireplace in the main room, where Mme Buffet subtly guided the conversation in much the same way that her grandmother had done at her literary salons in the previous century. One evening Mme Buffet asked Apollinaire to read some of his poems. "He recited them rather ceremoniously," according to Gabrielle, "in a restrained tone of voice, stressing the rhymes . . . He read several poems from the collection *Alcools,* which had not yet come out, and one of them, which retraced his life, his childhood, and his disappointments, made a great impression on my mother . . . She asked him the title of this poem. 'It's not finished yet,' he said, 'and it doesn't have a name.' Then, suddenly, gracefully, he turned to her and said, 'I will call it *Zone.*' "

In her memoir of the week in Etival—a week that would have lasting repercussions in the work of all three artists involved—Gabrielle barely mentions Duchamp. One might assume that Marcel's quiet ironies had been overshadowed by the extravagant conversational styles of Apollinaire and Picabia, and to a certain extent this was probably the case. Toward the end of her very long life, though, Gabrielle Buffet-Picabia revealed in an interview that she and Duchamp had been much closer than anyone suspected.

During the many evenings that Duchamp spent at the Picabias' large apartment on the avenue Charles-Floquet, he had become increasingly drawn to Gabrielle. A beautiful and highly intelligent woman who gave up a promising career in music when she married Picabia—she had studied counterpoint with Gabriel Fauré and composition at the Schola Cantorum with Vincent d'Indy—Gabrielle understood better, perhaps, than her husband did the impulses that led artists, scientists, and many others in those early years of the twentieth century to try to capture what she once called

"the 'nonperceptible.'" She could also be a very sympathetic and perceptive friend. At that time, as she recalled, "Marcel was much less liberated than one imagines . . . He had remained a provincial young man very attached to his family and to his brothers, for whom he had great respect, while at the same time he was a revolutionary at heart. Clearly he felt that with us he could be himself, which was impossible with him *vis-à-vis* his brothers. The influence of Francis on him was extraordinary, and mine, too, given the customs of the epoch: a woman who dared to have free ideas . . . I believe that it was I who extracted Marcel from his family."

Seven years older than Duchamp, Gabrielle had been startled but perhaps not surprised when he telephoned her in June 1912, just before he left for Munich, to say that he was in love with her and wanted desperately to write her a letter. Gabrielle told him that he could write to her in Hythe, an English summer resort, where she would be staying with her two children (but not Picabia) for a brief period in July. She received two "very beautiful letters" from him in England, she said, one of which compared their situation to that of the couple in André Gide's recently published novel, *Strait Is the Gate,* a bleak tale of idealistic lovers who struggle so valiantly to deserve each other that they deny themselves the happiness of a life together. "I remember being astonished by this letter," Gabrielle said. "These clandestine things greatly troubled me, but at the same time I was very moved by his friendly attitude to me. He said he wanted so badly to see me alone."

There must have been further communications between them, because later that summer, when Marcel was in Munich and Gabrielle and the two children were staying with her mother in Etival, she agreed to meet him secretly. Their rendezvous took place at the railroad station at Andelot, in the Jura, where the branch line from Etival joined the main line to Paris. Gabrielle, who was making a brief trip back to Paris without the children, had told Duchamp that she would be there for an hour or so between trains, but she did not really expect him to show up; she was "stupefied" to find him on the platform at Andelot when she arrived. They had several hours together in the waiting room of the little railroad station. "There was only the main train [to Paris] which went by at about two o'clock in the morning, and another later," she said. "And I stayed: instead of taking the first, I took the second. We remained in the station on a wooden bench. We spent the night, and I left before him. Even now I find it really astonishing and very moving, very young, too. It was a kind of madness, idiocy, to travel from

Munich to the Jura to pass a few hours of the night with me. It was utterly inhumane to sit next to a being whom you sense desires you so much and not even to have been touched. . . Above all, I thought, I must be very careful with everything I say to him because he understands things in quite an alarming way, in an absolute way."

The door opens a crack, then closes. We do not know what they talked about all night. Duchamp's detached and contradictory personality clearly fascinated Gabrielle. In the published essay-memoir in which she wrote of the young Duchamp's "ineptitude for life" and his "almost romantic timidity," she went on to say that there were times when this " 'sad young man in a train' was transmuted into a captivating, impressive incarnation of Lucifer." Gabrielle once told another interviewer that she thought she had "initiated" Duchamp; she used the French verb *déniaisé,* which usually implies sexual initiation, but in this case she must have meant it metaphorically. What seems more likely is that Duchamp, who carried, hidden away somewhere, a lifelong resentment toward his "cold and distant" mother, was able to say things to Gabrielle that he could not have said to anyone else, and perhaps Gabrielle confided in him as well—her marriage to Picabia, a notorious womanizer and a domestic tyrant, gave her plenty of opportunities for unhappiness. The emotional echoes of their secret rendezvous two months earlier must have been in the air, at any rate, during that October week in Etival.

Duchamp was not feeling well on the car trip back to Paris. He slept fitfully and said little. The long drive, however, was the stimulus for a two-page manuscript that he jotted down soon after their return. Written in ink on a sheet of lined paper that is folded in half and dated 1912, it is a document whose Roussel-like mixture of puns, pseudo-scientific descriptions, erotic fantasy, and ultimately indecipherable wordplay sets the tone for all the notes he would later collect in *The Green Box.* Not until the end of the note does it become clear that he is describing a painting—one that he never made.

The two principal images in the text are the *enfant phare,* or "headlight child," and the *chef des cinq nus,* the "chief of the five nudes." The headlight child, a "pure child of nickel and platinum" who dominates and conquers the Jura-Paris road, is a surprisingly romantic metaphor; it could be represented graphically, Duchamp says, by "a comet, which would have its tail in front, this tail being an appendage of the headlight child . . . which absorbs

by crushing (gold dust, graphically) this Jura-Paris road." The visual reference here is clear enough to anyone who has watched a car's headlights probe the dark road ahead. The "chief of the five nudes," on the other hand, is much harder to get a fix on. (We know that there were five people in Picabia's car on the trip back to Paris, counting Gabrielle and the chauffeur.) As any number of commentators have pointed out, *cinq nus* can be read as a pun on *seins nus* (bare breasts), just as *enfant phare* suggests *en fanfare* (with a flourish). But does this help? Not really. We learn from Duchamp's note that the Jura-Paris road, which is "infinite only humanly," has its "termination at one end in the chief of the 5 nudes, at the other in the headlight child," but beyond that nothing is certain. Like many other artists during this period, Duchamp was trying to make visible a "nonperceptible" experience, but he went about it in a way that was new even to him. The "Jura-Paris Road" note shows him entering, for perhaps the first time, the verbal-visual landscape of *The Large Glass*. "From Munich on I had the idea of *The Large Glass*," Duchamp once said. "I was finished with Cubism and with movement—at least movement mixed up with oil paint. The whole trend of painting was something I didn't care to continue. After ten years of painting I was bored with it—in fact I was always bored with it when I did paint, except at the very beginning when there was that feeling of opening the eyes to something new. There was no essential satisfaction for me in painting ever . . . Anyway, from 1912 on I decided to stop being a painter in the professional sense. I tried to look for another, personal way, and of course I couldn't expect anyone to be interested in what I was doing."

Duchamp's explanation, so long after the fact, leaves unanswered questions. Could he really have been bored with painting? The two exquisitely painted Munich canvases hardly look like the work of a jaded artist. What really bored him was the Paris art world, with its competing factions and fervent theories. For nearly a year, ever since he had removed his offending *Nude* from the Indépendants exhibition, Duchamp had been moving away from the concerns of other artists. Now, in order to concentrate his energy on the large-scale work that he had conceived in Munich, he decided to withdraw from all other artistic activities and to look for a job that would supplement the modest allowance he still received from his father. What sort of job? One that would not take up too much of his time, obviously. Picabia found the solution. His uncle, a bon vivant and man-about-town

named Maurice Davanne, happened to be the director of the Bibliothèque Sainte-Geneviève, one of the city's most distinguished research institutions. With Davanne's assurance of a future position, Duchamp enrolled that November in a librarian's course at L'Ecole Nationale des Chartes. A library job appealed to him because it meant "taking an intellectual position as opposed to the manual servitude of the artist," but he was not giving up art. As he would later explain, "There are two kinds of artists: the artist who deals with society; and the other artist, the completely freelance artist, who has nothing to do with it—no bonds."

Society, however, does not always respect an artist's decision to have none of it. At that moment, in early November 1912, three American artists were visiting galleries and studios and private collections in Paris in a somewhat frantic ten-day search for examples of the most advanced art. Walt Kuhn, one of the principal organizers of what would come to be called the Armory Show, had been stunned by the examples of contemporary art that he had seen earlier in the month at the Sonderbund exhibition in Cologne and at other exhibitions in The Hague, Berlin, and Munich. When he got to Paris, he was joined by Arthur B. Davies, a deeply conservative painter who nevertheless found much to admire in Cubism, Fauvism, Orphism, and other radical trends. Kuhn and Davies agreed that this work must be a prominent part of the big International Exhibition of Modern Art that they were planning to put on in New York, but they knew very little about it. They needed help, and they found it in the person of Walter Pach, an American painter and writer on art who had been living in Paris since 1907. Pach spoke fluent French and German, was sympathetic to advanced art, and knew many of the artists personally. He took Kuhn and Davies to see Brancusi, Redon, Matisse, Delaunay, Gleizes, Léger, Picabia, and a number of other artists; he took them to the apartment of Gertrude and Leo Stein at 27, rue de Fleurus, where they saw the groundbreaking Cubist work of Picasso and Braque; and he also took them out to Puteaux. Pach greatly admired Jacques Villon's paintings and was even more impressed by Raymond Duchamp-Villon—he would later write the first important monograph on Duchamp-Villon's sculpture—but had not paid much attention to the third Duchamp brother until the month before, when he had seen Marcel's pictures at the Section d'Or exhibition. The impression they made then was strong enough to persuade him that "the pictures painted by Duchamp in the years before 1913 stand with the greatest art of modern times."

Marcel was not present on the day that Pach, Kuhn, and Davies visited the studios of his brothers at 7, rue Lemaître in Puteaux. He had just enrolled in L'Ecole des Chartes and was busy learning to be a librarian. Several of his pre-Munich paintings were there, however, brought over from Neuilly for the occasion, and the American visitors decided to borrow four of them for their upcoming show: *The King and Queen Surrounded by Swift Nudes, Sad Young Man in a Train, Portrait of Chess Players,* and *Nude Descending a Staircase.* They also chose nine canvases by Villon, and five of Duchamp-Villon's sculptures—including the dynamic *Torso of a Young Man,* whose features were modeled on Marcel's. Arthur B. Davies, the oldest of the three Americans, was particularly struck by Marcel's paintings. "That's the strongest expression I've seen yet," he said in an aside to his colleagues. It was a sentiment that would be echoed in various, mostly negative ways when the Armory bombshell hit New York three months later, altering the course of American art forever and inflicting on Marcel Duchamp the kind of raucous, derisive fame that is America's specialty.

No one could have been more surprised than Duchamp.

Scandal at the Armory

Can one make works which
are not works of "art"?

The International Exhibition of Modern Art, which opened in New York's 69th Regiment Armory on the evening of March 17, 1913, has been written about so often and so extensively that it has become a fabulous myth—American art jolted from its provincial slumber by the shock of European modernism. What is not so well known is how little attention this great event received in Europe. "The Armory Show wasn't well accounted for in Paris," Duchamp recalled. "I don't think there was even a newspaper account of it, except for short notes." Duchamp himself, isolated in his Neuilly studio, did not learn until weeks later that he had become famous in America.

That his fame derived from a single painting must have made it all the more astonishing. What was it about *Nude Descending a Staircase,* with its somber colors and utter lack of prurient interest, that excited such an enormous furor? "Her room was mobbed every day," according to one authoritative account. "People formed queues, waiting for thirty, even forty minutes just to stand momentarily in her presence, venting their shocked gasps of disbelief, their rage, or their raucous laughter before giving way to the next in line." Newspaper reporters stumbled over each other trying to think up funny descriptions of it—Julian Street's "explosion in a shingle factory" was the one people remembered, along with J. F. Griswold's cartoon takeoff in the *Evening Sun,* called "The Rude Descending a Staircase (Rush Hour at the Subway)." The *American Art News* offered a ten-dollar

prize for the best explanation of the picture and awarded it to a poem called "It's Only a Man":

> *You've tried to find her*
> *And you've looked in vain*
> *Up the picture and down again,*
> *You've tried to fashion her of broken bits,*
> *And you've worked yourself into seventeen fits;*
> *The reason you've failed to tell you I can,*
> *It isn't a lady but only a man.*

To a great many visitors, the painting seemed to sum up everything that was arbitrary, irrational, and incomprehensible in the new art from Europe. The public response to it, though, was not really angry. Nobody wanted to burn Duchamp in effigy, as Chicago art students talked of doing to Matisse, Brancusi, and Walter Pach when the show came there. Matisse was the main villain in the eyes of established American artists and critics, the "Apostle of the Ugly" whose violent colors and distortions of the human figure (in particular the "female form divine," as it was often referred to then in American art circles) were decried as "epileptic," "depraved," "coarse," "hideous," and "revolting." The attacks on Duchamp, by comparison, seemed relatively good-natured. Duchamp always maintained that the reactions to his *Nude* had to do mainly with its title, and in the United States this certainly seems to have been the case. Nudes weren't supposed to come down stairs in art, and paintings weren't supposed to have their titles written on the canvas, either, and any artist who broke the rules in such an irreverent manner must be kidding, right? Could it be that Duchamp was making fun not only of Cubism—as the Puteaux Cubists had suspected when they asked him to change the painting's title—but of modern art in general? Kidding was very much in the American grain, at any rate, and Duchamp's *Nude,* the only European work that seemed to lend itself to such an interpretation, may have appealed to some of the same prejudices that found it so outrageous.

The chorus of derision that was directed at Duchamp and the other European artists did not keep them from stealing the show. Only about one-third of the 1,300 works of art on view came from Europe, but they outsold the local product by more than two to one—of the 174 works sold, 123 were by foreign artists. Seen in the context of advanced modernism, American

art suddenly looked backward and banal, at least to the small group of collectors for whom the Armory Show came as a great beam of light into the future. John Quinn, the brilliant New York lawyer who had helped to organize the show and who served without fee as its legal counsel, was the largest single buyer—he spent a total of $5,808.75 for works by Derain, Pascin, Redon, Segonzac, Villon, Duchamp-Villon, and other European and American artists. The second biggest buyer, a Chicago lawyer named Arthur Jerome Eddy, traveled to New York for the show and acquired, among other things, two of the four paintings submitted by Marcel Duchamp: *Portrait of Chess Players* and *The King and Queen Surrounded by Swift Nudes.* The Duchamp brothers all did remarkably well. Raymond sold three of the four sculptures he had sent over, Jacques Villon sold all nine of his paintings, and Marcel ended up selling four out of four. A young painter named Manierre Dawson bought *Sad Young Man in a Train* in April, after the show had moved to Chicago on the second leg of its New York–Chicago–Boston tour. The infamous *Nude Descending a Staircase* found its buyer near the end of the show's New York run, when a San Francisco antiques dealer named Frederic C. Torrey, en route home from his visit to the Armory Show, suddenly had a brainstorm. He got off the train in Albuquerque, New Mexico, and sent a telegram to Walter Pach saying, "I will buy Duchamp nude woman descending stairway please reserve."

The good news about sales reached Puteaux by way of a letter from Pach, who had become so deeply involved in the Armory Show that he had moved back to New York to become its chief administrator and publicist. Duchamp's receipts for the four paintings came to $972—$324 apiece for *Nude Descending* and *The King and Queen Surrounded by Swift Nudes,* $162 each for the other two. These were not big prices in 1913. Cézanne's *La Colline des Pauvres,* the highest-priced painting in the Armory Show (and the first Cézanne to enter a public collection here), went to the Metropolitan Museum of Art for $6,700, while Matisse's *Panneau Rouge* (now known as *Red Studio*), which did not sell, was listed at $4,050. Although the sales must have done something for Duchamp's ego, they did not change anything so far as he was concerned. "It came from so far away!" as he said, and besides, it was "a local success. I didn't attach much importance to it."

The Duchamp brothers received firsthand reports on the great event from Francis and Gaby Picabia. The only artist of the European avant-garde to attend the show, Picabia had a marvelous time in New York. He gave a

number of exuberant press interviews in which he "explained" modern art—not hesitating to stress his own leading position in the Cubist movement—and as a result his four large and colorful paintings received considerably more attention in the press than the work of Picasso and Braque, who were not particularly well represented. (Cubism, in fact, was seen by many Armory Show visitors as a movement dominated by Picabia and Duchamp.) Two days after the show closed in New York, Picabia had a one-man exhibition at Alfred Stieglitz's Little Galleries of the Photo-Secession. This oasis of modernism, located at 291 Fifth Avenue and referred to by everyone as "291," had been, until the Armory Show, the only place in America to see work by Picasso, Matisse, and other advanced European artists, and it was also the focal center for the best and most radical American artists of the day: John Marin, Charles Demuth, Marsden Hartley, Arthur Dove, and a few others. The Picabias met most of these artists, and they also rubbed elbows with the writers, editors, anarchists, labor organizers, and assorted free spirits who came to weekly soirées at the Greenwich Village apartment of Mabel Dodge, who had moved back to New York from Europe the year before and established herself as a leading promoter of the new freedoms in literature, art, and social behavior. Picabia was enthralled by New York. He loved its vitality, its bright lights and soaring bridges, its hectic pace and high spirits. When the Picabias left in April, Stieglitz wrote to a friend, "All at '291' will miss them. He and his wife were about the cleanest propositions I ever met in my whole career . . . Picabia came to '291' virtually daily and I know he will miss the little place as much as we miss him."

The early morning of modernism in New York could hardly compare, however, to the avant-garde's high noon in Paris. Paris was where the twentieth century was, as Gertrude Stein would say, and 1913 was the watershed year in that century's self-discovery, the moment when the rising tide of experiment and innovation in all the arts was eroding the barriers between one art and another. The fragments of newspaper advertisements that Picasso and Braque glued to the surface of their canvases were echoed by the colloquial references in Apollinaire's *Alcools,* a collection of fifty-five poems published in 1913 whose originality, freshness, and evocation of modern urban life would have a galvanic effect on French literature. (The opening poem, "Zone," was the one he had read to Gabrielle Buffet-Picabia's mother during their stay in Etival.) The decisive plunge into pure abstraction by Delaunay, Kupka, Mondrian, and several other artists working in Paris

(Picabia included) had its counterpart in the dissolution of conventional harmonic structures in the music of Debussy and Stravinsky. When the Picabias got back in late April, the city was buzzing with excitement over Sergey Diaghilev's Russian ballet company and its upcoming production of a new work called *The Rite of Spring,* with music by Stravinsky and choreography by Vaslav Nijinsky. Diaghilev's dancers had been electrifying Parisians since their first appearance there in 1909, when, according to Marcel Proust, they had set off "a fever of curiosity . . . as intense as that aroused by the Dreyfus case." Enthusiasts saw the company as the living embodiment of Richard Wagner's famous call for the "total art work" that would be a synthesis of music, drama, and the visual arts. Each season the choreography became more daring, and the dancing more erotic. The year before, Nijinsky had caused an uproar with his performance as the faun in *Afternoon of a Faun,* which he himself had choreographed to music by Debussy; his skin-tight costume and sensual movements—in particular, a simulated orgasm while clutching the recently fled nymph's scarf to his loins—had appalled and infuriated the guardians of public decency, whose disapproval only served to heighten the fervor of Diaghilev's partisans. Rumors that *The Rite of Spring* would prove to be even more scandalous had generated tremendous excitement in Paris. The rival forces went to the May 29 premiere at the Théâtre des Champs Elysées prepared for battle, and hostilities broke out a few moments after the opening bassoon notes of Stravinsky's dissonant, percussive score. A chorus of whistling and booing from the audience was instantly countered by frenzied cheers, and the rest of the performance took place in a cacophony of noise, fistfights, and near-riot. Nothing could have symbolized better the breakdown of the traditional distance between art and spectator. The people who jeered and whistled and those who applauded wildly were acting out a drama of their own making, one that had little or nothing to do with Stravinsky's ferocious evocation of a primitive folk ritual. As the "chosen maiden" danced to her sacrificial death on the stage, the audience hurled itself into the battle of tradition against change, authority against rebellion, rational against irrational, absolute values against the Bergsonian *élan vital* of perpetual growth, and other current manifestations of the ancient struggle between age and youth.

Marcel Duchamp was in the audience that night. He would "never forget the yelling and the screaming," as he later recalled, but the performance itself apparently did not make much of an impression on him. The great

prewar fever of artistic activity in Paris seemed, in fact, to hold relatively
little interest for Duchamp, who was starting to question certain assump-
tions that even the most radical avant-gardists took for granted. Apollinaire
said something very odd about Duchamp in *The Cubist Painters,* which
came out in March 1913. A collection of published pieces and new writings,
the book includes brief essays on nine painters (Picasso, Braque, Metzinger,
Gleizes, Laurencin, Gris, Léger, Picabia, and Marcel Duchamp) and one
sculptor (Duchamp-Villon), essays notable more for their enthusiasm and
occasionally brilliant turns of phrase than for their penetrating insights
regarding the new art. In his essay on Duchamp, Apollinaire's bravura style
gallops off in several different directions. "Marcel Duchamp's pictures are
still too few in number, and differ too much from one another, for one to
generalize their qualities, or judge the real talents of their creator," he
begins, reasonably enough. He goes on to say that Duchamp "is the only
painter who today [Autumn 1912] concerns himself with the nude" (a state-
ment contradicted by Picasso's *Standing Nude* and *Female Nude: "J'aime
Eva"* of that same year, not to mention Matisse's great *Nasturtiums and the
"Dance"*), and he makes the interesting observation, apropos Duchamp's
habit of writing the title of a painting on the canvas itself: "Thus literature,
which so few painters have been able to avoid, disappears from his art, but
not poetry." His concluding sentence is the real stunner. After suggesting
that Duchamp's work "may even play a social role," he ends with this
thought: "Perhaps it will be the task of an artist as detached from esthetic
preoccupations, and as intent on the energetic as Marcel Duchamp, to rec-
oncile art and the people."

Art and the people? "What a joke!" Duchamp said when Pierre Cabanne
asked him about this statement half a century later. "That's all Apollinaire! At
the time, I wasn't very important in the group, so he said to himself, 'I have to
write a little about him, about his friendship with Picabia.' He wrote what-
ever came to him." Duchamp told Cabanne that he "couldn't have cared less"
about communicating with the public. This was quite true. Duchamp never
showed any interest in finding a wide audience for his work, then or later, and
the artists who did so invariably provoked his scorn. There is another sense,
though, in which Apollinaire's words suggest a prophetic insight. It can be
argued that Duchamp's subsequent efforts to demystify art and knock it off
its pedestal, to deny the superior moral status that so many artists claimed for
themselves, and to enhance the role of the spectator as an essential participant

in the creative process were all moves in the antielitist direction that Apollinaire, with his poet's intuition, had been the first to discern. Contradiction—including self-contradiction—was already becoming one of Duchamp's defining character traits; for the rest of his life he would entertain and express both elitist and populist ideas about the art process. In the spring of 1913, though, Apollinaire's prophecy must have sounded extremely foolish to Duchamp, whose retreat from the art world and its generally hostile public was already well advanced.

Having completed his course in library science at L'Ecole des Chartes, Duchamp started work as an intern at the Bibliothèque Sainte-Geneviève in April or May. "It was a wonderful job, because I had so many hours to myself," he said. "My hours were ten to twelve and one-thirty to three, and I got five francs a day. My father helped me, and I wasn't married, so it was plenty." Duchamp took advantage of the library's research facilities during this period to carry out the only serious, sustained reading that he would ever do in his life. The Sainte-Geneviève library had a great deal of material on the science of perspective, from its invention in the fifteenth century up to the present; Duchamp apparently read through a good deal of it—enough, at any rate, to master the principles and techniques that he would put to use in his *Glass*. He also took the opportunity to reread some of the ancient Greek philosophers whom he had studied at the lycée in Rouen. The one who interested him the most, he said, was Pyrrho of Elis (circa 365–275 B.C.), a little-known thinker—he had started out as a painter, interestingly enough, but had abandoned art for philosophy—whose teaching seemed at this particular moment to reinforce certain ideas that had already taken root in Duchamp's mind. Disputing Plato's theory of ideal forms, Pyrrho denied the existence of absolutes. There was no possibility of arriving at an objective truth, he said, because "nothing is in itself more this than that." Since nothing was either wholly true or false, one should cultivate an attitude of "indifference" and "imperturbability" toward life, according to Pyrrho, avoiding judgments and opinions but keeping oneself in a state of alertness to each passing moment. Pyrrho's thinking was very close in some ways to the central tenets of Zen Buddhism. It was of more than passing importance to Duchamp, who began at this time to make references in his notes to the "beauty of indifference."

The only other philosopher whom Duchamp ever mentioned as having influenced him was Max Stirner, a nineteenth-century German whose one

book, *Der Einzige und sein Eigentum* (*The Ego and Its Own*), originally published in 1844, had enjoyed a modest revival of interest in Paris during the early years of this century. Picabia admired Stirner and probably turned Duchamp on to him in 1912 or 1913. The whole argument of his book is contained in the first few pages: "My concern is neither the divine nor the human, neither the true, good, just, free, etc., but solely what is mine, and it is not a general one, but is—*unique,* as I am unique . . . Nothing is more to me than myself." This all-out deification of the self is repeated over and over, with little variation, throughout the book, "a remarkable book," as Duchamp described it, "which advances no formal theories, but just keeps saying that the ego is always there in everything." It is hard to believe that this relentlessly humorless and repetitive tract could have been a major influence on Duchamp, who managed throughout life to keep his own ego under strict control, but reading Stirner may very well have encouraged him to persevere in his own thoughts and inclinations, which had so little in common with those of his brothers or the other artists of the Paris avant-garde.

The drastic shift that became apparent in Duchamp's work after his 1912 trip to Munich is a central element in the Duchamp legend. Up until then he had been a painter working within the recognized tradition of Western art since the Renaissance. In spite of his disdain for "retinal" painting and the impatience that had led him to assimilate and then quickly discard each new vanguard style, from Post-Impressionism to Cubism, Duchamp had stayed within the medium of oil on canvas and within the general concepts of art and the art process that were shared by his colleagues and contemporaries. After 1912 this was no longer the case. Not only traditional methods and materials but the whole notion of the artist's sensibility as the guiding creative principle simply disappeared from his approach, to be replaced by mechanical drawing, written notations, the spirit of irony, and experiments with chance as a substitute for the artist's conscious control.

Several explanations have been put forward to account for this radical change of course. Arturo Schwarz is one of the main proponents of the alchemy thesis; he believes that, from Munich on, Duchamp's work was based on a system of hidden alchemical symbols and should be seen as an esoteric voyage of the soul. (According to Schwarz, Duchamp also used alchemy to sublimate his feelings of incest—guilt regarding his sister

Suzanne.) Some formalist art critics, on the other hand, view the shift as evidence of a failure of nerve. According to this argument, Duchamp realized that he could never hope to compete on equal terms with his older brothers, much less with Picasso and Braque, and so he coolly and cynically set out to change the rules of the game. In his later life Duchamp never took issue with these or any other of the ingenious and sometimes outlandish theories that were advanced about him or his work. His attitude, quite simply, was that such theories reflected the mind and personality of the theorist, that they were more or less interesting for that reason, but that they had nothing in particular to do with him.

One trouble with the psychological, alchemical, and formalist explanations is that they miss or ignore a much more obvious one. Duchamp had started to withdraw from the Paris art scene as early as 1908, when he moved from Montmartre out to Neuilly. Ever since then, his work had become increasingly cerebral, hermetic, and detached from current trends and movements. When Duchamp went to Munich in the summer of 1912 and spent two months in a rented room, a number of ideas that he had been exploring for some time came together in his mind in new ways and led to a breakthrough into the verbal-visual terrain that he would explore for the next ten years. It does not really require an esoteric theory to explain what looks very much like an artist's natural course of development. At the age of twenty-five, Duchamp was becoming Duchamp.

In his Neuilly studio he worked exclusively on notes, drawings, and preparatory studies for the work that he had conceived in Munich. One of his early notes indicates that he originally thought of this work as "a long canvas, upright." The idea of doing it on glass seems to have occurred to him sometime in 1913. "It came from having used a piece of glass for a palette, and looking through at the colors from the other side," as he explained in 1964. "That made me think of protecting the colors from oxidation, so there wouldn't be any of that fading and yellowing you get on canvas." That was one explanation at any rate; some years earlier he had offered a more interesting one. "If a painter leaves the canvas blank," he said then, "he still exposes to the viewer something that is considered an object in itself. This is not true of glass; the blank parts, except in relation to the room and the viewer, are not dwelt upon . . . Every image in the glass is there for a purpose and nothing is put in to fill a blank space or to please the eye." Pleasing the eye was for "retinal" painters, from whose ranks Duchamp was in the

process of separating himself forever. A painting on glass could be looked at and looked through at the same time, and the experience of looking was therefore ambiguous, open-ended, and unfixed. Change was built into it. Duchamp's interest in trying to represent physical motion in painting had been superseded by his concern with movement of another kind—with the transition from one mental or psychological state to another. This had been the subject of his Munich painting *The Passage from the Virgin to the Bride,* a work that could be seen as representing the actual moment of change, change itself. As *The Large Glass* gradually took shape in his mind, the notion of *passage* was one of its primary motifs.

A great many of the 1912 and 1913 notes concern the bride, that "apotheosis of virginity" whose sexual *passage* is activated by her own "ignorant desire, blank desire (with a touch of malice)." The earliest sketches and studies, though, have to do mainly with the bachelor apparatus that was to serve "as an architectonic base for the bride." In the fall of 1912 or the first months of 1913, Duchamp did a large *Perspective Sketch for the Bachelor Machine* in oil on cardboard (since lost) and also two schematic drawings showing the plan and elevation of the lower part of the glass. Over the next two years he would make drawings or studies for the principal elements in this lower section, starting with the *Chocolate Grinder.*

Soon after his return from Munich, Duchamp had gone to visit his parents in Rouen. Walking along the rue Beauvoisine, near the center of town just north of the cathedral, he stopped in front of Gamelin's confectionery shop to watch the chocolate-making machine in the window. It was a sight that had always fascinated him when he was a schoolboy; three rollerdrums turning slowly in a circular basin refined a smooth brown paste of crushed cocoa beans, vegetable oil, and sugar, which, warmed by a burner underneath the basin, sent its delicious aroma out into the street. The process seemed to stir something deep in Duchamp, as he revealed in a late interview. "Always there has been a necessity for circles in my life," he said, "for . . . rotation. It is a kind of narcissism, this self-sufficiency, a kind of onanism. The machine goes around and by some miraculous process that I have always found fascinating, produces chocolate."

When he decided to adapt this same machine as a central element in the bachelor apparatus, however, he stripped it of all subjective overtones. *Chocolate Grinder (No. 1),* the first oil-on-canvas study for *The Large Glass,* which he painted in February 1913, is a long way from the moist and

Chocolate Grinder (No. 1), 1913.

tender tonalities of his Munich *Bride*. Its three roller-drums are rendered with hard-edged exactitude, as is the fanciful three-legged platform on which they rest. (Duchamp made careful preparatory drawings for the platform's delicately curved Louis XV–style legs.) He had a commercial jobber print the title and date in gold letters on black leather, which he glued to the canvas in the upper right corner, like a trademark. The little painting was "the point of departure for a new technique," according to Duchamp. He had wanted to find a "dry" method of drawing, one that would be more impersonal than the method he had used two years before in his little painting of the *Coffee Mill* (the real precedent for the *Chocolate Grinder*). The form he had hit on was mechanical drawing, which ruled

out any hint of the artist's personal touch. "The problem was how to draw and yet avoid the old-fashioned form of drawing," Duchamp explained. "Mechanical drawing was the saving clause. A straight line done with the ruler, not with the hand. Forgetting the hand completely, that's the idea . . . When you draw, no matter what you do, your taste comes in subconsciously. But in mechanical drawing you are directed by the impersonality of the ruler . . . You can see that the young man was revolting against the old-fashioned tools, thinking that he could express something else through new media. Probably naive on my part, but I don't care . . . I wanted to find something to escape that prison of tradition . . . I didn't completely get free, but I tried to, consciously. I unlearned to draw . . . I actually had to forget with my hand." In French there is an old expression, *la patte,* meaning the artist's touch, his personal style, his "paw." *Chocolate Grinder (No. 1)* marks Duchamp's decisive break with *la patte.* He would describe it as "the real beginning of *The Large Glass.*"

Many of the notes that Duchamp selected for inclusion in *The Green Box* suggest the playful, ironic, or absurdist aspects of his thinking about the *Glass.* Bride and bachelors have their existence in "a reality which would be possible by slightly stretching the laws of physics and chemistry"—a reality that owes much to Alfred Jarry's 'pataphysics and Raymond Roussel's linguistic games. Metals are "emancipated," density "oscillates," objects move by "inversion of friction," electricity is employed by means of its "width," sexual arousal is conceived as a two-stroke internal combustion cycle. Duchamp once explained that he was interested in bringing "the precise and exact aspect of science" into art, but that "it wasn't for love of science that I did this; on the contrary, it was rather in order to discredit it mildly, lightly, unimportantly." All this is in keeping with Duchamp's description of the *Glass* as a "hilarious" picture—one whose original inspiration, he once said, came from the booths at traveling street fairs in France, where people tried to knock down painted bride and groom figures by throwing balls at them.

The *Green Box* notes, however, are not the only ones that relate to *The Large Glass.* Another batch of seventy-nine early notes was published in 1967 with Duchamp's somewhat hesitant approval, and a third, even larger group was discovered after his death and published in 1980. At least half the notes in the 1967 publication, which is entitled *A l'infinitif (In the*

Infinitive), deal with perspective and the fourth dimension, and these are very different in tone from the notes in *The Green Box*. Abstruse, cryptic, and unmarked by irony or humor, they show a far greater understanding of non-Euclidian mathematics than Duchamp was inclined to admit to in his later years, and they raise the question of what, exactly, he was trying to do. Some of the language in these notes comes right out of Gaston de Pawlowski's *Voyage au pays de la quatrième dimension* (*Voyage to the Land of the Fourth Dimension*), a rather lighthearted treatment of fourth-dimensional concepts that had been serialized in French newspapers before its 1912 appearance in book form; but it is also clear that Duchamp had studied and absorbed the writings of Henri Poincaré and Pascal Esprit Jouffret, two eminent French mathematicians who wrote books for non-technical readers. Although he tended, later on, to play down his own mathematical capacity, and to insist that he and the other artists of the Puteaux group had only the most superficial grasp of fourth-dimensional concepts, the notes in *A l'infinitif* show that Duchamp, alone among the Paris artists, made a serious effort to master the subject and that his understanding was far from superficial.

At the Bibliothèque Sainte-Geneviève, he put himself through a crash course in Renaissance perspective, which the Cubists had relegated to the dustbin of art history—"that miserable tricky perspective," as Apollinaire described it, "that infallible device for making all things shrink." Vanishing-point perspective, which gave the illusion of three dimensions on a two-dimensional surface, had been abandoned by modern artists who wanted their art to be a real thing rather than an imitation of reality. Why, then, did Duchamp, who certainly shared that ambition, choose to master such a dis-credited device? Was he looking for a mathematical formula through which he could actually evoke the presence of a fourth dimension? Whatever serious ambitions he may have had along these lines he abandoned soon enough. As the *Green Box* notes show, non-Euclidian geometry gave way in the end to playful physics, affirmative irony, and Pyrrho's beauty of indifference.

Duchamp spent a number of convivial evenings with Picabia in the spring of 1913, but more often, after finishing at the library, he would go back to Neuilly and immerse himself in research and studies for *The Large Glass*. This solitary existence had its low points, as he indicated in a letter to Walter

Pach in early July: "I am very depressed at the moment and do absolutely nothing," he wrote. "These are short unhappy moments." In the same letter he mentioned that Frederick C. Torrey, the San Francisco antiques dealer who bought *Nude Descending a Staircase,* had just made a visit to Puteaux, where he met all three Duchamp brothers; they found him "an excellent man," and Marcel made him a present of the little drawing he had done for a Laforgue poem, "Encore à cet astre," which had led to the idea for *Nude Descending.* From the beginning of his career as an artist, Duchamp had made a practice of giving away his work. Many of the early paintings and drawings had gone to his brothers and sisters, others to friends like Dumouchel, Tribout, and Gustave Candel. He gave his Munich *Bride* (which he came to consider his finest painting) to Picabia, and in 1915 he would give *The Passage from the Virgin to the Bride* to Walter Pach. There was always something distasteful to Duchamp about the idea of selling his work. Art should not be mixed up with commerce, he said—an attitude that did not prevent him, later on, from buying and selling an occasional work of art (including some of his own) as a means to earn a living.

In August 1913, Duchamp went to England with his eighteen-year-old sister, Yvonne, who needed a chaperon while she took a three-week course in English at Lynton College in Herne Bay, on the north coast of Kent. Writing from there to his old friend Raymond Dumouchel in Paris, he made the trip sound like a carefree vacation: "Superb weather. As much tennis as possible. A few Frenchmen for me to avoid learning English, a sister who is enjoying herself a lot." Even on holiday, though, Duchamp continued to work on the *Glass.* Several detailed notes and sketches done at Herne Bay that summer deal with the workings of the bride's *sex cylinder,* or *wasp,* and with the arcane concept of the *pendu femelle.*

From Herne Bay, Marcel and Yvonne traveled to London, where they spent four days exploring the city—Yvonne acting as translator for her indulgent older brother. Duchamp's withdrawal from the art world had done nothing to weaken the affection he felt for his family. That summer his parents had rented a summer house in the seaside village of Yport, on the Normandy coast between Fécamp and Etretat, and Marcel and Yvonne joined the rest of the family there for ten days at the beginning of September.

The whole family gathered again a month later in Puteaux for the marriage of Jacques Villon and Gabrielle Charlotte Marie Boeuf, a placid, undemanding woman who would stand by him faithfully through decades

of nonrecognition and near-poverty. Although Villon rarely showed his own work in those years, he never stopped painting. His gift was lyrical and meditative; his beautifully controlled style had none of the violent rhythms and dislocations of Picasso, and he was not interested in tackling the large social themes or subjects that attracted some of the other Puteaux Cubists. What he made of his younger brother's post-Munich work and ideas is not really known, but his loyalty was never in doubt. Years later, when Walter Pach asked Villon what he thought about Marcel's career, Villon said simply, "It is *his* decision, and we must respect it. The course he is following is not an easy one, and if he takes it, he has his own reasons."

Duchamp moved back to Paris in October. After five years in Neuilly, he may have felt that his life was becoming a little too quiet and isolated. He rented a small flat at 23, rue Saint-Hippolyte, on the Left Bank, in a rather nondescript area that was a long way from Montmartre and not much closer to the newly burgeoning artists' quarter in Montparnasse. Duchamp probably chose his new neighborhood because Raymond Dumouchel and Ferdinand Tribout, his Rouen schoolmates, had both completed their medical studies and found apartments there. Although he continued to avoid his fellow artists for the most part, he did meet the new mother superior of the avant-garde sodality, Gertrude Stein. In New York both Stieglitz and Mabel Dodge had told the Picabias that they must call on Gertrude Stein when they got back to Paris; they did so in November and took Duchamp with them. Although Stein would come to disapprove of Picabia's "incessantness" and "delayed adolescence," she reported favorably on their first visit in a 1913 letter to Mabel Dodge: Gabrielle Picabia was "full of life and gaity, Picabia dark and lively," she wrote, while "the young Duchamp . . . looks like a young Englishman and talks very urgently about the fourth dimension." Both Stein and Dodge were keenly interested in the fourth dimension, which fascinated writers as well as painters then with its vague promises of a breakthrough into new forms of cosmic consciousness. Stein usually set the conversational agenda in gatherings at her rue de Fleurus apartment, and it is likely that she broached the subject, but Duchamp's response suggests that the fourth dimension was very much on his mind as well.

The building that Duchamp moved into was brand-new—so new, in fact, that it was still under construction, and for a while he had to climb a

ladder to get into his flat. Duchamp put one of his newly plastered walls to immediate use. Carefully and precisely, using the exact calculations he had worked out over many months, he drew on it in pencil a full-scale perspective rendering of *The Large Glass,* with all the elements that he had plotted so far in his preliminary drawings and sketches. For the next year and a half this wall drawing would be his principal guide and checkpoint, to which other elements were added as he worked them out in his drawings and studies.

"Can one make works which are not works of 'art'?" Duchamp had asked himself in a 1913 note that he included in *The Green Box.* It is an insidious question, implying that anything made by man, from stone axes to saxophones, requires the same mental activities (discipline, skill, intention, and so forth) that go into the creation of an esthetic masterpiece. Duchamp had already found a way to subvert the skill factor, by letting mechanical drawing take the place of "*la patte.*" Now, toward the end of 1913, he short-circuited conscious intention through the use of chance.

With the methodical patience of a scientist performing an experiment, he cut a length of white sewing thread exactly one meter long, held it, stretched taut, at a distance of one meter above a rectangular canvas that he had painted Prussian blue, and let it fall. He did the same thing with two more threads, allowing each one to fall, "twisting as it pleases," onto a separate canvas, and gluing it down carefully with drops of varnish in the shape it had assumed. The result was *3 Stoppages Etalon,* or *3 Standard Stoppages,* in which, as Duchamp once said, he "tapped the mainspring of my future." *Stoppages* is the French term for invisible mending. What Duchamp had done was to mend, or, rather, to amend, the French unit of length, a formerly impregnable measurement marked by two scratches on a platinum bar kept under unvarying conditions of temperature and humidity in a government vault. The spirit of playful physics was at work in this "new image of the unit of length," whose contours were dictated by chance, and which Duchamp would come to look upon as one of the key works in his development as an artist. "In itself it was not an important work of art," he said, "but for me it opened the way—the way to escape from those traditional methods of expression long associated with art. I didn't realize at the time

what I had stumbled on. When you tap something, you don't always recognize the sound. That's apt to come later. For me the *Three Stoppages* was a first gesture liberating me from the past."

Not until sometime in 1914 did it occur to him that his invention could be put to use in *The Large Glass:* the lines formed by the dropped threads became the Capillary Tubes through which the illuminating gas is transported from the bachelor moulds to the sieves. Once again his methods were precise and painstaking. Duchamp traced the wavy outlines of the three dropped threads onto three templates and used those to inscribe nine black lines (three from each template) on an old canvas that he had already painted on twice before—first for the second version of his 1911 painting *Young Man and Girl in Spring* and more recently to make a half-scale perspective study for *The Large Glass.* Although the new work was also a study, a preliminary plotting of the Capillary Tubes that would appear in the *Glass,* it took on a strange and powerful presence all its own, with the heavy black lines standing out in bold relief against the palimpsest of earlier images; today it hangs in the Museum of Modern Art under the title *Réseaux des Stoppages* (*Network of Stoppages*).

The idea of using chance as a creative tool had been around, of course, since ancient times. Pliny the Elder tells us how the painter Protogenes, unable to render the lather around a horse's mouth, flung a sponge at his picture, and "the sponge deposited the colors with which it was charged in the very manner which he had sought in vain." Leonardo da Vinci, in his *Treatise on Painting,* advised looking at stains on a wall and other chance markings as "a way of developing and arousing the mind to various inventions." Mallarmé evoked chance over and over in his search for the secret language of "pure" poetry (the last poem he completed was called "One Throw of the Dice Will Never Abolish Chance"), and Raymond Roussel turned it into a working principle. Every artist makes use of chance to a certain extent, knowingly or not, and as Duchamp pointed out, in the years before 1914 many people were thinking about using it more systematically. Duchamp's notion of chance, however, was decidedly unusual. Although he looked on it as a means to escape from tradition, taste, and conscious intentions, he considered chance a highly personal matter. "Your chance is not the same as mine, is it?" he said. "If I make a throw of the dice, it will never be the same as your throw. And so an act like throwing dice is a marvelous expression of your subconscious."

Network of Stoppages, 1914.

Duchamp and his two younger sisters amused themselves during the New Year holidays at their parents' apartment in Rouen by "composing" a piece of chance music. Each of them "drew as many notes out of a hat as there were syllables in the dictionary definition of the word: *imprimer*," he explained. They wrote the notes on music staff paper just as they came from the hat and sang the result, which Duchamp named *Erratum Musical,* to the other family members. Chance also played a role in the birth of an object that appeared in Duchamp's rue Saint-Hippolyte studio sometime in 1913: the front wheel of a bicycle, in its straight fork, mounted upside down on an ordinary kitchen stool. Who could have predicted the repercussions that this artifact—the first "readymade," not to mention the first mobile sculpture—would eventually have on twentieth-century art history? Certainly not Duchamp, who always said that he had no specific idea in mind when he made it. The *Bicycle Wheel* "just came about as a pleasure," he said, "something to have in my room the way you have a fire, or a pencil sharpener, except that there was no usefulness. It was a pleasant gadget, pleasant for the movement it gave." He found it wonderfully restful to turn the

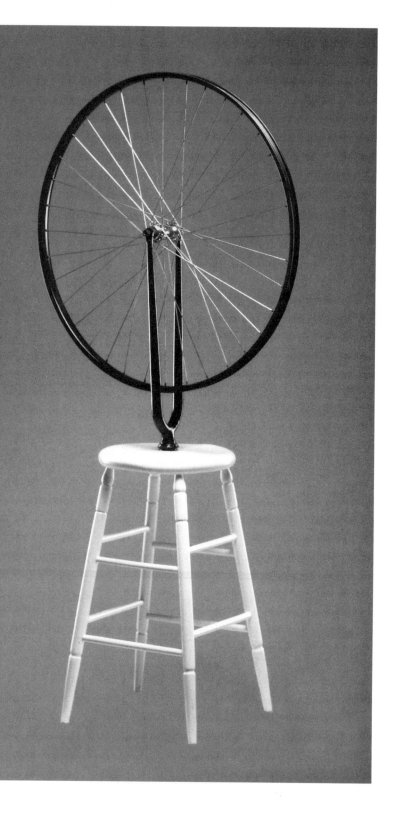

wheel and watch the spokes blur, become invisible, then slowly reappear as it slowed down; something in him responded, as he said, to the image of a circle that turns on its own axis, endlessly, onanistically. "It was not intended to be shown," he said; "it was just for my own use." Duchamp agreed nevertheless that the *Bicycle Wheel* "was the first expression of the thing that would be called the readymades two years later."

Two more readymades-before-the-name materialized in 1914. Riding the train from Paris to Rouen one late-winter evening, Duchamp saw a pair of lighted windows in the distance. "This gave me the idea of putting some color to those lights," he said, "with the idea of a pharmacy."

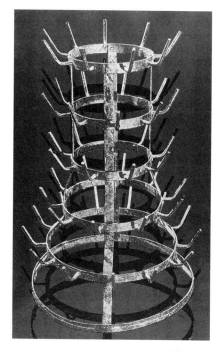

Bottle Rack, 1914. Replica of the lost original.

Soon afterward, he went to an art-supply store and bought three copies of an insipid color lithograph of bare trees and a winding stream. He added two dots of watercolor to each—red and green, like the colored liquids in pharmacists' store-window jars. A number of people have assumed that *Pharmacy,* as Duchamp called his limited three-print "edition," refers to Suzanne's 1914 divorce from her pharmacist-husband, but according to Duchamp it was simply "a distortion of the visual idea to execute an intellectual idea"—a good description of certain later readymades, although it does not apply to the next example. This was an ordinary cast-iron bottle-drying rack, which suffered no visual distortions whatsoever. Thrifty French families reused their wine bottles in those days, taking the empties to the local wine shop to be refilled from a barrel (the custom still exists in parts of rural France), and circular cast-iron drying racks with five tiers of upward-pointing pegs were an

Opposite: *Bicycle Wheel*, 1913. Replica of the lost original.

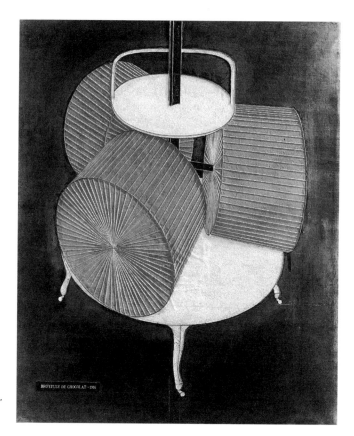

Chocolate Grinder
(No. 2), 1914.

essential element in many households. But when Duchamp picked up one of
these items at the Bazar de l'Hôtel de Ville, a large housewares emporium in
the center of Paris, and brought it back to his studio, he did not intend to use
it for drying bottles. "I had purchased this as a sculpture already made," he
explained two years later in a letter to his sister Suzanne. It occurred to him at
the time to write something on it, a phrase that would be "without normal
meaning," but he never got around to doing so. The bottle rack gathered dust
in a corner. The readymade idea had not yet been born.

 Throughout 1914 he continued to carry out detailed studies for major
elements of *The Large Glass.* In February he completed *Chocolate Grinder
(No. 2),* an even more mechanical rendering of this subject, in which the
painted shadows of the 1913 version have been eliminated, and the lines of
the roller-drums are made of stretched threads, glued down with varnish
and sewn to the canvas at their point of intersection at the drum's center. In

May he started work on *Glider,* the first study to be done on glass. Duchamp bought a large semi-circular piece of plate glass, placed it horizontally on two sawhorses, and set about the difficult task of transferring to its top surface his design for a schematic "sliding machine" on runners. His first idea was to etch the design on the glass with fluoridic acid, a powerful corrosive used by commercial glass workers. "I bought paraffin to keep the acid from attacking the glass except where I wanted," he said, "and for two or three months I struggled with that, but it made such a mess, plus the danger of breathing those fumes, that I gave it up. It was really dangerous. But I kept the glass. Then came the idea of making the drawing with lead wire—very fine lead wire that you can stretch to make a perfect straight line, and you put a drop of varnish on it and it holds. It was very malleable material, lovely to work with." (Duchamp used fuse wire, a coil of which was a staple in Paris apartments then.)

Like the *Network of Stoppages* and the two *Chocolate Grinder* studies, the *Glider* turned out to be an independent work of art. Duchamp, however, had no interest in showing these new works. He had exhibited nothing in Paris since the Section d'Or show in the fall of 1912, and it was clear that many of the concerns of his fellow artists now struck him as hopelessly antiquated. Fernand Léger told a story about going to the annual Paris Salon de l'Aviation exhibit one year with Duchamp and Constantin Brancusi, the Romanian sculptor: "Marcel, who was a dry type with something inscrutable about him, walked around the motors and propellors without saying a word. Suddenly he turned to Brancusi: 'Painting is finished. Who can do anything better than this propellor? Can you?' "

When Germany declared war on France on August 3, 1914, Duchamp was on vacation at his parents' rented villa in Yport. Both his brothers were called up within the first few weeks, but Duchamp, having completed his one year of military service, was temporarily exempt. At that point many Frenchmen were predicting confidently that the war would not last six months. Duchamp saw no reason to interrupt his progress on the *Glass*. He started work that month on a study—on glass—of the *9 Malic Moulds,* the "male-ish" figures that were conceived as hollow repositories of the amorous bachelors. Two preparatory drawings had preceded it, each called *Cemetery of Uniforms and Liveries.* (Why a cemetery? When he drew the

moulds, he said, they looked like coffins—no other reason.) In the first drawing there were only eight moulds: priest, department store delivery boy, gendarme, cuirassier, policeman, undertaker, flunky, and busboy. The stationmaster was added in the second drawing, along with the Capillary Tubes, whose contours had been established by the Standard Stoppages. The addition of a ninth bachelor reflected Duchamp's inclination to do things in threes. "For me this is a kind of magic number," he said, "but not magic in the ordinary sense. As I said once, number one is unity, number two is the couple, and three is the crowd. In other words, twenty million or three is the same for me." Threes or multiples of three recur throughout *The Large Glass:* there are nine Capillary Tubes, nine Shots, three Draft Pistons, three Crashes, three Oculist Witnesses, three strips of glass to represent the bride's clothes, three rollers for the Chocolate Grinder, and nine Malic Moulds.

Duchamp invoked chance again to design the Draft Pistons, the three apertures through which the bride telegraphs her "commands, orders, authorizations, etc." in the top section of the *Glass*. He hung a square piece of dotted gauze in front of an open window and photographed it three times. In each photograph the square was distorted in a slightly different way, according to the manner in which it had been "accepted or rejected by the draft," and these distortions, preserved by the camera, generated the irregular shapes of the Draft Pistons. It was another case of a natural force being used to produce art-by-chance: gravity for the Standard Stoppages, wind for the Draft Pistons. The new element this time was photography, which would become increasingly important in Duchamp's work from then on. Photography was also involved in the *Box of 1914,* the first collection of his manuscript notes. Duchamp selected sixteen notes and one drawing, *Avoir l'apprenti dans le soleil (To Have the Apprentice in the Sun)*—the one that shows a man on a bicycle riding up an inclined plane—and had them mounted on matboard; at least four photographs were made of each item, and the sets were then placed in cardboard boxes that had originally contained Kodak photographic plates. His reasons for "publishing" this extremely limited edition and for choosing these particular notes out of so many others on hand are thoroughly obscure. Three of the notes concern the Standard Stoppages, but the rest seem to have little or no relationship to *The Large Glass* or to one another; several are incomplete, and the drawing is a complete mystery.

9 Malic Moulds, 1914–15.

A bright spot in Duchamp's life during that first summer of the war was Walter Pach's visit to Paris. The American painter and writer (more writer than painter at this point) had come over at the urging of John Quinn, Arthur B. Davies, and Walt Kuhn, all of whom were eager—as Pach was—to widen the beachhead that the Armory Show had established by organizing more New York shows of recent European art. Duchamp's brother Raymond, Pach's closest friend among the Paris artists, had agreed to assemble a group of works for exhibition in New York, but by the time Pach arrived, Raymond was a medical officer in the French army, stationed at the military hospital in Saint-Germain-en-Laye, outside Paris. Pach managed nevertheless to collect enough paintings for three successive exhibitions of modern French art at the Carroll Galleries, whose financial backer was John Quinn, and he also laid the groundwork for important shows of Matisse and Cézanne. Pach and his new wife, a German-born artist named Magdalene (Magda) Frohberg, apparently had no problems with the intense anti-German feeling that gripped the French capital. He carried a letter of recommendation from former President Theodore Roosevelt, and he could also count on the goodwill of the many artists he had come to know during his five years in Paris. He and Duchamp spent a

lot of time together on this visit, and judging from their subsequent corre-
spondence, they discussed the possibility of Duchamp's coming to New
York. It was an idea that began to seem more and more attractive as the war
stretched on in Europe.

Jacques Villon, who had joined the 21st Territorial Infantry Regiment
in October 1914, was serving in the front lines. Many of the French artists in
Paris had been called up—Picabia, Léger, Braque, Gleizes, Metzinger, de la
Fresnaye, Dufresne. Apollinaire, an Italian citizen by birth, applied for
French citizenship so that he could volunteer for service; he was assigned to
an artillery regiment. Tribout and Dumouchel both became army doctors,
and Duchamp's sister Suzanne and his two sisters-in-law, Gaby Villon and
Yvonne Duchamp-Villon, joined the nursing corps. As the fighting intensi-
fied and the German troops overran Belgium, deferments were canceled.
Duchamp was summoned before a draft board in January 1915. In the
course of his physical exam, however, it was discovered that he had a slight
rheumatic heart murmur—nothing serious, but enough to keep him out of
the army. "I have been condemned to remain a civilian for the entire dura-
tion of the war," he wrote to Pach, who was back in New York by this time.
"They found me too *sick* to be a soldier. I am not too sad about this decision:
you know it well."

Duchamp's attitude toward the war was characteristically skeptical. He
could no more go along with the prevalent patriotic fervor than he could
accept the dogmas of the Puteaux Cubists, who believed that nudes should
refrain from coming downstairs. This was not a highly tenable attitude in
wartime Paris. Duchamp was "spared nothing in the way of malicious
remarks," as he later confided to his friend Robert Lebel. Yvonne Duchamp-
Villon, Raymond's wife, took it upon herself "to reproach the younger
brother for being 'behind the lines,' " and there were occasions when
strangers would spit at him on the street. None of this appears in the letters
that he wrote to Walter Pach that spring. Pach sent him news of exhibitions
and sales—John Quinn had bought two of the five Duchamp paintings that
had been in a show at the Carroll Galleries: *The Chess Game* and *Apropos of
Little Sister*. Duchamp wrote back terse descriptions of life in the war-
shuttered capital, with its unlit streets and early shop closings. In April he
notified Pach that he was shipping over a number of Raymond's sculptures
and three more of his own works: the first version of *Nude Descending a*

Staircase; a "large drawing on board" that was almost certainly the first perspective layout for *The Large Glass* (now lost); and *The Passage from the Virgin to the Bride.*

"Now here is what interests me particularly," he wrote to Pach on April 2:

I have absolutely decided to leave France. As I had told you last November, I would willingly live in New York. But only on the condition that I could earn my living there. 1st. Do you think that I could easily find a job as a librarian or something analogous that would leave me great freedom to work (Some information about me: I do not speak English, I graduated with my Baccalaureate in literature (don't laugh!!!), I worked for two years at the Bibliothèque Ste. Geneviève as an intern. —2nd. I will leave here at the end of May at the earliest. Do you think this is a good time or should I rather wait until September. I have told no one about this plan. Thus I ask you to answer me on this topic on a separate sheet in your letter so that my brothers do not know anything before my resolution is completely made.

Three weeks later, in response to a letter from Pach, he spoke openly of his reasons for wanting to come:

You miss Paris, yes, I understand this very well because here you were living the free life of an artist with all the joys and all the hard times that one likes to remember—My stay in New York is a very different matter. I do not go there to seek what is missing in Paris. I do not hope to find anything there but individuals—If you remember our talks on the Boulevards St. Michel and Raspail, you will see my intention to depart as a necessary consequence of these conversations.—*I do not go to New York I leave Paris.* It is altogether different.
 For a long time and even before the war, I have disliked this "artistic life" in which I was involved.—It is the exact opposite of what I want. So I had tried to somewhat escape from the artists through the library. Then during the war, I felt increasingly more incompatible with this milieu. I absolutely wanted to leave. Where to? New York was my only choice, because I knew you there. I

hope to be able to avoid an artistic life there, possibly with a job that would keep me very busy. I have asked you to keep the secret from my brothers because I know that this departure will be very hard on them.—The same for my father and my sisters . . . I think that my father has done enough for me. I also refuse to envision an artist's life in search of glory and money. I am very happy when I learn that you have sold these canvases and I thank you very sincerely for your friendship. But I am afraid to end up being in need to sell canvases, in other words, *to be a society painter.* —I will probably leave on May 22nd or possibly 29th.

The family accepted his decision when he summoned up the nerve to tell them about it. Raymond "finds the idea good enough but he disapproves of the date," Duchamp wrote to Pach. "He thinks that I should wait. As I expected, he has sentimental and family reasons, which I share. But I thought about everything long enough not to change my mind." He had booked his passage on the SS *Rochambeau,* a passenger liner whose scheduled departure date was June 6. That morning Duchamp turned over the keys to his rue Saint-Hippolyte studio to Léo and Marthe, the girlfriends of Tribout and Dumouchel, and took the train to Bordeaux. His baggage included *9 Malic Moulds* (carefully crated to protect the glass), a "final study" on paper of *The Large Glass,* and several other drawings, but relatively few personal items. The *Rochambeau,* named for the marshal of France who had fought beside Washington in the American Revolution, slipped out of the harbor late at night, all lights extinguished because of the submarine threat.

"*I do not go to New York I leave Paris,*" he had written, with a young man's bitter candor. New York and Duchamp, however, would prove to be an almost perfect match.

New York

You don't give a damn about
Shakespeare, do you? You're
not his grandsons at all.

New York City was sweltering through one of its early summer heat waves when the *Rochambeau* docked at about noon on June 15, 1915. "There had been a breeze until then," Duchamp recalled, "but suddenly I became aware of being terribly hot. I was dumbfounded—I thought there must be a fire somewhere." Walter Pach was waiting on the pier to greet him. The Pachs put him up for the first few days in their small apartment on Beekman Place. Pach then arranged for him to move into Walter and Louise Arensberg's large duplex at 33 West 67th Street; the owners were away, spending the summer in a rented house in Pomfret, Connecticut.

Walter Arensberg was one of the people whose life had been permanently altered by the Armory Show. He had almost missed the show in New York, coming down from Boston, where he and his wife were living at the time, only a day or so before it closed, but the experience had "hit him between wind and water," as his friend William Ivins said, and it had started him on his career as an impassioned, daring, and astute collector of advanced modern art. He did not trust his own instincts at first. The only thing he bought from the Armory Show that day was a Vuillard lithograph for twelve dollars. When the show came to Boston in late April, though, he went back to it again and again. By this time it was too late to acquire the

things he really wanted, although he would eventually manage to buy seven of these from their original owners. On closing day in Boston, he exchanged his Vuillard and bought two other prints, a Cézanne and a Gauguin, and he also paid eighty-one dollars for the last unsold painting by Jacques Villon, a study for a large Cubist composition called *Puteaux: Smoke and Trees in Bloom.* From then on he was hooked. His addiction to modern art and his wide-open hospitality to some of its more lively practitioners, both European and American, would eventually consume his own inheritance and a good part of his wife's.

Walter Conrad Arensberg, born in 1878, had grown up in the well-to-do suburbs of Pittsburgh, where his father was part owner and president of a crucible steel company. Like many an industrialist's son, he made it clear early on that he wanted nothing to do with the family business, although he was perfectly willing to accept the benefits that it provided. At Harvard he majored in English and philosophy, edited the literary monthly, and was elected class poet, edging out his classmate Wallace Stevens for that honor. After the obligatory *wanderjahr* in Europe, most of which he spent in Florence learning Italian so that he could translate Dante's *Divine Comedy,* he returned to Harvard for a year of assistant teaching, then moved to New York to work as a reporter and occasional art critic for the *Evening Post.* In 1907 he married Mary Louise Stevens, the sister of one of his Harvard classmates (another Stevens, not Wallace), whose family was a lot richer than his. Their wealth came from the J. P. Stevens textile mills in Massachusetts, and Louise's share of it allowed them to buy Shady Hill, the estate in Cambridge that had once been the home of Henry Wadsworth Longfellow and more recently Charles Eliot Norton, who had founded the department of art history at Harvard. Walter abandoned journalism for poetry around this time. The poems that he wrote at Shady Hill showed the influence of Mallarmé, Verlaine, Laforgue, and other French Symbolists, many of whose works he had translated, but intellectual brilliance, hard work, and technical proficiency could not make up for Walter's lack of any real poetic gift. By 1913 his prodigious mental energy was in search of a new outlet, which the Armory Show provided.

He began buying art in a major way the following year, when he and Louise left Shady Hill and moved to New York. Their timing was just right—at least five galleries had recently opened in Manhattan to show the

Walter Arensberg's
passport photograph.

Louise Arensberg at home, photographed by Beatrice Wood.

new art that until the Armory Show had been visible only at Stieglitz's "291," and some of the established galleries were also starting to present contemporary work. Arensberg bought mainly from the Carroll Galleries and later from the Modern Gallery, which was set up in 1915 by the artist Marius de Zayas as a sort of commercial offshoot of the rigorously high-minded "291." (Stieglitz, who would sell only to clients whom he considered sufficiently worthy, had given his reluctant assent to the new venture.) By the time Duchamp arrived, the Arensbergs' apartment already contained an impressive display of vanguard painting and sculpture—Cubist Picassos and Braques; Brancusi sculptures; works by the Puteaux Cubists, including Albert Gleizes and Jacques Villon; and in the place of honor over the fireplace, Matisse's great portrait *Mlle Yvonne Landsberg,* which Arensberg had bought a few months earlier from the Matisse exhibition that Walter Pach put on at the Montross Gallery.

Arensberg had heard a lot about Duchamp from Walter Pach, whom he had met during the Armory Show's run in Boston and who was now his main adviser on art. When Pach introduced them—either before the Arensbergs went away for the summer or during one of Walter's trips down to the city—the two men took to each other instantly. "Duchamp was the spark plug that ignited him," as one of Arensberg's friends put it; Arensberg, as patron, admirer, and friend, would play a major role in Duchamp's subsequent career. For the rest of his life Duchamp carried happy memories of those first few months in New York. Although he barely spoke English when he arrived, he found the city and its inhabitants wonderfully congenial and full of pleasant surprises. "For a Frenchman, used to class distinctions, you had the feeling of what a real democracy could be," he said in 1964. "People who could afford to have chauffeurs went to the theater by subway, things like that." Pach introduced him to Greenwich Village, which struck Duchamp as "a real Bohemia. Delightful. Why, Greenwich Village was full of people doing absolutely *nothing.* Now they feel they have to take drugs, at least." The Village, as its inhabitants liked to call it, had recently come into its own as a haven for artists, radicals, and free spirits of all sorts. Rents were cheap, and you could get a good dinner and a glass of wine for less than a dollar in popular restaurants like Polly's, the Pepper Pot, the Dutch Oven, and Bertolotti's. Mabel Dodge, after several years of Renaissance discomfort at her Villa Curonia in Florence, had forsaken Italy and established her famous "Evenings" in four rooms at 23 Fifth Avenue,

where the featured speaker might be Margaret Sanger on birth control, John Reed on the Mexican revolution, or Dr. A. A. Brill on Freud's theory of the unconscious. Social issues outweighed esthetic ones here, but a number of artists usually showed up, and the atmosphere was buoyantly modern. Picabia greatly enjoyed Mabel Dodge's Evenings, but Duchamp found them trying and stayed away.

Arensberg came into town for a few days in August and treated his new friend to dinner at the Hotel Brevoort, a block north of Washington Square at the corner of Fifth Avenue and 8th Street. The Brevoort and its basement café functioned then as an outpost of France. The owner, the manager, and the waiters were all French, and French army officers in their sky-blue uniforms made it their New York headquarters. "Dinner at the Brevoort, a dollar twenty-five," Duchamp recalled. "Very good. Always a Bronx or a Manhattan first. 'We had a Bronx last night. Let's have a Manhattan tonight.' " Arensberg brought his friend and classmate Wallace Stevens to dinner that evening at the Brevoort. The poet didn't know what to make of Duchamp's work when they all went back to the Arensberg apartment afterward, but he liked Duchamp, and as he wrote proudly to his wife afterward, "When the three of us spoke French, it sounded like sparrows around a pool of water."

Duchamp was learning English rapidly. He had discovered that the best way to do this—and to earn a little money at the same time—was to teach French. He gave two or three private lessons a day, at two dollars an hour, to Americans whom he met through Pach, the Arensbergs, or their friends. His pupils all spoke some French to begin with (Duchamp insisted on that), and the lessons probably helped his English more than their French. For several of his women students, it was a welcome opportunity to spend some time with a romantically handsome young Frenchman. His best client that summer, though, was John Quinn, the lawyer and collector, who would often take Duchamp out to dinner and the theater after his lesson.

Modern art had become Quinn's dominant interest. Fees from his wealthy corporate clients enabled him not only to collect it on a lavish scale but to work for the abolition of tax barriers that Congress had set up against imported works of art. In 1909 his lobbying efforts had been instrumental in eliminating the tax on imported art more than twenty years old; five years later, furious at having had to pay 15 percent duty on the paintings he bought at the Armory Show, Quinn single-handedly persuaded Congress to remove

the tariff on recent works as well. Tall, imperious, irascible, generous, and brilliant, this Ohio-born son of Irish immigrants usually got what he wanted. His art collecting had grown out of, and overshadowed, his earlier interest in literary material connected with Irish nationalism and the Irish literary renaissance. Having become friends with Lady Gregory, William Butler Yeats, and several other Irish dramatists and poets, Quinn started to buy paintings by George Russell and by Jack and John Butler Yeats (the poet's brother and father), and this soon led to a consuming interest in the art of the Impressionists, the Post-Impressionists, and their successors in the European avant-garde—Matisse, Picasso, Brancusi, and also Raymond Duchamp-Villon, whom Quinn considered the second most important sculptor alive, after Brancusi. Although he would eventually buy several works by Marcel Duchamp, including the first version of *Nude Descending a Staircase,* he passed up the opportunity a few years later to buy the definitive version of that work; when Walter Pach informed him in 1919 that Frederick Torrey, the San Francisco antiques dealer who had purchased it from the Armory Show, was troubled by "the high price of gasoline" and would like to sell *Nude Descending a Staircase, No. 2* for $1,000, Quinn decided that the price was much too steep and declined even to make a counteroffer. Pach then offered it to Walter Arensberg, who paid the asking price without a moment's hesitation.

Pach, who advised Quinn as well as Arensberg on art matters, had arranged for Duchamp to meet Quinn in July, within a month of his arrival. A few days later Quinn called and invited Duchamp to join a party that he was taking to the Coney Island amusement park that same evening—the others were Frederic James Gregg, an art critic for the *Evening Sun;* Walt Kuhn, the artist; and a young lady whose name Duchamp couldn't remember—probably Jeanne Robert Foster, Quinn's very beautiful and dedicated companion. (A lifelong bachelor, Quinn was a well-known connoisseur of pretty women.) Duchamp reported on the outing in a letter to Pach. Noting that Quinn "could be for me a hearty supporter," he went on to say (writing in French), "I appreciated him even more than the first time. He is very anxious to know whether Cubism was killed by the war and he has general questions about art and Europe over the next three years. As soon as my English will allow me to do so I promise to make him give up this 'political' vision of art, and I will try to express thoroughly to him our ideas which are outside of any influence of milieu or the period—up to a *certain point* of course." (The reference to "our ideas" is perplexing; Duchamp scorned Cubist theories, and the

ideas that interested him then were exclusively his own.) In addition to taking French lessons from Duchamp, Quinn also paid him to translate his letters to and from the French artists whose work he was buying, including Jacques Villon and Raymond Duchamp-Villon. "I think you will soon be writing perfectly idiomatic English," Quinn commented that fall, somewhat prematurely; Duchamp's letters to Quinn show him struggling with English syntax throughout the next year. In August, deciding that Duchamp looked tired and thin, Quinn sent him a railroad ticket and a paid hotel reservation for a few days' vacation in Spring Lake, an ocean resort on the New Jersey shore. Duchamp showed his gratitude by dashing off a pen-and-ink sketch of the collector and presenting it to him "en souvenir d'un bontemps à Spring Lake."

Duchamp might have learned English more quickly if he had not found so many French friends in New York. Francis Picabia got there a few days before he did, in June. Picabia had managed to stay out of the trenches by getting himself posted as chauffeur to a French general who happened to be an old friend of his father-in-law. When it looked as though he might be

New York, 1917. Picabia is at the wheel, Gabrielle is sitting on the hood, Walter Arensberg is on the running board. The standing woman is Louise Arensberg, and the man in the background is probably Henri-Pierre Roché.

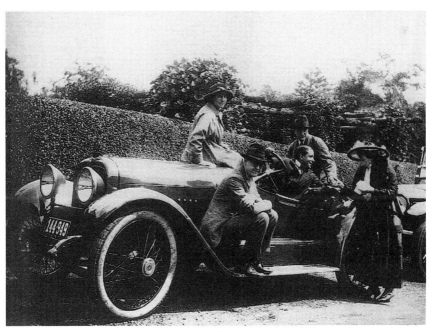

reassigned to the infantry, family contacts again came to the rescue: Picabia was sent to Cuba on a military procurement mission to buy sugar and molasses for the French army. His navy ship docked first in New York, though, whereupon Picabia decided that the mission could wait. He went straight to the Hotel Brevoort, got in touch with Stieglitz and other friends he had made when he came over for the Armory Show two years earlier, and launched himself on a tide of parties and alcohol. Picabia also threw his ebullient energy into helping Marius de Zayas and others get out the second issue of an avant-garde journal called *291* (after the Stieglitz gallery) and into setting up the Modern Gallery.

In October the Swiss-born painter Jean Crotti and his French wife, Yvonne, became New York residents—they had spent the previous month visiting Crotti's relatives in Columbus, Ohio. A week later Albert Gleizes arrived with his bride of a few weeks, the former Juliette Roche. Gleizes, like Picabia, had been drafted in the first weeks of the war, but his prospective father-in-law, a wealthy and powerful newspaper owner, member of the Chamber of Deputies, and former government minister named Jules Roche, had managed to get him out of the army under an only-in-France policy (unwritten, of course) designed to prevent the slaughter of recognized artists. Duchamp took great delight in showing the city to the newlyweds. His guided tour included the Hudson and East Rivers, the financial district, the forty-fifth-floor office of a businessman he knew, Greenwich Village, Chinatown, and "the joys of the drugstore and its soda fountain." The next evening he arranged a dinner in their honor at the Brevoort, where they met the Arensbergs, Alfred Stieglitz, Joseph Stella, Man Ray, Louise Norton, Max Weber, and several other American artists in the Arensberg and Stieglitz circles—but not Picabia. Gabrielle Buffet-Picabia had recently arrived from Switzerland, where she had taken their two children for the duration of the war, and this levelheaded and amazingly tolerant woman had made her husband realize that he was in danger of a military court-martial for deserting his mission. To make sure that he proceeded to Cuba as required, she had gone along with him on the boat.

It took the news media two months to discover that Duchamp was in New York. "The Nude-Descending-a-Staircase Man Surveys Us" was the headline over a Sunday feature story in the *New York Tribune* on September 12, the first of several interviews published in newspapers or magazines during the fall of 1915. Most of the interviewers were surprised to find that

the Armory Show's bête noir was so agreeable. "He neither talks, nor looks, nor acts like an artist," marveled one reporter. Another described him as "a young, decidedly boyish human with the quietest air and the most genial simplicity in the world." This writer (the poet Alfred Kreymbourg, writing in the *Boston Evening Transcript*) went on to say,

> He talks in a low, gentle, humorous voice, tinged at unconscious intervals by a curious undertone of quiet enthusiasm. Words are few with him, phrases concise, and they are delivered slowly, even when he uses his mother tongue. He is proud in a gleeful way of his English, of which he can deliver a perfect sentence on rare happily inspired occasions ... His blunders are laughable, but he laughs long before you do; as a matter of fact, you laugh at his amusement, not at him.

These early interviews contain a good deal of misinformation (one spells his name "Duchamps," another reports that he is "away from the French front on a furlough"), and the writers can't seem to agree on what he looks like. *Arts and Decoration* gives him "red hair, blue eyes, freckles, a face ... and a figure that would seem American even among Americans," while the *Tribune* reporter calls him "quite handsome, with blond, curly hair," and says he could be taken for "a well-groomed Englishman rather than a Frenchman." (In a photograph that accompanied an unsigned article in *Vanity Fair*—it was taken by Pach Brothers, the well-known portrait studio run by Walter Pach's father and uncle—he looks very grave and indelibly French. The U.S. Immigration and Naturalization Service records for 1915 list Duchamp as five feet ten inches tall, with a fair complexion, brown hair, and "chestnut" eyes.) The interviewers were obviously charmed by Duchamp, and Duchamp, in spite of his natural inclination to listen to them rather than to talk about himself (several reporters mentioned this), rewarded their curiosity with some highly quotable thoughts and opinions. Here he is, for example, on American women:

> The American woman is the most intelligent woman in the world today—the only one that always knows what she wants, and therefore always gets it. Hasn't she proved it by making her husband in his role of slave-banker look almost ridiculous in the eyes of the whole

world? Not only has she intelligence but a wonderful beauty of line is hers possessed by no other woman of any race at the present time.

And this wonderful intelligence . . . is helping the tendency of the world to completely equalize the sexes, and the constant battle between them in which we have wasted our best energies in the past will cease.

On America's future as a center for art:

The capitals of the Old World have labored for hundreds of years to find that which constitutes good taste and one may say that they have found the zenith thereof. But why do people not understand what a bore this is? . . . If only America would realize that the art of Europe is finished—dead—and that America is the country of the art of the future . . . Look at the skyscrapers! Has Europe anything to show more beautiful than these?

New York itself is a work of art, a complete work of art . . . And I believe that the idea of demolishing old buildings, old souvenirs, is fine . . . The dead should not be permitted to be so much stronger than the living. We must learn to forget the past, to live our own lives in our own time.

On Cubism:

But that word cubism means nothing at all—it might just as well, for the sense it contains, have been policarpist. An ironical remark of Matisse's gave birth to it. Now we have a lot of little cubists, monkeys following the motions of the leader without comprehension of their significance. Their favorite word is discipline. It means everything to them and nothing . . . I do not believe that art should have anything in common with definite theories that are apart from it. That is too much like propaganda.

On the war:

From a psychological standpoint I find the spectacle of war very impressive. The instinct which sends men marching out to cut down

other men is an instinct worthy of careful scrutiny. What an absurd thing such a conception of patriotism is! . . . Personally I must say I admire the attitude of combatting invasion with folded arms.

The self-confident, ironic tone of his remarks—delivered in a language that still gave him plenty of trouble—makes one wonder what had become of the shy, withdrawn young man whose "ineptitude for life" had struck Gaby Picabia only a few years earlier. There is no doubt that in New York Duchamp suddenly felt freer than he ever had before. He loved the city on sight, and he particularly enjoyed the open friendliness of the women he met there. Bessie Breuer, the *New York Tribune*'s Sunday editor, who had done the first interview with him, became a real *copain*. She took him all over the city, introduced him to cheap bars and restaurants and other journalists' hangouts, and taught him a lot of useful American slang. "In the first days of our comradeship he knew few English words, but we spoke only in English," she said. Duchamp felt a natural sympathy for the woman's suffrage movement that was gathering momentum when he arrived in New York, and he admired the uninhibited behavior and the clean, athletic look of many of the "new women" who were demanding the right to vote. Unlike most Frenchmen (and Americans) of his generation, he did not believe in the natural superiority of men.

Duchamp seemed to feel that in America the past, the cultural record, was somehow canceled out. "In Paris, in Europe, the young men of any generation always act as the grandsons of some great man," he once said. "Of Victor Hugo in France, and I suppose of Shakespeare in England. They can't help it. Even if they don't believe it, it goes into their system, and so, when they come to produce something of their own, there is a sort of traditionalism that is indestructible. This does not exist here. You don't give a damn about Shakespeare, do you? You're not his grandsons at all. So it is a perfect terrain for new developments." Duchamp really did think that "the dead should not be permitted to be so much stronger than the living." He was also convinced that the formal doctrines that certain artists (Albert Gleizes, for one) had built up around Cubism were as deadening as the ones laid down by the Académie des Beaux-Arts. Ever since Munich, his overriding ambition had been to invent a new means of expression that had nothing to do with "retinal" painting, Cubist theories, or any other accepted

methods of making art—to find something that neither he nor anyone else had thought of before—and New York, with its bumptious and light-hearted iconoclasm, seemed like the right place to do that.

If he had wanted to, Duchamp could certainly have used the interviews to promote his own career as an artist—an artist who was already more famous at that moment in America than Picasso or Matisse. He talked very little about his own work, though, and during the three years that he spent in New York he never deviated from his refusal to lead "an artist's life in search of glory and money." Instead of painting new pictures, he gave French lessons. "I could almost live on what I made this way," he said, "because everything was so much cheaper then. You could live on five dollars a day." By his own admission, however, he was not a good teacher— "too impatient," as he said—and the lessons didn't really bring in enough to live on. Duchamp had moved out of the Arensbergs' apartment when they returned from Connecticut in September. He had taken a furnished room on Beekman Place, across the street from Walter and Magda Pach. It was "in a house that had a Turk as a proprietor," according to Duchamp. "He must have been a magician or something, because he had all kinds of surrealistic things hanging from the ceiling or lying around, very strange. I didn't like it at all." After three months he moved again, to the Lincoln Arcade building on Broadway between 65th and 66th Streets. This large apartment building offered studios suitable for artists; the American painter Robert Henri had established his School for Independent Artists there in 1909. In order to pay the $40-a-month rent, though, Duchamp needed more income than his French lessons were bringing in, so he decided to get a job.

All it took was a letter from Pach to John Quinn, who knew everybody. "He has always made his living at other employment," Pach explained, "and while neither he nor I have any idea that he would grow commercial if he were to rely on his art for a livelihood he would not have the sense of independence he has had so far—and it has been of great importance to him." Learning that Duchamp had worked as a librarian in Paris, Quinn arranged for him to meet Belle da Costa Greene, the flamboyant and rather intimidating director of the late J. P. Morgan's great private library on East 36th Street. "She is a brash American woman but don't let that make you shy," Quinn wrote. "She won't bite you." Duchamp reported back to his mentor in fractured but jubilant terms on November 5: "I saw Miss Belle Greene at the Library at 3:45 P.M. She asked me my wishes, as number (how

many) of working hours, and as remuneration. She decided to ask to the President of the French Institute for: 4 hours in the afternoon every day (from 2 o'clock to 6) and $100 a month. My hope is surpassed: I assure you, instead this work will be an obstacle for my own work, I will have the entire freedom which I need." Duchamp's salary at the French Institute (a museum and study center attached to the French consulate in New York) was apparently paid by the Morgan Library through Belle Greene, and this somewhat unusual arrangement took care of his financial needs for the next two years.

Duchamp's room in the Lincoln Arcade building (1947 Broadway) was, as he wrote to Quinn, "a sort of studio which is comfortable enough." One of the first things he did after moving in was to buy two big sheets of heavy plate glass, set them up on sawhorses, and embark at last on the large-scale work that he had been planning for the last three years. Although virtually all his thinking about *The Large Glass* had been done in France, the work itself would be constructed in the United States.

He began with the upper panel, carefully outlining in lead wire the *pendu femelle,* the Top Inscription (or Milky Way), and the other elements of his mysterious bride-machine, working from a scale drawing on tracing paper attached to the other side of the glass. Since the forms would be seen *through* the glass, it was the back surface that he worked on. His eye had to be absolutely perpendicular to the drawing to avoid distortions caused by the thickness of the glass, and this involved a lot of arduous leaning and positioning and frequent trips to the floor so that he could look up through the glass and make sure that the wires were lined up exactly right. After gluing the lead wire to the glass surface with drops of varnish, he painted in the forms enclosed by the wire and then covered them with lead foil, thinking that this would seal and protect them from oxidation. (Unfortunately, the lead foil itself reacted chemically with the pigments, causing much subsequent discoloration.) It was a slow, tedious process, and after two hours of it he was usually ready to quit for the day. This was not entirely a matter of the work's technical demands. "You see," he explained, "it interested me but not enough to be *eager* to finish it. I'm lazy, don't forget that. Besides, I didn't have any intention to show it or sell it at that time. I was just doing it, that was my life. And when I wanted to work on it I did, and other times I would go out and enjoy America. It was my first visit, remember, and I had to see America as much as I had to work on my *Glass.*"

Jean Crotti shared Duchamp's Broadway studio with him for a few months in the winter of 1915–16. The two men probably had known each other in Paris, although there is no record of it. Crotti, who came there from his native Switzerland in 1901, had lived a few doors away from Duchamp on the rue Caulaincourt in Montmartre; they had both shown their work in the Salon des Indépendants and the Salon d'Automne in the same years, and they had many artist friends in common. In New York, at any rate, they became close friends, and the daily exposure to Duchamp and his work brought about a radical change in the somewhat older Crotti's approach to art. Until then Crotti had been painting semi-abstract landscapes. In 1916 he started painting machinelike images with sexual implications and working with wire, metal, and glass. The most arresting image of this relatively brief period in his development (later on he would retreat to a more conservative brand of abstraction) was his *Portrait of Marcel Duchamp,* a sculptured head with a painted metal brow and artificial glass eyes, held in place by a single piece of heavy wire that formed the subject's profile. This peculiar object provoked a good deal of derision when it was shown in a group exhibition at the Bourgeois Galleries the next spring, but it also impressed some observers as a striking likeness, one that caught Duchamp's mental intensity as well as his ironic detachment. "It is an absolute expression of my idea of Marcel Duchamp," Crotti said at the time. "Not my idea of how he looks, so much as my appreciation of the amiable character that he IS." The work was acquired by Walter Arensberg, but it got lost or destroyed at some unknown date and is known now only from photographs and verbal descriptions.

Crotti was with Duchamp when he bought the snow shovel. It was an ordinary snow shovel, with a flat, galvanized iron blade and a wooden handle, which he picked out in a hardware store on Columbus Avenue. There were thousands just like it in hardware stores all over America, stacked up in advance of the winter storms or, as Duchamp would say in the title that he inscribed on the metal reinforcing plate across the business end, *In Advance of the Broken Arm.* Why did he choose this particular item? He and Crotti had never seen a snow shovel before, he explained some years later—they did not make such things in France. Duchamp remembered very clearly how pleased and proud Crotti had looked as he carried their purchase, slung like a rifle on his shoulder, the few blocks to their shared studio in the Lincoln Arcade, where Duchamp, after painting on

the title and signing it "[from] Marcel Duchamp 1915" (to show that it was not "by" but simply "from" the artist), tied a wire to the handle and hung it from the ceiling.

In addition to being the first American readymade, the snow shovel brought to full, conscious fruition the readymade *idea* that had been hovering around in his mind for two years. It was a mass-produced, machine-made object with no esthetic qualities whatsoever, chosen on a basis of "visual indifference, and, at the same time, on the total absence of good or bad taste." The *Bicycle Wheel* on the kitchen stool, which is generally accepted today as the first readymade, was not a visually indifferent object; Duchamp himself said that looking at it gave him the same kind of pleasure that he got from watching an open fire. *Pharmacy,* with its two little dots of red and green paint in a rather insipid landscape, had esthetic qualities—negative, perhaps, but esthetic all the same. The iron bottle-drying rack that he had left behind in his Paris studio was potentially the real thing—a true readymade—but Duchamp had not yet turned it into one. Only by giving it a title and an artist's signature could it attain the odd and endlessly provocative status of a readymade, a work of art created not by the hand or skill but by the mind and decision of the artist.

Soon after buying and inscribing *In Advance of the Broken Arm,* Duchamp wrote a letter to his sister Suzanne in Paris. He thanked her for cleaning out his studio on the rue Saint-Hippolyte, then added the following:

Now, if you went up to my place you saw in my studio a bicycle wheel and a *bottle rack.* I had purchased this as a sculpture already made. And I have an idea concerning this bottle rack: Listen.

Here, in N.Y., I bought some objects in the same vein and I treat them as "*readymade.*" [This is Duchamp's first recorded use of the term, which is always in English.] You know English well enough to understand the sense of "*ready made*" that I give these objects. I sign them and give them an English inscription. I'll give you some examples:

I have for example a large snow shovel upon which I wrote at the bottom: *In advance of the broken arm,* translation in French, *En avance du bras cassé.* Don't try too hard to understand it in the Romantic or Impressionist or Cubist sense—that has nothing to do with it.

Another "readymade" is called: *Emergency in favor of twice,* possible translation in French: *Danger (Crise) en faveur de 2 fois.* This whole preamble in order to actually say:

You take for yourself this bottle rack. I will make it a "*Readymade*" from a distance. You will have to write at the base and on the inside of the bottom ring in small letters painted with an oil-painting brush, in silver and white color, the inscription that I will give you after this, and you will sign it in the same hand as follows:

(from) Marcel Duchamp.

He was too late. In clearing out his studio, Suzanne had thrown out both the bottle rack and the bicycle wheel, which she must have decided were useless junk. A similar fate would befall almost every one of the original readymades, including *Emergency in Favor of Twice,* which Duchamp may never actually have made—nobody seems to have seen it. Even the phrase that Suzanne was supposed to have written on the bottle rack has vanished into thin air. Most art historians have assumed that Duchamp wrote it out on a separate page of his letter, which somehow got lost. Francis Naumann has another theory—he believes that Duchamp meant for Suzanne to think up the inscription herself, using the other "examples" he had provided as a guide. Years later, in signing a replica of the bottle rack for the artist Robert Rauschenberg, Duchamp said that it was "impossible to remember" the original phrase. The bottle rack, which Duchamp sometimes referred to as a "hedgehog" (*hérisson*), has had to struggle through life without its inscription, but that scarcely mattered. The readymade idea had been loosed upon the world, with incalculable effects on subsequent art, art history, and critical discourse. As Duchamp said toward the end of his life, "I'm not at all sure that the concept of the readymade isn't the most important single idea to come out of my work."

A Little Game
Between I and Me

The curious thing about the
readymade is that I've never been
able to arrive at a definition or
explanation that fully satisfies me.

Duchamp's own statements about the readymades cut right through
the fogbanks of commentary by others. Readymades were his anti-
dote to retinal art, because "it was always the idea that came first,
not the visual example." They posed the question What is art? and sug-
gested, quite disturbingly, that it could be anything at all—a readymade, in
fact, was "a form of denying the possibility of defining art." Duchamp made
a note to himself to "limit the no. of readymades yearly," and he followed his
own instructions, producing no more than twenty in his lifetime (the exact
number depends on whether or not to include such debatable cases as *3 Stan-
dard Stoppages,* which Duchamp once referred to as his favorite readymade).
Only by limiting the output, he felt, could he avoid falling into the trap of
his own taste, and taste—good or bad—was "the greatest enemy of art."
Duchamp knew perfectly well that there was a contradiction here. Just by
selecting one object rather than another he was exercising taste, no matter
how hard he tried to avoid it, and each of the readymades can be said to
reflect Duchamp in its ironic, humorous, quietly diabolical ambiguity.
Duchamp's own conception of the readymades kept changing, in any case;
as he said, he could never find a definition that fully satisfied him. "My

intention was always to get away from myself," he said, "though I knew perfectly well that I was using myself. Call it a little game between 'I' and 'me.' "

The next example, purchased a week or so after the snow shovel, was an unpainted tin chimney ventilator—the kind that turns in the wind to make the chimney draw better. *Pulled at 4 Pins,* the English title that Duchamp gave to this object, is a literal translation of the phrase *tiré à quatre épingles,* whose meaning in French is something like "dressed to the nines." In English it means nothing at all, and this was what Duchamp liked about it—the words, making no sense and having no relation to the visual image, could lead the mind in unpredictable directions.

Three more readymades materialized in the spring of 1916. *Comb* was a metal dog-grooming comb, signed with the initials *M.D.,* dated *FEB. 17 1916 11 A.M.,* and bearing on its narrow back edge an inscription in white paint that reads, *3 OU 4 GOUTTES DE HAUTEUR N'ONT RIEN À FAIRE AVEC LA SAUVAGERIE (Three or Four Drops of Height [or Haughtiness] Have Nothing to Do with Savagery).* The phrase echoes Mallarmé's famous late poem "Un coup de dés jamais n'abolira le hasard" ("One Throw of the Dice Will Never Abolish Chance"). The signature and date reflect a *Green Box* note in which Duchamp speaks of "planning for a moment to come (on such a day, such a date, such a minute) to *inscribe* a readymade"—turning the act itself into an event, so to speak. The little dog comb bears the weight of these references without a murmur of protest; it has always been the most serenely "anesthetic" of all Duchamp's readymades, the one that has best retained the characteristics of a readymade as Duchamp defined them nearly half a century later: "no beauty, no ugliness, nothing particularly esthetic about it." The same traits apply to *Traveler's Folding Item,* a dust cover for a standard office typewriter, with "UNDERWOOD" stamped on it in large capitals. This item has the distinction of being the first "soft" sculpture known to art his-

With Hidden Noise, 1916.

tory; its resemblance to a woman's skirt has made it the focus of much schol-arly speculation linking it to the "clothes" of the bride in *The Large Glass.*

For his fourth American readymade, Duchamp enlisted the collabora-tion of Walter Arensberg. Dated "Easter 1916," it is a ball of household twine compressed between two square brass plates that are held in place by four long screws, and it is called *With Hidden Noise.* On Duchamp's instruc-tions, Arensberg had loosened the screws and placed a small object inside the ball of twine without telling Duchamp what it was. This is the "hidden noise," which can be heard when the object is shaken. The brass plates are engraved, top and bottom, with a cryptographic inscription, juxtaposing French and English words in which some of the letters are missing, "like in a neon sign when one letter is not lit and makes the word unintelligible," as Duchamp explained. Learning another language seemed to stimulate his love of wordplay. A few months after his arrival in New York, he had writ-ten a one-page English text called "The," which reads grammatically but without making sense, and in which the word "the" is replaced wherever it occurs by an asterisk. (It was published in the *Rogue,* an avant-garde liter-ary magazine financed by Walter Arensberg.) Duchamp's *Rendez-vous du Dimanche 6 Février 1916,* a set of four typed postcards to the Arensbergs, is a more complicated exercise in non-meaning, composed of perfectly correct sentences that cleverly elude interpretation. ("One will be without, at the same time, less than before five elections and also some acquaintance with little animals; one must occupy this delight so as to decline all responsibility for it . . .") Duchamp spent countless hours composing his brief message because, as he explained, "the minute I *did* think of a verb to add to the sub-ject, I would very often see a meaning," which required him to cross it out and start again. In recent years these early readymades and verbal texts have been subjected to the sort of deconstruction and micro-analysis that throttles the playful spirit behind them; at the time, though, his *jeux d'esprit* fell right in with the national fondness for practical jokes, high jinks, and general silliness.

Dining out with friends, either at the Brevoort or at one of the popular Village hangouts, and ending up several evenings a week at the Arensbergs' apartment, Duchamp had picked up the American habit of drinking hard liquor. "He learned to like our very bibulous American ways and to emulate them," according to Louise Norton, the poet Allen Norton's free-spirited

wife. ". . . Sometimes we would go to the Café-in-the-Park for breakfast. There remains in my memory a picture of one precociously warm spring morning. Four of us are sitting outside on the terrace. The forsythia is in bloom and Marcel—very anti-nature at that time—has firmly turned his back to the bushes, gloriously yellow against the drab winter background, and looking down at his hands examines them gravely; then holding them up for our inspection says, with his half-muted chuckle, 'Drink fingers.' " Duchamp talked of "signing" the Woolworth Building and thus converting what was then the world's tallest skyscraper (792 feet) into a readymade. He never did it, but one night at the Café des Artistes, where he was having dinner with Walter Arensberg and a few others, he did sign what he described as "a huge old-fashioned painting behind us—a battle scene, I think." Even "art" could become a readymade, it appeared, and thereby lose its esthetic bearings. (This was a notion that Duchamp returned to some years later when he proposed, as a "reciprocal readymade," using "a Rembrandt as an ironing board.") Duchamp's battle scene at the Café des Artistes was obliterated some years later when the painter Howard Chandler Christy covered the restaurant's walls with the coy female nudes who cavort there to this day.

Two readymades appeared subliminally in a group show at the Bourgeois Galleries that spring. (Stéphane Bourgeois was one of the new dealers specializing in modern art.) The exhibition catalog lists them under a single entry as "sculptures," and we are not even sure which ones they were. According to Duchamp, Bourgeois put the two readymades out in the vestibule, where visitors hung their hats, and nobody even noticed them. This was exactly the right response; it proved that they gave off no esthetic emanations. Duchamp also had three paintings and two drawings in the Bourgeois show: *The King and Queen Surrounded by Swift Nudes,* the two versions of *Chocolate Grinder,* a full-scale drawing for the *Bachelor Machine* (listed in the catalog as *Celibate Utensil,* a quaint translation of *Machine Célibataire*), and the Boxing Match drawing from *The Green Box.* During the same month of April, he showed three more paintings (*Yvonne and Magdeleine Torn in Tatters, Portrait [Dulcinea],* and an unidentified *Landscape,* all of which he had had sent over from Paris), plus the Munich drawing *Virgin (No. 1)* and the readymade *Pharmacy,* in a group show at the Montross Gallery. The show was called "Four Musketeers"—the other

three being Albert Gleizes, Jean Metzinger (the only one who was not in New York), and Jean Crotti, whose amazing metal-and-glass "portrait" of Duchamp received more comment than any other work in the exhibition.

The fact that Duchamp had arranged for more of his paintings and drawings to be shipped to New York and exhibited suggests that he was not oblivious to the commercial possibilities in America, where the Armory Show had proved to be such a bonanza for all three Duchamp brothers. Walter Arensberg was avid for anything he could get by Duchamp. Between 1915 and 1918 Arensberg acquired *The King and Queen Surrounded by Swift Nudes, Portrait (Dulcinea), Yvonne and Magdeleine Torn in Tatters, Sonata,* both versions of *Chocolate Grinder,* one of the pencil studies for *Portrait of Chess Players,* and a third version of *Nude Descending a Staircase,* which Duchamp had made to order for him in 1916 by hand-tinting a full-size photographic copy of the original with watercolor, ink, pencil, and pastel. (He signed this one "Marcel Duchamp [Fils]/1912–1916," to indicate that it was a "son" of the famous original, which Arensberg desperately wanted but would not acquire until 1930.) The prices were very low, however—less than $500 for the largest oils. Duchamp, who was still inclined to give away his best work, did not even consider selling his readymades. He gave *Pulled at 4 Pins* to Louise Norton, *With Hidden Noise* to Arensberg, and *Pharmacy* to Man Ray, a young American painter whose life and career were forever altered by his meeting with Duchamp.

They had met for the first time soon after Duchamp's arrival in New York. Man Ray, born Emmanuel Radnitsky, the son of an immigrant tailor, was living then in Ridgefield, New Jersey, in a community of avant-garde writers and artists whose common bond was a newly established little magazine called *Others.* Walter Arensberg, who was also putting up the money for this magazine, took Duchamp and Crotti to Ridgefield one early fall day in 1915 and introduced them to Alfred Kreymbourg, *Others'* editor; William Carlos Williams, a pediatrician and poet, who lived five miles away in Rutherford; the painter Samuel Halpert; and the rest of the *Others* group, including the diminutive, fast-talking Man Ray and his Belgian-born wife, Adon Lacroix. Man Ray was just catching up with modern art, which he had discovered at the Armory Show and at Stieglitz's "291" gallery; he painted jaunty, Cubist-inspired landscapes. Although he spoke no French, and Duchamp's English was severely limited, they established

an instant rapport. At one point during the afternoon, Man Ray and Duchamp played an impromptu game of tennis in front of Kreymbourg's cottage; there was no court and no net, but as Man Ray wrote in his autobiography, "I called the strokes to make conversation: fifteen, thirty, forty, love, to which Duchamp replied each time with the same word: yes."

Man Ray's lifelong fascination with Duchamp stemmed in part from their being natural opposites. Barely five feet tall, full of ambition but unsure of his talent, the American was in awe of Duchamp's French culture and of his elegant, detached, and at the same time remarkably open and direct manner. Baudelaire, in a famous essay called "The Painter of Modern Life" (published in 1863), had defined a personality type that he called the dandy and held up as a model for the modern artist. The Baudelairean dandy stood in opposition to the bourgeois society around him. An aristocratic observer who strolled through the crowd without becoming part of it, he suppressed all instinctive impulses, disdained the trivialities of daily life, and concentrated on developing his own unique, aloof, and necessarily cold personality. Duchamp has been described as a dandy in this sense, and to a certain extent he was one—for example, in his dedication to the "beauty of indifference." The analogy explains very little about his complex character, however, and it certainly does not account for the relaxed and uncompetitive openness that made people feel instantly drawn to him—qualities the poet André Breton would later sum up as "a truly supreme *ease*."

That keen observer Gabrielle Buffet-Picabia, whose emotionally charged relationship with Duchamp had settled into a deep and comfortable amity, found him greatly changed when she and Picabia came back to New York from Cuba early in 1916. The Picabias were amused by Duchamp's career as a French teacher. Picabia said that what he really gave his female pupils were love lessons. "Naturally all his pupils fell into his arms," said Gabrielle, "and he who used to be very timid with women, who didn't know how to approach them, had acquired considerable experience in how to handle himself in any situation, whether to take advantage of it or to escape. In other words he had blossomed, he was no longer the same man . . . He was very different, very seductive."

Some of this newfound confidence with women may have been helped along by alcohol. The French wartime visitors were astonished by the drinking habits of their American friends. Hard liquor was consumed all

the time and everywhere, according to Gaby Picabia, "in offices, in restaurants, in the best houses, by women as well as men." It shocked her to see "the most elegant and attractive women completely soused, leaning on their boy-friends to get to the bathroom." Albert Gleizes, who took a paternal attitude toward Duchamp (although he was only six years older), used to lecture him severely about his drinking. Duchamp's newfound enthusiasm for whiskey and cocktails was interpreted by Gleizes, a born moralist, as a desperate effort to escape from "those abysses of anxiety, of disenchantment, of protestation, of fatigue, of disgust" that he must be feeling in America, although there was nothing to indicate that Duchamp felt anything of the sort. Juliette Gleizes recalled Duchamp telling her husband, "My dear Gleizes, if I didn't drink so much alcohol I would have committed suicide long ago," but the remark sounds disingenuous. Duchamp thoroughly enjoyed the multiple freedoms—sexual and otherwise—of his New York life, and he was not above trying to shock the overly censorious Gleizes. Gleizes and Metzinger, after all, were the self-appointed guardians of Cubism who had argued in 1912 that Duchamp's *Nude Descending a Staircase* (or its title, anyway) was a threat to their movement, an argument that Gleizes dusted off and applied to the works that Jean Crotti submitted to the "Four Musketeers" show at the Montross Gallery; Crotti's paintings were all right, according to Gleizes, but the titles he had given them were overly provocative and might invite "potentially damaging criticism." It was perfectly within Duchamp's nature to dismiss the anxious careerist in Gleizes without losing his affection for the man. Duchamp did not hold grudges. In spite of "the pitiless pessimism of his mind," as Gaby Picabia put it, "he was personally delightful with his gay ironies. The attitude of abdicating everything, even himself, which he charmingly displayed between two drinks, his elaborate puns, his contempt for all values, even the sentimental, were not the least reason for the curiosity he aroused, and the attraction he exerted on men and women alike."

Without any apparent effort on his part, Duchamp had become the star of the Arensberg circle. His mental agility and ironic wit set the tone for the high-spirited, informal gatherings that took place three or four evenings a week in the duplex apartment at 33 West 67th Street, where paintings by Duchamp were starting to outnumber those of any other artist. Evenings at the Arensbergs' began around nine o'clock, after dinner, and did not break

up until long past midnight. In addition to the American artists Charles Sheeler, Joseph Stella, Charles Demuth, Morton Schamberg, John Covert (Walter Arensberg's cousin), and Man Ray, all of whom had been strongly influenced by European modernism, the regulars included a lively group of poets and writers: William Carlos Williams, Wallace Stevens, Alfred Kreymbourg, Walter Pach, Maxwell Bodenheim, Allen and Louise Norton, Carl Van Vechten and his pretty wife, the actress Fania Marinoff, and Arensberg's Harvard classmate Dr. Ernest Southard, a psychologist who was director of the Boston Psychopathic Hospital—Southard came whenever he was in New York and encouraged guests to tell him their dreams. A chess game was usually going on somewhere in the big high-ceilinged room. Both Arensberg and Southard had played on the Harvard chess team, and Alfred Kreymbourg competed in professional tournaments. Duchamp, who was becoming addicted to the game, played every night and won many more games than he lost.

In the Arensberg circle it was the Europeans who provided most of the intellectual and behavioral fireworks. Picabia, increasingly alcoholic but full of manic energy, served as a link between the Arensberg and the Stieglitz circles; although he still spoke no English, he had started writing "abstract" poetry in French, and he was one of the principal contributors to *291*, the bilingual, typographically adventurous avant-garde magazine that had replaced Stieglitz's high-minded journal *Camera Work*. Albert Gleizes propounded the gospel of his "reasonable" Cubism to anyone who would listen, undeterred by ironical looks and comments from Picabia and Duchamp. Edgard Varèse, a radical young French composer who had joined the group soon after his arrival in New York at the end of 1915 (he was introduced by Juliette Gleizes, whom he had known in Paris), mesmerized everyone with his plans for "the liberation of sound" through the use of gongs, sirens, and electrically generated noises in his musical compositions. There was also the Baroness Elsa von Freytag-Loringhoven, who was once described as leading a life "unhampered by sanity." Deserted in New York by her much younger, titled German husband—he was interned by the French while trying to return to Germany after the war broke out in 1914—the fortyish, blond, once-beautiful baroness moved to Greenwich Village, found work as an artist's model, and gave free rein to increasing eccentricities of dress and makeup—black lipstick, shaved hair, voluminous garments to which she sewed stuffed birds, flattened tin cans, and other

strange talismans. She conceived a great passion for Duchamp. Although she insisted that it was fully reciprocated, Duchamp would never touch "the hem of my red oilskin slicker," she explained, because "something of his dynamic warmth—electrically—would be dissipated by the contact." This haunted and haunting creature produced two rather arresting portraits of her idol; one was a collage drawing, the other an assemblage of found objects (feathers, a clock spring, a fishing lure, a ring) held together precariously in a wine glass. She also composed a poem, which she used to recite in her thick German accent: "Marcel, Marcel, I love you like hell, Marcel."

Stieglitz had brought European modernism to America. He had shown Cézanne, Matisse, Picasso, and Rodin for the first time in this country, and since 1908 his tiny gallery had served as the focal center of America's first artistic avant-garde. But Stieglitz's loyalties lay with the small group of American artists he championed—principally John Marin, Marsden Hartley, Arthur Dove, Max Weber, and starting in 1917, `Georgia O'Keeffe. Stieglitz's ivory tower attitude toward art, his belief in esthetic "purity," and his dictatorial self-righteousness made it very difficult for him to respond to the new, iconoclastic breezes from Europe. He thought Duchamp was a charlatan when they first met; later on he revised his opinion and said he greatly regretted not having shown his work. Louise Norton remembered Duchamp taking her to "291" and wandering around the gallery, smiling his crooked smile, while Stieglitz filled her ears with one of his humorless nonstop monologues on modern art.

By this time Stieglitz himself realized that his influence was waning. (Picabia's rather cruel "machine portrait" called *Ici, c'est ici Stieglitz,* which was published in a 1915 issue of *291,* shows a camera whose bellows do not connect with the lens; in the background are an automobile gear shift in neutral, and a hand brake in the "on" position.) Stieglitz had tried his best to run "291" as a "laboratory" for art, taking minimal or sometimes no commissions on sales and selling only to people whom he judged capable of appreciating the work. The purity of his noncommercialism eventually depleted his financial resources; he was forced to suspend publication of *Camera Work,* and in 1917 he would close "291." Marius de Zayas and Paul Haviland, the younger men to whom he reluctantly (and temporarily) passed the torch of his leadership, were more attuned to the iconoclastic spirit of the Arensberg circle than they were to Stieglitz's gospel of art-as-spiritual-salvation. Anarchistic, antitraditional, irreverent, and highly

receptive to anything touched by the vitality of modern urban life, the new avant-gardism, which sounds so thoroughly American, in fact reflected the pervading influence of Duchamp and Picabia.

Picabia's "machine" style, which appeared first in his 1915 portrait drawings in the magazine *291,* had a powerful effect on several of the American artists in the Arensberg group. As Picabia told a reporter at the time, "Almost immediately upon coming to America it flashed on me that the genius of the modern world is in machinery, and that through machinery art ought to find a most vivid expression . . . The machine has become more than a mere adjunct to life. It is really a part of human life—perhaps the very soul." Picabia's new drawings and paintings, with their machine-like forms and erotic titles (*Young American Girl in a State of Nudity,* for example, was a precise rendering of an automobile spark plug), addressed in cruder and more explicit fashion the very same theme that animated Duchamp's two *Chocolate Grinder* paintings and all the other studies for *The Large Glass.* Machinery with human attributes would soon turn up in works by Man Ray, John Covert, and Charles Sheeler. Covert's *Brass Band* (1919) not only looks like *Chocolate Grinder (No. 2),* with its cylindrical and interlocking forms, but is actually made in almost the same way, by gluing stretched strings to cardboard. Joseph Stella, the Italian-born painter who was rarely absent from the Arensberg gatherings, did a group of paintings on glass after he had seen the slowly developing masterwork in Duchamp's studio. Even Charles Demuth, whose delicate and incisive style seemed to owe nothing to Duchamp, would say in 1923 that Duchamp had been his "strongest influence in recent years."

Captivated by Duchamp's readymades, Man Ray began to turn out a whole series of objects made from the utensils of everyday life. The most famous was his 1921 *Cadeau (Gift),* a flatiron with a row of sharp tacks glued to its bottom surface. Like Picabia's sexual machines, though, Man Ray's object-sculptures lacked the dry, cerebral, Duchampian ambiguity; they were visual wisecracks that made their point at first glance but did not rever-berate in the mind. The only work by an American that came close to evok-ing Duchamp's mode of provocative cynicism was done in 1918, and there is some doubt as to just who did it—the work is usually attributed to Morton Schamberg, a Philadelphia artist who used to visit the Arensberg salon whenever he was in New York, but there is evidence to suggest that Scham-berg, who never did anything else remotely like it, made this strange object

in collaboration with the ineffable Baroness Elsa von Freytag-Loringhoven. It is a metal plumbing trap attached to a curved length of pipe, mounted in a carpenter's wooden miter box, and winningly entitled *God*.

Not all the Americans in the Arensberg circle succumbed to Duchamp's spell. William Carlos Williams, in his autobiography, tells of an evening when he followed Duchamp around the Arensbergs' living room, waiting for an opportunity to say something about a painting of his that was hanging on the wall—probably the 1911 *Portrait (Dulcinea)*, which shows a woman in five different states of dress and undress:

> He had been drinking. I was sober. I finally came face to face with him as we walked about the room and I said, "I like your picture," pointing to the one I have mentioned.
>
> He looked at me and said, "Do you?"
>
> That was all.
>
> He had me beat all right, if that was the objective. I could have sunk through the floor, ground my teeth, turned my back on him and spat . . . I realized then and there that there wasn't a possibility of my ever saying anything to anyone in that gang from that moment to eternity.

It is hard to imagine what was so devastating about Duchamp's "Do you?" Williams himself concedes, in the same passage, that he "bumped through these periods like a yokel." But in spite of what must have seemed to him an oversophisticated atmosphere at the Arensbergs', where French was spoken almost as much as English, Williams came to this room like a moth to the light. It was his main connection to the ideas that were shaping the new century's art and thought. "There had been a break somewhere," he wrote, "and we were streaming through, each thinking his own thoughts, driving his own designs toward his self's objectives . . . I had never in my life before felt that way. I was tremendously stirred."

The Arensberg Salon

Whether Mr. Mutt with his own
hands made the fountain or not has
no importance. He CHOSE it. He took
an ordinary article of life, placed
it so that its useful significance
disappeared under the new title and
point of view—created a new
thought for that object.

When Beatrice Wood was well past her hundredth year, she could still relive the day she met Marcel Duchamp. It was September 27, 1916. She had gone to visit Edgard Varèse in St. Vincent's Hospital, where he lay with his broken leg in a cast, having been knocked down by a taxicab while waiting for a Fifth Avenue bus. As she entered his room, "A cough made me turn to face a man sitting at the far side of the bed," she said in one of her many memoirs. "With a slight shock, I became aware of a truly extraordinary face. He did not exhibit the hardiness of a lifeguard flexing his muscles, but his personality was luminous. He had blue, penetrating eyes and finely chiselled features. Marcel smiled. I smiled. Varèse faded away."

Intensely romantic and unconventionally pretty, her pale skin accentuated by a mass of dark hair, Wood was twenty-two at the time and in full rebellion against her domineering, socially prominent mother. She had lived in France for two years, closely chaperoned, and when she met Duchamp she was acting with a French repertory theater troupe in New

York—her mother had reluctantly agreed to this, thinking "that my being an actress would not be so bad if I were acting in French." It was because of her French that she was visiting Varèse; a mutual friend had asked her to go to see him in the hospital because his English was poor and he knew so few people. This was her third visit. When the conversation in Varèse's hospital room that day turned to modern art, Beatrice showed her ignorance by saying that anybody could make such scrawls. "Why don't you try?" Duchamp suggested. The gentle sarcasm was tempered by his use of the familiar "*tu*."

A week later they had dinner together at the Dutch Oven in Greenwich Village, chaperoned by Beatrice's journalist friend, Alissa Frank. There were several more meetings, some with others present and some private. She brought him a drawing she had made. Duchamp said he would get his friend Allen Norton to publish it in his magazine *Rogue*. (Norton published it.) Why not try painting, he asked her. When she told him that there was no place to do that in her parents' apartment, Duchamp said she could use his studio, and Beatrice, whose heart "lost a beat" at the invitation, accepted without hesitation. It was understood that she would always telephone beforehand. If Duchamp said not to come, she assumed he had "a lady" with him. Duchamp had many ladies, she had heard, most of them quite homely. He told her that unattractive women made love better than beautiful ones. "Sex and love, he explained, were two very different things." Beatrice didn't believe that. She was still a virgin, and Duchamp, whose French upbringing ruled out initiating *jeunes filles,* treated her with a respect that she longed to break down. She could not help romanticizing his reserve: "When he smiled the heavens opened. But when his face was still it was as blank as a death mask. This curious emptiness puzzled many and gave the impression that he had been hurt in childhood."

Several afternoons a week she came to his studio, which by now was a one-room apartment just down the hall from the second-floor entrance to the Arensbergs' duplex at 33 West 67th Street—Duchamp had moved there from the Lincoln Arcade building in the fall of 1916, soon after he and Beatrice met. In her memory it was "a typical bachelor's niche," a square room on the back, with a Murphy bed that folded against the wall, two chairs, one table, clothing in untidy piles, strange objects (readymades) hanging from the ceiling or the wall, and always half-eaten boxes of crackers and Swiss chocolate on the windowsill. Beatrice sketched and painted, and Duchamp offered laconic criticisms, through which she began to understand

Florine (left), Carrie, and Ettie Stettheimer, around 1914.

something about modern art. "I felt an extraordinary harmony with him," she said. "We could spend hours together and not talk, and the silence was so potent. Marcel didn't seem to have any egotism. He had a real modesty and a real simplicity." Often he would take her to a cheap restaurant for dinner. At night she dreamed about him. "Except for the physical act," she wrote, "we were lovers."

The three Stettheimer sisters knew and cherished a different Duchamp—a "charming garçon," whom they referred to as "Duche." Florine, Henrietta (Ettie), and Caroline (Carrie) Stettheimer, who started taking French lessons from Duchamp in the fall of 1916, were "inveterate celibates," as he once described them, "entirely dedicated to their mother. They were so funny, and so far out of what American life was like then."

Born in Rochester, New York, the Stettheimer sisters had lived for many years in Europe. Their father, the scion of a German-Jewish banking family, abandoned the family around 1900, whereupon their mother, Rosetta, took the three younger girls off to Europe. (Walter and Stella, the oldest siblings, had both married and moved to California.) By the time they came back to America in 1914, the sisters were somewhat beyond marriage age—Ettie, the youngest, was thirty-nine—and their life patterns

were firmly set. Carrie, who was forty-three, ran the household and acted as official hostess. Florine, forty-one, had studied art since she was fifteen; after a thorough training in academic techniques, she had developed her own eccentric and original version of modernism—since their return to New York her subject matter consisted mainly of her family and their friends, shown in fancifully conceived, sometimes allegorical, but always clearly recognizable surroundings. Ettie was the family intellectual. She had a doctorate in philosophy from the University of Freiburg; her doctoral thesis, on William James's metaphysics, had prompted James himself to write her a letter in which he said there was "no university extant that wouldn't give you its *summa cum laude.*" The three sisters and their imperviously taciturn mother had established themselves and their Victorian furniture in a large and rather unattractive apartment at 102 West 76th Street—Ettie said it looked like a "salle d'attente deuxième classe"—where, in a setting of red taffeta and velvet, lace and brocade, cut-crystal vases, Aubusson carpets, and Florine's extravagant flower arrangements, they held court once a week for their oddly assorted circle of friends, some of whom, like the writer and photographer Carl Van Vechten and the art critic Henry McBride, could also be found at the Arensbergs'.

Duchamp went to the opening of Florine's one-person exhibition that fall at the Knoedler Gallery on Fifth Avenue. Florine had personally redecorated the gallery for the occasion, putting white muslin on the walls and suspending a gold-fringed canopy from the ceiling in an attempt to make the room look as much like her studio as possible. Even so, she was deeply apprehensive about this first public exposure of her very private art. "I am very unhappy—and I don't think I deserve to be," she wrote in her diary after hanging the show. "I thought I might feel happier after dinner—but I have had dinner." Recognition meant more to her than she was willing to admit. Although her show was praised by a few critics and a number of artists, including Duchamp—who saw a real talent behind the faux-naïf mannerism of her style—Florine was deeply disappointed that only one person asked to see the price list, and when the show closed, her diary entry summed up the event in two words: "nothing sold."

Duchamp brought Florine and Ettie to the Brevoort one evening in December to have dinner with Edgard Varèse, whose broken leg was now healed. Varèse had another recently arrived Frenchman with him that evening, a tall, serious-looking man named Henri-Pierre Roché. Excused

from active military service because of a bad knee, Roché had come to New York as a government-appointed adviser to the American Industrial Commission to France. His visit, which was supposed to last fifteen days, was extended indefinitely, thanks to the intervention of John Quinn; he was eventually attached to the French High Commission in Washington, D.C., and he ended up staying for three years. A journalist by default—he had first planned to become a diplomat, then a painter—Roché was by his own definition an inquiring mind. His real talent seemed to lie in befriending some of the most important artists, writers, and composers of his era and in being what Gertrude Stein called "a general introducer." (It was Roché who had introduced Picasso to Leo and Gertrude Stein.) Roché was on good terms with most of the established artists in Paris, and he occasionally supplemented his modest income by helping collectors buy their work. He did not know Duchamp, but their meeting that night was the beginning of a friendship that would last for more than forty years.

Roché's first impression of Duchamp was that he wore "a halo," an aura made up of "his outward calm, his easygoing nature, his keenness of intellect, his lack of selfishness, his receptivity to whatever was new, his spontaneity and audacity." Duchamp's reputation as a Frenchman in New York at that time, he said, "was equaled only by Napoleon and Sarah Bernhardt. He could have had his choice of heiresses, but he preferred to play chess and live on the proceeds of the exclusive French lessons he gave for two dollars an hour. He was an enigma, contrary to all tradition, and he won everybody's heart." Roché was a fairly charismatic figure in his own right. A thirty-seven-year-old dilettante who did not fully realize his literary gifts until the last decade of his life, when he wrote and published two novels based on his experiences as a young man (both of them, *Jules and Jim* and *Two English Girls and the Continent,* were made into films by François Truffaut), Roché devoted the major part of his energy and imagination over the years to his sexual relationships with a truly astonishing number of women. As an erotic connoisseur, he was very struck by Duchamp's success in that department. Soon after their first meeting at the Brevoort, Roché went with Duchamp to one of the fund-raising balls that were so much a part of Greenwich Village life in those years, at the old Vanderbilt Hotel. Although Duchamp himself did not dance, in Roché's memory he was always surrounded by girls, whose comings and goings seemed "like a great flower of fragrant dresses that constantly renewed itself." Roché's success with

women was no less impressive than Duchamp's, and he had fewer scruples when it came to initiating *jeunes filles*. He relieved Beatrice Wood of her troublesome virginity, and she fell ecstatically in love with him.

Beatrice Wood's love affair with Roché did not in the least diminish her infatuation with Duchamp. She still dreamed about him every night. When she confided this to Roché, "he only laughed, for he too loved Marcel." This *amour à trois* is reflected in *Victor,* the unfinished novel that Roché was working on when he died. The characters Patricia (Beatrice Wood) and Pierre (Roché) spend much of their time in the novel talking about Victor, who is clearly Duchamp. (Roché had spontaneously started calling Duchamp "Victor" on the evening of the Vanderbilt Hotel ball because he seemed so naturally victorious.) Victor "has no needs, no ambitions," Patricia says. "He says that only those with a vocation for it should have children, and that the more you own the less free you are ... He is for everybody, not for one person. I know four girls who love him almost as much as I do." Any number of people later assumed that the Duchamp-Wood-Roché triangle had inspired the three-way erotic relationship in Roché's novel *Jules and Jim.* This was not the case; *Jules and Jim* is a fictional re-creation of Roché's long involvement with a German couple named Frantz and Helen Hessel. But there could be no doubt about Duchamp's profound and lasting influence on Henri-Pierre Roché. *Victor,* the later, unfinished novel, is a meditation on the freedom that Duchamp was trying to achieve in his life. Roché saw very clearly that for Duchamp this kind of freedom of the mind and the imagination could be won only through restraint, refusal, and negation. "You must choose," Victor tells Patricia:

Either liberty and risk. Or the so-called straight path, also a risk, and children. Love makes you ... Love without restraint becomes empty and black. Too many loves coarsen like too many whiskies ... To remain yourself while loving. Not to take up residence in someone else ... One mustn't eat the other, or want to be eaten—it's indigestible ... I refuse all the time. I refuse you. Who says I haven't wanted you?

Duchamp had made his choice. The negations that were the basis of his work—negations of the eye, of the hand, of tradition, of emotional or subjective associations, of anything, in fact, that got in the way of art as a

Duchamp in 1917,
photographed by
Edward Steichen.

mental activity—were mirrored by the refusals in his private life. There was something cold-blooded about these refusals. Beatrice Wood, an incurable romantic, wrote in another memoir that his objectivity carried with it "a certain deadness . . . The upper part of his face was alive, the lower part lifeless." Armchair Freudians have made the obvious connection between this emotional deadness and Duchamp's "cold and distant" mother, who was already quite deaf by the time Marcel and Suzanne were born, but the truth, as usual, is more elusive. Duchamp's dandyish "indifference" (reinforced by the teachings of Pyrrho and Max Stirner) did not make him behave coldly or indifferently toward the women he slept with, and it never appeared to get in the way of his friendships with men or women. His lack of passionate attachments seemed rather to make him more lighthearted, more alert to everything, and less competitive than others. He was able somehow to keep the extravagant admiration and even love that he evoked in people from intruding on the solitude that was essential to his work. By

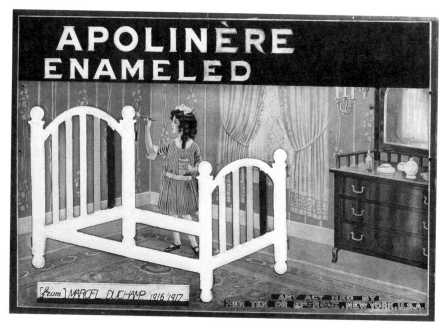

Apolinère Enameled, 1916–17.

restricting his needs to a few essentials, he avoided obligations. He loved but did not fall in love with the women who loved him. Love and sex were two different things.

Walter Arensberg had agreed to pay the rent on Duchamp's new studio at 33 West 67th Street. (It was $58.33 a month.) In exchange, Duchamp had promised to give him *The Large Glass* when it was finished. He was in no hurry to finish it. Days or weeks would go by without any appreciable progress. Now and then he produced a new readymade. A second version of *Bicycle Wheel* appeared in his studio sometime in 1916. An advertisement for Sapolin enamel paint, showing a little girl painting a wooden bedpost, became *Apolinère Enameled*—Duchamp simply painted out some letters painted in others to evoke the name of his poet-friend, and added, in a mirror on top of the bureau in the background, a reflection of the little girl's long hair. This was an example of an "assisted" or "rectified" ready-made, one requiring something more than just a title and the artist's signature. *Trébuchet,* which came along early in 1917, could be described as an

inadvertent readymade. It was a coat rack, four metal brackets on a wooden support, and according to Duchamp he bought it to use *as* a coat rack but never got around to hanging it on the wall. It stayed on the floor for several days, tripping him up occasionally, and this gave him the idea of nailing it down to the floor and calling it *Trébuchet*—from the verb *trébucher,* meaning "to trip," with the added connotation of the chess term for giving up a pawn in order to trap (or trip up) your opponent. *Hat Rack,* another 1917 readymade, was a circular wooden hat rack with six sinuously shaped prongs, which he hung from the ceiling by a wire. His room was becoming a stranger place than the apartment of his former Beekman Place landlord, the "Turk" who had inexplicable objects hanging from his ceiling. Beatrice Wood could never get the point of the readymades. When she told him so, in her naive way, he said it didn't matter—"Cela n'a pas d'importance." That, she had found, was one of his favorite expressions.

Beatrice Wood loved going to the Arensbergs'. Duchamp took her there for the first time in the fall of 1916, and in spite of her initial reaction to the art on the walls—shock, dismay, and an embarrassing urge to giggle—she felt immediately comfortable with Walter and Louise. The two of them struck her as being almost comically mismatched. Walter, with his unpressed suits, disheveled brown hair, and eyeglasses sliding down his nose, looked more like a college professor than a rich collector. He even had a pseudo-scholarly obsession, which involved searching for the hidden meanings and symbols that he thought were encoded, cryptographically, in the works of Dante and Shakespeare. Walter talked a great deal, drank too much, chain-smoked Murads, and sometimes cut people down with his sharp-tongued sarcasm, but he could also be charming and gracious; he enjoyed coaching Beatrice in her theatrical delivery, taking her off to his study and offering suggestions as she read lines from Marlowe's *Hero and Leander* or Mallarmé's *L'Après-midi d'un faune.*

Louise, by contrast, was quiet, painfully shy, and at the same time extremely forthright. A rather homely woman with a round face and a thin, delicate figure, she didn't smoke or drink and "could not acquire the knack of misbehaving," according to the English poet Mina Loy, "so always felt rather wistfully out of it." She was much more conservative than her husband—their votes usually canceled each other out at election time—and her first impression of the modern works in the Armory Show was that they were "weird and grotesque and simply frightful," but she soon changed her

mind about that. Over the next twenty years nearly everything Walter bought had her full approval. She liked modern music and could sometimes be persuaded to leave her regular place on the sofa long enough to play Schoenberg's "Six Piano Pieces" or some other advanced work on the grand piano—she was an accomplished pianist. Promptly at midnight Lou, as she was known to her friends, would go to the kitchen and return pushing a cart laden with pastries, hot chocolate, and rice pudding, whose main purpose (in Lou's mind, at least) was to provide an internal cushion for all the whiskey that was being consumed. Beatrice's conflict with her own mother, a continuing battle in which acts of revolt were followed by phases of meek submission, made her respond all the more eagerly to Lou's obvious affection for her. Beatrice would spend most of the evening sitting next to Lou Arensberg on the sofa or on the rug at her feet.

Much of the talk at the Arensbergs' apartment during the early weeks of 1917 had to do with plans for a second great exhibition of modern art in New York. The coalition that put together the Armory Show had fallen apart soon after the show ended. Several groups of American artists were eager to strike another blow for modernism and against the restrictive policies of the National Academy of Design, however, and they joined together in 1916 to form the Society of Independent Artists, whose main purpose was to mount annual exhibitions modeled on those of the Paris Salon des Indépendants, with a policy of "no jury, no prizes." Any artist who paid the five-dollar annual dues and a one-dollar initiation fee could become a member of the society and be entitled to show two works, and applications poured in from all parts of the country; within two weeks of the first announcement, the society had six hundred members. National pride and a sense of historical inevitability were in the air. European art had been shut down by the war, Paris was under siege, and any number of artists and critics believed that America, as Duchamp had said in one of his newspaper interviews, was destined to forge the new art of the twentieth century.

Three separate groups were represented on the society's board of directors. William Glackens, the president, George Bellows, Rockwell Kent, and Maurice Prendergast spoke for the American realist painters who were known collectively as The Eight or the Ash-Can School, artists whose modernism lay not in the way they painted but in their choice of earthy or proletarian subject matter. John Marin was the sole representative of the

Stieglitz group—an indication, perhaps, of its waning influence. The Europe-oriented Arensberg circle was represented by Arensberg himself (the managing director of the first exhibition), Man Ray, John Covert, Joseph Stella, Morton Schamberg, and Marcel Duchamp. (Picabia and Crotti were no longer in New York at this point; the Picabias had gone to Barcelona the previous June, and the Crottis, who were splitting up, had returned separately to Paris.) The indispensable Walter Pach was named treasurer of the society, and Katherine S. Dreier, a formidable woman who considered herself an artist, and who was put on the board because of her organizational skills, undertook to organize public lectures during the exhibition and to run an "educational" tearoom. Twelve prominent and moneyed New Yorkers, including Archer M. Huntington, Mrs. William K. Vanderbilt, and Mrs. Harry Payne Whitney, agreed to cover the estimated $10,000 in expenses for the initial exhibition, which was scheduled to open on April 10 at the Grand Central Palace, a very large exhibition hall on Lexington Avenue between 46th and 47th Streets.

Many of the society's meetings and planning sessions took place at the Arensberg apartment, where Duchamp's subtle influence could often be felt. It was Duchamp, as head of the Hanging Committee, who came up with the democratic notion of installing the works of art by alphabetical order of the artists' last names, starting with a letter that would be drawn from a hat—R, as it turned out. Robert Henri, the leader of The Eight, withdrew from the society over this exercise in antielitism, and John Quinn, who had donated his services as consultant and legal counsel to the society, complained that it was "Democracy run riot." Duchamp also confused a lot of people by proclaiming on the eve of the opening that the two great paintings in the show were *Supplication* by Louis Eilshemius and *Claire Twins* by Dorothy Rice. Duchamp was almost certainly being facetious about the latter, a huge canvas depicting two middle-aged, overweight, and distinctly ill-tempered-looking ladies, but he really did admire Eilshemius, a self-taught artist who had been proclaiming his own genius for years in angry letters to art critics and whose future reputation as a true original owed much to Duchamp's persistent enthusiasm.

The 1917 Independents exhibition was nearly twice as large as the Armory Show. It was the biggest art exhibition that had ever been put on in America, in fact, with 2,125 works of art by 1,200 artists—more than two miles of art, claimed Duchamp after he and John Covert had paced off all the

aisles in the vast exhibition space. Every sort of art could be found there, from Gertrude Vanderbilt Whitney's *Titanic Memorial,* an eighteen-foot-high granite statue of a Christlike young male, to Brancusi's *Portrait of Princess Bonaparte* (now known as *Princess X*), a bronze sculpture of a nearly abstract female bust that also suggested, indelibly, the male genitalia. Most of the works on view were by no means avant-garde. Because of the alphabetical hanging system, Cubist still lifes and academic landscapes cohabited with amateur photographs, batiks, and artificial flower arrangements. Beatrice Wood's entry, a drawing of a nude female floating in a bathtub, with a real cake of soap glued (at Duchamp's suggestion) to the pubic area, attracted a lot of attention—several gentleman viewers tucked their calling cards into the frame. Although Duchamp was rumored to be sending in a Cubist canvas called *Tulip Hysteria Coordinating,* no such work turned up either in the catalog or in the exhibition. Duchamp, in fact, is not listed as having contributed anything at all to the 1917 Independents. He was responsible, nevertheless, for the show's most notorious work—a work that the public never saw.

Walter Arensberg, Joseph Stella, and Marcel Duchamp went shopping for this item a week or so before the exhibition opened, after a spirited conversation at lunch. They went to the showroom of the J. L. Mott Iron Works at 118 Fifth Avenue, a manufacturer of plumbing equipment, where Duchamp picked out and purchased a flat-back, "Bedfordshire"-model porcelain urinal. Duchamp took it back to his studio, turned it upside down, and painted on the rim at the lower left, in large black letters, the name R. MUTT and the date, 1917. Two days before the official opening, this object was delivered to the Grand Central Palace, together with an envelope bearing the fictitious Mr. Mutt's six-dollar membership and entry fee, his fictitious Philadelphia address, and the work's title: *Fountain.*

The story of *Fountain's* rejection and the ensuing brouhaha has entered art history mainly through Beatrice Wood's eyewitness account. She described walking into one of the exhibition's storerooms and finding Walter Arensberg and George Bellows in the midst of a furious argument, with the "glistening white object" on the floor between them.

"We cannot exhibit it," Bellows said hotly, taking out a handkerchief and wiping his forehead.

"We cannot refuse it, the entrance fee has been paid," gently answered Walter.

"It is indecent!" roared Bellows.

"That depends upon the point of view," added Walter, suppressing a grin.

"Someone must have sent it in as a joke. It is signed R. Mutt; sounds fishy to me," grumbled Bellows with disgust. Walter approached the object in question and touched its glossy surface. Then with the dignity of a don addressing men at Harvard, he expounded: "A lovely form has been revealed, freed from its functional purpose, therefore a man has clearly made an aesthetic contribution."

... Bellows stepped away, then returned in rage as if he were going to pull it down. "We can't show it, that's all there is to it."

Walter lightly touched his arm. "This is what the whole exhibit is about; an opportunity to allow the artist to send in anything he chooses, for the artist to decide what is art, not someone else."

Bellows shook his arm away, protesting. "You mean to say, if a man sent in horse manure glued to a canvas that we would have to accept it!"

"I'm afraid we would," said Walter, with a touch of undertaker's sadness.

The issue was not resolved until an hour or so before the private opening on April 9, when ten members of the society's board of directors met and, according to an article in the *New York Herald,* "Mr. Mutt's defenders were voted down by a small margin." In his statement to the press, William Glackens, the president of the board, voiced the immemorial cry of the artistic rearguard when under attack: the object, he said, was "by no definition, a work of art." Duchamp and Arensberg immediately resigned from the board in protest.

What happened to *Fountain,* which disappeared forever soon after the exhibition opened, has been obscured by a welter of inaccurate newspaper accounts and conflicting statements by several of the participants, including Duchamp. Did Walter Arensberg seek out the urinal, which had been put away behind a partition, and then make a great show of buying it and carrying it in triumph from the Grand Central Palace, as Duchamp once reported? Since *Fountain* was never listed as part of the Arensbergs' collection and nobody ever saw it in their apartment, this story is almost certainly

apocryphal. Did Glackens "solve" the problem by lifting the "chamber pot" over his head and letting it smash on the floor of the exhibition, as his son, Ira Glackens, has written? We know this didn't happen, because the urinal turned up a week later at Alfred Stieglitz's "291" gallery. Duchamp took it there himself, and Beatrice Wood tells us why. "At Marcel's request, he [Stieglitz] agreed to photograph the *Fountain* ... He was greatly amused, but also felt that it was important to fight bigotry in America. He took great pains with the lighting, and did it with such skill that a shadow fell across the urinal suggesting a veil."

Fountain, 1917, photographed by Alfred Stieglitz.

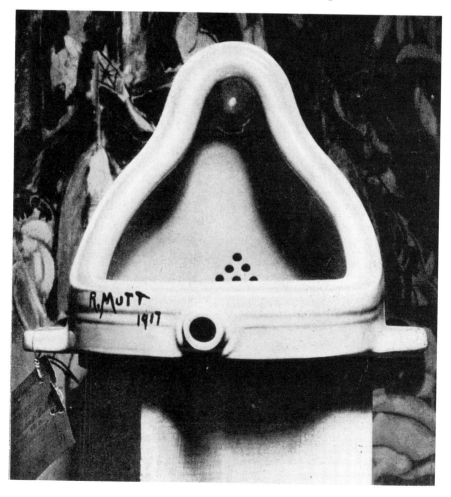

Not one of the accounts published at the time identified the controversial object as a urinal—decorum required that it be referred to as a "bathroom fixture." Not one reporter, moreover, seemed to be aware that R. Mutt was really Duchamp. Charles Demuth wrote a letter to the critic Henry McBride, the most liberal and perceptive of the New York art critics, in which he said that *Fountain* was made "by one of our friends," and he provided two telephone numbers that McBride could call for further information; one of the numbers was Duchamp's, the other was Louise Norton's, but apparently McBride didn't follow up on the lead. In his own subsequent comments on the affair, Duchamp explained that his testing of the society's "no jury" policy would have been compromised if people had known that the challenge came from one of the directors. The name "R. Mutt," he said, was a play on Mott, but it also referred to the comic strip "Mutt and Jeff"; the R. stood for Richard, which in French slang meant "moneybags." Duchamp's involvement remained a secret for several months. He wouldn't even tell his sister Suzanne in Paris. "One of my female friends under a masculine pseudonym, Richard Mutt, sent in a porcelain urinal as a sculpture" to the Independents exhibition, he wrote to Suzanne on April 11, adding that "I have handed in my resignation and it will be a bit of gossip of some value in New York." Why he felt obliged to doctor the truth for Suzanne has never been explained, and several other questions about the affair remain unanswered. Duchamp, Arensberg, and Stella obviously planned the whole thing as a deliberate provocation. They must have known that a urinal, which could not even be mentioned then in a family newspaper, would be unacceptable to the society's directors. But why should they want to annoy and embarrass the artists' group that they had helped to create? Perhaps they felt that the Bellows-Glackens faction was taking itself too seriously. Whatever his reasons, Duchamp had found a provocative new use for a readymade.

Together with Roché and Beatrice Wood, who were in on the joke, Duchamp put out a little magazine called *The Blind Man* to celebrate the Independents' opening. The first issue was not particularly impressive—eight pages of editorial comments by Roché, Wood, and the English poet Mina Loy, a recent arrival in New York—but the magazine's second number, which came out in May and had a picture of Duchamp's *Chocolate Grinder* on the cover, carried Stieglitz's photograph of *Fountain* inside, opposite an unsigned lead editorial on "The Richard Mutt Case." The

authorship of this sly and brilliant piece of prose is still another unsolved question. Beatrice Wood, in her autobiography, says she wrote it. Duchamp attributed it at one time to Louise Norton, who wrote, in the same issue, an essay on the urinal called "Buddha of the Bathroom," but in an earlier statement he said it had been done jointly by "the editors" of *The Blind Man*— that is, Roché, Wood, and himself. The ideas expressed in the editorial are clearly Duchamp's, however, and so is the succinct and not quite American-sounding syntax. Here is the text in full:

THE RICHARD MUTT CASE

They say any artist paying six dollars may exhibit.

Mr. Richard Mutt sent in a fountain. Without discussion this article disappeared and never was exhibited.

What were the grounds for refusing Mr. Mutt's fountain:—

1. Some contended it was immoral, vulgar.

2. Others, it was plagiarism, a plain piece of plumbing.

Now Mr. Mutt's fountain is not immoral, that is absurd, no more than a bathtub is immoral. It is a fixture that you see every day in plumbers' show windows.

Whether Mr. Mutt with his own hands made the fountain or not has no importance. He CHOSE it. He took an ordinary article of life, placed it so that its useful significance disappeared under the new title and point of view—created a new thought for that object.

As for plumbing, that is absurd. The only works of art America has given are her plumbing and her bridges.

The artist's choice gives birth to new ways of seeing and thinking. This was Duchamp's philosophy of art, reduced to its most basic level and expressed by the readymade. Duchamp, however, will never stay put on anything that even faintly resembles a basic level, and *Fountain* is one of his most insidiously subversive artifacts. Like *Bicycle Wheel,* it confounds Duchamp's own description of a readymade through its very real esthetic qualities— which Stieglitz caught and preserved in his photograph. Arensberg had referred to a "lovely form" in his argument with Bellows, and it does not take much stretching of the imagination to see in the upside-down urinal's gently

"As for plumbing . . ."
Duchamp at home, circa
1916.

flowing curves the veiled head of a classic Renaissance madonna or a seated
Buddha or, perhaps more to the point, one of Brancusi's polished erotic forms.
There is a cryptic note in Duchamp's *Box of 1914* which reads: "One only has:
for *female* the public urinal and one *lives* by it." The urinal, an object with
female attributes that serves as receptacle for male fluid, thus becomes—even
more provocatively than Brancusi's *Portrait of Princess Bonaparte*—a symbol
of the sexual comedy that underlies all of Duchamp's mature work.

It is no wonder, then, that this flat-back Bedfordshire fixture has been
the subject of so much in-depth study and analysis. The Menil Collection in
Houston devoted an entire museum exhibition to it in 1989, with examples
of the many replicas that have been made of it and a book-length essay by
the art historian William A. Camfield. Nobody has ever found out what
became of the original. The best guess is that it stayed on at "291" after
Stieglitz photographed it. Stieglitz wrote to the critic Henry McBride on
April 19, suggesting that he come see his photograph of the controversial
object, and he added: "The 'Fountain' is here too." At that time Stieglitz
was busy preparing for his next show, which would introduce the work of
his latest discovery (and future wife), Georgia O'Keeffe. That historic exhi-
bition was also the last one ever held at "291"; he closed the gallery for good
when it was over. The original *Fountain* was never seen again, and it seems
probable that it suffered the same fate as the first *Bicycle Wheel* and *Bottle
Rack*—thrown out with the trash.

The 1917 Independents exhibition and its attendant festivities marked
the high-water point of New York's first artistic avant-garde. America had

declared war on Germany a few days before the exhibition opened. Military needs and wartime restrictions would soon cut deeply into the freedom of thought, expression, and behavior that had made life in New York so agreeable for Duchamp and his friends, but for a while longer the war still seemed far away, and a hectic gaiety prevailed. The Picabias were back in town, after spending nine months in Barcelona. While there they had met and befriended the wildly eccentric Arthur Cravan, whom they encouraged to go to New York. He did so, and his presence now provided the impetus for a new scandal.

"Let me state once and for all," Cravan had once said: "I do not wish to be civilized." Massively built and brutally handsome, this prizefighter who claimed to be the nephew of Oscar Wilde was also a poet, a con man, and a gifted polemicist. Cravan had managed to insult most of the artists in Paris in his vituperative magazine, *Maintenant,* which he published from 1911 to 1913 and sold from a wheelbarrow at the entrances to sports stadiums. To escape wartime conscription in France, he had gone to neutral Barcelona, where he challenged the former world heavyweight boxing champion Jack Johnson, himself a fugitive—Johnson was in Spain to avoid U.S. prosecution under the Mann Act. Their highly publicized bout was a farce. Cravan had no real talent as a boxer; he had won the amateur light-heavyweight title in France through a bizarre series of defaults. Johnson carried him for six rounds before flooring him in a highly unconvincing knockout, but Cravan earned enough from this sorry affair to pay for his passage to New York. One of his fellow passengers was Leon Trotsky, the exiled Russian revolutionary, who recalled Cravan saying to him "that he preferred crushing the jaws of Yankee gentlemen in a noble sport to letting his ribs be crushed by a German."

Of the many events planned to promote and publicize the Independents exhibition, Arthur Cravan's "lecture" on "The Independent Artists in France and America" was the most unusual. Duchamp and Picabia, who set it up, took him to lunch beforehand and made sure he had plenty to drink. When Cravan arrived late at the auditorium in Grand Central Palace, it was immediately clear to the several hundred men and women in the audience that something was amiss. He climbed unsteadily to the speaker's platform and swayed back and forth, glaring balefully. According to the account of a *New York Sun* reporter who was present, Cravan then fell down, "striking the hard surface of the speaker's platform with an independence

of expression plainly heard on Lexington Avenue." He staggered upright and started to take off his clothes—coat, vest, collar, suspenders. A couple of house detectives intervened before he could drop his pants, and after a brief scuffle, they succeeded in handcuffing him. Walter Arensberg persuaded them to release the semi-naked giant into his custody, and Cravan spent the rest of the afternoon and evening sobering up at the Arensbergs' apartment. "What a wonderful lecture," Duchamp said.

Cravan resurfaced the next night at a fancy dress ball organized by the Society of Independent Artists. Nude under a bed sheet, with a towel wrapped around his huge head, he attached himself to the delicately beautiful Mina Loy, who had come to the ball with Duchamp. Loy was annoyed when Duchamp started "making love right under my nose to a horse-like woman," but she found Cravan's overtures revolting. "The putrefaction of unspoken obscenities issuing from that tomb of flesh, devoid of any magnetism, chilled my powdered skin," as she picturesquely recalled. She longed to reclaim the attentions of Duchamp, a "prestidigitator" who "could insinuate his hand under a woman's bodice and caress her with utter grace." A few evenings later, however, she fell violently in love with the tomb of flesh, whom she would eventually follow to Mexico and marry.

The Arensberg crowd turned out in force for the Blindman's Ball, which Duchamp, Roché, and Beatrice Wood organized to celebrate the publication of *The Blind Man*'s second number. The poster for the event, which featured Wood's drawing of a stick figure thumbing its nose (Duchamp had selected this one in preference to her more ambitious attempts), described it as "a newfashioned hop, skip and jump" at "the Ultra Bohemian, Pre-Historic, Post Alcoholic Webster Hall" on East 11th Street. Tickets cost $1.50 if bought in advance, $2.00 at the door. It was one of the last of the Village costume balls, an uninhibited affair with nonstop drinking. Beatrice Wood, in an elaborate brocaded dress, performed the Russian dances she had been taught by Pavlova's ballet master in Paris. Told that the artist Joseph Stella had challenged someone to a duel having to do with her honor, Miss Wood said rather proudly that her honor no longer existed. Around midnight, bored and very drunk, Duchamp decided to scale a wooden flagpole that projected out at a forty-five degree angle from the balcony. Roché watched anxiously as he crawled out farther and farther, "like a lady-bird on a large stalk . . . We were afraid he would fall on the dancers, but his movements were confident and he soon became part of the

decor." When he finally reached the flag, there was a round of applause. Duchamp raised his pink paper hat to acknowledge it before sliding back down to safety. Sometime later, after the ball, Roché and Wood saw Duchamp and the young widow he had left with walking precariously on the outer edge of the elevated train track above Third Avenue.

A group of revelers went back to the Arensbergs' apartment around three in the morning for scrambled eggs and wine. Duchamp turned up too, without the young widow. Deciding that it was too late to go home, Beatrice Wood, her friend Aileen Dresser, the painter Charles Demuth, and Mina Loy went upstairs to Duchamp's studio on the floor above and piled on to his bed. The image of that bedfull—tipsy yet innocent, in keeping with the period—is preserved in a drawing that Wood made a few days later, and it is vividly recalled in her autobiography. Squeezing herself into the narrow space between Marcel and the wall, she wrote, "I could hear his beating heart, and feel the coolness of his chest. Divinely happy, I never closed my eyes to sleep."

Beginning at Zero

Let each man proclaim: there is
a great negative work of destruction
to be accomplished.
—Tristan Tzara

Dada was born in a small cabaret in the staid, bourgeois city of Zurich. Hugo Ball, a young German conscientious objector with some experience as a stage manager, had rented the premises from a retired Dutch sailor, and he and his friends provided the nightly entertainment, which at first—in February 1916—was fairly innocuous. Ball played the piano. Emmy Hennings, his childishly pretty girlfriend, sang songs in French and Danish. Tristan Tzara, small and nervous, with spiky hair, thick glasses, and a resonating voice, recited his own poems in Romanian. Marcel Janco, another Romanian, had made the lurid red masks that hung on the walls, along with abstract paintings by Jean Arp, an Alsatian who had lived in Paris and known Picasso and Delaunay. Ball, Hennings, Tzara, Janco, Arp, and Richard Huelsenbeck—a German medical student who joined the group a few weeks later—had all come to neutral Switzerland for the same reason: they wanted nothing to do with the suicidal horror of the Great War. It is no coincidence that the Dada movement was launched in the spring of Verdun, whose combined casualties would number more than 750,000 dead and wounded. Dada's organized insanity was a direct response to the nightmare of unending, meaningless slaughter in the trenches.

The Cabaret Voltaire, as Ball and his friends had decided to call their venture, was an immediate success. The Swiss students who packed the little room from the first evenings sensed that something new was in the air, but they were hardly prepared for the increasingly aggressive shock tactics of the performers. Tzara, Janco, and Huelsenbeck initiated the device of simultaneous readings—each one reciting a different poem at the same time at the top of his lungs. Tzara and Huelsenbeck came out with stovepipes over their heads and did a dance called "Noir Cacadou," to the sound of someone banging on a tin can and howling like a dog. (Noise music, or *bruitisme,* was a Futurist technique.) Janco made fantastic costumes out of paper and colored rags, and all five participants tried to outdo each other in provoking their audiences to greater frenzies of excitement and derision. Their most provocative act, however, was the one that gave their movement its name. Flipping at random through a French-German dictionary, one of them (both Tzara and Huelsenbeck subsequently claimed to have been the discoverer) happened on the French word *dada,* a child's term for hobbyhorse. As Huelsenbeck said at the time, "The child's first sound expresses the primitiveness, the beginning at zero, the new in our art."

It can be argued that Dada was not new, nor was it art. Dada's spirit of anarchic nihilism had appeared again and again in world literature, from Aristophanes to Rabelais, from Rimbaud to Jarry and beyond. According to Tzara, whose statements and polemics would largely define the movement, Dada was "not at all modern"; it was, in fact, "more in the nature of a return to an almost Buddhist religion of indifference." As for art, Dada was and remains the only true antiart movement. "Art is not serious I assure you," said Tzara, while Arp, the mildest of the original dadas and the only one who became, almost in spite of himself, an important artist, once said that "the Dadaists despised what is commonly regarded as art, but put the whole universe on the lofty throne of art. We declared that everything that comes into being or is made by man is art." The original dadas disagreed with each other on principle, the principle laid down by Tzara when he said that "the true dadas are against Dada," but they were united in their belief that life was what mattered, not art. The great masterpieces in the museums were tainted, along with the books and the noble ideas of a murderous society that was tearing itself to pieces on the Western front. "We had found in the

war that Goethe and Schiller and Beauty added up to killing and bloodshed and murder," according to Huelsenbeck. "It was a terrific shock to us."

Dada's furious energy soon required new outlets. The group staged "Dada Nights" in various halls around Zurich, with wild "Cubist" dancing, shouted simultaneous recitations, noise music, and obscenities hurled at the audience. Their first printed texts appeared in the spring of 1916: Huelsenbeck's *Phantastiche Gebete* (*Fantastic Prayers*), nonsense verses with abstract woodcuts by Arp; Tzara's *La Première Aventure céleste de M. Antipyrene* (*The First Celestial Adventure of Mr. Antipyrene*), which he described as "a boxing match with words"; and an international review called *Cabaret Voltaire,* with writings by Apollinaire, Marinetti, Tzara, and Huelsenbeck, among others, and reproductions of drawings by Picasso, Modigliani, Arp, Janco, Otto van Rees, and Kandinsky. Ten copies of *Cabaret Voltaire,* in which the word "Dada" appeared in print for the first time, reached New York that November. Tzara had mailed them to Marius de Zayas, whose avant-garde magazine, *291,* he had seen in Zurich. De Zayas worked hard at developing contacts with avant-garde movements in other countries; he acknowledged Tzara's letter warmly, promised to place *Cabaret Voltaire* in New York bookstores, and sent back copies of the current issue of *291* (whose typography, layout, and general tone were a lot more advanced than anything in *Cabaret Voltaire*). He also offered to send to Zurich an exhibition of "Abstract Art in America." Nothing came of that proposal, and there were no further contacts between the Zurich Dadas and the New York group until the fall of 1918, when Picabia went to Switzerland and got in touch with Tzara.

Duchamp, who remembered reading a copy of Tzara's *Antipyrene* text (although not *Cabaret Voltaire*) either late in 1916 or early in 1917, saw in Dada "the spirit of Jarry, and long before him, Aristophanes—the antiserious attitude, which simply took the name of Dada in 1916." He must also have seen many parallels to his own point of view. Dada's rejection of all traditions, its nose-thumbing attitude toward social values (including art), its indifference, and at a deeper level its denial of art's interpretive function—Dada demanded that art be a part of life rather than a commentary on life or an improvement on life—all this was very close to Duchamp's own thinking. In later years, though, Duchamp wanted to make it clear that what he and his friends were doing in New York during those same years was different. "It wasn't Dada," he said, "but it was in the same spirit." What was the difference? "You see, the

dadas were really committed to action," Duchamp said. "They were not just writing books, like Rabelais or Jarry, they were fighting the public. And when you're fighting you rarely manage to laugh at the same time."

The original Dadaists were as dedicated to their nihilism as any band of fanatical world savers. "Above all, I wanted to change life, my life and that of other people," as Huelsenbeck wrote. Except for Arp, not one of them showed any evidence of a sense of humor, and the absence of this element— inimical to fanaticism of all kinds—was a crucial factor in Dada's explosive postwar growth and its equally rapid disintegration. In New York, on the other hand, things were a bit more lighthearted. Even such natural Dada personalities as Arthur Cravan and Elsa von Freytag-Loringhoven did not take their antiserious activities too seriously, and the brouhaha over *Fountain* was played out in a key of larky humor. The same spirit led Duchamp, the painter John Sloan, and five other merry souls to climb to the top of the Washington Square Arch one cold night in January 1917, using an unlocked door at ground level that one of them had discovered, and after drinking many toasts and affixing red, white, and blue balloons to the ramparts, to proclaim Greenwich Village "a free republic, independent of uptown."

Like the Zurich dadas, Duchamp was against the war. He had been rejected for military service once again, by a French military board in New York; after America became a combatant in April 1917, though, he faced the distinct possibility of being drafted into the United States Army. He was classified "F," the military designation used for foreigners, and told not to leave the country without official permission. In May, when Marshal Joffre, France's "hero of the Marne," visited New York on a military mission to mobilize support for the war effort, the three Stettheimer sisters took Duchamp in a chauffeur-driven car to City Hall in hopes of seeing him. The streets were too crowded, but Ettie talked a store manager into letting them watch the event from his second-floor windows. As she described it in her journal, the manager said, " 'You're ladies, so stay.' I said, 'We have a gentleman with us, but he's a Frenchman.' He said, 'All right, hats off to a Frenchman.' This was funny, because one of Duchamp's most positive ideas is that he won't fight."

Both Duchamp and Roché were increasingly nervous about their situation in the United States. Rather than put their own names on the masthead of *The Blind Man*'s second issue, they listed Beatrice Wood as publisher, a precaution that got Wood in trouble when the printer delivered the

magazines to her parents' apartment. Her father demanded that she withdraw her name from such a "filthy publication," arguing that if it was sent through the mail she might be prosecuted and sent to prison. Wood went for advice to Frank Crowninshield, the editor of *Vanity Fair,* and that urbane and highly sophisticated man thought perhaps her father had a point; as a result, she arranged to distribute *The Blind Man* by hand rather than by mail. It was an indication of how the atmosphere was already changing in New York as patriotic and moral fervors gained momentum. Under the Espionage Act passed by Congress in 1917, any statement criticizing the war was a crime, and periodicals that carried what the postmaster general considered antiwar material could be banned.

The Stettheimer sisters invited a dozen friends to André Brook, their rented summer house near Tarrytown, to celebrate Duchamp's thirtieth birthday on July 28. "Friday was a scorcher and we feared for our party," Ettie wrote in her journal, "but Saturday was perfect: cool and sunny and at night windless and moony and Marcel Duchamp's birthday party was a

Florine Stettheimer, *La Fête à Duchamp,* 1917.

great success. A series of pretty pictures—first, tea on the lawn under the maples and some of us 'sur l'herbe,' and afterwards 3 tables on the terrace and Japanese lanterns blue and green and yellow . . . strung across." Among the guests were Picabia, whom Ettie described as "a fat womanish enfant terrible, self-centered Bohemian with a high power automobile in which he and Duche came out later than anyone else"; the "serious, very talkative" Albert Gleizes and his "refined, interesting, European and 'feminine' wife"; the writer Carl Van Vechten (wearing a green suit) and his dazzling actress wife, Fania, in royal blue with a wide-brimmed straw hat; the playwright Avery Hopwood; Leo Stein, equipped with a black ear trumpet; the Marquis de Buenavista, Peru's ambassador to the United States; Elizabeth Duncan, Isadora's sister, who ran a school for young dancers; and Henri-Pierre Roché. "It seemed very real, French, and classical," Ettie's sister, Florine, noted in *her* journal. "In my memory it has become a classic. I am about to paint it and entitle it *La Fête à Duchamp*. One more advertisement for him added to the already long list." Paint it she did, in bright pastel colors on a large canvas in which the guest of honor is depicted three times—arriving in Picabia's convertible roadster; waving as he walks under a floral arch; and rising from the dinner table to acknowledge a toast in his honor, his head silhouetted against a Japanese lantern in a way that suggests, perhaps not by accident, that he is equipped with a halo.

Love and sex were disrupting the Arensberg circle. Poor Beatrice Wood was devastated when she learned that Henri-Pierre Roché, her first lover, had also been sleeping with her friend Alissa Frank. To cheer her up, Duchamp and Picabia took her to Coney Island. "Because I feared the roller coasters, they made me go on the most dangerous one over and over, until I could control my screams. They enjoyed themselves enormously. So did I, for with Marcel's arm around me, I would have gone on any ride into hell." The three of them posed for a souvenir photograph, slim Duchamp and portly Picabia in an oxcart, with Wood sitting sideways on the wooden ox's back, holding on to her big hat and smiling anxiously. It was soon after this outing that she slept with Duchamp for the first time. "It just happened in the most natural way," she remembered more than seventy years later. "He was as gentle in that as he was in everything else." Perhaps a little too gentle. "With Roché," she said, "it was one of those beautiful, emotional

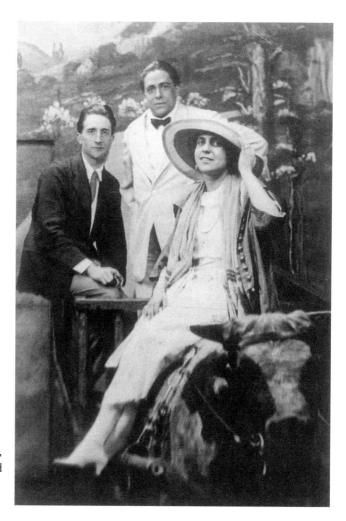

Duchamp, Picabia,
and Beatrice Wood
at Coney Island in
1917.

things, the kind of thing that women like myself live for. Marcel was far too much a realist. Marcel and I had a wonderful relationship without conflict, and, you could say, without passion."

Still inconsolable over Roché's infidelity, Beatrice Wood went to Montreal for a month's engagement with a French repertory theater group. She stayed on after the month was up, moved in with the company's Belgian manager, and eventually married him—a disastrous marriage, as it turned out. Lou Arensberg, meanwhile—shy, self-effacing Lou—had fallen deeply in love with Roché, and he with her. Their two-year love affair started in the summer and required all sorts of clandestine arrangements and meetings;

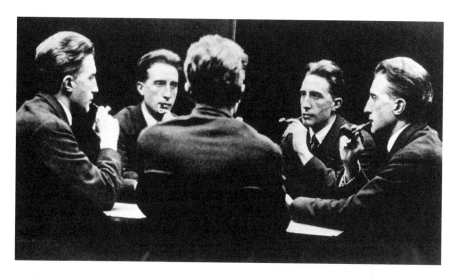

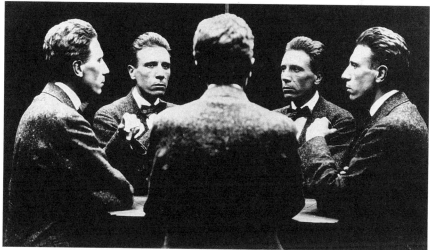

Duchamp and Roché multiplied by hinged mirror.

although Walter was quite open about his own infidelities, he had made it clear that he could not tolerate an unfaithful wife. Lou spent part of the summer in Boston, visiting her family (and seeing Roché), while Walter stayed in New York. Duchamp wrote to her while she was away, describing what New York was like in her absence:

> Here summer is just like winter. We drink a little. I got drunk a few times; and last night, at Joel's . . . the evening ended in a fight. Some

brutes at another table nearby started to sing too loudly near us, and they wanted to kiss "our women"—first a little discussion, then, more drunk than us, they knocked Walter down, without hurting him, and I got a terrific blow to the ear; I'm still bleeding and it's swollen—Nothing serious. Apart from that, I hardly work at all—I have a few lessons. We go to bed earlier. (3 instead of 5.)

Picabia was drinking more and more heavily and working himself into a manic state that would eventually lead to a nervous breakdown. Insatiably priapic, he embarked that summer on an affair with Isadora Duncan. At the same time he was painting some of the best pictures of his entire career, writing poetry, and putting out an avant-garde magazine called *391*, which he had started in Barcelona a few months earlier. (More casual and free-wheeling than Marius de Zayas's *291*, *391* served mainly as an outlet for Picabia's ideas, jokes, insults, and provocations.) Picabia considered *The Blind Man* a rival to *391*, and one night at the Arensbergs' he challenged Roché to a chess match that would decide the fate of the two magazines; Picabia's victory doomed *The Blind Man*, which ceased publication after its second issue. Duchamp and Roché printed the score of the chess game in *Rongwrong*, an eight-page one-shot publication that they brought out in July. The title was a printer's error that Duchamp decided to retain—it was supposed to be *Wrongwrong*; the magazine itself is of no great interest aside from its cover, which reproduces a mildly scatological illustration (taken from a book of matches) of two dogs sniffing each other's rear ends. The cost of printing these ephemeral little magazines was negligible in those days, which was one reason there were so many of them.

The Picabias had moved into a house at 110 West 88th Street that belonged to Louise Norton's parents. Louise and Allen Norton had separated, and Louise, whose parents were away, had rented (or lent) the ground floor to the Picabias and an apartment on an upper floor to Albert and Juliette Gleizes. "Picabia could not live without being surrounded morning and night by a troop of uprooted, floating, bizarre people whom he supported more or less," according to Juliette Gleizes. Picabia and Duchamp turned up at Louise Norton's apartment late one night, drunk and hungry; in a raid on her icebox, they devoured a cooked leg of lamb that belonged to the Gleizeses (who had asked Louise to keep it for them because their icebox was too small), and then, in a gesture that was pure Dada, left the picked-clean

bone with a note by the Gleizeses' door. (The Gleizeses were not amused.) Duchamp and Roché often ended their evenings in Louise Norton's apartment. In the first of Roché's many journal entries that refer to this little *ménage à trois,* dated April 18, 1917, Roché takes Beatrice Wood to see the play *Our Betters,* and afterward they join up with Duchamp, Arensberg, and Joseph Stella; they call on the Arensbergs' friend Frederick Sides, where they find Francis and Gaby Picabia; later, after leaving the others, Roché and "Tor" (Roché's abbreviation of "Totor," which was an adaptation of "Victor") spend a "beautiful night" making love to Louise Norton. After recording his own orgasms in the sexual code letters that pepper the journal, Roché writes "I help Tor"—a cryptic observation that is never explained (or repeated) anywhere else. Whatever went on in Norton's bed that night, it would not be the last time that Roché and Duchamp shared a woman.

Gabrielle Buffet-Picabia left New York in mid-September. Her tolerance for Picabia's drinking and womanizing had finally run out, and she wanted to be with her two children in Switzerland. Picabia invited Edgard Varèse to move into the ground floor apartment on West 88th Street with him. According to Louise Norton, who married Varèse a year later, "Varèse and Picabia would lie around and stalk around the apartment within a few inches, if that, of stark nakedness, thus informally receiving their feminine guests." (One frequent guest was Isadora Duncan, who "thought nothing of nudity either.") After a month of this, Picabia, who was being treated by a neurologist for "neurasthenia," the era's portmanteau term for psychic disorders, pulled himself together long enough to embark for Europe; he would never again in his long life return to the United States.

Duchamp told Roché that he was thinking about leaving New York too, but in October he took a nine-to-five job as personal secretary to a French army captain on a military mission to New York. In a note about it to Ettie Stettheimer, he said he was "going to be useful to my country after all," but that he was afraid he would no longer be worthy of her, having become a "miserable bureaucrat who abandons everything he had loved and loves in New York for two years." Although Duchamp told Ettie that his job meant he would not be giving any more French lessons, he in fact took on two new pupils that fall: Jean Acker, a glamorous film actress, and Katherine Dreier, a large, domineering woman who would become an important collector of Duchamp's work and a demanding presence in his life for the next thirty years.

It would be hard to find anyone less like Duchamp than Katherine Sophie Dreier. A decade older than he was, she had grown up in a family of wealthy German immigrants in Brooklyn, and her interests ran to volunteer social work and the spiritually uplifting powers of art. Dreier had studied art at the Brooklyn Art School and at Pratt Institute. Her own painting had evolved from Whistler-inspired landscapes to a heavy-impasto style reminiscent of Van Gogh, whose work had overwhelmed her when she saw it at the 1912 Sonderbund exhibition in Cologne. (Dreier bought a Van Gogh portrait soon afterward; a year later she loaned it to the Armory Show.) John Covert, Walter Arensberg's cousin, had invited her to become a founding director of the Society of Independent Artists in 1916, and it was at one of the society's early meetings that she first met and became fascinated by Duchamp.

Katherine Dreier voted with the majority against the inclusion of R. Mutt's *Fountain* in the 1917 Independents exhibition. She had no inkling that R. Mutt was really Duchamp, but when Duchamp resigned from the board of directors in protest, she was deeply troubled. "I feel so conscious of Duchamp's brilliancy and originality," she wrote to William Glackens, the society's president, "as well as my own limitation which cannot immediately follow him, but his absolute sincerity . . . would always make me want to listen to what he has to say. The very fact that he does not try to force his ideas on others but tries to let them develop truly along their own lines is in essence the guarantee of his real bigness." Dreier also wrote to Duchamp, urging him to reconsider his resignation and explaining her own reasons for rejecting the *Fountain*. She had voted against it, she said, because she did not see "anything pertaining to originality in it," but "that does not mean that if my attention had been drawn to what was original by those who could see it, that I could not also have seen it." To this end, she proposed that Duchamp give a lecture on his readymades at the Independents lecture hall, where Mr. Mutt's *Fountain* would be placed on view. Arensberg had suggested to her that there was a connection between the *Fountain* and the readymades, which she had seen in a group at Duchamp's studio, but Dreier still did not suspect just how close the connection was.

Although Duchamp declined to lecture or to come back on the board, Dreier's admiration of him soon developed into a full-fledged infatuation, of which she seems to have been largely unaware. Dreier had once been

married briefly to a man who turned out to have another wife from whom he was not divorced; the marriage was annulled, and she remained celibate for the rest of her life. Duchamp's understanding friendship was a balm to her spirit; he never made her feel awkward about her feelings toward him. She pressed her sister Mary to come along on her regular Tuesday night French lessons in Duchamp's studio. "It is $1.50 a person if there is more than one—$2.00 for single lessons. We are reading a very amusing French story which I am afraid will shock you, so you must be prepared . . . It is very humorous, but quite French in a naughty way." Katherine Dreier was not at all pleased to find in December that her teacher was sharing his quarters with a pretty young Frenchwoman, whom he introduced to her as his sister Magdeleine. Her suspicions were well founded. The young woman was not Magdeleine Duchamp but Madeleine Turban, a girl from Rouen who had come over a month earlier to organize a sale for the French Red Cross; mutual friends in Rouen had given her Duchamp's address, and after one or two meetings she had accepted his offer to move in with him.

Jean and Yvonne Crotti returned to New York early in January 1918, after a year's absence. They had been divorced in Paris the month before, quite amicably, and Crotti was now involved with Suzanne Duchamp, whose marriage to the pharmacist Charles Desmares had ended in 1916. Duchamp had told Crotti to look up Suzanne in Paris, where she was working as a nurse in a military hospital. The former Yvonne Crotti, who now used her maiden name, Yvonne Chastel, had been looking forward eagerly to seeing Duchamp again, and she was extremely irritated to find Madeleine Turban living in his studio. Madeleine moved out a week later. Marcel continued to see her, but he was soon sleeping with Yvonne, who also slept with Roché, who slept with several other women, although he was desperately in love with Lou Arensberg. It was very complicated, but they all

Yvonne Chastel.

managed to stay friendly and to turn up regularly at the Arensbergs', where Duchamp always seemed to be the guest of honor, even when he spent most of the evening playing chess.

Katherine Dreier commissioned Duchamp to paint a picture for her library. It had to fit into a long, narrow, rectangular space above a bookcase, and there is no telling why Duchamp agreed to do it—he had not made a painting on canvas since his 1914 *Chocolate Grinder.* It took him more than six months, working mostly on the weekends, and the result, which a good many people (including this writer) consider to be one of his three or four master-pieces, did not please him at all. Entitled *Tu m',* the painting is dominated by the cast shadows of three objects: *Bicycle Wheel, Hat Rack,* and a corkscrew that may have been going to but never did become a readymade. "I had found a sort of projector which made shadows rather well enough," he told Cabanne, "and I projected each shadow, which I traced by hand, onto the can-vas." The contours of the *3 Standard Stoppages* can be seen at the lower left and again at the right side of the picture, where they serve to link together color-ful vertical forms and circles that seem to belong in a Kandinsky abstraction. Starting at the center and receding in perspective to the upper left corner is a series of what look like diamond-shaped paint samples, which cover the spec-trum from bright yellow to pale gray. (Duchamp delegated the tedious job of painting these to Yvonne Chastel.) The first (yellow) sample is secured to the canvas by a bolt—real, not painted. Just to the right of the yellow diamond is what looks like a jagged rip in the canvas; although the rip is painted, not real, it is "closed" by two real safety pins. A real bottle brush has been inserted into the trompe l'oeil rip; it sticks out a good twenty-three inches from the paint-ing's surface. Below the rip and slightly to the left is a crudely painted hand, the index finger extended and pointing to the right. Duchamp hired a profes-sional sign painter to execute the hand, and he had the man sign his own mar-velously Duchampian name underneath: "A. Klang."

A lot of Duchamp's earlier ideas are recapitulated in *Tu m'.* There is a note in *The Green Box* in which he suggests making "a picture of cast shad-ows." Games of illusion and reality, new and personal forms of measure-ment, jokes that call into question the definition of art—all these were part of Duchamp's ongoing search for an art that moved beyond retinal effects to mental constructs, but apparently he felt that *Tu m'* did not push the search along in any useful ways. "The painting was a form of résumé," he said, "which is never a very attractive form of activity, and the fact that it was

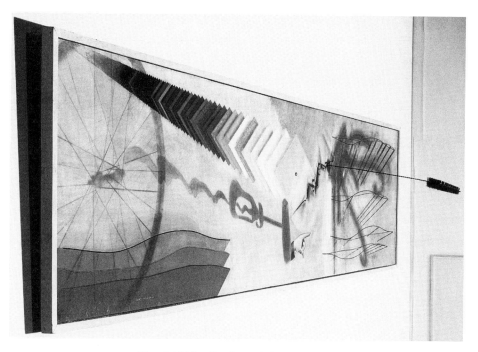

Tu m', 1918—Duchamp's last painting.

ordered to decorate a library probably didn't incite me to make something very important. I never liked that painting myself." The do-it-yourself title—the viewer is free to complete it with any French verb that begins with a vowel—is usually read as a contraction of *tu m'emmerdes,* a "very coarse verb" (according to Cassell's French dictionary) meaning "you bore me," and it may very well have summed up Duchamp's feelings at the time, not only about the painting but toward the lady who commissioned it. (In Roché's unfinished novel, *Victor,* Patricia says to Pierre: *"Tu m'emmerdes . . .* Don't be shocked. He taught me that.") Another reason suggests itself, however, for Duchamp's denigration of *Tu m'*. With all its visual puns and contradictions, this also happens to be a highly "retinal" picture—one that provides intense pleasure for its visual qualities alone. Duchamp may have decided that he was in danger of falling into the trap of art. *Tu m'*, at any rate, was the last painting on canvas that he ever made.

He felt a lot better about *Sculpture for Traveling,* a new readymade that appeared in his studio in July. Duchamp bought some rubber bathing caps in various colors, cut them into strips, glued the strips together at random

intervals, and attached the ends with long strings to nails in his studio walls, making what he described in a letter to Crotti (who had gone back to Paris by then) as "a sort of multicolored cobweb." In addition to being a soft sculpture, like the Underwood typewriter cover with a similar title (*Traveler's Folding Item*), this one had the distinction of being indeterminate in shape—"the shape could be changed at will." The new readymade may also have reflected his recent decision to leave New York. In the same letter to Crotti, he says that he "and probably Yvonne too" are going to Buenos Aires and mentions "many reasons that you already know: Nothing serious; only a sort of fatigue on the part of the A. [rensbergs]—Some ill-disposed people probably arranged things this way." (This may have been a reference to the Arensbergs' marital tensions.) Duchamp goes on to say that "Yvonne, I think, is happy to leave—for, as you've already noticed, everything here has changed, atmosphere and all. Constraints rule—I haven't worked on my glass since you came here and I have no desire to. A different country will probably allow me to have more energy."

Ettie Stettheimer, with whom Duchamp had been carrying on a chaste but lengthy flirtation, found his decision to go to Argentina quite inexplicable. "Duche expects to leave for Buenos Aires next month," she wrote in her journal in July, "but I couldn't make out why—excepting that he doesn't think he's happy here any more. He asked me to go with him 3 times! Whatever that expressed I don't know. He has no prospects nor friends down there. I told him to call on me if he got sick or penniless, but I don't believe he would. Poor little floating atom, a strange boy.—But a dear." Of the three Stettheimer sisters, Ettie was the only one who seemed to retain an interest in romantic involvements. Intellectual, witty, and inwardly sad, she was like a character in a novel by Henry James, whose style she imitated in the two novels she wrote and published during those years. Duchamp was not her only swain—she also had an extended flirtation with the French-American sculptor Elie Nadelman, but no one will ever know how far it went because in later years Ettie went through her own and her sister Florine's journals with a razor blade and cut out every intimate detail. The surviving entries that relate to Duchamp are sometimes more comic-opera than Henry James.

> At 5 little Duche came and we took tea at the Beaux Arts Cafe, a horrible place and then went up to the studio [Florine's painting studio],

where he made me go down on my knees for fun to get him to leave in time for me to dress for dinner [with Nadelman].

<div align="right">(June 30, 1918)</div>

Duche was here ... We lunched at Henri's, went shopping for a tortoise shell ring which he wanted to give me and which doesn't exist so he gave me a little gold band, really a guard ring and scratched something on it. I told him to send me a decent one when he made his fortune in South America ... Yesterday Gleizes spent the day trying to moralize tactfully to Duche and talking about him to me, and M. Barzun, a literary journalist over here on a mission, whom Duche wanted me to meet, God knows why, did the same, but both seemed more influenced than influencing ... D. leaves Saturday.

<div align="right">(August 5, 1918)</div>

Did "Duche" really want Ettie to go with him to Argentina? It seems unlikely in view of his already announced intention to take Yvonne Chastel. In his occasional letters to Ettie and her sisters in this period, Duchamp adopts a courtly, somewhat arch tone that reflects his exaggerated and amused respect for all three of them. "Are you coming to N.Y. this week?" he asks in a letter to the "Three Friends" at their current summer home in Bedford Hills, adding, "I would love to have you to dinner, or lunch according to your preference." On one of his weekend visits to Bedford Hills that summer, he brought out a meticulously drawn replica in miniature (about two by three inches) of his *Nude Descending a Staircase,* to hang in the elaborately furnished dollhouse that had become Carrie Stettheimer's rather surprising life work. Like most of their friends, Duchamp probably thought of the Stettheimer sisters as a triumvirate, inseparable and above reproach.

In preparation for his departure, Duchamp moved the two halves of *The Large Glass* from his studio to a storage closet in the Arensbergs' apartment. He had given away or sold most of his other works, including *9 Malic Moulds.* This important study—the first on glass—had been inadvertently shattered three years earlier, when a chair that it had been propped against in the Arensberg apartment rolled away and it fell flat on the floor; Duchamp had painstakingly reassembled the broken pieces and clamped

them between two sheets of plate glass in a wooden frame. Henri-Pierre Roché admired the work so extravagantly, cracks and all, that Duchamp made him a present of it early in 1918. Roché left New York in the spring, when he was transferred to the French Mission in Washington, D.C., but he came up on the train as often as he could manage, primarily to see Lou Arensberg. In August Duchamp wrote to say that he was leaving some things for him on the balcony at the Arensbergs': a painting by Louis Eilshemius, some unsold copies of *The Blind Man,* and several drawings by Beatrice Wood. "Good bye dear," Duchamp wrote (in English), adding, in French, "see you in two year's time, at least." He also wrote a note to Picabia, who was recovering from a nervous breakdown in the Swiss resort spa of Bex, comfortably ensconced in a hotel suite with his wife, his children, and Germaine Everling, his new mistress. Duchamp urged Picabia to come to Argentina, saying, "I would very much like to play chess with you again . . . The advantage is that it's far away."

Just before leaving for Argentina, Duchamp did this sketch for Florine Stettheimer.

The French film director Léonce Perret was shooting a war movie in New York that summer, called *Lafayette! We Come!* Duchamp was hired as an extra for a single scene, in which he played one of a group of blinded soldiers being read to by the film's female star, Dolores Cassinelli. The next day Duchamp and Yvonne Chastel boarded the SS *Crofton Hall,* a small, slow steamer that would take twenty-seven days to reach Buenos Aires. "I have a very vague intention of staying down there a long time," he had written to Jean Crotti; "several years very likely—which is to say basically breaking completely with this part of the world."

Buenos Aires

The curious thing about that
moustache and goatee is that when
you look at the *Mona Lisa* it becomes
a . . . real man.

The war was ending in a final bloodbath on the Western front. German advances during the spring of 1918 had been turned back by a vast Allied counteroffensive that broke the morale of Ludendorff's exhausted armies, and in late September the first peace feelers went out. German resistance was collapsing in many sectors when, on September 19, the SS *Crofton Hall* made its way up the broad Río de la Plata to Buenos Aires.

It had been a calm, leisurely voyage. "I only have light in the evening in a very hot and stuffy smoking room on account of the submarines," Duchamp had told the Arensbergs in a letter mailed from shipboard when they docked at Barbados. "I am working on my papers, which I am putting in order . . . No seasickness yet." No sign of German submarines either, although soon after leaving New York he had heard that an oil tanker had been sunk within a few miles of them, off Atlantic City. "Delightful voyage," Duchamp wrote to the Stettheimer sisters. "The boat is slow and gentle."

Why he chose Argentina as a refuge (rather than Spain or Switzerland) has never been clear. He did not speak Spanish, and he had no friends in that part of the world. Duchamp once told an interviewer that the parents of one of his Paris friends ran a brothel in Buenos Aires, but that seems to have been an invention. "I do not go to New York I leave Paris," he had written to

Walter Pach in 1915. Now, three years later, Argentina seemed to be an anti-
dote to New York, with its recruiting stations on every corner and its mount-
ing wartime restrictions; he was escaping once again from the patriotic
pressures that were not easy for a young man to ignore in those days, espe-
cially if he had two older brothers in active service. Jacques Villon, after
being in the front lines for nearly a year, had been transferred to the relative
safety of a camouflage unit near Paris. Raymond Duchamp-Villon could
have been excused from military service because of the rheumatic fever that
caused him to give up medical school, but he had enlisted as soon as war was
declared and had been assigned as a medical underofficer in the 11th Regi-
ment of Cuirassiers (cavalry). He was soon transferred from a military hos-
pital outside Paris to the front near Champagne, where, after more than a
year of hazardous duty, he came down with typhoid fever late in 1916. Only
partially recovered, he picked up a virulent streptococcus infection from a
wounded soldier he was treating. Severe blood poisoning set in. Raymond
spent more than a year in a hospital in Cannes, undergoing many operations
to drain the abscesses that kept cropping up in different parts of his body. He
became progressively weaker and died on October 7, 1918, while being oper-
ated on for the eighteenth time. Duchamp had been in Buenos Aires for less
than three weeks when he got the terrible news by transatlantic cable from
his sister Suzanne. "Tell Suzanne my despair at being so far from everyone
in such circumstances," he said in a strangely wooden postcript to a letter to
Jean Crotti that he had written before he heard the news but had not yet
mailed. "I cannot believe it, so much the less since I have not seen him for
such a long time and he was in good health then. I do hope the family bears
up!!!"

 Raymond's death a month before the armistice was signed received
only brief and perfunctory mention in Duchamp's letters from Argentina.
He extended his sympathy to Walter Pach, whose "deep friendship and
admiration" for his brother would cause him to "suffer more grief than any-
one else," but his own grief found no outlet. The emotional deadness that
Beatrice Wood had observed in Duchamp did not make him immune to
personal tragedy; his way of dealing with it seemed, however, as inadequate
as his response to the vast conflagration that changed forever the world he
had been born into. It was not really possible to confront "with folded
arms," as he had said, a war that decimated his own generation of French-
men. By doing so (trying to, anyway), Duchamp isolated himself from the

life of his time, but that course, as it turned out, would prove to be in keeping with his own long-term trajectory.

Although the war was virtually over, Duchamp saw no point in returning to France right away. He and Yvonne Chastel rented a small apartment in a nondescript section of Buenos Aires and set about exploring a city whose social and cultural structures were still firmly grounded in the nineteenth century. Yvonne was put off by the Argentinian *machismo;* since the only women to be seen in the nightclubs were third-rate hookers, Duchamp wrote to Crotti, "Yvonne finds herself deprived of her night life." Argentina's male-dominated society proved equally upsetting to Katherine Dreier, who turned up in Buenos Aires a week or so after Marcel and Yvonne. Dreier had come to write a series of articles on the situation of women in Argentina, a subject that apparently suggested itself to her only when Duchamp decided to go there. Her research efforts were complicated, as Duchamp put it in a letter to Walter Arensberg, because "Buenos Aires does not admit women on their own—it's senseless, the insolence and stupidity of the men here." On the other hand, as he noted in the same letter, "There really is the scent of peace, which is wonderful to breathe, and a provincial tranquillity, which allows and even forces me to work."

Duchamp worked in a room of his own at 1507 Sarmiento, a few blocks from the apartment he shared with Yvonne Chastel at 1743 Alsina. He had brought all his notes for the *Glass,* which remained the central focus of his thinking. "I have started a small glass in order to see an effect that I will transfer to *The Large Glass* when I return to New York," he wrote Crotti in October. Duchamp had also decided, within a month of his arrival, to introduce Buenos Aireans ("awaken these sleepy dark faces") to modern art by organizing an exhibition of Cubist painting. He wrote to a French friend in New York, Henri-Martin Barzun, asking him to send down about thirty Cubist pictures on consignment, and he told Crotti in Paris to mail him some literature on the subject: Apollinaire's book *The Cubist Painters,* Gleizes and Metzinger's *On Cubism,* copies of avant-garde magazines such as *Les Soirées de Paris,* and also four or five copies of Mallarmé's poem "Un Coup de dés jamais n'abolira le hasard." "I myself will exhibit nothing," he wrote to Arensberg, "according to my principles." What principles? Evidently he had discussed them with Arensberg, for as he went on to say in the same letter, "It is agreed . . . that you exhibit nothing of mine, if you want to please me, in the event that you are asked to lend something in New York."

The whole idea of showing and selling his own work had become repug-
nant to Duchamp, but apparently this did not interfere with his willingness
to show and presumably to profit from the sale of works by other artists. In
any event, Barzun let him down—he did nothing about Duchamp's request
for a shipment of pictures, and the plan to "cubify" Buenos Aires fell
through. "Buenos Aires does not exist," Duchamp wrote to Ettie Stett-
heimer a few weeks before Christmas. "Nothing but a large provincial
town with very rich people without any taste, everything bought in Europe,
the stone for their houses included. Nothing is made here . . . I have found
French toothpaste that I had completely forgotten about in New York."
Nevertheless, he added, "I am basically very happy to have found this
entirely different life . . . where one finds pleasure in working."

The pleasures of work were becoming overshadowed, however, by his
increasing obsession with the game of chess. Duchamp had played a lot of
chess in New York, at the Arensbergs' and also at the Marshall Chess
Club, which he joined in 1916. "It was down near Washington Square
then, and I spent quite a number of nights playing there until three in the
morning, then going back uptown on the elevated," he said. "That's prob-
ably where I picked up the idea that I could play a serious game of chess."
In Buenos Aires he had no one to play with at first, so he combed the book-
stores for chess literature. He clipped from chess magazines forty games
by José Raúl Capablanca, the great Cuban world champion, so that he
could study them. By the spring of 1919 he had joined a local chess club
and was taking lessons from its best player. "I play chess all the time," he
wrote to Walter Arensberg. "I have joined the club here where there are
very strong players classed in categories. I still have not had the honor of
being classified, and I play with various players of the second and third
categories losing and winning from time to time." He had a set of rubber
stamps made up so that he could play correspondence chess with Walter
Arensberg. He even designed a set of wooden chessmen that he carved
himself, all except the knight, which he farmed out to a local craftsman. In
May he wrote to the Stettheimers that painting interested him less and
less: "I play [chess] day and night and nothing interests me more than to
find the right move."

Duchamp's addiction to chess could be seen as another of those retreats
into a private world that Gabrielle Buffet-Picabia had noted several years
earlier—a retreat made necessary this time, perhaps, by the news of his

brother's death. For Duchamp, however, chess was much more than a retreat or a refuge; it was a near-perfect expression of the Cartesian side of his nature, which, like every Frenchman of his class and education, he had acquired as a matter of course. Although he once said that he had "never read Descartes, to speak of," Duchamp admitted to being "very much of a Cartesian." Cartesian doubt lay behind his habit of questioning every previous definition of art, so that, as he put it, "doubting everything, I had to find something that gave me no doubt because it didn't exist before. All along, I had that search for what I had not thought of before." In his pursuit of absolute originality and absolute freedom, he had rejected Cartesian logic, turning instead to Raymond Roussel, Alfred Jarry, and other antirationalists. But rejection was not the same as renunciation. Duchamp's working methods were marked by an almost mathematical precision, and one of the things he loved about chess was that its most brilliant innovations took place within a framework of strict and unbendable rules. "Chess is a marvelous piece of Cartesianism," he once told me, "and so imaginative that it doesn't even look Cartesian at first. The beautiful combinations that chess players invent—you don't see them coming, but afterward there is no mystery—it's a pure logical conclusion. The attitude in art is completely different, of course; probably it pleased me to oppose one attitude to the other, as a form of completeness." But Duchamp came to believe that art and chess were much closer than they seemed. In a brief address to the New York State Chess Association convention in 1952, in which he described the game as having a visual and imaginative beauty that was akin to the beauty of poetry, he ended his remarks by saying, "From my close contact with artists and chess players, I have come to the personal conclusion that while all artists are not chess players, all chess players are artists."

In Buenos Aires his chess-playing eventually became such a bore for Yvonne that she packed up and went back to France. "I insisted that she not leave," Duchamp wrote to Crotti. "But her little will power and my desire not to counteract any sort of whim, resulted in her deciding to go." Over the next ten years they would continue to see each other (and even to sleep together occasionally) until Yvonne married an Englishman and moved to London. She had a son by this marriage, Peter Lyon, who met Duchamp a number of times when he was growing up. "My mother didn't talk about him much," Lyon recalls, "but I always had the feeling that Marcel was *the* man in her life."

Katherine Dreier sailed back to New York in April 1919, carrying a sulfur-crested cockatoo named Koko and two works that comprised virtually the full extent of Duchamp's artistic activity in Argentina. One of these was a minor optical experiment called *Stéréoscopie à la main* (*Hand Stereoscopy*), a pair of photographs of a seascape on which Duchamp had drawn identical pyramid-shaped polyhedrons; when the photographs are looked at through a stereoscope, the pyramid appears to be floating on the water. The other work was the study on glass that he had started soon after his arrival. It was for the Oculist Witnesses section of *The Large Glass*—the area at the lower right, where the bachelors' splash is "dazzled" upward into the bride's domain. In this study Duchamp experimented with the laborious technique of silver scratching, in which he applied a mercury ground to the surface, then scratched it away around the forms he wanted. We can see the ends of the Scissors element of the bachelor apparatus and also one of the three oculist's charts for testing eyesight that would later appear in the *Glass*. But the study also includes several other elements that play no part in the larger work: a pointed vertical column that appears to support a round magnifying glass, which is in fact a real magnifying glass glued to the surface, and above that a large irregular pyramid formed by thin red, green, and yellow horizontal lines. The result is an independent and enigmatic work on which he conferred an enigmatic title: *To Be Looked at* (*from the Other Side of the Glass*) *with One Eye, Close to, for Almost an Hour.* Although Dreier may not have caught all the implications here— the viewer turned into a voyeur, peeping through a lens at the spectacle of a bride being stripped bare—she disliked the title so much that she changed it. Duchamp never accepted the title (*Disturbed Balance*) that his autocratic patron gave to the little glass, but he did not complain about it. Complaining was against his principles.

Only one readymade dates from Duchamp's stay in Buenos Aires. As a wedding present for his sister Suzanne and his close friend Jean Crotti, who were married in Paris on April 14, 1919, Duchamp instructed the couple by letter to hang a geometry book by strings on the balcony of their apartment so that the wind could "go through the book, choose its own problems, turn and tear out the pages." This *Unhappy Readymade,* as he called it, might strike some newlyweds as an oddly cheerless wedding gift, but Suzanne and Jean carried out Duchamp's instructions in good spirit; they took a photograph of the open book dangling in midair (the only existing record of the

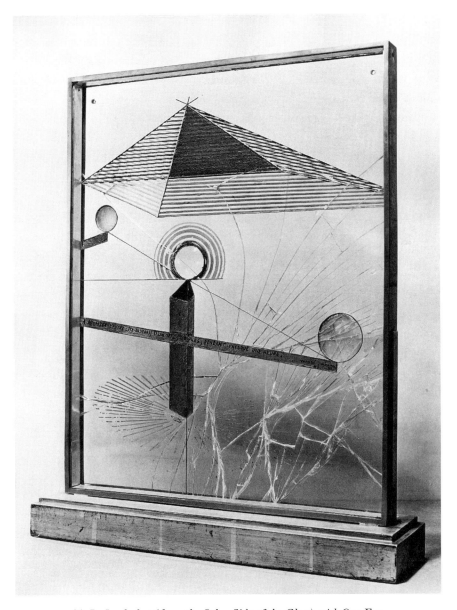

To Be Looked at (from the Other Side of the Glass) with One Eye,
Close to, for Almost an Hour, 1918.

work, which did not survive its exposure to the elements), and Suzanne
later painted a picture of it called *Le Readymade malheureux de Marcel*. As
Duchamp later told Cabanne, "It amused me to bring the idea of happy and
unhappy into readymades, and then the rain, the wind, the pages flying, it
was an amusing idea." Duchamp told one interviewer in later years that he

had liked disparaging "the seriousness of a book full of principles," and suggested to another that, in its exposure to the weather, "the treatise seriously got the facts of life."

Toward the end of his stay in Buenos Aires, Duchamp's interest in chess became all-consuming. "I feel I am quite ready to become a chess maniac," he wrote to Arensberg. "Everything around me takes the shape of the Knight or the Queen, and the exterior world has no other interest for me other than in its transformation to winning or losing positions." His chess mania may explain his failure to make contact with Mina Loy, who was in Buenos Aires for a month or more that spring. Mina Loy had followed Arthur Cravan to Mexico, where he had gone to avoid being drafted for military service in the United States. They were married in Mexico City. Cravan had taken up prizefighting again, but he earned little or no money from his losing matches, and when Mina's funds ran out they decided to try their luck in Buenos Aires. Cravan acquired an ancient sailboat, which he repaired and refitted himself. His plan was to exchange it for a bigger and more seaworthy craft, but when he took it out for a trial, he and the little boat disappeared over the horizon and were never seen again. Mina, pregnant with their child and nearly out of her mind with anxiety, waited for several days on the beach in the Pacific coast village of Salina Cruz, where they had been staying, until some American friends managed to get her on a steamship to Valparaiso. From there she traveled overland to Buenos Aires, where she remained for a month or so, hoping desperately for news of Cravan. Eventually she went home to England. The mystery of Cravan's disappearance was never solved. In spite of persistent rumors of his survival under another name (the writer B. Traven, for example), the likeliest explanation is that he drowned at sea.

Duchamp booked passage in June 1919 on the SS *Highland Pride,* an English boat bound for Southampton and Le Havre. He planned to stay only a few months in France and then go back to New York. "I dread very much my return to Puteaux, where poor Raymond will be missing," he wrote to Walter Pach. "It is an awful thing that one realizes with greater and greater precision as the simple event recedes in time." After nearly a month on the ocean and three days in London, he went directly to his parents' apartment in Rouen. His younger sisters thought he looked terribly thin, and they disliked his very short haircut—he had shaved his head in Buenos Aires to counteract what he and Yvonne Chastel diagnosed as a scalp condition that

was causing him to lose his hair. He had been away from France for exactly four years.

Paris, when he went there in August, seemed to him relatively unchanged. The same people lived in the same apartments "with the same dust," he said, although this observation hardly applied to his old friend Francis Picabia. Picabia and his mistress, Germaine Everling, were living on the boulevard Emile Augier, on the Right Bank, while Gabrielle and the three children stayed in the large Left Bank apartment on the avenue Charles

Duchamp with his hair shaved, Paris, 1921.

Floquet, near the Champ de Mars. Both women were pregnant by Francis— Gabrielle in her eighth month, Germaine due in January. Gabrielle seemed to accept the new domestic situation in her unflappable style, refusing to be crushed by her mercurial husband's latest defection. Since Duchamp had no place of his own in Paris, she invited him to stay with her as long as he liked; he promptly moved in, and he was still there a month later when, at three-thirty in the morning, Gabrielle gave birth to her fourth child. Picabia and Germaine came over a little later to see the baby boy, then went off together to register his birth at the *mairie*.

The Paris art scene was reviving slowly, but the war had left deep and bitter rifts between the generations. While two million Frenchmen were being slaughtered on the battlefields, most of the established literary figures had been content to echo the mindless patriotic chauvinism of the official war machine. For a brief period the younger artists and writers who were not yet in uniform had rallied around Guillaume Apollinaire, who was invalided out of the army with a severe head wound in mid-1916—his helmet had been pierced by shrapnel while he was sitting in a trench reading the latest issue of *Mercure de France*. His reappearance at the Café de Flore, wearing his uniform and a spectacular bandage around his large head, had given new heart to a group that included André Breton, Paul Dermée, and several others who would play important roles in the postwar avant-garde.

But Apollinaire never fully recovered from his head wound. Although he resumed his somewhat frenetic activities as a writer and editor and even published a new book of poems called *Calligrammes,* his friends felt that his old iconoclasm had been overtaken by a more conservative spirit and that he seemed more interested in being awarded the Legion of Honor than in breaking new ground esthetically. His health began to deteriorate in 1918. When a flu epidemic hit Paris that fall, he caught it and died five days later, on November 9, just two days before the armistice was signed. Apollinaire's death came as a shocking blow to all those who had shared the heady excitement of what he called "the new spirit" in the arts. It was a spirit that he evoked movingly in the last poem in *Calligrammes,* "La Jolie Rousse":

> *Be indulgent when you compare us*
> *To those who were the perfection of order*
> *We who look for adventure everywhere*
>
> *We're not your enemies*
> *We want to give you vast and strange domains*
> *Where mystery in flower spreads out for those who would pluck it . . .*
> *Pity us who fight always at the boundaries*
> *Of infinity and the future*
> *Pity our errors pity our sins . . .*

Picabia was far too nihilistic to assume Apollinaire's role as avant-garde spokesman and impresario, but his destructive energy had never been at a higher pitch. He was already working to bring the Dada movement to Paris, where it would achieve its most spectacular flowering. While recovering from his nervous breakdown at the Swiss resort spa of Bex, Picabia had been in frequent contact by mail with Tristan Tzara, who had taken over all Dada activities in Zurich. (Richard Huelsenbeck, Tzara's main rival as organizer and polemicist, had gone back to Berlin in 1918.) "Long live Picabia, the antipainter from New York!" Tzara proclaimed in the third issue of his review, *Dada 3,* which featured several Picabia poems and machine drawings. Early in 1919 Picabia and Gabrielle went to Zurich to meet Tzara. They stayed for three weeks, during which Tzara helped them produce a scintillating new issue of Picabia's magazine, *391,* and Picabia designed the cover for the combined fourth and fifth number of *Dada,* en-

titled *Anthologie Dada.* Picabia urged Tzara to come to Paris, but a year would pass before Tzara felt ready to do so.

Picabia's machine paintings, which had never been shown in Paris, created a noisy scandal at the 1919 Salon d'Automne, the first of the big national salon exhibitions since the wartime shutdown in 1914. The hanging committee tried to hide them away in an alcove under the staircase at the Grand Palais, but the critics heaped abuse on them anyway. The artist struck back at everybody in *391,* whose November issue carried an incendiary article that vilified Matisse, Marshal Foch, and France itself. (The article was actually written by Georges Ribemont-Dessaignes, a painter and writer whom Picabia had installed as *391*'s editor.)

Although Duchamp did not exhibit anything of his own at the Salon d'Automne, in line with his new principles, he and Jacques Villon got together nineteen of their brother Raymond's works for a Duchamp-Villon memorial that became one of the salon's highlights. It was already evident to many critics and artists that Duchamp-Villon's death at the age of forty-two had cut short a career of tremendous promise. Going beyond Rodin, whose influence on the art of sculpture was so immense that it had tended to inhibit further developments, Duchamp-Villon rivaled Brancusi in his ability to fuse tradition and innovation. He had found the means to suggest movement in his powerful forms—real movement, not the static representation of it that his younger brother had been after with his *Nude Descending a Staircase*—and in his breakthrough work, the 1914 *Horse,* he had brought the Cubist concept of simultaneity to sculpture. With its interplay of organic and mechanical forms, its sense of coiled movement and contained power, Duchamp-Villon's *Horse* transformed the nineteenth-century tradition of the equestrian monument into one of the sculptural icons of the twentieth century. Walter Pach brought Henri Matisse out to Duchamp-Villon's studio in Puteaux in 1914 to see the plaster maquette. "It's a projectile," Matisse said admiringly as he walked around it. Duchamp-Villon didn't agree—a projectile implied a single line of flight, whereas what he had in mind were the many complex rhythms of a horse's gait, the passage of time, and the metamorphosis of horse into machine as a symbol of the modern age and the Bergsonian *élan vital.*

With his synthesizing intelligence and his mastery of sculptural form, Duchamp-Villon seemed destined to become a very great artist. In the last months of his life, wracked by pain and exhaustion, he modeled a small

Raymond Duchamp-
Villon. *The Horse*,
1914.

head of his doctor that was unlike anything he had done before—it gave off the frightening emanation of a tribal fetish. "I have a clearer and surer vision of the road passed over and of the road to go over," he had written in 1916 to his American patron, John Quinn. "And it is restful to see that, without being satisfied in anything, I have nevertheless nothing to regret."

Henri-Pierre Roché, newly arrived from New York, showed up at Gabrielle Buffet-Picabia's apartment one day in the fall of 1919. He and Duchamp had not seen each other for more than a year. Roché thought Duchamp looked "a little tubercular," what with his loss of weight and his shaved head, but he also found him more "ripened" than before. The two friends quickly resumed their old camaraderie, and Roché was called on to help entertain Katherine Dreier, who after visiting her relatives in Germany had arrived in Paris for a stay of several weeks. (A month earlier Duchamp had met her boat in Rotterdam and helped her get a German visa.) They took her around to art galleries and theaters, to lunches and dinners at Lapérouse and other famous restaurants (paid for by Dreier, we may

assume), and Roché even arranged for her to meet Gertrude Stein. Roché described the meeting in his journal as "the shock of two heavy masses and Gertrude carried the day easily. Miss Dreier seemed frail by comparison." When an elderly American lady who was also present at Stein's rue de Fleurus apartment that afternoon made an anti-German remark, Dreier said, "I've been to Germany, and they're suffering there." "I hope so, the beasts," the lady replied, which shut Dreier up. Duchamp and Miss Dreier were also invited to a memorable dinner party at Brancusi's studio on the impasse Ronsin, to which Roché brought the composer Erik Satie, who was just entering upon his second career as the eccentric *maître* to the group of young French musicians who called themselves "Les Six." Brancusi and Satie had not met until that evening, and for a while their mutual shyness kept them from having much to say to each other, but later on, lulled by Brancusi's marvelous cooking (he had prepared goose and cabbage, Romanian peasant style) and by a lot of wine, they told each other stories about their past lives and became fast friends.

For Miss Dreier, though, the high point of her stay was being taken by Duchamp to meet his parents in Rouen. "They were all kindness themselves," as she later wrote, "and it was interesting to have so intimate a glimpse into a French family life." Dreier found Eugène Duchamp "tremendously alive at 71" and looking "like a very busy alive little bird with eyes like fire," but she decided that Marcel's originality must have come from his mother, Lucie, "who is very deaf and sits like an Eastern god—withdrawn, yet there. Absolutely part of the group although she can hear nothing." A few days after their visit to Rouen, Duchamp took Dreier out to Puteaux, where they spent a pleasant day with Jacques and Gaby Villon. Roché, who for some strange reason did not know Villon, came along too and was charmed by the house, the garden, the views of Paris, and Villon's recent paintings. When they went for a walk, Roché noticed that Dreier kept taking Duchamp's arm and that Duchamp kept disengaging it with a hint of irritation. Just what was going on, he wondered, between Marcel and this large blond American woman who sometimes appeared simple and naive but who could also be suspicious, stubborn, and "Boche"?

Duchamp's relationships with women were of continuing interest to Roché, who devoted so much of his own time and energy to sexual liaisons. Roché sought out love triangles—usually with two women, although sometimes with a woman and another man, as in his novel *Jules and Jim*—and

there are indications that he and Duchamp were both sleeping with Yvonne Chastel in Paris. (Since her return from Argentina, Yvonne had been living in Suzanne Duchamp's apartment at 22, rue la Condamine; Suzanne had moved out of it when she married Yvonne's ex-husband, Jean Crotti.) Roché's near-infatuation with Duchamp did not exceed the parameters of his own heterosexual bias, and he knew his friend well enough not to expect real intimacy in return. Large areas of Duchamp's private life would always remain private. Duchamp did not mention to Roché or anyone else the shock of his recent meeting with Jeanne Serre, the married woman with whom he had had his first serious love affair, in 1910, when they lived across the street from each other in Neuilly. They met by chance on the steps of a Métro station—Duchamp was walking down, she was walking up—and as they paused briefly to chat, Jeanne indicated, with a subtle yet unmistakable inclination of her head, that the pretty, well-dressed eight-year-old girl whose hand she held was Duchamp's child. Nothing was said about it then or later. Jeanne had remarried, and her second husband, a financier named Henry Mayer, was raising the girl as his own. What Jeanne managed to convey without words was that nothing was being asked or expected of him, and Duchamp did nothing. More than forty years would go by, in fact, before he saw his daughter again.

Duchamp was eager to get back to New York. He had told Walter Arensberg and other New York friends that he planned to spend only a short time in Paris, and nothing he saw there tempted him to change his mind. He booked passage on a ship that was due to sail at the end of December. Before leaving, though, he suddenly produced three new works. One took the form of an oversized bank check to his dentist, Daniel Tzanck, and it does not really qualify as a readymade because every mark on it was made by Duchamp. About twice as large as the average personal check, it is drawn on "The Teeth's Loan and Trust Company, Consolidated, 2 Wall Street, New York," in the amount of $115, and although the lettering looks printed, it is in fact hand-drawn except for the background pattern—"theteeth's-loanandtrustcompanyconsolidated" repeated over and over in red ink—which he applied with a rubber stamp. Tzanck was delighted to accept this sly joke on the commercial value of an artist's signature. (If the artist's name confers value on a drawing, why shouldn't he "draw" his checks as well?) An enthusiastic collector of modern art, the dentist had many artists and poets as patients because of his willingness to take their work in lieu of payment.

Some years later Duchamp bought the check back from him for 1,000 francs, which was a bit more than $115, and the *Tzanck Check*, as it is now known, became one more item in the slowly accumulating Duchamp oeuvre.

One day that fall, Duchamp bought, on the rue de Rivoli, a cheap postcard reproduction of the *Mona Lisa*. There was no reason, after all, why the most famous image in Western art should not become an "assisted" readymade. Duchamp accomplished this by giving the lady a black-penciled mustache (with rakishly upturned points) and a neat small goatee, and adding at the bottom, in large capitals, the letters *L.H.O.O.Q.* Meaningless in them-

L.H.O.O.Q., 1919.

selves, the letters, when read aloud in French, make the sound of *"elle a chaud au cul"* ("she has a hot ass.") The joke here is a lot cruder than the one in *Tzanck Check*, and its repercussions have not yet died down. With one stroke of his magic wand, Duchamp had pulled off the supreme Dada gesture. What could better signal a generation's revolt against tradition, Western civilization, and the cult of the old master-piece?

Ironically enough, *L.H.O.O.Q.* also set in motion a vast critical apparatus that would eventually discover many close affinities between Duchamp and Leonardo da Vinci. That most elusive and mysterious of Renaissance masters was enjoying a tremendous vogue in 1919, which happened to be the four hundredth anniversary of his death. According to Roger Shattuck, "no other human being, historical or imaginary, appears to have received so much systematic and such widely disseminated attention from Western culture" during those years. Gabriel d'Annunzio hailed his universal genius; Paul Valéry paid homage to him as a thinker who resolved the conflict between intelligence and emotion; Sigmund Freud analyzed his neuroses (including his supposed homosexuality); and the deluge of

books, papers, and scholarly treatises has continued to this day. There are a number of obvious parallels to be found in the mental preoccupations of Leonardo and Duchamp. Both of them were interested in mathematical systems, in optical phenomena and the science of perspective, in rotating mechanisms, and in the use of chance as a spur to the imagination, and they also shared a belief that art should not be just a visual or "retinal" experience but rather *"una cosa mentale,"* in Leonardo's famous phrase: a thing of the mind.

The trouble with these comparisons is that they tend to obscure the vast gulf that lies between the two artists and their respective centuries. Leonardo, needless to say, would not have given us anything remotely like *L.H.O.O.Q.,* an act of derision and a deliberately childish one at that. "It was using what they do on posters," Duchamp said once, "blackening the teeth and things like that. More or less a chapter of graffiti. The *Gioconda* was so universally known and admired, it was very tempting to use it for scandal." Since its theft from and return to the Louvre (the theft for which Apollinaire had spent a week in jail in 1911 as a prime suspect), the *Mona Lisa* had become doubly famous, notorious even, and it was therefore the perfect target for a dadaist provocation, but Duchamp's act also revealed something new about the famous picture. "The curious thing about that moustache and goatee is that when you look at the *Mona Lisa* it becomes a man," he said. "It is not a woman disguised as a man; it is a real man, and that was my discovery, without realizing it at the time." *L.H.O.O.Q.* thus functioned as another move in the confusion-of-gender game that Duchamp liked to play and that would lead him soon enough to add a female identity to his complex persona.

50 cc of Paris Air, 1919.

Duchamp spent Christmas with his family in Rouen. Two days later he left for Le Havre to board the SS *Touraine,* which was due to sail on the evening of December 27, but before leaving he visited a pharmacy on the rue Blomet, not far from Gaby Picabia's apartment. In those days liquid medicines and serums were often sold in sealed glass ampoules with gracefully curved necks. Duchamp had the pharmacist break the seal on a rather large (five inches high) bell-shaped ampule, pour out the liquid, and then reseal it. This would be Duchamp's present to Walter and Louise Arensberg. Since they had everything else, as he later explained, he was bringing them fifty cubic centimeters of *Paris Air.*

Enter Rose Sélavy

> Much better than to change religion
> would be to change sex.

I n spite of the few changes New York is still the same old New York," Duchamp wrote to John Quinn soon after his return. "Paris seemed dull to me during the few months I was in France." Many of the New York galleries that showed modern art had closed during the war, however, and the Arensbergs no longer kept open house for the avant-garde. Bad investments and slipshod bookkeeping (which included many unrepaid loans to artist friends) had severely eroded Walter Arensberg's working capital; instead of buying art, he devoted more time than ever to his arcane cryptographic studies whose goal was to prove that Shakespeare's plays had been written by Francis Bacon. America, moreover, was about to embark on a major and highly disruptive social experiment: the 18th Amendment (prohibition) would go into effect on January 17, 1920, just eleven days after Duchamp's arrival. A month later Duchamp wrote to Yvonne Chastel, "One doesn't drink here any more and it's quiet, too quiet."

He rented a ground floor apartment in a gloomy brownstone at 246 West 73rd Street, rejoined the Marshall Chess Club, and found some new pupils for private lessons in French. Although the Arensberg circle had largely dispersed, he saw Walter and Lou whenever they were in town— that winter they made the first of several extended trips to California. Beatrice Wood was back in New York, living on the edge of poverty with the Belgian theater manager she had married in Canada, mainly to escape the influence of her domineering mother. After going through her modest

dowry, her husband had managed, to Beatrice's horror, to borrow four thousand dollars from the Arensbergs. She did not talk about her miserable marriage when Duchamp took her out for dinner, but she felt that somehow he understood what she was going through. Gabrielle Buffet-Picabia came to New York toward the end of February, and Duchamp repaid her hospitality to him in Paris by putting her up at his apartment. Abandoned by Picabia, who would eventually divorce her to marry Germaine Everling, Gabrielle had come over on a business venture, to sell some dresses designed by the couturier Paul Poiret's sister. Toward the end of her life, Gabrielle indicated that she and Duchamp finally became lovers during the three months she stayed in New York, and that their physical relationship continued for the next three years.

Nobody was happier about Duchamp's return to New York than Katherine Dreier. Only just back from her own extended trip to Europe, where she visited museums, galleries, and artists' studios, Dreier had decided to take the momentous step of establishing a modern art museum in New York. She would use her own collection as the nucleus, and naturally she counted on Duchamp to help her with it. When she summoned him to her apartment in March to discuss the project, Duchamp brought along his friend Man Ray, whose presence, he thought, might help to counterbalance Dreier's heavy-duty evangelism—she truly believed in art's spiritual mission to improve the human race. What Dreier had in mind was not a conventional museum but an educational center, a nonprofit organization that would advance the serious study of modern art through exhibitions, lectures, publications, and loans to other museums. At that first meeting, Man Ray came up with the name for it. He had seen the words "*société anonyme*" in a French magazine and, knowing little French, had assumed that they referred to some sort of anonymous society. Duchamp explained that this was simply the French equivalent to "incorporated," but he thought it sounded like a fine name for a modern museum, and Dreier, who had originally planned to call her brainchild "The Modern Ark—A Private Museum," surprised both her collaborators by agreeing with him. Later, when the legal papers were being drawn up, the New York secretary of state's office added "Inc." to the title, so the project became, with dadaistic redundance, Société Anonyme, Inc.

Propelled by Katherine Dreier's organizational drive, the project went forward rapidly. Officers were named: Duchamp as president, Dreier as

treasurer, Man Ray as secretary. They rented a suite of rooms on the top floor of a brownstone house at 19 East 47th Street, and Duchamp took charge of renovating them; he had the moldings stripped off, lined the walls with white oilcloth, and turned a large closet into a reference library for art books and periodicals. Man Ray did the lighting and also the five-foot-long banner that hung down over 47th Street. As its logo, the Société adopted the image of a chess knight that Duchamp had designed in Buenos Aires for his portable chess set; the knight looked a bit like a laughing ass, but Katherine Dreier went along with that too—she was working hard at being light-hearted. In a newspaper interview that he gave to promote the Société Anonyme, Duchamp emphasized the need for levity. "People took modern art very seriously when it first reached America because they believed we took ourselves very seriously," he said. "A great deal of modern art is meant to be amusing." If Americans would simply remember their own "far-famed . . . sense of humor when they see our pictures," he added, and think for themselves instead of listening to the critics, "modern art will come into its own." This optimistic advice, which would have struck the Puteaux Cubists as frivolous and the Zurich dadas as sentimental, was a fairly shrewd appeal to the kind of American independence and open-mindedness that the Société's founders looked to as the key to reviving America's interest in modern art. That interest had virtually petered out in the years since the Armory Show, but Dreier was determined to bring it back to life.

The Société Anonyme's first exhibition, a small survey of modern art from Van Gogh to Brancusi, opened on April 30, 1920. The admission fee was twenty-five cents (Duchamp had suggested making it fifty cents for critics), and there were not many visitors, but Dreier and Duchamp pressed ahead with their plans for a new exhibition every six weeks, and Dreier dunned her wealthy friends for contributions. Over the twenty years of its existence, the Société Anonyme would organize eighty-five exhibitions, most of them devoted to advanced modern art. The works that Dreier did not own herself she borrowed from other collectors, such as the Arensbergs, or from leading dealers in America and Europe. The Société gave Archipenko, Kandinsky, Klee, Léger, Villon, and Louis Eilshemius their first one-man shows in America, helped to familiarize American viewers with the little-known work of Mondrian and Schwitters, and sponsored traveling exhibitions, lectures by artists and critics, and other special events. It also put on this country's first

comprehensive survey of postwar international art, at the Brooklyn Museum in 1926, three years before the Museum of Modern Art came into existence. Katherine Dreier deeply resented this upstart rival, whose wealthy backers, she felt, had stolen her mission and her ideas and even her name—the Société Anonyme's subtitle was "Museum of Modern Art." In truth, however, Dreier's tireless idealism could not make up for her lack of significant financial support. The Société Anonyme's exhibition rooms were too small, but Dreier's attempts to find larger quarters kept breaking down because the funds, which came mainly from her and her two sisters, were insufficient. Her society—as time went on it became more and more a one-woman operation—could and did claim precedence, nevertheless, as the first museum anywhere in the world that was devoted exclusively to modern art.

Duchamp managed to keep Miss Dreier and her demands from impinging too heavily on his own relatively quiet life in New York. One of the advantages of this new life, he wrote to Yvonne Chastel, was that he saw everybody but had close relations with no one. He was enjoying New York's "delightful, quite hot summer," and since liquor was illegal and very expensive, "drinking milk by gallons." That July he moved from West 73rd Street to the Lincoln Arcade building on Broadway, where he had lived for nearly a year in 1916. His $35-a-month room was half the size of the one he had had before but large enough for his needs; he whitewashed the walls and arranged to have his unfinished *Large Glass* brought over from the Arensbergs' apartment. There were still quite a few missing elements, which Duchamp was in no hurry to complete. For three months he let dust accumulate on the lower panel so that he could glue it down (with varnish) over the funnel-like sieves, thus giving them a color arrived at by chance and by time. He lived frugally, eating one meal a day in a cheap restaurant and supplementing his diet with milk, crackers, and candy bars. Duchamp preserved his independence by reducing his needs: few material possessions, minimal comforts, and no personal or emotional ties that could escalate into "bonds."

Toward the end of July, he took Beatrice Wood to dinner at the Brevoort. Her brutish husband had left her, but she was more miserable than ever, estranged from her family and sleeping with another man she did not love. "We chatted happily and never discussed my marriage," Wood recalled in her autobiography. "After dinner we walked down to Washington Square to visit some of his friends, where a chess tournament was in full

sway. On the way home, a block from my apartment, Marcel took an enve-
lope from his pocket, and pressed it into my hand. 'Read this when you are
alone in your room,' he said . . . Then he kissed me goodnight and walked
quickly away." She ran upstairs, opened the envelope, and found fifty dol-
lars. Deeply touched by his gesture, she was also a little disappointed; for a
moment she had thought it might be a proposal of marriage.

 Duchamp and Man Ray saw each other nearly every day. Man Ray's
quick wit and hard-boiled New York manner—he liked to talk out of one
side of his mouth—worked to keep his admiration for Duchamp from
becoming an annoyance, and his recently discovered talent for photogra-
phy, which he had taken up as a means to subsidize his painting, was
proving useful. Katherine Dreier had made him the Société Anonyme's
official photographer, responsible for its installation shots, postcards, and
publicity photographs, but his first real assignment involved Duchamp's
Glass. He came over one day with his big view camera and, using only the
light from a single hanging bulb, took a time exposure of the *Glass*'s lower
panel, which had been lying flat on sawhorses collecting dust. The result-
ing image was like a lunar landscape, with hills, valleys, and mysterious

Man Ray and Duchamp. *Dust Breeding*, 1920.

markings in low relief. Considered a joint work by Man Ray and Duchamp, it was given (by Duchamp) the evocative title *Elevage de Poussière* (*Dust Breeding*). Soon after this photograph was taken, Duchamp "fixed" the dust with varnish on the sieves, cleaned the rest of it away, and took the glass panel to a mirror manufacturing plant on Long Island, where he had it coated with silver in the Oculist Witnesses section at the lower right. Over the next few months he spent countless hours working on this section with a razor blade, scratching away the silver around three oculist's eye-test charts (circular patterns of radiating lines, like the one he had used in his Buenos Aires glass study), which he had applied to the back of the glass by means of a carbon-paper tracing. It was slow, tedious work. He did most of it late at night, after coming home from the Marshall Chess Club. Often he would work until four or five in the morning and then sleep past noon.

Man Ray also helped Duchamp build his first optical machine. Entitled *Rotary Glass Plates (Precision Optics)*, it was a fairly crude affair, a triangular metal structure with an electric motor attached; the motor turned a horizontal rod on which he had mounted five rectangular glass plates of graduated lengths. Duchamp painted curved black lines on the glass plates, so that when the motor turned them the viewer, standing at a precise distance from the machine, would see continuous concentric circles on the same plane. Man Ray brought his camera over to record the machine's first test and set it up where the spectator was supposed to stand. "Duchamp switched on the motor," according to Man Ray's subsequent account.

> The thing began to revolve, I made the exposure, but the panels gained in speed with the centrifugal movement and he switched it off quickly. Then he wanted to see the effect himself; taking his place where the camera was. I was directed to stand behind where the motor was and turn it on. The machine began again to revolve slowly, then gaining speed was whirling like an airplane propellor. There was a great whining noise and suddenly the belt flew off the motor or the axle, caught in the glass plates like a lasso. There was a crash like an explosion with glass flying in all directions. I felt something hit the top of my head, but it was a glancing blow and my hair had cushioned the shock.

Luckily they both escaped unhurt. Afterward, Duchamp "ordered new panels and with the patience and obstinacy of a spider reweaving his web repainted and rebuilt the machine."

Duchamp did not consider *Rotary Glass Plates (Precision Optics)* an art object. Machine images had appeared in his work ever since the 1911 *Coffee Mill,* to be sure, but his urge to put together an actual machine seemed to have less to do with art than with the French tradition of *bricolage,* or amateur tinkering—he did it for the sake of doing it, with no particular end in mind. Duchamp was moving further and further away from an esthetic point of view. He intimated to Man Ray that he might stop painting altogether after he finished his *Large Glass*—if he ever finished it.

His old interest in depicting motion, which had resurfaced with *Rotary Glass Plates,* made him curious about cinema techniques. Katherine Dreier bought him one of the first handheld movie cameras, and he and Man Ray tried using it to make a three-dimensional film. Their subject was the Baroness von Freytag-Loringhoven shaving her pubic hair, an activity that might well have inspired Andy Warhol five decades later. (The baroness was still in New York then and more than willing to participate.) Man Ray had found a mechanic who helped them mount another, rented movie camera alongside Duchamp's so that the two lenses would film in tandem. The cinematography went well, but when they tried to develop the film themselves in the dark, winding it around radiating circles of nails that Duchamp had patiently hammered into a plywood disc, then immersing the disc in a garbage can lid filled with developer, the film stuck together and was ruined. Man Ray managed to save two small matching strips of film, which when projected, gave enough of the desired stereoscopic effect for Duchamp to call the experiment a success.

None of these sporadic activities seemed to interest him nearly as much as chess. He had become a member of the Marshall Chess Club team, which was made up of the club's eight best players, and he looked forward intensely to the matches against other New York teams. Frank Marshall, the club's founder, a world-class player who was the U.S. chess champion from 1909 to 1936, often played simultaneous matches against twelve people at a time; Duchamp entered several of these and won two games from him. "I've made enormous progress and I work like a slave," he wrote to Jean and Suzanne Crotti. "Not that I have any chance of becoming champion of France, but I will have the pleasure of being able

to play with almost any player in one or two years. Naturally this is the part of my life that I enjoy most."

Rose Sélavy sprang full-grown from the mind of Marcel Duchamp during the late summer or early fall of 1920. Insouciant, mocking, a bit of a slut perhaps, with her talent for elaborately salacious puns, she would lend her name to all sorts of verbal and visual Duchampian artifacts until 1941, when she quietly retired from the scene. Why did Duchamp, who gave freer rein than most men to the feminine side of his nature, feel the need to invent a female alter ego? "It was not to change my identity," he once said, "but to have two identities." His first thought had been to choose a Jewish name to offset his Catholic background. "But then the idea jumped at me, why not a female name? Much better than to change religion would be to change sex . . . Rose was the corniest name for a girl at that time, in French, anyway. And Sélavy was a pun on *c'est la vie.*"

Her name soon attached itself to a new readymade, the first since *Paris Air.* Duchamp had a carpenter make a miniature French window, thirty inches high by seventeen wide; Duchamp himself put in the eight glass panes, which he then covered with sheets of black leather. The window stood on a wooden base, to which Duchamp affixed the title in large industrial-style capital letters: FRESH WIDOW COPYRIGHT ROSE SELAVY 1920. The double pun, besides announcing Rose Sélavy's favorite activity, also hinted at her other characteristics: fresh, in the sense of impertinent; French, without question; a widow, perhaps, but a merry one (who wears black leather rather than black crepe); a closed window, which nevertheless can be opened without great effort. The sexual overtones here are irresistible to Freudian antennae. Need we mention that Arturo Schwarz finds a castration symbol in the "widow" (*veuve* in French is also the slang term for the guillotine) and that he applies it to Duchamp's subconscious fear of incest?

Untroubled by such dark implications, Rose Sélavy soon posed for Man Ray's camera, wearing a fur neckpiece and a cloche hat that came down to her eyebrows. Her features were clearly Duchamp's and perceptibly masculine; unlike the *Mona Lisa,* Duchamp was not a convincing transsexual. The photograph would eventually figure in a highly feminine readymade, however, a bottle of Rigaud perfume whose punning label, underneath Rose's glamorous image, had been doctored to read "Belle Haleine—Eau de

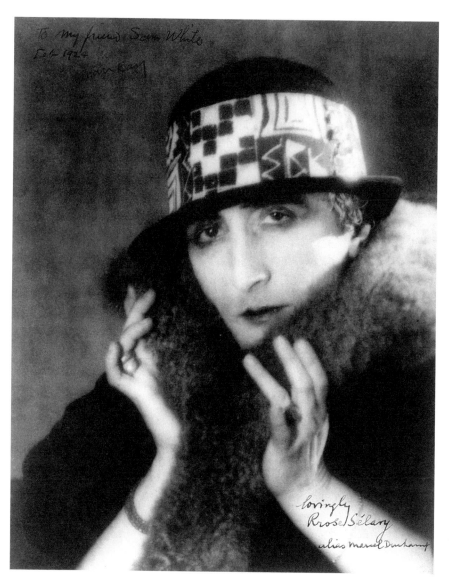

To my friend Sam White
Feb 1924
Man Ray

lovingly
Rrose Sélavy
alias Marcel Duchamp

Marcel as Rose, photographed by Man Ray.

Voilette" (Beautiful Breath—Veil Water). Man Ray's photograph of this object appeared on the cover of *New York Dada,* another ephemeral magazine that Duchamp put together with Man Ray's help and published the following spring. Only four pages long, it included an Alfred Stieglitz photograph of a woman's leg and foot (encased in a too-tight shoe); a letter from Tristan Tzara authorizing the editors to use the word Dada in their title ("Dada belongs to everybody. Like the idea of God or of the tooth-

brush"); a cartoon by Rube Goldberg; and a long poem by the Baroness von Freytag-Loringhoven, accompanied by two photographs of her nude torso.

Dorothea Dreier, Katherine's sister, wished to own a work by Duchamp. A little envious, perhaps, of Katherine's close relationship with the artist, she gave him carte blanche to do whatever he wanted, and the result was a very peculiar readymade. Duchamp bought a small wire birdcage and painted it white. At a marble-cutting shop, he ordered 152 white marble cubes of a specified dimension—the same dimension, in fact, as the large sugar cubes that were served then in French restaurants. The marble cubes filled the birdcage, in which Duchamp nevertheless found room to insert an ordinary fever thermometer and a piece of cuttlebone. The title of this object, inscribed on the cage's underside, is *Why Not Sneeze Rose Sélavy?* (Nobody has yet been able to find any dark implications *there,* Freudian or otherwise.) Although Dorothea paid the agreed-on price of $300, she disliked the work so intensely that she gave it to her sister, but Katherine couldn't stand it either; she returned it to Duchamp. Walter Arensberg eventually bought it for the original price of $300, and Dorothea got her money back. It is hard to know why the Dreier

Why Not Sneeze Rose Sélavy?, 1921.

sisters found this little object so distasteful. There is nothing risqué about the contents or the title (which, of course, have no relation to each other), and nothing very subversive either, unless the profusion of cubes is interpreted as a mild dig at Cubism. More "assisted" than most readymades, it is actually a trompe l'oeil sculpture—if you pick it up thinking it is full of sugar cubes, as Duchamp pointed out, you will be surprised to discover how much it weighs.

Perhaps the sisters' real problem lay with Rose Sélavy. As hard as she tried, Katherine Dreier never quite came to terms with Rose's sardonic, untrammeled humor. It was the same sort of humor that distinguished New York Dada, as practiced by Duchamp and Man Ray, from the far more virulent strain that was currently erupting in Paris.

Tristan Tzara's long-delayed arrival from Zurich in January 1920 had touched off the explosion of Paris Dada. Led by Tzara, Picabia, and a charismatic younger poet named André Breton, the Paris dadas were wildly successful at goading and infuriating the public, which turned out in large numbers for their public performances. The dadas attacked everyone and everything and showed an unparalleled talent for publicity. Their exuberant announcements fooled the gullible time after time. One claimed that Charlie Chaplin had converted to Dada and would attend a coming Dada *"matinée"*; another promised that the dadas would all have their heads shaved onstage. Although the promised activities rarely occurred, going to Dada events became a must for chic Parisians, and the audiences soon became Dada too, bringing along eggs, vegetables, and even beefsteaks to throw at the performers onstage. If Rose Sélavy represented the spirit of New York Dada, her counterparts in Paris were two widely circulated images by Francis Picabia: an ugly splatter of black ink on a white page in *391,* entitled *La Sainte Vierge (The Blessed Virgin)*, and a *Dada Painting* that consisted of a child's stuffed monkey nailed to a board, with "Portrait de Cézanne, Portrait de Renoir, Portrait de Rembrandt, Natures Mortes" painted around the edges.

The lack of any real humor in Dada's programmed absurdity was evident to some sharp-eyed observers. Like most of the literary men in Paris, André Gide went to a Dada soiree and set down his impressions of it: "I kept hoping to have a better time and that the dadas would take greater advantage of the unsophisticated stupor of the public. Some young people, solemn, stilted, tied up in knots, got up on the platform and as a chorus declaimed insincere inanities. In the back of the room someone called out,

'Make a gesture or two!' and everyone broke out laughing." Picabia would take care of Gide in his own way, declaring that "if you read André Gide aloud for ten minutes, your breath will stink." Before the first Dada season ended that spring, though, Picabia was feuding with both Tzara and Breton, mainly because he thought their approach was too serious and too *intentional.* Tzara, small and myopic, with his jerky motions and high-pitched voice, was still in furious combat with the murderous logic that had sent so many millions to their death in the war. A moral fervor, a rage to free life's natural anarchy from the charnel house of logic, tradition, and tradition's natural ally, high art, underlay the Dadaists' absurdist antics, most of which were thought up and organized by Tzara and Breton. The tone of their manifestos can be gauged from the following lines, which were shouted simultaneously by seven dadas at one of their first Paris rallies, in February 1920:

TO THE PUBLIC:

Before going down among you to pull out your decaying teeth, your running ears, your tongues full of sores,

Before breaking your putrid bones,

Before opening your cholera-infested belly and taking out for use as fertilizer your too-fatted liver, your ignoble spleen and your diabetic kidneys,

Before tearing out your ugly sexual organ, incontinent and slimy,

Before extinguishing your appetite for beauty, ecstasy, sugar, philosophy, mathematical and poetic metaphysical pepper and cucumbers,

Before disinfecting you with vitriol, cleansing you and shellacking you with passion,

Before all that,

We shall take a big antiseptic bath,

And we warn you:

We are murderers.

For Tzara and the other Paris Dadaists, Duchamp was the absent prince, admirable and beyond reproach. They knew about him mainly

from Picabia. A reproduction of the *Tzanck Check* appeared in Picabia's magazine *Cannibale* (yet another ephemeral sheet, this one expired after two issues), and the March number of *391* had *L.H.O.O.Q.* on the cover or, rather, Picabia's version of *L.H.O.O.Q.* Since Duchamp had taken the original back to New York with him in 1919, Picabia drew another from memory, reproducing the *Mona Lisa*'s mustache quite accurately but forgetting to put in her goatee. Jean Crotti and Suzanne Duchamp wrote to Duchamp in the spring of 1921, suggesting that he send over something for the Dada Salon that Tzara was organizing at the Galerie Montaigne. (The Crottis were not really part of the Paris Dada group, but Tzara had asked them to contact Duchamp.) Duchamp wrote back that he had nothing to exhibit and that, in any case, the verb to exhibit (*exposer*) sounded too much like the verb to marry (*épouser.*) This flippant refusal failed to discourage Tzara, who got Crotti to send a telegram with a more urgent request for his brother-in-law's participation. Duchamp's reply, a three-word telegram reading "PODE BAL—DUCHAMP," would become famous in Dada annals. It was a pun on *peau de balle,* or, roughly, "balls to you." He meant it, and the Dadaists, having nothing by Duchamp to show, were reduced to hanging blank placards in the spaces they had reserved for him.

Duchamp himself came back to Paris in June. His U.S. visa had to be renewed every six months, and this time, instead of going to the trouble of renewing it, he opted for a temporary repatriation. After visiting his parents in Rouen for a few days, he moved in with his former Buenos Aires companion, Yvonne Chastel, who was still living in Suzanne Duchamp's old apartment near the place de Clichy. Henri-Pierre Roché took note in his journal of Duchamp's "exquisite smile, subtle and gay"—the same smile that had captivated him when they first met in New York; he also noted that Yvonne Chastel greeted him, Roché, with a certain reserve on his arrival at her apartment, and he took this as an indication that she was again sleeping with Duchamp. Picabia welcomed Duchamp back to Paris with great enthusiasm and introduced him to the Dada activists at the Café Certa, their regular meeting place in the passage de l'Opéra. The group included Tzara, Breton, Jacques Rigaut, Louis Aragon, Paul Eluard and his wife, Gala, Theodore Fraenkel, and Philippe Soupault—all poets or writers; even Picabia was doing more writing than painting at that point. Predisposed to admire the newcomer, they were not disappointed. André Breton sensed "an immediate exchange and correspondence" with a supe-

rior mind (that is, one equal to his own). Pierre de Massot, a minor figure in the Dada group, remembered vividly his first meeting with Duchamp, which took place not at the Café Certa but at Picabia's apartment. As he described it nearly thirty years later:

> Someone came in by the window, with a bottle of cognac in his pocket; it was Marcel Duchamp whom I had been hearing about for more than a year, and whose every act, every word that was repeated to me, had opened up in me unlimited perspectives on the future . . . Immediately, I liked that face, that admirable profile of a purity without equal, that sovereign elegance in clothing, gestures, and speaking, that kind of haughty dandyism that tempered the most exquisite politeness. And that silent laugh that cut the ground from under pedants.

Duchamp went to some of the Dada manifestations in Paris that spring, but he took no part in them, and apparently he found them rather boring. "From afar," he wrote to Ettie Stettheimer, "these things, these Movements are enhanced with a charm which they don't have in close proximity." The only group activity that involved Duchamp had to do with Picabia's painting *L'Oeil cacodylate* (*The Cacodylactic Eye*), which Picabia asked about fifty friends (and some enemies) to sign or otherwise embellish. Duchamp's contribution, an extended pun linking Picabia's name to that of Rose Sélavy by means of the French word *arroser* (to sprinkle), gave him the idea of adding an extra "r" to Rose's name—she would be Rrose Sélavy from then on. Next to his inscription on the canvas, Duchamp glued two tiny photographs of his head: one with his hair very short, as it had been when he came back from Buenos Aires, the other with the hair in back shaved to form a five-pointed star—a Dadaist gesture whose purpose, if any, remains obscure.

When Man Ray arrived in Paris that summer, Duchamp, who had encouraged him to come, went out of his way to make him feel at home. He met the boat train at the Gare Saint-Lazare and took his friend to an inexpensive small hotel in Passy, where a room was waiting for him—it had been vacated a week earlier by Tristan Tzara. (Man eventually moved into a maid's room on the sixth floor of Yvonne Chastel's building on the rue la Condamine, where Duchamp was living.) Duchamp also introduced him to the dadas at the Café Certa and helped him get photographic

assignments—from Picabia, who engaged him to photograph his art collection, and later from Paul Poiret, who provided his entrée into fashion photography. Man Ray would become a familiar presence in Paris for the next twenty years, but during those first few months, when he spoke no French and seemed unable to learn the language, he was completely dependent on Duchamp. They spent a lot of time together, in Paris and at the Villons' house in Puteaux, where they worked on another short film. This one involved spiral patterns inscribed on circular discs, which they mounted on a bicycle wheel set up in Villon's garden; as the discs revolved, the spirals appeared to advance or retreat.

Paris was full of Americans that summer. "The whole of Greenwich Village is walking up and down Montparnasse," Duchamp informed the Stettheimer sisters. He had seen Marsden Hartley, Charles Demuth, and Henry McBride, and also John Quinn, who came out to Puteaux and ordered a bronze cast of Duchamp-Villon's *Horse.* Quinn had engaged Roché as his European art-buying agent, and during the next three years Roché would help him make some of his most important purchases, including Seurat's *The Circus* and Henri Rousseau's *The Sleeping Gypsy.* Having undergone cancer surgery in 1918, Quinn was determined to acquire only works of first-rate importance to add to his collection. He also wanted to enjoy life more, a wish that Roché encouraged by introducing him to Matisse, Picasso, Braque, Satie, Brancusi, and other legendary figures and by arranging convivial dinners with the artists at Lapérouse, not to mention a hilarious golf match with Brancusi (Satie was an interested spectator) at a private club in Fontainebleau. Although Brancusi had never played before, Quinn, his most dedicated patron, contrived to let him win and subsequently presented him with a set of brand-new golf clubs, which Brancusi proudly displayed on the wall of his studio for years afterward.

The need to make art no longer seemed to exist for Duchamp. Aside from the short film of turning spirals, the only work he produced during seven months in Paris was a single readymade called *La Bagarre d'Austerlitz* (*The Brawl at Austerlitz*). Like *Fresh Widow,* it was a miniature French window, this one set into a wall of imitation bricks, with white glazier's smears on the glass panes. (The title is a pun on the Gare d'Austerlitz and the Napoleonic battle [*bagarre*] of the same name.) Windows held a special fascination for Duchamp. In one of his earliest notes, he speculates on "the interrogation of shop windows," a typically ambiguous phrase that leaves us

uncertain about who, or what, is doing the interrogating. The same note also refers to "the coition through a glass pane with one or many objects of the shop window"; the "penalty" of such coition, he adds, "consists in cutting the pane and in feeling regret as soon as possession is consummated." This, of course, is a central theme in *The Large Glass*. The *Glass* itself is a window, a transparent membrane through which the viewer can take part in an infinitely delayed act of coition that involves no penalty (no regret) because it is never consummated. "I could have made twenty windows," Duchamp said once, "with a different idea in each one, the windows being called 'my windows,' the way you say, 'my etchings.' " By 1921, though, he seemed less and less inclined to do anything that smacked of art. He kept his distance from the Dadaists, whose internal feuds and dissensions delayed a renewal of their Paris activities until the following spring. Through Albert Gleizes he made arrangements for a show of Florine Stettheimer's paintings in Paris that fall, at the Galerie Povolozky, but he told the Stettheimer sisters that Paris was "deadly dull" and that he looked forward to being back in New York.

A letter from Walter Arensberg that fall brought the startling news that he and Lou were moving to California. Their decision had been pending for some time for various reasons, the most pressing of which were Walter's financial problems and Louise's wish to get him away from their hectic, hard-drinking New York social life, but it came as a shock to Duchamp all the same. "What could you be doing for 24 hours a day in California," he wrote back; "nature must repeat itself quite often." In response to Walter's comment that they might have to part with some important works from their collection, Duchamp suggested that he could help them sell their Picassos through the Paris dealer Léonce Rosenberg, whom he knew; this was the first hint of his willingness to engage in the commercial side of art, but for the moment, at least, the Arensbergs did not require his services.

In the same letter Duchamp told his friends that he was looking for a cheap passage to New York soon after the first of the year. "I've already had enough of Paris and France in general . . ." he said. "In N.Y. I plan to find a 'job' in movies—not as an actor, rather as an assistant cameraman." He added that he was hoping "to get a little further with my glass and perhaps finish it, if it goes the way I want it to—all that's left is a little work with lead wire, nothing extraordinary. Maybe I'll die before it's finished."

Bedbugs Are Required

> The only thing which could interest
> me now is a potion that would let me
> play chess *divinely*.

The postwar migration of American writers, painters, musicians, and pleasure seekers to Paris was gaining momentum in 1922. For many of them, the incentive was not just the favorable rate of exchange, which allowed Americans to live so agreeably in France, but a strong desire to escape from what seemed to be an increasingly repressive and puritanical social climate at home. It would be a year or so before the Jazz Age arrived to shake up the social order, and in the meanwhile, as the expatriate painter Gerald Murphy said, "You had the feeling that the blue-noses were in the saddle and that a government that could pass the Eighteenth Amendment could, and probably would, do a lot of things to make life in the States as stuffy and bigoted as possible." His feeling was widely shared but not, apparently, by Duchamp. Although Paris had become the magnetic center of postwar culture, Duchamp seemed to prefer living in New York. When asked why, he usually said that in New York people were more inclined to leave him alone. At the age of thirty-four, Duchamp was making another of his periodic withdrawals.

He had kept his small room in the Lincoln Arcade building. The lower panel of *The Large Glass* still rested horizontally on sawhorses there, waiting for Duchamp to put in the missing elements and to add some finishing touches in other areas. "I work a little on it," he wrote to Man Ray. "What a bore!" After seven years of intermittent labor, Duchamp had virtually lost

interest in the *Glass*. He had wanted it to be sui generis, "something that absolutely didn't need . . . to be compared with other works of art of the time," and for several years his search for new ways of thinking and working had given the project a life of its own. Once all the ideas for the *Glass* had been developed in verbal notes or worked out in drawings and preliminary studies, though, the effort of transferring these ideas to the glass surface held less and less appeal. "I became bored with it," he said. "I asked myself, what's the use to go on."

French lessons, his old standby, brought in just enough money for him to live on. He went less frequently to the Marshall Chess Club and spent more time studying chess problems or playing correspondence chess at home. In a letter to Roché, he wrote that he was "fed up with the idea of being a painter or a filmmaker," and he added: "The only thing which could interest me now is a potion that would make me play chess *divinely*." With the Arensbergs in California and prohibition in effect, his social life in New York was much quieter than before. He saw Beatrice Wood now and then. Katherine Dreier was away on an eighteen-month picture-buying world tour, and the Société Anonyme's exhibition program had been shut down until she came back. (Duchamp had resigned as president the year before, but he remained on the Société's board of directors.) Once or twice a month he went to tea or dinner at the Stettheimer apartment on West 76th Street, where the three maiden sisters still lived with their aging mother. Here he found old friends like Henry McBride, Walter Pach, Carl and Fania Van Vechten, and Alfred Stieglitz and met some new ones, including, later that year, the painter Georgia O'Keeffe, who would become Stieglitz's second wife in 1924. O'Keeffe retained a vivid memory of her meeting with Duchamp. She and Stieglitz had come to one of the large parties that Florine Stettheimer gave whenever she completed a new painting. "I don't remember seeing anyone else at the party," as she later recalled, "but Duchamp was there and there was conversation. I was drinking tea. When I finished he rose from his chair, took my teacup and put it down at the side with a grace that I had never seen in anyone before and have seldom seen since."

It was this unconscious and indelible grace—Ettie Stettheimer described it as "the charm of his physical fineness"—that drew women to him with so little effort on his part. Ettie herself set great store by their extended flirtation. Writing to Ettie from Rouen the year before, he had said what a pleasure it had been to see her again in Tarrytown, "where you and I have

spent such good times, without flirting though. Not everyone can abstain from flirting." Ettie certainly couldn't, and their relationship became fairly intense again in the summer of 1922, which the Stettheimer clan spent at their aunt's house at Sea Bright on the New Jersey shore. Duchamp came down to visit them during the Fourth of July weekend and wrote afterward to Ettie that he had "left with tears in my eyes. (Why not?) To you who do not like men to cry, I did not want to show it." He returned to celebrate Ettie's birthday on July 30—two days after his own. They exchanged presents. Ettie gave "Duche" a box of pink writing paper that was really intended for Rrose Sélavy, and Marcel/Rrose gave her a set of beige cardboard luggage tags, with strings, bearing Rrose's name and address and under it, in large capitals, "VOUS POUR MOI?" This somewhat enigmatic gift seems to have made Ettie cross. It "does more credit to his thoughtfulness than his thinking power," she wrote in her diary. Later that summer she sent him a little poem in copybook French called "Pensée-Cadeau: vers un ami," which was her delayed response to the gift:

> *Je voudrais être faite sur mesure*
> *pour toi, pour toi*
> *Mais, je suis readymade par la nature,*
> *pour quoi, pour quoi?*
> *Comme je ne le sais pas j'ai fait des rectifications*
> *Pour moi—*
>
> (I would like to be made to measure
> for you, for you
> But, I am readymade by nature,
> for what, for what?
> Since I don't know I have made adjustments
> For me—)

Ettie Stettheimer had recently finished writing a novel, which Alfred Knopf would publish the following year. Called *Love Days,* by "Henrie Waste" (a contraction of Henrietta Walter Stettheimer), it is a brittle, self-consciously clever tale of eight "love episode crises" in the life of a young New York woman, Susanna Moore, who is obviously a stand-in for Ettie herself—she is intellectual, vaguely feminist, and eager for love, provided it

arrives in a spiritually uplifting form. Duchamp appears in the narrative as Pierre Delaire, a fairly minor character, but his one scene with the heroine provides interesting insights into their real-life relationship. Pierre, who has just returned from Paris after a long absence, comes to call on Susanna in her apartment, and what we get, aside from some stilted dialogue, are mainly her impressions of him:

> He never was hurried nor flurried, this Pierre, this Pierre Delaire, whose name so mysteriously suited him! Stone of air . . . Hard and light; like stone dependable and definite, and immaterial and imponderable and cool like air; and as mysterious as their paradoxical combinations.
>
> Most people considered him beautiful as well as irresistibly "sympathique," but Susanna could not share this view of him. She thought rather that his delicate fairish classicality of a dry and cerebral quality had all of beauty except beauty's peculiar thrill.
>
> She felt him pleasantly as a charming and rare creature, sensitive, delicate and with a rare polished finish. She knew him as set, definitely set somehow, in character, and subtly eccentric in intellect, although she was unable to follow rationally his philosophy of complete rejection of what he conceived to be the trammels of convention,—and convention for him included all intellectual tools that had become masters: language and logic itself, and indeed all forms of culture that were past and yet potent.

During their conversation Pierre chides her for refusing to come abroad with him "when I suggested it twenty-four hours before the boat sailed." (This obviously refers to the invitation that Duchamp may or may not have made to Ettie in 1918, when he was preparing to go to Argentina.) Susanna replies that she didn't want to go and defends herself against the accusation that she doesn't like or want adventures: "But you see . . . I regard the bare fact of your having asked me to go as an adventure in itself—unforeseen, unaccountable, fantastic, odd,—though pleasant."

The visit ends, Pierre leaves, but Susanna's musings continue. She decides that she really loves him, "delightfully, actively, interestedly and yet calmly, without the wish for complete intimacy." She thinks about "the happiness his presence bestowed on her," but realizes that "she forgot him

in between their meetings with dreadful ease." And then, all at once, she understands why this is so:

> He was not in love with her. If he were . . . if a great emotion had communicated itself from him to her,—it might have resulted in her falling in love. Instead, there was this strange tendency to forget him, not to be affected by him permanently owing to *his* strange tendency—strange in so positive a personality—to be neutral in a relationship, so to say. And suddenly Susanna was quite certain that he forgot her in between their meetings even more completely than she forgot him.

The tendency to be neutral in relationships was only one aspect of a more generalized detachment. Reducing his material needs to a bare minimum was one thing; increasingly, however, Duchamp seemed inclined to do without other needs as well: love affairs, friendships, finishing *The Large Glass.* For an artist whose ambition had been nothing less than to redefine the nature and purpose of art (even if only for himself), this growing detachment was a troubling sign. Unlike other artists in midcareer, he had nothing to fall back on. Duchamp's refusal to repeat himself ruled out the course taken by many artists, his brother included, who after an early period of innovation and rebellion, spend their mature years mining and developing their youthful discoveries. Duchamp greatly admired Villon's dedication to the lyrical brand of Cubist abstraction in which he had become a minor master, but his own ambitions had been larger, more rigorous, and less forgiving. He had wanted to put painting at the service of the mind, and now, for reasons that were not clear to him or to anyone else, his mind had run out of ideas. Rather than becoming a drunk, contemplating suicide, or adopting any of the other remedies that artists tend to favor in extreme cases, he simply grew more detached.

He kept himself busy with various unrelated activities. During the summer he edited an anthology of writings by Henry McBride, the New York art critic who, more than any other, had consistently and intelligently supported the cause of modern art. It was published in December by the Société Anonyme in a loose-leaf notebook format that Duchamp had concocted: the type started out very small and got larger for each page, so that on the next-to-last page there were only ten lines in huge type. (The last

page reverted to the small type of the first.) The title was *Some French Moderns Says McBride*. Duchamp also became involved in two money-making ventures, neither of which made any money. He suggested to Tristan Tzara that they go into business together—a mail-order business to sell, for a dollar apiece, small metal chains on which would be strung the four letters D A D A; these could be worn as bracelets or tie clasps and advertised as a "universal panacea, or fetish, in this sense: if you have a toothache, go to see your dentist and ask him if he is a Dada." Duchamp proposed that Tzara handle European distribution, and he would "take care of the United States," but nothing ever came of the idea.

Duchamp actually did go into business, briefly, with a New York acquaintance named Leon Hartl. "I am a businessman," he announced in a letter to Man Ray. "Hart and I bought a dye shop—He dyes and I keep books—If we are successful, we don't know what we will do." Leon Hartl, a Frenchman who had emigrated to New York in 1912, was a painter of landscapes and still lifes who also happened to be an expert on aniline dyes. He had made his living in Paris dyeing ostrich and other rare feathers for milliners and couturiers, and in 1922, when a New York entrepreneur offered to set him up in a fabric and feather-dyeing shop, Hartl asked Duchamp to come in as an equal partner. Duchamp, who had plenty of free time, saw no reason to refuse. He borrowed three thousand francs from his father to finance his share and lost it all when the business went belly up six months later.

The major event in his life that fall was playing against Raúl Capablanca at the Marshall Chess Club. The visiting Cuban grand master played simultaneous games against twenty-four of the club's members and won twenty of them, including his match with Duchamp.

Work on the *Glass* had almost stopped. Stieglitz and Georgia O'Keeffe saw the two panels leaning against the wall when they dropped by his studio one day. O'Keeffe was greatly distressed by the disorder and the layers of dust on everything. "The room looked as though it had never been swept," she said, "—not even when he first moved in. There was a single bed with a chess pattern on the wall above it to the left. Nearby was a makeshift chair. There was a big nail in the side of it that you had to be very careful of when you got up or you'd tear your clothes or yourself . . . and the dust everywhere was so thick that it was hard to believe." Although Duchamp confided in no one, a strain of bitterness sometimes revealed

itself. When Stieglitz asked a number of artists, photographers, and critics to state their opinion on the question "Can a Photograph Have the Significance of a Work of Art?" Duchamp's reply was scathing. "You know exactly how I feel about photography," he wrote back. "I would like to see it make people despise painting until something else will make photography unbearable."

If Duchamp had largely withdrawn from the challenge of redefining art, though, others were eager to claim him as a guide and mentor. André Breton, who was preparing in 1922 to gather up the spent energies of the Paris Dada movement and channel them into the adventure of Surrealism, had recently become one of his most vocal admirers. Breton's essay on Duchamp in the October issue of *Littérature* that year laid the foundations for a Duchamp legend which—in France, at least—would take the place of any real acquaintance with his work for the next forty years. "It is by rallying around this name, a veritable oasis for those who are still searching," Breton wrote in his sonorous and oracular style, "that we might most acutely carry on the struggle to liberate modern consciousness from that terrible fixation mania which we never cease to denounce in these pages." He then proceeded to describe Duchamp in terms that bordered on infatuation:

A face of admirable beauty, although none of its details is particularly striking . . . a polished surface that conceals everything going on behind it, and yet a merry eye without irony or indulgence which dismisses the slightest suspicion of seriousness and demonstrates a concern to remain outwardly extremely cordial, elegance in its most fatal form, and over and above the elegance a really supreme ease—this, on his last visit to Paris, was the picture I had formed of Marcel Duchamp, whom I had never seen and whose intelligence, from the little I had heard of it, I expected to be wondrous.

And in the first place we should note that Marcel Duchamp's situation in relation to contemporary movements is unique, in that the most recent groups more or less claim to be acting in his name, although it is impossible to say whether or not they have ever had his consent especially when we see the perfect liberty with which he detaches himself from ideas and movements whose originality was largely due to him . . . Could it be that Marcel Duchamp gets to the crux of ideas more quickly than anyone else?

... I have seen Duchamp do an extraordinary thing: toss a coin in the air and say, "Heads I leave for America this evening, tails I stay in Paris." And this without the *slightest* indifference; no doubt he would infinitely have preferred either to go or to stay. But Duchamp is one of the first people to have proclaimed that choice must be independent from individuality, which he demonstrated, for example, by signing a manufactured object ...

For Marcel Duchamp, the question of art and life, as well as any other question likely to divide us at the present time, does not arise.

Breton's hero worship of Duchamp was based to some degree on the hero's elusiveness. His own attempts to claim Duchamp for the Surrealist cause were never successful, but Breton understood that if he pressed too hard he would risk losing him entirely. Breton, a natural leader who demanded almost unlimited moral authority over the lives of his followers and who ended by excommunicating most of them from the Surrealist movement, continued to venerate Duchamp for the rest of his life—always from a respectful distance.

Breton, with his large, strikingly handsome features, noble bearing, and beautifully articulated but self-important and often rhetorical manner of speech, lacked the casual grace and vivacious wit that people associated with Duchamp. "Breton did not smile," according to the Paris book dealer Adrienne Monnier, "but he laughed sometimes, a brief and sardonic laughter which surged as he spoke without disturbing his features, as in the case of women mindful of their beauty." He considered himself the rightful successor to Apollinaire as spokesman and standard-bearer for the avant-garde (this was the source of his bitter rivalry with Tzara), and he sincerely believed that Duchamp, more than any living artist, was in touch with intellectual and spiritual forces that were changing not only art but human life as well.

How he came to this belief is somewhat unclear. He had obviously heard about Duchamp from Picabia and also from Apollinaire, whom Breton had made a point of meeting in 1918, when Apollinaire's head wound brought him back from the trenches. Breton, however, could have seen no more than two or three of Duchamp's paintings when he wrote his 1922 essay about him, and it is doubtful he even knew about the early notes that Duchamp had published in his *Box of 1914*. The only evidence of his hero's

genius that Breton offered, to go with his essay in the October *Littérature*, were six of the "strange puns" that Duchamp turned out from time to time, complicated and frequently salacious bits of wordplay such as "*Rrose Sélavy trouve qu'un incesticide doit coucher avec sa mère avant de la tuer; les punaises sont de rigueur.*" (Rrose Sélavy finds that an incesticide must sleep with his mother before killing her; bedbugs are required.) In the December issue of *Littérature,* Breton printed eight pages of similar phrases, spoonerisms, and extended puns that the poet Robert Desnos claimed to have "received" from Rrose Sélavy when he was asleep or in a trance state. (Duchamp was amused by Desnos's telepathic receptions; he suggested that Desnos and Rrose Sélavy become engaged.) Breton considered Duchamp's puns of "extreme importance" and informed his readers that "words have stopped playing. Words are making love." Breton went on to define two distinct characteristics of these puns (including the ones "sent" by Rrose to Desnos): their "mathematical rigor (the displacement of a letter within a word, the exchange of a syllable between two words, etc.), and on the other hand the absence of the comic element, which used to be thought inherent in the genre but which was enough to deprecate it." Did he mean that they were good because they weren't funny? "To my mind," Breton announced, "nothing more remarkable has happened in poetry for many years."

All this makes Breton sound a bit silly, which is often the case with people who take themselves as seriously as he did. Duchamp never assigned any sort of seriousness to his games with words, although he did talk about using words in their "poetic" sense. "For me," he said once, "words are not merely a means of communication. You know, puns have always been considered a low form of wit, but I find them a source of stimulation both because of their actual sound and because of the unexpected meanings attached to the interrelationships of disparate words. For me, this is an infinite field of joy—and it's always right at hand." Apparently Breton read more into Duchamp's puns than Duchamp did. He also worked hard to promote the legend of Duchamp the seer, the avant-garde prophet, at the very moment when Duchamp himself, empty of ideas, was approaching an impasse in his work and his life.

Soon after the New Year, Duchamp began making preparations to return to Paris. It was not just the six-month visa requirement this time; except for three relatively brief trips to the United States in 1926–27, 1933–34, and 1936, he would live in France for the next twenty years. He

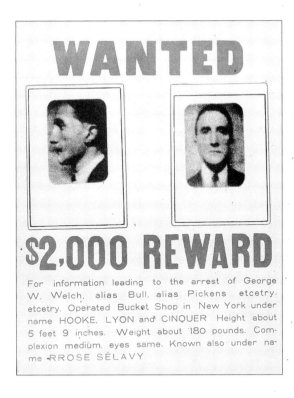

Wanted/$2,000 Reward, 1923.

gave no reasons for this decision. New York may have become associated in his mind with the drying up of his imaginative energies; perhaps, after Breton's overtures in *Littérature,* he thought the intellectual climate of Europe might help to recharge them. His life in Paris, however, would be as withdrawn and as isolated as it had been in New York. Shortly before leaving, he produced one last American readymade. He had seen in a restaurant a joke "Wanted" poster offering a $2,000 reward for "Information leading to the arrest of George W. Welch," who had "Operated Bucket Shop in New York under the name HOOKE, LYON, and CINQUER." Duchamp had a printer reproduce the poster, changing its last line to read "Known also under name RROSE SELAVY," and then pasted two passport photographs of his own face, profile and head on, in the spaces under WANTED. Eight years after the delirious scandal of his *Nude Descending a Staircase* at the Armory Show, there was a sad sort of irony in this farewell appearance as a petty crook.

Katherine Dreier, back from her world tour, had agreed to buy *The Large Glass* from the Arensbergs. Although the Arensbergs had talked

about selling off part of their art collection to offset their financial losses, in the end they had sold practically nothing; their decision to part with the *Glass* was made solely because they believed it was too fragile to be shipped to Los Angeles, where they had now taken up permanent residence. Dreier paid $2,000 for the work (the same amount offered by Duchamp's joke poster), half of it outright and the rest in installments over the next two years. Duchamp oversaw the transfer of the heavy glass panels from his studio to Dreier's apartment on Central Park West, where they were installed, one above the other, in the freestanding wooden frame that he had designed for them. He had decided by then to leave his most important work of art "definitively unfinished," as he phrased it. The inscription on the back of the lower panel, in black paint, reads "LA MARIEE MISE A NU PAR/SES CELI-BATAIRES, MEME/Marcel Duchamp/1915–1923/*inachevé.*"

Most of the missing elements were in the lower half, the domain of the bachelors. They included the Waterfall, the Hook, the Benedictine Bottle, the Butterfly Pump, the Toboggan, and the Mobile Weight with Nine Holes. Two important operations, the Boxing Match and the Handler of Gravity, which were supposed to take place just below and just above the division between the panels, had also been left out, and their absence meant, in effect, that the "electrical stripping" of the bride could not take place. In the Boxing Match, a clockwork mechanism was activated by two vertical Rams, whose up-and-down motion would lift and unfasten the bride's clothes. The three-legged Handler of Gravity was supposed to balance a ball on a tray while standing on the bride's garment, whose fall would cause him to lose his equilibrium. Both these elements had been worked out by Duchamp in detailed drawings, which he could have applied to the *Glass* without great difficulty. Why didn't he? Again and again over the ensuing years, when he was asked this question, Duchamp would simply repeat that he was bored, that he lost interest, that he was too lazy to finish it. A few years before he died, however, Duchamp said something quite revealing to the museum curator Katharine Kuh. "It may be that subconsciously I never intended to finish it because the word 'finish' implies an acceptance of traditional methods and all the paraphernalia that accompany them," he said. The need to escape from tradition, to make something that had never before been seen or thought of in the world, had been Duchamp's principal incentive ever since—with Raymond Roussel's *Impressions d'Afrique* fresh in his memory—he had isolated himself in a furnished room in Munich and

made the first small drawing of a semi-abstract bride flanked by two mechanistically menacing bachelors. But it was not only tradition that Duchamp was trying to circumvent. He was also determined to escape from himself.

"I was really trying to invent, instead of merely expressing myself," Duchamp told Katharine Kuh. "I was never interested in looking at myself in an esthetic mirror. My intention was always to get away from myself, though I knew perfectly well that I was using myself. Call it a little game between 'I' and 'me.' " But in playing this little game, Duchamp may have tricked himself into a deeper form of self-expression. Just as the bride remains forever free and unpossessed, in that ecstatic delay before "the orgasm which may (might) bring about her fall," the artist, by not finishing his masterpiece, remains free of its inevitable limitations. He also eludes the trap of art, in which every valid discovery takes its place, sooner or later, in the evolving fabric of tradition.

Duchamp, at any rate, was content to leave *The Large Glass* as it was and to let the onlookers have the last word. His next step, for all he knew, might take him out of art altogether.

Drawing On Chance

Question d'hygiène intime:
Faut-il mettre la moelle de l'épée
dans le poil de l'aimée?
(Question of intimate hygiene:
Should you put the hilt of the foil
in the quilt of the goil?)

When Duchamp returned to Europe in 1923, he was no longer a practicing artist. His last painting, *Tu m'*, had been completed five years earlier; since then, aside from his desultory and inconclusive efforts to finish *The Large Glass,* he had produced a few ready-mades and the optical device called *Rotary Glass Plates*—objects that he did not wish to be thought of as works of art. The process of hagiology, which began to overtake Duchamp in the 1960s and which has been gathering momentum ever since, tends to assign esthetic significance to everything he did or thought or said, but the truth is that for about fifteen years, from 1918 to 1933, Duchamp's activities had very little to do with art. The myths that grew up around him would eventually cause his dropping out to be seen as an important artistic statement in itself, but that was hardly what he had in mind at the time.

"My ambition is to be a professional chess player," he had said in a 1921 letter to Picabia. Two years later he set out quite systematically to achieve that goal. Duchamp sailed from New York in February 1923 on the Dutch liner SS *Noordam,* bound for Rotterdam. Instead of going to Paris, he spent the

next four months in Brussels, playing chess every day. He joined a chess club, met several of the best Belgian chess players, and gained a high enough rating in club matches to qualify for the Brussels Tournament that fall, the first important one he had entered. "I am starting with the small nations..." he wrote to Ettie Stettheimer; "maybe one day I will decide to become French Champion." He did surprisingly well in the tournament, winning seven and a half points out of ten against experienced opponents and finishing in third place—a brilliant start for a newcomer to international chess competition.

By then he had moved back to Paris. In the spring he attended his sister Yvonne's wedding in Rouen to Alphonse Duvernoy, a French civil servant who was stationed in Indochina. Soon afterward he abandoned Brussels for good and rented a tiny room at 37, rue de Froidevaux in Montparnasse, where he devoted most of his time to studying chess problems. Although he agreed to serve on the jury of that year's Salon d'Automne, he steered clear of the extremely lively Paris art scene. For fashionable Parisians the temporary vacuum left by the disintegration of the Dada movement a year earlier had been filled by the sensational performances of the Diaghilev ballet and the Ballets Suédois, by concerts of modern music by Les Six, by the elaborate costume balls put on by Count Etienne de Beaumont, at which the *gratin* of Paris society mingled with the artistic avant-garde, and by the opening of Le Bœuf sur le Toit, the nightclub made famous by Jean Cocteau, where Picabia's painting *The Cacodylactic Eye* hung on the wall (along with photographs by Man Ray) and a chic crowd gathered every night to hear the latest jazz and to rub elbows with artists, musicians, and their high-society admirers. André Breton, who detested Cocteau, did not go to Le Bœuf sur le Toit. Breton was consolidating his position then as standard-bearer for the authentic avant-garde as opposed to Cocteau's society version. He hoped to enlist Duchamp's participation in the psychic word games and the experiments with subconscious, nonrational thought which he and his followers had been pursuing for some time and which would lead in 1924 to the formal establishment of Surrealism. Although Duchamp allowed a number of Rrose Sélavy's puns and sayings to appear in Breton's magazine, *Littérature,* he avoided the Surrealist meeting places and seances. Breton described him at this time, in a letter to Jacques Doucet, as "the man from whom I would be the most inclined to expect something, if he wasn't so distant and deep down so desperate."

Breton had taken a part-time position as librarian and artistic adviser to Jacques Doucet, the couturier, who was then in the process of forming his third major art collection. Having started out with Impressionism, Doucet had gone on to amass a splendid collection of eighteenth-century French paintings, porcelains, and furniture, most of which he sold before the First World War; now, advised by Breton, he was buying advanced contemporary art—his most daring purchase was Picasso's *Les Demoiselles d'Avignon,* which he bought when Breton took him to the artist's studio in 1924. (This epochal work had been shown in public only once since it was painted in 1906–7; Picasso kept it turned to the wall in his studio, like a dangerous engine whose destructive power had to be held in check.) A few months earlier, on Breton's recommendation, Doucet had acquired two works by Duchamp: a Fauvist 1910 painting called *Two Nudes* and *Glider Containing a Water Mill in Neighboring Metals,* the first study on glass for an element in *The Large Glass.* (Duchamp had given the *Glider* to his brother Raymond, whose widow sold it to Doucet.) Breton also arranged for Duchamp to have lunch with Doucet, and the friendship formed during this meeting led a few months later to Doucet's commissioning Duchamp to construct a second optical machine, the *Rotary Demisphere,* which he worked on sporadically, with the help of an engineer, through most of 1924.

More sophisticated (and much safer) than the earlier *Rotary Glass Plates,* which had nearly decapitated Man Ray, the new apparatus had as its main feature a white wooden globe, cut in half, with black concentric circles painted on it; when the globe was turned by a small electric motor, the circles appeared to move forward and backward in space. The globe was mounted on a flat base covered with black velvet, and both globe and base were enclosed by a glass dome that was secured by a copper disc on which

Rotary Demisphere (Precision Optics), 1925.

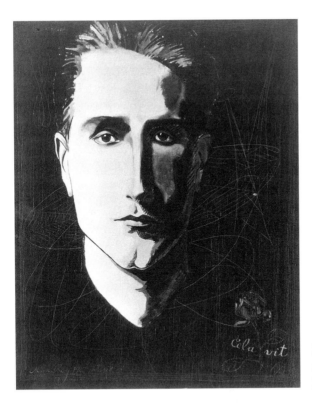

Man Ray. *Cela Vit*
(portrait painting of
Duchamp), 1923.

Duchamp had engraved one of his extended puns: *Rrose Sélavy et moi esquivons les ecchymoses des esquimaux aux mots exquis* (meaning, roughly, "Rrose Sélavy and I avoid the bruises of the Eskimos of exquisite words"). Doucet paid for the cost of the materials and the engineer and received the machine as a gift in return—Duchamp insisted that the transaction was "an exchange and not a payment." Duchamp also made it clear that he hoped Doucet would not lend the work out for exhibition purposes. "All expositions of painting or sculpture make me ill," he said in a letter to his patron. "And I'd rather not involve myself in them. I would also regret it if anyone saw in this globe anything other than 'optics.' "

Although he had seceded from any overt participation in art, Duchamp never really cut his ties to other artists. His closest friends (aside from Henri-Pierre Roché) were Man Ray and Francis Picabia, and from 1923 on he saw a great deal of Constantin Brancusi. The Romanian sculptor kept himself more aloof from the Paris art scene than Duchamp did. He had no regular dealer, then or later (neither did Duchamp), and he rarely went out,

preferring to have his friends visit him at his combined house and studio on the impasse Ronsin, a dead-end street of ramshackle studios and workshops that had been built originally for the foreign artisans who came to work on the 1889 International Exposition. In his whitewashed studio, surrounded by his sculptures and the tools of their making, he cooked marvelous Romanian meals for his guests on a homemade forge. When the New York art critic Henry McBride came to Paris that year, Duchamp and Gabrielle Buffet-Picabia arranged to take him to Brancusi's for dinner. McBride was sick that day, but Duchamp wouldn't let him off. "You'd better come along," he said, "you can die any time." Restored to health by Brancusi's cooking, McBride ventured the remark that he, too, had one or two specialties. "*Oui,*" Brancusi said dryly, "*comme les artistes modernes.*"

Brancusi was an immensely appealing character. Vigorously handsome and brimming with confidence in his own genius, he had an earthy, peasant humor and a fund of fascinating stories drawn from his struggles to survive as an artist. His reputation, like Duchamp's, was greater in the United States than it was in France, thanks largely to the enlightened patronage of John Quinn. Although Quinn did not buy any of the four sculptures that Brancusi had sent to the Armory Show in 1913, a year later he acquired a

Dinner at Brancusi's with Duchamp and two unidentified women.

marble version of *Mademoiselle Pogany* from Brancusi's first one-man show in America, at Stieglitz's "291" gallery, and over the next ten years he bought at least one version of nearly every sculpture that Brancusi made. Quinn considered him the greatest living sculptor. When Quinn made his second and last trip to Paris in the fall of 1923—he died the following year—his happiest evenings were spent at the impasse Ronsin. Henri-Pierre Roché describes an evening there in 1922 when Erik Satie was present: "Dinner at Brancusi's—splendid. His famous cold beans puree, with garlic vinaigrette, his grilled steak . . . he multiplies himself, cooks, serves . . . there were two violins, Satie and Brancusi playing duos, teasing each other, we laugh so hard our jaws ache."

Duchamp's unheated studio on the rue Froidevaux was so cold in the winter that he gave it up and moved to the Hôtel Istria, a few blocks away on the rue Campagne-Première. He would live there for the next three years. Man Ray and the irrepressible Kiki (née Alice Prin), his mistress at the time, lived on the same floor; their noisy arguments and reconciliations were part of the ongoing show at the Istria, a cheap and tolerant haven in those days for artists and writers. According to Kiki's friend Thérèse Treize, Duchamp spent a great deal of time alone in his room, working on chess problems. He would usually show up around midnight at the Dôme, the big café on the boulevard Montparnasse, where he invariably ordered *œufs brouillés baveux* (moist scrambled eggs), but after an hour or so he would go back to his room and work on chess problems until four in the morning. This hermitlike pattern did not seem to rule out an active sex life, which is admiringly documented in Henri-Pierre Roché's journals.

In the spring of 1924, Duchamp introduced Roché to Mary Reynolds, an American war widow living in Paris. Duchamp's liaison with her had apparently begun several months earlier, and in spite of his refusal to let it impinge on his freedom, it lasted for the better part of two decades. Roché found her immensely attractive. With her blond hair and striking carriage, she impressed him at first sight as "a beautiful, tall dancer, calm and noble." A few weeks later, after a visit to her house when Duchamp was not present, he described her as "a handsome spectacle. Slender heroic body with dark circles under her eyes. Great calm. She seems to have something like a desire to die. She drinks each night until she gets drunk. In that state loses neither her charm nor her nobility . . . We see to it that our fingers do not touch, even by chance, in handling books and objects."

Roché was often attracted to the women Duchamp slept with. Duchamp even told Mary Reynolds, rather insultingly, that Roché would become her lover, saying, "He's had lots of my mistresses." This never happened. Roché got her to confide in him, though, and he wrote it all down in his journal:

> She suffers. Marcel is debauched. Has loved, perhaps still loves, very vulgar women. He holds her at arm's length at the edge of his mind. He fears for his freedom. She wants to attach herself to him as he says (Mary's eyes moisten with offended sweet pride). She has no *laissez-aller* with him. He comes to see her every day. Hides their relationship from everybody. Doesn't want her to speak to him at the Café du Dôme when they see each other each evening. Hides her. Gets out of their taxi a hundred yards before arriving at the home of friends. She loves him, believes him incapable of loving . . . Just as a butterfly goes for certain flowers, Marcel goes straight for beauty. He could not not go for Mary, but he protects against her his life, his calm, his solitude, his chess games, his amorous fantasies.

It was obvious to Roché that Mary Reynolds accepted Duchamp's callous behavior toward her only because she was so deeply in love with him. She was an independent, highly intelligent woman who had many friends in Paris, where she had been living since 1920 on a modest income derived partly from family money and partly from her government pension as a war widow. Born in Minneapolis, she had married Matthew Reynolds, of St. Louis, soon after she graduated from Vassar in 1917; her husband was killed a year later while serving with the 33rd Infantry Division in France, and Mary, largely to escape from the pressure her parents were putting on her to remarry, had moved to Paris. Her circle of friends there was a wide one. Cocteau admired her, and so did Brancusi, and she became a favorite of the American writer Janet Flanner, who wrote the *New Yorker*'s "Paris Letter." Everyone who knew her agreed that she was a lovely person, warm and direct, with natural dignity and a generous spirit.

Duchamp's efforts to distance himself from Mary Reynolds included going to bed with young women whom Roché considered "unworthy of him," girls he picked up at the Dôme and other bars. Roché was much taken, however, with a compliant brunette stenographer whom Duchamp told him to look after one evening (Duchamp was going out of town for a few days)

and who promptly became Roché's mistress as well. This young woman "with eyes of fire, not entirely parallel" was so accommodating that on the eve of her own departure from Paris for a visit with her parents in Angoulême, she arranged a surprise "bouquet of three flowers" for Duchamp—three naked girls in her bed instead of one. Roché could hardly wait to wring the details from her the next morning and then to have them confirmed by his friend. "What youngsters," Duchamp commented. "There were moments when I didn't know where I was, when all three were occupied with me at the same time. Pity you weren't there to help me." Soon after this diversion, Mary Reynolds told Roché that Marcel had broken off their relationship. She had said something harsh to him in a café when she was feeling wounded and a little drunk, and he had used that as an excuse for the break that he obviously wanted. "She has no hope," Roché wrote in his journal, "but still wants to see him again at the café for a few minutes before he leaves on a trip." (Duchamp was going to Germany this time, to meet Katherine Dreier; they visited the Bauhaus in Weimar, talked with Kandinsky and Paul Klee, and made plans to show their work at the Société Anonyme.) Roché took Mary Reynolds in a taxi to the Dôme and watched her sit down with Duchamp at one of the little tables on the terrace. A month later they had slipped back into their strange semi-clandestine love affair.

Duchamp often left Paris for weeks at a time to play in chess tournaments. He played in Rouen, where he had joined the Cercle Rouennais des Echecs, and in the spring of 1924, he spent a month on the Riviera, playing for the Nice team against other local clubs. "The climate suits me perfectly, I would love to live here," he wrote to Jacques Doucet, his new patron. He also told Doucet that he was experimenting with roulette and *trente-et-quarante* at the casino, trying out various systems, and that he had found he could do this quite objectively, without succumbing to the temptations of gambling. In a letter to Picabia, Duchamp described in more detail his attempts to work out a "martingale," or system, for winning at roulette. He had been winning regularly, he said, and he thought he had found a successful pattern. "You see," he said, "I have not ceased to be a painter, I am now drawing on chance."

Chess was his main preoccupation, though, and he used the local Riviera matches as warm-ups for more important competitions. In June he was back in Brussels, where he did slightly less well than he had in the previous year's tournament, placing fourth instead of third. That summer he was invited to

play for the French national team in the first chess "olympiad," a tournament organized to coincide with the Olympic Games in Paris. (The French team placed seventh against seventeen others.) A month later he entered the French championship matches at Strasbourg. Duchamp fared rather poorly there, placing eleventh out of thirteen very strong contestants. In September, though, he redeemed himself by winning a three-day tournament in Rouen and was declared the champion of Haute-Normandie. "M. Duchamp thoroughly earned his title, considering his solid and profound game," according to an article in the *Bulletin de la fédération française des echecs*. "His imperturbable composure, his ingenious style, the impeccable way he exploits the slightest advantage, make him a formidable opponent at all times."

In between chess matches, Duchamp found time that fall to finish the *Rotary Demisphere* and to launch his very own bond issue. The *Monte Carlo Bond,* as it came to be known, was a standard financial document but so heavily doctored that it could hardly be called a readymade. A Man Ray photograph of Duchamp's head—the face lathered with shaving soap and the hair soaped into two devilish-looking horns—was superimposed on the image of a roulette wheel, against a background of the Duchampian pun, printed over and over, *moustiques domestiques demistock.* Thirty copies were issued, hand-signed by Duchamp and by Rrose Sélavy and priced at five hundred francs apiece, and prospective purchasers were offered an annual dividend of twenty percent on their investment. As described on the back of the document in legalistic French, the investment was in Duchamp's system for the "exploitation" of roulette, *trente-et-quarante,* "and other mines on the

Monte Carlo Bond, 1924.

Côte d'Azur," a system he had been refining and developing since the previous spring, which was based on mathematical calculations relating to one hundred thousand throws of the roulette ball. Jacques Doucet bought a bond. So did the painter Marie Laurencin, and eventually about a dozen other people. Duchamp sent one to Jane Heap, the editor of the *Little Review* in New York, and she ran a note on it in her next issue: "If anyone is in the business of buying art curiosities as an investment, here is a chance to invest in a perfect masterpiece. Marcel's signature alone is worth much more than the 500 francs asked for the share." Katherine Dreier thought it was a terrible idea. The "psychological atmosphere" of a gambling casino was very bad "for a person as sensitive as Marcel," she felt; she was willing to give him five thousand francs to go south for the sake of his health, but only if he abandoned the absurd Monte Carlo project. Marcel, she clucked maternally, "is like a small child who doesn't think."

André Breton, who had virtually nothing else in common with Katherine Dreier, felt a similar dismay over Duchamp's current activity. How could a man so intelligent—the most profoundly original mind of the century, according to Breton—devote his time and energy to such trivialities? Searching for an explanation, Breton could only conclude that some hidden malaise must be at work—what he had described to Jacques Doucet as Duchamp's "desperate" state of mind. Breton's lack of humor made him susceptible to such ex-cathedra judgments. Surrealism, the movement conceived, shaped, and dominated by Breton, would have no use for humor. What could there be to laugh about in an enterprise whose goal was to launch a revolution in human consciousness?

For Breton and his followers, Surrealism was always much more than a literary or an artistic movement. Its avowed purpose was to "change life" by freeing the human mind from all the traditional strictures that enslaved it, including religion, morality, the family, and the "straightjacket" of rationality. The Surrealists believed they could accomplish this by tapping the power of the subconscious. Dada had turned logic and rationality upside down to demonstrate the sickness of a world gone mad; Surrealism embraced irrationality, dreams, and even madness for the insights they could yield into unexplored realms of the human spirit. It was through man's unconscious mind, above all, that the Surrealists hoped to change life.

All this can be viewed, of course, as simply another cycle in the Romantic movement that had been around for more than a century, with its

emphasis on private experience and the inner life of emotion and feeling, and in fact the Surrealists were eager to cite their historical antecedents. They worshiped Rimbaud, who had decreed that poetry should be an act of discovery and divination; they found much to admire in the works of the Marquis de Sade and the English "Gothic" novelists Horace Walpole and M. G. ("Monk") Lewis; and they freely acknowledged a debt to the brilliantly jarring dislocations of meaning in the poems of Guillaume Apollinaire, whose 1917 play, *Les Mamelles de Tirésias,* subtitled *drame surréaliste,* had given the name to their movement. Breton, a former medical student who had been assigned as an intern at the psychiatric division of a military hospital in Nantes during the war, had been deeply struck, moreover, by the writings of Sigmund Freud. He had gone to Vienna in the summer of 1921 to meet the doctor and had come away disappointed because Freud showed no interest in Breton's view that the subconscious was *better* than the conscious mind. By this time Breton and Philippe Soupault had been experimenting for two years with the technique of automatic writing—sitting in a dark room, cultivating a trancelike state of mind, and writing down whatever came to them. The ex-Dadaists who had allied themselves with Breton used to meet regularly at the Café Cyrano or at Breton's apartment nearby at 42, avenue Fontaine to share their dreams and psychic experiences and to play the mind games with which they coaxed the subconscious into revealing its marvels.

Since Surrealism's origins were mainly literary, it is not surprising that Duchamp's writings (or rather, Rrose Sélavy's) caught Breton's interest. Having already declared that "nothing more remarkable has happened in poetry for many years," he continued to publish Rrose Sélavy's punning phrases in *Littérature,* and their appearance no doubt helped to keep Duchamp's name (if not his presence) a live issue among the Surrealists. In 1924 Pierre de Massot brought out a little paperback called *The Wonderful Book: Reflections on Rrose Sélavy,* which indicated the difficulty some Surrealists felt in dealing with this admirable yet elusive figure. On the title page is a quote from Gertrude Stein: "I was looking to see if I could make Marcel out of it but I can't." De Massot's brief introduction refers to his own, ever-frustrated wish to write a book about Duchamp, whom he considers "the greatest genius he knows." This is followed by twelve blank pages, each of which has the name of a month at the top and nothing more.

Fifteen of Rrose/Marcel's sayings are reproduced on the back cover, including *Etrangler l'étranger* (Strangle strangers), *Daily lady cherche démêlés avec Daily Mail* (Daily lady will dally with Daily Mail), and—in English—*My niece is cold because my knees are cold*. As evidence of literary genius, they may leave something to be desired, but the author, after all, was not trying to change people's lives.

If Rrose Sélavy's playful humor seemed somewhat at odds with the missionary spirit of early Surrealism, Breton nevertheless looked to Rrose and her alter ego as allies and potential collaborators. He entertained no such hopes for Picabia, whose withering scorn for Surrealism and its claims led to another (final) break between him and Breton. In October 1924, the same month that saw the publication of Breton's First Surrealist Manifesto, marking the official founding of the movement, Picabia launched a violent attack in the pages of his magazine, *391,* which he had recently revived in Paris. Surrealism, he said, was "a poor imitation of Dada," and André Breton "is not a revolutionary . . . he is an arriviste." For all Picabia's self-contradictions and abrupt changes of course—he was then in the process of abandoning his Dada-machinist painting style and returning to figurative art—his bedrock commitment to spontaneous, unplanned, untheorized, individual experience never wavered, and in this sense he remained, all his life, a true Dadaist. "Art is not fabricated," he wrote in *391, "it is,* simply, but rare. You are too numerous, Messrs. the surrealists, for there to be a rare man among you."

Picabia, who would leave Paris for good the following year to live in a large château in the hills above Cannes, was still a volcano of frenetic activity. His major project that fall was the ballet *Relâche,* on which he collaborated with the composer Erik Satie and the dancer-choreographer Jean Borlin. It had been commissioned by the Ballets Suédois, the Paris-based Swedish ballet company whose director, Rolf de Maré, emulated Diaghilev by enlisting contemporary artists and musicians to collaborate on avant-garde dance spectacles. Picabia had been invited to participate by the writer Blaise Cendrars, who had worked with Fernand Léger and Darius Milhaud the year before on the Ballets Suédois' *The Creation of the World.* When Cendrars went off to Brazil, though, Picabia and Satie dispensed with his preliminary scenario and substituted an entirely different one of their own. They also persuaded de Maré to commission a young filmmaker named René Clair to make a short film with a script by Picabia, which

would be shown during the intermission. An intense publicity campaign led up to the scheduled opening on November 27, with articles in the major papers by Rolf de Maré and Picabia. *Relâche* "is perpetual movement, life, it is the minute of happiness we all seek," Picabia promised; "it is light, richness, luxury, love far from prudish conventions; without morality for fools, without artistic research for the snobs." He advised the audience to bring dark glasses and ear plugs, and urged any ex-Dadaists among them to shout, "Down with Satie!" and "Down with Picabia!"

A large and fashionable crowd turned out for the opening at the Théâtre des Champs-Elysées, only to find the doors shut and plastered with the notice *"relâche,"* which means "theater closed." Since this was also the ballet's title, almost everyone assumed that they were being subjected to a typical Picabia hoax. The crowd stood patiently in front of the theater for quite a while, observed by Picabia, Duchamp, and Man Ray from the bar across the street, until the word finally got around that it was not a hoax after all. What had happened was that Jean Borlin, the principal dancer, had fallen ill at the last minute, and the performance really had been canceled.

Most of the critics turned thumbs down on *Relâche* when it finally opened a week later. They did not like the backdrop of automobile-size headlights whose beams occasionally blinded the audience, nor were they amused by the fireman on stage who poured water ceaselessly from one bucket into another, nor by the single ballerina (among troops of men) who danced only when the music stopped and stopped dancing as soon as it began again. The audience, curiously enough, seemed enthusiastic throughout and gave the company a rousing ovation at the final curtain. For audience and critics alike, though, the real hit of the evening was the twenty-two-minute film called *Entracte,* which was shown during the *entracte* (intermission). It is hard to know who was primarily responsible for this Dadaist gem. Picabia, with untypical modesty, said later that he had given René Clair "a little scenario of nothing at all; he made it a masterpiece," while Clair insisted that his contribution was "limited to realizing technically the aims of Francis Picabia." The film opens with rapidly juxtaposed images of a dancer in white tights and tutu, filmed from beneath through a sheet of glass, and shots of Paris traffic at night; it then shifts to a scene on the roof of the Théâtre des Champs-Elysées where Man Ray and Marcel Duchamp are sitting at the edge of a parapet, playing chess—the game ends suddenly when a powerful jet of water sweeps the pieces from

Duchamp and Man Ray in a scene from *Entracte*.

the board. More shots of the leaping ballet dancer, who now sports a long beard, are followed by a shooting-gallery sequence, with Jean Borlin as a frustrated marksman in Tyrolian costume, after which we come to the incomparable set piece, a funeral procession in which the hearse is pulled by a camel. A long line of top-hatted and hobble-skirted mourners winds through the streets of Paris, taking long, leaping strides as the hearse moves faster and faster, breaking into a dead run as it goes off on its own, leaves the road, hurtles onto the track of a roller coaster, and finally comes to a crashing halt in an open field, whereupon the casket falls out on the ground and the rejuvenated corpse (Borlin again) leaps up and taps the mourners on the shoulder, causing them all to disappear.

Duchamp also made an appearance, live, in a divertissement that Picabia and Clair concocted for the last evening of *Relâche*'s run at the Théâtre des Champs-Elysées. Called *Ciné Sketch,* it was an absurd sex farce done in a staccato style that made it look like an early movie. The plot involved a wife, her lover, a thief, the lover's wife, a policeman, a maid, a

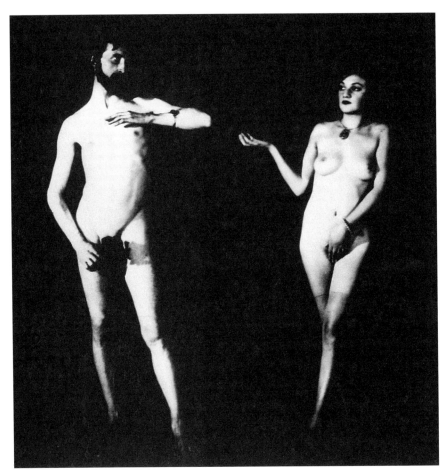

Adam (Duchamp) and Eve (Bronia Perlmutter) in *Ciné Sketch*.

ballerina (Jean Borlin), and for no apparent reason, Adam and Eve, glimpsed briefly in the nude, at the moment when Eve proffers the apple to Adam. Eve was Bronia Perlmutter, one of two very pretty Swedish sisters who had recently become much in demand as artists' models—the poet René Char, who was up on a ladder working the lights, fell in love with Bronia during the performance and married her soon afterward. Adam, wearing a false beard and shielding his private parts with a barely adequate fig leaf, was Duchamp, looking very handsome and only slightly apprehensive. Their pose was modeled after the famous Lucas Cranach *Adam and Eve,* which Duchamp had seen many times in the Alte Pinakothek during his 1912 stay in Munich.

Duchamp would lend his talents to the Surrealist cause on a number of occasions during the next three decades, but he never embraced Surrealism. Like Picabia, he shied away from anything that smacked of theories and doctrine. Speaking of Surrealism in 1967, a year after Breton's death and not long before his own, he said with his usual candor, "I myself have never had a part in any such group explorations of unknown lands, due to that something in my character which prohibits me from exchanging the most intimate things of my being with anyone else."

Duchamp Married!!!

> My life hasn't changed in any way, I
> must make money but not for two.

D uchamp's parents died within a week of each other in 1925. Only four months earlier the family had gathered in Rouen to celebrate their fiftieth wedding anniversary. Lucie Duchamp, completely deaf, was then in the later stages of the cancer that would kill her, but Eugène, who was seventy-six, had seemed as alert and energetic as ever. Since giving up his notarial practice in Blainville and moving to Rouen, he had been active in municipal affairs—a member of the city's Administrative Commission, its hospital board, and its Office of Public Instruction—and in recognition of his services he had recently been awarded the rank of Chevalier de la Légion d'Honneur. At Lucie's funeral on a bitterly cold February day, Eugène had been determined to walk behind the hearse from the church to the cemetery on a hillside above the city, but halfway up the steep slope he had shown signs of exhaustion, and other family members had persuaded him to get into one of the funeral cars. The next day in his apartment at 71, rue Jeanne d'Arc, he suffered a sudden, fatal heart attack.

Although Duchamp felt no great affection for his mother, he had stayed in touch with his parents all his life, going back to Rouen for New Year's holidays and visiting them during the summer in the vacation houses they rented by the sea—he had spent five days with them the previous August in a house at Val de la Haye, on the Seine near Rouen. He would inherit some money from his father, whose long career had provided him with a number of business opportunities (in real estate, for example) that he had used to

profitable advantage, but in Marcel's case the sum was less than $10,000. It always amused Duchamp in later life to describe how Eugène Duchamp, the *notaire,* had kept a careful record of all the monthly allowances paid out to his artist-children so that the totals could be deducted from each one's inheritance. Yvonne and Magdeleine, the two youngest daughters, were the only ones who received substantial bequests.

Eight days after his father's funeral, Duchamp left Paris for the south of France. He would stay in Nice for a good part of the next six months, playing in chess tournaments and trying out his system for winning at roulette. "My statistics give me full confidence," he wrote to Ettie Stettheimer. "I am going to play there in this frame of mind: a mechanized mind against a machine. Nothing romantic in the venture, nor luck." He put it slightly differently in a letter to Jacques Doucet, saying that he wanted "to force roulette to become a game of chess"—in other words, a game of intellect rather than chance. Duchamp sent Doucet a check for fifty francs in December, representing six months' "interest" on his *Monte Carlo Bond,* but by that time it had become clear that future dividends would not be forthcoming. Even though Duchamp's winnings consistently outweighed his losses, the margin of profit was so small, and waiting for the right combinations to appear was so tedious, that he soon lost interest in the whole venture. The real winners were those few subscribers who had the foresight to hold on to their original certificates; eventually they would be worth a great deal.

Chess brought in no money at all then, but it provided richer satisfactions. The French chess championship matches were held in Nice that spring. Duchamp designed the poster for the tournament, a striking image of pink and black cubes contained within the outlines of a chess king, and he finished his matches in sixth place—not as high as he had hoped but good enough for him to be awarded the official title of master of the Fédération Française des Echecs. He very nearly won his seventh-round match against Robert Crepeaux, the reigning French champion, who retained his title by winning the tournament; after four hours of play in which Duchamp held a significant advantage, he made a crucial error that allowed Crepeaux to recover and defeat him.

Toward the end of the year, Duchamp used the initial payment on his inheritance to make a film and to go into the art business. The film, shot in Man Ray's studio with the help of the cinematographer Marc Allégret, was a seven-minute animation of nine punning phrases by Rrose Sélavy. These

had been pasted, letter by letter, in a spiral pattern on round black discs that were then glued to phonograph records; the slowly revolving texts alternate with shots of Duchamp's *Discs Bearing Spirals,* ten abstract designs whose turning makes them appear to move backward and forward in an erotic rhythm. The little film, which Duchamp called *Anemic Cinema,* had its premiere that August at a private screening room in Paris.

Becoming an art dealer was an even more novel departure. Duchamp's often-expressed scorn for the commercialization of art is a little hard to reconcile with the fact that, for the next two decades, he would earn his living mainly by buying and selling the work of other artists. To be sure, he never made much money from his transactions, and at times he actually worked against himself, arguing that the price suggested for a painting he was handling seemed much too high. Duchamp's goal in business was "to break even, plus ten percent"; while he often did less well than that on a sale, he rarely, if ever, did better. He took his first significant plunge early in 1926, when he bought eighty paintings, drawings, and watercolors by Francis Picabia and put them up for auction at the Hôtel Drouot in Paris. Picabia, who had moved permanently to the south of France, helped Duchamp choose works from his own collection that represented virtually every phase of his career; he was clearing the decks, in a sense, for his hedonistic new life on the Côte d'Azur and his somewhat startling return to representational painting. Duchamp brought the eighty Picabias back to his room at the Hôtel Istria in Paris, had most of them reframed, and got out an impressive catalog with a preface by Rrose Sélavy. The sale on March 8, 1926, was a success, if not exactly a triumph. Among the interested buyers were Jacques Doucet, who bought a large early painting; Henri-Pierre Roché, who bought six of the "machine-style" watercolors from the Dada period; and André Breton, who snapped up *Procession Seville*—one of Picabia's best pictures—and four other important early works. (Like several other Surrealist poets, Breton supported himself largely through his activities as a private dealer.) Duchamp ended up with a profit of about ten percent on his investment—just right, from his point of view.

Soon after this, Duchamp and Roché started negotiating to buy the Brancusi sculptures from the estate of John Quinn. When Quinn died in 1924, he left the largest and by far the most important collection of late-nineteenth- and early-twentieth-century art in existence. Never exhibited or even cataloged, the works were stacked up against the walls in his eleven-

room apartment on Central Park West—more than fifty Picassos, including *La Toilette* and *Three Women at the Spring;* nearly as many works by Derain and Matisse (among them Matisse's famously shocking *Blue Nude: Souvenir of Biskra*); examples of virtually every major sculpture by Brancusi and Raymond Duchamp-Villon; and some of the greatest Post-Impressionist masterworks by Cézanne, Van Gogh, Gauguin, and Seurat. He had collected right up until the end, buying mainly through Roché, his European agent; his last purchase was Henri Rousseau's *The Sleeping Gypsy,* which is now one of the treasures of the Museum of Modern Art. Quinn, who had no heirs, made specific provisions in his will for only three paintings. The Metropolitan Museum, which he believed (rightly) to have no interest in modern art, would receive two works by Puvis de Chavannes, while the Louvre, which had been slow to recognize the Post-Impressionists, would get Seurat's late masterpiece *The Circus.* All the others were to be sold at auction.

The news that Quinn's executors were planning to disperse his vast collection at auction sent alarm bells ringing throughout the international art community. The market for modern art was not strong enough to absorb such a large number of important works all at once, and there was widespread apprehension that prices would be low and some artists' reputations would be damaged as a result. Nearly a year before the sales, Duchamp and Roché discussed buying from the estate the four Duchamp paintings in the Quinn collection: *Apropos of Little Sister, The Chess Game, Brown Skin,* and the first version of *Nude Descending a Staircase.* Roché did buy *Apropos of Little Sister,* and Duchamp was able to retrieve *The Chess Game,* which he immediately sold to a collector in Brussels. (The other two Duchamps found enthusiastic buyers: Alfred Stieglitz bought *Brown Skin* at the 1927 auction, and Walter Arensberg was delighted to pick up *Nude Descending a Staircase, No. 1.*) Meanwhile, Duchamp and Roché were meeting with Brancusi, who had no regular dealer and who was afraid that the dumping of so many of his own works on the market would result in a "massacre." Duchamp dropped out of the negotiations at one point, convinced that it would take too much money to buy Quinn's thirty-odd Brancusis from the estate. (He estimated their market value then at $21,700.) In the end, however, they were able to buy twenty-nine of them for a total of $8,500, with the help of a New York society woman named Mrs. Charles Rumsey. (A daughter of E. H. Harriman, the railroad millionaire, she had been involved in several of Quinn's own art ventures, including the financial backing of the Carroll Galleries in

New York.) Mrs. Rumsey put up $1,500 of the initial $4,500 down payment to the Quinn estate and received in return a *Bird in Space* and a *Torso of a Young Girl;* Roché and Duchamp paid the remaining $4,000 over the next six months. (Duchamp's three-sevenths share took virtually all his remaining inheritance.) They divided up the twenty-nine sculptures, and over the next fifteen years, whenever Duchamp needed money, he would sell one—often to Roché, who acted as his personal banker.

Joseph Brummer, the New York art dealer, had offered to help sell works from the Quinn collection privately, and to this end he scheduled a major Brancusi show at his gallery in the fall of 1926. It was to be made up largely of the Quinn sculptures, augmented by a number of pieces from Brancusi's studio in Paris. Brancusi himself went to New York in September to oversee the installation plans. (It was his second trip to the United States.) Duchamp, who had agreed to pack and ship twenty of the sculptures in his studio, along with their carved wooden or stone bases, sailed with them aboard the SS *Paris* a month later. "You will see me from 2 October in the parallel streets of New York," he wrote to Ettie Stettheimer, delighted by this opportunity to revisit his favorite city. Both he and Brancusi were in for a shock, however, when a United States Customs inspector opened the crates in the *Paris's* hold and decided, in his infinite bureaucratic wisdom, that the contents were not works of art.

Under the federal guidelines that John Quinn had battled for and won, any work of art could now be brought into the United States duty-free. Shortly before Duchamp's arrival, however, the photographer Edward Steichen had returned to New York from Paris with a bronze *Bird in Space* that he had bought from Brancusi's studio, and a customs official, to whom the polished form looked like nothing more than an ordinary piece of metal, had obliged him to pay a forty percent tariff on its declared value of $600. The inspector assigned to Duchamp's shipment made a similar decision. This particular individual knew art when he saw it—he was an amateur sculptor—and the Brancusis did not meet his qualifications; they were commercial objects, he maintained, and subject to duty as such. The shipment was admitted into the country on a temporary basis, under bond, for the purposes of the Brummer exhibition only. If the objects left the country unsold, there would be no charge, but if any of them remained in the United States, the buyer would have to pay forty percent of the purchase price in duty. Advised that this ruling could be contested, Duchamp got in

touch with a Philadelphia lawyer named Maurice Speiser, who knew Brancusi, and Speiser agreed to represent the artist in a legal challenge to the decision.

While Brancusi worked to clean and refurbish his works in the Quinn collection, Duchamp renewed old ties. He saw Beatrice Wood, Walter and Magda Pach, and Allen Norton (Louise Norton's ex-husband), who put him up in his apartment on West 16th Street. He visited the Stettheimer sisters at their new apartment in the Alwyn Court on West 58th Street and saw for the first time the portrait that Florine had done of him in 1923—a double portrait with Duchamp sitting in an armchair, holding a long crank attached to a round platform on which Rrose Sélavy perches, pink and enigmatic, one hand raised conversationally. Florine did another strange portrait of him around this time, a small penciled head that appears to radiate energy into the surrounding space; apparently Duchamp didn't think much of it, because he declined to accept it when it was offered to him as a gift after Florine's death in 1944. Duchamp did a pencil sketch of Florine during his 1926 visit, which she was very pleased to accept. Since it was not signed, she inscribed it herself: "Portrait of me by Marcel Duchamp."

Duchamp also spent a good deal of time in New York with Katherine Dreier, who was busy organizing a large International Exhibition of Modern Art that the Société Anonyme had been invited to put on at the Brooklyn Museum in November. For the last six months Duchamp had been helping Dreier get together the more than three hundred works that would be shown in this important exhibition. He had taken her around to the artists' studios when she came to Paris in March, and he had even joined her for a few days of consultations and sightseeing in Venice. ("Understand nothing about this 'town,' where everything is traveling except the pigeons," he had written on a postcard to Jacques Doucet.) Although Picasso never replied to Duchamp's note asking if he could bring Miss Dreier to his studio, Dreier managed to get what she wanted from everyone else, and the exhibition, which opened on November 19, was the most comprehensive showing of international modern art in this country since the Armory Show in 1913. Duchamp himself supervised the installation of *The Large Glass* in one of the main galleries, where, curiously enough, it received little or no comment from the reviewers, although Alfred Stieglitz referred to it in a lecture at the museum as one of the grandest works of art of all time. This was the first public showing of Duchamp's masterpiece, and it was also the last time anyone would see it in its

original, intact state. Katherine Dreier had given instructions that it was to be put in storage when the Brooklyn Museum exhibition closed. The two glass panels were placed, one on top of the other, in a single crate and transported by truck to the Lincoln Warehouse in Manhattan, with disastrous results that would not be discovered until nearly five years later.

Brancusi's one-man show at the Brummer Gallery was a modest success. In spite of continuing questions about the import duty—questions that would not be resolved until Brancusi won his legal challenge to the U.S. Customs office decision on November 26, 1928—six of the pieces that Duchamp and Roché had bought from the Quinn collection were sold for a total of $7,100, considerably less than what Quinn had paid for them but nearly enough to repay Duchamp's and Roché's investment. Brancusi went back to Paris soon after the opening. Duchamp stayed on, and when the show closed in December, he assumed responsibility for packing, shipping, and reinstalling it at the Arts Club of Chicago, where it was on view for nearly a month. He had a fine time in Chicago. "I go to the opera every night," he wrote Ettie Stettheimer. "I have at least a lunch a day and tea as well—and it is a real delight to see myself swimming in these social perfumes. Knowing this will not last a lifetime, I am perfectly satisfied." His offbeat opinions charmed the art critic for the *Chicago Evening Post,* C. J. Bulliet, who devoted part of his review of the Brancusi show to an interview with Duchamp. "M. Duchamp—what is he doing? Nothing," Bulliet wrote, "just loafing and enjoying life in Paris, he will tell you, with amused indolence. Why isn't he painting, and renewing the renown that came to him with his Cubistic nudes? Because if he should paint again, he would merely repeat himself, so what's the use. All painters should be pensioned at 50, he observes, and compelled to quit work. The government should see to it that the retired painters live on their pensions, and do not work clandestinely and secretly."

Duchamp came back to New York toward the end of January, in time for the three-day auction of the John Quinn collection at the American Art Galleries. (This was the second Quinn sale; a somewhat smaller auction had been held in Paris the previous October.) Duchamp bought two Picasso drawings, a drawing by André Derain, and a plaster model of *The Cat* by his brother, Raymond Duchamp-Villon. Why hadn't he tried to buy any of the nineteen Duchamp-Villon sculptures in the Quinn collection prior to the auction sales, as he had done with the Brancusis? The likely answer is that he and Roché could not afford to do both and decided to

stake their limited financial resources on Brancusi, who actively encouraged them to do so.

In late February Duchamp returned to Europe on the *Paris,* along with several crates of unsold Brancusi sculptures. The crossing was enlivened by his conversations with Julien Levy, a young man who had introduced himself to Duchamp at the Brummer Gallery during the Brancusi exhibition. Levy wanted to be a filmmaker, but he was fascinated with modern art (he would eventually become the Surrealists' principal dealer in New York), and he had talked his father, a well-to-do New York real estate entrepreneur, into buying a marble version of Brancusi's *Bird in Space* from Brummer. Duchamp, who took a liking to this intelligent and somewhat antic esthete, had suggested that he come to Paris—they might even work together on an experimental film, he said, using Man Ray's studio and equipment—and Levy had promptly booked passage on the *Paris.*

"On that first voyage with Duchamp, we would sit together in the lounge . . . smoking, drinking moderately, beer or Cinzano *à l'eau,* until the time Marcel would find himself a chess game," Levy recalled in his autobiography. "We talked—I intently, Marcel tolerantly. Marcel giggled; it made him seem younger despite all his tired irony. He seemed to remain a boy . . . I felt him to be more of an elder brother than a figure of imposing authority." Levy also recalled watching Duchamp toy with two pieces of wire, "bending and twirling them, occasionally tracing their outline on a piece of paper. He was, he told me, devising a mechanical female apparatus . . . He said, jokingly, he thought of making a life-size articulated

Duchamp leaving New York for
Paris, 1927.

dummy, a mechanical woman whose vagina, contrived of meshed springs and ball bearings, would be contractile, possibly self-lubricating, and activated from a remote control, perhaps located in the head and connected by the leverage of the two wires he was shaping. The apparatus might be used as a sort of '*machine-onaniste*' without hands. I fell in with this fantasy and suggested that she could be equipped with a mechanism by which the lower portion of her body was activated by one's tongue thrust into the mouth in a kiss. It was then that Marcel unbent, giggled for the first time, and admitted me to his inner circle of intimate friends."

As a verbal or visual image, the *machine-onaniste* comes up again and again in Duchamp's work. The lower half of *The Large Glass* is a "bachelor machine" whose individual elements enact the rituals of masturbation, and the *Green Box* notes that apply to these elements are full of references to onanism ("the bachelor grinds his chocolate himself"; the spangles of solidified gas are "hallucinated quite onanistically"). Duchamp's *Bicycle Wheel* and his obsession with circular forms; his optical machines whose spiral patterns oscillate in a pulsating, back-and-forth rhythm; his invention of Rrose Sélavy, a female alter ego; and the very fact that in *The Large Glass* the unfortunate bachelors never do manage to strip bare the willing but imperious bride—all these can be seen as signposts in the life cycle of the solitary male, one who yearns for but does not quite believe in the possibility of union with the opposite sex. There may have been more autobiography here than the artist chose to admit. On the eve of his fortieth birthday, Duchamp himself seemed not simply resigned to bachelorhood but committed to it, wedded to it, in fact, with a fidelity sustained by the undemanding love of his mistress, Mary Reynolds, whom he kept at arm's length, and by an ever-changing supply of demimondaines who served as compliant *machines-onanistes.* Imagine, then, the astonishment of Duchamp's friends in the spring of 1927 when they suddenly learned of his engagement to Lydie Sarazin-Levassor, the daughter of a well-to-do *haut bourgeois* automobile manufacturer in Paris.

The Picabias had introduced Duchamp to Lydie in March, soon after his return from New York. Germaine Everling, Picabia's second wife, was a friend and confidant of Lydie's father. She knew that he wanted to divorce his wife so that he could marry an opera singer named Jeanne Montjovet; she also knew that Mme Sarazin-Levassor, in an effort to delay or perhaps derail the divorce, had made her husband agree that he would do nothing until they had found a husband for their twenty-four-year-old daughter,

Lydie. Perhaps she thought this would never happen. Lydie was extremely fat, and while not unpleasing in other respects, so far she had attracted no suitors. When the Picabias arranged for Marcel and Lydie to meet at a dinner party at the Grand Veneur restaurant in March, at any rate, there can have been no doubt in Duchamp's mind (or in Lydie's) about the underlying purpose.

Two nights later there was a second dinner, at Prunier. Lydie, who had found Duchamp "handsome, nice, elegant" on their first encounter, was thoroughly smitten by him this time. Things moved quickly after that. Duchamp made his formal proposal during Easter weekend, which he spent at the Sarazin-Levassors' country house in Etretat, on the Normandy coast, and the engagement was announced a month later. Duchamp took his fiancée to meet the Villons in Puteaux. He introduced her to Brancusi, who found her very sympathetic; in fact, Brancusi soon began calling her "Morice," the term of affection he conferred on intimate friends (including Duchamp) who lived up to his own standards of unaffected honesty and naturalness. Roché's impression was less favorable. On the night he met Lydie, his journal entry read: "desastrous [sic]—but it may change—I hope it will." The engaged couple looked at apartments together and window-shopped for furniture. Duchamp had recently moved into a two-room seventh-floor walk-up at 11, rue Larrey, in a quiet neighborhood not far from Montparnasse; since this was too small for a couple, they had decided to keep it as his studio and to look for another place to live. As the June 8 wedding date approached without their having found anything suitable, though, Duchamp got Man Ray and Antoine Pevsner, the Russian refugee artist, to help him install a bathroom at 11, rue Larrey. They did so by borrowing space from the tiny bedroom and installing a door at such an angle that it served for both bedroom and bath.

Lydie's father brought his mistress, Jeanne Montjovet, to see the rue Larrey flat. He commented that the bed looked much too narrow. ("If he had known that we had tried it out!" Lydie wrote years later in her privately printed memoir of the marriage and its aftermath.) Hearing shouts in the street below, they all went to the window and saw people pointing to a dot in the sky. It was the *Spirit of St. Louis,* coming in for its historic landing. The four of them decided to drive out to Le Bourget to welcome Lindbergh, but everyone in Paris appeared to have had the same idea—they were stuck in traffic for several hours.

Katherine Dreier learned of the wedding only a few days beforehand. "An important news," Duchamp wrote her in a letter dated May 27. "I am going to be married in June—I don't know how to tell you this, it has been so sudden that it is hard to explain." Mlle Sarazin-Levassor "is not especially beautiful nor attractive," he said, "—but seems to have rather a mind which might understand how I can stand marriage." Duchamp went on to say that the marriage was not going to make him rich because "her money is for the present hardly enough to make her live, and is hers." Then why was he doing it? One sentence in the letter to Dreier may be as close as Duchamp ever came to an explanation: "I am a bit tired of this vagabonding life and want to try a partly resting one—whether I am making a mistake or not is of little importance as I don't think anything can stop me from changing altogether in a very short time if necessary."

Worshipers at the shrine of Saint Marcel tend to touch very lightly, if at all, on his marriage to Lydie. Arturo Schwarz deals with it in a brief paragraph, Robert Lebel in a single sentence. Some of Duchamp's friends claimed that Picabia put him up to it as a sort of Dadaist joke, but in that case the episode becomes even more discreditable—if it was a joke, it was a singularly heartless one. The unavoidable conclusion seems to be that Duchamp had made a cold-blooded decision to marry for money. Not a great deal of money, as he emphasized in his letter to Dreier, but Henri Sarazin-Levassor, after all, was the son of a highly successful automobile manufacturer, the co-founder of the company that made Panhard cars, and Duchamp must have thought that the marriage would bring him a measure of financial security. One of the more puzzling aspects of the whole affair is that when he learned at the formal signing of the marriage contract, in the presence of lawyers representing both parties, that the sum Lydie's father was prepared to settle on her came to only 2,500 francs a month (slightly more than $1,000 in today's terms of exchange), Duchamp did not immediately back out. He turned pale, according to Lydie, but he signed the contract. Afterward he took her to the Luxembourg Gardens, sat her down, and somberly informed her that he had no regular income of his own. Lydie went home that day feeling "annihilated." Could it be true that Marcel was a fortune hunter, as her mother had been telling her all along? Or was he just trying to warn her that their life together would not be an easy one? She chose to believe the latter explanation. The wedding plans proceeded on schedule.

Duchamp and Lydie Sarazin-Levassor, June 8, 1927.

Lydie insisted on a formal "white" wedding, with bridesmaids and ushers, banks of flowers, and nearly a hundred guests. Man Ray brought along his movie camera to film the bridal couple as they left the Protestant Temple d'Etoile on the avenue de la Grande-Armée (the Sarazin-Levassors were Protestants); in the film Lydie looks happy and voluminous in yards and yards of white tulle, while Marcel, wearing a large white carnation in the

buttonhole of his morning coat, looks terminally solemn, and Picabia, who had acted, with Villon, as a witness at the civil ceremony the day before, appears to be roaring with laughter. The reception took place immediately afterward at the Sarazin-Levassors' large house at 6, square du Bois de Boulogne, where the wedding gifts—a daunting assortment of lamps, vases, and tableware—filled several long tables. From there the newlyweds went on to Brancusi's studio on the impasse Ronsin for an intimate dinner with Germaine and Francis Picabia, and after that they went home to the narrow bed at 11, rue Larrey.

Reactions to the marriage shot back and forth among Duchamp's friends on both sides of the Atlantic. Carrie Stettheimer arrived in Paris two days after the wedding, met the bride, and wrote home to her sisters that Duchamp had married "a very fat girl." Ettie passed the news on to Alfred Stieglitz, adding that she felt sorry for Duchamp. "I rather expected just about this to happen," she wrote grimly, "even the lack of practical brilliancy to the solution."

"Duchamp married!!!" Stieglitz replied. ". . . I oughtn't to be surprised for last winter I remarked to him now that he had become a 'Salesman of Art'—what next? . . . At any rate it's a woman he married. That's all right enough to suit any of us insisting on Convention of some sort being served—even by Duchamp."

Henry McBride, informed by Florine Stettheimer that Duchamp had married "a very fat girl . . . very, very fat," wrote back to ask, "Why didn't he then, since he likes 'em fat, marry Katherine Dreier?" Miss Dreier may have been wondering the same thing. She pulled herself together, though, sent the newlyweds a silver bowl from Tiffany, and recast her relationship with Duchamp in a new light; from now on, "Dee" would be her "adopted son." Falling easily into the maternal role, she wrote to him that, judging from the photograph of Lydie that Man Ray had sent her, his new wife was "very powerful. Of course I know that if she becomes too powerful that out of self-protection you will vanish as you always have. I hope that with her power she has the wisdom to keep it in check." As for Dreier's own hurt feelings over not being invited to the wedding, "It was very neglectful but a mother forgives much."

In Lydie's memoir the first weeks of their marriage were blissful. Unable to leave Paris because of Duchamp's various business dealings, which included the sale of his two Picasso drawings at the Hôtel Drouot,

they took a "gastronomic" honeymoon in the different quarters of Paris, dining out every night at a different restaurant. This was evidently one of Lydie's favorite pastimes, and she was delighted to find Marcel "a real epicure, drawn to all the sensual pleasures, except music." It amazed her that he "owned nothing: no object, no family furniture, no souvenir. All he had was contained in an old trunk where he kept a few photos and notes relating to his past work." She also learned that "he had an almost morbid horror of all hair." When he urged her to remove her body hair, she was happy to comply. "Why not, if it pleased him?" Until the end of June, she said "we were very close, very intimate."

Her rosy picture of their first weeks is borne out, more or less, in a letter from Duchamp to Walter and Magda Pach in New York. The marriage was "a charming experience so far," he wrote, "and I hope that will continue. My life hasn't changed in any way, I must make money but not for two." He looked forward to having the Pachs meet his wife, "who is really very nice."

The notion that his life would remain the same was something he clung to tenaciously. "As I said in my first letter, my life won't be changed essentially and if I have to make my living I don't intend to feel too responsible for the upkeep of a household," he wrote to Katherine Dreier. By the middle of July, though, marital tensions were building up. The trouble had started, according to Lydie, with the arrival in Paris of American "clients" of Marcel's. The client in this case was Mrs. Charles Rumsey, the woman who had helped Duchamp and Roché buy the Brancusi sculptures. Brancusi had agreed to design a spiral staircase for her house, and Duchamp, who was helping him calculate the measurements, rented a hotel room to work in. He began spending more and more time in his hotel room. At home he was often lost in silent meditation, looking out the window and smoking his pipe. Lydie finally met the American clients at a dinner party in Brancusi's studio, but they interrogated her so mercilessly, she felt, about her family and her views on modern art (of which she knew nothing) that she was humiliated. Marcel, moreover, sat by and did nothing to stop "the massacre."

In August they left for the south of France in Lydie's little Citroën. (Lydie drove; Duchamp had never learned how.) They spent the first night in Tournus and saw an amazing sight—a great cloud of small insects hovering over the banks of the Saône, and the townspeople capturing them in

large sacks. "What could they do with them?" Lydie wondered. "Perhaps they are edible," Marcel suggested. "Ephemeron omelette! What a specialty." The next night they saw a play at the Roman amphitheater in Orange. Lydie's hopes for the marriage rose again during this trip, but at Mougins, which they reached after three days of driving, there was little chance for intimacy *à deux*. They stayed in the house that Lydie's father had built for Jeanne Montjovet, who was on hand to welcome them. The Picabias' Château de Mai was nearby; so was the little vacation house that Marcel's sister Suzanne and her husband, Jean Crotti, had recently acquired. Man Ray and Kiki, who were vacationing in Cannes, often appeared for meals. Crotti asked Lydie to pose for him in the nude; to Lydie's dismay, Marcel offered no objection. Duchamp himself was mostly absent, playing in a chess tournament in Nice that he had entered as a warm-up for the French championships, which were being held the next month in Chamonix. According to Man Ray (an inventive and none-too-reliable witness), Lydie became so annoyed by Duchamp's staying up very late to study chess problems that one night, after he had finally gone to sleep, she got up and glued the pieces to the board.

Duchamp went to Chamonix at the beginning of September, leaving Lydie in Mougins. Although he played well against the eventual winner of the tournament—their match was a draw—he disappointed himself by finishing in seventh place overall. When Lydie arrived on the day after the tournament ended, having driven alone over the Alps from Mougins, she found him thin, tired, and in very low spirits. He shocked her by putting part of the blame for his mediocre performance in the championships on "the amorous excesses we had engaged in during the preceding weeks." (Amorous excesses? Lydie's narrative is sometimes baffling.) Their trip back to Paris in Lydie's car was a nightmare, plagued by engine trouble and broken springs.

Before they left for the south of France, Duchamp had found an apartment for them at 34, rue Boussingault, out near the Parc Montsouris. Lydie, who was paying the rent on it, had her furniture brought over from her family's house, but nothing had been unpacked on the day they were supposed to move in, and so she insisted, over Duchamp's strenuous objections, that they spend one more night at 11, rue Larrey. When they went there, though, she discovered that in the few hours since she had moved her belongings out, Duchamp had restored everything exactly the way it had

been before the wedding. "That extra night was one night too many," she lamented in her memoir—a document written many years later, it should be remembered, and perhaps not infallible. (Duchamp never gave his side of the story.) She described him as being cold and distant toward her the next day. After dinner he told her that he was going to play chess with Man Ray, and he did not come back to the rue Boussingault, not that night or any other night. For a few weeks they continued to see each other during the daytime. Then, in late October, Duchamp asked her to come to the rue Larrey for a talk. He explained, as gently as he could, that he could no longer support the moral weight and responsibility of marriage. He wanted a divorce, he said, but then he added, according to Lydie, that it would change nothing between them—they could continue to see each other and be close. Lydie agreed, as she usually did. She applied for a divorce on the grounds of desertion.

They had a few amicable lunches and dinners together after that. Toward the end of January, Duchamp left Paris by train for Hyères, where he was to play in a chess tournament. Lydie drove down a few days later, as agreed, only to find that he had arranged for her to stay in a separate hotel. When he took her to her room there and she tried to embrace him, he rebuffed her, saying, "Haven't you understood yet?" Their divorce was granted on January 25, 1928. Poor Lydie, who would eventually remarry, have a son, and write her sad memoir, never understood any of it.

The Most Singular
Man Alive

Don't see any pessimism in my
decisions: they are only a way
toward beautitude.

I enjoy every minute of my old self again," Duchamp wrote to Katherine Dreier from Nice, where he was living "bachelorly" after his recent divorce. "The 'wife,' " he added, was nearby in Saint-Raphael; they still saw each other every other week. He had won a chess tournament in Hyères and had also been awarded the brilliancy prize for his second-round victory against the English player H. Smith. "Chess is my drug, don't you know it!" he wrote, signing the letter, "*Affectueusement,* Dee(Vorced)."

He showed no remorse over the failed marriage. He simply resumed his former life, as though nothing had happened. Mary Reynolds took him back. She had been devastated by the marriage, according to Roché and others. Her friend Kay Boyle, the novelist and short story writer, remembered her going "on a sort of wild thing afterward," drinking heavily and sleeping with other men. "She was so devoted to him," Boyle said, "and she could never explain why. It occurred to me many times that Marcel had all these things you would normally disapprove of—he was disloyal to the women he fell in love with, he would do anything to get some money—and yet, with Marcel, you accepted it. I think he just assumed he was going to be able to continue his love affair with Mary after he got married. Later, when he did something to disappoint her, she would often say, 'That's when I

should have kicked him out, when he came back from that marriage.' But of course she never did."

It was hardly accurate to say that Duchamp would do anything to get money. Man Ray tells in his autobiography of having dinner one night in the 1920s with "the old art dealer Knoedler who expressed regret that Duchamp did not paint any more. The dealer appealed to me, asked me as his friend to speak to him and say that there was ten thousand dollars a year at his disposal if he would return to painting—all he need do was to paint one picture a year. When I broached the offer to Duchamp he smiled and said he had accomplished what he had set out to do and did not care to repeat himself." Joseph Brummer, who had been very impressed by Duchamp's hanging of the 1926 Brancusi show, offered him a thousand dollars a month in 1928 to come to New York and run his large new modern art gallery. Duchamp told Katherine Dreier that he was "almost ready" to accept the position, but in the same letter he said that he had arranged his rue Larrey studio so perfectly "that I don't see why I should ever make any effort toward 'more money' as it costs me very little to live this way." He didn't take the job. Duchamp preferred to eke out a living through occasional forays into the art market, even though he was coming to detest the commercial side of art more and more. "The feeling of the market here is so disgusting," he wrote to Stieglitz. "Painters and Paintings go up and down like Wall Street Stock. It was not exactly like that 20 years ago, and much more amusing."

His sour feelings about the market and the artists who made themselves dependent on it spilled over in a letter to Katherine Dreier, who had told him that she was thinking of suspending the Société Anonyme's activities for lack of support:

> The more I live among artists, the more I am convinced that they are fakes from the minute they get to be successful in the smallest way.
>
> This means also that all the dogs around the artists are crooks. If you see the combination *fakes and crooks* how have you been able to keep some kind of faith (and in what?) Don't name a few exceptions to justify a milder opinion about the whole "art game." In the end, a painting is declared good only if it is worth "so much." It may even be accepted by the "holy" museums. So much for posterity.
>
> . . . This will give you an indication of the kind of mood I am in—stirring up the old ideas of disgust. But it is only on account of

Duchamp with
Katherine Dreier in
Seville, 1929.

you. I have lost so much interest (all) in the question that I don't suf-
fer from it. You still do.

Dreier dismissed this sort of talk, setting it down to Duchamp's habit-
ual pessimism. She would keep the Société Anonyme going for another ten
years, often enlisting his help to do so, and she continued to ask his advice
about the problems of her busy, public-spirited life. There has been specula-
tion that she gave him money in these years, but this seems not to have been
the case; the checks that she deposited to his account were installments on
the money she owed him for Brancusi's *Maiastra,* which she bought from
him and installed in the garden of her country house in Connecticut.

Although Dreier was hit hard by the Depression, she would buy three more Brancusis from Duchamp during the next decade. She continued to live comfortably enough, but she often complained of being in financial straits in the 1930s and 1940s, and Duchamp often had to wait for payment for the expenses he incurred in carrying out her many requests.

When they were together, it was understood that Miss Dreier would pick up the check. In the early spring of 1929, she got him to accompany her and her Scottish companion, a Mrs. Thayer, on a five-week motor trip through Spain. Duchamp met their boat at Gibraltar and traveled with them to Málaga, Granada, Ronda, Seville, and Madrid. A few weeks later, wearing a new suit that Miss Dreier had bought for him, he met her again in Germany; they went to Hanover to visit Kurt Schwitters and then to Dessau, the new home of the Bauhaus, where they were cordially received by Wassily Kandinsky, the director, and his wife. Kandinsky's theories about the spiritual dimensions of art held great appeal for Dreier, whose Germanic soul vibrated to the call of the ideal. Both Kandinsky and Dreier were avowed theosophists, believers in the existence of a spiritual reality that was available to certain individuals who had attained—either through natural clairvoyance or by means of long meditation and study—a high degree of psychic awareness. Kandinsky was such a person, in Dreier's view; but then, so was Duchamp. In spite of the cynicism and the sometimes wayward behavior of her "adopted son," she truly believed him to be in touch with spiritual insights of the highest order, insights that had allowed him to turn his back on fame, material goods, and every other distraction in order to pursue his own way in the world, which was the way of self-knowledge.

Time after time during these years she turned to him for guidance and support. Usually her requests were practical and immediate, and he took care of them without complaint. He rounded up the works of art she wanted to borrow for her exhibitions, and he met her at the boat or the train station on her trips to Paris. When she decided she wanted to live for part of the year in Paris, he even rented an apartment for her on the Ile de la Cité and helped to furnish and decorate it. "England loved my beauty," Dreier rhapsodized in a letter to Duchamp, "—so I was there when I was at my best—Germany loves my spirit—and now maybe the time has come that France will love me because of my intelligence and discrimination." (France apparently failed to do that. Dreier, who spoke no French, soon changed her mind about living

in Paris, and Duchamp had to get her out of her seven-year lease.) Her letters to him are rambling and diffuse; his replies (often long delayed) are brief and to the point. "Do you think that I am terrible that I always want you to help me?" she asks him. "But somehow I always turn to you—sometimes I feel that you are another side of me . . . So, no matter how often you say no— I always come back."

Now and then she pushed too hard. "You must understand . . ." he wrote to her in 1929, when she was trying to persuade him to become the salaried manager of a revived Société Anonyme, "it can be no more question of my life as an artist's life: I gave that up ten years ago; this period is long enough to prove that my intention to remain outside of any art manifestation is permanent." He did not want to come to America, as she had been urging; he told her that he preferred to be alone as much as possible and that he refused to fight for any belief or cause. "Don't see any pessimism in my decisions: they are only a way toward beautitude . . ." he wrote. "Please understand that I am trying for a minimum of action, gradually."

Dreier came to Europe again in the spring of 1931. "Well are you going to meet me in Paris or are you going to meet me in Cherbourg?" she had demanded. "Am I going by train or will we motor?" Her autocratic bluster was nothing new, but this time it could barely conceal her inner anxiety. She had some very bad news, which she waited to tell him until several days after her arrival, when they were having lunch alone together in a restaurant in Lille. Two months earlier the crate containing *The Large Glass*—in storage since the closing of the Brooklyn Museum exhibition in early 1927—had been shipped from the Lincoln Warehouse to "The Haven," Dreier's country house in West Redding, Connecticut, where she planned to have it permanently reinstalled. On opening the crate, however, the workmen had discovered that the two heavy glass panels, packed one on top of the other with very little in between, were shattered from top to bottom. Duchamp's first reaction was to console Dreier, who seemed so upset by the disaster that she could hardly speak. "That's too bad. Too bad," he said quietly. Years later, in retrospect, he remembered that he really hadn't felt much emotion when he heard about it. "I was a little sorry, that big thing. I didn't know how much it was broken, whether it could be repaired or not. But on principle I was not going to cry. Because after all, it had no value in the artistic world at that time, nobody cared for it, nobody saw it or even knew about it." A refusal to cry, to react emotionally, to become involved in

any sort of behavior that might interfere with his freedom of thought and action: was this the beauty of indifference? At the time, anyway, the shattering of Duchamp's most important work seemed like one more confirmation of his decision to give up being an artist.

The energy and ambition that he had once poured into art now belonged exclusively to chess. Duchamp played two of the finest matches of his career at the 1930 Tournoi International de Paris, where he competed against some of the world's top players. Although he finished in last place overall, he defeated the Belgian champion, George Koltanowski, and he drew his match against Xavier Tartakower, the tournament's eventual winner. The next year and for several years following, he played in international competitions as a member of the French chess team, whose captain, the Russian-born Alexander Alekhine, had wrested the world championship from Capablanca in 1927. Alekhine was one of the great players of all time, but the French team seldom won during those years—a fact that suggests the team's other members were not very strong. Duchamp lost many more matches than he won. He was coming to realize that he did not have it in him to play consistently at the highest level, the level of a Tartakower or an Alekhine. Duchamp had become one of his country's best players, a remarkable accomplishment in itself, but he was not a chess genius, nor was he in those years a particularly innovative tactician. He stuck to the classic principles he had studied in the chess literature, and because he was often matched against stronger players, his strategy tended to be cautious rather than daring. The absolute iconoclast in art became in chess a sound and sober conformist. Later on in life, when he played mainly for his own amusement, he was able to give his chess imagination a freer rein. The American grand master Edward Lasker considered him "a very strong player" and "a marvelous opponent," one who "would always take risks in order to play a beautiful game, rather than be cautious and brutal to win." If American chess players had been ranked in the 1950s, said Lasker, Duchamp would certainly have been in the top twenty-five.

"Of course you want to become champion of the world, or champion of something," Duchamp said once, referring to his early ambitions as a professional chess player. "I never succeeded, but I tried, for ten years or so I really took it quite seriously." He gave up his championship ambitions in 1933, the year he played in his last important tournament, at Folkestone, England. By then, however, he had already begun to find other outlets for his love of the

game. For more than a year he had worked, in collaboration with the well-known German chess expert Vitaly Halberstadt, on the text of a chess book that was entirely devoted to a very rare situation in the end game, when all the pieces have been captured except for the opposing kings and one or two pawns on each side. Published in 1932 as *Opposition and Sister Squares Are Reconciled,* this beautifully printed and somewhat arcane study excited only modest interest in chess circles; today it is known primarily as a rare item in Duchamp's ever-expanding oeuvre. Duchamp also translated (from very bad French into good French) the text of a much more influential handbook on chess openings by Eugène Znosko-Borovsky, whom he had played against in several tournaments, and for several years he would write a weekly chess column (unsigned) for the Paris newspaper *Ce Soir,* whose editor was the Surrealist poet Louis Aragon. In 1935 he began to explore the strange, hermetic world of correspondence chess. The snail-like pace of this form of chess, in which a contestant receives his opponent's move in the mail and then has a limited time in which to send off his answering move, must have suited Duchamp's solitary frame of mind at the time. He won the First International Chess by Correspondence Olympiad, which took four years to complete, and also a concurrent correspondence chess master tournament, going undefeated and scoring nine points out of a possible eleven in both. Roché remembers visiting Duchamp at the time in the rue Larrey studio, which was "arranged like a boat," and seeing him "with his pipe, settled in a deep chair not too far from his well-regulated Irish stove, carrying on four chess games by mail, working out his moves on four large vertical chess boards attached to the walls. He was so obviously content that we got in the habit of not disturbing him."

Duchamp took no part in the schisms and upheavals of the Surrealists, who broke apart over the movement's relationship to the Communist party. Breton's "revolution in consciousness" had embraced Marx as well as Freud. Proclaiming that in order to change life it was also necessary to fight for social and economic justice, Breton had led his followers into a shaky alliance with the Communists in 1925, but he insisted on preserving Surrealist freedom of thought. This haughty attitude, which merely irritated the Communist authorities in Moscow and Paris, set off an internal feud between Surrealists (like Louis Aragon) who favored a total commitment to Moscow and those who wanted no political alliances of any sort. Enraged by the challenge to his own supreme authority, Breton formally expelled most

of his early disciples in 1929 and issued a Second Surrealist Manifesto, in which he announced that the movement would now go in the direction of a "true and profound occultation." Surrealism, however, was then in the process of changing from a literary and political movement into an artistic one. From 1930 on, it would be dominated by visual artists, the best of whom were far too independent to submit to any sort of party discipline or shared purpose. Max Ernst, Yves Tanguy, René Magritte, Joan Miró, and (especially) Salvador Dalí made Surrealism a household word during the ensuing decade, but their widely differing explorations of subconscious material had very little to do with the movement's original, messianic goals.

The two artists whom Breton most wanted to claim for Surrealism were Picasso and Duchamp. In his 1928 essay "Surrealism and Painting," Breton spoke of Picasso as "the man from whom we persist in expecting more than from anyone else," and he went so far as to say that "a single failure of will power on his part would be sufficient for everything we are concerned with to be at least put back, if not wholly lost." The series of "monster" paintings that Picasso did in the late 1920s clearly suggest the influence of Surrealism, with their malignant heads and brutal distortions of the human body, but Picasso also continued to paint in at least two other very different styles—synthetic Cubist and neoclassical—and he never showed any inclination to fraternize with Breton or others in the Surrealist group. As for Duchamp, whom Breton described as "the most singular man alive as well as the most elusive, the most deceptive," there was never any question of his formal adherence to the movement. Duchamp was friendly with Ernst, Tanguy, Dalí, and several other Surrealist painters, whose work he approved of because, in addition to its innovative qualities, it appealed to the mind as well as the eye. But programmatic delving into the unconscious was not exactly Duchamp's style, and besides, he suspected that some of the Surrealist artists were doing a little too much delving, turning what should have been a disinterested experiment into a production-line operation for the dealers who were making Surrealism the height of chic in Paris and New York. The commercial recognition of Surrealist painting was reason enough for Duchamp to give it a wide berth.

During the 1930s Duchamp and Mary Reynolds settled into a more comfortable pattern of life together. Mary had moved from her apartment near the

Eiffel Tower to a small house on the rue Hallé, in a quiet neighborhood out beyond the Lion de Belfort. "Totor is nicely installed with Mary," Roché wrote in his journal, "that is, he comes to see her every day." The house had an inner courtyard with a pretty garden and one big tree, and the rooms were furnished in a comfortably bohemian style—stone floors, no carpets, an old sofa covered with a wonderful piece of material. Duchamp took an interest in the decor, according to Man Ray; he wallpapered one of the small rooms with maps and devised a pair of curtains made from closely spaced strings. Mary's niece, Marjorie Watkins, who came to visit her there several times, remembered that the house had a warm, relaxed feeling. "Often there would be people for dinner, but informally—it was not a salon. Mary was a fine cook, and the food was delicious. With Mary you just had a sense of constant celebration. Her eyes twinkled, and she always seemed about to smile. Gentle Mary, we called her—she was very soft-spoken—but there could be explosions when she got ruffled. The relationship between Mary and Marcel seemed very settled and harmonious. Marcel was just there, always, although I don't remember whether he stayed overnight or not." Most nights, in fact, he insisted on going back to his seventh-floor retreat on the rue Larrey.

Mary Reynolds had taken up bookbinding. She apprenticed for a year at a commercial bindery in Paris, then set up shop in her house on the rue Hallé. She became known for using highly unusual materials (such as perforated copper, sponge rubber, and toad skin) to bind single copies of books that appealed to her: the Shakespeare and Company edition of James Joyce's *Ulysses,* Henry Miller's two *Tropics,* twelve books by Raymond Queneau and six by Alfred Jarry, and a thin volume of Duchamp's puns, among others. Duchamp designed the ingenious binding that Reynolds made for Jarry's *Ubu Roi.* Its front and back covers were cut out to form two large U's, which when the volume was opened, flanked an elongated B on the spine to spell out UBU.

When Duchamp went to another city or country to play in a chess tournament, Mary Reynolds would sometimes meet him there, and they would travel together afterward. They visited Budapest and Vienna that way, and Aix-les-Bains, and London. For several years they spent the month of August in a villa that Mary rented in Villefranche-sur-Mer, on a hill overlooking the Mediterranean. Brancusi came to stay with them there in 1931; he set up his big camera on the terrace and took the photograph that was used on the cover of the Duchamp-Halberstadt chess book—a picture of

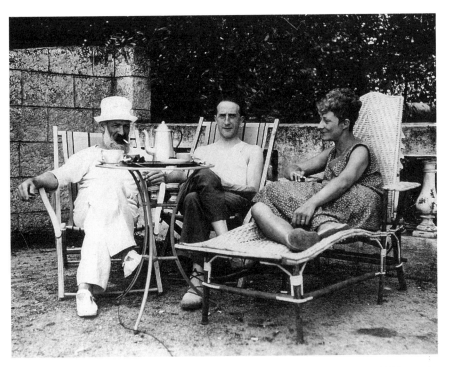

Brancusi, Duchamp, and Mary Reynolds in Villefranche, summer 1931.

the shadows cast by zinc stencils of the title and the authors' names. In 1933 Mary, Marcel, and their friend Mary Callery, an American sculptor, discovered Cadaqués, a fishing village on the Spanish coast north of Barcelona, where the prices were much lower than in France. "Ideal weather and charming peseta," Duchamp wrote to Man Ray, who joined them there a few days later. They also saw a lot of Salvador Dalí and Gala Eluard, his Russian-born companion and muse. Dalí, who was born and raised in this region, returned often to paint in the tiny village of Port Lligat, a short walk from Cadaqués. His obvious admiration for Duchamp seemed to make him behave less outrageously than usual, and Duchamp found him excellent company. Even Gala, a voracious man-eater who had left the poet Paul Eluard because she sensed that she could get more mileage out of Dalí's genius, was on her best behavior that summer.

There was something inconsistent about Duchamp's attitude toward art and artists. In spite of the disgust he felt for the art market and the "fakes and crooks" who exploited it, in spite of his own retirement from art

making and his concentration on chess, he never turned his back on the art world. Most of his friends were artists. He saw Man Ray nearly every day, and Brancusi once or twice a week, and he kept up with interesting new developments in art. It was Duchamp who suggested to Alexander Calder, an American living in Paris, that he call his wire sculptures with moving elements "mobiles"; Calder used that title for the first time a month later, when he showed them at the Galerie Vignon in 1932. Duchamp, moreover, continued to earn his living by selling works of art to a few select customers, including his old friend Walter Arensberg.

After several years in which there had been no communication between them, Arensberg had written a letter to Duchamp in 1930 that rekindled the friendship. "It is still the great lacuna that I never see you . . ." he began. "There isn't a day that I don't pass some time with your pictures. They are your conversation." Arensberg went on to say that he had recently bought Duchamp's *Portrait of Chess Players* from the widow of Arthur Jerome Eddy (who had bought it out of the Armory Show). He also asked whether Duchamp or Roché might help him repurchase Brancusi's marble *Newborn* (Arensberg referred to it as *Tête d'enfant*), which he and Lou had once owned—it was one of the two works they had sold when they were feeling financially pressed, the other being *The Large Glass*. Duchamp was happy to oblige, since the marble *Newborn* had been sold to John Quinn and was now owned by Duchamp and Roché. The Arensbergs were terribly shocked by the $1,000 asking price—Louise Arensberg wrote indignantly to Beatrice Wood that Duchamp and Roché "are simply trying to play us for suckers"—but they ended up buying it anyway, and from then on Duchamp would act as their unofficial purchasing agent in Europe, taking a small commission on each work that he bought for them and shipped to their California home. The Arensberg collection would eventually come to include thirty-five works of art that had been acquired through Duchamp, in addition to thirty-six works by Duchamp himself.

In the past Duchamp had often told the Arensbergs and others that he wished they would not lend his own works for exhibition purposes, but that injunction was no longer in force. He gave Arensberg permission to lend *Nude Descending a Staircase, No. 2* to a gallery exhibition in New York in 1930, and throughout the decade works by Duchamp kept appearing in group exhibitions in the United States and Europe. It was clear that he kept a watchful eye on the peregrinations of his paintings and *objets*. When

Jacques Doucet died in 1930, Duchamp was very pleased by Madame Doucet's decision to give the *Rotary Demisphere* to Roché, and Duchamp himself saw to it that *Glider,* his important study for an element in *The Large Glass,* eventually went to the Arensbergs.

Another large Brancusi exhibition at the Brummer Gallery brought Duchamp back to New York again in the fall of 1933, for the first time in seven years. Brancusi didn't come over—he trusted Duchamp to install his fifty-eight sculptures and to deal with any problems that might arise. None did arise—the amateur critics at the United States Customs had been obliged by a 1928 court decision to acknowledge that Brancusi's work was indeed art—and while only five of the sculptures found buyers (it was the depth of the Depression), Duchamp could report to Brancusi that the show had been a success with the critics and the public. He went down to Philadelphia one day to meet Albert Barnes, the collector, in hopes that he would buy a Brancusi; although the terrible-tempered Barnes was "very kind," according to Duchamp, in showing him around his collection of modern masterpieces, there was no sale. Duchamp also visited Katherine Dreier's country house in Connecticut and assessed the damage to his *Large Glass.* It could be repaired, he decided, but he would need at least a month to carry out the laborious, sliver-by-sliver reconstruction. That job would have to wait until his next trip over.

New York in the Depression was not nearly so grim as the Paris that Duchamp returned to early in 1934. The buoyant optimism of only a few years earlier, when France's thriving economy, brilliant social and artistic life, and skillful diplomacy had established it once again as the leading power in Europe, had been undermined by the worldwide Depression and also by the internal hatreds and conflicts that occasionally boil over and disrupt the surface *bonheur* of French life. Political rallies in Paris often broke up in pitched battles between Communist and ultra-right-wing groups such as the Camelots du Roi. On the night of February 6, the worst street rioting since the days of the Paris Commune in 1870 left thousands injured and sixteen dead on the place de la Concorde and brought down the Daladier government. To many of its frightened citizens, France seemed dangerously close to civil war.

The conflicts between right- and left-wing zealots meant little to Duchamp, whose political attitudes were governed by the same beauty of indifference that he applied to life and art. Soon after he returned from

New York, he set to work on a new project, which was to gather together and publish all his notes relating to *The Large Glass*. He had intended originally to make the notes available to viewers of *The Large Glass* in some "dry" and nondidactic form—like a Sears, Roebuck catalog, as he put it. In the *Box of 1914* he had reproduced sixteen of the notes and one drawing as a sort of trial run, but there were only four copies of the *Box of 1914* (he had given the original notes to the Arensbergs in 1915), and the project had lain dormant ever since. Now, twenty years later, Duchamp took it up again. There was nothing tentative about his approach this time. Duchamp had always maintained that his *Glass* was not just something to be looked at but "an accumulation of ideas," in which verbal elements were at least as important as visual ones, perhaps even more so. Without the notes, after all, nobody looking at the *Glass* would have the slightest idea what the various visual elements represented or what they were doing there. As Duchamp would say in a 1959 interview, he had "tried in that big Glass to find a completely personal and new means of expression; the final product was to be a wedding of mental and visual reactions; in other words, the ideas in the Glass were more important than the actual visual realization." Since the ideas were contained (more or less) in the notes, their long-delayed publication would become a new chapter in the continuing saga of his unfinished, shattered, but far from defunct masterpiece.

It was important to Duchamp that his original notes be reproduced exactly as they were, with all their crossings-out and revisions, second thoughts, incomplete phrases, contradictions, marginal scribblings, ink blots, and pencil smudges. In later years Duchamp admitted that some of the notes had deteriorated so badly that he was obliged to recopy them, but even there he went out of his way to make the reproductions conform in every detail to the originals, some of which were no more than tiny fragments torn from envelopes or bits of wrapping paper. "I wanted to reproduce them as accurately as possible," he told Michel Sanouillet in 1954. "So I had all of these thoughts lithographed in the same ink which had been used for the originals. To find paper that was exactly the same, I had to ransack the most unlikely nooks and crannies of Paris. Then we cut out three hundred copies of each lithograph with the help of zinc patterns that I had cut out on the outlines of the original papers."

This absolute fidelity to the physical appearance of his notes is puzzling. If the ideas in them were what mattered, why wouldn't he have wanted to

make those ideas as clear as possible—for example, by getting rid of inconsistencies and contradictions? One reason could have been that the ideas themselves were not as important to him as the process by which they had come into existence—the *passage* from a thought's conception to its later development. Not for the first time, Duchamp was invoking the elements of time and delay, which had been profoundly important to his conception of *The Large Glass*. If the process of making art (or thinking) was more significant than the result, moreover, then by implication the viewer, by being drawn into that process, would become an active participant rather than a passive observer. This notion, which goes back to Mallarmé and the Symbolists, is one of the keys to Duchamp's continually expanding influence today, when art increasingly has come to be seen as a process that involves the artist, the art object, and the viewer in an open-ended game of mutual creation and interpretation.

He had selected for reproduction seventy-seven notes and sketches that were directly related to *The Large Glass*. In addition, he made reproductions of seventeen of his earlier works—from the 1911 *Coffee Mill* to *The Large Glass* itself (shown in a photograph taken while it was still intact and on exhibition at the Brooklyn Museum). He also included a few oddities such as Man Ray's *Dust Breeding* photograph and the score for the musical composition that Duchamp and his younger sisters had made in 1913 by drawing notes out of a hat. The total came to ninety-four separate items, which he published, unbound and in no special order, in a rectangular green flocked-cardboard box. The title, picked out in white dots on the front and the spine of the box, was *La Mariée mise à nu par ses célibataires même*—exactly the same as *The Large Glass*, except for the omission of the comma between *célibataires* and *même*.

Duchamp planned to bring out his *Green Box* in an edition of three hundred, plus ten deluxe copies, each of which would contain one of the original notes. He was counting on a small family legacy to help him pay for the reproduction and printing costs, but the whole operation became so expensive that he turned to Roché for help. In exchange for the necessary funds, Duchamp gave Roché *Cariatide,* one of his Brancusi sculptures; later he borrowed an additional 5,000 francs with another Brancusi as collateral. The printing was done during the summer, carefully supervised by Duchamp, and the first boxes appeared in September 1934, along with an announcement that listed the publisher as Editions Rrose Sélavy, 18, rue de la Paix—the address of an American bank that failed soon afterward.

"Well dear your amazing book has arrived!!!!" Katherine Dreier wrote to him a month later. "It is one of the most perfect expressions of Dadaism which has come my way. I was terribly amused at myself, how annoyed I was when I saw all those torn scraps—and of course the glass *was* broken!!!! At first it seemed to me that I just could not bear all those torn pieces of paper—and then I woke up to the fact—how right Dada is to jolt us out of our ruts." In her eagerness to respond favorably, Dreier had got it all wrong, as usual—some of the notes may have a Dada bite to them, but the whole painstakingly crafted enterprise was hardly Dadaistic. Dreier did everything she could to publicize and promote her adopted son's latest enterprise, however, and so did other friends of Duchamp's in Europe and the United States. By the end of that year, Duchamp was able to write to Dreier that he had sold ten deluxe and thirty-five ordinary boxes and had almost recouped his printing costs.

No one read the notes in *The Green Box* with more enraptured interest than André Breton. Here, at last, was a miraculous text of the kind that Breton lived for, "a capital event," as he described it in a famous essay, "in the eyes of all who attach any importance to the determination of the great intellectual motives of our day." The title of Breton's essay, "La Phare de la mariée" ("The Lighthouse of the Bride"), echoed Baudelaire's reference to certain great artists as "lighthouses" for future generations. It appeared in the December 1934 issue of *Minotaure,* the lavishly printed art magazine whose editors, Albert Skira and Edouard Tériade, had commissioned Duchamp to design the cover—one of his spiral designs from the film *Anemic Cinema* against a background of Man Ray's photograph *Dust Breeding.* Although Breton had seen *The Large Glass* only in reproductions, he did not hesitate to put it in the highest rank of contemporary masterpieces. "In this work," he wrote, "it is impossible not to see at least the trophy of a fabulous hunt through virgin territory, at the frontiers of eroticism, of philosophical speculation, of the spirit of sporting competition, of the most recent data of science, of lyricism and of humor." Citing Duchamp's rigorous "spirit of negation" as the source of his unparalleled originality, he provided a brief retrospective survey of the paintings and objects by Duchamp that had led up to his great work and then proceeded to summarize, quoting freely from the notes, the bewilderingly complex series of actions by which the bride sets in motion her "blank desire (with a touch of malice)" and the bachelors respond in their yearning and

servile fashion—right through to the "dazzling of the splash" and the imminent but never-consummated stripping bare of the bride.

It was a virtuoso performance, tuned more to Duchamp's succinct irony than to Breton's sonorous organ notes, and it set a standard that very few subsequent commentaries on *The Large Glass* have come close to matching. The great original, Breton concluded, was not only one of the most significant works of the twentieth century but a prophetic landmark for generations to come. "It is wonderful to see how intact it manages to keep its power of anticipation," he marveled. "And one should keep it luminously erect, to guide future ships on a civilization which is ending."

Vacation in Past Time

Every picture has to exist in the
mind before it is put on canvas, and
it always loses something when it is
turned into paint. I prefer to see
my pictures without that muddying.

In Paris one day, the artist Naum Gabo asked Duchamp why he had
stopped painting. "Mais que voulez-vous," Duchamp replied, spreading
his arms wide, "je n'ai plus d'idées." He would offer other explanations
over the years, but this one was probably closest to the truth. After *The Large
Glass,* Duchamp had run out of ideas, and rather than repeat himself he sim-
ply stopped making art. Early in 1935, however, two new projects began to
take shape simultaneously in his mind. Like *The Green Box,* both of them
involved multiple reproductions of his own past work.

He described the first in a letter to Katherine Dreier as "an album of
approximately all the things I have produced." *The Green Box* had included,
in addition to the ninety-three black-and-white facsimiles of his notes,
sketches, and drawings, a reproduction in color of *9 Malic Moulds.* Duchamp
had chosen to reproduce this painting by means of the slow and antiquated
technique of pochoir printing, in which the color is applied by hand, through
stencils. The result must have pleased him because he now decided to re-
create, in miniature, virtually everything he had done that he considered
worth preserving. He planned to start out by making color prints of ten of
his "better works"; by selling those he hoped to earn enough money to
finance the complete album.

The project, to which he would devote a great deal of time and energy during the next five years, seems incompatible with his principles. Why would Duchamp, who had such a horror of repeating himself, want to undertake the laborious task of reproducing what he had already done? A great deal of critical analysis has been devoted to this question, but the answer may lie simply in Duchamp's failure to come up with new ideas. Since the only art that interested him was idea art—Leonardo's *cosa mentale* —then rather than give up the game entirely (as he often pretended to have done), he would become the principal curator and preserver of his earlier ideas, in the hope, perhaps, that those ideas might reveal themselves in greater depth and complexity. He had come to see the paintings and other works he had done since 1910 as a linked series in a sustained process of thought. Perhaps he had always seen them that way. Certain early paintings—*Portrait (Dulcinea), Coffee Mill*—showed him breaking away from existing art styles to experiment in a new direction, whose main goal was to depict movement on canvas. *Nude Descending a Staircase* and the other paintings of semi-abstract bodies in motion led directly to the *Virgin* and *Bride* pictures, where motion became internalized and psychological, and these in turn prepared the way for the erotic cycle that culminated in *The Bride Stripped Bare by Her Bachelors, Even* and the readymades. All these strange images were steps in the development of Duchamp's complex verbal-visual thinking, with its ambiguous and often jokey references to "the most recent data of science" (Breton's phrase), to non-Euclidian geometry and the fourth dimension, and to the breaking down of barriers between art and life—a process that had been set in motion half a century earlier by Rimbaud and Mallarmé. One idea led to the next, just as each painting or object related to the ones that had gone before and the ones that would come later, and only by seeing the works together could the viewer participate fully in the mental activity that had given rise to them. Of course, he also hoped to earn a little extra income from his efforts. Sales of *The Green Box* had already paid back the initial investment, and there was reason to think that the "album" might do even better.

Duchamp's other new project was more frankly commercial. It was an optical "playtoy," as he explained to Katherine Dreier, adapted from the revolving spiral designs that he had used in his film *Anemic Cinema*. The designs would be printed by photo-offset on cardboard discs, which, when placed on the turntable of an ordinary home record player, would give the

illusion of a three-dimensional image. Duchamp used two of the most effec-
tive abstract designs from *Anemic Cinema,* and he worked out ten other vari-
ations in which off-center circles and ellipses, when activated by turning,
became simple three-dimensional forms such as a wineglass, an egg in a cup,
and a swimming fish. He planned to have the discs made up in sets of six,
playable on both sides and priced at fifteen francs a set. "This second project
is less expensive than the other and I am working very seriously at it," he
wrote to Dreier. "Please don't speak of this, as simple ideas are easily stolen."

Duchamp decided to launch his playtoy at the Concours Lépine, an
amateur inventors' fair held every year on the outskirts of Paris, out near the
Porte de Versailles—it had been started more than thirty years earlier by a
former prefect of Paris named Lépine. With financial backing from Roché,
he managed to produce five hundred sets of the *Rotoreliefs,* as he had decided
to call his invention, and the two entrepreneurs had high hopes when the fair
opened to the public on August 30. Roché couldn't resist going out on open-
ing day to observe the action at the booth that Duchamp had rented. "All the
discs were turning around him at the same time," he reported, "some hori-
zontally, others vertically, a regular carnival . . . but I must say that his little
stand went strikingly unnoticed. None of the visitors, hot on the trail of the
useful, could be diverted long enough to stop there. A glance was sufficient
to see that between the garbage compressing machine and the incinerators
on the left, and the instant vegetable chopper on the right, this gadget of his
simply wasn't useful. When I went up to him, Duchamp smiled and said,
'Error, one hundred per cent. At least, that's clear.' "

In three days he sold two sets to friends and a single disc to a stranger.
Duchamp returned the extra paper he had ordered from the manufacturer
(in case the original five hundred sets proved to be insufficient) and hired an
assistant to stand in the booth for the rest of the fair's month-long run, dur-
ing which there were no further sales. The *Rotoreliefs* were a commercial
fiasco. Duchamp thought that some of the costs might be recouped by sell-
ing them in artistic circles, though, and with this in mind he mailed a set to
Katherine Dreier and a few more to the New York art critic Henry
McBride, both of whom tried to promote them in the United States. Dreier
thought he had priced them far too low at $1.25 a set, which was equivalent
to fifteen francs at the then-current rate of exchange. "If people find it too
cheap, too bad, but the cost of making it does not allow me to more profit,"
Duchamp wrote back, nailing down his credentials as a less than hard-

headed businessman. Macy's department store took one set on approval but did not reorder.

Duchamp, meanwhile, reported "an amazing detail" to Katherine Dreier. He had shown a *Rotorelief* to some optical scientists in Paris, who told him that it was "a new form, unknown before, of producing the illusion of volume or relief" and that it might even be helpful in restoring three-dimensional vision to people who had lost the sight of one eye. "That serious side of the playtoy is very interesting," he noted. Optical phenomena still fascinated Duchamp. Asked to design a cover for the magazine *Cahiers d'art* that spring, he exploited a well-known optical illusion known in France as *"coeurs volants,"* or "flying hearts," in which the juxtaposition of two strongly contrasting colors makes them appear to detach themselves from the surface and "fly" toward the viewer. Duchamp's cover design used alternating blue and red hearts, superimposed in a collage that he called, appropriately, *Coeurs Volants.* The same issue of *Cahiers d'art* carried a perceptive article on Duchamp's optical machines by his old friend Gabrielle Buffet-Picabia.

Dreier urged Alfred H. Barr, Jr., to stock the *Rotoreliefs* at the Museum of Modern Art's gift shop. She also suggested that he exhibit one set of them instead of *Rotary Glass Plates,* Duchamp's first optical machine, which Barr had asked her to lend to an important exhibition he was organizing, called "Cubism and Abstract Art." The embarrassing truth was that Dreier couldn't find *Rotary Glass Plates.* She had put it in storage after the 1926 Société Anonyme show at the Brooklyn Museum, along with *The Large Glass, 3 Standard Stoppages,* and several other works by Duchamp, all of which had subsequently been transferred from a New York warehouse to her property in Connecticut. When Barr requested the loan of *Rotary Glass Plates,* she thought at first that he was referring to *3 Standard Stoppages* (the three narrow canvases with dropped threads glued to them); Duchamp tried in several letters to explain to her the difference between the two pieces. But Dreier could not seem to locate the disassembled parts of the rotary machine. "I hope you will find it again," Duchamp commented dryly. At one point she wrote to him that she simply did not have the energy to look for it anymore. "Dee," she added plaintively, "am I getting old?"

There was no particular urgency about the matter because Duchamp wanted nothing to do with Alfred Barr. He had asked Walter Arensberg not to lend *Nude Descending a Staircase* to Barr's show, and he urged Walter

Pach to take the same position of refusing to lend, "with a tame excuse, without acrimony." Duchamp's own acrimony toward the museum's brilliant young director is unexplained. He seems to have agreed with Katherine Dreier that Barr's understanding of modern art was limited and doctrinaire—according to Dreier, the founders of the rival museum (as she considered it) had "neither love nor intelligence regarding art." Dreier was willing to lend works from her own collection to Barr's exhibitions, though, and she seemed to feel no particular ill will toward Barr himself. Duchamp, on the other hand, had written to Pach in 1934 of his "lack of confidence in Barr" and of Barr's "feeling of hostility towards me (in particular) which manifested itself by small vexations through which his narrowness became clear to me." Declaring himself "determined to fight him in my own manner," Duchamp had gone on to predict that Barr's "spiteful incompetence will turn against him automatically in the future." Whatever the mysterious vexations were that had led to this un-Duchampian rancor, Barr soon managed to overcome them. When his landmark "Cubism and Abstract Art" show opened at the Museum of Modern Art in March 1936, it included no fewer than five works by Duchamp: *Nude Descending a Staircase, No. 2* (the definitive version, lent by the Arensbergs); *The Bride* (which had recently been acquired by the Julien Levy Gallery); *Cemetery of Uniforms and Liveries* (pencil and watercolor drawing) and a photograph of *To Be Looked at (from the Other Side of the Glass) with One Eye, Close to, for Almost an Hour* (both lent by Katherine Dreier); and following Miss Dreier's suggestion, a set of *Rotoreliefs*.

After carefully calculating the expenses, Duchamp decided to come to New York in the late spring of 1936 to undertake, at long last, the job of repairing and reconstructing *The Large Glass*. Katherine Dreier had agreed to pay for the materials and also for the services of a carpenter, a metalworker, and any other assistants he might need. Duchamp planned to use the same method he had used in repairing Roché's 9 *Malic Moulds,* the glass study that had broken years earlier in New York. Rather than trying to glue the shattered fragments back together, he would clamp them in place between sheets of plate glass secured by steel frames—one for each half of *The Large Glass*. He assured Dreier that, aside from the cost of the materials, "there

would not be any more expenses attached to the repairing as I would do it all myself, except occasional help for handling the big glasses." As the date of his departure approached—he had booked passage (third class) on the *Normandie,* leaving from Le Havre on May 20—Duchamp's spirits rose steadily higher. The Arensbergs, whom he had not seen since 1921, had invited him to visit them in California. "This is my first summer in America for *years!*" he wrote to Dreier. "It will be grand."

He spent the months of June and July at "The Haven," Katherine Dreier's house in West Redding, Connecticut, where for six or seven hours a day he worked slowly and methodically to restore his magnum opus. Carl Rasmussen, a local carpenter and contractor, had transported the crate containing the *Glass* to a large barn on the property, and he had also assembled the sheets of plate glass and the other required materials. When Duchamp

Katherine Dreier's living room in West Redding, Connecticut, with the newly repaired *Large Glass.* The painting over the bookcase is *Tu m'.*

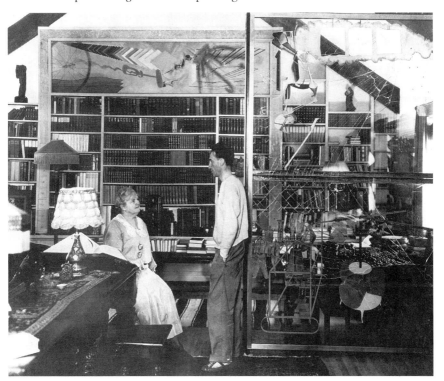

examined the two shattered panels, he was intrigued to find that the cracks ran in a sort of sweeping pattern from the lower right to the upper left of the bottom panel, and in the top panel from upper right to lower left. One section in the top panel was too badly shattered to be repaired; Duchamp had to remake this area, which included part of the Milky Way and the area of the Nine Shots, on a new piece of glass that was cut to fit into the space—it is the only section free of cracks. The bride's "clothes"—three narrow strips of glass inserted horizontally between the upper and lower panels—also had to be replaced. Almost everywhere else, however, the shards and fragments were still held in place by the lead wires that he had glued to the back of the glass to outline his forms, and this made the job of restoration much easier. As he wrote to Roché in July, "I have become a glazier who . . . thinks of nothing else than to repair broken glass." While he was at it, Duchamp located the crate containing *Rotary Glass Plates,* which he cleaned and reassembled, and he also did some work on his *3 Standard Stoppages*—mounting the three narrow canvases (each with its length of dropped white thread) on strips of glass, and fitting out a long wooden croquet-mallet box to hold the glass plates and also the three wooden rulers that had been cut in 1918 to conform to the meandering outlines of the dropped threads. Once or twice during the summer he slipped off to New York City. Dreier had offered him the use of her painting studio in the Carnegie Hall building on West 57th Street, and he spent a few nights there, visiting old haunts and seeing old friends, but these were the only interruptions in his patient labor. He finished work on *The Large Glass* (except for a few minor details) on July 31, just two days before he was due to leave for California.

A young artist-friend of Katherine Dreier's named Daniel MacMorris, who had a studio near hers in the Carnegie Hall building, had asked Duchamp to sit for a portrait. Duchamp did so during the two days he spent in New York before his train left on August 2, and in the process he also obliged the younger artist by answering a number of questions about *Nude Descending a Staircase.* The famous *Nude,* Duchamp said, was not really a painting but "an organization of time and space through the abstract expression of motion." As he went on to explain, "A painting is necessarily a juxtaposition of two or more colors on a surface. I purposely restricted the *Nude* to wood colorings so that the question of painting, per se, might not be raised." That much was consistent with Duchamp's present thinking, although not,

perhaps, with his intentions at the time he painted the picture in 1912. The real stopper came a little further on in the interview (which found its way into print soon afterward). "When the vision of the *Nude* flashed upon me," Duchamp is quoted as saying, "I knew it would break forever the enslaving chains of naturalism." Enslaving chains? Duchamp never talked that way, and the high-flown rhetoric makes us wonder how much of the interview is really in his own words. He also told MacMorris (according to MacMorris) that he himself had become "only a shadowy figure behind the reality of 'that painting' "—a plight that MacMorris tried to remedy by including a shadowy detail of the *Nude* in the background of his assertively naturalistic portrait of Duchamp.

Duchamp's playful or contradictory replies to questions about himself or his work sometimes inspired interviewers to remarkable flights of interpretation. Journalists found him irresistibly charming, and no wonder—he treated them as equals in the game of question-and-answer, just as he looked on viewers as co-participants, along with the artist, in the creative act. He did not take their questions (or himself) too seriously, but he had a way of making even the most uninformed interviewers feel intelligent, and that more or less guaranteed their good will.

It had been seventeen years since Duchamp and Walter Arensberg had seen each other, but they fell right back into their close and mutually stimulating friendship during the fortnight that they spent together in the Arensbergs' Hollywood home. Beatrice Wood, who now lived in California, where she had found her true vocation as an original and gifted potter, came to the house with her friend Helen Freeman; she was thrilled to find Marcel as handsome as ever, with "the same beautiful expression." There were cocktail parties and dinners in his honor and a visit to the Twentieth Century–Fox studios with the Arensbergs' friend Kenneth MacGowan, an associate producer there, and wonderful weather throughout his stay. "The air is delicious," he wrote to Katherine Dreier; moreover, he had "not seen yet what people seem to object to in Hollywood 'bad taste.' " Duchamp took the opportunity to make precise color notes for each of his paintings in the Arensberg collection to guide him in reproducing them for his album. The only sour note of the trip was a snide article in *Time* magazine, whose Los Angeles reporter must have had other things on his mind when he came to the Arensbergs' house to interview Duchamp. The piece, which contained several

absurd inaccuracies, described Duchamp as a "morose, poker-faced painter" derailed by "his own ineffectualness," and quoted him as saying that he "would rather be shot, kill myself or kill someone than paint again."

On the trip back, he stopped off to see the Grand Canyon. He also made a stop in Cleveland to visit the Cleveland Museum and make color notes for his *Nude Descending a Staircase,* which the Arensbergs had loaned to the museum's "Twentieth Anniversary Exhibition." Several members of the museum's staff greeted him so somberly that Duchamp wondered whether he had done or said something wrong. The director, William M. Milliken, took him aside and explained the problem: through a ghastly error, he was listed in the exhibition catalog as "Marcel Duchamp (1887–1933)," as though he had been dead for three years. Duchamp made light of the gaffe and returned in fine spirits to "The Haven," where he finished the work of framing *The Large Glass* and overseeing its installation in Katherine Dreier's library. The two glass panels, reunited again and sandwiched between protective sheets of plate glass, stood in front of a large picture window, where the morning light gave the intricate network of cracks a dangerous brilliance. For Duchamp, there was no doubt that the *Glass* had been much improved. "The more I look at it the more I like the cracks," he would later tell the museum director James Johnson Sweeney. "They are not like shattered glass; they have a shape. There is a symmetry in the cracking . . . There is almost an intention here—a curious extra intention that I am not responsible for, an intention made by the piece itself, what I call a 'ready-made' intention; and I respect that."

Returning to Europe on the *Normandie* in September, Duchamp wrote to Dreier that the trip had been "a wonderful vacation in my past life . . . vacation in past time instead of a new area." Past time and past accomplishments, though, were now the main focus of his activity. Back in Paris, he concentrated on the slow, tedious work of overseeing the reproductions for his album. By the end of the year his printer—the firm of Vigier et Brunissen, on the rue LeBrun, not far from his rue Larrey studio—had finished printing the collotypes for nine of his works, including the second (1914) *Chocolate Grinder,* the *Glider* (which was printed on celluloid), and *9 Malic Moulds.* The process required Duchamp's direct involvement much of the time. Relying on his own color notes of the originals, he himself applied the necessary colors to a first proof of each reproduction; these unique hand-colored proofs guided the printers as they prepared a series of stencils—one

for each color—through which the colors were laid down with a round, flat brush. In some cases a plate might require thirty or more colors. It took a skilled printer about a month to obtain a satisfactory first proof, and then, after Duchamp had made the necessary corrections and adjustments, it took seven or eight weeks more to print the full edition of four hundred copies. The costs kept mounting, and Duchamp, who had abandoned his initial plan to finance the project by selling individual prints of his "better works," turned once again to Roché for help. He sold Roché his share of Brancusi's *Two Penguins* and used the money to pay the printer's bills.

Alfred Barr proved his deepening commitment to Duchamp by including eleven of his works in the enormously influential "Fantastic Art, Dada, Surrealism" exhibition, which opened at the Museum of Modern Art in December 1936. He had written to Duchamp that spring, saying that he hoped the museum could borrow his *Large Glass* for the show and adding that he would like sometime to arrange a one-man show of Duchamp's work. "I have always been so much impressed by it," he said, "and in our recent Abstract show, *The Bride* belonging to Julien Levy stood out as one of the great pictures in the entire exhibition—finer to my mind by far than the famous *Nude*." *The Large Glass* was too fragile to lend, but the substantial number of Duchamp's other works on view made him a major figure in this important exhibition—one of a series in which Barr would educate a generation of Americans in the history and development of modern art. In addition to *Bride, Cemetery of Uniforms and Liveries,* and *Rotoreliefs,* which had been in the "Cubism and Abstract Art" exhibition earlier in the year, Barr presented three works that had never been exhibited before: *Coffee Mill,* which was still owned by Raymond Duchamp-Villon's widow (now remarried); *3 Standard Stoppages;* and *Rotary Glass Plates,* which Duchamp had put back in running order—the latter two were prominently featured in the exhibition's first gallery. Also on display were the little readymade drawing *Pharmacy* and the watercolor-and-gouache study called *The King and Queen Traversed by Nudes at High Speed,* both of which Duchamp had given to Man Ray; the marble-filled birdcage called *Why Not Sneeze Rose Sélavy?;* André Breton's copy of the *Monte Carlo Bond;* and a Man Ray photograph of the readymade *Bottle Rack.* Katherine Dreier, who thoroughly approved of the prominence that Barr's exhibition gave to her dear friend and adopted son, was appalled nevertheless by Barr's decision to broaden the context of Dada and Surrealism by including, in addition to

such historical precursors as Hieronymous Bosch and William Blake, a whole section of art by children and the insane. She was so upset, in fact, that she called a press conference to announce that she was withdrawing her loans to the show when it went on tour.

"Fantastic Art, Dada, Surrealism" appeared at the San Francisco Museum of Art early in 1937. The Arensbergs saw it there and added to their Duchamp holdings by buying three works from it: *Why Not Sneeze Rose Sélavy?, The King and Queen Traversed by Nudes at High Speed,* and *Bride.* The Munich *Bride,* which Barr found so impressive, had a distinguished provenance. Duchamp had given it originally to Picabia, who seems to have sold it a few years later to the poet Paul Eluard; from Eluard it had passed to André Breton and then to Julien Levy, who had become the main Surrealist dealer in New York. Levy kept it only a few months. "I was operating on a very low margin then," he said, "and I needed two thousand dollars to pay back rent on the gallery, to stay open. I don't know how Marcel's wireless operates, but he called me about that time, and said he understood I needed some money, and that he had arranged for Arensberg to buy the *Bride* for two thousand dollars. He said, 'I would like him to have it now.' He wanted all his work to go eventually to Arensberg." The Arensbergs also wanted to buy *Coffee Mill,* the prophetic little painting that Duchamp had made for his brother Raymond's kitchen. They got in touch with Raymond's widow, whose name was now Yvonne Lignières, but she refused to part with it.

Thanks to Katherine Dreier and the Arensbergs (and now, especially, Alfred Barr), Duchamp's name retained a certain resonance in the United States. In France, however, outside the Surrealists' small circle he was virtually unknown. If he was mentioned at all there, people tended to confuse him with his brother, Duchamp-Villon. Duchamp himself did little to counteract this situation. For one thing he had no dealer—then or ever—to buy and sell his work as it turned up on the secondary market; if something did turn up, such as the Munich *Virgin* drawing that a complete stranger to Duchamp named Bernard Poissonnier offered for sale in Paris in 1939 for $1,000, Duchamp was usually scandalized by the asking price. (The Arensbergs bought the *Virgin* drawing.) Three years earlier Walter Pach had written to tell Duchamp that he was thinking of putting *Sad Young Man in a Train* on the market for $3,500, out of which he proposed to give Duchamp $700, or twenty percent. (Manierre Dawson, the young artist who bought

this painting from the Armory Show, had sold it to Pach in the 1920s.) In his belated reply to Pach (one year later), Duchamp asked him to reduce the asking price to a figure between $2,000 and $2,500 and indicated that he would be perfectly content with a $100 commission. Duchamp also said that he would like to see the painting join "its brothers and sisters" in California. "I am convinced that my production because it is on a small scale has no right to be speculated upon," he wrote to Pach, "that is, to travel from one collection to another and get dispersed and I am certain that Arensberg, much like myself, intends to keep it as a coherent whole." Curiously enough, Pach did not even offer the painting to Arensberg, against whom he seems to have harbored an obscure grudge. Pach held on to *Sad Young Man in a Train* until the 1940s, when to Arensberg's great annoyance, he sold it to Peggy Guggenheim.

The Chicago Arts Club, a small but intrepid gallery in a city more receptive to modern architecture than to modern art, gave Duchamp his first one-man show in 1937, a few months before his fiftieth birthday. Alice Roullier, the director of the Arts Club's lively exhibition program, had met Duchamp a decade earlier, when he brought the Brancusi show from New York to Chicago. They became friends and saw each other on several subsequent occasions during Roullier's annual trips to France. Half French herself, she put on exhibitions of Picasso, Braque, Modigliani, and other vanguard French artists (as well as Brancusi) in the Arts Club's modest galleries, and it was only natural that she would want to show Duchamp as well. She chose nine works in all—five of them borrowed from the Arensbergs (including *Nude Descending a Staircase, No. 2, Chocolate Grinder (No. 2),* and *Sonata*) and two from Walter Pach (*Sad Young Man in a Train* and *The Passage from the Virgin to the Bride*)—but the fact that she mounted simultaneous shows of works by André Derain and Kees Van Dongen in the Arts Club's adjoining galleries tended to take the emphasis off Duchamp. Van Dongen, at the height of his vogue then as a painter of racy-looking nudes and society women, was the only one of the three artists to attend the opening, and as a result he received most of the publicity. The *Chicago Daily News* critic C. J. Bulliet, who had interviewed Duchamp at the time of the 1926 Brancusi show, made an effort nevertheless to remind readers of his place in history. "Duchamp had the lightest touch of all the Cubists," Bulliet observed in the *Daily News.* "He played airily with ideas that were being taken so seriously by Braque, Gleizes and even Picasso . . . Duchamp is at home in Chicago's

loop, on New York's Broadway. Picasso, you can imagine exploring the tombs of Egypt or the catacombs of Rome."

André Breton, who was not known for his lightness of touch, never stopped trying to involve Duchamp more actively in the Surrealist cause. When Breton decided to open a Surrealist gallery on the rue de Seine in 1937, he got Duchamp to design the entrance—the silhouette of a man and woman arm in arm, cut out of a large glass panel. Breton's "Gradiva" gallery soon failed. Later that same year, though, Breton achieved a breakthrough by persuading Duchamp to become the main designer and idea man for the International Exposition of Surrealism, which opened in Paris at the beginning of 1938.

The Surrealists had held a number of group exhibitions, but this one was something new. For several years Breton and his followers had wanted to mount an exhibition that would be a creative act and a Surrealist event in itself, one in which the paintings and objects could function as elements in a totally Surrealist environment. This opportunity arose when the right-bank Galerie des Beaux-Arts turned over its spacious premises to them and gave Breton complete freedom to do what he wanted. As the show's officially designated "generator-arbitrator," Duchamp temporarily set aside his album project and put his imagination to work. He took a playful approach to the job, feeling that "anything that could bring out the meeting of two incompatible elements would be welcome." The results were visually stunning. Opening-night visitors in full evening dress found themselves confronted in the outer lobby by Salvador Dalí's *Rainy Taxi,* an old-fashioned Paris cab equipped with tubing that produced a steady drizzle inside. There was a shark-headed creature in the driver's seat, and in back a blond-wigged mannequin whose evening dress was festooned with heads of lettuce and chicory and hordes of live extra-large Burgundy snails. On the other side of the lobby was "Surrealist Street," a long corridor lined on both sides by more than twenty female wax mannequins, each one costumed by a Surrealist artist: one had her head enclosed in a birdcage and wore a black velvet band over her mouth, with a single pansy pasted in the middle (André Masson); another had fat tears running down her cheeks and soap bubbles emerging from pipes hidden in her hair (Man Ray); a third had a water-filled glass jar for a stomach, in which a goldfish darted back and

forth (Léo Malet). Duchamp's contribution was a mannequin wearing a man's felt hat, shirt, tie, and jacket, with a blinking red lightbulb in the breast pocket and nothing below the waist—Rrose Sélavy in one of her more provocatively androgynous moods. At intervals along the wall were blue enamel signs bearing the names of Paris streets, both real (rue Vivienne, where the comte de Lautréamont once lived) and imaginary (rue Faible, rue aux Lèvres, rue de la Transfusion du Sang.)

The corridor led to the main gallery of the exhibition, which Duchamp had transformed into a fantastic subterranean cave. Twelve hundred coal sacks hung from the ceiling. Stuffed with newspapers instead of coal, they nevertheless exuded a light sifting of pungent black dust. (Duchamp had first planned to use inverted umbrellas, but he hadn't been able to find enough used ones in time.) Dead leaves, ferns, and grasses carpeted the floor, in a corner of which, next to a luxuriously appointed bed (one of four in the room), lay a pool of water. Roasting coffee beans filled the air with delicious "perfumes of Brazil." On opening night the only light in the room came from a rather dim bulb hidden inside a large coal brazier, which was mounted on a dais under the coal sacks. Duchamp's original idea had been to install "electric eye" sensors that would be activated when people stood in front of the paintings, but this had proved to be unworkable. Instead, Man Ray handed out flashlights to the visitors, who generally forgot to give them back. Art works by sixty artists from fourteen countries hung obscurely on the walls or on revolving-door partitions devised by Duchamp; Meret Oppenheim's famous *Fur-lined Cup, Saucer, and Spoon* could be made out in one of the vitrines, along with other well-known Surrealist objects. Duchamp himself had five works in the show: *9 Malic Moulds* and *Rotary Demisphere*, both loaned by Roché; a replica of *Bottle Rack; Pharmacy*, on loan from Man Ray; and the readymade window called *The Brawl at Austerlitz*, on public view for the first time.

The opening itself was a hugely gratifying scandal, attended by *le tout Paris* and providing ample measures of shock and outrage to those who still went in for such outmoded reactions. Breton and his acolytes basked once again in the limelight of controversy. Duchamp, however, was nowhere to be found. The Surrealist artist and art historian Marcel Jean saw him in the main gallery shortly before the opening, taking a last look at his creation. Later the Surrealists learned that he had gone straight from the gallery to the Gare Saint-Lazare, where he and Mary Reynolds took the train to London.

Box-in-a-Suitcase

> You have invented a new kind of
> autobiography . . . You have become the
> puppeteer of your past.
> —Walter Arensberg, 1943

Peggy Guggenheim was not as rich as people thought. Her father, Benjamin Guggenheim, a tireless womanizer and the most feckless of the seven Guggenheim brothers, had been excluded from the family mining and smelting operations; his own business ventures fared poorly, and when he went down with the *Titanic* in 1912, Peggy's share of the inheritance came to $450,000—a comforting amount in those pre-income-tax days but a lot less than the millions that would descend on her cousins in their turn. Peggy, moreover, had rebelled against the family's hard-won bourgeois respectability by living in Europe, going to bed with unsuitable men, and—her most recent vice—becoming a dealer in modern art. Her gallery at 33 Cork Street in London, called Guggenheim Jeune in a self-conscious echo of the well-known Bernheim-Jeune gallery in Paris, opened on January 24, 1938, with a show of recent paintings and drawings by Jean Cocteau, selected and installed by Marcel Duchamp. When Duchamp went to London on the eve of the big Surrealist exposition in Paris, it was to hang Peggy's first show.

The American heiress and her new mentor had met a year or so earlier at Mary Reynolds's house in Paris. Peggy's ex-husband, the flamboyantly eccentric Laurence Vail, had introduced her to Mary Reynolds, with whom he had once had a long love affair, and the two women had become friends

in spite of Peggy's immediate and obvious crush on Duchamp. "Marcel was a handsome Norman and looked like a Crusader," as she described him in *Out of This Century,* the revised version of her strenuously indiscreet memoirs. "Every woman in Paris wanted to sleep with him." Although Duchamp proved resistant to Peggy's far from subtle sexual overtures, he did agree to help her get started in the art business—no small commitment on his part, as it required a complete course of education in modern art. "I could not distinguish one modern work from another," Peggy confessed, "but he taught me the difference between Surrealism, Cubism, and abstract art. Then he introduced me to all the artists. They all adored him and I was well received wherever I went. He planned shows for me and gave me all his best advice. I have him to thank for my introduction to the modern art world." Candor regarding her own ignorance was one of the redeeming qualities of this gauche, insecure, overbearing, and ravenously promiscuous woman, who became the latest in a long line of Duchamp's love-struck admirers.

Serving as Peggy Guggenheim's unpaid gallery director did not relieve Duchamp of his obligations to Katherine Dreier, who continued to bombard him with requests of all kinds. Dreier wanted his advice on what to do about the very large Société Anonyme collection, now that the society itself was virtually moribund. Should she sell it at auction, or should she build a private museum for it in her meadow? At one point she wrote to tell Duchamp that Sidney Janis, a shirt manufacturer with a passionate interest in art, wanted to start a modern museum in Los Angeles with the Arensberg and Dreier collections as its nucleus, but that she had declined to participate because California was too far away. In 1939 she came up with the "very exciting idea" of making "The Haven" itself a "country museum." That would solve the dual problem, as she wrote to Duchamp, "of your Glass and my freedom. For it was your Glass that turned this house into a museum." Duchamp gave the idea his guarded approval, but he suggested that she lend, rather than give, her own personal collection to the new museum. Dreier had a sizable private collection apart from the Société Anonyme's holdings, and as Duchamp reminded her then and later, it was more important to keep this collection intact (with its significant complement of his own works, including *The Large Glass*) than to think in terms of a personal "monument."

Considering the time he devoted to Katherine Dreier and Peggy Guggenheim, it was a wonder that Duchamp could keep up with his own

long-range project, but he did, moving forward steadily on the reproductions that he had decided, sometime in 1938, to gather together unbound in boxed form rather than in an album or a book. Far more intricate than the *Box of 1914* and *The Green Box,* this one would have interior fittings and sliding panels that would make it, in effect, a miniature portable museum of his work. When Walter Arensberg saw the finished product in 1943, he commented that Duchamp had invented "a new kind of autobiography . . . a kind of autobiography in a performance of marionettes. You have become the puppeteer of your past." The urge to preserve (through reproduction) his past work may have acquired by this time a new incentive: the increasingly ominous threat of a European war. The *Anschluss* in 1937, the Munich conference and Hitler's annexation of the Sudetenland, the Nazi-Soviet nonaggression pact, and the menacing buildup of Germany's armed forces all pointed to the inevitability of a general conflict, which Europeans awaited with fatalistic resignation. Duchamp, like many others, was packing his bags.

Figuring out how to reproduce *The Large Glass* in miniature presented major problems. Duchamp had been delighted by an article on his *Glass* that had appeared in the May 1937 issue of the American magazine *Architectural Record.* The first important essay on the *Glass* in English, it had been written by Frederick Kiesler, a Viennese-born architect and sculptor who was now an American citizen and a friend of Katherine Dreier, in whose house he had seen and been fascinated by the recently restored masterwork. Kiesler had brought the photographer Berenice Abbott to West Redding, and he used her dramatically lit pictures of the *Glass* to illustrate his article. The photograph that really interested Duchamp, though, was the one that Kiesler had inserted as the frontispiece to his offprint of the published version; it was a view of the lower portion of the *Glass,* reproduced on a sheet of transparent cellophane. Duchamp decided immediately that he could adapt this method for his own use. In a letter to Kiesler that was full of praise for his insights into the *Glass* (it would be followed by a complimentary copy of *The Green Box,* which Kiesler had never seen), Duchamp said that he needed some direct, head-on views of the *Glass* to avoid distortion, and he asked whether Berenice Abbott could provide them. Evidently she couldn't, or wouldn't, and a year went by before Katherine Dreier finally managed to get a commercial photographer to take the "full-face" pictures that Duchamp wanted. Duchamp and his printer worked with these for another whole year and succeeded finally in producing a print on celluloid

that reproduced the forms and the colors with great accuracy. To make the cracks as visible as they were in the *Glass,* the printer scratched them into the celluloid with an etching needle after the printing was done.

By the late summer of 1939, most of the reproductions for Duchamp's new box had been completed. Among them were miniature three-dimensional replicas of three readymades—*Paris Air, Traveler's Folding Item,* and *Fountain*—each of which would assume a prominent place when the box was assembled. The other readymades were shown in photographs. Some of them were blown up to the same size as the originals, and a number of other items that might have seemed to be of minor or peripheral importance in Duchamp's total oeuvre also appeared in surprisingly large scale: the *Tzanck Check,* for example, and Man Ray's photograph of *Dust Breeding.* Relative size did not seem to have anything to do with relative importance; aside from certain major works that confronted the viewer on first opening up the box, everything else was presented as having approximately equal value—paintings, drawings, readymades, optical machines, *Rotoreliefs,* magazine cover designs such as *Coeurs volants,* and twenty-five of his extended puns and wordplays, an anthology of which had recently been published in Paris in a limited edition entitled *Rrose Sélavy.*

When Hitler's troops invaded Poland that September, Duchamp and Mary Reynolds were taking their annual vacation in the south of France. "Well, it had to come," Duchamp wrote to Katherine Dreier. "How long will it last? How will we come out of it, if we come out of it?" He was fifty-two years old, so there was no chance of his being called into service. At first he thought of volunteering for some sort of civilian duty, but instead of that, he and Mary spent the fall looking for a place to live in the south of France. They looked first in Aix-en-Provence and then closer to the sea, near Montpellier, but the idea of sitting out the war in some rural retreat did not appeal to Mary Reynolds. By mid-December they were back in Paris, where Peggy Guggenheim, who had been staying in Mary's rue Hallé house during their absence, proceeded to commandeer a lot of Duchamp's time. Peggy had closed down her London gallery in June. Having decided to put her energy and resources into starting a museum of modern art instead, she had hired the distinguished English art historian Herbert Read to organize it and skipped off to Paris with a shopping list of artists and art works that

Read had drawn up for her. The war changed her mind about establishing her museum in London (tough luck for Herbert Read), but she still liked the idea of having one, and in those months of what was being called the "phony war," when the Western allies waited passively for the German attack, she embarked on a frenetic program of buying a picture a day.

Peggy, who had moved from the rue Hallé to a large apartment on the Ile Saint Louis, later claimed that she had no idea she was acquiring a major art collection at bargain prices. "I didn't know anything about the prices of things," she insisted. "I just paid what people told me." A lot of the artists in Paris were desperate to leave the country, though, and nobody else was even thinking about buying art then; when word got around that an American heiress was visiting studios and paying in cash, her telephone began to ring night and day. Steered by Duchamp and also by Howard Putzel, a young California art dealer who knew Mary Reynolds, she bought for less than $40,000 the nucleus of one of the great collections of modern art. In the two months before the Wehrmacht ended the phony war by invading Denmark and Norway, she bought important pictures by Braque, Léger, Klee, Kandinsky, Gris, Picabia, Gleizes, Mondrian, Miró, Ernst, Tanguy, Dalí, de Chirico, Magritte, Man Ray, Van Doesberg, Brauner, Severini, and Balla, and sculptures by Brancusi, Lipchitz, Giacometti, Arp, Moore, and Pevsner. Picasso turned her down flat; when she visited his studio on the rue des Grands-Augustins, he pointedly ignored her at first, then walked over and said contemptuously, "Lingerie is on the next floor." (Perhaps he thought she was a department store heiress.) Brancusi refused to bargain with her. Although Peggy claimed to have gone to bed with him several times, he would not give her a special price on his *Bird in Space;* rather than pay the $4,000 he was asking, she bought an earlier Brancusi bird, *Maiastra,* from the couturier Paul Poiret's sister for $1,000. A month later, though, when the Germans had overrun Holland and Belgium and were driving toward Paris, she went to lunch at Brancusi's studio to collect the *Bird in Space,* which she had decided to buy anyway.

The swiftness of the German blitzkrieg stunned everyone. Still believing in the impregnability of their Maginot line defenses, the Parisians, who for the last six months had complacently gone about their lives, were suddenly thrown into panic by the German breakthrough at Sedan, and a great many of them fled the city. Duchamp left earlier than most on May 16—the day after the Sedan breakthrough—by train for Arcachon, a seaside town

on the Atlantic coast due west of Bordeaux, where Salvador and Gala Dalí and several other artists were already in residence. Mary Reynolds joined him there a few days later. They settled into a rented villa with Duchamp's sister Suzanne and her husband, Jean Crotti, and listened to the fall of France on the radio.

The Germans took Paris on June 14. Under the terms of the armistice signed a week later by Marshal Henri Pétain, France was divided into two regions: an occupied zone covering the northern and western third of the country, and an unoccupied zone for the rest, under the nominal authority of Pétain's puppet regime based in Vichy. Arcachon was in the occupied zone. To the dismay of those who had gone there to avoid the war, moreover, it very soon became a designated rest area for German troops. But "the organization of the country is not as disagreeable as I might have feared . . ." Duchamp wrote to the Arensbergs in mid-July. "Civilian life continues without the Germans interfering much—Many refugees from Belgium and the North have left and the Germans who come here are 'to rest' (4 days by parcels of 4,000 at a time). They come and go nonstop." In any case, as he noted in a letter to Beatrice Wood, "The 'dramatic' is over."

Getting back to Paris was impossible because the railroad bridges had been blown up and few trains were running. Duchamp found a good printer in Arcachon, and during the three months that he and Mary spent there, he was able to continue working on reproductions for his box. The main problem was money. Arensberg offered to send some, but how should he go about it? The best way, Duchamp naively informed him, was by ordinary personal check, which Duchamp would find someone to cash for him. (Such transactions were out of the question, as he soon learned.) Duchamp offered to send Arensberg two "small things" in return when he got back to Paris: the handmade *Tzanck Check,* which the good dentist was willing to sell for $50, and the original *L.H.O.O.Q.,* "the Joconde with the moustache," which Duchamp still owned. "Do you think that $100 is too much for the said Joconde?" he inquired. Arensberg, strangely enough, declined to buy either work, but over the next two years he would devote a great deal of energy and expense to getting Duchamp out of France.

Early in September, while the Battle of Britain raged in the skies over London, Mary Reynolds and Duchamp made their way back to Paris. German soldiers were everywhere, but no one had broken into Mary's house on the rue Hallé, and the Brancusi sculptures that Duchamp and

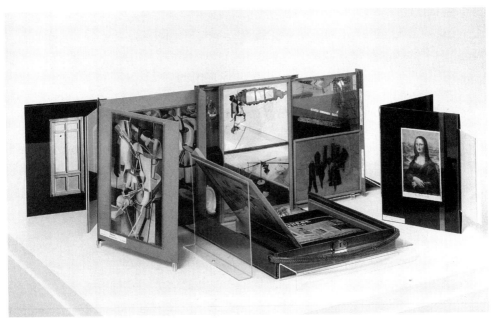

Boîte-en-valise (Box-in-a-Suitcase), 1941.

Roché had stored in her basement were intact. Duchamp spent that fall overseeing the completion of the last remaining elements for his box of reproductions, on which he had been working for nearly six years. He decided to introduce it in a deluxe, leather-bound edition limited to twenty copies (plus four more *hors de commerce*), and in January he finished assembling the first one. This deluxe version, a wooden box inside a leather suitcase with a leather handle, would be known as the *Boîte-en-valise (Box-in-a-Suitcase)*, to distinguish it from the larger edition of more than three hundred *Boîtes* (without the leather case), which would appear gradually in batches over the next thirty years.

Each leather-bound *Boîte-en-valise* contained sixty-nine separate items "of or by Marcel Duchamp or Rrose Sélavy," as the hand-lettered inscription (in French) on the box's lid phrased it, plus one original art work unique to each box—in the first twelve, the original is one of the hand-colored prints that Duchamp made to guide the printers. Open the leather case, lift up the lid of the inner box until it rests in a vertical position, pull out the sliding partitions on either side, and there cleverly displayed are Duchamp's most significant paintings: *The Large Glass* in the center, on

transparent celluloid, flanked to the left by *The Bride* and *The King and Queen Surrounded by Swift Nudes,* and to the right by *Tu m', 9 Malic Moulds,* and *Glider* (the latter two are also on transparent celluloid). But wait— where is *Nude Descending a Staircase?* It is on the other side of the left-hand panel that holds *The Bride.* To see it, you must fold back that panel, thereby covering up *The King and Queen Surrounded by Swift Nudes.* The focus of this permanent "installation" is on *The Large Glass* and its tributaries—the famous *Nude* is a sideshow.

Four readymades also greet the eye: a photograph of *Comb* on the right-hand panel and, directly to the left of the *Glass,* hanging one above the other in a narrow vertical space, three-dimensional replicas of *Fountain, Traveler's Folding Item,* and *Paris Air.* For the very first time, Duchamp seems to indicate in this way that the three readymades (and by implication all the others) have a direct connection to *The Large Glass. Paris Air* (the chemist's flask that Duchamp brought to New York as a present for Arensberg) is at the top, on a line with the Draft Pistons through which the bride issues her commands. *Traveler's Folding Item,* the miniature typewriter cover that looks like a woman's skirt, corresponds to the bride's "clothes"—the three horizontal sheets of glass inserted between the upper and lower panels. And the solid, masculine bulk of *Fountain,* the little porcelain urinal, echoes the bachelor forms in the lower section. The *Boîte-en-valise* not only reproduces Duchamp's works but comments on them at every turn.

It also raises new questions. Where is *Young Man and Girl in Spring,* the 1911 painting that Arturo Schwarz calls the key to all Duchamp's later work? It is nowhere to be found, whereas *Tu m',* a picture that Duchamp often described as a mere compendium of earlier ideas and thus of relatively little interest to him, is prominently displayed. What is so special about *Comb,* the steel dog comb inscribed with a cryptic French phrase that reads, in translation, "Two or three drops of height have nothing to do with savagery," and what, if anything, does *it* have to do with *The Large Glass?* And why, for that matter, is the little urinal mounted right side up instead of in its more familiar inverted position? The search for consistent and logical explanations is doomed, as usual. We are in the ever-changing Duchampian environment where thought, language, and visible form interact with our own freedom of interpretation.

Another three-dimensional readymade, *Why Not Sneeze Rose Sélavy?,* pops up from the floor of the box, near *The Large Glass.* A fold-out

photograph of *3 Standard Stoppages* nestles along the box's left edge, and between these two is a rectangular cardboard box-within-a-box that holds the rest of the sixty-nine reproductions, from *Sonata,* which is mounted on the lid, to *Coffee Mill,* the little picture that marked Duchamp's first step in a direction all his own and is permanently installed, appropriately, at the bottom of the pile. The other works are pasted into loose black-paper mats, which can be lifted out for closer examination. Each item is identified by a tiny printed label giving its title, date, dimensions, and other pertinent data, just as it would be in a museum.

One of the first things the viewer notices about the box and its contents is their handmade look. The color reproductions are much closer in value to the original paintings than they would be in any art book, mainly because collotype printing, as Duchamp employed it, is virtually a hand-painting process. There is a slightly makeshift quality about the materials themselves and about the way they are put together. The sliding panels—those wings on either side of *The Large Glass,* which have led many a critic to suggest that what Duchamp had in mind here was a medieval or Renaissance altarpiece—do not slide in and out very easily, and the heavy cardboard they are made of becomes a little dog-eared with frequent use. The unsupported celluloid *Glider,* attached by a hinge of transparent tape to the left sliding panel, was always a problem; it warped, so that the panel would not close, and Duchamp eventually decided to leave it out of the regular (nondeluxe) boxes. He kept making little changes and improvements in the boxes as he went along, and as a result each one of them is, to some degree, a unique artifact. In the end Duchamp turned the process of mechanical reproduction into a form of personal expression. It was the reverse of what he had done in his early studies for *The Large Glass,* when he delegated mechanical drawing and careful measurement to stand in for the artist's sensitive hand and eye.

Duchamp reserved the first *Boîte-en-valise* for Peggy Guggenheim. In the general exodus from Paris the previous spring, Peggy had gone southeast instead of west—to Megève in the French Alps (unoccupied zone), where her ex-husband, Laurence Vail, was living with his seven children (two of whom were also Peggy's) and his current wife, Kay Boyle. Since Duchamp did not know Peggy's address, he mailed her valise to Henri-Pierre Roché, who had recently moved with his mistress and their son to a small town near Grenoble; Roché would give it to Peggy when he saw her.

"I am reserving one for you," he told Roché. "I sell them for 4,000 francs each, and I am having difficulty finding the skins to make the outer valise."

Several people were working to get Duchamp out of France. Walter Arensberg formally invited him to become the curator of the Francis Bacon Library art collection in Los Angeles (i.e., the Arensberg collection) and also to paint a mural there, and he was pulling strings in Washington to get him a temporary visa. It was very difficult to write to anyone in the occupied zone, though, and in the absence of regular communication, Arensberg became increasingly frustrated and annoyed by the endless delays, which he attributed to Duchamp's failure to take the necessary steps at his end. At one point Arensberg complained that it looked as though Duchamp, after all the efforts made on his behalf by himself and others (Katherine Dreier was pulling strings quite independently of Arensberg, and so was Mary Reynolds's brother in Chicago), could not make up his mind whether he wanted to come to America or not. There may have been some truth in this. Mary Reynolds, "stubborn as a horse," did not want to leave her house or her cat, as Duchamp explained later to his Chicago friend Alice Roullier. Life in Paris under the occupation had not yet become as hard as it would the following winter. Duchamp and Reynolds were able to get chicken, veal, eggs, butter, and cheese from Gustave Candel, the wholesale cheese dealer whom Duchamp had known since his student days in Montmartre, and they managed to stay warm enough through the cold months. "One never goes out in the evening," he wrote to Roché. "We have had coal until now—but it's the end—we hope a few hundred kilos more to finish winter." Jacques and Gaby Villon had returned to Puteaux after several months spent with friends in the country; they had no intention of leaving, and neither did Jean and Suzanne Crotti. Duchamp, moreover, was temperamentally ill equipped to deal with the Vichy regime's Kafkaesque bureaucracy. In order to get to the United States, for example, you needed a valid passport, a U.S. visa, a French exit visa, and a transit visa for any country that you passed through on the way. By the time all these documents were secured, it was very likely that one or more of them would have expired, so that the would-be traveler was obliged to go through the process all over again—and the regulations kept changing. All through 1941, however, Duchamp quietly went about preparing in his own way for his eventual departure.

"I thought of a scheme," he said. "I had a friend, Gustave Candel, who was a wholesale cheese merchant in Les Halles, and I asked him if he could

commission me to go and buy cheese for him in the unoccupied sector. He gave me a letter, which I took to the German authorities, and with that letter and a bribe of twelve hundred francs I got from a secretary that famous little red card, called an *Ausweis,* which allowed me to travel by train from Paris to Marseilles. I thought I had to be very careful and buy cheese, and probably give an account of my expenses when I crossed the border between two zones, but the Germans never asked me any questions." He made three trips to Marseilles in the spring of 1941, carrying a large suitcase filled not with cheese but with the materials for some fifty of his Boxes, which he planned to assemble in America. Duchamp's younger sister, Yvonne Duvernoy, and her husband were living at this time in the village of Sanary-sur-Mer, a pretty town on the Mediterranean coast just east of Marseilles. On each of his three trips, Duchamp would go there first and drop off his batches of reproductions.

In April he traveled to Grenoble, the provincial capital of the French alpine region, where he saw Roché and Peggy Guggenheim and applied for his passport and exit visa. Peggy had managed to have her recently acquired art collection stored in the Grenoble Museum. She had also discovered that she could have it shipped to the United States as "household goods" with no export problems, and she was perfectly willing to include in the shipment two cases filled with the ingredients of Duchamp's museum-in-a-box. On Duchamp's third trip to the south in June, therefore, he brought all his materials to Grenoble and entrusted them to René Lefebvre-Foinet, the Paris art-supply merchant, who was packing Peggy's paintings and sculptures in the Grenoble Museum.

He did not go back to Paris after that. For the next eleven months he lived with his sister in Sanary, making periodic excursions to Marseilles and Grenoble in pursuit of the elusive documents he needed in order to leave the country. Marseilles at that point was full of artists, antifascist intellectuals, and political activists in imminent danger of being arrested by the Nazis. Most of them were in touch with the Emergency Rescue Committee, an American volunteer organization that had been set up the year before expressly to help them. Varian Fry, the committee's young director, had rented a large house a few kilometers outside the city, called Château Air-Bel, where penniless refugees could stay while he tried to arrange for their escape. The house became a Surrealist haven that spring. André Breton stayed there for several weeks with his exotic blond wife, Jacqueline

Lamba, and their five-year-old daughter, Aube. The day they arrived, Breton caught two praying mantises in a bottle and placed them on the dining table in lieu of flowers. Max Ernst, Victor Brauner, Oscar Dominguez, Wilfredo Lam, André Masson, Hans Bellmer, René Char, and Tristan Tzara all lived in the Château Air-Bel at one time or another, taking part in the Surrealist games that Breton organized, and most of them eventually made it to the United States.

Varian Fry got Peggy Guggenheim to help fund his underfinanced operation—she also paid for the Breton family's passage to America. Later, when Peggy left Grenoble and moved down to Marseilles to arrange for her own departure, she claimed the dazzlingly handsome Max Ernst as her new lover. Ernst was in no position to resist. Interned as an enemy (German) alien soon after war was declared, then released a few months later, he had been rearrested by the Vichy regime in 1940. He escaped, was caught and interned again, escaped again, and made his way to the house in Saint-Martin-d'Ardèche, about 48 kilometers north of Avignon, where he had been living since 1937 with the strikingly beautiful English painter Leonora Carrington, only to find that Carrington, driven to despair by his arrest, had sold the house to the cousin of a German army officer for a bottle of brandy. (Carrington then fled to Madrid, where she broke down completely and was committed to a mental hospital.) Ernst was still obsessed with his lost Leonora when he showed up at the Château Air-Bel, carrying a large roll of his paintings, but he had no money and no papers. Peggy bought his entire stock of paintings and offered to take him to the United States with her. During a dinner to celebrate Ernst's fiftieth birthday at a black-market restaurant in Marseilles, Max whispered in Peggy's ear, "When, where, and why shall I meet you?" and Peggy whispered back, "Tomorrow at four at the Café de la Paix and you know why." Of all the artists she went to bed with, Ernst, with his prematurely white hair, birdlike features, and achingly blue eyes, was her proudest conquest.

Duchamp never stayed at the Château Air-Bel. He had his own refuge in Sanary and his own network of sponsors working to get him an American visa. From Duchamp's point of view, moreover, Surrealist games and other group activities were things to avoid, especially when they involved complicated sexual undercurrents. One evening in July, Duchamp was having a drink in a Marseilles café with Max Ernst, Peggy Guggenheim, Peggy's ex-husband, Laurence Vail, and Vail's now-estranged wife, the

writer Kay Boyle. The Vails' marriage had come apart the previous summer in Megève when Kay Boyle fell in love with an impoverished Austrian baron whom they had engaged to give their children German lessons. She left Vail and moved in with the baron, whom she later married; every other week she took the bus from Megève to Marseilles to work on getting the necessary papers for him to come to the United States with her. Kay Boyle, whom Varian Fry described as "like her books: intense, emotional, and finely wrought," had been reluctant to meet them at the café—she and Peggy detested each other—but Vail had told her that Duchamp would be there. "Of course," as she said later, recalling the incident, "I was very fond of Marcel, so I stupidly went. It was fairly friendly for about forty-five minutes, but Laurence had been drinking a great deal, and suddenly he knocked all the glasses off the table and then wrenched off the table's marble top and started to crown me with it. Marcel *leaped* forward, threw himself between Laurence and me, and then he held Laurence while I ran out of the café. I was running down a dark street with tears pouring down my face, and I realized that Marcel was running with me on one side, and Laurence was on the other side, and they were both yelling. Marcel was yelling, 'I'm in hotel such-and-such, come there and I'll take care of you,' and Laurence was yelling, 'If she goes with you I'll kill you both.' I stopped at the curb, and I said, 'Marcel, I have to talk to him.' So Laurence and I went to a hotel, and sat up all night talking. I explained to him that he had to accept the fact of our separation, and he calmed down—Laurence always had these two sides, he could be very violent and very gentle. Afterwards, whenever Marcel and I spoke of that night, he'd say he didn't know how he'd had the courage to do what he did. He said it was the bravest thing he'd ever done." It was also the sort of scene he very much preferred to avoid.

Duchamp did a lot of traveling from his base in Sanary. He went to Grenoble several times and to Monte Carlo and Aix-en-Provence, and once he even slipped across the Swiss border to Geneva and back, to pick up some money that was owed to him. Often his trips were enlivened by reunions with Roché, who was teaching English in a school to the south of Grenoble, near Montélimar. The two old friends enjoyed each other's company as much as ever, and their chess games, which Duchamp would try to make more evenly matched by giving up a knight or a rook, took their minds off the increasing privations of life in defeated France. Chess was still a primary passion for Duchamp, even though he had not competed in professional

tournaments for several years. "I remember arriving in Grenoble with him one night in 1941," Roché wrote in one of his memoirs of Duchamp:

> He needed a good chess game like a baby needs his bottle. He wasn't thinking only of giving me one more lesson; rather he was anticipating new opponents and spoiling for a fight. After making inquiries, we were directed to the café where the best players of the town held forth.
>
> For a while Duchamp watched from a distance, then he decided on one of the players, and sat down casually next to him, watching but hardly appearing to follow the game. "Would you care to?" he invited when the game was finished.
>
> His adversary was an engineer, a shrewd, correct-looking man whose curtness contrasted sharply with Duchamp's ready smile. They played and Duchamp lost. "I often lose the first time," he said afterwards. "I try to figure out my opponent's game." He won the second, third and fifth games, losing the fourth. The two men enjoyed themselves and parted with respect for each other.

Roché, who had made a good deal of money in his years as a private art dealer, served once again as Duchamp's banker during this precarious period. In addition to buying a deluxe *Boîte-en-valise* for 4,000 francs, he lent him 30,000 francs on one occasion and 20,000 a few months later. (Both loans were eventually repaid.) Roché worried about his friend's health. Duchamp had lost weight, and he was experiencing blurred vision. "It is the first time I have seen him a little down," Roché noted in his journal when they met in Saint-Raphael in July. "His departure for the U.S.A. now seems uncertain." Although Duchamp got his passport and exit visa a month later, his American visa would not come through until the following March. Mary Reynolds had opted to stay in Paris, and without her, Duchamp often seemed depressed and irritable. Although he managed during these months to put together three more deluxe *Boîtes-en-valise,* in addition to the ones he had sold to Peggy Guggenheim and Roché, that project was essentially on hold until he got to the United States, and in the meantime he did not quite know what to do with himself.

"Work—it's horribly difficult to put my hand on a 'tangible' idea," he wrote to Roché. He was trying to develop a concept he had been thinking

about for several years, a concept he referred to as *infra-mince* or "infra-thin"; he described it to Roché, rather unhelpfully, as "a production which is no longer manual but *coudique* (as in 'elbow')." Duchamp was in much better shape when Roché saw him in Montélimar in December. He had put on weight, and his eye trouble had cleared up. To repay part of his debt to Roché, he proposed giving him the original terracotta model for the tiny urinal in his *Boîte-en-valise*. Roché made the mistake of saying that he would prefer to have drawings. "Why not watercolors of the Riviera?" Duchamp asked sarcastically, adding that he might be driven to something like that to make ends meet. When Duchamp came through Montélimar in March, though, and gave Roché the terracotta *Fountain* as a present, Roché decided that it was "a little masterpiece of humoristic sculpture, the color of cooked shrimp, with such absurd and carefully made tiny holes." Duchamp had finally received his American visa. "It's a new turning point in his life," Roché wrote in his journal, "and who knows if we will see each other again?"

He was getting out not a moment too soon. Most of the refugee artists and intellectuals had left months before. The Emergency Rescue Committee would be closed down by the police in June, after having helped more than a thousand people to find passage on ships or else to travel across Spain to neutral Portugal. (In November the Germans would move into the unoccupied zone and cut off this escape route for good.) Duchamp left Marseilles on May 14, 1942, on a small steamer bound for Casablanca. The good luck that so often seemed to smooth his path through life did not desert him. He described the eighteen days that he passed in Morocco, waiting for the boat that would take him the rest of the way, as a "very pleasant holiday," during which he managed to avoid staying with the rest of the transit passengers in their crowded camp by sleeping "alone in a bathroom, very comfortable . . . by the sea, 7 km. from Casa[blanca]."

On June 7, carrying a minumum of baggage, he boarded the Portuguese ship *Serpa Pinto,* bound for New York, with a week's stopover in Bermuda en route. Since Portugal's neutrality was respected by both sides, there was no fear of submarines. This was his thirteenth Atlantic crossing and, according to Duchamp, "the best trip of all. It was perfectly delicious. All the lights were on and we had dancing on deck every night."

New York, 1942

I am dumbfounded at my position as a
kind of "vedette" in this town.

Of all the European artists who spent the war years in New York,
Duchamp was the only one who seemed at home there. André
Breton haughtily refused to learn a word of English because, as he
explained, he did not wish to disturb the purity of his classical French.
Léger and Mondrian were fascinated by the city's restless energy, but many
of the others were appalled by the noise level, the weather, the food, and the
absence of café life. In Paris, as Max Ernst said, he could go to his café at six
every evening and be sure of finding certain friends, but in New York you
had to telephone people in advance, and that took all the pleasure out of
meeting them. None of this bothered Duchamp. He had always loved New
York, and he adjusted with ease to its particular rhythms and to the sense of
freedom that the city gave him.

For the first month he stayed with the Robert Allerton Parkers in their
comfortable apartment at 1 Gracie Square. Parker was one of the journalists
who had interviewed Duchamp when he came to New York for the first time
in 1915—he remembered being impressed by the "smiling composure" with
which Duchamp answered every "impertinent and puerile question" put to
him by the brash American reporters. They had kept in touch over the years,
and when Parker and his wife, Jessica Daves, a *Vogue* editor who would even-
tually become that magazine's editor-in-chief, learned that Duchamp was try-
ing to get out of France, they had written a letter inviting him to stay with
them as long as he liked. In July he moved to much grander surroundings.

Peggy Guggenheim, who was now married to Max Ernst, had offered to let Duchamp stay in her town house at 440 East 51st Street, overlooking the East River, while she and Max were summering on Cape Cod. The materials for fifty of his *Boxes* were already there, having arrived from France in the same shipment with Peggy's art collection, and he looked forward to spending the months of July and August alone in the house, working on them. As it turned out, he found himself sharing the premises with Peggy's nineteen-year-old son, Sindbad, whose main ambition that summer was to have sex there with as many girls as possible. Peggy and Max came back in mid-August, after a vitriolic dispute with their landlady in Wellfleet—it had ended with her denouncing Max to the FBI as a possible German spy.

Hale House, as the 51st Street residence was known (it occupied the site where the Revolutionary War spy Nathan Hale had been hanged), quickly reverted to its pre-July status as the meeting place for a motley crowd of European artists in exile and American show-biz types, sports stars, writers, and assorted hangers-on. A permanent party seemed to be in progress there, fueled by an endless supply of potato chips and Golden Wedding whiskey, which Peggy, with the stinginess of the rich, considered adequate for her guests. John Cage, the avant-garde composer, was dazzled by the atmosphere at Hale House. Invited to stay there by Max Ernst, whom he had met a few months earlier in Chicago, Cage and his wife, Xenia, arrived in New York at the beginning of the summer and suddenly found themselves surrounded by "people whose names were written in gold in my head—Piet Mondrian, André Breton, Virgil Thomson, Marcel Duchamp, even Gypsy Rose Lee . . . Somebody famous was dropping in every two minutes, it seemed." The nastier side of Peggy's nature surfaced when she learned that Cage, who was virtually unknown then, was planning a concert of his percussion music at the Museum of Modern Art. Peggy wanted him to give a concert at the opening of her Art of This Century gallery in the fall, and she was so annoyed about the MOMA concert, which would precede her opening, that she canceled the one at her gallery and rescinded her offer to pay for shipping Cage's percussion instruments from Chicago. She also informed Cage and Xenia that they would have to move out of Hale House. Stunned by this harsh news—he was literally penniless at the time—Cage retreated through the usual crowd of revelers until he came to a room that he thought was empty, where he broke down in tears. Someone else was there, though,

sitting in a rocker and smoking a cigar. "It was Duchamp," Cage said. "He was by himself, and somehow his presence made me feel calmer." Although Cage could not recall what Duchamp said to him, he thought it had something to do with not depending on the Peggy Guggenheims of this world.

Walter Arensberg had withdrawn the offer to make Duchamp the curator of his Francis Bacon Foundation in California. The purpose of the offer had been to help him get a visa, but now, as Arensberg put it in a letter to Robert Parker, any plans for him to work in California would have to be postponed because of the war. Since Pearl Harbor, he said, the authorities had warned that the West Coast was in imminent danger of being bombed. Duchamp was perfectly happy to stay in New York. He thought he could support himself for a year or more by selling his deluxe *Boîtes-en-valise,* one of which he was preparing to send to the Arensbergs as a gift. They retailed for $200 apiece—did the Arensbergs know anyone in Hollywood who might like to buy one? He also told the Arensbergs that he was going to change his tourist visa to a regular immigration visa, which was the necessary first step in filing for U.S. citizenship.

Duchamp's position as the live-in guest of honor at Peggy Guggenheim's did not keep him from seeing his other New York friends. There were dinners with the Stettheimer sisters—still unmarried and more self-consciously eccentric than ever—and Connecticut weekends with Katherine Dreier, who had given up the idea of turning her house into a country museum. Dreier had chosen instead to donate the entire Société Anonyme collection to Yale. Sidney Janis was still pursuing the idea of a Los Angeles museum that would unite the Arensberg collection and Dreier's personal art holdings, but nothing would come of this. Duchamp brought Dreier to Hale House on a hot afternoon in late July while Peggy and Max were still away, to see Peggy's collection. While a violent thunderstorm raged outside, the telephone rang, and Duchamp answered it. The caller was Joseph Cornell, whose collages and poetic, boxlike assemblages had recently impressed André Breton as the most authentically Surrealist work he had seen by an American artist. Cornell had met Duchamp some years earlier, at the Julien Levy Gallery in 1933, but the shock of finding him on the other end of the telephone, as he described it in his diary, was "one of the most delightful and strangest experiences I ever had." He summoned the nerve to invite Duchamp to visit his studio, on Utopia Parkway in Queens, and Duchamp

cordially agreed to come the following Friday. It was the start of a relation-
ship that would be enormously important to the younger artist. Duchamp
took a keen interest in Cornell's work, in which glass, language, and enig-
matic found objects seemed to reflect an esthetic that was close to his own.
He persuaded Peggy Guggenheim to buy several of Cornell's things, and
later he acquired at least two Cornell boxes himself. To the pathologically
shy and reclusive Cornell, the fact that someone he admired as much as
Duchamp, who treated him with respect and friendship (there would be
many more visits to Utopia Parkway), seemed an almost unbelievable
stroke of luck.

André Breton managed to enlist Duchamp's help in organizing a large
Surrealist group show in New York, for the benefit of the Coordinating
Council of French Relief Societies. While Breton rounded up paintings and
sculptures by virtually all the artists associated with the Surrealist movement
except Dalí—whose highly publicized capers in the United States had
caused Breton to rechristen him "Avida Dollars" and to excommunicate him
from Surrealism's sacred ranks—Duchamp was entrusted, as he had been
four years earlier at the first big Surrealist show in Paris, with the job of pro-
viding a suitably provocative installation. The "First Papers of Surrealism"
exhibition (the title referred to an immigrant's application for U.S. citizen-
ship) would take place that fall in the ornate Whitelaw Reid mansion at 451
Madison Avenue. Duchamp designed the catalog, which included what he
called "compensation-portraits" of the artists—"found" photographs that
suggested some relatively obscure personal attribute or characteristic.
(Duchamp and/or Rrose Sélavy appeared as an anonymous gaunt-faced
woman in a photograph by Ben Shahn.) The organizers had been told by
Elsa Schiaparelli, the show's official sponsor, to spend as little money as pos-
sible on the installation, and Duchamp, resourceful as ever, found someone
in the cordage business to sell him sixteen miles of string. With help from
André and Jacqueline Breton, Max Ernst, Alexander Calder, and the young
American sculptor David Hare, Duchamp proceeded to spin a vast spider's
web throughout the rooms of the Reid mansion, winding the string from
chandeliers and mantels and pillars in crisscrossing skeins that made it
nearly impossible to see some of the works on display—a metaphor, perhaps,
for the often-cited obscurity of modern art.

He had seriously overestimated the amount of string they would need.
In the end they used only about one mile of it—or, rather, two miles,

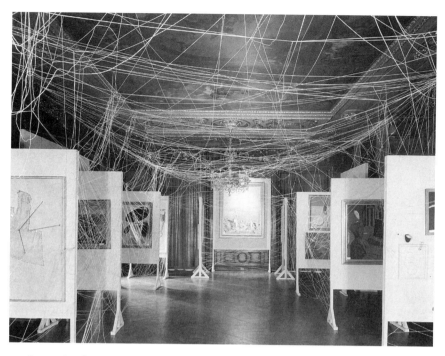

One mile of string. The "First Papers of Surrealism" show in New York, 1942.

because they wound the string too near the lightbulbs the first time around; it caught fire, and they had to do it all over again. Duchamp also made a secret arrangement with Sidney Janis's eleven-year-old son, Carroll, to show up at the mansion on opening night with a bunch of his friends. When the invited guests arrived for the benefit in their evening clothes, they found the premises already inhabited by a dozen boys and girls in athletic gear, kicking and passing balls and skipping rope and chasing each other around and through the barriers of string. If anyone objected, the children had been instructed to say that "Mr. Duchamp told us we could play here." Mr. Duchamp, true to form, never showed up.

Less than a week later, a crowd of chic New Yorkers flocked to the opening of Peggy Guggenheim's Art of This Century at 30 West 57th Street. The main attraction there was the gallery itself, which Frederick Kiesler had turned into a visual fun fair with curved walls, eccentric lighting, sound effects, peep shows, and other phantasmagoria never before used to display works of art. Paintings floated in space, attached to floor-to-ceiling ropes, or protruded from the wall on cantilevered baseball bats that

could be adjusted to different angles. Duchamp's *Box-in-a-Suitcase* was on public view for the first time; one looked through a tiny window, turned a huge spiral wheel, and saw fourteen of the reproductions appear, one after another. (A somewhat similar apparatus revealed paintings by Paul Klee.) Kiesler had infuriated Peggy by spending more than twice the amount she had agreed to for his interiors, but the results were so spectacular that she forgave him. Kiesler had provided the setting for Peggy's emergence, at long last, as a celebrated personage and patroness. She proudly welcomed her guests on opening night, wearing a white dress and her famously mismatched earrings, one by Yves Tanguy and the other by Alexander Calder, which symbolized, as she liked to say, her impartiality between Surrealist and abstract art.

At first even Peggy had trouble deciding just what Art of This Century was supposed to be. Clearly it was something other than the museum she had planned to establish, although most of the works on display in the opening exhibition were from her own collection and were not for sale. In its early days it functioned as a showcase for the Surrealists and the other European artists in exile—particularly for Max Ernst, whose new paintings definitely were for sale, but also for André Masson, Marc Chagall, Fernand Léger, Jacques Lipchitz, Yves Tanguy, Kurt Seligmann, Piet Mondrian, and others, many of whom used the gallery as a meeting place and message center. Very early, though, encouraged by her adviser Howard Putzel, Peggy began to show work by younger American artists. Joseph Cornell's boxes were featured in her second show, along with Duchamp's *Box-in-a-Suitcase* (again) and some fancifully painted bottles by Laurence Vail. An "Exhibition by 31 Women" came next. Duchamp had suggested it. A large and very mixed group show, it included female Surrealists (Leonor Fini, Valentine Hugo, Meret Oppenheim, Leonora Carrington), abstract painters (Irene Rice Pereira, Hedda Sterne, Sophie Tauber-Arp), sea-green originals (Louise Nevelson, Frida Kahlo), and a few rank amateurs (Gypsy Rose Lee, Peggy's sister, Hazel, and Peggy's daughter, Pegeen Vail), but the artist who would register most painfully in Peggy's mind and make her say later that she had included one woman too many was Dorothea Tanning, a vivacious dark-haired beauty with whom Max Ernst fell promptly and publicly in love.

Giving the nod to women artists in a group was about as far as the Surrealists were willing to go in the direction of equal opportunity. For Breton and his followers, a woman's role was to inspire or enthrall but not to par-

ticipate in the Surrealist revolution. Peggy herself never questioned the male-dominant hierarchy in modern art. She refused to be intimidated by Breton, however, and when Alfred Barr joined Howard Putzel in urging her to show the work of younger American artists as well as the Europeans in exile, she listened. Several Americans were included in a show of collages at Art of This Century in the spring of 1943, and a month later Peggy unveiled her first annual "Spring Salon for Young Artists." Picked by a jury whose members were Duchamp, Mondrian, Barr, Putzel, James Johnson Sweeney, James Thrall Soby, and Peggy Guggenheim (André Breton and Max Ernst were significantly excluded), the spring salon presented paintings by some thirty artists, among them a belligerent, hypersensitive, hard-drinking young unknown named Jackson Pollock.

On the day the jury met at Art of This Century to choose the paintings for the spring salon, Peggy walked over to a corner of the room where Mondrian, who had arrived early, was looking at a painting that Pollock had submitted, a dense thicket of abstract and semi-abstract forms called *Stenographic Figure.* "Pretty awful, isn't it?" she said. "That's not painting, is it? There is absolutely no discipline at all." She went on for a while in that vein until Mondrian looked up and said it was the most exciting painting he had seen in a long time. "You can't be serious," Peggy gasped. "You can't compare this and the way you paint." But Mondrian was completely serious. "The way I paint and the way I think," he said, "are two different things." Soon afterward Peggy was observed leading another jury member over to the Pollock and saying, "Let me show you something very, very interesting."

If Peggy's ears were better than her eyes, though, the point was that she did listen, and often to the right people. At Howard Putzel's insistence, she visited Pollock in his downtown studio a few weeks later, saw more of his work, and offered him a one-year contract that guaranteed him $150 a month—just enough to let him quit his menial job at, of all places, the Museum of Non-Objective Art, which was owned by Peggy's very wealthy uncle, Solomon Guggenheim. Pollock's first one-man show in November 1943 was the highlight of Art of This Century's second season and the launching pad for his rocket-like takeoff. A great many viewers hated the violent, clotted energy in such paintings as *The She-Wolf, Guardians of the Secret,* and *Moon-Woman Cuts the Circle,* but several critics were impressed; Clement Greenberg, writing in *The Nation,* singled out two of the smaller works as "among the strongest abstract paintings I have yet seen by an

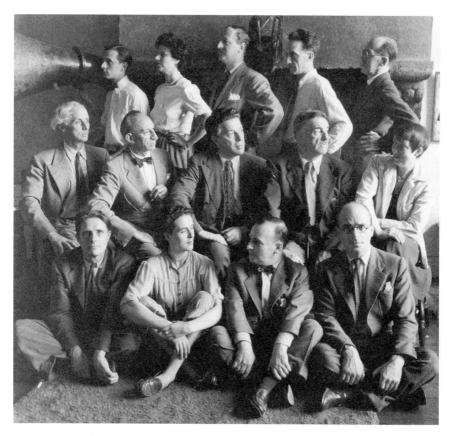

European artists (and a few Americans) in New York, 1942. Left to right, front row: Stanley William Hayter, Leonora Carrington, Frederick Kiesler, Kurt Seligmann; second row: Max Ernst, Amédée Ozenfant, André Breton, Fernand Léger, Berenice Abbott; third row: Jimmy Ernst (Max's son), Peggy Guggenheim, John Ferren, Marcel Duchamp, Piet Mondrian.

American." Pollock would show annually at Peggy's until 1947, the year she closed the gallery and went back to Europe—it was also the year Pollock began doing the dripped and splattered paintings that would make him famous. Although there were not many sales (even at prices that now seem laughable), Pollock had become the brightest star in a gallery whose focus, more and more, was on American artists of his own generation. William Baziotes, Robert Motherwell, Mark Rothko, and Clyfford Still all had their first one-man shows at Art of This Century, and most of the others in that first, pioneer generation of Abstract Expressionists were represented in group exhibitions there.

The gallery's shift in emphasis gradually alienated the Surrealists, whose presence in New York during the war years had helped to fertilize the development of the New York School. Just how much the European exiles influenced the younger Americans is debatable. The artists of Pollock's generation were an independent, contentious lot, and their outlook was anything but provincial. Most of them had worked on the Federal Art Project during the Depression; it had allowed them to devote themselves full-time to painting and sculpture, and it had also provided a kind of group solidarity that few American artists had known before. Living in New York, meeting regularly to talk about their work, and haunting the Museum of Modern Art, where Alfred Barr had assembled a collection of key works that was far more comprehensive than anything to be found in Europe then, these artists turned their backs on the prevailing American styles of regionalism and social realism (Arshile Gorky called the latter "poor art for poor people") and steeped themselves in the achievements of the European avant-garde. They followed the latest developments in *Cahiers d'art* and other international art journals and discussed them endlessly. By 1940, as Clement Greenberg would write, "a number of relatively obscure American artists already possessed the fullest painting culture of their time." The wartime migration of a sizable bloc of European artists to New York nevertheless served as a powerful stimulant. Pollock and several others began about this time to experiment with the kind of automatic techniques and chance effects that the Surrealists had been using for years, and to explore primitive myths and Jungian psychology as sources for new imagery. Pollock may even have gotten the idea for his drip paintings (which would not materialize until several years later) from Max Ernst's trick of punching holes in a paint-filled tin can and swinging it over a canvas. "I am particularly impressed with their [i.e., the Europeans'] concept of the source of art being the unconscious," Pollock said in 1944. "This idea interests me more than these specific painters, for the two artists I admire most, Picasso and Miró, are still abroad."

Arshile Gorky, Robert Motherwell, and David Hare became friendly with the Breton circle, and a number of others (including Pollock) fell temporarily under the spell of Matta (Roberto Matta Echaurren), the youngest of the Surrealists, who spouted ideas in such scintillating profusion (in fluent English) that he sometimes seemed to be challenging Breton's intellectual hegemony. For the most part, though, the Americans resented the visitors' aura of cultural superiority, and they were suspicious of Surrealism's

messianic pronouncements. Although both groups shared the romantic ambition to tap new sources of personal emotion, the New York painters' approach was more visceral and less intellectual. For Pollock, Gorky, and many others, the real god and main obstacle was Picasso, who had always shied clear of orthodox Surrealism. In their struggle to break away from Picasso's overwhelming influence, they took what they wanted from the Surrealist bag of tricks but rejected the movement's literary and intellectual underpinnings. Their goal was not to change life; it was to make great art.

Duchamp, who had helped to select the artists for Peggy's 1943 spring salon, felt no particular enthusiasm for Pollock's work. The two tendencies that would soon be lumped together under the blanket term Abstract Expressionism—the gestural style of Pollock, Willem de Kooning, Philip Guston, and Franz Kline, and the open chromatic fields of Mark Rothko, Clyfford Still, and Barnett Newman—were both "retinal," in the sense that their appeal was to the eye rather than to the mind, and as such they held little interest for Duchamp. The Abstract Expressionists, for their part, did not consider Duchamp's work or his ideas an important part of the modernist canon. As Abstract Expressionism rose to become the dominant art of the mid-century, Duchamp's reputation and Duchamp's influence would inevitably decline.

Shortly before the opening of the "First Papers of Surrealism" show in October 1942, Duchamp left Hale House and moved in with Frederick Kiesler and his wife, Steffi, who had offered to rent him a room and bath in their twentieth-floor penthouse on lower Seventh Avenue. Kiesler was a difficult, at times insufferable, character, a tireless self-promoter with the arrogance that often afflicts very short men (Kiesler was an inch or so under five feet). He idolized Duchamp, however, and in 1937 he had bought Duchamp's palimpsest painting, *Network of Stoppages,* from the artist Joseph Stella, to whom Duchamp had given it during his early years in New York. (Kiesler sold the painting in 1946; it now hangs in the Museum of Modern Art.) Duchamp's arrangement with the Kieslers gave him a good deal of privacy—his room had its own outside door, so he could come and go as he pleased—and after moving there in the fall of 1942, he resumed many of his old New York habits. He started giving French lessons to a few select pupils. He joined the Greenwich Village Chess Club and played there

almost every evening. Duchamp had designed a pocket chess set with tiny plastic chessmen and pins to keep them in place; for a while he tried to market it, but no one seemed interested. A good deal of his time was spent in his room, working on the *Boxes*. Looking for someone to help him with the tedious work of assembling the standard (nondeluxe) edition, he thought of Joseph Cornell, who had been making his own, highly evocative shadow box assemblages since the early 1930s. Cornell was a willing accomplice. He assembled and fitted out several of the early Duchamp *Boîtes,* but there are no records to show how many, or which ones, or how much Duchamp paid him for his labors. The arrangement seems not to have been entirely satisfactory, in any case, because Duchamp soon turned over the making of his boxes to Xenia Cage, John Cage's wife, who became the fabricator of record for the first series—approximately sixty boxes. Now and then Duchamp signed a deluxe, leather-encased *Box-in-a-Suitcase* for a specific client. "I have sold 7," he wrote to his Chicago friend Alice Roullier, who had just persuaded Mrs. Walter Paepcke to buy a deluxe *Suitcase*. "So I have 13 left and you realize that, especially at the moment, they don't sell like hotcakes."

Duchamp also served as one of the editorial advisers to *VVV,* the quarterly "almanac" that Breton had started as a rival publication to Charles Henri Ford's avant-garde magazine, *View.* Expensively printed and bilingual—some texts were in French and others in English—*VVV* was intended to keep the fires of Surrealism aglow in the movement's wartime exile, but it flickered out after three issues. Duchamp designed the cover for the second (double-length) number. He found an etching by an anonymous artist, of a scythe-carrying horseman wearing a shirt that resembled the American flag, and superimposed it on a globe of the earth. Duchamp was also responsible for the magazine's back cover, in which a piece of chicken wire was inserted in a cutout of a woman's torso in profile; the reader was instructed to make a "Twin-Touch-Test" by placing his or her hands on either side of the wire screen, "fingertips touching each other and slide gently along screen towards you."

Duchamp's quietly attentive friendship helped Breton through a rough period in his private life. His wife, Jacqueline Lamba, had fallen in love with David Hare, the young American sculptor whom Breton had installed as managing editor of *VVV.* Hare moved in with Jacqueline and seven-year-old Aube (whom Breton adored) in their apartment in the Village, and Breton retreated to a gloomy single room on West 56th Street. Just across the

Allégorie de Genre (Genre Allegory), 1943.

street was Larré's French restaurant, a congenial place where in those days a three-course meal with a glass of wine cost less than two dollars. During the lunch hour Breton, who earned a meager living by making French-language broadcasts for the Voice of America, exercised his dwindling authority at a big table near the window, surrounded by loyal old followers and an occasional new recruit. One day Enrico Donati, an Italian-born artist whose work had recently been discovered by Breton in a show at the New School for Social Research, saw Breton jump up from the table and rap urgently on the window. Duchamp, who had been passing by outside, came into the restaurant a moment later and Donati was astonished by the reverence with which Breton greeted him. "What the hell is this?" he remembers thinking, but by the time they finished lunch, Donati and Duchamp had become great friends. Without the least effort on his part, it seemed, Duchamp attracted admiration and respect. It made him uncomfortable sometimes. As he wrote to Katherine Dreier, "I am dumbfounded at my position as a kind of 'vedette' in this town and not to be able to at least make an ordinary living out of it."

Alexander Liberman, *Vogue*'s highly sophisticated, Russian-born art director, was so impressed by Duchamp's legendary status—and by his

maze of string at the "First Papers" exhibition—that he asked him to pro-
vide some ideas for the cover of the "Americana" issue of *Vogue,* whose pub-
lication date was February 15, 1943. Duchamp brought his proposal in to
Liberman's office a few weeks later. It was a collage portrait of George
Washington. The unmistakable profile was made of bandage gauze,
stained with reddish-brown stripes that looked distressingly like dried
blood and pinned down by thirteen gold-headed stars. Turned on its side,
the portrait's outline became a map of the United States, but *Vogue*'s editors
never noticed that—they were too upset by the stained gauze, which to
some of them suggested used sanitary napkins. What Duchamp was up to
with this little bombshell, which he called *Allégorie de Genre* (*Genre Alle-
gory*), is anybody's guess. He must have known that *Vogue* would never pub-
lish it. Since anti-American feelings were not in his makeup, it is tempting
to speculate that he was making a sulfurous comment on the always-
incipient marriage of art and fashion in *Vogue*'s glossy pages. At any rate,
after some time had gone by with no response from Liberman, Duchamp
finally telephoned him, and Liberman, greatly embarrassed, explained that
the work was "not for *Vogue*" but that he would receive $50 for "expenses."
André Breton subsequently paid him $300 for the collage, which he repro-
duced in the third number of *VVV.* Some forty years later the Musée de l'Art
Moderne of the Centre Georges Pompidou in Paris would acquire it from
Breton's estate for the equivalent of $500,000.

Ever since he left Paris for the last time in the spring of 1940, Duchamp
had been living the life of a *célibataire.* There was no evidence of any new
liaisons, either in the south of France or in New York. Peggy Guggenheim
claimed that he kissed her one night during a party at her apartment and
that later, when her marriage to Max Ernst was breaking up over Dorothea
Tanning, she and Duchamp had consummated their physical desire for
each other, "which had been hanging fire for twenty years." Most of
Duchamp's friends (and Peggy's as well) put this down to wishful thinking
on her part. David Hare didn't believe that the fastidious Duchamp could
make love to someone as ugly as Peggy, with her dyed black hair, bulbous
nose, blotchy skin, and smeared lipstick. Their skepticism overlooked his
past history. Duchamp had once married a fairly unattractive woman, after
all, and he had talked to Roché about the pleasures of making love to
women with ugly faces but beautiful bodies, which they must show off "or
be deprived of any life." That description could easily be applied to Peggy,

who liked to parade around at home in transparent silks with nothing on underneath and who was so sex-obsessed that she would encourage male guests to go to bed with her nymphet-daughter, Pegeen. (In her auto-biography Peggy described an evening at Hale House when Max Ernst, John Cage, Xenia Cage, and Duchamp took off all their clothes to prove how detached they could be, while Peggy and the Kieslers looked on with "contempt"—an unlikely reaction to an improbable event.) Max Ernst, who bedded several younger women during his brief marriage to Peggy, had a jealous fit at one point over her relationship to Duchamp, so perhaps there was some basis to her claim. Even Peggy admitted, though, that on the nights she spent with Marcel, he "behaved more like a nurse than a lover" and that, because of Mary Reynolds, "we could never have a serious affair."

Mary Reynolds finally arrived in New York in April 1943 after a har-rowing escape from occupied France. The reason she had stayed so long in Paris was that she was working for the Resistance. Her house on the rue Hallé became the nerve center of a Resistance unit that had been started by Jeannine Picabia, the artist's daughter; Samuel Beckett worked with this group, and so did Jeannine's mother, the redoubtable Gabrielle Buffet-Picabia. Reynolds occasionally hid people on the run from the Gestapo—one of them was the painter Jean Hélion, who had escaped from a German prison ship near Stettin and made his way back to Paris. (When he turned up in New York a year later, Hélion rescued Pegeen Vail from her mother's sex orgies by marrying her.) Mary Reynolds also picked up microfilm for the British at the apartment of a music teacher. On one occasion the concierge there made a small sign to her when she arrived, indicating dan-ger—two Gestapo agents were in the music teacher's apartment. Mary went upstairs anyway, told the agents that she was a friend of the tenant, who was not there, and calmly said she would sit down and wait for her. The agents continued to search the apartment. At a moment when both of them were in another room, Mary got up and retrieved the spool of microfilm from its hiding place. She left the apartment with the unsuspecting Gestapo pair, bid them a pleasant good-day, and delivered the microfilm.

Once the United States declared war on the Axis powers, life became very difficult for American citizens who had stayed in Paris. The men were rounded up a week after Pearl Harbor and sent to a detention camp in Compiègne, and the women were instructed to report every week to the

police. In September 1942 the Nazis rounded up the remaining American women and sent them to an internment camp in the spa town of Vittel. (They were subsequently released and allowed to come back to Paris.) A week before her friends Noel Murphy and Sylvia Beach were interned, Mary Reynolds had decided to make a run for it. By asking questions in cafés, she established contact with a guide who agreed—for a fee of 5,000 francs—to get her over the border into the unoccupied zone. She crossed at three o'clock in the morning, fording a stream with four Jewish refugees and then proceeding by train to Lyon, where she stayed for eight weeks before she was able to procure the necessary papers to get her to Lisbon. When she went to pick up her Spanish visa, the most difficult of all to obtain, she learned that the Spanish border had just been closed. The Nazis had moved into the unoccupied zone in November, and they were sealing off all the remaining escape routes. The only way to get to Spain, she was told, was to walk over the Pyrenees.

Mary went by train to Pau, in the foothills, where it took her twelve days to find a guide who would let her join one of the little bands of desperate escapees. She was forty-five years old, "statuesque, unmelodramatic . . . a seasoned traveler, and nobody's fool," according to her friend Janet Flanner, but nobody wanted to take a middle-aged woman along on a grueling twenty-hour climb, especially when there was a good chance of being shot at by Vichy border patrols. She was finally allowed (for 35,000 francs) to join a group that made the ascent in three days, sleeping in abandoned and unheated shepherds' huts, only to be arrested by the Guardia Civil in the first Spanish village they came to after crossing the border. Released because her papers were miraculously in order, she reached Madrid early in December and sent cables to her brother in Chicago and to Duchamp in New York. Duchamp, who had heard nothing from her since mid-September, was tremendously relieved. "I thought she was trapped and I feared the concentration camp for her," he wrote to Walter Pach. But her ordeal was not yet over. Once she got to Lisbon, it took her three months to get a seat on the Pan Am Clipper because there were so few flights and so many people trying to get on them. The flight itself took four days, going by way of Liberia, Brazil, Trinidad, Puerto Rico, and Bermuda. She arrived in New York during the first week of April, seven months after leaving Paris. Exhausted, sick, and very weak, she considered herself lucky to be alive.

Silence, Slowness, Solitude

> Marcel Duchamp [is] the only one of all his
> contemporaries who is in no way
> inclined to grow older.
>
> —André Breton, 1945

Duchamp and Mary Reynolds, who had not seen each other since Duchamp left Paris in the late spring of 1941, seemed at first to settle back into their old, comfortable relationship. She took a furnished room in Greenwich Village, not far from the Kieslers' apartment, where Duchamp was staying. They met frequently and went to restaurants and dinner parties together, but things were not the same between them. Mary found New York unbearable and longed to get back to Paris. Marcel was thinking seriously about applying for U.S. citizenship. Perhaps they understood each other too well after nearly two decades; what was once a deep, if somewhat unequal attraction had subsided into friendship. Except for a few brief interludes, their lives would never again run in parallel directions.

In the fall of 1943 Duchamp moved from the Kieslers' to a one-room apartment at 210 West 14th Street, in the middle of the block between Seventh and Eighth Avenues. His room was on the top floor, up four flights of stairs. It had a floor-to-ceiling window facing north across 14th Street and a bathroom that he shared with two other tenants. The rent was $35 a month. A legendary aura would gradually attach itself to this sanctuary, which Duchamp held on to for twenty-two years. There was no telephone, so people who wanted to get in touch with him had to write in advance or (if

the weather was warm and his window was open) call up to him from the street below. The relatively few people who did gain admittance were struck by the austerity of Duchamp's living arrangements. William Copley, a young California art dealer who later became an artist, retained a vivid memory of his first visit to the place: "It was a medium-sized room. There was a table with a chess board, one chair, and a kind of packing crate on the other side to sit on, and I guess a bed of some kind in the corner. There was a pile of tobacco ashes on the table, where he used to clean his pipe. There were two nails in the wall, with a piece of string hanging down from one. And that was *all.*" Nobody could figure out how he occupied himself during the countless hours he spent alone in that room. What little reading he did seemed to be limited to the study of chess problems. From time to time he would sell one of his *Boxes*—the going price was $100. That and the minuscule income from the private French lessons he still gave took care of his material needs. Beatrice Wood, who came to New York in 1944 for a show of her ceramics at America House, saw the tiny portable chess set that Duchamp had designed and urged him to market it. "What would I do with the money?" he inquired. "I have enough for my needs . . . If I had more money I would have to spend time taking care of it and that is not the way I want to live."

Robert Motherwell, the youngest and the best educated of the first-generation Abstract Expressionists, used to have lunch with Duchamp now and then at an Italian bistro near his 14th Street studio. "Duchamp always had the same lunch," he said, "a bowl of plain pasta, with a pat of butter on it and a little Parmesan cheese, and small glass of red wine. Once I said to him, 'Marcel, you're so French, why do you prefer New York?' He said, 'Because Paris devours you.' He used the image of a basket of crabs, clawing away at each other. In New York he felt unclawed."

Just before moving to 14th Street, Duchamp had supervised the transfer of his *Large Glass* from Katherine Dreier's house to the Museum of Modern Art, where it would remain on extended loan for more than two years. He went out to Connecticut to oversee the crating operation and then rode in the truck that brought it down to New York. The driver was under strict orders not to go faster than 15 miles per hour, but even so, a few slivers of broken glass were jarred loose in transit, and the next day Duchamp spent several hours fitting them back where they belonged. James Thrall Soby, then the museum's assistant director, was on hand to oversee the

Glass's installation in a large gallery on the third floor. Soby later described his own anxiety "as the huge panel moved into place on its dolly" while Duchamp, unconcerned, "puffed serenely on his pipe and said, 'We must be careful not to drop it; it might break someone's foot.' "

Duchamp was held in high regard at the Museum of Modern Art—by the staff, at any rate. There was not a trace of the old misunderstanding with Alfred Barr, who had pulled strings in Washington the year before to help expedite Duchamp's American visa and who was responsible for getting Katherine Dreier to lend *The Large Glass.* (Duchamp had given the museum one of his deluxe *Boîtes-en-valise* in 1943.) Unfortunately, Barr himself was in serious trouble at the museum just then, as a result of his long-simmering feud with Stephen Clark, the conservative president of the board of trustees. A month after *The Large Glass* arrived, in fact, Barr was summarily fired as the museum's director. He refused to leave—the museum was his creation, after all. For the next few years he occupied a tiny office within the library, where he wrote and studied and gave discreet guidance to members of the staff, most of whom never doubted that it was still Barr's museum; this went on until 1947, when the trustees came to their senses and named him director of museum collections. During his years in limbo, Barr used to go down to Duchamp's 14th Street walk-up for an occasional game of chess. He was a good player, if not quite on Duchamp's level, and they greatly enjoyed each other's company.

Without any apparent effort on his part, Duchamp hovered like a benign genie over the New York art scene. Two exhibitions of work by the three Duchamp brothers—the first at the Mortimer Brandt Gallery in 1944, the second in 1945 at the Yale University Art Gallery, which had received the Société Anonyme collection as a gift from Katherine Dreier—served to remind people how far the youngest brother had traveled outside previously accepted limits of art. George Heard Hamilton, the young art historian who organized the show at Yale, included *3 Standard Stoppages, Disturbed Balance* (Dreier's title for the study-on-glass that Duchamp called *To Be Looked at [from the Other Side of the Room] with One Eye, Close to, for Almost an Hour*), *Rotary Demisphere,* a set of *Rotoreliefs,* the *Tzanck Check,* a *Green Box,* a *Box-in-a-Suitcase* (on loan from Dreier's private collection), *Fresh Widow,* and *In Advance of the Broken Arm.* The latter was a re-creation, a new snow shovel that Hamilton had bought in a New York City hardware store to replace the

lost original; Duchamp painted the title on the blade and signed it, and Hamilton took it back to New Haven on the train one balmy April evening, "startling the commuters who thought I must have heard a dire report about our fickle New England weather." When the Yale show went on tour the following winter, according to Hamilton, a janitor in a small Minnesota museum used the shovel to clear away a snowdrift—an understandable confusion and an interesting gloss on Apollinaire's prophecy about Duchamp reconciling art and the people.

View, the avant-garde art and literary quarterly, devoted its March 1945 number to Duchamp. The cover had been designed by Duchamp himself; it showed a photograph of a very dusty wine bottle with smoke coming out of it, floating up into a deep blue, starry night sky. (Duchamp had drilled a hole in the bottom of the bottle in order to pipe smoke through the neck.) The image was evocative but ambiguous. It could be taken as an ironic comment on his own genie-like reputation, as ephemeral as smoke; it might also refer to *The Large Glass* or to the war (the wine bottle's label was actually Duchamp's old military service record) or to the notion of "infra-thin" (the idea he had discussed with Roché in 1941), which was evoked on the magazine's back cover in an example provided by Duchamp: "Quand la fumée de tabac sent aussi de la bouche qui l'exhale, les deux odeurs s'épousent par infra-mince." ("When the tobacco smoke also smells of the mouth which exhales it, the two odors are married by infra-thin.")

The editorial contents of this special issue veered close to canonization. André Breton, whose "Lighthouse of the Bride" essay appeared here for the first time in English, also contributed an ardent "Testament" in which he paid homage to Duchamp's "unshakeable fidelity to the sole principle of *invention, mistress of the world*" and called him "the only one of all his contemporaries who is in no way inclined to grow older." James Thrall Soby, Harriet and Sidney Janis, Nicolas Calas, and Gabrielle Buffet-Picabia weighed in with laudatory essays, and the editors filled out the issue's fifty-four pages with photographs of Duchamp and his works, excerpts from *Love Days* by "Henrie Waste" (Ettie Stettheimer), admiring memoirs by Man Ray, Robert Allerton Parker, Julien Levy, and Mina Loy, and a six-page montage by Frederick Kiesler that showed Duchamp in his 14th Street studio, surrounded by earlier works (*The Large Glass, The Brawl at Austerlitz,* and others), which were there in spirit if not in fact. The

Duchamp number of *View* confirmed his status as a cultural icon for the small band of New York art and literary intellectuals who still looked primarily to Europe for guidance. *Vogue,* which liked to rub shoulders with this cultural elite, photographed a model through a section of *The Large Glass* for the cover of its July 1945 issue, when the *Glass* was still on view at the Museum of Modern Art; the magazine informed its readers, none too helpfully, that the work itself was "regarded as the ideal marriage of painting and sculpture." Duchamp's name no longer registered with most Americans, however, and over the next fifteen years his reputation would gradually fade to the point of invisibility, even within the tiny milieu of advanced modern art.

Although Duchamp produced during these years very little that even remotely qualified as art, he could almost always be counted on to help promote the work of his friends. When Florine Stettheimer died in 1944, he wrote to Monroe Wheeler, the Museum of Modern Art's director of exhibitions, suggesting that the museum give her a memorial exhibition and offering his services to organize it. "Besides my personal admiration for her work," he wrote to Wheeler, "I think her large allegories of New York as well as her portraits and family scenes deserve to be shown since, as you know, she seldom exhibited during her life." Duchamp did the catalog cover for Man Ray's show at the Julien Levy Gallery that year; it showed a black couple kissing in extreme close-up, an image taken from a single frame of an early Hollywood movie, which Duchamp had enlarged and rephotographed several times. To publicize André Breton's new book, *Arcane 17,* Duchamp, Breton, and Matta collaborated on a Surrealist window display at Brentano's bookstore on Fifth Avenue. Duchamp's main contribution was a headless female mannequin, nude except for a scanty maid's apron, with a water faucet glued to her right thigh—a reference, perhaps, to Rrose Sélavy's "article of lazy hardware, a faucet that stops running when nobody is listening." The mannequin and Matta's adjacent drawing of a bare female breast attracted sidewalk crowds, and almost immediately representatives of both the Society for the Suppression of Vice and the League of Women made strenuous protests that led Brentano's to request that the tableau be removed. Duchamp and Breton reinstalled it in the window of the Gotham Book Mart, a block away on West 47th Street, where in spite of continuing protests by New York's quaint but still-influential guardians of public virtue, it remained for a week.

Window display for Breton's *Arcane 17*.

Duchamp, Breton, and Man Ray celebrated the end of the war in
Europe by having dinner together at Luchow's, the famous old German
restaurant on 14th Street. Man Ray was in town for his show at Julien
Levy's. After leaving Paris in 1939, he had ended up in Los Angeles, not
New York; there was more Surrealism in Hollywood, he maintained, than
all the Surrealists could invent in a lifetime. He lived there until he went
back to Paris for good in 1947, accompanied by his young American wife,
the former Juliet Browner, whom he had married a year earlier in a joint
ceremony with Max Ernst and Dorothea Tanning. (Before meeting Man
Ray, Juliet had lived for a brief period with Willem de Kooning.) Man Ray's
hero worship of Duchamp was undiminished. As he wrote to him soon
after his New York visit that spring, "The most insignificant thing you do
is a thousand times more interesting and fruitful than the best that can be
said or done by your detractors." What detractors? Among the European
artists in New York, Duchamp seemed to be the only one who remained on
good terms with everybody.

Mary Reynolds was back in her Paris house two months before V-E Day. She deeply regretted having left it, and her unrelenting efforts to establish diplomatic contacts that would speed her return had finally succeeded. Duchamp, who had been having a lot of trouble getting his visitor's visa renewed, now seemed to lean toward returning to France himself, but he was in no hurry about it. He often said he preferred the tranquillity of life in New York. In a letter to his old girlfriend Yvonne Chastel (now Yvonne Lyon), he wrote that New York was a "paradise" for him, but then he added, "the human animal is so stupid that one ends up no longer seeing the paradise."

A lassitude, a sort of weary resignation, seemed to have come over Duchamp. He saw less and less of Breton and the other European exiles, whose jealousies and quarrels had shredded the group's wartime solidarity. Alone in his room, he studied chess problems for at least four hours every day. Silence, slowness, solitude—these were his guideposts now, according to a conversation he had that summer with the Swiss writer-philosopher Denis de Rougemont, who was in charge of French transmissions at the Voice of America. Duchamp spent several days as de Rougemont's guest in a big summer house on the shore of Lake George in the Adirondacks, and de Rougemont's diary records their discussions. Duchamp took an elitist position in some of them, arguing that the American masses could never be educated and that it was important to react against their impatience and their materialism by cultivating silence, slowness, and solitude. He also confided to de Rougemont that ever since his father died, he had felt deprived of any sense of authority in his own life. "Marriage, for example," he said. (A surprising example from such a dedicated bachelor.) "It seems to me that first of all I should go and ask my father's opinion . . . Probably I never grew up."

When de Rougemont asked Duchamp whether it was true that he had decided at the height of his career to give up painting, Duchamp laughed and said that he hadn't decided any such thing. He had simply run out of ideas, he explained, and he did not want to copy himself and become a slave to the market. The next day, however, sitting on the front porch, looking out over the lake through a screen of tall pines, Duchamp talked about his idea of "infra-thin." It had to do, in a decidedly nonscientific way, with infinitesimal spaces and subtle relationships. The space between the front and the back of a sheet of paper was an example of infra-thin, he said, and so was the sound made by

his corduroy trousers rubbing together when he walked. The concept of infra-thin never surfaced in any new works of visual art by Duchamp—not directly, at any rate—but he kept on playing with it verbally for the rest of his life. It seems odd that Duchampian idolaters have not yet established a connection between this notion and contemporary developments in atomic physics, which had recently found a way to unlock the tremendous power residing in infinitesimally small units of matter. The morning after Duchamp talked about "infra-thin" on the front porch at Lake George, Denis de Rougement walked into town and brought back the newspaper, whose banner headlines proclaimed that the world's first atomic bomb had been dropped on Hiroshima.

The exile colony in New York was breaking up. Max Ernst had gone to live in Arizona with Dorothea Tanning. Léger, Masson, and several others returned to Paris soon after V-E Day. Yves Tanguy and Kay Sage, his American artist-wife, had moved to Connecticut. Duchamp stayed on in his 14th Street room, a somewhat shadowy presence whom others nevertheless continued to seek out. He did another Surrealist window display at Brentano's, for Breton's book of essays, *Le Surréalisme et la peinture*—this one escaped public protests—and he designed the cover for Breton's new book of poems, called *Young Cherry Trees Secured Against Hares*. (Breton's friends thought the title referred to David Hare's treachery.) A film producer enlisted Duchamp, Alfred Barr, and Sidney Janis as judges for the *Bel-Ami* Award, to go to a painting on the theme of "The Temptation of Saint Anthony." The winner was Max Ernst, whose painting would be featured in a movie version of Maupassant's novel *Bel-Ami*. Duchamp himself appeared in one of the episodes of Hans Richter's film *Dreams That Money Can Buy*, a heavy-handed Surrealist effort that took three years to complete; in the Duchamp sequence a nude female rather prosaically descends a flight of stairs, accompanied by John Cage's atonal collage of "found" sounds.

Katherine Dreier, who had sold her house in West Redding, naturally required Duchamp's help in redecorating the Georgian mansion she bought in Milford, Connecticut. Agreeable as always, he spent several days painting the elevator in the front hall, which was something of an eyesore, in the same decorative floral pattern as the wallpaper. When the place was

Katherine Dreier in the
elevator that Duchamp
painted to match the
wallpaper.

ready, Duchamp also supervised the reinstallation of his *Large Glass* in
Dreier's new sitting room. The Museum of Modern Art, meanwhile, had
invited him to serve as guest director of a Florine Stettheimer memorial
exhibition scheduled for the fall of 1946 (the exhibition he had proposed to
Monroe Wheeler the year before) and awarded him a one-year fellowship
to pay for his time and expenses.

Alfred Barr was still in temporary eclipse at the museum then, but
James Johnson Sweeney, the Irish-born poet and art historian who had
recently been named director of the Department of Painting and Sculp-
ture, was proving to be an even greater admirer of Duchamp than Barr.
Sweeney became the prime mover behind the trustees' decision to pur-
chase *The Passage from the Virgin to the Bride* from Walter Pach in Decem-
ber 1945—the painting, which had belonged to Pach ever since Duchamp
gave it to him in 1915, was the first major work by Duchamp to enter a
public collection. Sweeney also began interviewing Duchamp in two-hour

Maria Martins in
Vogue, 1944.

sessions once a week for a book-length monograph that he never found the
time to write.

Sometime in 1946 Duchamp inscribed one of his leather-covered *Boîte-en-
Valise* to Maria Martins, the wife of the Brazilian ambassador to the United
States. Their liaison was still a secret then, although it would become an
open one the following year. A small, dark-haired, vibrantly attractive
woman who was known as the Washington diplomatic colony's most pop-
ular hostess, Maria Martins had another life as a recognized sculptor. She
had studied with Oscar Jespers in Belgium and with Jacques Lipchitz in
New York, and her work—powerfully expressionist sculptures in bronze,
terracotta, plaster, and wood, many of which evoked Brazilian folk
themes—had been shown by the Corcoran Gallery in Washington, D.C.,

and in several solo exhibitions in New York. She also made jewelry; *Vogue,* which had already taken note of her double career as a sculptor and a Washington hostess, published photographs of her jewelry in 1944. Duchamp may have met Maria Martins as early as 1943, when her sculptures were paired with paintings by Mondrian in a show at the Valentine Gallery on 57th Street. She would have been forty-three at the time—thirteen years younger than he was. By 1946 their relationship had advanced considerably, judging from the original art work that was included in the *Boîte-en-valise* he gave her. The originals in most of the early *Valises* had been Duchamp's hand-painted color guides, made to assist the printer of the collotype reproductions. For Maria Martins, however, he had done a surpassingly strange drawing on celluloid backed with black satin: an abstract, flowing, amoeba-like shape that resembled nothing else in his entire oeuvre. Not until 1989 did chemical analysis disclose that his drawing medium was ejaculated seminal fluid. Duchamp's title for this erotic talisman was *Paysage fautif,* or *Faulty Landscape.*

The highly original art
work in Maria's *Valise*.

Maria Martins lived both her lives to the hilt. From 1939 to 1948 she and Carlos Martins, her husband, gave the liveliest and most interesting dinner parties in Washington, parties at which they complemented each other perfectly; Carlos, the dean of the foreign diplomatic corps, seemed to bask in the warmth of his wife's exuberant hospitality. They had lived in many different cities—Copenhagen, Brussels, Paris, Tokyo—but the verve and brio that they brought to Washington's staid social life seemed uniquely and enchantingly South American. In New York, on the other hand, Maria's friends were almost all artists. She kept a duplex apartment at 421 Park Avenue, which she visited as often as she could on weekends and sometimes for longer periods, usually without her husband, and it was there that she did most of her work. The sculpture studio on the lower floor had a double-height ceiling. She pulled her own prints on a press in the next room, having learned the technique at Stanley William Hayter's famous Atelier 17, which had moved from Paris to New York during the war years. Maria's recent sculpture (she used the single name Maria for all her art work) had been strongly influenced by Surrealism. She knew most of the European artists in exile before she met Duchamp; André Breton, who admired her work enough to write the catalog essay for one of her New York shows, fell heavily under her spell. So did quite a few others. Nelson Rockefeller, who had resigned as president of the Museum of Modern Art in 1940 to run the newly designated Office of Inter-American Affairs in Washington, was rumored to have had an extended affair with her, and it was not entirely by coincidence, perhaps, that MOMA acquired three of her sculptures for its permanent collection.

"My mother could seduce anybody," her daughter Nora remembers proudly. "I can just see her bending close to someone and saying, 'I like you very much. Tell me who your enemies are, so that I can help you hate them.' She was beautiful, highly intelligent, and a great actress—someone who could make an adventure out of a trip to the drugstore. She was certainly the most fascinating woman I have ever known." Nora was thirteen years old when she first met Marcel Duchamp. A student at the Madeira School in Virginia, she came to stay in her mother's New York apartment one weekend, and Duchamp took her to lunch at a restaurant on Third Avenue. Like most young people, she found him gentle, relaxed, amusing, and interested in what she had to say. His relationship with her mother never made

Etant donnés: Maria, la chute d'eau et le gaz d'éclairage (Given: Maria, the Waterfall, and the Lighting Gas). First study for the secret work.

her feel uncomfortable. "He was always there in the apartment," she said. "My father was probably aware of it, but he was so crazy about her that he said nothing." Of all her mother's admirers, she came to feel, Duchamp was the only one she listened to. Nora also sensed that their love affair was more cerebral than physical, "although I know my mother would be furious to hear me say that."

In the past Duchamp had been careful to keep a certain distance between himself and the women he was involved with—sexually or otherwise. Gabrielle Buffet-Picabia, Yvonne Chastel, Katherine Dreier, the unfortunate Lydie Sarazin-Levassor, even Mary Reynolds were denied access to large areas of his life and thoughts, which he barred off to protect the solitude that his freedom required. Maria Martins swept aside the bars. She was his opposite in most respects—confrontational, eccentric, flamboyant, and emotionally fearless—but she valued her freedom as much as he

did, and this probably served to increase his desire for her. Maria Martins gave Duchamp an intensity of happiness and, in the end, of pain that was altogether new to his experience. She also played a role in his reincarnation as an artist. Soon after they met, he embarked on a major new work—the first since *The Large Glass*—that would occupy him, intermittently and in absolute secrecy, for the next twenty years.

A small pencil drawing by Duchamp, dated 1947, is believed to be the first study for this new work. It shows a faintly but realistically drawn nude woman, headless, slender, full breasted, with one leg raised and bent at the knee. The view is frontal, and its most prominent feature, rendered in slightly darker pencil lines than the rest of the composition, is her pubic bush. Duchamp's signature is at the bottom of the sheet. Just above it he has penciled in the title, which comes (with one significant addition) from a note in *The Green Box* that Duchamp had also used as a sort of subtitle to *The Large Glass*. It reads: *Etant donnés: Maria, la chute d'eau et le gaz d'éclairage* (*Given: Maria, the Waterfall and the Lighting Gas*). This drawing was unknown until the mid-1970s, when the director of the Moderna Museet in Stockholm, Pontus Hulten, borrowed it from Nora Lobo, to whom it had passed after her mother's death in 1973. In addition to the little drawing, Hulten also borrowed from Nora a relief study of the same figure. Its material construction is very curious—translucent cowhide, painted on the inside and stretched over a plaster model. On the back Duchamp had written: "Cette dame appartient à Maria Martins/avec toutes mes affections/Marcel Duchamp 1948–1949" ("This lady belongs to Maria Martins/with all my love . . ."). It would be hard to imagine a more carefully wrought, less sentimental valentine.

Maria

. . . this cage outside the world.

Crossing the Atlantic on the Cunard liner SS *Brazil* in May 1946, Duchamp traveled light, as always. Unlike his fellow passenger Virgil Thomson, the composer, who was returning to his quai Voltaire flat with ten trunks of personal effects and consumer goods to distribute to Parisian friends, Duchamp did not plan to stay long. He was coming to see his family and renew old ties and also to negotiate the purchase of several works of art (by Picabia, Brancusi, Delaunay, and others) that James Johnson Sweeney wanted to add to the Museum of Modern Art's permanent collection.

Although Paris had the look and feel of a defeated city—food was scarce and mostly ersatz, and the euphoria of the Liberation had given way to a deep cynicism about the future—Duchamp's brother and his three sisters were all in relatively good health. Jacques Villon, moreover, was at last becoming recognized as an important French artist. The dealer Louis Carré had given him his first important one-man show in 1944, and its success had enabled him to concentrate full-time on his own painting. (Until then he had supported himself by making prints of other artists' work.) "The first fifty years are always the hardest," as Villon wryly observed.

Henri-Pierre Roché now lived with his wife and son in the suburban town of Sèvres, but he still kept his Paris apartment at 99, boulevard Arago, which he had shared with his mother until her death a few years earlier. Duchamp introduced him to Maria Martins when she came to Paris in June for a brief visit; since Roché was planning a trip to the United States, it was

arranged that they would travel together on the same TWA flight. Mary Reynolds was apparently unaware of Duchamp's love affair with Maria Martins. In late July, at any rate, Duchamp and Mary Reynolds left Paris for a five-week vacation in Switzerland. They went first to Bern, where the French ambassador, Henri Hoppenot, put them up in grand style in his official residence. (Mary had come to know the Hoppenots' daughter, Violaine, when they both worked for the same Resistance network in Paris during the war.) After several luxurious days at the embassy in Bern, Mary and Marcel took a train to Lausanne, and from there they went to the village of Chexbres to spend a week in a small hotel that Hélène Hoppenot had recommended, on a hillside overlooking Lake Geneva. Chexbres and the neighboring town of Puidoux were separated by a deep ravine, whose rushing stream drove the windmills that gave power to a number of small local industries. In this picturesque spot Duchamp's attention was caught one day by an absurdly photogenic waterfall. He took several pictures of it from different angles. The scene would eventually appear, virtually unaltered, as the landscape background of the secret project that he had started to work on in New York.

Back in Paris at the beginning of September, Duchamp found that he would have to wait at least a month for a new American visa. A visitor's visa to the United States was good for six months, and the immigration authorities, under pressure from right-wing congressmen, were making it more and more difficult to get or renew one. The current delay meant that Duchamp would not be able to install the Florine Stettheimer memorial show that he had helped to organize for the Museum of Modern Art—it was scheduled to open in October. He stayed on in Paris through the fall, shuttling back and forth between Mary Reynolds's house and his own tiny flat on the rue Larrey. Mary wanted to buy a place in the country. She and Duchamp went house hunting in Touraine and in the Loir-et-Cher, but they saw nothing in Mary's price range that suited her—only "the dreariest structures representing the anxious economies of thrifty little people," as Mary wrote to Hélène Hoppenot. Although she went on to say that they would probably try Normandy the next spring, "if the retirement fever still burns," a country house was her dream, not his. Duchamp knew by then that he wanted to stay in New York. (He would apply for United States citizenship the following year.) His visa finally came through in December, and he was able to get a berth on a ship leaving early in January. He turned

his rue Larrey flat over to a friend from New York, Isabelle Waldberg, the former wife of the art historian Patrick Waldberg. When Duchamp's ship put in at Southampton, en route from Le Havre to New York, he mailed a brief note to his old love Yvonne (Chastel) Lyon, who was still living in London: "Farewell, dear Yvonne, another leap ended . . ."

André Breton, remarried, repatriated, and determined to re-establish Surrealism as the leading intellectual and cultural force in postwar Europe, had decided to stage another big international group show in Paris that summer. The mise-en-scène for "Le Surréalisme en 1947" was conceived jointly by Breton and Duchamp, who had agreed to serve as its New York organizer and coordinator. On Duchamp's recommendation, Frederick Kiesler went over to Paris to design and install the show at the Galerie Maeght. (Kiesler later claimed credit for many of the ideas as well.) There was a "Hall of Superstitions," an egg-shaped chamber containing works by Miró, Matta, David Hare, Enrico Donati, Tanguy, and others; a "Rain Room" with artificial grass, a steady fall of Surrealist moisture, and a billiard table that served as a base for one of Maria Martins's sculptures; and a "Labyrinth of Initiations," which was divided into twelve "altars," each one dedicated to "a being, a category of beings or an object susceptible of being endowed with mythical life." Two objects in the exhibition catalog were directly associated with Duchamp, although he did not make them himself. He had authorized Kiesler to make a photographic installation called *Le Rayon vert* (*The Green Ray*); peering through a glass porthole in the Hall of Superstitions, the viewer saw an intermittent beam that was supposed to look like the flash of green light that sometimes appears just as the setting sun sinks below the horizon, across an open sea. The other Duchampian object was a "Juggler of Gravity"—one of the missing elements in *The Large Glass*. Executed by Matta, it was a three-legged table, suspended at an angle, with a ball glued to its top. This peculiar contribution was exhibited on the seventh altar of the Labyrinth of Initiations, under the astrological sign of Libra.

Duchamp designed and produced the "Le Surréalisme en 1947" catalog, which showed a female breast in relief on the front cover and, on the back, the words *Prière de toucher* (Please touch). For a special, limited edition of 999 copies, Duchamp and Enrico Donati bought 999 foam-rubber "falsies" and

Donati helped him glue them to the cover, where they were framed by irregularly shaped pieces of black velvet. "We painted every nipple ourselves," Donati recalled. "We had them all laid out on the floor of my studio, prior to packing them in corrugated cardboard boxes to send to Paris. As I was closing one of the boxes I noticed that when the top was lifted they all sprang up— whoof! I showed Marcel, and he wrote a letter to Breton, telling him to bring a photographer and get him to take a picture of the customs inspector opening a box."

Please Touch, 1947.

Instead of revitalizing Surrealism, the 1947 exhibition turned out to be the movement's last hurrah. Breton continued for the rest of his life to preside over the dying embers of his "revolution in consciousness"; he would mastermind several more international Surrealist exhibitions, but by then the intellectual and creative energies of the postwar period had found different outlets, the most significant of which were Existentialism in Europe and Abstract Expressionism in the United States.

When Peggy Guggenheim closed her Art of This Century gallery in 1947, several of the New York artists were on the verge of major breakthroughs. Jackson Pollock's first drip paintings and Clyfford Still's jagged fields of color appeared in 1947; Willem de Kooning's interlocking black-and-white abstractions and Barnett Newman's monochrome canvases divided by one or more vertical stripes in 1948; Mark Rothko's floating chromatic rectangles and Franz Kline's broad-brush, girderlike verticals and diagonals in 1950. Having assimilated Cubism and Surrealism, these New York painters moved beyond them, and in doing so, they changed the course of modern art. Cubism was an art of relationships; each line, shape, and color had a direct relationship to the rest of the composition and to the framing edges of the painting. The Abstract Expressionists broke away from relational art. Their "all-over" paintings, which had no single center of interest, often looked as though they could be fragments of much larger wholes.

Almost immediately it became evident that the new school was made up of two different and in some ways contradictory wings: the gestural or "action" painters, such as Pollock and de Kooning, for whom the canvas served, in the critic Harold Rosenberg's famous phrase, as "an arena" in which to act, and the more contemplative artists (Newman, Rothko, Still), who used large expanses of subtly manipulated color to evoke a visionary or a mystical experience. During the years when the movement was gathering momentum, however, both wings were united in the largeness of their ambition and in their total commitment to the *process* of painting. De Kooning spoke for all of them when he said that painting was "a way of living today, a style of living, so to speak. That is where the form of it lies."

Duchamp's attitude toward Abstract Expressionism may be deduced from an incident in 1945 when Peggy Guggenheim called him and David Hare in to deal with a crisis involving a twenty-foot-long mural painting by Jackson Pollock. The mural was too long for the space it had been commissioned to fill, in the entrance hall of Peggy's apartment. Duchamp coolly advised cutting eight inches off one end. According to David Hare, "Duchamp said that in this type of painting it wasn't needed." Pollock apparently had no objection, so the painting was relieved of its superfluous inches.

The young painter who interested Duchamp the most at this time was Matta. Born and raised in Chile, the pampered son of well-to-do Basque parents (Spanish father, French mother), Roberto Matta Echaurren had studied for three years with Le Corbusier in Paris, preparing himself for an architectural career. Then, in 1937, he happened to see a reproduction of Duchamp's painting *The Passage from the Virgin to the Bride* in the magazine *Cahiers d'art*. The image, and the accompanying article by Gabrielle Buffet-Picabia, struck him with the force of revelation. As Matta put it, "I saw at once that Duchamp had attacked a whole new problem in art with this picture, and solved it—to paint the moment of change. The Cubists had concerned themselves with the object in space, the Futurists with objects in motion, but *Passage* was entirely new. This man with a hairdresser's name wanted to paint change itself, and nothing is more complex than change because we don't have a point of reference to measure it." Matta, who was living in London at the time, traveled to Paris soon afterward, got Duchamp's address from the office of *Cahiers d'art,* and went to see him. The meeting convinced him that Duchamp, not Le Corbusier, held the key

to his future. Although Matta had no money to speak of, he bought an edition of *The Green Box* from Duchamp, arranging to pay for it in five-dollar monthly installments. Soon afterward he presented himself to Breton, who was so impressed by Matta's visionary drawings that he welcomed him into the Surrealist movement. Without a moment's uncertainty, Matta abandoned architecture for painting.

Matta and Yves Tanguy came to New York in 1939, in advance of the general exodus. The only one of the European exile artists (besides Duchamp) who spoke fluent English, Matta went out of his way to establish contact with Robert Motherwell, Arshile Gorky, and several other young New York painters. Motherwell described him as "the most energetic, poetic, charming, brilliant young artist that I ever met." Endlessly voluble and overflowing with ideas, Matta had a "cataclysmic effect" (Motherwell's words) on the budding New York School. He initiated a series of informal weekly seminars at a friend's downtown loft, where he filled in the locals on a wide range of subjects, from the literary and philosophical origins of Surrealism to the new vocabulary of forms that artists should extract (according to Matta) from the latest scientific discoveries. Matta's ideas and Matta's paintings, with their molten, visceral forms and incandescent colors, had a decisive influence on Arshile Gorky, an immensely gifted artist who had been unable until then to break free of Picasso's influence. Matta introduced Gorky to the Surrealists' use of automatic techniques and persuaded him to thin his paints with turpentine for a fresher, looser, more spontaneous and lyrical form of abstraction. Gorky may also have assimilated Matta's fascination with Duchamp: elements of *The Large Glass,* which had inspired Matta's 1943 painting *The Bachelors Twenty Years After,* can be detected in the two versions of Gorky's *Betrothal* (1946–47) and also in *The Limit* (1947).

Some of the Americans balked at Matta's tendency to act like a group leader. Pollock soon stopped coming to the informal seminars. Breton himself felt at times that Matta was trying to usurp his authority, but Matta was far too mercurial to do that, and in any case, his marital problems would have ruled it out. In 1942 he divorced his first wife, an American art student named Ann Clark whom he had met in Paris and married just before coming to New York, because she had the effrontery to become pregnant with twins. (Matta would marry several more times and have a number of children, but at the moment the prospect of compound fatherhood terrified

him.) A year later he moved out to Snedens Landing with his new wife, Patricia Kane O'Connell, whose mother was a well-to-do Newport, Rhode Island, socialite, and became a somewhat less galvanic presence on the New York art scene. He came into town at least once a week, though, to have lunch with Duchamp. They never discussed art or serious ideas, according to Matta; with Duchamp you didn't do that. Matta's private theory was that Duchamp, having become involved with something really profound in *The Passage from the Virgin to the Bride,* had promptly disengaged himself before the subject impinged on his freedom. Matta saw himself as Duchamp's intellectual heir. In his own painting he grappled again and again with the problem of change and metamorphosis—the same problem, he claimed, that occupied the minds of the twentieth century's most advanced scientists and mathematicians. Although Duchamp no longer cared about change and metamorphosis—had made a joke of them, in Matta's view, with his ready-mades—the younger artist felt that he understood Duchamp and Duchamp's work in a way that others did not. Matta and Katherine Dreier published a collaborative "Analytical Reflection" on *The Large Glass* in 1944; since the authors approached their subject from totally different points of view, the pamphlet was somewhat incoherent. Duchamp enjoyed Matta's company and genuinely admired his work, which struck him as having an intellectual dimension beyond its retinal appeal. In a brief entry that he wrote on Matta for the catalog of the Société Anonyme collection, Duchamp called him "the most profound painter of his generation."

When Arshile Gorky was found hanging from a beam in his Connecticut barn in 1948, some of the New York artists thought Matta was to blame. Gorky had killed himself, they said, because his wife had left him for Matta. This was hardly the case. Although Gorky's beloved "Mogouch" had an affair with Matta, their marriage was disintegrating for other reasons, and Gorky's troubled spirit had been battered by a series of disasters: a studio fire that destroyed twenty-seven of his recent paintings; an operation for cancer; an automobile accident that left him with a broken neck. Frederick Kiesler wrote a letter to Breton accusing Matta of being responsible for Gorky's death, however, and soon afterward Breton read Matta out of the Surrealist movement for "moral turpitude," a sin that Matta always referred to as "moral turpentine." Duchamp and Maria Martins were among the few artists who took Matta's side. They saw him nearly every day—Matta was becoming estranged from Patricia by then—and Duchamp broke off rela-

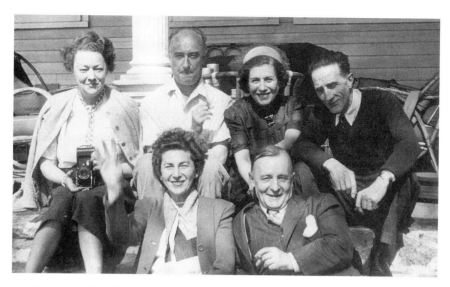

Kay Sage, Yves Tanguy, Maria Martins, Duchamp (top row), and Lillian and Frederick Kiesler (bottom row) at Sage's house in Woodbury, Connecticut.

tions with the Kieslers because of Kiesler's malicious letter to Breton. Upset and embittered by the accusations, Matta eventually went to Machu Picchu in Peru, then to Argentina, and eventually back to Europe, where it took him several years to regain his creative vitality and momentum.

Duchamp had fallen deeply in love with Maria Martins, as he discovered when he was on the verge of losing her. After nine years in Washington, D.C., Carlos Martins was named Brazil's ambassador to France in the spring of 1948. Maria stayed on for a few months longer, spending as much time as possible in New York with Duchamp. She had become a physical presence in his new work—the model for a life-size, three-dimensional, reclining nude that was its central element. The pose was the same as the one in the 1947 drawing and the subsequent plaster relief study, with one leg raised and bent at the knee. Duchamp gave her both these early studies. He also arranged for her to buy from Raymond Duchamp's widow (who was finally willing to part with it) his 1911 *Coffee Mill,* the little painting that had unlocked the door to his future work.

Maria Martins moved to Paris in the summer. It would be Carlos Martins's last post—he retired from the diplomatic service eighteen months later,

and they both returned permanently to Brazil. Although she and Duchamp would meet only a few more times, they wrote to each other for nearly four years. In his letters to her, Duchamp often alluded to the work that was gradually taking shape in his studio. Most of the allusions were to the nude figure, "my woman with open pussy," as he called it. In 1949 he sent the clay model out to be cast in plaster, and by the summer of 1949 he was working on it with great intensity—up to eight hours a day, he claimed—scraping and painting and refining the plaster to give it the quality he wanted, which was the quality of "skin as opposed to the sculpture of bones and volumes." Unlike *The Large Glass,* whose erotic theme was not visible to the eye alone, the new work would reflect the frank sensuality that kept breaking through in his letters. ("In fact, we both have a need for physical love and these long chastity parentheses do nothing but sharpen a new razor's edge . . ." he wrote to her in May 1949. "Kiss my flower for me.") Several letters suggest that he wanted her to leave her husband and live with him. When one of the other studio apartments on his floor became available, he told her that this could become the "absolute retreat" of their dreams: "You could isolate yourself with me there and *no one* would know about this cage outside of the world." Maria did not accept the offer. Duchamp took the room himself and turned it into a second studio, known to no one, where for many more years he worked in secret on the *tableau vivant* that he once called, in a letter to Maria, "*N.D. [Notre Dame] des désirs.*"

Duchamp's letters to Maria Martins show a depth of feeling that he never expressed in any other form. It was the first time he had loved a woman openly and without reservation—perhaps he could not have done so if she had been more accessible. In the end, though, his deep longing for her had given way to a sad resignation. "I accept the situation as it is," he wrote in 1951, "and no longer hope for a miracle. I feel happy when I think of you."

According to Nora Martins Lobo, her mother would never have abandoned her marriage for Duchamp. She was too much of a realist for that. When Carlos Martins retired from the diplomatic service, she engineered a new career for him in Rio. She gave a series of dazzling dinner parties to introduce him to Brazil's business and social elite, and soon he was on the boards of several important corporations. "She created him again," Nora said. "Maybe she knew she couldn't have done that with Marcel. And she sold off her collection of modern art to keep them afloat in the meanwhile." (In the past, whenever one of her sculptures was sold by the Valentine

Gallery in New York, Maria had asked to be paid in works of art, and as a result she had acquired a number of first-rate pictures by Tanguy, Matta, Miró, Dalí, and the other Surrealists.) She never sold Duchamp's *Coffee Mill,* however, or the two studies for his "woman with open pussy."

This extraordinarily dynamic woman continued to work as a sculptor after returning to Brazil. She executed a number of large-scale public commissions, and she also became one of the principal organizers of the São Paolo Bienal, the biannual art exhibition that put Brazil on the map of international modern art. She and Duchamp did not see each other again until 1951, when she came to New York for a visit. He met her at the boat and took a room in a hotel near the St. Regis, where she was staying, so that they could be together without being seen.

There were no more letters after that.

Mary Reynolds passed through New York in the summer of 1948 before going to visit her brother and his family at their vacation home in northern Minnesota. (Maria Martins had left for Paris by then.) She found Duchamp "thinner than ever but quite well—the only familiar sight in this bewildering world." In September she came back and stayed for several weeks at the Chelsea Hotel on West 23rd Street, where the front desk, she said, made a specialty of losing her letters. Duchamp had just returned from playing in the New York State chess championships at Endicott, New York (near Binghamton); he had done exceptionally well there, winning six matches and missing the final by only half a point. Mary thought he looked very tired when he saw her off on the boat to Europe. "Though I left him with a few pounds added," she wrote to her friend Hélène Hoppenot, "it wasn't enough, and I hated to see him walk off the boat so fragile."

His life had become increasingly solitary. He played chess two or three nights a week at the London Terrace Chess Club, which he had joined in 1943, but he seldom went out to dinner anymore, and he did not go to openings at the 57th Street galleries, where Abstract Expressionism was becoming more and more visible. (In a letter to Yvonne Lyon in 1949, a year when Pollock and Rothko both had important New York shows, Duchamp asked whether there was the same "debacle in painting" in London that existed in New York.) The art world, however, was not quite willing to let Duchamp slip through the cracks. Early in 1949 he was invited to participate in the

"Western Round Table on Modern Art" in San Francisco, a three-day seminar whose other panelists would include the artist Mark Tobey, the critics Kenneth Burke, Robert Goldwater, and Alfred Frankenstein, the composer Darius Milhaud, the anthropologist Gregory Bateson, the curator Andrew Ritchie, and the architect Frank Lloyd Wright. This blue-ribbon panel was put together by a young Canadian named Douglas MacAgy, formerly curator of the San Francisco Museum of Art and currently director of the California School of Fine Arts. MacAgy was out to challenge the results of a similar roundtable discussion in New York the year before, sponsored by *Life* magazine, at which several of the participants had taken the position that modern art was a hoax—or worse. This was still a widely held attitude at the time. The State Department had canceled a European tour of sixty-nine contemporary American paintings in 1946 because some congressmen viewed the work as "communistic," and President Harry S. Truman had gone on record with his opinion that "so-called modern art is merely the vaporings of half-baked, lazy people."

MacAgy's roundtable took place in April at the San Francisco Museum of Art. The sessions were moderated by Professor George Boas of Johns Hopkins University, and their consistently high level of discourse was marred only by the boorish comments of Frank Lloyd Wright, who seemed to think that modern art was degenerate. At one point Wright cited Mallarmé, that mild-mannered schoolteacher, as an example of modernism's self-destructive degeneracy. (Perhaps he was thinking of Verlaine or Rimbaud.) Duchamp was treated with considerable deference by all the panelists except Wright, who expressed surprise that anyone could still consider *Nude Descending a Staircase* a great picture. ("More so" than ever, Duchamp shot back.) The San Francisco Museum had borrowed Duchamp's famous *Nude* and a number of other modern works for a special exhibition to coincide with the roundtable.

On several occasions Duchamp was asked to clarify his concept of the "esthetic echo," which had intrigued the others when he proposed it at the first session. Works of art could not be understood by the intellect, he maintained, nor could their effect be conveyed in words. The only valid approach to them was through an emotion that had "some analogy with a religious faith or a sexual attraction—an esthetic echo." This echo, however, was heard and appreciated by very few people. It could not be learned—either you had it or you did not—and it had nothing whatsoever to do with taste, which was merely a parroting of established opinion. "Taste gives a sensuous feeling, not

an esthetic emotion," Duchamp said. "Taste presupposes a domineering onlooker who dictates what he likes and dislikes, and translates it into beautiful and ugly," whereas "the 'victim' of an esthetic echo is in a position comparable to that of a man in love or a believer ... when touched by esthetic revelation, the same man in an almost ecstatic mood, becomes receptive and humble." This sounds surprisingly romantic, coming from a man who wanted to return painting to the service of the mind. The French word *esprit,* however, has a much wider range of meaning than the English "mind." In addition to intellect, it refers to spirit, soul, vital principle, understanding, wit, fancy, humor, temper, and character, all of which figured in Duchamp's thinking. When he said that painting could not be understood by the intellect, he was using the word in its specific and limited sense: the intellect *alone.*

There was an important corollary to Duchamp's theory. Duchamp assigned to the person capable of hearing the esthetic echo an essential role in the creative process. The artist, in his view, was merely one of the three elements necessary to that process; the others were the work of art itself and the rare onlooker able to respond to its essence. "We don't emphasize enough that the work of art is independent of the artist," he said. "The work of art lives by itself, and the artist who happened to make it is like an irresponsible medium."

"Now, Mr. Duchamp," Gregory Bateson intervened at this point, "what you are saying is that the artist is the picture's way of getting itself painted. That is a very serious and reasonable thing to say, but it implies that, in some sense, the work of art exists before it is there on the canvas."

"It is a kind of race between the artist and the work of art," Duchamp conceded, leaving the question open.

And where did the critic fit into Duchamp's scheme of things? "The critic transposes, translates an emotion into another medium, the medium of words," Duchamp said, "and I wonder if such translation can at all express the poetic 'essentials' of that other language commonly called art." Asked by George Boas what, in that case, he expected the critic to do or say, Duchamp cheerfully replied, "Nothing much."

After three days in San Francisco, Duchamp headed for Los Angeles and a long-awaited reunion with Walter and Louise Arensberg, whom he had not seen since his last visit in 1936. They were in their seventies now (Duchamp was about to be sixty-two), and their health was breaking down. Walter had had a severe cerebral hemorrhage the year before. Louise was

riddled with the cancer that would eventually kill her; thin and frail, she kept wringing her hands to alleviate the constant pain that she refused to acknowledge. Having Duchamp in the house was like a shot in the arm for Walter; his spirits rose perceptibly throughout the twelve-day visit, and their conversations seemed to give him new energy. Katharine Kuh, then a young curator of modern art at the Art Institute of Chicago, would later describe the visit in some detail—she was working on a catalog of the Arensberg collection prior to its exhibition at the Art Institute that fall, and she came to the house every day to measure and take notes on the pictures. Kuh, who had never met Duchamp, found him even more impressive than his legend. He "was very, very beautiful in those days . . ." she said, "and not so emaciated as he became later. He was cool, impervious, and *so* polite. I liked him from the first second he walked in the door." Duchamp made a tour of the house as soon as he arrived, surveying the collection that he had helped to build. "He walked around and looked at all his own works, impartially," Kuh recalled; "he looked at everything. The only painting of his he commented on was *The King and Queen Surrounded by Swift Nudes.* He looked at it carefully and said, 'That's a good painting. It holds up.' "

Kuh was amazed to see how easily and naturally Duchamp handled himself in this odd, tension-filled household. She herself never knew, when she arrived each morning, whether Walter Arensberg would even let her in; he was just as likely to announce that the Chicago exhibition was off and send her away. "He changed his mind not from day to day, but from hour to hour," she said. Upstairs in the house, Arensberg's Francis Bacon Foundation kept three researchers busy collecting evidence to prove that Bacon was the real author of Shakespeare's plays. Meals were scanty and often inedible—dates, raisins, and a hard-boiled egg for lunch, and before each overcooked dinner, an awful bourbon-and-ginger-ale highball that Walter insisted everyone drink. Duchamp supplemented this diet with Hershey bars, which he bought during his daily excursions with Man Ray. The Arensbergs were not on speaking terms with Man Ray, who lived a few streets away from their Hollywood house. He had complained once about their lack of interest in his paintings, and Walter had consigned him to outer darkness. Every afternoon, on the pretext of taking a walk, Duchamp would go to the corner where Man was waiting for him in his sporty blue Cord roadster, and they would go off to a nearby bar or restaurant to talk. Sometimes Katharine Kuh joined them. Duchamp also arranged, without

telling his hosts, to see the somewhat eccentric young dealer William Copley, who ran a Surrealist gallery in Beverly Hills. Copley had visited Duchamp in New York before starting his gallery, and Duchamp had introduced him to a number of artists and dealers—had "opened every door" for him, as Copley gratefully remembered. The gallery was failing, and so was Copley's first marriage; without saying anything specifically about either problem, according to Copley, Duchamp somehow managed to make him feel better about both of them.

The future of the Arensberg collection had become an issue of some urgency. Walter and Louise had no children, their health was precarious, and they were not rich enough to build and endow their own private museum, as Albert Barnes, Duncan Phillips, and other wealthy collectors had done. The problem had supposedly been solved in 1944, when with considerable fanfare the Arensbergs bequeathed their collection to the University of California. The university had neglected to come up with the promised funds for a museum building, however, and the agreement had been annulled in 1947. During the next two years the Arensbergs were approached by more than twenty institutions, including the Museum of Modern Art, the Metropolitan Museum of Art, the National Gallery of Art, the Philadelphia Museum of Art, the Art Institute of Chicago, Stanford and Harvard Universities, and a fledgling museum of modern art that Vincent Price and others, picking up where Sidney Janis had left off, were trying to start in Los Angeles. Some of these institutions could never have met the Arensbergs' stringent conditions, which included keeping the collection together for twenty-five years and providing for the continuation of the Bacon/Shakespeare research, but no museum wanted to pass up a shot at the Arensberg collection. In addition to thirty-six works by Duchamp (thirty-seven, counting their *Box-in-a-Suitcase*), the Arensbergs had nineteen Brancusis, ten Braques, twenty-eight Picassos, nineteen Klees, and approximately eight hundred other works, many of the highest quality. A considerable number of these paintings and sculptures had been acquired on the advice of Duchamp, who had acted for years as their European buying agent. Duchamp had also alerted the Arensbergs whenever one of his own things was coming back on the market, and as a result they owned most of his important paintings. "The core of our collection, and its unique feature, is the group of your works," Arensberg had written to Duchamp a few years earlier, soon after the University of California agreed to take the

collection and build a museum for it. "In a way, therefore, the museum will be a monument to you, and . . . will serve as a means of defining how completely individual is your contribution to the art of the twentieth century." When his old friend asked him for help in deciding where the collection should go, therefore, Duchamp was prepared to offer it.

Toward the end of April Duchamp flew back to New York, stopping off en route to visit Max Ernst and Dorothea Tanning in Arizona—they had found refuge from Peggy Guggenheim and the art scene in the spectacular red rock country near Sedona. Soon after his return Duchamp went down to Philadelphia to see Fiske Kimball, the director of the Philadelphia Museum of Art, and Sturgis Ingersoll, its president. Kimball had been pursuing the Arensberg collection with great persistence. He and his wife, Marie, had made several trips to California to see the Arensbergs, with whom they got on very well, and Kimball and Arensberg had even drawn up a tentative installation plan for the collection in the Philadelphia Museum, a vast, neo-classical building whose gallery space had never been fully occupied. Arensberg asked Duchamp to go down and look at the space that had been proposed. Duchamp took careful notes and made sketches of the rooms, which he mailed to Arensberg. While clearly enthusiastic about the possibilities, he urged the Arensbergs to visit both the Philadelphia and the Chicago museums before making a final decision.

Duchamp also kept in close touch with Katharine Kuh, who had many questions to ask him in connection with the catalog for the upcoming Arensberg exhibition at the Art Institute of Chicago. Unaware of the Arensbergs' negotiations with Fiske Kimball, Kuh and Daniel Catton Rich, the Art Institute's director, thought they had the inside track. They had outmaneuvered the Museum of Modern Art's Monroe Wheeler by getting the Arensbergs to let them exhibit the collection, and they were doing everything they could to accommodate the Arensbergs' demands. Even so, signs of trouble kept appearing. Worried about cost overruns, Rich suggested that the Art Institute and the Arensbergs share the cost of cataloging their pre-Columbian and primitive objects, which made up about a third of the collection. This annoyed the Arensbergs so much that they withdrew the pre-Columbian and primitive material from the show. They were further displeased to learn that the institute's restorers, without notifying them, had repainted the frame on one of their Légers. The Arensbergs did not go to the opening of their exhibition that October—a very bad sign. Their excuse

was that they did not like airplanes and were not feeling well enough to travel by train. Duchamp, who did attend, wired them a glowing report ("opening great success presentation gives new life to collection"). He also met with Rich, Kuh, and Samuel Marx, one of the Art Institute's most influential trustees, who came up with a specific proposal for housing the collection permanently. They were all very enthusiastic about having the collection in Chicago, Duchamp wrote the Arensbergs, but "the point I insist on, is that you must see your collection flying on its own wings."

When the Arensbergs finally did make the long train trip to Chicago in December, two weeks before the exhibition closed, it was a disaster. They hated the installation, mainly because the pictures and the sculptures were separated instead of being shown together. Walter was particularly upset by the Brancusi section, with its "flimsey [sic] and inappropriate ply-wood decor." The Arensbergs really wanted their collection to look just the way it looked in their own house, where paintings and drawings covered every inch of wall space and interacted with modern and pre-Columbian sculptures, early American antiques, Oriental rugs, faded curtains, and their own vivid memories. They had said that they did not want any parties or receptions in their honor, and Rich and Kuh took them at their word—another mistake. When the Arensbergs got home, they wrote a curt letter to Rich, flatly rejecting the institute's offer. Katharine Kuh later described it as the "saddest, saddest episode" in her professional life.

As a recently elected trustee of the Francis Bacon Foundation, Duchamp now became the Arensbergs' main emissary in negotiations with other museums. He met with a number of museum directors, including the Metropolitan's Francis Henry Taylor, who let it be known that the scathing remarks he had made about modern art in the past did not apply to the Arensberg treasures, but after the Chicago debacle it became clear that Philadelphia was at the top of the list. Fiske Kimball and his trustees were willing to meet all the Arensbergs' conditions except one (funding the Bacon/Shakespeare research project); the space they proposed was ample; and they would let Duchamp have a major say in deciding how that space was divided and the collection installed. The formal deed of gift was signed on December 27, 1950, stating that the Walter and Louise Arensberg collection would go, after their death, to the Philadelphia Museum of Art. Duchamp, who had played such a key role in the decision, was now poised to preside over his own posterity.

Teeny

My capital is time, not money.

Henri-Pierre Roché was always ready to act as Duchamp's unofficial agent, business partner, banker, and all-purpose facilitator. When Walter Arensberg's flask of *Paris Air* was accidentally broken by a neighbor's son in 1949, it was Roché, acting on instructions in a letter from Duchamp, who went around to the pharmacy on the rue Blomel, where it had come from originally, and had the chemist empty out and then reseal another one exactly the same size to replace it. Not long after this, on learning that Jacques Villon had discovered a forgotten cache of Duchamp's early paintings and drawings in his studio in Puteaux, Roché offered to see what he could do about selling them. "I don't think there will be great demand," Duchamp wrote to his old friend, "in spite of the good advisers who regret that I no longer paint."

Among the newly discovered canvases were some of Duchamp's earliest efforts. He hesitated to set a value on them, but Roché, who was to receive forty percent of the proceeds, got him to agree to a price scale of $500 for the oils and $100 for the drawings. Roché himself bought five paintings—two nude studies and three portraits. Walter Arensberg claimed the very early *Church at Blainville* and also the 1904 *Portrait of Marcel Lefrançois,* which Roché had chosen for himself—Roché obligingly sold it to him and took the 1910 *Nude with Black Stockings* instead. The rest did not find buyers for some time; as Duchamp had prophesied, there was no great demand as yet for his apprentice work. Duchamp offered Mary Reynolds her pick of the lot as a gift, and she chose a nude study and *Garden and Chapel at*

Blainville, an Impressionist-inspired landscape of the family home that he had done in 1902, when he was fifteen.

Only a few months later, in the spring of 1950, Mary Reynolds was admitted to the American Hospital in Neuilly. The diagnosis was uremic poisoning. After weeks of intense pain and largely ineffective treatments, she put herself in the hands of Dr. Franz Thomassin, who ran a private clinic at La Preste in the Pyrenees, but still her symptoms did not abate. By then she had lost twenty-four pounds, and she was growing progressively weaker. Duchamp, who received reports on her condition from Roché and also from his sister, Suzanne Crotti, seemed not to want to believe that she was seriously ill, but by mid-July he was forced to come to grips with it. "I have never uttered the word cancer," he wrote to Roché, "but do you think that there is a dreadful possibility there? Don't hesitate to tell me." Still he put off going to France to see her, rationalizing that Mary did not know how sick she was and that his turning up might come as a dangerous shock to her morale. As he wrote to Roché, "The main thing is to die without knowing it, which incidentally always happens that way; but to avoid the fears and physical sufferings."

Over the last few years Duchamp had become friendly with Mary Reynolds's brother, Frank Brookes Hubachek, the lawyer for a large household finance company in Chicago. Brookes and Mary had been exceptionally close when they were growing up, and his children were very fond of her. When Mary returned, barely able to walk, from the clinic in La Preste to her house on the rue Hallé, Hubachek sent his former secretary (who had become a trained nurse) to take care of her, and that September he offered to pay Duchamp's way over as well. Hubachek knew how much it would mean to Mary to see him again. Duchamp sailed on the *Queen Mary,* and he was with her for the last ten days of her life. "Her brain is so lucid," he wrote to Roché, "her heart and her lungs are in such an almost perfect state, that one hardly understands that it is impossible to undertake anything in the way of a 'cure.' " Mary's doctors had only recently discovered that she had a cancerous tumor on her uterus, undetected before and too far advanced to be operable. When she slipped into a coma and died on September 30, Duchamp was at her bedside. He arranged for the cremation at Père Lachaise cemetery, and he sent her ashes back to Brookes Hubachek, who would eventually bury them under a hand-carved wooden Cross of Lorraine on his property in northern Minnesota.

Some of Mary Reynolds's Paris friends blamed Duchamp for not coming sooner when he knew she was dying. Describing Mary's last days in a letter to Kay Boyle, though, Janet Flanner said that she "had undergone a kind of miraculous revival for a few days after he arrived: his magic or her love had the power . . . she even had the energy to begin running her house again, from her hospital bed." Flanner's letter also reported a remarkable thing that Mary had said to their mutual friend Elizabeth Hume, who repeated it to Flanner. In those last weeks, when she could neither eat nor sleep, Mary had said that everybody was "people" and that she could no longer stand their presence. "Elizabeth said, 'Am I people, too?' " according to Flanner, "and Mary answered with the rueful laughter so characteristic of her, 'Yes, even you, too. Marcel is the only person I ever met who was not people. He could be in a room with me and I still felt alone.' " It was a strange tribute. One of the key elements in Duchamp and Mary Reynolds's long friendship was an abiding respect for solitude, their own as well as each other's; it held them together and kept them apart in equal measure, which was almost certainly what Duchamp wanted—a gentler version, perhaps, of the erotic standoff in *The Large Glass*. But Mary Reynolds, a proud, quiet woman who made sure that her life never depended on his, might have preferred to feel less alone. In *Victor,* Roché's unfinished novel about Duchamp, the Mary Reynolds character says to the narrator at one point, "He insisted that I be unfaithful to him. It wasn't my nature . . . What he liked best was not when we lived together for whole months, but when he came to sleep with me two nights a week. I accepted it for him: not for me."

Duchamp stayed on in Paris for two months, emptying out the house on the rue Hallé, which had been for so many years the center of their life together. Her books and papers included a great deal of important material on the Surrealist movement and the literary and artistic life in Paris between the wars; these he shipped to Brookes Hubachek, who would donate them to the Ryerson Library at the Art Institute of Chicago. Roché agreed to find space in his house in Sèvres for three large cartons full of reproductions for Duchamp's *Valise,* which Mary had been keeping for him since 1941. Aside from Roché, Duchamp made no effort to see his Paris friends during this time. It was his own past he was sorting through, along with Mary's, and he wanted to do it in private, away from the talkative curiosity of those he referred to as "the Parisian crocodiles." If there were

letters from him among her papers, he must have destroyed them. He left finally in late November, sailing on the *Mauritania*.

Duchamp sometimes said that he lived a hermit's life in New York. He also liked to give the impression that he did very little work. "Deep down I'm enormously lazy," he would tell Pierre Cabanne. He worked every day on his "woman with open pussy," nevertheless, in the back room behind his 14th Street studio; he was trying out various possible solutions to the problem of how to cover the plaster nude with stretched pigskin so that it would have the appearance of human flesh. His work on the project also led in the 1950s to a series of small erotic sculptures, cryptic by-products for which there was no immediate explanation. When Man Ray and his new wife, Juliet, came through New York in 1951 on their way to Europe, where they would live permanently from then on, Duchamp saw them off on the boat and brought along, as a parting gift to Man, something that looked like a wax impression of a woman's vulva. It was actually a handmade sculpture in galvanized plaster, on the underside of which Duchamp had scratched the title, *Feuille de vigne femelle* (*Female Fig Leaf*). This was followed a year later by *Objet-Dard* (*Dart Object*), a shaft of galvanized plaster that looked more like a bent penis than an objet d'art. This peculiar item was a literal by-product, although Duchamp did not reveal its origin for many years. It had been part of a plaster armature under the breast of his life-size nude, which held the pigskin in place while the glue dried; the armature broke into several pieces when it was being removed, and Duchamp was intrigued by the shape of that particular fragment.

By the 1950s Duchamp had become a peripheral presence in the New York art world. The Abstract Expressionist painters and sculptors who had made New York the vital center of international contemporary art were no more concerned with him than he was with them. De Kooning, to be sure, referred to Duchamp in 1951 as "a one-man movement . . . for me a truly modern movement because it implies that each artist can do what he thinks he ought to—a movement for each person and open to everybody." It was a perceptive remark but one that would apply more directly to the next generation of American artists. With the exception of Robert Motherwell, none of the Abstract Expressionists ever became friendly with Duchamp, and

according to Motherwell, they rarely thought about him or mentioned him in their discussions. A few influential people in the New York art world did continue to think about Duchamp, nevertheless; one of them was Sidney Janis, now a dealer, whose 57th Street gallery had emerged as the primary showcase for the New York School. Before taking on Pollock, Kline, Rothko, and other first-generation Abstract Expressionists, Janis had established his reputation as a dealer in classic, blue-chip modern art, and in the early 1950s he put on a series of loan shows that were museumlike in their scholarly focus. Each of them featured work by Duchamp. *The Chess Game,* now owned by Walter Pach, was in "Twentieth Century Old Masters" in 1950. A replica of the lost (and never exhibited) *Fountain* hung from the ceiling in "Challenge and Defy" a few months later—Duchamp had authorized Janis to procure a new urinal, which differed in several respects from the notorious original. A replica of *Bicycle Wheel* appeared in Janis's 1951 "Climax in XXth Century Art: 1913," which also included *3 Standard Stoppages* from Katherine Dreier's collection. And *Nude Seated in a Bathtub* and *Portrait of Chauvel,* both borrowed from Roché, were in "Brancusi to Duchamp," also in 1951.

Duchamp planned, organized, and installed a major historical show of international Dada at the Janis Gallery in 1953. More than two hundred works of art and documents were on view, each one identified in a Duchamp-designed "catalog" that was itself pure Dada—a tissue-thin broadsheet with written texts (by Jean Arp, Richard Huelsenbeck, Jacques-Henri Lévesque, and Tristan Tzara) in contrasting typefaces, set in narrow columns that ran diagonally down the page. When the sheets were delivered to the gallery, Duchamp took one, crumpled it up into a ball, and told Janis to mail it that way, and Janis did so, to the confusion of numerous art lovers who wondered why they were being mailed trash. (A wicker basket of crumpled catalogs stood beside the gallery door at the opening.) Janis was in awe of Duchamp. He went to him for advice about other exhibitions and often asked his opinion of artists he was thinking of taking on. "Marcel had that inner confidence that I've observed in only one other painter, Mondrian," he once said. "Both Marcel and Mondrian liked things that were very different from what they were doing. They didn't have to protect their own point of view all the time." While the Dada show was being installed, two former Dadaists, Richard Huelsenbeck and Hans Richter, came into the gallery and started to rearrange it. According to Janis, who was not there when they arrived, they

moved several of Duchamp's works out of the front room to make space for others they considered more representative. Duchamp refused to make an issue of it. "Marcel's attitude was to let them do it," Janis remembered. "He had no objection at all to being put in the back room. I wouldn't have it, and I finally had to lay down the law to the other two and tell them it was my show. Well, now, did Duchamp *know* I was going to do that? Or didn't he really care? I just don't know—and no one else does either." Duchamp was represented in Janis's Dada show by four works: *Tu m'*, his last painting on canvas; *To Be Looked at (from the Other Side of the Glass) with One Eye, Close to, for Almost an Hour,* the glass study he had done in Argentina; the ready-made *Fresh Widow;* and Janis's replica of *Fountain,* installed over the door at the entrance, with a sprig of mistletoe dangling from its inverted bowl.

Although Duchamp consistently discouraged Roché's efforts to arrange exhibitions of his early work in Paris, arguing that the early paintings were of interest only in relation to what he did later, he seemed perfectly willing to have his things appear in group shows—especially those in which he could exercise some degree of influence or control. The 1952 show of works by Villon, Duchamp-Villon, Duchamp, and Suzanne Crotti at the Rose Fried Gallery on East 68th Street had actually been suggested to Rose Fried by Duchamp. He thought up the show's title, "Duchamp Frères & Soeur, Oeuvres d'Art," which made it sound, as he said, like "a family firm," and when the New York press picked up on the family connection, he submitted cheerfully to a number of interviews. *Life* ran a ten-page spread on "Dada's Daddy," with a time-lapse photograph by Elias Elisofon of Duchamp descending a flight of stairs ("Don't you want me to do it nude?" Duchamp had asked him), and an appreciative article by Winthrop Sargeant. Duchamp persuaded the Arensbergs to lend his *Nude Descending a Staircase* and *The Bride* to James Johnson Sweeney's "Twentieth Century Masterpieces" show, which opened at the Musée de l'Art Moderne in Paris in the spring of 1952 and then traveled to the Tate in London. (Both paintings belonged to the Philadelphia Museum of Art by then, but the Arensbergs gave the museum permission to lend them.) He also spent a lot of time with Fiske Kimball and the curatorial staff at the Philadelphia Museum of Art, where the future installation of the Arensberg collection would provide, in effect, a permanent Marcel Duchamp retrospective.

Katherine Dreier had agreed to Duchamp's request that *The Large Glass* go to Philadelphia when she died. Her health had been in decline for

some time, although she refused to acknowledge it. She kept right on plan-
ning new activities, writing long letters, and demanding favors from her
friends. George Heard Hamilton, who had been delegated to deal with
Dreier regarding her gift of the Société Anonyme collection to Yale, used to
marvel at her relationship with Duchamp. "She would browbeat him
unmercifully over all sorts of trivia," Hamilton recalled, "and he never
reacted at all. At first I thought he had no backbone, until I came to see that
there was nothing he could have done about it. She adored him, but as a son,
and he was content to play that role." Hamilton worked with Dreier on a
comprehensive catalog to the Société Anonyme collection, published in
1950. He soon discovered that the brief essays she had written on various
artists in the collection were full of glaring errors, including many wrong
dates, but when he telephoned her and said, as tactfully as he could, that he
would like to suggest a few changes, she haughtily informed him that the
essays would have to stand as written. "Some facts may be wrong," she said,
"but it is the truth." Duchamp himself wrote brief entries on thirty-three of
the artists in the Société Anonyme catalog, no doubt because Dreier bullied
him into doing so; he would later refer to these notes as "too short and inad-
equate" to be republished in the book-length monograph that Robert Lebel,
a French art critic, was writing about him and his work.

　　Katherine Dreier and Duchamp had been friends for thirty-five years.
She remembered all his birthdays—with a letter when he lived in Paris, with
a gift (or a poem) when he was in New York. She was his "adopted mother"
or, sometimes, his "other self." In her letters to him, she often apologized for
having "bothered" or annoyed him, but her demands never ceased, and he
almost always did what she wanted. In spite of her blind spots and failings—
not the least of which was a nasty strain of anti-Semitism—Duchamp was
genuinely fond of her, and he certainly admired her lifelong dedication to
the cause of modern art. On her seventy-fifth birthday in September 1951, he
gave her his drawing of a chess knight, inscribed "To Katherine Dreier,
Knight of the Société Anonyme." She died the following March after a pro-
tracted battle with cancer.

　　As one of the three executors of Dreier's will, Duchamp was responsible
for the disposition of her personal collection. He had often discussed with
her the advantages of having *The Large Glass* rejoin its "brothers and sisters"
at the Philadelphia Museum of Art, where it would serve as the capstone to
the Arensbergs' unrivaled collection of his work. "Miss Dreier always had it

in mind, and she actually spoke to me about it only a few weeks before she died," he wrote to Fiske Kimball. Kimball was delighted to accept *The Large Glass.* He had offended Dreier, though, by making it clear that he did not want the rest of her collection (mainly because of the conditions she attached to its display), and so *The Large Glass* was all he got. Duchamp eventually divided the several hundred remaining works up among a number of other institutions in which Dreier had taken a particular interest: the Phillips Collection in Washington, D.C.; the Yale University Art Gallery; the Guggenheim Museum; the Museum of Modern Art. Alfred Barr had been hopeful that his museum, which owned only one important work by Duchamp, might get *The Large Glass.* Disappointed when it went to Philadelphia instead, Barr laid siege to Duchamp and was rewarded by the gift of 102 works from Dreier's collection, including Duchamp's *To Be Looked at (from the Other Side of the Glass) with One Eye, Close to, for Almost an Hour,* which Dreier had carried back from Argentina with her in 1919, and *3 Standard Stoppages.* The Guggenheim received 34 works, and the Phillips got 17. Yale, the principal beneficiary, received nearly 300 paintings, sculptures, and works on paper to add to the enormous body of work that had come to it through Dreier's earlier gift of the Société Anonyme collection, and it also was awarded *Rotary Glass Plates* and Duchamp's last oil on canvas, *Tu m'.* The complicated negotiations that these various gifts involved took up a lot of Duchamp's time, but they also gave him considerable satisfaction. And in any case, as he had said to Winthrop Sargeant, who quoted it in his *Life* article, "My capital is time, not money."

Max Ernst and Dorothea Tanning still lived in Arizona, but they kept a small apartment in Manhattan for their occasional trips east. On one of these trips in the fall of 1951, they invited Duchamp to drive out with them for a country weekend at Alexina Matisse's house in Lebanon, New Jersey, about an hour and a half due west of the city. Alexina, known as Teeny, was the former wife of Pierre Matisse, the art dealer, whose 57th Street gallery represented many of the leading School of Paris artists, including Miró, Dubuffet, Giacometti, Balthus, and Pierre's illustrious father, Henri Matisse. Although she and Duchamp had met a number of times, both in New York and in Paris, they barely knew each other; Pierre Matisse disliked Duchamp, whose apparent lack of commitment to anything seemed to him highly

irresponsible. During the weekend at Teeny's house, however, Dorothea Tanning became aware of "some electric element floating around, which was of course the vibration of two people getting together"—just what she had had in mind when she invited Duchamp to come along. A few days later Duchamp invited Teeny to have dinner with him at Tavern on the Green, the large restaurant in Central Park. They had lunch together that same week at a restaurant in Greenwich Village, and she came to see his studio afterward. It all happened naturally and serenely, according to Dorothea Tanning; they got together at just the right moment in their lives. Teeny had been deeply hurt by her divorce two years earlier, but she was over that. She was forty-five years old, an attractive woman (blond, athletic, stylish in ways that had nothing to do with fashion) whose three children were either grown up (two were in college) or about to be grown up; in addition, she was financially independent, an art world insider, a good chess player, and a fine cook. Duchamp, at sixty-three, seemed to have aged hardly at all. His gaunt, quintessentially French features and gently ironic manner were as seductive as ever. The affair with Maria Martins had changed him, though; instead of retreating into himself afterward, he seemed more open and less inclined to monkish isolation. In Teeny he found someone who would make his life a great deal more agreeable while respecting his need for solitude. Friends noticed that being with Duchamp seemed to bring out the warmth and spontaneity that had been somewhat suppressed during her previous marriage. He began spending weekends at Lebanon. Later in the year, when Max and Dorothea decided to move to France, Marcel and Teeny took over their New York apartment, a fourth-floor walk-up in a dilapidated brownstone at 327 East 58th Street. In order to keep the apartment, Dorothea had told the landlord that Teeny was her cousin; she continued to pay the rent, and Teeny and Marcel sent their checks to her. The name plate above their buzzer downstairs read "MATISSE-DUCHAMP-ERNST."

Teeny, who had acquired her nickname when she was in the cradle because of her low birth weight, was the youngest of six daughters of a well-known Cincinnati eye surgeon named Robert Sattler. She grew up in a cultivated household where all the children learned to speak French and German at an early age. Teeny's mother, who was Sattler's second wife, had spent twelve years of her childhood living in Italy. (One of her cousins was Mabel Dodge.) She was an accomplished violinist, and after her marriage to Sattler their house in Cincinnati became a gathering spot for visiting musi-

cians, artists, and European friends. The Sattler family's summer vacations in Europe had been interrupted by the First World War—they went to Biddeford Pool in Maine during those years—but in 1921 Teeny's sister Agnes persuaded her parents to let her go to school in Paris, and a year later Teeny was allowed to join her. She was only fifteen at the time, but an old friend of her mother's, Mariette Mills, had volunteered to look out for her and to have Teeny stay in her house in Paris on weekends and vacations.

Mariette Mills was married to an American businessman named Heyworth Mills, who was based in Paris. They had a big apartment on the rue Boissonnade in Montparnasse and a château in the country near Rambouillet, and like the Cincinnati Sattlers, they welcomed the company of artists, writers, and musicians. Mariette was a sculptor and had studied with Antoine Bourdelle. She was also a good friend of Constantin Brancusi, who occasionally came to stay with the Millses at their country place; Teeny, the youngest person in the household, was often delegated to bring him his breakfast in the tower room. It was the custom for everyone to take a walk in the woods after dinner. One day Brancusi climbed into the upper branches of a pine tree and, with the children gathered in a circle below him, told them Romanian folk tales. "We were all enchanted by Brancusi," Teeny remembered. "Later on, I showed him some of my art-school drawings, and he made useful criticisms."

The first winter Teeny was in Paris, the Millses gave a ball in their rue Boissonnade apartment. While she was dancing, Teeny sensed a sudden rise in the level of excitement. Someone told her that Marcel Duchamp had arrived; even then he was known in Paris as an extraordinary person who rarely appeared at parties like this one. Teeny was introduced to him and found him charming. He had come in with the American expatriate writer Robert McAlmon, who created a minor 1920s-type sensation by peeing over the railing of the Millses' circular staircase.

After spending a year in Vienna taking art courses at the Kunstgeverba School, Teeny came back to Paris to study sculpture at the Académie de la Grande Chaumière. Sculpture was what she cared about, not painting, and she was serious about it, but her marriage to Pierre Matisse in 1929 put an end to any ambitions in that line. Pierre, who had suffered enough as the son of a world-famous artist, did not want another artist in his family. What he had in mind was a wife who would run an efficient household, entertain wealthy collectors, and offer a soothing respite from artistic egos. Teeny did

all those things admirably for the next twenty years, in addition to bringing up their three children—Jacqueline, Paul, and Peter. She also stepped in to run Pierre's New York gallery for several months in 1939 when Pierre, who had neglected to register the births of his children in France, was called up for service as a childless French citizen in the early days of the Second World War.

The sudden breakup of the marriage in 1949 came as a great shock to her. Pierre had fallen in love with Matta's estranged second wife, Patricia, an intensely neurotic and seductive young woman, more striking than beautiful, with a fearless manner and a keen eye for pictures. Several other men were in love with Patricia Matta at that time (the dealer Leo Castelli was one of them), and they could never understand what she saw in the laconic, rather chilly Pierre Matisse, who was by no means a wealthy man at that point. Teeny received their country house and a large stock of important paintings as a settlement. For the next few years, she supported herself as a private dealer, buying and selling works by Brancusi, Joan Miró, and other artists whom she had known for a long time.

Duchamp, who once told William Copley that he had "developed parasitism to a fine art," was still living on practically nothing then. The rent on his 14th Street studio was still only thirty-five dollars a month. He owned one suit, which he brushed and cleaned himself. When he went to spend a weekend with Teeny in Lebanon or at Teeny's childhood friend Gardie Helm's house in Easthampton, where they were often invited during the summer months, he never took a suitcase. He would wear two shirts, one on top of the other, and carry a toothbrush in his jacket pocket. About this time, however, Duchamp began receiving quarterly checks from a trust fund set up in his name by Brookes Hubachek, Mary Reynolds's brother. As Hubachek explained it, he was simply using some of the money that he had inherited from Mary to carry out what he thought she would have wanted to do if she had been well enough to understand her own financial situation. "She really had little property which was hers to dispose of because practically all of it was in trusts created by others," he wrote, "but it would have been possible for her to have expressed her feelings toward you by bequests of some amount. Being positive of this I shall do something toward carrying out what would have been her intentions . . . In addition, Marcel, I feel the most profound gratitude to you not only for what you were able to do while she lived but for your invaluable efforts in taking care of things in France

after her death." Hubachek calculated that the trust, which would revert to his own children after Duchamp's death, would provide Duchamp with somewhere between five and six thousand dollars a year—a substantial sum for someone whose total annual income from all sources had rarely exceeded that.

Duchamp was amazed by the news and deeply grateful. He went to spend ten days with the Hubachek family in the summer of 1953 at their camp on Basswood Lake in northern Minnesota, where he took part cheerfully in all the hikes and canoe trips and treasure hunts and other deep-woods activities that this vigorous midwestern family considered essential. The Hubacheks' two children found him a droll and relaxed companion. He even produced a work of art for his host, a small drawing called *Moonlight on the Bay at Basswood,* executed on blue blotting paper with materials he found on the houseboat that served as his sleeping quarters—a fountain pen, a lead pencil, talcum powder, and chocolate. (The drawing now belongs to the Philadelphia Museum of Art.) Brookes Hubachek's daughter, Marjorie Watkins, remembers how much her father enjoyed having Duchamp at the lake. "They were real soulmates," she said. "They used to talk about all kinds of modern art that Dad couldn't understand, and finally Marcel would say, 'Well, Brookes, it sells, you can understand that.' There was always a lot of laughter." Years later Hubachek would say that on almost every subject they discussed, Marcel eluded him. "He neither retreated nor sidestepped, he merely was one step ahead or aside on every occasion." Nobody in the family seemed to hold it against Duchamp that he and Mary Reynolds had drifted apart. They all took a great liking to Teeny when Marcel brought her to Basswood Lake three years later.

Duchamp spent that Christmas with Teeny, her daughter, Jacqueline, and her two sons, Paul and Peter, in the big stone house in Lebanon. Paul had come down from Harvard, and Jackie, the eldest, had flown back from Paris, where she was studying at the Sorbonne. The three Matisse children felt completely at ease with Duchamp. "With him, there was never this concern for the person in the mirror," Paul said. "He just lived directly." Soon after the Christmas holidays, a long-buried strain of bourgeois morality revealed itself in the mind of the notary's son. For the children's sake, he told Teeny, he thought they should get married. There were other reasons, needless to say. Marcel and Teeny were very happy together; Paul Matisse described their relationship as "harmonic," never out of tune. She clearly

Duchamp and Jackie Matisse prepare for a scene in Hans Richter's 1952 film, *8 x 8*.

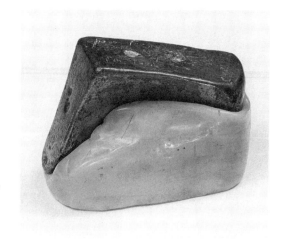

Top right: *Feuille de vigne femelle (Female Fig Leaf)*, 1950.

Middle: *Objet-Dard (Dart Object)*, 1951.

Bottom: *Coin de Chasteté (Wedge of Chastity)*, 1954.

adored him, and his feeling for her, if less visible to others, was just as sure. They decided to get married right away, without fuss or ceremony, at New York's City Hall.

A huge snowstorm battered the area on January 16, 1954, the day they had chosen for the wedding. There were no taxis running, so Marcel and Teeny went downtown on the Lexington Avenue subway. In spite of the weather, there was a crowd of prospective newlyweds in the large waiting room. Each couple had brought along at least one witness, but not Teeny and Marcel, who didn't know they would need one. Looking around the room, Duchamp heard a man's voice call out, "Marcel, what are you doing here?" It was a chess player from the London Terrace Chess Club, with his bride-to-be, her mother, and a party of friends. To the mother's great annoyance, this Samaritan left his group to stand up with Marcel and Teeny when it was their turn to go before the judge.

They made their way back uptown through the storm for a glass of champagne with Jackie Matisse at her pied-à-terre on East 60th Street. That same evening they drove in Teeny's car out to Lebanon, where they spent the next few days alone, enjoying the winter landscape and ignoring the telephone.

Duchamp gave Teeny a very odd wedding gift. It was a small two-part sculpture—the third in the series that included *Female Fig Leaf* and *Dart Object*—whose interlocking elements were a wedge of galvanized plaster, snugly inserted into the cleft in a chunk of pink dental plastic. Its title, inscribed on the wedge, was *Coin de Chasteté* (*Wedge of Chastity*).

The Artist and
the Spectator

All in all, the creative act is not
performed by the artist alone.

Walter and Louise Arensberg never saw their collection in the
Philadelphia Museum of Art. Louise died on Thanksgiving
Day in 1953, and Walter suffered a fatal heart attack two
months later. "I never expected [Walter] to die of a heart attack," Duchamp
wrote to Fiske Kimball, "and yet it is the weapon I would choose if I were
asked." The death of another old friend, Francis Picabia, came as an added
shock that fall. Thoughts of his own mortality prompted the cable that
Duchamp sent to 26, rue Danielle Casanova in Paris, the house where
Picabia had been born and where he died on November 30. It read, "Francis, à bientôt."

Duchamp himself was hit by an unexpected barrage of medical problems in the spring and summer of 1954. On a visit to Cincinnati to meet
Teeny's family, he was rushed to the hospital with an acute appendicitis
attack, and while recuperating from that, he contracted pneumonia. He
returned to the Cincinnati hospital a month later to be operated on for a
prostate condition, which the doctors had diagnosed when he was there the
first time. Both operations were successful. It was "a new and immense
pleasure to piss like everyone else, a pleasure I have not known for 25
years," he wrote to Roché in May. A month later he was able to reassure
Roché, who would surely have wanted to know, that "even sex exercises are

completely normal." Duchamp had used the same jocular tone to inform people of his surprise wedding. "Another mere piece of news is that I married last Saturday Teeny Matisse, the ex-wife of Pierre," he had written to Walter Arensberg. "In growing old, the hermit turns devil."

As soon as he was well enough, Duchamp resumed his frequent trips to Philadelphia, where the Arensberg collection was being installed under his supervision in ten spacious, high-ceilinged galleries that had been specially designed for it. One of the largest rooms was devoted to his own work. The Arensbergs had kept right on adding to their Duchamp holdings. They bought *The Chess Game* from Walter Pach in 1950, and in 1951 Duchamp's old school chum, Raymond Dumouchel, who had retired from medical practice and was living in the south of France, agreed to sell them the portrait that Duchamp had done of him in 1910, with the luminous aura surrounding his hand. Thanks to Katherine Dreier their collection had regained its centerpiece, *The Large Glass,* the great "delay" that held in suspension the nonretinal ideas of its making. Duchamp was on hand when the *Glass* was installed in the middle of the room, facing a doorlike window that had been cut into the wall on his instructions. The window looked out on a courtyard. There was a large fountain in the center of the courtyard, and on the other side of the fountain there were two monumental pieces of sculpture. One of them, a nude female figure in bronze called *Yara,* was by Maria Martins. (Its title referred to a river in Cuba.) Whether by accident or design (and everything we know about Duchamp suggests that it was not by accident), the sculpture was sited in such a way that you could look through the Glider element of *The Large Glass,* through the window, through the outdoor fountain (*la chute d'eau*), and see it in the background.

Duchamp and Teeny came down to Philadelphia in October 1954 when the Louise and Walter Arensberg Collection was formally dedicated and opened to the public. The opening was disrupted by Hurricane Edna, which felled a tree on the Pennsylvania Railroad tracks; the train carrying the Duchamps and other New York guests, all of whom were in evening dress, did not get to Philadelphia until two o'clock the next morning. Since they had planned to return to New York after the opening, no one had booked hotel rooms. They all sat up in the lobby of a downtown hotel until the museum opened and they could go over (still in their evening clothes) and see the exhibition. "Marcel enjoyed every minute of it," according to his

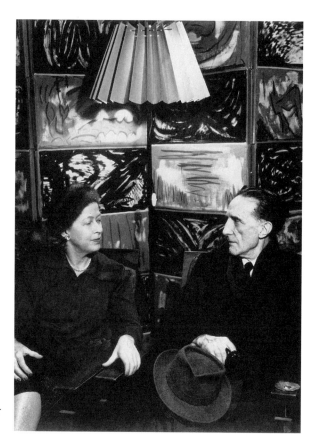

Teeny and Marcel, photographed by Man Ray, soon after their marriage.

friend Enrico Donati. "He didn't like openings, and he couldn't have been happier with the way things turned out."

The Duchamps went to Paris together in November. Roché had invited them to stay in his empty apartment on the boulevard Arago; they were very grateful because Paris hotel rooms were becoming expensive and their funds were limited. The Musée National d'Art Moderne had recently acquired, from Jacques Villon, Duchamp's 1911 oil sketch for *The Chess Players*—it was the first and for several years to come the only work by Duchamp in a French public collection. When Alain Jouffroy, an influential French art critic, proposed doing an interview with Duchamp for the weekly *Arts et spectacles,* however, the magazine's editor, André Parinaud, asked, "Who is he?" Jouffroy's interview ran with an admiring preface by Henri-Pierre Roché, and soon afterward the weekly *Les Nouvelles littéraires* carried a longer interview by Michel Sanouillet. To Jouffroy he revealed his disdain

for the "vulgarization" of art by the new mass audience. "While nobody dares to butt into a conversation between two mathematicians for fear of being ridiculous," he said, "it is perfectly normal to hear long conversations at dinner on the value of one painter in relation to another." Neither of the interviews caused much of a stir in Paris, where Duchamp was still an unfamiliar name. The French literati had caught a whiff of what was to come, however, in Michel Carrouges's recently published book, *Les Machines célibataires,* which compared the fantastic, psycho-sexual mechanisms in works by Franz Kafka, Raymond Roussel, and Marcel Duchamp. Asked by André Breton for his opinion of this somewhat labored exercise in French overthink, Duchamp replied that while Carrouges's reading of the *Green Box* notes had led to some interesting insights, his analysis of *The Large Glass* certainly did not coincide with Duchamp's own thoughts about it. Carrouges's conclusion about the "atheist" character of the bride was a case in point: so far as Duchamp was concerned, atheism and belief in God were simply opposite sides of the same issue, an issue that did not interest him at all. The older he became, in fact, the less interest he took in religious questions. "For me," as he wrote to Breton, "there is something other than *yes, no,* and *indifferent*—it is for example the *absence of investigations of this kind.*"

While he was in Paris, Duchamp worked out an arrangement with the publisher and book designer Ilia Zdanevitch, who called himself Iliazd, to produce the next series of his *Box-in-a-Suitcase*—thirty boxes in all. Xenia Cage had made the first series—some of which, however, were assembled by Joseph Cornell. That series had been financed first by Peggy Guggenheim's Art of This Century gallery, and then, after Peggy returned to Europe, by Patricia Matta, the future Mrs. Pierre Matisse. (Patricia bought the *Tzanck Check* and the original *L.H.O.O.Q.* from Duchamp and the painting *Network of Stoppages* from Kiesler. She was an ardent admirer of Duchamp's work and of Duchamp himself, with whom she flirted at every opportunity.) Xenia Cage was a gifted artist. The skill and dedication that she brought to the task of assembling and fitting and gluing the reproductions in place was never surpassed by anyone else, but there were some problems with the design and stability of these early boxes. Iliazd solved most of them in his improved version, which did not actually appear until 1958—largely because the cases of reproductions that Duchamp had sent over from New York were held up for months until French customs inspectors finally decided to admit them, duty-free, as "samples." After the Iliazd series of thirty boxes,

Duchamp had great difficulty finding someone to do the work of assembling the remaining 182 (out of 300). That problem was not solved until 1961, when Jackie Matisse, Teeny's daughter, offered to take it on. She did them in batches of twenty or thirty, with long lapses in between—the demand for them was never particularly pressing, even though the retail price was fixed in those years at $300. She finished the last one in 1971, just a little more than thirty years after Duchamp had signed the first copy.

Jackie's marriage to Bernard Monnier, an urbane and charming Parisian financial analyst, took place in Paris while the Duchamps were there in 1954. Pierre Matisse, who was paying for the wedding, had made it clear that Teeny and Marcel would not be welcome at the church or at the reception afterward. (He was said to be very resentful that his ex-wife had made what many of their mutual friends considered to be a brilliant remarriage.) The Protestant minister who was performing the ceremony told Teeny to come to the church anyway, which she did—she sat inconspicuously in the balcony. Later, after the reception, Teeny and Marcel took the bride and groom to dinner at Lapérouse, the famous old Belle Epoque restaurant on the quai des Grands-Augustins.

After protracted and perplexing delays, Marcel Duchamp became an American citizen on December 30, 1955. The previous spring, accompanied by his two sponsors, Alfred Barr and James Thrall Soby, he had gone to the office of the Immigration and Naturalization Service in New York to petition for his final citizenship papers and had been told that he would be called back within a week or so to take the oath of citizenship. The call never came, though, and after eight months had passed without a word from the immigration authorities, Barr wrote a letter to Nelson Rockefeller, who was then serving as Under Secretary of Health, Education, and Welfare in President Eisenhower's cabinet, asking if he would look into the matter. "I realize that there are factors in Marcel's past such as his association with the Dadaist and Surrealist movements, which may disturb our security investigators," Barr explained. Barr had good reason to suspect that the problem involved more than bureaucratic delay. Senator Joseph McCarthy had paralyzed large sections of the government with his campaign of slander and invective against purported Communists in public office, and modern artists were high on the list of potential subversives. A few years earlier Congressman George A.

Dondero, a Republican from Michigan, had delivered a speech in the House in which he singled out Duchamp as one of the "four leaders of the Cubist group," all of whom were dangerous "reds"; Duchamp and other émigré artists had come to America, he warned, "to aid in the destruction of our standards and traditions." Rockefeller, who had helped out before when Duchamp was having trouble getting his American visa renewed, stepped in once again and managed to convince the immigration authorities in Washington that he did not pose a threat to the republic. On December 30 Duchamp was finally allowed to take the oath.

Less than three weeks later, as though in public confirmation of his status as a newly minted American, Duchamp appeared on network television. He was the subject of a thirty-minute program on the NBC-TV series called "Conversations with the Elder Wise Men of Our Day." James Johnson Sweeney, who was by this time the director of the Solomon R. Guggenheim Museum in New York, led viewers on a guided tour of Duchamp's work—a relaxed and simplified tour (filmed in the Philadelphia Museum of Art) in the course of which Duchamp did not try to explain *The Large Glass* or the ideas behind it but simply responded to Sweeney's questions about his career with matter-of-fact answers that avoided the usual traps of false modesty or special pleading. Duchamp came across as a very unselfconscious television performer. There were two kinds of artists, he said in his agreeably French-accented English, "the artist who deals with society, who is integrated with society; and the other artist, the completely freelance artist, who has nothing to do with it—no bonds." Speaking as an artist of the second category, he added, "The danger for me is to please an immediate public—the immediate public that comes around you, and takes you in, and accepts you, and gives you success, and everything. Instead of that, I would rather wait for the public that will come fifty years—or a hundred years—after my death." At the very end of the interview, though, Duchamp said something about himself that he had never said before, something that made public recognition, if and when it came, seem relatively insignificant. "As you know," he told Sweeney,

> I like to look at the intellectual side of things, but I don't like the word "intellect." For me intellect is too dry a word, too inexpressive. I like the word "belief." In general when people say "I know," they don't know, they believe. Well, for my part, I believe that art is

the only form of activity in which man, as man, shows himself to be a true individual who is capable of going beyond the animal state. Art is an outlet toward regions which are not ruled by space and time. To live is to believe, that's my belief.

A surprising statement, coming from a man who supposedly had abandoned the serious practice of art more than thirty years before. It was also a surprise to hear this world-class agnostic speak of "belief." At first he seemed to be using the word in its casual sense—you believe (think) something is true without being sure; but then he put a much stronger construction on it—"To live is to believe"—in order to reinforce his own conviction that art was one of the highest forms of human activity. The shift reflects Duchamp's ambivalent attitude toward words in particular and language in general. Duchamp liked to call himself a nominalist—one who believes that abstract concepts do not really exist apart from the names we give to them. "I do not believe in language," he wrote soon after the television broadcast in response to a letter from a Frenchman who had sent him a detailed critique of Michel Carrouges's *Les Machines célibataires.* "I am a great enemy of written criticism, because I see these interpretations and these comparisons with Kafka and others only as an occasion to open a faucet of words . . . which instead of explaining subconscious thoughts, in reality creates the thought by and after the word." Paintings and other works of visual art were not translatable in verbal terms, according to Duchamp. Moreover, "All this twaddle—the existence of God, atheism, determinism, free will, societies, death, etc., are the pieces of a chess game called language, and they are only amusing if one does not preoccupy oneself with 'winning or losing this game of chess.'" But Duchamp, the chess master, was himself addicted to the game of language. Words were suspect, he felt, because they tended to take on a life of their own. This made them relatively useless for communicating thoughts or ideas, but it did not prevent them from functioning as keys to the meta-rational world of the imagination that finds its true voice in poetry.

In his early notes for *The Large Glass,* Duchamp had tried to escape from the limitations of written prose. The notes and the *Glass,* taken together, were intended to trigger a fusion of verbal and visual impulses that would give rise to a new language, one that could speak on as many different levels as a poem by Mallarmé. After *The Large Glass,* however, the wellsprings of Duchamp's creative language had gone dry. Everything he

had produced since then—optical machines, *Rotoreliefs,* puns and spooner-isms, the rue Larrey door that was both open and closed, the magazine cov-ers and book jackets and designs for exhibitions, the erotic objects—all these minor efforts, which today are treated with reverence as examples of the great, undivided Duchampian oeuvre, were really no more than indica-tions that Duchamp was still waiting for a new idea. He said so himself nearly every time he was asked why he no longer painted. "I didn't make a vow, damn it," he had told Michel Sanouillet. "I could have taken up the paintbrush again overnight, if I'd wanted to . . . The truth is that I have nothing to say."

The possibility that great pain and frustration lay beneath these re-peated answers to the same question never seems to have occurred to his questioners, probably because Duchamp was so adept at concealing any such emotions. In the mid-1940s, though, his long wait had come to an end. He had started to work on the new, secret project that would occupy him for the next twenty years and would eventually be seen, after his death, as both the culmination and the antithesis of *The Large Glass.* Unlike the *Glass,* the new work would be primarily visual, with no verbal dimension to sus-tain it—no notes, no explanations, not a single word by Duchamp (aside from the title) to accompany the prodigious, composite image. His work on it had renewed the flow of his creative language, however, and this appar-ently made it possible for him to link together in one sentence, without irony, the words *art* and *belief.*

Duchamp had never really stopped thinking about art. From 1912 on, his thinking had diverged decisively from that of most of his contempo-raries, and over the years he had come to certain conclusions that were incompatible, to say the least, with the currently popular concept of the artist as a tragic hero—a concept that gained momentum when Jackson Pollock killed himself and a young woman passenger in a drunken driving accident in 1956, and was often heard, implicitly or explicitly, in the rhetor-ical statements by other prominent artists of the New York School. Duchamp had proposed his own, very different view of the artist's role in society at the Western Round Table on Modern Art, when he described the artist as an "irresponsible medium" who was by no means fully aware of what he was doing. He gave a more complete statement of this point of view in April 1957 in a brief talk to the American Federation of Arts Convention in Houston.

Up until then Duchamp had almost always refused invitations to lecture. An important exhibition of work by the three Duchamp brothers opened at the Guggenheim Museum that February, however, organized by James Johnson Sweeney with Duchamp's active assistance; the show would move to the Houston Museum of Fine Arts at the end of March, and Duchamp, no doubt with encouragement from Sweeney, may have felt under some obligation to help promote it. He spent very little time writing the Houston speech, according to Teeny. "Marcel did everything so easily," Teeny recalled. "The ideas were there to begin with, pretty much worked out in his head."

"The Creative Act," which is both the subject and the title of his eight-hundred-word essay, starts out by defining "the two poles of the creation of art: the artist on one hand, and on the other the spectator who later becomes the posterity." For Duchamp it was very clear that a work of art was incomplete until it had been seen and thought about by one or more spectators—that there could be no such thing as an unknown masterpiece. The main reason this was so, in his view, was that the artist performed only one part of the creative act, and he did this, moreover, without any real understanding on the conscious level of what he was doing. "To all appearances, the artist acts like a mediumistic being who, from the labyrinth beyond time and space, seeks his way out to a clearing . . ." as Duchamp phrased it. "I know that this statement will not meet with the approval of many artists who refuse this mediumistic role and insist on the validity of their awareness in the creative act—yet, art history has consistently decided upon the virtues of a work of art through considerations completely divorced from the rationalized explanations of the artist." In other words, no matter what the artist may think he is doing, what he actually produces is largely determined by factors over which he has little or no conscious control; for this reason there will always be a gap between the intention and the realization—between what Duchamp wittily terms "the unexpressed but intended and the unintentionally expressed." The spectator's essential role is to step into this gap and, by interpreting what he sees, to complete the process that the artist has set in motion.

By "spectator," Duchamp did not mean the art critic with his "faucet of words." A few years later he would define the spectator as "the whole of posterity and all those who look at works of art who, by their vote, decide that a thing should survive," but at other times he seemed to have in mind

certain highly sensitized and committed onlookers, such as Walter Arensberg or André Breton. At the Western Round Table, Duchamp had spoken of the relatively rare individuals who were capable of hearing the "esthetic echo" emanating from works of art. In Houston he described "a transference from the artist to the spectator in the form of an esthetic osmosis taking place through inert matter, such as pigment, piano or marble." Only when this osmosis occurred could the spectator enter into the creative act and proceed "to determine the weight of the work on the esthetic scale."

"All in all," Duchamp concluded, "the creative act is not performed by the artist alone. The spectator brings the work in contact with the external world by deciphering and interpreting its inner qualifications and thus adds his contribution to the creative act. This becomes even more obvious when posterity gives the final verdict and sometimes rehabilitates forgotten artists."

The little essay is wickedly subversive. By reducing the artist to a "mediumistic" being and making the spectator a virtual co-partner in the creative process, Duchamp can be perceived as thumbing his nose at the inflated claims of the Abstract Expressionists, some of whom tended to sound like high priests of a new religion. Duchamp, however, was not just being subversive. He was describing the creative process as he had experienced it—a process in which, as he frankly acknowledged, there had been a notable gap between his own intentions and the end results. "The Creative Act" makes a mockery of all the critical verbiage that has been expended to prove that incestuous feelings for his sister, or alchemy, or the works of Alfred Jarry, or some other specific source was "responsible" for Duchamp's art. In that brief essay Duchamp argues that the sources of any creative act are too various and too complex to be pinned down in such an absurdly pedantic fashion and that many of them have very little to do with the mind, the emotions, or the biography of the artist. He quotes with admiration a famous sentence from T. S. Eliot's essay "Tradition and the Individual Talent," in which Eliot writes: "The more perfect the artist, the more completely separate in him will be the man who suffers and the mind which creates." But Duchamp goes a step further than Eliot by insisting that the true work of art is, or should be, *independent* of the artist. In saying this, moreover, he strikes the note that will be picked up by one young artist after another in the half century to come. Duchamp's vast influence today can be traced in large part to his conception of the artistic process, which makes

self-expression in any form appear trivial and irrelevant. Instead of the artist-as-hero, the master artificer who can embody, in James Joyce's great phrase, the uncreated conscience of his race, Duchamp proposes the work of art as an independent creation, brought into being in a joint effort by the artist, the spectator, and the unpredictable actions of chance—a free creation that, by its very nature, may be more complex, more interesting, more original, and truer to life than a work that is subject to the limitations of the artist's personal control.

Nothing Else but
an Artist

There is no solution because there
is no problem.

With the Houston lecture safely behind them, the Duchamps took a three-week vacation in Mexico. They visited Teeny's friend Rufino Tamayo, the painter, and his wife, Olga, at their houses in Mexico City and Cuernavaca and then headed south, to the old colonial town of Oaxaca and eventually to the Yucatán, where they explored the ruins of Chichén Itzá and Uxmal. In spite of inevitable bouts with *la turista,* they were fascinated by "the Mexican phantasmagoria," as Duchamp called it, and delighted to discover how much fun they had traveling together.

"It feels like a happy marriage," Beatrice Wood had written to Henri-Pierre Roché in 1956, after having lunch with the Duchamps on a visit to New York. "I am as much in love with him as ever," she added. "He has an extraordinary quality, an ageless charm." Teeny was often surprised by his thoughtfulness and dependability. He left the 58th Street apartment every morning between ten and eleven, took the bus to 14th Street, and returned punctually at five. "He would always appear at the time he'd said he would," she marveled. Now and then Teeny would go downtown and clean the studio herself; she dusted and swept the front room but not the room in back, which was a welter of electrical extension wires, unfinished metal and wooden elements, and plaster dust. By the time they got married, Duchamp

had been working on his secret project for eight years, and he was in no hurry to finish it. "He worked on it all the time, but never like a workman," Teeny said. "He would work for fifteen or twenty minutes and then he'd smoke a cigar or study chess problems or do something else." Duchamp still spent several hours a day studying chess problems. At least one night a week, he and Teeny went to the London Terrace Chess Club on West 23rd Street; they preferred it to the old and somewhat moribund Marshall Chess Club, where Duchamp used to play in earlier years. Teeny had learned chess as a child by watching her father play. She had a natural talent for the game, and in the 1950s she took some lessons at the New School for Social Research, but she and Marcel never played together. "Chess was such a part of our lives," she said. "Instead of going to a movie or a restaurant, we would go to the chess club. I never wanted to compete against Marcel, though, the way Dorothea did against Max Ernst."

They spent the summer of 1958 in Europe. Marcel took Teeny to see his birthplace in the village of Blainville, which he had not visited since his parents moved to Rouen in 1905 and which had changed hardly at all. The house he had grown up in was still occupied by M. Le Bertre, who had bought it (as well as the town's notarial practice) from Eugène Duchamp. A week later they left Paris for the south of France in a rented car. Teeny drove—Marcel never did learn how. They stopped for several days in Massiac, where Marcel's paternal grandparents had run the Café de la Paix for half a century. Going on to Les Eyzies-de-Tayac, in the Dordogne, they were joined by Max Ernst and Dorothea Tanning, who went with them to see the prehistoric paintings in the Lascaux cave—it was still open to the public then. "Marcel didn't like caves," according to Teeny. "He descended *very* briefly, looked around, and left."

In mid-July they spent a fortnight with Marcel's sister Suzanne in Sainte-Maxime. Jean Crotti, Suzanne's husband and Marcel's old friend, had died in January at the age of seventy-nine, and Suzanne had asked Marcel and Teeny to come and stay with her in a friend's villa on a hillside overlooking the Mediterranean. Neither Jean nor Suzanne had achieved any real recognition as artists. That was nothing to worry about, as Duchamp had told Crotti once, in response to Crotti's request for an honest appraisal of his work. "Artists of all times are like Monte Carlo gamblers," Duchamp had replied, "and the blind lottery advances some and ruins others . . . In your particular case, you are certainly the victim of the 'Ecole

de Paris,' this great joke that has lasted 60 years (the pupils themselves award the prizes, in money)." Crotti's work since the late 1930s had taken the form of illuminated colored-glass constructions that he called *"gemmaux."* Suzanne had become a painter of expressionistic, rather slapdash landscapes, about which Marcel contrived to say very little. Suzanne's earthy, boisterous humor revived during the fortnight in Sainte-Maxime, and the three of them had a good time together. At the end of their stay in the "Villa Kermoune," which had been lent to them by the Crottis' friends Claude and Bertrande Blancpain, Duchamp left a handmade hostess present in the linen cupboard, a small, fragile collage made with pencil, watercolor, and pine needles; entitled *Délices de Kermoune,* it would eventually find its place in the Duchamp catalogue raisonné.

At the beginning of August, the Duchamps took a plane from Nice to Barcelona and a taxi from Barcelona to the village of Cadaqués, where Duchamp had spent two weeks with Mary Reynolds in the summer of 1933. Cadaqués had changed more than Blainville in the years since his last visit, but it was not yet the international summer colony that it would soon become. An ancient fishing village nestled at the foot of rugged coastal mountains, it had been attracting artists since the turn of the century—Picasso and Derain had both painted there. The Surrealists had discovered it through Salvador Dalí, who now lived for much of the year in the nearby village of Port Lligat. There were few tourists and not even a third-class hotel in Cadaqués in 1958. Duchamp had written ahead to the owner of the principal café in town, a man named Meliton, and he had arranged for them to rent a small apartment for the month of August. (Meliton—nobody ever seemed to know him by any other name—was the village fixer. A handsome man with flowing white hair, he had learned French as a teenager working in French vineyards, and he was one of the few Catalan-speaking natives who could communicate easily with outsiders.) The apartment the Duchamps lived in that first summer was over a donkey stable. It had no view of the sea, no running water, a wood stove, straw mattresses, and many flies (from the donkeys), but Teeny loved it. "We are having the most heavenly time," she wrote to her daughter, Jackie. "I have bathed almost every day in a different little beach or rocky bay which we walk to—Marcel has been an angel to come with me and he's gotten all sunburned—Cadaqués itself is the quaintest town you could ever imagine." They went out in a boat with Salvador and Gala Dalí to see the strange rock formations

at Cape Creus, which figured in so many of Dalí's paintings and also in *L'Age d'or,* the Surrealist film by Dalí and Luis Buñuel. Dali's usual exhibitionism subsided when he was with Duchamp; the two of them treated each other with great respect and an almost comical formality. Gala, however, took an instant and visible dislike to Teeny, who wisely pretended not to notice. The Duchamps returned to Paris in mid-September and spent two weeks in Max Ernst's vacant apartment before leaving for New York. Roché described them in a letter to Beatrice Wood as being like two newly-weds: "Sweet. Enchanting. Serious. Smiling. Happy."

Duchamp once told Teeny that these were the happiest years of his life. The pleasures of marriage were about to be enhanced, moreover, by accumulating honors and the subtle onset of fame. Three important books on Duchamp's life and work were under way in the late 1950s. Michel Sanouillet, the Toronto University scholar who had interviewed him in New York, was compiling a volume (in French) of Duchamp's writings—it would include the notes from the *Box of 1914* and *The Green Box,* the short entries on artists that Duchamp had written for the Société Anonyme catalog, the various sayings of Rrose Sélavy, and a number of other short texts. In addition, the major monograph and catalogue raisonné that Robert Lebel had been working on since 1953 was nearing completion, and George Heard Hamilton, the Yale art historian who had edited the Société Anonyme catalog, had agreed to do the English translation. Hamilton was also collaborating with a young English artist named Richard Hamilton (no relation) on a typographic version in English of the *Green Box* notes. These three volumes would make Duchamp's ideas more readily available to a younger generation of artists, many of whom were already primed to receive them.

Richard Hamilton, one of the originators of the Pop art movement in England, had seen Duchamp's work for the first time in 1952, when James Johnson Sweeney's "Twentieth Century Masterpieces" show came to the Tate Gallery. Soon afterward he had managed to borrow a copy of *The Green Box* from a friend. Hamilton did not speak French, but he persuaded a French-speaking fellow lecturer at Durham University in Newcastle-upon-Tyne to help him translate Duchamp's notes into English. The other lecturer's field was sixteenth-century Venetian art; although he had no idea what the notes meant, he was able to provide a literal reading of the French words, and Hamilton could then retranslate them in ways that made sense to him. Hamilton subsequently used the *Green Box* notes as the basis for a lec-

ture on *The Large Glass* at the Institute of Contemporary Arts in London. During the question period after his lecture, a man in the audience stood up and ridiculed him, saying that Duchamp's notes were nothing more than a big joke, and this led Hamilton to wonder whether he might have misunderstood them. He decided to find out by sending some of the translated notes to Duchamp, along with a schematic drawing that he had made of *The Large Glass.* Duchamp did not answer his letter for nearly a year, but then he wrote to say that he liked the way Hamilton had deciphered the notes and that he was putting him in touch with George Hamilton at Yale—the two of them might work together, he said, on an English translation of the notes in book form.

The two Hamiltons worked for three years on this book. Their labors were financed in large part by a grant from William Copley, the painter and former Los Angeles gallery owner, who had come into a sizable inheritance from his father's newspaper-chain fortune. Duchamp was very pleased by Richard Hamilton's efforts to duplicate typographically the look of the original notes. Hamilton often wondered why Duchamp wanted to reproduce all the mistakes and crossed-out words. Duchamp never explained why, but in his letters to Richard and George Hamilton, he gave clear and specific answers to many of their other questions. The words *"arbre-type"* in one of the notes describing the bride machine meant "kind of a tree, tree-like column," he wrote—but when Richard pointed out to him that "arbor" was a term used in engineering to refer to an axle, Duchamp opted enthusiastically for changing the translation from "tree-type" to "arbor-type." He preferred "feeble" to "weak" cylinders in the bride motor, and he decided that *"pendu femelle"* should be left in French because there was no good English equivalent. On more general questions concerning the various elements of *The Large Glass* and how they related to each other, he was much more elusive. The mysteries of the *Glass* were not going to be cleared up by Duchamp. "There is no solution," as he liked to say, "because there is no problem."

The publication date of Robert Lebel's *Sur Marcel Duchamp,* the first comprehensive monograph on Duchamp and his work, kept being postponed. Lebel and Duchamp became so exasperated by the delays and by the "profound indifference" of Arnold Fawcus, the French publisher, that at one point they considered terminating the contract with Fawcus's Editions de Trianon and taking the book to the New York art book publisher

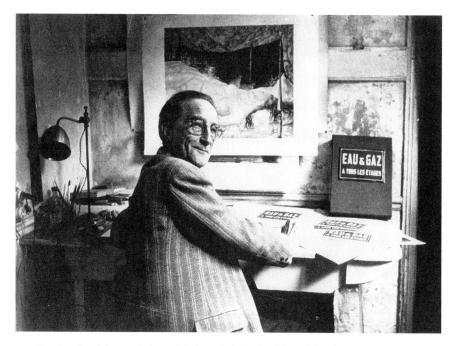

Signing the deluxe edition of Robert Lebel's *Sur Marcel Duchamp*, Paris, 1959.

George Braziller instead, but the disputes and difficulties were eventually ironed out, and the book's French edition appeared in 1959. Duchamp, who was largely responsible for its design and layout, produced two new works of art that were included in a deluxe special edition. The first was a self-portrait in profile made by the old technique of tearing a sheet of colored paper around a metal template. (The only self-portrait he ever did, it was signed *Marcel déchiravit.*) The second was an "imitated readymade" facsimile of an enamel-on-metal sign reading EAU & GAZ A TOUS LES ETAGES (WATER AND GAS ON ALL FLOORS)—a sign that could be seen at one time on the facade of every new apartment house in Paris; it served here as a colloquial reminder of the two elements, falling water and lighting gas, that played such a prominent role in *The Large Glass* and *The Green Box,* and which would figure prominently in the new *tableau vivant* that was slowly taking shape in his 14th Street studio.

Lebel's biographical essay, in spite of some rather windy passages ("having foretold Freudianism, he has also foreseen relativity"), provided on the whole a clear and accessible introduction to Duchamp's life and work. In

addition to Lebel's essay, readers could find the complete texts of Duchamp's Houston lecture on "The Creative Act" and André Breton's "The Lighthouse of the Bride," together with an evocative memoir by Henri-Pierre Roché, whose last sentence—"His finest work is his use of time"—would be quoted again and again in the years to come. Lebel's catalogue raisonné listed no fewer than 208 works by Duchamp, among them such recent additions as the *Wedge of Chastity* (his wedding gift to Teeny) and one of the readymade waistcoats that Duchamp gave to friends and family members, with the buttons lettered to spell the recipient's name. Duchamp must have approved the listing of such items as part of his collected oeuvre, but his reasons for doing so were not quite the same as Lebel's. Lebel and others seemed to think that anything Duchamp did, per se, should qualify as a work of art. Duchamp begged him to leave out certain items. "Otherwise," he warned, "I will send you all my daily doodles made while waiting for a telephone number." Duchamp enjoyed casting doubt on all attempts to define what art was or was not. Tracing the word back to its Sanskrit origins in the verb "to make," he insisted that anything made by man would have to be considered a work of art. (It might be bad art, he explained, but it was still art, the way a bad emotion was still an emotion.) But even that definition had been undermined by his readymades—manufactured objects raised to the status of art by the decision of the artist. The readymades, he pointed out, were "a form of denying the possibility of defining art."

The deluxe edition of Lebel's book appeared in the spring of 1959. Duchamp did not attend the reception in its honor at the Galerie La Hune in Paris. He and Teeny had already gone to Cadaqués, where they would spend the spring and part of the summer in a much more attractive apartment than the one they had occupied the year before—it was on the parlor floor of a house on the waterfront, with splendid views and no flies.

The day after they arrived, Duchamp learned that his old friend Henri-Pierre Roché had died of a heart attack a week earlier. Fame would touch Roché posthumously, when *Jules and Jim* became a hit film by François Truffaut. Truffaut had met Roché in 1957 and had introduced him to Jeanne Moreau, whose role in that film would make her a star. Roché published another semi-autobiographical novel, called *Deux Anglaises et le continent* (*Two English Girls and the Continent*)—it also became a movie by Truffaut, although not in the class of *Jules and Jim*—and when he died he was working on *Victor,* his novel about Duchamp. It must have given him pleasure to

relive those scenes in which Duchamp, Beatrice Wood, Walter and Louise Arensberg, and Roché himself pursued their youthful adventures in the New York of 1915—the costume balls, the flirtations, the conversations in Victor's (Duchamp's) studio where *The Large Glass* was slowly gathering its necessary quota of dust. His unfinished novel reads like a film script, with rapid scene shifts and many pages of telegraphic dialogue. "You have to choose," Victor tells Patricia (Beatrice Wood) at one point. "Either freedom and risk. Or the so-called straight path, also a risk, and children. Love makes you . . . Too many loves are as brutalizing as too many whiskies . . . What should you become? Yourself, purely, unmixed, without sham, clean." Roché himself did not observe the warning against too many loves, as the many volumes of his intimate diary demonstrate on almost every page, but in his own way he was as dedicated to absolute personal integrity as Duchamp. "Yes, he was great," said his friend Jean Paulhan, who edited *Jules and Jim* for Gallimard, "with something languorous about him. He didn't surprise you because he enchanted you. He had a great deal of love for the human race. He thought people were admirable."

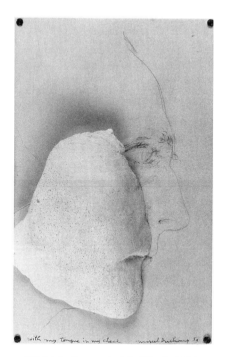

With My Tongue in My Cheek, 1959.

Duchamp kept busy that summer doing illustrations for a magazine article that Robert Lebel had been commissioned to write—in the spirit of Dada, neither he nor Lebel was supposed to know what the other one was composing. Duchamp, who had taught himself to make plaster casts for his secret project, got Teeny to make a cast of his cheek, which he puffed out by holding a walnut in his mouth; he then glued the cast to a piece of paper on which he had drawn in the rest of his profile, and called the resulting collage *With My Tongue in My Cheek*. He also made a plaster cast of the sole of his foot with several large, dead houseflies embedded in it (this one was titled *Torture-morte*), and he

commissioned a pastry shop to make up a marzipan assemblage in the shape
of a man's head (it looked like a three-dimensional version of one of Arcim-
boldo's sixteenth-century fruit and vegetable paintings), which he called
Sculpture-morte.

Later, in July, when he and Teeny had left Spain and gone to spend
three weeks in a friend's house not far from Grasse, Duchamp did a small
drawing that would perplex and fascinate future Duchampians. It showed
The Large Glass with a telegraph pole added in the foreground and the faint
outline of a mountain range visible behind the glass, in the bride's domain.
The title of this little exercise was *Cols alités,* written on the back of the
sheet, and after it Duchamp had added: *Projet pour le modèle 1959 de "La
Mariée mise à nu par ses célibataires, même." Cols alités* can be translated as
"Bedridden Mountains," which is cryptic enough. It could also be read as a
pun on "causality," the doctrine of cause and effect, which Duchamp had
always declined to accept. The telephone pole, with its wires and insulators,
adds a new element to the "electrical" stripping of the bride; the mountain
range may refer to the "landscape of the water mill," mentioned in Du-
champ's notes but missing from *The Large Glass.* In the absence of any hints
from Duchamp, however, there is no telling what he had in mind with this
"1959 model" of his most important work.

Duchamp's collected writings, edited by Michel Sanouillet, came out in Paris
that fall with the suitably punning title *Marchand du sel.* (The English edi-
tion, called *Salt Seller,* would not appear until 1973.) A month later Grove
Press in New York published Robert Lebel's *Sur Marcel Duchamp* in
English—its title was simply *Marcel Duchamp*—and a few New York jour-
nalists, surprised to find that such a legendary figure was living quietly
among them, called him up to ask for an interview. One of them was this
writer. I was working for *Newsweek* magazine then, and when the assign-
ment to interview him came my way, I knew practically nothing about
Duchamp and very little about modern art. One of the first things I discov-
ered, when I met him for drinks in the King Cole Bar of the St. Regis Hotel,
was his gift for putting people at ease and for making the most inane ques-
tions seem intelligent or, at any rate, acceptable. Inevitably, of course, I asked
about his reasons for not painting. "I became a non-artist," he said, "not an
anti-artist . . . The anti-artist is like an atheist—he believes negatively. I don't

believe in art. Science is the important thing today. There are rockets to the moon, so naturally you go to the moon. You don't sit home and dream about it. Art was a dream that became unnecessary." Sitting back in his chair, puffing comfortably on a cigar and sipping a glass of dry vermouth, Duchamp dismissed the Abstract Expressionists as retinal painters, and their work as "acrobatics, just splashes on canvas." I kept trying to find out how he spent his time. "All my life I've been able to live on very little money," he gently explained. "I spend my time very easily, but wouldn't know how to tell you what I do . . . I'm a *respirateur*—a breather. I enjoy it tremendously." One of my *Newsweek* colleagues said later that he had never read an interview in which the subject managed so gracefully to say so little, but that wasn't the way it seemed to me. Although the symptoms did not show up right away, I had become a fan—one of a rapidly increasing number.

The growth of Duchamp's influence during the 1960s coincided with a loss of faith in other gods. For the first time in more than half a century, Picasso had ceased to be the dominant force in modern art. Although he would continue to paint right up until his death in 1973, a critical consensus had formed around the notion that he had done nothing of real importance since the late 1930s. That consensus would eventually break down, but Picasso's influence never regained its monolithic power—in large part because the vital center of contemporary art making, art criticism, and art buying had passed by then from Paris to New York. Picasso, who never visited the United States and never showed any interest in doing so, would lose out in the influence department to Duchamp, who became a U.S. citizen. But that did not happen right away. For a great many younger artists in the United States and in Europe, Jackson Pollock was the new hero (tragically but safely defunct), and gestural abstraction the ruling international style. Its methods and precepts were taught in almost every art school, and the work of its major artists was selling for higher and higher prices to museums and collectors. In becoming an established style, however, the movement had lost its momentum. Work by second generation Abstract Expressionists often seemed derivative and mannered. Conservative critics such as the *New York Times*'s John Canaday kept prophesying a return to "humanist" (i.e., figurative) painting, but the critics, as usual, were in for a shock. They had scarcely noticed the amazing shift in attitude and outlook that was already well advanced in the work of some younger New York artists, poets, dancers, filmmakers, musicians, and performance artists.

The Duchamps and
John Cage in 1965.

John Cage, the avant-garde composer, was one of the main catalysts of this shift. Born and raised in California, the son of an inventor, Cage, in his writings and teachings no less than in his experimental music, proposed a concept of art that was directly opposed to that of the Abstract Expressionists. Instead of an art that emphasized the artist's personal "touch" and deepest feelings, he envisaged an art based on chance, in which every effort was made to exclude the artist's personality; rather than a few geniuses creating masterpieces, he urged a perpetual process of artistic discovery in daily life. The purpose of art, Cage wrote in 1957, was "purposeless play," which put the artist in sync with nature—not nature's outward appearance, that is, but nature's way of working. Cage's art of purposeless play was "not an attempt to bring order out of chaos nor to suggest improvements in creation," as he wrote, "but simply to wake up to the very life we're living, which is so excellent once one gets one's mind and one's desires out of its way and lets it act of its own accord." The clearest (and the

most extreme) example of Cage's egoless art is his 1952 "silent" composi-
tion, entitled *4'33"*, whose score calls for a pianist to sit for four minutes
and thirty-three seconds at the piano without playing a single note, while
the audience listens attentively to the ambient sounds (coughing, rustling,
creaking, and so on) in the concert hall.

Cage's humor, his lucidly expressed ideas, and his sunny, optimistic per-
sonality had a profound effect on innumerable young artists. During the
1950s his fellow musicians tended to dismiss him as a bad joke, but artists
went regularly to his concerts and to the dance recitals of Merce Cunning-
ham, whose plotless, pure dance choreography was often accompanied by
Cage's music. (Cage had been the Cunningham company's musical adviser
since 1949.) Robert Rauschenberg and Jasper Johns, the most gifted and
innovative artists of the first post–Abstract Expressionist generation, both
became directly involved with the Cunningham dance troupe, designing sets
and costumes for the dancers and serving successively as the company's artis-
tic director. Although each of them had arrived independently at an
approach to art that had much in common with Cage's esthetic, their friend-
ship with Cage and Cunningham (and with each other) gave them much-
needed encouragement at a critical moment in their careers. Rauschenberg,
like Cage, was committed to breaking down the barriers between art and
life. He often thought of his own work as a "collaboration with materials"
rather than a manipulation of them, and many of the materials he used in his
"combine paintings" were lifted straight out of everyday life—rocks, dirt,
growing grass, light bulbs, newspapers, mirrors, Coke bottles, parasols, his
own pillow and quilt, and memorably, a stuffed Angora goat with a tire
around its middle. Although Johns was more focused on painting than
Rauschenberg, he, too, wanted his work to be part of the real world rather
than an imitation of it, and he was determined to exclude his own emotions,
tastes, and memories. Johns's paintings of numbers, targets, flags, maps, and
other images that "the mind already knows" dealt with the complex rela-
tionship between art and life. One cannot paint the "image" of the number
seven, for example; one can only paint a seven. The trails blazed by Johns
and Rauschenberg would lead to Pop art, Happenings, Minimal art, Con-
ceptual art, and several other developments, but they also led back to Cage
and, beyond Cage, to Duchamp.

For years Cage had been too much in awe of Duchamp to approach
him. Although they had met at Peggy Guggenheim's in 1942, and Cage had

written the music for the Duchamp sequence in Hans Richter's Surrealist film *Dreams That Money Can Buy,* "Marcel's quiet way gave me the feeling that he did not want attention," as Cage put it, "so I stayed away from him, out of admiration." In the early 1960s, though, Cage decided to seek out his idol. He did so by asking whether Duchamp would consider giving him chess lessons. Duchamp agreed (after first making sure that he knew the moves), and Cage began going to the Duchamps' apartment one or two nights a week. By then Marcel and Teeny had moved downtown to 28 West 10th Street. They lived on the second floor of a fine old nineteenth-century town house, in two high-ceilinged rooms hung with paintings by Matisse, Miró, and Balthus, many of which Teeny had received in her divorce settlement with Pierre Matisse. Over the fireplace was Duchamp's *9 Malic Moulds,* the only major example of his work they owned—Teeny had bought it from Roché in 1957. "I was living in the country then," Cage told me, "and I would bring wild mushrooms that I had gathered and a bottle of wine, and Teeny would cook dinner. The way Marcel taught was to have Teeny and me play chess. He sat in that amazing chair he had inherited from Max Ernst, the one with the very high back. He sat and smoked his cigar and didn't even follow the game. Now and then he would come over and remark that we were playing very badly. There was no real instruction. Sometimes we would talk afterward, but it was never about art or ideas. Oh, but I do remember him saying one thing, several times. He said, 'Why don't artists require people to look at a painting from a specified distance?' It wasn't until his last work was finally revealed that I saw what he meant."

Rauschenberg and Johns were introduced to Duchamp in 1960, not by Cage but by the art critic Nicolas Calas. Calas brought Marcel and Teeny to Rauschenberg's loft studio on Front Street, and Johns came upstairs from his studio, which was on the floor below. The four of them enjoyed each other's company so much that they met frequently after that—once they even had Christmas dinner together at a restaurant in Chinatown. Rauschenberg and Johns went to Philadelphia to see the Duchamps in the Arensberg collection. (When Rauschenberg tried surreptitiously to lift *Why Not Sneeze Rose Sélavy?,* the readymade birdcage filled with marble cubes, to see how heavy it was, a bored guard came over and said, "Don't you know you're not supposed to touch that crap?") *The Large Glass* was a revelation to both of them. "It's very much in the present tense," as Johns once said. "Many paintings try to place you somewhere else, but *The Large Glass* doesn't do that. It involves

"An ageless charm." Duchamp in the 1960s, at 28 West 10th Street.

you with yourself and with the room you're in, and it seems to require a kind of alertness on your part. It's not just something you look at, although the forms and the spatial arrangements are interesting visually."

Rauschenberg bought a replica of Duchamp's *Bottle Rack* in 1960. It had been sent over from Paris by Man Ray, on Duchamp's instructions, for

a group show called "Art and the Found Object," which was organized by the American Federation of Arts. (Man Ray had gone to the Bazar de l'Hôtel de Ville and bought four bottle racks in four different sizes because he wasn't sure of the dimensions of the lost original.) Learning that most of the works in the show were for sale, Rauschenberg had asked the price of *Bottle Rack* and, to his enormous surprise, had found that he could buy it for three dollars. He asked Duchamp to sign it the next time they met, and Duchamp did so with pleasure. Both Rauschenberg and Johns would acquire other works by Duchamp, and both would make paintings in homage to him: Rauschenberg's *Trophy II* (1960–61), in which Teeny's name is misspelled in block letters ("TINI"), and Johns's *According to What* (1964), a very large painting that is a virtual compendium of Duchampian images and themes—cast shadows, color charts, printed words, plaster casts, and even a rendering of Duchamp's profile on a hinged section that can be opened and closed. References to Duchamp have cropped up in Johns's work ever since. He has used the image of the *pendu femelle* in two pictures and the *Mona Lisa* in two others, and he has obviously read and thought a great deal about the notes in *The Green Box,* which became available in book form when the Richard Hamilton–George Heard Hamilton typographic version was published in 1960. (Johns already owned a copy of *The Green Box* itself.) While Rauschenberg responded directly to Duchamp's iconoclasm and his willingness to push beyond the accepted limits of art, Johns became deeply engaged with Duchamp's work and with the thinking behind it. "He was the first to see or say that the artist does not have full control of the esthetic virtues of his work," Johns once wrote, "that others contribute to the determination of quality." When Johns commented, in the same essay, on Duchamp's having gone beyond retinal boundaries, "into a field where language, thought and vision act upon one another," he was also describing the territory of his own ambiguous and highly cerebral art.

The lengthening shadow of Duchamp touched the Pop movement only peripherally. In their rejection of Abstract Expressionist heroics, Pop artists Claes Oldenburg, Jim Dine, Roy Lichtenstein, James Rosenquist, and Andy Warhol were looking outward at the world around them rather than focusing on their emotional reactions to it, and what they saw was a world of comic strips and commercial advertisements and other stigmata of America's thriving popular culture. Duchamp had helped to open the door to such "low" and banal subject matter, to be sure, and also to the possibility of

taking an anti-serious attitude toward art, but the American Pop artists were not much interested in ideas. Their counterparts in Paris, the so-called Nouveaux Réalistes, were more Duchampian in outlook; they also used common, everyday objects in their work, but their main inspiration for doing so derived from Duchamp's readymades. When the "new realist" Jean Tinguely came to New York in 1960, hoping to build a gigantic motorized scrap-metal construction whose sole purpose would be to destroy itself in the garden of the Museum of Modern Art, one of the first people he approached for help and guidance was Duchamp. They had met a few years earlier in Paris, when Tinguely spotted Duchamp in a café on the rue Vaugirard, killing time before he called on Brancusi. Tinguely introduced himself and invited Duchamp to visit his studio—it was on the impasse Ronsin, near Brancusi's; Duchamp agreed, they set a date, but when Duchamp showed up a few days later, on schedule, Tinguely wasn't there. (Apparently he had forgotten all about it.) Duchamp, who never took offense at such things, went to Tinguely's show of "meta-matic" painting machines at the Iris Clert Gallery soon afterward and tried out one of them—the machine, activated by a coin, sent two felt-tip pens skittering erratically over a blank sheet of paper and produced a creditable-looking abstract painting in less than a minute. Duchamp liked Tinguely's mordant, ironic humor and his *je m'en foutre* (don't give a damn) approach to tradition, and he and Teeny were in the audience when Tinguely's clanking, white-painted assemblage of bicycle wheels, motors, saws, klaxons, a hot-air balloon, an Addressograph machine, and other picturesque detritus committed mechanical suicide more or less as planned, in the garden of MOMA, on the evening of March 17, 1960. Two years later Tinguely put the Duchamps' discarded refrigerator into the first joint show of Pop artists and Nouveaux Réalistes at the Sidney Janis Gallery—he had equipped it with a red light bulb inside and a very loud siren that went off when the door was opened.

Duchamp's attitude toward Pop art, or neo-Dada, as it was often referred to in the early 1960s, was somewhat ambivalent. He found it amusing, but he also thought it "an easy way out" and a misreading of Dada. "When I discovered readymades I thought to discourage esthetics," he wrote to Hans Richter, the Surrealist filmmaker. "In Neo-Dada they have taken my readymades and found esthetic beauty in them. I threw the bottlerack and the urinal into their faces as a challenge and now they admire them for their esthetic beauty." This statement is slightly suspect, in

that Richter seems to have written it himself, based on a conversation with Duchamp, and then sent it to Duchamp for approval before using it in a book he was writing. Duchamp approved it, at any rate. Pop art was too simpleminded and too commercially successful to appeal to him. It was about "liking things," as Andy Warhol once said. Duchamp came to believe that Warhol was an important artist, but for reasons that Warhol himself might not have recognized or even understood. Referring to Warhol's soup-can pictures, he said that their interest was not so much retinal as conceptual. "If you take a Campbell soup can and repeat it fifty times," he said, "you are not interested in the retinal image. What interests you is the concept that wants to put fifty Campbell soup cans on a canvas."

Richard Hamilton, whose paintings showed a marked preoccupation with the eroticism of machines and other man-made artifacts, was the main conduit for Duchampian ideas in England. Duchamp had been immensely gratified by Hamilton's work in translating the *Green Box* notes. "We are *crazy* about the book," he wrote to him after seeing the first copy in 1960. "Your labor of love has given birth to a monster of veracity and a crystalline transubstantiation of the French green box—the translation, thanks above all to your design, is enhanced into a plastic form so close to the original that the Bride must be blossoming ever more." Hamilton would later construct, with Duchamp's approval, an exact full-scale replica of *The Large Glass,* working from Duchamp's original drawings, perspective studies, measurements, and notes. It was not, however, the first such cloning; an earlier replica of the *Glass* was made in 1961 by Ulf Linde and two other Swedish artists for an exhibition called "Art in Motion" at the Moderna Museet in Stockholm. Duchamp and Teeny traveled to Stockholm to see the show, and Duchamp certified their replica as a *copie conforme* (true copy). He also approved replicas of the *Bicycle Wheel* and *Fresh Widow,* which Linde and another colleague had made for the Moderna Museet. Although Duchamp's attitude toward the readymades changed over the years (his insistence on their esthetic "indifference" being a relatively late concept), he never thought of them as unique works of art, and he saw no reason why others shouldn't feel free to duplicate them, as Janis had done with *Fountain,* or Man Ray with *Bottle Rack.* The idea was Duchamp's, but the objects, so to speak, were on their own.

Duchamp often spoke scathingly about the commercialization of art and the integration of the artist in society. During a panel discussion at the

Philadelphia Museum College of Art in 1961, he said that there had been an "enormous dilution" in the quality of art since Impressionism, and he predicted that "the great artist of tomorrow will go underground." In the rapidly commercializing field of contemporary art, however, Duchamp himself was a more and more visible presence. He served on exhibition juries, gave interviews, organized and installed a Surrealist group show at the D'Arcy Gallery in New York, and even accepted invitations to lecture about his work—something he had found he could do quite easily after all, with Teeny's moral and tactical support. (She learned to type so that she could copy out his manuscript and lecture notes.) In 1960 he received the American cultural establishment's defining badge of approval: election to the National Institute of Arts and Letters, along with Willem de Kooning and Alexander Calder. "I'm nothing else but an artist, I'm sure," he said a year later in a filmed interview with Richard Hamilton and Katharine Kuh for the BBC, "and delighted to be . . . the years change your attitude, and I couldn't be very iconoclastic any more." Was he serious? He said the same thing, more or less verbatim, on at least one other occasion. How else, after all, was he to think of himself? Even if he had stopped being a practicing artist, he had never stopped thinking about art, and his thinking had become, more and more, a decisive element in the work of other artists. As for his iconoclasm, Duchamp put that in perspective during a symposium held at the Museum of Modern Art during William Seitz's huge "Art of Assemblage" exhibition. (The exhibition included thirteen works by Duchamp.) At the end of an unusually lively discussion—enlivened mainly by the bumptious and provocative sallies of Robert Rauschenberg, who was also on the panel—Seitz asked Duchamp, "Did you, or do you, really want to destroy art?" Duchamp replied, "I don't want to destroy art for anybody else but myself, that's all."

Jacques Villon died early on the morning of June 9, 1963. He was eighty-seven and had been in poor health since he broke his leg three years earlier. Recognition as an artist came very late to Villon, who never deviated from his quiet, lyrical form of Cubist painting. He had been rescued from oblivion and near-poverty during the war by Louis Carré, one of the leading Paris dealers; Carré bought out the contents of his studio in 1942, gave him a monthly stipend against future work, and then shrewdly promoted his late (rather weak) paintings as the work of an important School of Paris master. Villon won first prize at the Carnegie International in Pittsburgh in 1950,

and a year later the Musée de l'Art Moderne in Paris gave him a major retrospective. In 1956 he was awarded the Grand Prix for painting at the Venice Biennale. The old man accepted these honors with gratitude and humility and kept right on painting. "He was the same at eighty as he had been at twenty or thirty," according to the art critic Pierre Cabanne, "rather small, with a baby face, pink-cheeked, with mischievous blue-grey eyes, and thin lips. While we were talking, his face would light up and his eyes sparkle: 'Ah, you've been to New York! Did you see Marcel?' Gaby [his wife] fussed around discreetly, as resigned to fame as she had been to poverty." Asked by an art magazine in 1956 what advice he gave to young artists, Villon replied, "I tell them I don't know any more than they do. I've spent my life searching, and I'll go on, because I don't know what painting is exactly." The French government had condemned the little suburb of Puteaux to oblivion by authorizing construction of the vast architectural complex known as La Défense, but André Malraux, the minister of cultural affairs, postponed the start of the project until after Villon's death so that the artist could continue to live in the studio that had been his home since 1905.

Duchamp and Teeny were in Italy when they got the news that his oldest brother had died. They flew back immediately to Paris and joined Marcel's three sisters, Suzanne, Yvonne, and Magdeleine, at 7, rue Lemaître in Puteaux. Duchamp and Villon had never really been close. Villon did not understand Duchamp's work or his ideas, but each one respected the other's integrity, and family ties meant a great deal to both of them. Although Cabanne has suggested that Duchamp was somewhat resentful of Villon's late success, no one else ever saw any evidence of that. When Duchamp and Teeny arrived at the house in Puteaux, he walked straight to his brother's bedside and stood there for a long time. He reached down to touch Villon's shoulder lightly, turned, and said, "He is like Father, without the beard." A family friend noticed that there were tears in his eyes.

Wanted

I am entering my sex maniac phase.
I am ready to be raped by and to
rape everyone.

The strain of pessimism that had often shaded Duchamp's outlook on the world disappeared in his last decade. Breton's comment about him—that he was the only man of his generation who was in no way inclined to grow older—seemed truer than ever. He had a second prostate operation in 1962, but few people were aware of it. "Marcel was such a good patient," Teeny wrote to Jackie afterward, "never any pity for himself, ignoring gloom . . . He has the most extraordinary way of accepting realities, simply, and not letting them change his way of being himself."

A month after getting out of the hospital, he went with Teeny to Utica, New York, for the opening of the "Armory Show—50th Anniversary Exhibition" at the Munson-Williams-Proctor Institute. Duchamp's *Nude Descending a Staircase* and more than three hundred other works from the 1913 Armory Show had been brought together for this event, which would move down in April to its original location at the 69th Regiment Armory in New York City. In addition to designing the exhibition poster and delivering an illustrated lecture in Utica on his own "Recollections of the Armory Show"—recollections from afar, that is, since he had not been there to see it—Duchamp gave a number of interviews in which he was more caustic than ever about the current state of art. "The entire art scene is on so low a level," he told Francis Steegmuller, "is so commercialized—art or anything to do with it is the lowest form of activity in this period. This century is one

of the lowest points in the history of art, even lower than the 18th Century, when there was no great art, just frivolity. Twentieth century art is a mere light pastime, as though we were living in a merry period, despite all the wars we've had as part of the decoration." All artists since the time of Courbet had been "beasts," he went on to say, and should be put in institutions for exaggerated egos. "Why should artists' egos be allowed to overflow and poison the atmosphere? Can't you just smell the stench in the air?"

Interviewed for *Vogue* by William Seitz, the Museum of Modern Art curator who had organized the "Art of Assemblage" show, Duchamp aired his theory about the short lifespan of works of art. Suppose, he said, we accept "the idea of an esthetic 'smell' or 'emanation' from a work of art . . . I think that emanation doesn't last more than twenty or thirty years . . . I mean, for example, that my *Nude* is dead, completely dead." He was having fun, of course, unloading such heresies on a museum man, but he was at least half serious. Duchamp wanted to desanctify art. Painting for him had never been an end in itself, he told Seitz, but only a tool, "a bridge to take me somewhere else. Where I don't know . . . Art doesn't interest me. Artists interest me." And words were even more suspect than art. Words "such as truth, art, veracity, or anything else are stupid in themselves," he said, then promptly turned the argument in on himself: "so I insist *every word I am telling you now is stupid and wrong.*"

He enjoyed contradicting himself. Besides keeping interviewers on their toes, self-contradiction came naturally to him, by temperament and belief. "I have forced myself to contradict myself in order to avoid conforming to my own taste," he had said once, years earlier. It was not really surprising, then, that after several decades of discouraging people from organizing one-man shows of his work, Duchamp should suddenly agree in 1962 to a full-scale retrospective exhibition at the Pasadena Art Museum in California. This former private mansion, an imitation Chinese pagoda built around an open central court, was not exactly a major museum. Since the 1930s it had served mainly as a haven for local artists and craftspeople, but a new director, Thomas Leavitt, had recently turned it into a much livelier place. Leavitt and Walter Hopps, his very young curator, managed to get part of the Museum of Modern Art's important Kurt Schwitters exhibition there in 1962, and Hopps also put on a big catch-all show of California Pop art and other advanced trends. It was Leavitt who encouraged Hopps to start thinking about a Duchamp retrospective.

As a math-oriented teenager growing up in Los Angeles, Walter Hopps had gone one Saturday, with other members of his high school class, to visit the Arensbergs' house and collection. He became so fascinated by the paintings and objects there that he returned again and again, at Arensberg's invitation, to look at them and to read about modern art in the extensive library. Once the library door opened and a man put his head in long enough to say hello—it was Duchamp, as he learned later. Hopps went on to become, while he was still in graduate school at UCLA, an imaginative impresario for avant-garde art on the West Coast and a co-founder (with the artist Edward Kienholz) of the Ferus Gallery, where a new generation of California painters, sculptors, and mixed-media assemblagists first made its mark. The commercial skills of art dealing eluded him, however, and when Leavitt offered him the curatorial job at the Pasadena Art Museum in 1961, he quit the gallery and took it. The following spring, after Leavitt had broached the idea of a Duchamp retrospective, William Copley arranged a meeting between Hopps and Duchamp at the Copleys' apartment in New York. Hopps reminded Duchamp of their first meeting thirteen years earlier and said he had been looking forward ever since to continuing the conversation they had started then. His intimate knowledge of Duchamp's work and his obvious familiarity with the ideas behind it made a strong impression on Duchamp, who not only agreed to the Pasadena show but gave Hopps a free rein in putting it together. "He seemed pleased," according to Hopps, "but neither particularly surprised nor excited."

Duchamp and Teeny flew out to Los Angeles a week before the show opened in the fall of 1963. Copley was on the same flight, and so was Richard Hamilton, who had come over from London—"the only Duchamp expert," as he commented, "who has never seen a Duchamp painting." Duchamp had specifically asked to stay at the Green Hotel in Pasadena, a slightly run-down Italianate palace that he knew from a previous visit. The hotel was within walking distance of the museum, and Duchamp strolled over every morning, quite early, to chat with the museum gardener, a gently alcoholic man who spoke French and loved the poems of Apollinaire. Hopps welcomed advice from Duchamp, whose suggestions were tactful and discreet—"He never tried to control things," as Hopps put it. At one point, prompted by his own hunch that Duchamp might be working on something new, Hopps asked him a hypothetical question: if, in fact, there happened to be a secret project, would this exhibition be the right time and place to dis-

close it? There was a rather long silence, he recalled, at the end of which Duchamp said, "If that were the case, then no, this would not be the right time." The folded invitation that Hopps had designed for the opening reception had a round peephole on the front flap, through which Duchamp (photographed in front of his two-way door in the rue Larrey apartment) looked out at the recipient; it was like a weird premonition of the twin peepholes through which viewers would eventually be required to view Duchamp's new work. Hopps recalled that when he first showed it to Duchamp and Teeny, they both seemed somewhat shocked.

Duchamp designed the poster for the Pasadena show. It was an adaptation of his 1923 *Wanted/$2,000 Reward* readymade, the joke notice that he had altered by inserting two photographs of himself at the top and changing the name at the bottom to read "RROSE SELAVY." For the Pasadena poster he added, in his own handwriting, the name of the museum and the legend "by or of Marcel Duchamp or Rrose Sélavy"—whose joint works certainly were a good deal more "wanted" now than they had been in 1923.

The entire Los Angeles art community turned out for the black-tie opening on October 7. Hopps, who was the museum's acting director by this time (Leavitt having been fired several months earlier), had given a great deal of thought to the installation. He wanted to emphasize "the metamorphic quality that Duchamp's art went through," as he later explained. "The first room was kind of informal, with photographs, posters—nothing didactic, but interesting divertissements, like a theater lobby. Lebel's book had made that possible. The second room was an early-twentieth-century salon, with some of his drawings for *Le Rire* and other papers—wonderful, charming drawings; Marcel was surprised I wanted them, but then he became very cooperative—and a few of the Fauve paintings, things from Philadelphia, with the portrait of his father as the centerpiece. The next room happened to have wood paneling and leaded glass windows, and what we did there was jump right to chess, with the portable chess sets he'd designed and drawings and paintings on the chess theme." After that came a Cubist room: two versions of *Nude Descending a Staircase* (Nos. 2 and 3), *Portrait (Dulcinea), The King and Queen Surrounded by Swift Nudes, The Passage from the Virgin to the Bride,* and *The Bride,* none of which could have been borrowed from Philadelphia without Duchamp's special urging. And then the climax, a big gallery painted white for the occasion, in the middle of which stood Ulf

Linde's copy of *The Large Glass* (on loan from the Moderna Museet in Stockholm), surrounded on all sides by the various studies for it and also by replicas of certain key readymades: the bicycle wheel, the bottle rack, the urinal, *Fresh Widow, Why Not Sneeze Rose Selavy?, The Brawl at Austerlitz.* This was the first time anyone except Duchamp (in his *Box-in-a-Suitcase*) had made a direct connection between the *Glass* and the readymades, which had always been perceived as coming from an entirely different area of his mind.

The two final rooms in the Pasadena show were devoted to Duchamp's optical works (*Rotoreliefs* and others) and to his *Box-in-a-Suitcase,* along with a few bits of ephemera such as the little chocolate and talcum-powder drawing he had done for Brookes Hubachek, called *Moonlight on the Bay at Basswood,* which Hopps saw as a comment on the "watery landscape" of *The Large Glass.* In all there were 114 works on view, each one virtually unique and yet related by many subtle ties to the others and to the whole amazing ensemble. There had never been an exhibition quite like this before, one with so little to please and flatter the eye and so much to occupy the mind. And yet, as Richard Hamilton would write in a triumphant article on the retrospective in *Art International,* "It is a shock to find that the assembled work reveals a hand of fine sensitivity, an eye of acutely personal taste, and a mind capable of taking key thoughts of our time and translating them into subtle plastic expression ... Anti-Artist my fanny." Seeing all these difficult and sometimes inexplicable works together was a life-changing experience for some young artists; it offered a new concept of what art was or could be, and it continued to reverberate in the mind for a long time afterward.

At the opening Duchamp found himself treated like a hero by a large group of California artists. Edward Kienholz, Billy Al Bengston, Larry Bell, Robert Irwin, Edward Ruscha, Ed Moses, and many others (including Andy Warhol, who was in Los Angeles for a show of his own at the Ferus Gallery) came to celebrate what they clearly considered a historic occasion. They were astonished by the work, which few of them had ever seen, and excited to discover that Duchamp had anticipated so many recent developments in art. After the opening they all went to a party given by Robert A. Rowan, the Pasadena Museum's first vice president, in the ballroom of the Green Hotel. The artists crowded around Duchamp and persuaded him to join them in signing a pink tablecloth as a readymade. The actor Dennis

Hopper, a close friend of Walter Hopps, swiped a sign for the Green Hotel from the lawn outside; the sign was in the form of a hand with one pointing finger, quite similar to the one in Duchamp's painting *Tu m'*, and of course Duchamp obliged Hopper by signing it. Duchamp was in superb form that night: cool and witty and attentive and lighthearted. The only person who had a better time than he did was Beatrice Wood, who brought an Indian friend to the party and then forgot all about him as she danced until dawn with a succession of handsome young men.

Duchamp stayed on in California for a week after the opening, giving interviews and playing chess with thrilled visitors in the *Large Glass* gallery. He told Hopps that he was entering his "sex maniac phase—I am ready to be raped by and to rape everyone." William Copley organized a weekend trip to Las Vegas with the Duchamps, Walter Hopps and his wife, Richard Hamilton, and the Los Angeles collectors Betty Asher and Donald and Betty Factor. Duchamp selected the Golden Nugget for their night of gaming—he preferred its working-class ambience to the more

Stardust Hotel, Las Vegas, 1963. From left: Teeny Duchamp, Richard Hamilton, Betty Factor, William Copley, Donald Factor, Walter Hopps, Betty Asher, Marcel Duchamp.

strenuous glitz of Caesar's Palace. While the others tried their luck at various tables, Duchamp and Hopps sat down in the roulette section. Duchamp kept a watch on three tables, and from time to time he suggested that Hopps place a bet at one of them. Hopps found that winning numbers were coming up more and more frequently. "One way or another there was no doubt in my mind about it being HIS game," Hopps recalled later. "I did nothing but what he suggested and we stopped when he said it was a nice time to stop." By then the current adaptation of Duchamp's old Monte Carlo gambit had increased Hopps's original stake from $20 to more than $2,000. It would have been a lot more if Hopps had not limited himself to two dollar chips.

The morning after their return to Pasadena, Duchamp showed up very early at the museum for a photo sitting that had been arranged several days before by the Los Angeles photographer Julian Wasser. It was Wasser's notion to show Duchamp sitting in front of *The Large Glass,* playing chess with a nude woman. Eve Babitz, the twenty-year-old student and art groupie who had agreed to strip bare for the occasion, was already there when Duchamp arrived, and she was understandably nervous. For one thing, as she later revealed, she had just started taking birth-control pills, and her breasts had swelled alarmingly—"like two pink footballs," she said. Her first impression of Duchamp that morning, though, was "a feeling of gentleness." He was "like a very old Walter Hopps—a Walter Hopps with a history instead of a future." They sat down at the chess table, Eve dropped her wrapper, and Wasser started taking pictures. Duchamp won the first game in three moves. He won all the others too, although Eve got a little better as her nervousness receded. At one point Walter Hopps walked into the room and stopped short. Although he had been unaware of the photo shoot, he realized immediately that everyone would assume he had set it up, since he was having an affair with Eve Babitz at the time. None of them could have known that Wasser's photograph would become part of the proliferating documentation on Duchamp, giving rise to no end of symbolic interpretations. (Aging bachelor checkmates young bride, etc.) Reprinted again and again, it served as an erotic and very Californian footnote to Walter Hopps's historic show.

Arturo Schwarz, the Milan art dealer, had developed a reverence for Duchamp that bordered on obsession. "There was no person in the world I admired more," he once said. "Marcel taught me tolerance for other points

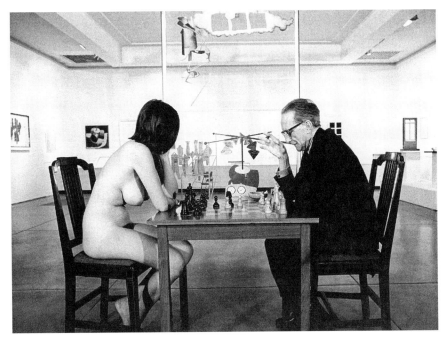

Eve Babitz strips bare. Pasadena Museum, 1963.

of view, the refusal of any kind of dogmatism, the importance of a fresh approach to everything in life. My parents were divorced when I was four, so I never had a real father. Marcel became my elective father."

Born in Alexandria, Egypt, in 1924, the son of a German father and an Italian mother, Schwarz had once wanted to be a psychiatrist. He was expelled from the medical school at Farouk University for political activities, though, and after that he went to Paris, took a degree in philosophy from the Sorbonne, was converted to Surrealism by André Breton, and moved on to Milan, where he established a small bookstore that specialized in Dada and Surrealist publications. The bookstore eventually became an art gallery, the Galleria Schwarz. One day Schwarz had a vivid dream about Duchamp, whom he had never met. In the dream Duchamp found some drawings he had lost—they were behind a desk drawer, pushed up against the back of the desk. Schwarz promptly sat down and wrote Duchamp a letter in which he described his dream, and sometime later Duchamp wrote back to say that he had indeed found an envelope of his drawings behind a desk drawer. (Teeny Duchamp later scoffed at this; her recollection was that Schwarz simply

came to see them one day in New York.) At any rate, a correspondence
ensued, meetings took place, and in 1957 Schwarz started to gather material
for what would become, twelve years later, a definitive monograph and cat-
alogue raisonné of Duchamp's work.

It was Duchamp, according to Schwarz, who first proposed the idea of
replicating the most important readymades in limited "editions." Several of
them had been remade before, of course. Duchamp had authorized Sidney
Janis to make copies of *Bicycle Wheel* and *Fountain* for his Dada show in
1953; Ulf Linde had reproduced *Fresh Widow* and *Bicycle Wheel* for the "Art
in Motion" show in Stockholm, and then had gone on (with Duchamp's per-
mission) to reproduce several other readymades as well; Walter Hopps had
included facsimiles of *9 Malic Moulds* and *3 Standard Stoppages* in the
Pasadena retrospective. These replicas had been made solely for exhibition
purposes, however, not for sale, and the prospect of commercial editions pro-
duced by a Milanese art dealer came as a shock to some of Duchamp's friends
and admirers. Even Max Ernst, whose iconoclasm rivaled Duchamp's,
admitted to thinking that "the value of the gesture which established the
great beauty of the readymade seemed compromised." So far as Duchamp
was concerned, however, reproduction was perfectly in keeping with his
original idea. The readymades were not *art*. They were common manufac-
tured objects, and since the originals had almost all disappeared, a copy could
serve just as well to carry the message.

Duchamp admitted that he had never been able to arrive at a satisfac-
tory definition of the readymades. In a number of interviews and state-
ments during the 1960s, though, he went out of his way to emphasize their
nonart credentials. "The idea was to find an object that had no attraction
whatsoever from the esthetic angle," he said in 1963. And similarly, a few
years later, "As for recognizing a motivating idea: no. Indifference . . . The
common factor was indifference."

The art historian William Camfield, in his book-length essay on *Foun-
tain*, has pointed out that some of the early readymades don't seem all that
indifferent. For example, Duchamp often mentioned the pleasure he got
from watching the *Bicycle Wheel* turn in his studio. (Although not techni-
cally a true readymade, since it predated the concept, *Bicycle Wheel* settled
very early into the readymade canon.) As for *Fountain*, the notorious urinal,
it had been described by Walter Arensberg and others in 1917 as "a lovely

form" whose "chaste simplicity" resembled the image of a seated Buddha, and Alfred Stieglitz had photographed it in a way that accentuated those esthetic qualities. In a panel discussion at the Museum of Modern Art in 1964, Alfred Barr challenged Duchamp's assertion that he had selected each readymade on the basis of visual indifference. "But, oh, Marcel," Barr said, "why do they look so beautiful today?" The reply was vintage Duchamp: "Nobody's perfect," he said.

Finding an object that had no esthetic qualities was far from simple, as Duchamp made clear. "Manufactured objects had the advantage of being repeated," he said, "and this added to the impersonality. But the danger was that you would choose too many readymades and direct it toward a taste. You could be taken in by the readymade idea to become an artist again, a tasty artist, choosing more and more. This gave me the idea of defining art as a habit-forming drug. Art is a habit-forming drug, that's all it is, for the artist as well as the collector. So in the readymades I avoided that by not choosing them too often."

If the readymades were his way of avoiding the habit-forming drug of art, though, what was the point of making commercial "editions" of them? The point, as several of Duchamp's friends concluded, was quite simple: his increasing fame had brought him no financial benefits, and his marriage had given him the incentive to earn a little money. "I'm getting something out of it," he told me. "We can travel first class now, except, of course, on airplanes." The point may also have been that Duchamp liked to contradict himself and to turn the tables on his most reverent admirers—in this case by refusing to take the readymade idea as seriously as they did. He was very pleased, though, that Schwarz wanted the replicas to be absolutely accurate in every detail. *Fountain* was remade by a Milanese ceramicist who worked from the original Stieglitz photograph in *The Blind Man*. Duchamp approved the working drawings for it and for the other replicas, each of which became—irony of ironies—a piece of sculpture imitating a manufactured object. They were introduced to the public in 1964 (the fifty-first anniversary of the original *Bicycle Wheel*) in a show at the Galleria Schwarz in Milan—thirteen objects in all, each reproduced in an edition of eight (plus four more examples *hors concours:* one for Schwarz, one for Duchamp, and two others to be used exclusively for exhibition purposes), and priced at $25,000 for a complete set. Schwarz promised Duchamp fifty percent of the

profits, which did not show up for some time—the production costs had
been higher than expected, and the demand was not overwhelming. Not at
first, anyway. In 1987 a Schwarz *Bicycle Wheel* was sold privately for
$350,000.

Although he claimed to be lazy, Duchamp sometimes seemed indefati-
gable. In his last decade he produced a steady stream of occasional works
for every sort of occasion—posters, sketches, multiples, illustrations for
poems by friends, a pair of "aprons" (actually pot holders, slyly altered by
the manufacturer to suggest male and female attributes) for the deluxe edi-
tion of André Breton's book *Boîte alerte*—dozens of objects, each one of
which is listed in Arturo Schwarz's encyclopedic catalogue raisonné. Dur-
ing the summer of 1965 in Cadaqués, Duchamp did nine etchings of
selected details from *The Large Glass,* which Schwarz would publish and
sell. (Schwarz printed the etchings in a lavish volume called *The Large
Glass and Related Objects, Volume I.*) Two years later Duchamp completed
nine more etchings for Schwarz on the theme of "The Lovers"—figurative
images taken from famous erotic works by Rodin, Courbet, Ingres, and
other sources, including the photograph of Duchamp and Bronia Perlmut-
ter performing nude as Lucas Cranach's Adam and Eve in Picabia's
Ciné Sketch.

Duchamp gave many interviews in the 1960s and served on a number
of art panels and juries. He also devoted a lot of time to raising money for
the American Chess Foundation, to help Americans compete in interna-
tional matches. (There was no real money in championship chess then; this
was one of the things Duchamp loved about the game.) A benefit auction of
183 works of art at the Parke-Bernet Galleries in 1961, organized by
Duchamp and Teeny, brought in a total of $37,000, including the "fabulous"
sum of $1,100 for a Duchamp *Boîte-en-valise.* Duchamp and Teeny fol-
lowed with great interest the development of Bobby Fischer, whom they
had first met when he was a twelve-year-old phenomenon playing at the
Manhattan Chess Club. Fischer used to take the subway from Brooklyn
every day after school and go home the same way several hours later. In
1967 the president of the Manhattan Chess Club asked the Duchamps to go
along as "chaperones" when Fischer, who was twenty-four by then, played
in and won a major tournament in Monte Carlo. They had to wake him up
every morning, which was not easy, but aside from that they found him well
behaved, respectful, and quite likable.

In spite of the increasing demands on his time, Duchamp could still manage to keep the world at bay. When asked to do something, he would usually say yes, because for him that was the easy way out—easier to say yes and design the book jacket or write the two-line letter of recommendation than to say no and explain why. He agreed to let Andy Warhol film him in 1966. The result was a twenty-minute film called *Screen Test for Marcel Duchamp,* in which he simply sat in a chair and smoked a cigar. During the filming, according to Duchamp, "a cuddly little actress came and sat by me, practically lying on top of me, rubbing herself up against me," but no one would know it from seeing the film—his expression throughout is imperturbable. Duchamp did not go to gallery openings, and he saw only the exhibitions that Teeny, who kept up with new art, told him he should see. They did attend a number of "Happenings," the performance pieces by visual artists that enlivened the downtown art scene in the early 1960s. "Very seldom do I like any piece of theater," Duchamp said at the time, "but a Happening is not theater, it's not stagy, and it's not painting, either, although it's certainly visual. It is also a form of ennui, or boredom, and the more bored you are the more Happening it is. Bored is not the right word, but in a Happening things just happen, as they would happen anywhere else. It is a nice form of indifference."

When David and Denise Hare came over to the Duchamps' apartment on West 10th Street, as they did nearly every Sunday for lunch—David Hare, the sculptor, had edited the magazine *VVV* in the 1940s and been close to the European Surrealist group, and Denise was a close friend of Teeny's—the conversation was never about art. It was mostly about family matters. "Marcel really pushed us into getting married," David Hare said. "Denise and I both had children from previous marriages, and Marcel argued that our not being married was unfair to the son we'd had together, mainly for practical reasons—what would happen if I died, and so forth. Marcel was interested in your well-being, which always seemed a little surprising." Duchamp paid attention to other people's children. Noticing that Denise Hare's nine-year-old son had a talent for chess, he tutored him and arranged for him to play regularly at the London Terrace Chess Club. He also arranged to have a tape recording made of Denise's daughter practicing scales on the piano and then used the tape, with its mistakes and hesitations, as the background "score" for the Surrealist show he organized at the D'Arcy Gallery. Denise Hare remembered that when Marcel and Teeny

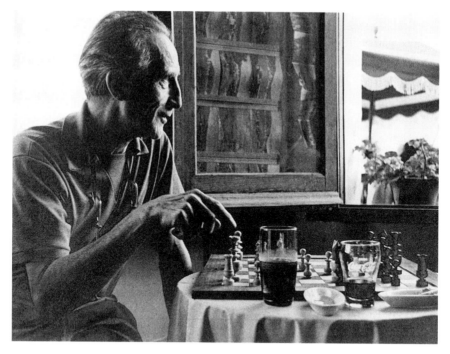

At the Café Meliton in Cadaqués.

came to their apartment, "there was a lot of looking up words in the dictio-
nary. I had an old, classic Larousse, and at some point Marcel would nearly
always get it out. He loved the format, the little illustrations on every page."

In the summers they escaped to Cadaqués. It was a haven for both of
them, a place where you could be a *respirateur* without even having to explain
it. Teeny, who loved to swim, would go off in a friend's boat each morning to
one of the little coves on the rocky coast, and Marcel would play chess at the
Café Meliton. In Cadaqués he was looked upon not as a famous artist but as
a friendly gentleman who liked chess. One day while Duchamp was in the
middle of a game, an American art dealer walked into the café with a friend
and called out, rather ostentatiously, "Bonjour, Marcel." Duchamp looked
up, nodded coolly, and said, "Bonjour et au revoir." Chess was a serious occu-
pation, and there were a number of good players in Cadaqués. He avoided
the sun and the water—like many Frenchmen of his generation, he had
never learned to swim—but he loved to sit outdoors on the balcony of his
apartment, with its sweeping view of the bay. The terrace could be very
windy. At the beginning of each summer, he would build a windbreak out of

straw mats and string, with a big rock to anchor it; the flimsy apparatus always disintegrated over the winter, and he would patiently rebuild it the next year. Duchamp was a great *bricoleur;* he enjoyed making and fixing things. To stop the water dripping from his shower in Cadaqués, he melted lead and made a round disc with protrusions that fitted into the holes in the shower head—it was later declared a "medallic sculpture," entitled *Bouche-Evier (Sink Stopper)*, and reproduced in an edition of 300 casts (100 bronze, 100 stainless steel, 100 sterling silver).

Cadaqués went through an American phase in the mid-1960s. Peter Harndon, a young architect with a beautiful German wife and several blond-haired children, built a house there for the New York art dealer George Staempfli and his rich wife and another for Mary Callery, a wealthy American sculptor who was said to have slept with Picasso, Mies van der Rohe, and several other sacred monsters. Mary Callery did not approve of Duchamp. She complained that he had been too ready to live off women (not including herself, which may have been the trouble). Once in a great while the Dalís would invite everyone to a party at their fantastic Surrealist environment in Port Lligat. Those who were accustomed to Dalí's theatrical ego were always amazed to see him and Duchamp in relaxed conversation, like old friends who felt no need to impress each other.

Emilio Puignau, the local contractor, a much-respected man who also served as the mayor of Cadaqués, sent his best mason over to build a fireplace in the Duchamps' apartment. Duchamp had him do other small jobs from time to time—a permanent windbreak for their terrace, an electric heater for cold days. It was Puignau, moreover, who removed and packed for shipment to New York a crude wooden door that Duchamp had seen on a house in a small town several kilometers from Cadaqués and had arranged to buy from the owner. This ancient, battered door, of a sort often seen on poor farm buildings in that region, would become the barrier between viewers and the erotic landscape of Duchamp's last work, the secret project in his 14th Street studio. Looking through two eye-level holes at the brilliantly lit scene behind the door—the splayed "woman with open pussy," supine in a trompe l'oeil landscape—Emilio Puignau would certainly have been startled and quite possibly scandalized. Not for another year, however, would anyone except Teeny know that such a work existed. The secret was still intact.

Marcel and Teeny at a country restaurant near Cadaqués, with waterfall.

Duchamp lost his 14th Street studio at the end of 1965. The building was sold, and after twenty-four years he had to move out of his two rooms on the top floor. He carefully disassembled the intricate *tableau vivant* that he had worked on for so many years and transported its more fragile elements himself, making countless trips down the four flights of stairs and then proceeding by taxi to 80 East 11th Street, where he had rented a small room. His new studio was on the fourth floor of an elevator building of small offices—the room next to Duchamp's housed Local 662 of the A.F.L.-C.I.O. Salesmen & Poultry Workers Union. Duchamp spent the first two months of 1966 reassembling the work in this anonymous space, whose single window overlooked an airshaft. The wooden door that had been shipped over from Spain was set up just inside the entrance, and the scene behind it completely filled the rest of the room.

A few last details remained to be worked out. Duchamp and Teeny also had to make a decision about the future of this unclassifiable work of art. They elected to show it first to William Copley. Copley owned a number of Duchamp paintings and objects, several of which he had bought from the estate of Henri-Pierre Roché. He was, in addition, a good friend, an artist (whose humorously erotic paintings were signed "CPLY"), and a wealthy man. In the spring of 1966, Copley got a telephone call from Duchamp. "He said he had something to show me," Copley recalled. "We went to that one-room studio on 11th Street, and I saw the new piece. Marcel seemed very proud—he said he'd been working on it for twenty years. I was overwhelmed, of course."

It was understood that Duchamp wanted the work to go, after his death, to the Philadelphia Museum of Art. Copley was in complete agreement, and he immediately began negotiations with the museum through his privately owned Cassandra Foundation. Teeny thought the museum's trustees might balk at accepting such a sexually explicit work of art, but this proved not to be a problem. Evan Turner, the director, was enthusiastic from the start, and if any trustees felt qualms, they kept quiet about them. The Cassandra Foundation purchased Duchamp's last major work in 1966 for a sum that, while never disclosed, was in the neighborhood of $60,000, and donated it soon after Duchamp's death in 1968 to the Philadelphia Museum of Art. "The whole thing went very smoothly, over a couple of lunches," according to Copley. "It was settled in a very short time."

Duchamp kept working on the piece for the rest of the year, refining certain elements and also writing out, in longhand, a set of detailed instructions, illustrated by Denise Hare's photographs, which showed precisely how the whole sculpture-construction should be put together again after it was taken apart and shipped to the museum. These notes, which were purely factual—none of the playful poetry of the *Green Box* jottings—were collected in a loose-leaf binder, which also included a three-dimensional, folding cardboard model of the installation. Duchamp's directions were clear and specific but also somewhat informal—he left room for a degree of "ad libitum" in the reassembling. It was a characteristic mingling of seemingly opposed tendencies: precision and indifference. Let's be serious, in other words, but not too serious.

Toward the end of the year, he signed the work and dated it. The dates were 1946–1966. The title, written on the nude woman's right shoulder,

where it is out of sight to the viewer, is taken from one of the earliest notes
for *The Large Glass:*

> *Etant donnés: 1. la chute d'eau*
> *2. le gaz d'éclairage . . .*

> Given: 1. the waterfall
> 2. the lighting gas . . .

It invokes once again the two elements, water and gas, which power the
erotic encounters in that earlier work, even though everything is different
here and the bride has been stripped bare at last.

Not Seen and/or
Less Seen

> There won't be any difference
> between when I'm dead and now,
> because I won't know it.

The Pasadena retrospective had opened an alternative vista on modern art, one in which Duchamp's influence rivaled or even surpassed that of Picasso and Matisse. This amazing discovery was soon picked up by the sensitive antennae of the international art establishment, and a swarm of newly hatched Du-champions now rushed in to acquire, exhibit, or write about his work.

In New York the Cordier & Ekstrom Gallery put on a show called "NOT SEEN and/or LESS SEEN by/of MARCEL DUCHAMP/RROSE SÉLAVY 1904–1964," which later traveled to five American museums. It included a large number of Duchamp's early (pre-Cubist) drawings and paintings, most of which had been purchased very recently from two sources—the estates of Henri-Pierre Roché and Gustave Candel—by Mrs. William Sisler, whose late husband had been one of the principal heirs to the Firestone Tire & Rubber Company fortune. Mary Sisler had never before shown the slightest interest in modern art. Her son by a previous marriage, David Hayes, an art history student at Yale, persuaded her that Duchamp was a transcendent genius, however, and Arne Ekstrom, of Cordier & Ekstrom, arranged for her to buy so many of his pre-1910 sketches, humorous drawings, and oils that Duchamp proposed, to Ekstrom's dismay, that the show be called "Teenage Work." The Sisler

collection also included a *Box-in-a-Suitcase,* a full complement of Schwarz readymade replicas, the *Rotary Demisphere* that had once belonged to Jacques Doucet, the *Network of Stoppages,* and many other items. It was Ekstrom's and Duchamp's understanding that Mrs. Sisler planned eventually to donate all of it to a museum—a mistaken understanding, as they soon found out. Although in the end she gave a selection of works to several museums (taking a substantial tax write-off in the process), she neglected to pay Ekstrom for some of the items that he had bought for her, and she sold a number of the others at a substantial profit. "She had no real interest in or feeling for the work," according to Ekstrom. Mrs. Sisler greatly enjoyed the attention that was paid to her at Cordier & Ekstrom's black-tie opening in January 1965, which was attended by Salvador Dalí, Andy Warhol, and virtually every other famous name in the New York art world. Duchamp had designed the invitation to this event. On it, a playing-card-size reproduction of the *Mona Lisa,* sporting neither beard nor moustache, was mounted on a white card that bore Duchamp's signature at the lower right and above it, also in his handwriting, "*L.H.O.O.Q.*" and "*rasée*" (shaved).

A year and a half later, in the summer of 1966, "The Almost Complete Works of Marcel Duchamp" opened at the Tate Gallery in London. Organized by Richard Hamilton, this full-dress retrospective included 185 works, one of which was a new replica of *The Large Glass,* on which Hamilton had been working for the last year. Hamilton felt that Ulf Linde's *Glass,* the one shown in Pasadena, was seriously flawed and inaccurate in many of its details. He wanted to re-create the original, not just copy the look of it, and so he went back and worked directly from Duchamp's preliminary drawings, perspective studies, and notes; he obtained color analyses from the conservators at the Philadelphia Museum of Art, and he consulted with Duchamp at every stage. Although Hamilton himself said that he could not always match the exquisite workmanship that Duchamp had lavished on the original, both he and Duchamp agreed that his version was as close as anyone could come to the way it had looked before the glass was broken, and they both signed it, as a joint work.

When he was getting together the material for the Tate show, Hamilton wrote a letter to Maria Martins in Brazil, asking if she would be willing to lend the 1911 *Coffee Mill.* The answer was yes and, by the way, would Hamilton be interested in showing "something else" of Marcel's? Hamilton instantly wrote back to say that he would. The something else, casually

wrapped in newspapers, did not arrive until he was hanging the show. It was a painted leather-over-plaster study for *Etant donnés,* showing a nude female torso with legs spread apart, and inscribed on the back (in French) "This lady belongs to Maria Martins/with all my love/Marcel Duchamp 1948–1949." At this point nobody knew about Duchamp's last work. Since Maria Martins did not provide a word of explanation about the mysterious item, Hamilton decided to hang it in the same room with *Dart Object, Female Fig Leaf,* and *Wedge of Chastity,* assuming that it must have some sort of relationship to those late erotic objects. Duchamp saw it there when he came to view the installation shortly before the opening. "Where did you get that?" he demanded. "He was clearly angry," according to Hamilton. "I somehow got the feeling that I had betrayed him. But he offered no information about it, and he said nothing about removing it from the show."

In the flurry of reviews and articles about the Tate exhibition, there were a few stridently sour notes. One British critic found the work itself "shockingly disappointing," and several others concluded that the gullible Americans, as usual, had been taken in by an inveterate jokester. The *New York Times* reviewer, Hilton Kramer, while conceding the accuracy of Richard Hamilton's statement in the catalog that "no living artist commands a higher regard among the younger generation than Marcel Duchamp," went all out in denouncing both the work and the Duchamp legend; the artist was nothing more than "a pasticheur of refined taste but little force or originality," he wrote, and the show was a "surpassingly unfunny" exercise in "resplendent triviality." A backlash of anti-Duchamp sentiment was to be expected, of course, considering the occupational venality of art critics and the fact that modern art was becoming a more and more expensive commodity, with vested interests and bankable reputations to uphold. Kramer was a critic who could be counted on to denounce Jasper Johns, Robert Rauschenberg, Frank Stella, or any other artist whose work did not fit into his prim conception of what art had always been and should continue to be, but other, less doctrinaire voices were also being raised in opposition. Thomas B. Hess, the editor of *Art News* and for more than a decade the most articulate champion of the first-generation Abstract Expressionists, had stated the case against Duchamp the year before, at the time of the Pasadena show, in an article called "J'Accuse Marcel Duchamp." Conceding that "to attack Duchamp is, *a priori,* to join the know-nothings," Hess cleverly provided both sides of the argument—calling Duchamp "a second-rate

painter," for example, he went on to say that he had done "two or three of the masterpieces of modern art." (*The Large Glass, Network of Stoppages,* and *Tu m'* were the masterpieces, in Hess's view). The real core of Hess's argument was that Duchamp, by confusing art with life, had tried to turn himself into a work of art, and by doing so he had become "a corruptor of youth."

Hess undoubtedly spoke for the Abstract Expressionists, some of whom were put off, to say the least, by Duchamp's reiterated comments about "retinal" art, the spectator's role in the creative act, and the absurdity of artists' egos. Art was a habit-forming drug, Duchamp had said. "I'm afraid I'm an agnostic in art," he told this writer when I was interviewing him for a 1965 profile in the *New Yorker.* "I just don't believe in it with all the mystical trimmings. As a drug it's probably very useful for a number of people, very sedative, but as religion it's not even as good as God." To painters for whom art *was* a kind of substitute religion—Mark Rothko wanted viewers of his mystical floating fields of color to have the same spiritual experience in looking at them that he had had in painting them, and both Rothko and Barnett Newman produced ambitious cycles of paintings on biblical themes—Duchamp's irreverence must have been deeply irritating, although, like Hess, most of them hesitated to attack him openly. Clyfford Still did write, in a letter to the magazine *Artforum,* that "few men could better exemplify the antithesis of my work than Marcel Duchamp." De Kooning, however, told Hess that he didn't know where he was going, but he knew it "was on the same train as Marcel Duchamp." Hess himself, covering all bases, ended by absolving Duchamp of the sin of corrupting young artists. "Duchamp is not responsible for the errors of his followers because they should have known that only Duchamp can be his own work of art," Hess wrote toward the end of his article. "When Duchamp did it first, he did it last."

Why Duchamp's followers should have been expected to know that is somewhat unclear. Dazzled by his example, it was all too easy to fall into the seductive fallacy that anything goes. Anything does go in art, as Duchamp had demonstrated with the readymades, but only when art is approached in the way he approached it: not as self-expression or therapy or social protest or any other of the uses to which it is regularly subjected, but as the free activity of a rigorous and adventuring mind. The failure to grasp that essential point about Duchamp's work and Duchamp's life has given rise to a prodigious amount of tiresome and self-indulgent art in our time, and in that sense it is certainly possible to argue that Duchamp has

been a destructive influence. The surprising fact is that the attacks on him have been so muted, isolated, and ineffectual. Three young artists showed a collaborative work at the Galerie Creuze in Paris in 1965, entitled *Vivre et laisser mourir, ou la fin tragique de Marcel Duchamp (Live and Let Die, or the Tragic End of Marcel Duchamp)*. It consisted of eight crudely realistic paintings depicting the artists themselves—Gilles Aillaud, Antonin Recalcati, and Eduardo Arroyo—in the act of murdering Duchamp and throwing his corpse down a flight of stairs, where it is draped with an American flag and carted off by a group of his American and French admirers: Rauschenberg, Warhol, Claes Oldenburg, Martial Raysse, Arman, and Pierre Restany. The paintings infuriated Breton, Arturo Schwarz, and other Duchamp loyalists, fifty of whom signed a statement condemning it as "a loathsome crime disguised as a ritual assassination." Duchamp greatly annoyed Breton by refusing to sign the statement. Having been to see the show the day before it opened, at the invitation of the nervous gallery owner, he had said afterward that "the only thing to do is ignore it: these people want to get noticed, that's all."

A few days after the opening of the Tate exhibition in 1966, the Duchamps were in Paris for the unveiling of Raymond Duchamp-Villon's *Le Cheval-Majeur* at the Galerie Louis Carré. Duchamp had authorized Carré to make a larger version of his brother's most important sculpture, the *Grand Cheval,* and he and Teeny were on hand for the press conference on June 22 and for the show's formal opening the next night. Among the invited guests that evening was Jeanne Mayer, the former Jeanne Serre, whom Duchamp had not seen for nearly half a century. Carré had said that she might be there—that she came to any event involving members of the Duchamp family. Teeny knew about Marcel's youthful love affair with Jeanne Serre; he had also told her about meeting Jeanne by chance in the Paris Métro in 1918 and catching a glimpse of the shy little girl with her who was probably his daughter. What happened next was almost entirely Teeny's doing. When they were introduced to one another at the Duchamp-Villon opening, Teeny took an immediate liking to Jeanne, whom she later described as "a lovely person, so dignified." Marcel asked Jeanne about her daughter and learned that she was an artist, that she was married to an engineer named Jacques Savy, and that they lived in Paris. A few days later, carrying a Duchamp *Box* as a gift, Marcel and Teeny went to pay a call on Jacques and Yvonne Savy.

A phenomenal and exquisite discretion was established at this first meeting. They all knew what had brought them together, but the fact that Yvonne was Duchamp's daughter (if it was a fact) did not come up, then or later. At her birth in 1911, Yvonne had been baptized under the name Serre, after her mother's first husband. In 1921, M. Serre having died, her mother married a French businessman named Henry Mayer, who was deported during the Second World War and who barely survived the death camps. Yvonne's mother had always wanted Yvonne to became an artist. When she did become one, she decided to call herself Yo Sermayer, combining the last names of her two stepfathers. It was not until after Henry Mayer's death that Jeanne decided to renew her acquaintance with the Duchamp family—she had seen Villon shortly before he died. She also must have told Yvonne about her relationship to Marcel, but when Marcel and Teeny came to the Savys' apartment that day in 1966, no one said anything about it. They simply became friends. Jacques Savy, an engineer, was a first-rate chess player, and he and Duchamp enjoyed many games together during the next two years. Marcel and Teeny went to stay with the Savys at their country house outside Paris, and the Savys visited the Duchamps at their apartment in Neuilly, not far from where Duchamp had first met Yvonne's mother—the apartment, which used to belong to Jean and Suzanne Crotti, had been left to them when Suzanne died, a few months after Jacques Villon in 1963.

"You see, it has been a vivid thing in my life, a kind of flame, but also something that for me was a little like a legend, no more," Mme Savy said to me when I went to see her many years later. She was still living in the top-floor flat where Marcel and Teeny had gone to call on her that first time—you took the elevator to the fourth floor, then walked up a flight of stairs to reach it. Jacques Savy had died the year before, and she seemed unredeemably sad, a thin, erect woman dressed in black, with pale but slightly reddish hair and Duchamp's straight mouth and long, tapering fingers. She spoke in a deep voice roughened by many years of chain-smoked Gitanes. When something amused her, she would duck her head and laugh soundlessly. She showed me some of the paintings in her large studio—mostly paintings by other artists, only a few by her. Her pictures were portraits of chairs. One of them was of a ghostly wooden chair in pale green and white, part of it cut off by the picture's edge. Another showed an angular modern chair seen from above against a dark background, with a fiery orange-red streak slashing across it diagonally. Duchamp had

Robert Lebel at the
Duchamps' flat
in Neuilly. The
painting on the wall
is by Yo Sermayer.

arranged for her to have a show of her paintings in 1967 at the Bodley
Gallery in New York. Yvonne came to New York for the opening, which
Duchamp had asked a number of his art world friends to attend. He
stunned William Copley a few days afterward by telling him that Yo was
his daughter.

This was one of the few times he acknowledged the relationship. Yo
never pressed him to do so, and since Duchamp's death her reticence on the
subject has been virtually impenetrable. "He came often to my show in
New York," she told me, "and he did everything so gracefully, then and
later, but in the end there was still an immense barrier between us, impossi-
ble to cross. One had one's position in life, it was too late . . . He was a very
mysterious person."

Family ties claimed Duchamp's attention again the next year, when the Musée des Beaux-Arts in Rouen put on an exhibition called "Les Duchamps," which included works by Jacques Villon, Raymond Duchamp-Villon, Marcel Duchamp, and Suzanne Crotti. Duchamp, the only living member of this family quartet, arrived three days before the April 15 opening and helped to install the show. He thoroughly beguiled the museum's chief curator, Olga Popovitch, who had known and greatly admired Jacques Villon but had never met his younger brother. Duchamp greeted a bevy of local and national officials at the formal opening and sat with smiling equanimity through their interminable speeches. Two weeks later he came back to Rouen to unveil a plaque on the house at 71, rue Jeanne d'Arc, where his parents had lived for the last twenty years of their lives. Flanked by Teeny, her daughter, Jacqueline, and his two younger sisters, Yvonne Duvernoy and Magdeleine Duchamp, he pulled the string that uncovered a bronze tablet whose wording has often been cited since then for its inaccuracy, although it was Duchamp himself who had composed the words:

Ici a vécu, entre 1905 et 1925 une famille d'artistes normandes: Jacques Villon (1875–1963), Raymond Duchamp-Villon (1876–1918), Marcel Duchamp (1887–), et Suzanne Duchamp (1889–1963)

None of them had really lived there, but Duchamp evidently believed that the truth of plaques was not necessarily factual.

The Musée de l'Art Moderne in Paris showed a truncated version of the Rouen exhibition in June—it included only works by Duchamp and Duchamp-Villon. In spite of the proselytizing zeal of Breton, Lebel, and younger art critics such as Pierre Cabanne, whose extended series of interviews with Duchamp would be published in 1967, Duchamp's work was still largely unknown in France. The Musée National d'Art Moderne owned only one of his works, the 1911 oil study for *The Chess Players,* and it showed little interest in acquiring others. Olga Popovitch had gone to see the widow of Duchamp's school friend Ferdinand Tribout, whom she found living alone and in poverty in Rouen. Mme Tribout was quite willing to sell the drawings and paintings that Duchamp had given to her husband—she had

no idea how much they were worth—but when Mme Popovitch passed this information on to the museum in Paris there was no response.

Not until 1977 would France's national museum of modern art, under its new director, Pontus Hulten, put on a major Marcel Duchamp exhibition— it was the opening show at the spectacular new Centre National d'Art et de Culture Georges Pompidou, known popularly as the Beaubourg. Hulten had been saying for years that Duchamp was one of the most important artists of the century; it was Hulten, as director of the Moderna Museet in Stockholm, who got Ulf Linde interested in replicating *The Large Glass* and some of the readymades. When he came to the Beaubourg, Hulten made a serious effort to acquire more examples of Duchamp's work, but by then it was almost too late. Most of the originals were in American museums, and the French, like everyone else, had to make do with copies—the *Box-in-a-Suitcase,* the replicas by Schwarz and others, the ephemera of his later years. This was fine with Duchamp, who never regretted his decision to become an American citizen and live in New York. He was not a bit surprised that New York should have taken over Paris's former role as the vital center of contemporary art. "There is more freedom here," he told me, "so it's a better terrain for new developments. Also, people leave you alone. In my case, anyway, I've found in America a little better acceptance of my right to breathe."

He went to André Breton's funeral in the fall of 1966. Duchamp and Breton had had a falling-out the year before, after all their years of miraculously uncompromised friendship. Hearing that Duchamp was in Paris, Breton sent word that he would be at his café at a certain hour; Duchamp failed to show up, Breton took offense, and they stopped speaking to each other. In a conversation with André Parinaud that was excerpted in *Arts et loisirs* soon after Breton's funeral, however, Duchamp made up for the lapse. "I have not known a man who had a greater capacity for love . . ." he said. "Breton loved as a heart beats. He was the lover of love in a world that believes in prostitution. That is his legacy." And what, Parinaud asked him, was the legacy of Surrealism? "For me," said Duchamp, "it embodied the most beautiful dream of a moment in the world."

Now and then he seemed to be cheerfully aware that his own time was running out. "I have had an absolutely marvelous life . . ." he told an interviewer in 1966. "I had luck, fantastic luck. I never had a day without eating, and I have never been rich, either. So, everything turned out well." A year later

he concluded another interview by saying that he was "quite simply waiting for death." And yet he showed no signs of flagging energy. He worked for months on his second series of etchings for Schwarz ("The Lovers"), and he devoted a lot of energy to overseeing the translation into English of a group of his unpublished early notes, which Arne Ekstrom brought out in 1967 in a deluxe edition called *A l'infinitif* (*In the Infinitive*). Many of these notes dealt with mathematical speculations on the concept of the fourth dimension, and the artist Cleve Gray, who was doing the translations, reports that at one point Duchamp seemed dubious about publishing them at all. (None of them had appeared in *The Green Box,* where all the notes had some connection to *The Large Glass.*) "Do you think this is all right, all of this?" he asked Gray. "I mean, does it make sense? . . . I don't want to appear foolish." When Gray murmured something encouraging, Duchamp said, "Well, what I mean is that this was written long ago, and mathematics today has become such a special and complicated field, perhaps I ought not to get involved in it now."

The notes in *A l'infinitif* show that Duchamp, who sometimes said he knew nothing about mathematics, had in fact made a serious effort to understand the writings of Henri Poincaré, Pascal Jouffret, and G. F. B. Riemann. Just why he did this, and why he suddenly gave it up in favor of the "playful physics" with which he undermined and made fun of scientific laws, is an unsolved question. Duchamp told Pierre Cabanne that his interest in science had always been "in order to discredit it, mildly, lightly, unimportantly," but this does not appear to have been the guiding spirit behind the *A l'infinitif* notes, whose technical complexity makes them almost unreadable to anyone who is not a trained mathematician. Even more intriguing, perhaps, is the fact that recent developments in theoretical physics would appear to have followed Duchamp's lead. In the new universe of subatomic particles, for example, scientists have identified twelve different varieties of the quark (a term taken from James Joyce's *Finnegans Wake:* "Three quarks for Muster Mark!"), which are distinguished by six flavors, three colors, three anti-colors, and varying degrees of "strangeness." Chance, random order, and game playing, those familiar tools of the contemporary artist, have invaded scientific methodology, and many of the familiar laws of science have become as shaky as Duchamp liked to think they were. "In spite of Einstein," as the cultural historian O. B. Hardison, Jr., put it, "it is fair to say that the dominant movement of twentieth-century science, especially mathematics, physics, and cosmology, has been away from certainties and toward masks and games."

At a certain point early in his career, Duchamp stopped taking science seriously. "We have to accept those so-called laws of science because it makes life more convenient," Duchamp told me in 1964, "but that doesn't mean anything so far as *validity* is concerned. Maybe it's all just an illusion. We are so fond of ourselves, we think we are little gods of the earth—I have my doubts, that's all. The word 'law' is against my principles. Science is so evidently a closed circuit, but every fifty years or so a new 'law' is discovered that changes everything. I just don't see why we should have such reverence for science, and so I had to give another sort of pseudo explanation. I'm a pseudo all in all, that's my characteristic. I never could stand the seriousness of life, but when the serious is tinted with humor, it makes a nicer color."

The first half of 1968 was a busy time for the Duchamps. They went to Toronto in February to take part in a musical "event" by John Cage. Entitled *Reunion,* the event consisted of Cage and Duchamp (and then Cage and Teeny) playing chess on stage on a board that had been equipped with

Carolyn Brown, Duchamp, and Merce Cunningham, after the first performance of *Walkaround Time,* 1968.

contact microphones; whenever a piece was moved, it set off a gamut of amplified electronic noises and oscilloscopic images on television screens visible to the audience. A month later Marcel and Teeny were in Buffalo for the first performance of *Walkaround Time,* a new Merce Cunningham dance whose set, by Jasper Johns, was based on *The Large Glass.* (Johns said that when he proposed this idea to Duchamp, Duchamp asked, "with a look of horror on his face," who would do the work. Johns said he would, whereupon Duchamp immediately relaxed and agreed to it.) The set, which was strikingly beautiful, was made of inflated, movable, clear-plastic forms on which Johns had painted the various elements of the *Glass*—Glider, Malic Moulds, *pendu femelle,* etc. Duchamp's only request was that at some point during the hour-long performance the forms should be moved into the same relative positions they occupied in *The Large Glass.* At the premiere in Buffalo, Cunningham stepped forward after the final curtain and beckoned for Duchamp to come up on stage. Making his way out to the aisle, Duchamp asked Jasper Johns, who was in the same row, "Aren't you coming?" Johns said he was not. "I'm just as scared as you are," Duchamp said reproachfully. Nobody would have known it. "I remember seeing Marcel Duchamp at the end of that first performance, on the stairs," Cunningham wrote some years later, "coming up to the stage, eyes bright, head up, none of that looking down at the steps . . . He was a born trouper."

Thirteen works by Duchamp were on display in "Dada, Surrealism, and Their Heritage," the large and important exhibition that opened at the Museum of Modern Art in late March. William S. Rubin, the museum's curator of painting and sculpture, had borrowed *The Bride* and *Chocolate Grinder (No. 1)* from Philadelphia and also Richard Hamilton's replica of *The Large Glass,* and in his catalog essay he devoted considerable space to Duchamp's influence on the Dada movement and on more recent art. The Duchamps came to the black-tie opening on March 25, and they also attended a three-day symposium on the show that was sponsored by the City University of New York—Duchamp was asked to speak at the final session, but he declined. A few days later they were off to Europe. They went to watch a chess tournament in Monte Carlo, spent some time in Italy with Gianfranco Baruchello, a well-to-do artist who would subsequently write two books about Duchamp, and returned to Paris in mid-May to find the city paralyzed by a general strike and massive student demonstrations against the government of President Charles de Gaulle. ("I am too old to

meddle, even to have an opinion about all this nonsense," Duchamp wrote to his old friend Raymond Dumouchel.) Marcel and Teeny were frightened by the size of the demonstrations. Like many Parisians, they decided to get out of the city. Although most of the gas stations were closed and shuttered, they were able to buy, from a mechanic in their Neuilly neighborhood, a full tank of gas and a spare jerrican for the Volkswagen they had purchased the summer before, and with Teeny at the wheel they left on May 23, heading for Switzerland. They spent the next fortnight in peaceful Lucerne. One day they drove to the town of Chexbres, near Lake Geneva, so that Marcel could show Teeny the landscape with the little waterfall that he had reproduced in the background of *Etant donnés,* but the woods had grown up so much in the meanwhile that they couldn't be sure they had found it.

On June 5 they flew from Zurich to London to hear Arturo Schwarz lecture on Duchamp at the Institute of Contemporary Arts. It was quite a lecture. Schwarz chose this occasion to present his theory about Duchamp's incestuous childhood passion for his sister Suzanne, a theory buttressed by iconographical references to details in Duchamp's paintings up to and including *The Large Glass* and laced with citations from Freud, Jung, Mircea Eliade, and other heavy-duty smelters of subconscious motivation. "Capital!" Duchamp exclaimed to Schwarz at a dinner party immediately following the lecture. "I couldn't hear a word, but I enjoyed it very much." Teeny was furious, however, and later that evening, when she and Marcel got back to Richard Hamilton's house in Highgate, where they were staying, she kept insisting that Marcel had to do something about it. The incest theory was obviously going to be a major element in the definitive monograph on Duchamp that Schwarz was about to publish, and Teeny felt very strongly that Marcel should make a formal statement of denial. Duchamp eventually grew irritated with her—something that Hamilton had never seen before. Hamilton remembers him saying something like "All right, Teeny, you write your book and let Schwarz write his." Even though Schwarz's theory was "rubbish," according to Duchamp, the man had a right to his opinions, and in one sense (the Duchampian sense) it could even be said that Schwarz was adding new elements to the creative process that Duchamp had begun. As Duchamp would say on another occasion, the book was not *about* him—it was *by* Schwarz.

Alas, poor Schwarz. When he finally delivered *The Complete Works of Marcel Duchamp* to his publisher after working on it for twelve years, the

manuscript contained not one word on *Etant donnés*, because Duchamp had never told Schwarz of its existence. Schwarz found out about it while his book was being printed. He took the next plane to Philadelphia, where the nude and her landscape had just been installed in a room of their own, and by a truly herculean effort he managed during the next few days to write a detailed description and analysis of the work, not excluding certain references to incest, of course, and with a psychological explanation as to why it had been necessary for Duchamp to keep his last work a complete secret. This essay appears, along with a photograph of the wooden door, in the catalogue raisonné section of Schwarz's book, and like the book itself, it is a hugely impressive performance. Disagree as we may with some of the Milanese scholar's theories about his elective father, his book is more than a labor of love—it is a profound effort to understand the least understandable artist of our century and one of the three or four indispensable works on Duchamp. Schwarz could even be humble in the face of his great task. At the end of the essay on *Etant donnés*, he refers to Duchamp's reiterated belief that works of visual art are not subject to evaluation or interpretation in words, and he goes on to say, "So let us not try to seek a message which would anyway elude any attempt at synthesizing and which is as transparent and complex as glass. The reader must discover this message by himself, disregarding, of course, the misleading hints we have offered from time to time in our vain attempts to come closer to its magnetic core."

After three days in London, the Duchamps flew back to Zurich and then, without pausing to unpack, headed south in their Volkswagen Beetle. Instead of driving all the way to Spain, they put the car and themselves on an overnight boat from Genoa to Barcelona, arriving at seven the next morning and getting to Cadaqués in time for lunch. For the last two summers, they had rented a lower apartment in the same house, because climbing the stairs to their previous apartment had become difficult for Duchamp. He was very tired when they got to Cadaqués this time, after a month of strenuous traveling. Throughout his life he had rarely been ill. He took no medicines, and he never complained, but Teeny could see that he was feeling "bum." He worked on a new project, nevertheless, a pair of "anaglyphic" pencil drawings of their fireplace chimney, one in blue and the other in red, which, when viewed through a pair of red-and-green spectacles, would appear in three dimensions. He also did a small charcoal sketch of Emilio Puignau, the local builder, and gave it to him.

It was their eleventh summer in Cadaqués. They celebrated Marcel's eighty-first birthday with the visiting Man Rays at a local restaurant on July 28—Man Ray photographed the cake, which had ten candles. The pattern of their days was the same as it had been in previous summers, with Teeny going off in a friend's boat each morning while Marcel went to Meliton's for a few games of chess. An American filmmaker named Lewis Jacobs came to Cadaqués in July to make a short film called *Marcel Duchamp in His Own Words;* it shows Duchamp, wearing a denim cap and a denim jacket, walking around the town and sitting in his apartment, talking laconically about this and that.

In September, as they were preparing to go back to Paris, Duchamp caught a cold. It grew worse instead of better, with severe stomach and back pains, and they had to postpone their departure. Teeny, who had known ever since his second prostate operation in 1962 that he had prostate cancer (Duchamp never did know this; the symptoms never surfaced), was seriously worried. After ten days he felt better, though, and they took the train from Barcelona to Paris on September 20. Duchamp wrote to Brookes Hubachek two days later from Neuilly, saying that in view of his recent illness he didn't want to overexert himself but that he and Teeny still planned to attend the October 17 opening of "Dada, Surrealism, and Their Heritage" at the Art Institute of Chicago.

The dinner party on October 1 was at 5, rue Parmentier in Neuilly, the studio apartment that the Duchamps had inherited from Suzanne. The guests were old friends—Robert and Nina Lebel, Man and Juliet Man Ray—and to all four of them Duchamp, although he looked quite pale, seemed to be in fine spirits. He had gone out that morning to the Vuibert bookshop on the boulevard Saint-Germain, and had been delighted that they still stocked the book on anaglyphs, which he had found there in the 1930s, along with the two-color spectacles for viewing them—he bought several of each. He also bought a new edition of the puns and humorous writings of Alphonse Allais, one of his favorite French authors. During the evening he was witty and gay, and Teeny was pleased to see him take a second helping of the pheasant she had cooked. For a while after the guests left, Marcel and Teeny stayed on in the living room, talking about the evening. Marcel read aloud to her some passages from the book by Alphonse Allais, which made

them both laugh. A little before one o'clock in the morning, Marcel went into the bathroom to get ready for bed. It seemed to Teeny that he was staying longer than usual. She called to him, but there was no answer. When she went in, he was lying on the floor, fully dressed.

Teeny knew immediately that he was dead. "He had the most calm, pleased expression on his face," she said. Later, after the burial in Rouen, in one of the many letters that she wrote to their friends, Teeny told Beatrice Wood that "much as I miss him, I am so grateful for the almost magic way he died. I am quite sure he did not know when it happened, and that was the way he always wanted it."

His death was reported on the front page of the *New York Times* and other leading newspapers throughout the world. (In Paris, however, *Le Figaro* listed it in the chess column.) John Canaday, the *Times*'s chief art critic, wrote that Duchamp was quite possibly the most destructive artist in history and also, with Picasso, the most adventurous. The fact that he had abandoned art for chess featured prominently in most of the obituaries, but none of them, of course, made any mention of his last major work, which was known only to a few people. In his will Duchamp had requested that there be no funeral ceremony. His ashes were buried in the Cimetière Monumental de Rouen alongside those of his parents, his brothers, and his sister. Duchamp wrote his own epitaph, which appears on the flat headstone:

D'ailleurs, c'est toujours les autres qui meurent
(Besides, it is always the others who die)

Etant Donnés

I have forced myself to contradict
myself, in order to avoid conforming
to my own taste.

*E*tant donnés: 1. la chute d'eau/ 2. le gaz d'éclairage went on view at the Philadelphia Museum of Art in June 1969. There was no formal opening, no private ceremony, not even a press release to announce the event. Duchamp had wanted the new installation to take its place quietly with the rest of his things in the Arensberg collection, and the museum's staff, guided by Teeny, did all they could to honor his wish. Word leaked out beforehand, however, and a few wildly inaccurate stories appeared in Philadelphia newspapers, including one report that access to the work would be restricted to adults only. As a result, there were quite a few curiosity seekers among the crowds that made their way during the month of June to the newly opened room at the far end of the Duchamp gallery. What they saw there, unchanged from that day to this, has been described by the artist Jasper Johns as "the strangest work of art in any museum."

The windowless room is dark, and at first glance it appears to be empty. Embedded in one wall, however, is an arch of bricks framing an old wooden door. Only by walking up close to the door will you discover that there are two worn peepholes in it, just at eye level. (It is at this moment that the viewer becomes a voyeur.) Repeated visits do not diminish the visual shock of the three-dimensional tableau on the other side. A naked woman lies on her back on a bed of (real) dead branches, twigs, and leaves. Her legs extend toward you, right leg out straight, left one drawn up and bent at the

Behind this door, the strangest work in any museum . . .

knee. Her head and her right arm are hidden by a brick wall, which also cuts off the view of both feet—you are actually looking at the nude through a jagged hole in the bricks. Her left arm, which is fully visible, is extended and slightly raised, and she holds in her left hand an old-fashioned gas lamp of the Bec Auer type. The lamp glows faintly against a realistic backdrop of woods, white clouds in a blue sky, a small lake or pond from which mist rises, and a tiny waterfall sparkling in the sun. The scene is bathed in a bril-

Etant donnés: 1. la chute d'eau/2. le gaz d'éclairage.

liant but uneven light, as on those days in early autumn when the sun dis-
appears behind clouds and then suddenly reemerges; some of the back-
ground areas are in shadow, but the light shines full on the nude and on the
distant waterfall.

She is neither young nor old, this full-bodied nude. Although her skin
is smooth and taut, it has seen better days. A lock of blond hair falls across
her left shoulder, and there is blond fuzz under her arms as well, but not a

trace of it in the genital area. Fully exposed and opened by the position of her legs, her hairless cunt draws the viewer's gaze like a magnet. There is something anatomically peculiar about this gaping orifice; it has no inner labia, and on second or third view it begins to look disturbingly like a vertical, speaking mouth. Your eye keeps going back to the articulate cunt and to the phallic lamp held aloft and to the distant waterfall: water and gas combine in the mind of the beholder as the bride, stripped bare at last, completes (by herself, apparently) the process that was so endlessly and hilariously delayed in *The Large Glass.*

That is one way of looking at *Etant donnés,* at any rate: as the sequel and conclusion, after nearly half a century, to *The Bride Stripped Bare by Her Bachelors, Even* (*The Large Glass*). Many elements of the earlier work can be found in the later one, including some, like the waterfall, that were mentioned in Duchamp's notes but never carried out visually in the *Glass.* The subject of both works is sexual encounter—incipient but perpetually delayed in the *Glass,* consummated (perhaps) in *Etant donnés*—and in both of them it is the female who dominates and controls the action. She is queen of the game, as powerful and as dominant as the queen in chess. No wonder Duchamp has become in recent years one of the very few male deities in the new feminist pantheon. The bachelors are not even on the scene this time, unless we choose to see them symbolized in the Bec Auer lamp that the nude holds up in one hand, its wick still bravely alight. Is it a reborn Rrose Sélavy who presides here at the center of Duchamp's sexual fable? If so, she has achieved what a note in the *Green Box* calls her *state of Rest (or allegorical appearance),* and it is up to us to *isolate the sign of the accordance between, on the one hand, this state of Rest (capable of innumerable eccentricities) and, on the other, a choice of Possibilities authorized by these laws and also determining them.* It is up to us, in other words, to play the game—the game of art according to Duchamp, in which laws and possibilities are interactive, and *eros c'est la vie.* Duchamp said that he wanted "to grasp things with the mind the way the penis is grasped by the vagina." In his last major work, the viewer's mind is grasped by the image of an open pussy, arousing and inciting it to complete the creative act that the artist has begun.

There are, of course, other ways of looking at *Etant donnés.* It has also been interpreted as a sort of antithesis to *The Large Glass,* a work so different and so opposed in every particular to the masterpiece of his youth that it can be seen only as a vulgar parody, "a banal affair," as one critic called it, "a peep-

hole tableau." Duchamp's friend Robert Lebel found it repellent. Others saw it as evidence of a frightful decline. "If earlier works by Duchamp are in the most dubious ways still lovely," the critic Joseph Masheck wrote, "this one seems startlingly gross and amateurish. It dissolves into a senile hobby, altogether private in its psychological function, out of place and embarrassingly unengaging . . . It is not a masterwork of any kind."

The most dedicated Duchampians tended to be the most upset by the new piece, because it overturns or contradicts so many aspects of his earlier work. Here we are, once again, in the grip of illusion, that age-old trap from which art had providentially escaped (thanks to Duchamp and others) to become a real thing-in-itself. The forms in *Etant donnés* are blatantly figurative rather than abstract or enigmatic, and the viewer, instead of being free to wander about and look at and through them from any angle (as in *The Large Glass*), is restricted to a single, fixed viewpoint. John Cage felt that *Etant donnés* denied the fusion of art and life that had seemed such an essential aspect of Duchamp's whole approach. "It has, rather, the most exact separation," he said. (Cage went on to say that "only a great body of work could include such an extreme reversal.") If *Etant donnés* is the antithesis to *The Large Glass,* though, it is still a meditation on the same theme, or themes: eros and sex, female and male, spirit and flesh. As a work to which Duchamp gave twenty years of his life, moreover, it is hardly something to be overlooked or dismissed—although this is more or less what happened to it during the next two decades.

Part of the problem was that nobody had the slightest idea what Duchamp was thinking when he made it. Aside from the title, which came from a note that appears in two slightly different versions in *The Green Box,* there were no verbal clues—no other notes, no statements, no answers to anybody's questions. Duchamp's reiterated belief that the effect of a work of visual art could never be conveyed in words did not prevent him from saying quite a lot during his lifetime about his paintings and readymades; by the time *Etant donnés* made its appearance, though, it was too late to interview him. Duchamp's only words on the subject are contained in the loose-leaf notebook that shows how to take the work apart and reassemble it—a manual of instructions, factual and specific, known only to a few people until the Philadelphia Museum of Art published it in 1987. To the ever-increasing tribe of Duchampians, the absence of verbal information seemed to present an insurmountable obstacle. Deprived of the verbal structure of

The Large Glass—a structure that Duchamp himself had said was as important as the visual one—they hesitated to deal with this new enigma.

After all, there was still so much other Duchamp territory to map and colonize. Throughout the 1970s and the 1980s, the literature on Duchamp grew at a phenomenal rate. A new generation of American and European art historians, critics, and museum curators staked claim to particular aspects or periods of his work—the readymades, the optical works, the year 1912. Ecke Bonk's comprehensive book *Marcel Duchamp: The Box in a Valise*, William Camfield's extended catalog essay on *Fountain*, Linda Henderson's work on Duchamp and early-twentieth-century scientific thinking, and a few other studies have made valuable contributions to an understanding of Duchamp, but the rising tide of books, articles, and academic papers also brought a wrack of nonsense. Several writers zeroed in on alchemy and other esoteric disciplines as the secret "key" to *The Large Glass*. Alchemy— the ancient search for a "philosopher's stone" that would convert base metals into gold—was a rich lode for Duchamp fanatics (the ones who believed in keys, at any rate) because of its crypto-sexual imagery. In the late 1960s Ulf Linde had published a symbolic drawing from a medieval alchemical manuscript that bore a striking resemblance to Duchamp's first pencil sketch for *The Bride Stripped Bare by Her Bachelors, Even*—it showed a young woman being disrobed by two men. Although the French scholar Jean Clair was able to prove some years later that the drawing actually represented a hermaphroditic male figure rather than a woman, the image convinced Linde and others that Duchamp must have delved deeply into alchemical literature, and once convinced, they had no trouble finding any number of alchemical symbols and references lurking in the verbal-visual thickets of *The Large Glass*. Duchamp, who did not like to stamp on other people's interpretations, never flatly denied the alchemy connection. He even told one interviewer that "alchemy was in the air" around 1910 in Paris, which was quite true. A revival of popular interest in alchemy had been under way in France since around the turn of the century; it had received a great boost, moreover, from the scientific discovery of radioactivity and X rays, whose power to transform matter and make visible the invisible seemed to offer a modern counterpart to the mythical philosopher's stone. Duchamp was certainly aware of these discoveries, and he could hardly have avoided reading articles in the popular press that linked the new scientific phenomena with the alchemists' ancient claims. In later years he made it clear, however, that he had never

read an alchemical text, and when Robert Lebel raised the subject with him, as we have seen, he gave what one might assume to have been a definitive reply: "If I have practiced alchemy, it was in the only way it can be done now, that is to say without knowing it."

Arturo Schwarz did not dispute Duchamp's slyly ironic statement to Lebel. He got around it by insisting that the cornucopia of alchemical lore he had found in *The Large Glass* and *The Green Box* and in earlier paintings such as *Young Man and Girl in Spring* had been "entirely unconscious" on Duchamp's part! Some of the other alchemy theorists were less cautious. The American art writer Jack Burnham, in two long and virtually incomprehensible articles in *Artforum,* claimed (on no evidence whatsoever) that Duchamp had gone to Munich in 1912 in search of an alchemist manuscript, and he went on to assert that the *Green Box* notes "represent a series of stepping stones" in the traditions of Gnosticism, the occult religions of Egypt, the Orphic mysteries of Greece, the cabalistic studies of the Jews, the Masonic orders, "and, in the East, in the doctrines of Tantric Buddhism and the Golden Flower of Taoism." For a certain breed of obsessive academic, it seemed, Duchamp could easily become an intellectual black hole. What Burnham and others somehow failed to notice was that their subject had spent a good part of his life undermining and making fun of systematic theories. Alchemy could very well have been one of the sources of Duchamp's ideas—along with Raymond Roussel's *Impressions d'Afrique,* the writings of Jules Laforgue and Alfred Jarry, and Henri Poincaré's speculations about the fourth dimension—but to suggest that it was the principal or exclusive source is to misunderstand the nature of his endlessly inventive, playful, and self-contradicting mind.

Several art historians found parallels between Duchamp and Leonardo da Vinci. Both artists had viewed art as "a mental thing" (Leonardo's "*cosa mentale*"); both had been interested in science, machines, measurement and mathematics, optics and perspective, experimentation and the use of chance procedures; both had been solitary and secretive but greatly admired for their personal charm. More to the point, they had both recorded their thinking in the form of cryptic notes (Leonardo's notebooks were read and discussed by the Puteaux circle of artists), and neither of them had been satisfied to work within the artistic boundaries recognized by their contemporaries. Leonardo was a musician, a poet, an architect, an engineer, and a natural scientist, as well as a painter and sculptor. Although Duchamp's range of skills

and interests was narrower, he came to be revered as the artist who, more than any other, had pushed back the boundaries of art in the twentieth century. (To say nothing of altering forever our mental image of the *Mona Lisa*.) "After Duchamp," Roger Shattuck wrote in 1972, "it is no longer possible to be an artist in the way it was before."

Duchamp's doubt and Duchamp's irony and Duchamp's questioning of every previous assumption about the nature and purpose of art had a profound effect on what came to be known in the 1980s as postmodernism. Neither a movement nor a set of shared ideas or principles, postmodern art—eclectic, historicizing, playful, and antiheroic—is distinguished primarily by its rejection of high modernism's esthetic goals. Those goals had been codified with great clarity by Clement Greenberg, the leading American art critic in the period from 1945 to about 1960. According to Greenberg, the driving force behind modern art, from Manet to Rothko, was an attempt to purge and purify it of every element that was not intrinsic to the medium itself; in the case of painting, this meant a restrictive concentration on color, line, and shape applied to a flat surface. Greenberg had been one of the first to champion the genius of Jackson Pollock, but in time even Pollock's work struck him as too impure and emotional for the modernist canon, in which the only possible subject of art was art. Formalist art criticism became a dominant influence in the 1950s and 1960s. Scores of lesser critics took up the Greenberg party line, prating endlessly of "flatness" and "the integrity of the picture plane," and quite a few "Greenberg collections" were formed by dutiful patrons of the artists he had anointed.

Then, all of a sudden, it seemed, the formalist esthetic was knocked on its ear. Pop art, Happenings, Process art, Earth art, Video art, Art and Language, Conceptualism, and the other brash developments that erupted on the scene in the 1960s and 1970s, mainly in New York, all seemed to be bent on introducing more and more extraneous elements into the mix—on including rather than excluding. Some Conceptualists carried Duchamp's antiretinal thinking to its logical conclusion by proposing to do away with the work of art altogether—just having the idea was enough. The artists at the cutting edge of these new tendencies were keenly aware of Duchamp. "All the environmental pieces, activities, slice-of-life video works, Information pieces, and Art-Tech shows we've become accustomed to owe their existence to Duchamp's idea about a snow shovel," Allan Kaprow, one of the early Happening-makers and theorists, wrote in 1973. Joseph Kosuth, a

leading Conceptual innovator, said that Duchamp's readymades had made it possible for art to speak another language. "With the unassisted ready-made," Kosuth wrote, "art changed its focus from the form of the language to what was being said." Several posthumous Duchamp retrospectives—at the Philadelphia Museum of Art, the Museum of Modern Art, and the Art Institute of Chicago in 1973; at the Pompidou Center in 1977; in Barcelona and Madrid in 1984; in Venice in 1993—helped to confirm what many young artists in America and (finally) in France had already discovered on their own: that in the matter of influence, Duchamp, rather than Picasso, was the artist of the century.

The formalist critics and artists, quite naturally, came to look on him as the archenemy. A "yearning for relaxation" from the lofty standards of modernism had "become outspoken in presumably avant-garde circles for the first time with Duchamp and Dada," Greenberg wrote. With the exception of ever-predictable Hilton Kramer, who lost no opportunity to dismiss Duchamp as the century's most overrated artist, even the hostile critics appeared to be in awe of his influence. If he had been a corruptor of youth, as Thomas Hess suggested, he was also in some sense unassailable—youth should have known better than to follow his example. Unfortunately, it did not. "Certainly the whole fabric of current American art has been altered by the virus of Duchamp," Max Kozloff wrote in 1968. Greenberg, who considered his influence pernicious, found it all-embracing. "The Futurists discovered avant-gardeness, but it was left to Duchamp to create what I call avant-gard*ism*," he wrote in a much-quoted 1970 essay. "In a few short years after 1912 he laid down the precedents for everything that advanced-advanced art has done in the fifty-odd years since. Avant-gardism owes a lot to the Futurist vision, but it was Duchamp alone who worked out, as it now looks, every implication of that vision and locked advanced-advanced art into what has amounted to hardly more than elaborations, variations on, and recapitulations of his original ideas."

Greenberg's analysis, which reduces most contemporary art to warmed-over Duchamp, implies that Duchamp's influence has been preemptive and deadening. Not many artists today would agree with that. Ask the question, and the answer is almost always that Duchamp's influence has been liberating—that he opened doors, removed barriers, and demonstrated by his own example that the goal of art is not the work itself but the freedom to make it. The truth is that Duchamp has had no real followers. There are no

late-model allegories painted on glass, no erotic peep shows for one spectator at a time, and precious few readymades that bear the authentic stamp of Duchampian "indifference." Jasper Johns, who is often spoken of as the most Duchampian artist of our time, has used images and motifs from Duchamp's work again and again, but he has used them in paintings whose ideological freight is secondary to their sensuous retinal appeal. It may be that Andy Warhol was Duchamp's truest heir—the one artist who pushed the implications of Duchamp's ideas to conclusions that not even Duchamp had foreseen. Publicity, repetition, and all-out commercialism, the elements on which Warhol's art was based, can each be seen as the flip side of Duchampian indifference. By erasing the barriers between avant-garde art and the mass public, moreover, Warhol went a long way toward fulfilling Apollinaire's prophecy about Duchamp—that he was destined to reconcile "art and the people."

In 1987, on the one hundredth anniversary of Duchamp's birth, the Philadelphia Museum of Art reissued the *Bulletin* that it had devoted to *Etant donnés* in 1969, and published a facsimile edition of Duchamp's looseleaf binder of instructions for assembling and installing the work. Several new critical studies of *Etant donnés* appeared around this time, some with photographs. (Until 1984 the museum, in agreement with Teeny and William Copley, had prohibited photographs of anything but the wooden door, on the correct assumption that photographs could give only a partial and misleading impression of the three-dimensional tableau.) Duchamp's last work, it seemed, was finally starting to receive the attention it deserved.

One or two observers discovered a connection between *Etant donnés* and Gustave Courbet's painting *The Origin of the World*. This frankly pornographic work, commissioned in 1866 by a Turkish diplomat and bon vivant named Khalil Bey, and acquired, soon after the Second World War, by the French psychoanalyst Jacques Lacan, was never on public view during Duchamp's lifetime, but Duchamp had almost certainly seen reproductions of it. The picture shows a recumbent female nude from her mid-thighs to her breasts, with the visual emphasis centered on her pubic bush. Was it conceivable that Courbet—the artist who was mainly responsible, in Duchamp's view, for setting art on its exclusively "retinal" course in the nineteenth century—had influenced Duchamp's last major work? In

his 1968 series of etchings called "The Lovers," Duchamp presented several sly variations on works by older masters, and one of the images he used was taken from another Courbet painting, the 1861 *Woman with White Stockings*. The original shows a partially reclining nude woman, with her knees raised and a hint of pubic hair showing between her upper thighs; Duchamp's contribution was to add a bird in the foreground—a *faucon* (falcon), as he explained to Arturo Schwarz, which functioned as a visual/verbal pun, in that the picture now contained a *faux con* (false cunt) and a real one. Courbet was on Duchamp's mind in 1968, in any case, and we might as well ask why not? A mind that had always been prone to self-contradiction could apparently find room, in the end, even for Courbet and retinal art. *Etant donnés,* with its explicit nude and its photorealist landscape, is undeniably retinal. Perhaps Duchamp had found that the retinal could finally be accepted—had to be accepted—as the inescapable basis for the *cosa mentale*. In *Etant donnés* the retinal and the idea, the appearance and the apparition, the mind and the body merge in the context of eroticism—the only ism, as Duchamp once said, in which he could truly believe.

In recent years the increasing tendency among younger artists to deal with the "issues" (as they like to call them) of gender, sexuality, and the human body in their work has led more and more of them to the darkened room behind the Duchamp gallery in Philadelphia. When they look through the peepholes for the first time, their reaction is often a mixture of

Gustave Courbet. *The Origin of the World*, 1866.

surprise and awe. No matter what they may have read or heard about *Etant donnés,* nothing quite prepares them for the initial shock. If there are no other voyeurs waiting—and often there are not—they look for a long time, and then, after paying homage to *The Large Glass, Nude Descending a Staircase, The Bride,* and the other Duchamp paintings in the outer gallery, they return for another viewing of the woman with open pussy.

She is not exactly in mint condition. Her skin has a dingy cast to it, and there is a three-inch vertical crack just above her right thigh. (The crack was there before she came to the museum; thanks to precise temperature and humidity controls, it hasn't grown any larger.) Duchamp used pigskin for his nude because he wanted it to look as much like human skin as possible. After he had stretched and glued the semi-translucent leather to the plaster maquette, he decided that, in order to get the skin tone he wanted, he would have to paint the inside surface; this required taking it off again, a long and tedious process. According to Teeny, the nude was far more beautiful before he did that—more subtle in color, with a soft, velvety texture. The museum's curators and conservators, amazingly enough, have no idea what is under the skin—whether it is a plaster cast or a metal armature of some sort. The figure, they believe, is too fragile to be taken out and X-rayed. Teeny Duchamp, who died in 1995 at the age of eighty-nine, was reluctant to talk about her husband's working methods, and nobody really knows what they were. There is a mysterious study that Duchamp did on transparent Plexiglas, in which he drilled small holes to outline the nude figure; probably he used it to line up the skin when he was gluing it to the maquette. Duchamp never asked for help or advice with the technical problems. He worked alone and in secret, following his own stated view that the contemporary artist's only recourse was to be underground.

We can assume that the torso conforms to the rather voluptuous proportions of Maria Martins, but the left arm and the hand, which holds the gas lamp, are Teeny Duchamp's (from a plaster cast), and the fall of blond hair on her shoulder is the same color as Teeny's hair. Marcel and Teeny worked together to gather the dead branches and leaves she lies on from the woods near Teeny's house in Lebanon, New Jersey. The bricks for the inner wall came from vacant lots and construction sites in Manhattan; Marcel and Teeny used to take shopping bags with them when they went out in the evening, and if they saw a likely brick on the way home they would squir-

rel it away. The bricks framing the wooden door, like the door itself, are from the countryside near Cadaqués.

The landscape background is a photographic blowup of the Swiss ravine near Puidoux, hand-colored by Duchamp and with some collage elements added. The most intriguing of these elements is the tiny waterfall, a trompe l'oeil effect produced by an amazing feat of bricolage. Hidden behind the backdrop, as we know from photographs in the loose-leaf binder, is a medium-size tin box that once held Peak Freen biscuits. There is a light bulb inside the box and a hole in one end. The light passes through the hole and then through a perforated metal disc that is turned by a small motor; the rotating disc breaks the light into downward-moving spots that are reflected by a piece of translucent plastic set into the backdrop, giving a near-perfect illusion of falling water. Paul Matisse, Teeny's eldest son, who was entrusted with the job of disassembling *Etant donnés* in Duchamp's studio and then reassembling it in Philadelphia, has described the "joyful chaos" he found when he ventured behind the wooden door—a great tangle of mismatched extension cords, bits of wood fastened together with nails that were too long or too short, masking tape used as a permanent binding agent. "One thing that really struck me," he said, "was the perforated disc that activates the waterfall. When you mount something like that on a motor-driven shaft, there is a setscrew, and us common folk usually set the setscrew. Not Marcel. The screw was loose. The disc was turning because there was no reason for it not to turn. It was perfectly well balanced, and the friction on the bushing was enough to turn the disc. But it was so typical of Marcel not to force the issue! A disc that could turn or not, as it wished. When I put it back together, I did not set the setscrew."

A deep stillness lies over *Etant donnés*. Time has stopped, and the silent water-fall, the only moving thing in the landscape, has a hypnotic effect. Instead of being lulled, though, the mind becomes more alert. Questions form. Why does the nude lie on a wintry bed of dry branches and leaves? The light and the hints of changing color in the background foliage suggest a day in late summer or early fall. Why this harsh and desiccated bower, if what we are seeing is *the blossoming of this virgin who has reached the goal of her desire*? (The *Green Box* notes are the only guide we have here.) Another *Green Box* note

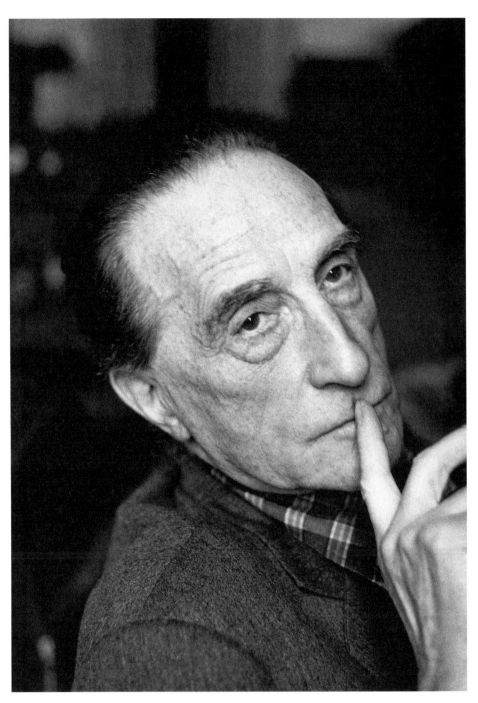

"There is no solution because there is no problem."

refers, however, to *the orgasm which may (might) bring about her fall.* Downfall? The fall of (wo)man into sin and death? Vestigial echoes of the Christian legend hover about the edges of the work, as they do in *The Large Glass;* someone will surely capture them sooner or later in a full-fledged systematic theory. The bride is no longer above, at any rate; she has quite literally come down to earth, and her pose, according to many observers, is clearly postcoital. But the bachelors, whom she may (might) be holding up in the form of a gas lamp, seem to be as impotent as ever. Why, come to think of it, are they called bachelors? Wouldn't suitors be more appropriate? In French the word *célibataire* has overtones of monkish abstinence and self-denial. And why are the bachelors plural? Only one is required to perform the act that will change this ready maid into a full-fledged woman—unless, of course, the erotic drama is taking place solely within the mind and imagination of our all-powerful, quite shameless *mariée* during the exquisitely delayed moment before she gives in to the splendid vibrations that are the goal of her desire. Does she achieve her goal? Or does she remain, perhaps, in the absolute freedom of the delay, a MARiée CELibataire?

There are no answers to such questions, which is to say there are as many answers as you and I can find.

In the collection of the late Mme Marcel Duchamp, there is a small pencil sketch of a hanging gas lamp, Bec Auer type, which Duchamp drew in 1902 or 1903, when he was a boarder at the Ecole Bossuet in Rouen. The lamp in *Etant donnés* is also a Bec Auer, a slightly different model, but clearly recognizable all the same. The image, preserved in the artist's mind for more than half a century, carries a sexual charge that is approximately equal and opposite to that of the distant waterfall, sparkling endlessly in the sun. If there is a sign of accordance between the waterfall and the lighting gas, female and male, Eros and Thanatos, it is found in the mediumistic practice of art. "I am nothing else but an artist, I'm sure," Duchamp said in 1963, "and delighted to be. All these things that happened to me during my life . . . the years change your attitude, and I couldn't be very iconoclastic any more."

It's merely a way of succeeding in no longer thinking that the thing in question is a picture—to make a "delay" of it in the most general way possible, not so much in the different meanings in which "delay" can be taken, but rather in their indecisive reunion.

Notes

The principal sources of letters and other unpublished material on Marcel Duchamp are the following:

AAA: Archives of American Art, Smithsonian Institution, Washington, D.C. (Jean Crotti and Suzanne Duchamp, Walter Pach, Beatrice Wood).

BLJD: Bibliothèque Littéraire Jacques Doucet, Universités de Paris, Paris, France (André Breton, Duchamp, Francis Picabia, Tristan Tzara).

HRC: Harry Ransom Humanities Research Center, Carlton Lake Collection, University of Texas, Austin, Tex. (Duchamp, Man Ray, Henri-Pierre Roché).

NYPL: New York Public Library, Manuscript and Archives Division, New York, N.Y. (Duchamp, Walter Pach, Henri-Pierre Roché, John Quinn).

PMA: Philadelphia Museum of Art, Arensberg Archives, Philadelphia, Penn. (Walter and Louise Arensberg Archives, Duchamp).

YCAL: Yale Collection of American Literature, Beinecke Rare Book and Manuscript Library, Yale University, New Haven, Conn. (Katherine Dreier, Duchamp, Henry McBride, Man Ray, Francis Picabia, Société Anonyme, Alfred Stieglitz, Ettie and Florine Stettheimer, Marius de Zayas).

The Bride Stripped Bare

Page

1 *Bride above—bachelors below*—This and all other italicized quotations in chapter one are from *The Bride Stripped Bare by Her Bachelors, Even,* a typographic version by Richard Hamilton of Marcel Duchamp's notes in *The Green Box,* translated by George Heard Hamilton. (This is the same translation used in *Salt Seller: The Writings of Marcel Duchamp,* edited by Michel Sanouillet and Elmer Peterson.)

1 "hilarious"—Ibid.

1 glass lady—Lawrence D. Steefel, Jr., *The Position of Duchamp's "Glass" in the Development of His Art,* p. 164.

3 he simply got bored and lost interest—Interview with author.

3 "definitively unfinished"—Interview with author.

3 "fun and poetry in my own way"; "the word *même* came to me without even looking for it"—Interview with author.

4 "is not meant to be looked at (through esthetic eyes)"—Jean Suquet, *Miroir de la mariée,* p. 247.

5 the French critic Jean Suquet points out—In an unpublished 1994 lecture on the occasion of the "Et Qui Libre?" colloquy on Duchamp, at the Ecole Regionale des Beaux-Arts de Rouen.

11 "a comic and infernal portrait"—Octavio Paz, *Marcel Duchamp: Appearance Stripped Bare,* p. 70.

11 "put painting once again at the service of the mind"—Marcel Duchamp, in James Johnson Sweeney, "Eleven Europeans in America," *Museum of Modern Art Bulletin,* pp. 19–21.

12 "I believe that art . . ."—Ibid.

14 "The *Glass* is not my autobiography"—Interview with author.

Blainville

15 All sorts of unsuccessful tries marked by indecision—Marcel Duchamp, "Notes for a Lecture, 1964."

16 "For my part I shall have to wait . . ."—Robert Lebel, *Marcel Duchamp,* p. 2.

17 "discretion, prudence, honesty . . ."—Michel Sanouillet, "Marcel Duchamp and the French Intellectual Tradition," in *Marcel Duchamp,* edited by Anne d'Harnoncourt and Kynaston McShine, p. 48.

19 "placid and indifferent"—Alice Goldfarb Marquis, *Marcel Duchamp: Eros, c'est la vie,* p. 10.

19 "intensely disliked" his mother—Ibid.

24 the name Duchamp . . . was simply too prosaic for an artist—Francis Steegmuller, "Duchamp: Fifty Years Later," *Show.*

25 "a long way from doing what he could"—Jennifer Gough-Cooper and Jacques Caumont, *Ephemerides on and About Marcel Duchamp and Rrose Sélavy, 1887–1968* (hereafter cited as *Ephemerides*), July 27, 1901.

Page

25 his older brother was such a natural artist—Pierre Cabanne, *The Brothers Duchamp,* p. 22.

27 Monet, "my pet Impressionist at the time"—Marcel Duchamp, "Notes for a Lecture, 1964."

29 "I am glad to be back . . ."—Jennifer Gough-Cooper and Jacques Caumont, *Ephemerides,* August 25, 1903.

29 "was already a reaction against the Impressionist influence . . ."—Marcel Duchamp, "Notes for a Lecture, 1964."

Swimming Lessons

31 I understood at a certain moment—Pierre Cabanne, *Dialogues with Marcel Duchamp,* p. 15.

32 "Villon's mocking laughter . . ."—John Richardson, *A Life of Picasso,* p. 160.

32 "how different I was even from my brother"—Francis Steegmuller, "Duchamp: Fifty Years Later," *Show.*

33 "That was the fashion among artists . . ."—Arturo Schwarz, *The Complete Works of Marcel Duchamp,* p. 381.

33 "was composed of master craftsmen . . ."—Pierre Cabanne, *Dialogues with Marcel Duchamp,* p. 20.

34 "The worst thing for me"—Pierre Cabanne, *The Brothers Duchamp,* p. 23.

35 Picasso had been so impressed by Steinlen and Forain . . . —John Richardson, *A Life of Picasso,* p. 126.

37 "[Matisse's] paintings at the 1905 Salon d'Automne . . ."—Pierre Cabanne, *The Brothers Duchamp,* pp. 23–24.

38 his godmother Julia Pillore—Emile Nicolle, Duchamp's maternal grandfather, had married for the second time in 1883, sixteen years after the death of his first wife. His new wife, a widow named Marie Pillore, had an eighteen-year-old daughter named Julia, a lively and attractive young woman who became Marcel's godmother.

39 "We were delighted to be pariahs"—Interview with author.

40 *"très vilains"*—Guillaume Apollinaire, *L'Intransigeant,* March 20, 1910.

40 Bergmann's diary—Jennifer Gough-Cooper and Jacques Caumont, *Ephemerides,* March 1–April 29, 1910.

41 "The things life forces men into . . ."—*New Yorker,* Talk of the Town interview, May 4, 1957.

42 "The conversation centered above all on Manet."—Pierre Cabanne, *The Brothers Duchamp,* pp. 22–23.

42 "a typical example of my cult of Cézanne mixed up with filial love."—Marcel Duchamp, "Notes for a Lecture, 1964."

44 "*not* expressly motivated by Dumouchel's hand . . ."—Duchamp to Walter Arensberg, July 22, 1951, PMA.

46 "swimming lessons"—Pierre Cabanne, *Dialogues with Marcel Duchamp,* p. 27.

Puteaux Cubism

Page

62 "Obviously, it opened up new horizons . . ."—Ibid.

64 "When you paint in green light . . ."—Ibid., p. 27.

The New Spirit

65 There is absolutely no chance . . .—Interview with author.

66 "pure art . . . containing at once . . ."—Charles Baudelaire, *The Painter of Modern Life and Other Essays,* p. 204.

66 "to paint not the thing itself, but the effect that it produces"—Wallace Fowlie, *Mallarmé,* p. 145.

67 "the sympathy by which one transports oneself to the interior of an object . . ."—Henri Bergson, *Introduction to Metaphysics;* cited in Roger Shattuck, *The Banquet Years,* p. 327.

67 "is essentially a current sent through matter"—Henri Bergson, *Creative Evolution,* p. 289.

67 "Everyone rebelling against convention in conduct . . ."—Ibid., introduction.

67 "persistence of the past in the present"—Ibid., p. 27.

68 "insofar as they recognize the primacy of change in life . . ."—Lawrence Gold, "Interview with Marcel Duchamp," appendix to unpublished senior thesis, Princeton University, 1958.

68 "There is absolutely no chance for a word ever to express anything . . ."—Interview with author.

68 "Words get their real meaning and their real place in poetry"—Ibid.

68 "One is the poet and the other the painter of the Idea"—Octavio Paz, *Marcel Duchamp: Appearance Stripped Bare,* p. 78.

68 "The contemplation of objects . . ."—Stéphane Mallarmé, in Francis Steegmuller, *Apollinaire: Poet Among the Painters,* p. 36.

69 "to make oneself a seer . . ."—Wallace Fowlie, trans., *The Complete Works of Arthur Rimbaud,* p. 307.

69 "a way of living today . . ."—Willem de Kooning, in "What Abstract Art Means to Me," a symposium held February 5, 1951, at the Museum of Modern Art and reprinted in the *Museum of Modern Art Bulletin* 18 (spring 1951).

70 "my sacred herb"; "Antialcoholics are unfortunates . . ."—Roger Shattuck, *The Banquet Years,* p. 202.

71 "The interruptions continued . . ."—Ibid., p. 208.

72 "that which blows"; "that which rolls"—Ibid., pp. 212, 215.

72 *"Voilà"*—Ibid., p. 215.

72 "If that should ever happen, Madame . . ."—Ibid., p. 215.

73 "the laws which govern exceptions . . ."—Ibid., pp. 241–42.

73 "no direct influence . . ."—Marcel Duchamp, in Serge Stauffer, trans. and ed., *Marcel Duchamp: Die Schriften,* letter March 28, 1965.

73 "Rabelais and Jarry . . . are my gods, evidently"—Interview with author.

Page

73 "the cult of childhood"—For analysis of the four traits, see Roger Shattuck, *The Banquet Years,* pp. 31–36.

74 "the most spirited party"—Ibid., p. 209.

74 "After us the Savage God"—Ibid.

Nude Descending

75 Reduce, reduce, reduce was my thought . . . —Marcel Duchamp, in James Johnson Sweeney, "Eleven Europeans in America," *Museum of Modern Art Bulletin,* p. 20.

75 "swimming lessons"—Pierre Cabanne, *Dialogues with Marcel Duchamp,* p. 27.

75 "Though very much detached from the conventions of his epoch . . ."—Gabrielle Buffet-Picabia, "Some Memories of Pre-Dada: Picabia and Duchamp," p. 256.

76 "emulated one another in their extraordinary allegiance to paradoxical, destructive principles . . ."—Ibid., p. 257.

76 "I don't know how it came about . . ."—Interview with author.

77 the young man is sad, Schwarz instructs us—Arturo Schwarz, *The Complete Works of Marcel Duchamp,* p. 110.

78 "the world's splendor has been enriched by a new beauty . . ."—First Manifesto of Futurism, 1909. (See Joshua C. Taylor, *Futurism,* pp. 124–25.)

79 "urban Impressionists who make impressions of the city rather than the countryside"—Pierre Cabanne, *Dialogues with Marcel Duchamp,* p. 35.

79 "My aim was a static representation of movement . . ."—Marcel Duchamp, in James Johnson Sweeney, "Eleven Europeans in America," *Museum of Modern Art Bulletin,* p. 20.

80 Duchamp's "*Nude* hardly compares in adventurousness . . ."—William Rubin, "Reflexions on Marcel Duchamp," *Art International.*

80 "The *Sad Young Man in a Train* already showed my intention of introducing humor into painting . . ."—Pierre Cabanne, *Dialogues with Marcel Duchamp,* p. 29.

80 "It was just a vague, simple pencil sketch . . ."—Interview with author.

80 "descending machine"—Robert Lebel, *Marcel Duchamp,* p. 9.

81 "definitely feminine"—Jennifer Gough-Cooper and Jacques Caumont, *Ephemerides,* October 19, 1949. The word for "nude" in French is always *nu,* whether male or female.

81 "The Cubists think it's a little off beam . . ."—Interview with William Seitz, "What's *Happened* to Art?" *Vogue.*

83 "It was a real turning point . . ."—Interview with author.

84 "It's normal today to have paintings in your kitchen . . ."—Ibid.

84 "a window onto something else"—Pierre Cabanne, *Dialogues with Marcel Duchamp,* p. 31.

84 "I . . . was just making a present for my brother."—Interview with author.

Munich, 1912

85 In 1912 it was a decision for being alone . . .—Marcel Duchamp, in Jean-Marie Drot, "Jeu d'échecs avec Marcel Duchamp."

85 "to grasp things with the mind the way the penis is grasped by the vagina"— Lawrence D. Steefel, Jr., *The Position of Duchamp's "Glass" in the Development of His Art,* p. 312.

87 "a bit Futurist"—Pierre Cabanne, *Dialogues with Marcel Duchamp,* p. 35.

87 " 'father and mother' machines . . ."—Robert Lebel, *Marcel Duchamp,* p. 13.

87 Duchamp said he had decided to reuse this canvas . . . —Unpublished interview with William Camfield, May 21, 1961.

87 *"The King and Queen* never was to be interpreted otherwise than from an esthetic angle . . ."—Ibid.

88 "less attracted by Laforgue's poetry than by his titles"—Marcel Duchamp, in James Johnson Sweeney, "Eleven Europeans in America," *Museum of Modern Art Bulletin,* p. 19.

88 "that silly little parvenue" and subsequent Laforgue quotations—William Jay Smith, *Selected Writings of Jules Laforgue.*

90 *Sad Young Man in a Train* was originally called *Pauvre Jeune Homme M*—Michel Sanouillet, "Marcel Duchamp and the French Intellectual Tradition," in *Marcel Duchamp,* edited by Anne d'Harnoncourt and Kynaston McShine, p. 50.

90 alongside such items as "the 'advice to the lovelorn' "—Robert Lebel, *Marcel Duchamp,* p. 8.

91 Regarding the date of Duchamp's first meeting with Apollinaire: In an unpublished interview with Harriet and Sidney Janis in 1953, Duchamp said that while he was in Munich he had received a letter from Apollinaire and they met for the first time when he returned to Paris that October. Ten years later, in an article published in the February 1963 issue of *Vogue,* Duchamp is quoted by William Seitz: "In Munich I received a letter from Apollinaire asking me for a photograph of myself, because he was writing a book on Cubism. He had never met me then; we met for the first time at the show [the Section d'Or exhibition in October 1912]. In 1964 Duchamp said to this writer, referring to the Section d'Or exhibition in 1912: "In fact that was where I met Apollinaire. I had never met him before . . . Our first meeting was in October."

91 Duchamp said that he had read the text of *Impressions d'Afrique* sometime after he saw the play—Pierre Cabanne, *Dialogues with Marcel Duchamp,* p. 34.

91 he spoke of Apollinaire's having "first showed Roussel's work to me"—James Johnson Sweeney, "Eleven Europeans in America," *Museum of Modern Art Bulletin,* p. 21.

91 "it is curious to note . . ."—*Marcel Duchamp: Letters to Marcel Jean,* p. 72.

91 "It was fundamentally Roussel who was responsible for my glass . . ."—Ibid.

92 Roussel believed "that a work of literature must contain nothing real . . ."— Wayne Andrews, *The Surrealist Parade,* p. 117.

92 "One didn't really listen"—Pierre Cabanne, *Dialogues with Marcel Duchamp,* p. 33.

93 "the madness of the unexpected"—Ibid.

93 "I would have gone anywhere in those days"—Interview with John Russell, *London Sunday Times,* June 9, 1968, p. 54.

93 "In 1912 it was a decision for being alone . . ."—Jean-Marie Drot, "Jeu d'échecs avec Marcel Duchamp."

Page

95　"I love those Cranachs..."—Jennifer Gough-Cooper and Jacques Caumont, *Ephemerides,* August 25, 1912.

95　Postcards and letter from Germany—See Jennifer Gough-Cooper and Jacques Caumont, *Ephemerides,* June 19, June 25, August 7, August 25, September 26, and September 27, 1912.

98　the next two drawings—Duchamp did a fourth drawing that summer in Munich, a small abstract sketch called *Airplane,* which does not seem to be related to the Virgin-Bride series.

98　"the reference is not to sexual initiation..."—Jerrold Seigel, *The Private Worlds of Marcel Duchamp,* p. 73.

99　Arturo Schwarz identifies it as an "alembic"...—Arturo Schwarz, *The Complete Works of Marcel Duchamp,* p. 118.

99　"My stay in Munich was the scene of my complete liberation..."—Marcel Duchamp, "Notes for a Lecture, 1964."

99　"juxtaposition of mechanical elements and visceral forms"—Robert Lebel, *Marcel Duchamp,* p. 15.

99　he had caught a glimpse...of the fourth dimension—Lawrence D. Steefel, Jr., *The Position of Duchamp's "Glass" in the Development of His Art,* p. 110.

101　"in a state of virtual anesthesia"—Interview with author.

101　"had become an enormous beetle-like insect..."—Robert Lebel, *Marcel Duchamp,* p. 73.

102　"great pleasure to find Cubism again"—Jennifer Gough-Cooper and Jacques Caumont, *Ephemerides,* September 26, 1912.

The Jura-Paris Road

103　The whole trend of painting was something I didn't care to continue—Marcel Duchamp, in Walter Pach, *Queer Thing, Painting,* p. 162.

103　Jacques Villon was responsible for the show's title—John Golding, *Cubism,* p. 15, note.

104　In later years he said that the *Painting* might have been *Sad Young Man in a Train*—William A. Camfield, "La Section d'Or," unpublished master's thesis Yale University, 1961.

104　an example of the worst and most outrageous tendencies—*Gil Blas,* October 14, 1912, cited in John Golding, *Cubism,* p. 20.

104　Fernande Olivier...described him this way—Francis Steegmuller, *Apollinaire: Poet Among the Painters,* p. 154.

105　Picasso biographer John Richardson suggests another reason—John Richardson, "Picasso Among Thieves," *Vanity Fair,* December 1993, p. 224.

106　"I have never seen this man"—Ibid., p. 226.

107　Apollinaire described Orphism—Guillaume Apollinaire, *Les Peintres Cubistes,* p. 130.

Page

107 Apollinaire "never wrote penetratingly about our art . . ."—Francis Steegmuller, *Apollinaire: Poet Among the Painters,* p. 130.

107 "like that of a hound who picks up too many scents . . ."—Ibid., p. 138.

108 Marcel's "very ugly" nudes in the 1910 Indépendants—*L'Intransigeant,* March 20, 1910.

108 "making great progress"—*L'Intransigeant,* November 19, 1911.

108 "Marcel Duchamp's strange drawing"—*L'Intransigeant,* September 30, 1912.

108 according to his friend Jean Mollet—Francis Steegmuller, *Apollinaire: Poet Among the Painters,* p. 87.

108 "forays of demoralization"—Gabrielle Buffet-Picabia, "Some Memories of Pre-Dada: Picabia and Duchamp," in *The Dada Painters and Poets,* edited by Robert Motherwell, p. 257.

110 "He recited them rather ceremoniously . . ."—Gabrielle Buffet-Picabia, *Rencontres,* p. 71.

110 Gabrielle Buffet-Picabia revealed in an interview—Jennifer Gough-Cooper and Jacques Caumont generously showed me a fuller version of their notes on this interview, which is the basis of the October 26, 1912, entry in *Ephemerides.*

111 "the 'nonperceptible' "—Gabrielle Buffet-Picabia, "Some Memories of Pre-Dada: Picabia and Duchamp," in *The Dada Painters and Poets,* edited by Robert Motherwell, p. 258.

111 "Marcel was much less liberated . . ."—Notes on an interview with Gabrielle Buffet-Picabia by Jennifer Gough-Cooper and Jacques Caumont, *Ephemerides,* October 26, 1912.

111 "I remember being astonished . . ."—Ibid.

111 "There was only the main train . . ."—Ibid.

112 "ineptitude for life . . ."—Gabrielle Buffet-Picabia, "Some Memories of Pre-Dada: Picabia and Duchamp," in *The Dada Painters and Poets,* edited by Robert Motherwell, p. 256.

112 Gabrielle thought she had "initiated" Duchamp—The interviewer in this case was Malitte Matta.

112 a two-page manuscript—This "Jura-Paris Road" note is included in *The Green Box* notes. See Marcel Duchamp, *Salt Seller: The Writings of Marcel Duchamp* (hereafter cited as *Salt Seller*), pp. 26–27.

113 "From Munich on I had the idea . . ."—Calvin Tomkins, *The Bride and the Bachelors: The Heretical Courtship in Modern Art* (hereafter cited as *The Bride and the Bachelors*), p. 24.

114 "taking an intellectual position as opposed to the manual servitude of the artist"—Jennifer Gough-Cooper and Jacques Caumont, *Ephemerides,* November 4, 1912.

114 "There are two kinds of artists . . ."—James Johnson Sweeney, "A Conversation with Marcel Duchamp," in *Wisdom: Conversations with the Elder Wise Men of Our Day* (hereafter cited as *Wisdom*), edited by James Nelson, p. 93.

114 "the pictures painted by Duchamp in the years before 1913 stand with the greatest art of modern times"—Walter Pach, *Queer Thing, Painting,* p. 156.

Page

115 "That's the strongest expression I've seen yet"—Milton W. Brown, *The Story of the Armory Show*, p. 70.

Scandal at the Armory

116 Can one make works which are not works of "art"?—Marcel Duchamp, *Salt Seller*, p. 74.

116 "The Armory show wasn't well accounted for in Paris"—Interview with William Seitz, "What Happened to Art?" *Vogue*.

116 "Her room was mobbed every day"—Rudi Blesh, *Modern Art USA*, p. 53.

117 "It's Only a Man"—Milton W. Brown, *The Story of the Armory Show*, p. 136.

117 Matisse was the main villain—Ibid., pp. 168–72.

118 "I will buy Duchamp nude woman descending stairway please reserve"—Francis M. Naumann, "Frederic C. Torrey and Duchamp's *Nude Descending a Staircase*," in *West Coast Duchamp*, edited by Bonnie Clearwater, p. 12.

118 "It came from so far away!"—Pierre Cabanne, *Dialogues with Marcel Duchamp*, p. 44.

119 "All at '291' will miss them . . ."—William A. Camfield, *Picabia*, p. 56.

120 "a fever of curiosity . . . as intense as that aroused by the Dreyfus case"—Modris Eksteins, *Rites of Spring: The Great War and the Birth of the Modern Age*, p. 26.

120 "never forget the yelling and the screaming"—Jennifer Gough-Cooper and Jacques Caumont, *Ephemerides*, May 29, 1913.

121 "Marcel Duchamp's pictures are still too few in number . . ."—Guillaume Apollinaire, *Les Peintres Cubistes*, pp. 90ff.

121 "What a joke! . . ."—Pierre Cabanne, *Dialogues with Marcel Duchamp*, p. 38.

122 "It was a wonderful job . . ."—James Johnson Sweeney, "A Conversation with Marcel Duchamp," in *Wisdom*, edited by James Nelson, p. 93.

122 "My hours were ten to twelve and one-thirty to three . . ."—*New Yorker*, Talk of the Town interview, April 6, 1957.

122 "nothing is in itself more this than that"—Thomas McEvilley, "Empyrrhical Thinking (And Why Kant Can't)," *Artforum*.

123 Picabia admired Stirner—Gabrielle Buffet-Picabia, *Rencontres*, p. 37.

123 "My concern is neither the divine nor the human . . ."—Max Stirner, *The Ego and His Own*, p. 5.

123 "a remarkable book . . ."—Interview with author.

124 "a long canvas, upright"—Only a few of Duchamp's notes are dated, which makes their chronology problematic. Arturo Schwarz puts this note first in his monumental *Notes and Projects for "The Large Glass*," and the evidence suggests that it was written in 1912.

124 "It came from having used a piece of glass for a palette . . ."—Calvin Tomkins, *The Bride and the Bachelors*, pp. 29–30.

124 "If a painter leaves the canvas blank . . ."—Lawrence S. Gold, unpublished senior thesis, Princeton University, p. 54.

Page

125 "Always there has been a necessity for circles in my life . . ."—Francis Roberts, "I Propose to Strain the Laws of Physics," *Art News,* December 1968.

126 "the point of departure for a new technique"—James Johnson Sweeney, "A Conversation with Marcel Duchamp," in *Wisdom,* edited by James Nelson, p. 92.

127 "The problem is how to draw . . ."—Interview with author.

127 "the real beginning of *The Large Glass*"—James Johnson Sweeney, "A Conversation with Marcel Duchamp," in *Wisdom,* edited by James Nelson, p. 92.

127 "the precise and exact aspect of science . . ."—Pierre Cabanne, *Dialogues with Marcel Duchamp,* p. 39.

127 traveling street fairs in France—Jean Schuster, "Marcel Duchamp, vite," *Le Surréalisme, même,* pp. 143–45.

128 "that miserable tricky perspective . . . that infallible device for making all things shrink"—Guillaume Apollinaire, *Les Peintres Cubistes,* p. 45.

129 "I am very depressed at the moment and do absolutely nothing"—MD to Walter Pach, July 2, 1913, AAA. (See also Marcel Duchamp, "Amicalement, Marcel.")

129 "an excellent man"—Ibid.

129 "Superb weather . . ."—Jennifer Gough-Cooper and Jacques Caumont, *Ephemerides,* August 8, 1913.

130 "It is *his* decision . . ."—Walter Pach, *Queer Thing, Painting,* p. 160.

130 Although Stein would come to disapprove of Picabia's "incessantness" and his "delayed adolescence"—William A. Camfield, *Picabia,* p. 57, note 1.

130 Gabrielle Picabia was "full of life and gaiety . . ."—Jennifer Gough-Cooper and Jacques Caumont, *Ephemerides,* November 20, 1913.

130 "the young Duchamp . . . looks like a young Englishman and talks very urgently about the fourth dimension"—Linda Dalrymple Henderson, *The Fourth Dimension and Non-Euclidian Geometry in Modern Art,* p. 207.

131 "tapped the mainspring of my future"—Katharine Kuh, "Marcel Duchamp," in *The Artist's Voice: Talks with Seventeen Artists* (hereafter cited as *The Artist's Voice*), p. 81.

131 "In itself it was not an important work of art . . ."—Ibid.

132 Pliny the Elder tells us how the painter Protogenes . . . —Marcel Jean, *The History of Surrealist Painting,* p. 23.

132 Leonardo da Vinci . . . advised looking at stains on a wall—Ibid.

132 as Duchamp pointed out—Pierre Cabanne, *Dialogues with Marcel Duchamp,* p. 46.

132 "Your chance is not the same as mine, is it?"—Interview with author.

133 "drew as many notes out of a hat"—Jennifer Gough-Cooper and Jacques Caumont, *Ephemerides,* May 6, 1951.

133 The *Bicycle Wheel* "just came about as a pleasure . . ."—Calvin Tomkins, *The Bride and the Bachelors,* p. 226.

135 "It was not intended to be shown . . ."—Interview with author.

135 "This gave me the idea of putting some color to those lights . . ."—Interview with author.

135 limited three-print "edition"—only one copy of *Pharmacy* has survived.

135 "a distortion of the visual idea to execute an intellectual idea"—Interview with author.

Page

136 "I had purchased this as a sculpture already made"—MD to Suzanne Duchamp, January 1916, AAA. (See also Marcel Duchamp, "Affectueusement, Marcel.")

136 "without normal meaning"—Radio interview with Georges Charbonnier, Paris, 1960.

137 "I bought paraffin to keep the acid from attacking the glass . . ."—Interview with author.

137 "Marcel, who was a dry type . . ."—*Marcel Duchamp,* edited by Anne d'Harnoncourt and Kynaston McShine, p. 128. The authenticity of this remark is questionable. When asked about it by Arturo Schwarz, Duchamp did not recall the incident (see Arturo Schwarz, *The Complete Works of Marcel Duchamp,* p. 595).

138 "For me this is a kind of magic number . . ."—Arturo Schwarz, *The Complete Works of Marcel Duchamp,* p. 131.

140 "I have been condemned to remain a civilian . . ."—MD to Walter Pach, January 19, 1915, AAA. (See also Marcel Duchamp, "Amicalement, Marcel.")

140 "spared nothing in the way of malicious remarks"—Robert Lebel, *Marcel Duchamp,* p. 37.

140 "to reproach the younger brother for being 'behind the lines' "—Ibid.

141 "Now here is what interests me . . ."—MD to Walter Pach, April 2, 1915, AAA. (See also Marcel Duchamp, "Amicalement, Marcel.")

141 "You miss Paris, yes . . ."—MD to Walter Pach, April 27, 1915, AAA. (See also Marcel Duchamp, "Amicalement, Marcel.")

142 Raymond "finds the idea good enough . . ."—MD to Walter Pach, May 21, 1915, AAA. (See also Marcel Duchamp, "Amicalement, Marcel.")

New York

143 "You don't give a damn about Shakespeare . . ."—Interview with author.

143 "There had been a breeze until then . . ."—Interview with author.

143 "hit him between wind and water"—William Ivins to Fiske Kimball, March 15, 1954. Arensberg Archives, PMA.

146 "Duchamp was the spark plug that ignited him"—Francis M. Naumann, "Walter Conrad Arensberg: Poet, Patron, Participant in the New York Avant-Garde, 1915–1920," *Philadelphia Museum of Art Bulletin,* Spring 1980, p. 11.

146 "For a Frenchman, used to class distinctions . . ."—Interview with author.

146 "a real Bohemia . . ."—Francis Steegmuller, "Duchamp: Fifty Years Later," *Show*.

147 "Dinner at the Brevoort, a dollar twenty-five . . ."—Ibid.

147 "When the three of us spoke French . . ."—Wallace Stevens to his wife, August 3, 1915, in *Letters of Wallace Stevens.*

148 Torrey . . . troubled by "the high price of gasoline"—B. L. Reid, *The Man from New York: John Quinn and His Friends,* p. 392.

148 Quinn "could be for me a hearty supporter . . ."—MD to Walter Pach, July 28, 1915, AAA. (See also Marcel Duchamp, "Amicalement, Marcel.")

149 "I think you will soon be writing perfectly idiomatic English"—John Quinn to MD, November 13, 1915, NYPL.

Page

150 His guided tour included the Hudson and East Rivers . . . —Daniel Robbins, *The Formation and Maturity of Albert Gleizes,* p. 201.

151 "He neither talks, nor looks, nor acts like an artist"—"A Complete Reversal of Art Opinions by Marcel Duchamp, Iconoclast" (hereafter cited as "A Complete Reversal"), *Arts and Decoration,* September 1915.

151 "a young, decidedly boyish human . . ."—"Why Marcel Duchamp Calls Hash a Picture," *Boston Evening Transcript,* September 18, 1915.

151 "away from the French front on a furlough"—"A Complete Reversal," *Arts and Decoration*.

151 "The American woman is the most intelligent in the world today . . ."—Marcel Duchamp, interview in *New York Tribune,* September 12, 1915.

152 "The capitals of the Old World have labored for hundreds of years . . ."—Ibid.

152 "New York itself is a work of art . . ."—"A Complete Reversal," *Arts and Decoration*.

152 "But that word Cubism means nothing at all . . ."—Ibid.

152 "From a psychological standpoint I find the spectacle of war very impressive . . ." —"The European Art Invasion," *Literary Digest,* November 27, 1915.

153 "In the first days of our comradeship . . ."—Bessie Breuer, unpublished manuscript.

153 "In Paris, in Europe, the young men of any generation . . ."—Interview with author.

154 "I could almost live on what I made this way . . ."—Interview with author.

154 "too impatient"—Interview with author.

154 "in a house that had a Turk as a proprietor . . ."—Interview with author.

154 "He has always made his living at other employment . . ."—Walter Pach to John Quinn, October 10, 1915, NYPL.

154 "She is a brash American woman . . ."—John Quinn to MD, November 4, 1915, NYPL.

154 "I saw Miss Belle Green at the Library . . ."—MD to John Quinn, November 5, 1915, NYPL.

155 "a sort of studio which is comfortable enough"—MD to John Quinn, January 1, 1916, NYPL.

155 "You see," he explained, "it interested me but not enough to be *eager* to finish it . . ." —Interview with author.

156 "It is an absolute expression of my idea of Marcel Duchamp . . ."—Jean Crotti, letter to *World* (New York, August 27, 1916), quoted in *Tabu Dada: Jean Crotti and Suzanne Duchamp, 1915–1922,* edited by William A. Camfield and Jean-Hubert Martin, p. 12.

156 how pleased and proud Crotti had looked—Unpublished interview with Duchamp by Harriet and Sidney Janis, 1953.

157 "visual indifference, and, at the same time, on the total absence of good or bad taste"—Pierre Cabanne, *Dialogues with Marcel Duchamp,* p. 48.

157 "Now, if you went up to my place . . ."—MD to Suzanne Duchamp, around January 15, 1916, AAA. (See also Marcel Duchamp, "Affectueusement, Marcel.")

158 "I'm not at all sure that the concept of the readymade . . ."—Katharine Kuh, "Marcel Duchamp," in *The Artist's Voice,* p. 92.

A Little Game Between I and Me

Page

159 The curious thing about the readymade . . .—Katharine Kuh, "Marcel Duchamp," in *The Artist's Voice*, p. 90.

159 "it was always the idea that came first . . ."—Interview with author.

159 "a form of denying the possibility of defining art"—Marcel Duchamp, BBC interview by George Heard Hamilton, January 19, 1959.

159 limit the no. of readymades yearly—One of the notes from *The Green Box*. (See Marcel Duchamp, *Salt Seller,* p. 33.)

159 *3 Standard Stoppages* . . . his favorite readymade—Francis Roberts, "I Propose to Strain the Laws of Physics," *Art News,* December 1968.

159 "the greatest enemy of art"—Katharine Kuh, "Marcel Duchamp," in *The Artist's Voice,* p. 92.

159 "My intention was always to get away from myself . . ."—Ibid., p. 83.

160 "no beauty, no ugliness . . ."—Marcel Duchamp, "Notes for a Lecture, 1964."

161 without telling Duchamp what it was—Arensberg never told anyone what he had put inside the ball of twine, and Duchamp never knew. When *With Hidden Noise* came to the Pasadena Museum for Duchamp's first retrospective exhibition, in 1963, Walter Hopps, the director, promptly took it apart and broke the secret, to himself anyway. Although a number of people now know what is inside, I see no reason to do away with the pleasure of not knowing.

161 "like in a neon sign . . ."—Marcel Duchamp, "Notes for a Lecture, 1964."

161 "the minute I *did* think of a verb . . ."—Arturo Schwarz, *The Complete Works of Marcel Duchamp,* p. 457.

161 "He learned to like our very bibulous American ways . . ."—Louise Varèse, "Marcel Duchamp at Play," in *Marcel Duchamp,* edited by Anne d'Harnoncourt and Kynaston McShine, p. 224.

162 "a huge old-fashioned painting . . ."—Arturo Schwarz, *The Complete Works of Marcel Duchamp,* p. 462.

162 "a Rembrandt as an ironing board"—Quoted by William Seitz, *The Art of Assemblage,* p. 20.

162 the most likely candidates are the snow shovel and the typewriter cover—Arturo Schwarz, *The Complete Works of Marcel Duchamp,* p. 463.

164 "I called the strokes . . ."—Man Ray, *Self-Portrait,* p. 56.

164 "a truly supreme *ease* . . ."—André Breton, "Marcel Duchamp," in *The Dada Painters and Poets,* edited by Robert Motherwell, p. 209.

164 "Naturally all his pupils fell into his arms . . ."—Gabrielle Buffet-Picabia, "Un Peu d'histoire," in *Paris–New York,* p. 97.

165 "in offices, in restaurants, in the best houses . . ."—Ibid., p. 93.

165 "those abysses of anxiety . . ."—Daniel Robbins, *The Formation and Maturity of Albert Gleizes,* p. 201.

165 "My dear Gleizes . . ."—Ibid., p. 200.

165 "potentially damaging criticism"—Francis M. Naumann, *New York Dada,* edited by Rudolf E. Kuenzli, p. 10.

Page

165 "the pitiless pessimism of his mind . . ."—Gabrielle Buffet-Picabia, "Some Memories of Pre-Dada: Picabia and Duchamp," in *The Dada Painters and Poets*, edited by Robert Motherwell, p. 260.

166 "unhampered by sanity"—Remark attributed to Jane Heap, in Jennifer Gough-Cooper and Jacques Caumont, *Ephemerides*, March 12, 1957.

167 "the hem of my red oilskin slicker . . ."—Steven Watson, *Strange Bedfellows: The First American Avant-Garde* (hereafter cited as *Strange Bedfellows*), p. 271.

167 "Marcel, Marcel, I love you like hell, Marcel"—Ibid.

167 Stieglitz . . . regretted not having shown his work—*The Dada Painters and Poets*, edited by Robert Motherwell, p. xxvii.

168 "Almost immediately upon coming to America . . ."—William A. Camfield, *Francis Picabia*, p. 77.

168 "strongest influence in recent years"—John Tancock, "The Influence of Marcel Duchamp," in *Marcel Duchamp*, edited by Anne d'Harnoncourt and Kynaston McShine, p. 163.

168 some historians now believe that Schamberg . . . in collaboration with the ineffable Baroness Elsa von Freytag-Loringhoven—Robert Reiss, "My Baroness," in *New York Dada*, edited by Rudolf E. Kuenzli, p. 88.

169 "He had been drinking . . ."—*The Autobiography of William Carlos Williams*, p. 137.

169 "There had been a break somewhere . . ."—Ibid., p. 138.

The Arensberg Salon

170 Whether Mr. Mutt with his own hands . . . —Beatrice Wood, Marcel Duchamp (and others?), "The Richard Mutt Case," in William A. Camfield, *Marcel Duchamp/Fountain*, p. 38.

170 "A cough made me turn . . ."—Beatrice Wood, "Marcel," in *Marcel Duchamp: Artist of the Century*, edited by Rudolf E. Kuenzli and Francis M. Naumann, p. 12.

171 "that my being an actress would not be so bad . . ."—Beatrice Wood, *I Shock Myself: The Autobiography of Beatrice Wood* (hereafter cited as *I Shock Myself*), p. 6.

171 "Why don't you try?"—Beatrice Wood, "Marcel," in *Marcel Duchamp: Artist of the Century*, edited by Rudolf E. Kuenzli and Francis M. Naumann, p. 12.

171 his use of the familiar "*tu*"—Beatrice Wood, *I Shock Myself*, p. 23.

171 whose heart "lost a beat"—Beatrice Wood, "Marcel," in *Marcel Duchamp: Artist of the Century*, edited by Rudolf E. Kuenzli and Francis M. Naumann, p. 12.

171 "Sex and love, he explained, were two very different things"—Beatrice Wood, *I Shock Myself*, p. 24.

171 "When he smiled the heavens opened . . ."—Ibid., p. 23.

171 "a typical bachelor's niche"—Beatrice Wood, "Marcel," in *Marcel Duchamp: Artist of the Century*, edited by Rudolf E. Kuenzli and Francis M. Naumann, p. 12.

172 "I felt an extraordinary harmony with him . . ."—Interview with author.

172 "Except for the physical act . . ."—Beatrice Wood, *I Shock Myself*, p. 225.

172 "inveterate celibates"—Interview with author.

Page

173 "no university extant that wouldn't give you its *summa cum laude*"—Steven Watson, *Strange Bedfellows*, p. 258.

173 "salle d'attente deuxième classe"—Ibid., p. 252.

173 "I am very unhappy—and I don't think I deserve to be . . ."—Barbara J. Bloemink, *The Life and Art of Florine Stettheimer*, p. 74.

173 "nothing sold"—Ibid., p. 75.

174 what Gertrude Stein called "a general introducer"—Gertrude Stein, *The Autobiography of Alice B. Toklas*.

174 "a halo . . . his outward calm . . ."—H. P. Roché, "Souvenirs of Marcel Duchamp," in Robert Lebel, *Marcel Duchamp*, p. 79.

174 "was equaled only by Napoleon and Sarah Bernhardt . . ."—Ibid.

174 "like a great flower of fragrant dresses . . ."—H. P. Roché, *Victor*, p. 29.

175 "he only laughed, for he too loved Marcel"—Beatrice Wood, "Marcel," in *Marcel Duchamp: Artist of the Century*, edited by Rudolf E. Kuenzli and Francis M. Naumann, p. 13.

175 Victor "has no needs, no ambitions . . ."—H. P. Roché, *Victor*, p. 19.

175 "You must choose . . ."—Ibid., pp. 93–94.

176 "a certain deadness"—Beatrice Wood, "Marcel," in *Marcel Duchamp: Artist of the Century*, edited by Rudolf E. Kuenzli and Francis M. Naumann, p. 16.

177 It was $58.33 a month—Francis M. Naumann, *New York Dada*, edited by Rudolf E. Kuenzli, p. 228, note 42.

178 he bought it to use *as* a coat rack—Interview with author.

178 "Cela n'a pas d'importance"—Beatrice Wood, *I Shock Myself*, p. 26.

178 "could not acquire the knack of misbehaving . . ."—Carolyn Burke, *Becoming Modern: The Life of Mina Loy*, p. 215.

178 "weird and grotesque and simply frightful"—Francis M. Naumann, *New York Dada*, edited by Rudolf E. Kuenzli, p. 25.

180 Robert Henri . . . withdrew from the society—Steven Watson, *Strange Bedfellows*, p. 313.

180 "Democracy run riot"—Ibid., p. 312.

180 The 1917 Independents exhibition—Most of my information on this event comes from two sources: "The Big Show," I and II, two articles by Francis M. Naumann in *Artforum*, February 6, and April 8, 1979, and William A. Camfield, *Marcel Duchamp/Fountain*.

181 a flat-back, "Bedfordshire"-model porcelain urinal—Matthew Armstrong, "Searching High and Low," *Museum of Modern Art Quarterly*, fall 1990, pp. 4–7.

181 Beatrice Wood's eyewitness account—Beatrice Wood, *I Shock Myself*, p. 29.

182 "Mr. Mutt's defenders were voted down by a small margin"—*New York Herald*, April 14, 1917, p. 6.

182 "by no definition, a work of art"—Ibid.

182 Did Walter Arensberg seek out the urinal . . . —See Arturo Schwarz, *The Complete Works of Marcel Duchamp*, p. 466.

183 Did Glackens "solve" the problem . . . —Ira Glackens, *William Glackens and the Ashcan Group*, pp. 187–88.

Page

183 "At Marcel's request . . ."—Beatrice Wood, *I Shock Myself,* p. 30.

184 "by one of our friends"—Francis M. Naumann, *New York Dada,* edited by Rudolf E. Kuenzli, p. 185.

184 In his own subsequent comments on the affair—See Arturo Schwarz, *The Complete Works of Marcel Duchamp,* p. 466.

184 "One of my female friends . . ."—MD to Suzanne Duchamp, April 11, 1917, AAA. (See also Marcel Duchamp, "Affectueusement, Marcel.")

184 "They must have known that a urinal . . . would be unacceptable"—In a 1966 radio interview on the BBC, Duchamp claimed that he did *not* expect *Fountain* to be rejected by the Independents. Like several other statements in this interview, this one is open to doubt.

185 Beatrice Wood . . . says she wrote it—Beatrice Wood, *I Shock Myself,* p. 31.

185 Duchamp attributed it at one time to Louise Norton—Interview with the Arts Council of Great Britain, June 19, 1966.

185 but in an earlier statement—Serge Stauffer, trans. and ed., *Marcel Duchamp: Die Schriften,* question 16.

186 "The 'Fountain' is here too"—Alfred Stieglitz to Henry McBride, April 19, 1917, YCAL.

187 "Let me state once and for all . . ."—Steven Watson, *Strange Bedfellows,* p. 246.

187 Jack Johnson, himself a fugitive—Roger L. Conover, "Mina Loy's 'Colossus': Arthur Cravan Undressed," in *New York Dada,* edited by Rudolf E. Kuenzli, p. 103.

187 "that he preferred crushing the jaws of Yankee gentlemen . . ."—Francis M. Naumann, *New York Dada,* edited by Rudolf E. Kuenzli, p. 165.

187 Arthur Cravan's "lecture"—Francis M. Naumann, "The Big Show: The First Exhibition of the Society of Independents," *Artforum,* p. 38.

188 "making love right under my nose . . ."—Roger L. Conover, "Mina Loy's 'Colossus': Arthur Cravan Undressed," in *New York Dada,* edited by Rudolf E. Kuenzli, p. 106.

188 "The putrefaction of unspoken obscenities . . ."—Ibid.

188 Duchamp a "prestidigitator . . ."—Ibid., p. 107.

188 "a newfashioned hop, skip and jump . . ."—Arturo Schwarz, *The Complete Works of Marcel Duchamp,* p. 585.

188 "like a lady-bird on a large stalk . . ."—H. P. Roché, *Victor,* p. 55.

189 "I could hear his beating heart . . ."—Beatrice Wood, *I Shock Myself,* p. 33.

Beginning at Zero

190 Let each man proclaim . . .—Tristan Tzara, "Dada Manifesto 1918," in *The Dada Painters and Poets,* edited by Robert Motherwell, p. 81.

191 "The child's first sound . . ."—Richard Huelsenbeck, "Dada Lives!" (1936), in *The Dada Painters and Poets,* edited by Robert Motherwell, p. 280.

Page

191 Dada was "not at all modern . . ."—Tristan Tzara, "Lecture on Dada, 1922," in *The Dada Painters and Poets,* edited by Robert Motherwell, p. 247.

191 "Art is not serious I assure you"—Tristan Tzara, "Manifesto of Mr. Antipyrene," in *The Dada Painters and Poets,* edited by Robert Motherwell, p. 76.

191 "the Dadaists despised what is commonly regarded as art . . ."—Jean Arp, "Looking," in *Arp,* edited by James Thrall Soby, p. 13.

191 "the true dadas are against Dada"—Tristan Tzara, "Seven Dada Manifestoes," in *The Dada Painters and Poets,* edited by Robert Motherwell, p. 92.

191 "We had found in the war . . ."—Richard Huelsenbeck, interview with author.

192 "the spirit of Jarry . . ."—Francis Steegmuller, "Duchamp: Fifty Years Later," *Show.*

192 "It wasn't Dada . . ."—Pierre Cabanne, *Dialogues with Marcel Duchamp,* p. 56.

192 "You see, the dadas were really committed to action . . ."—Interview with author.

193 "Above all, I wanted to change life . . ."—Richard Huelsenbeck, *Memoirs of a Dada Drummer,* p. 15.

193 "a free republic, independent of uptown"—Steven Watson, *Strange Bedfellows,* p. 412. See also John Loughery, *John Sloan: Painter and Rebel,* p. 228.

193 "You're ladies, so stay . . ."—Ettie Stettheimer Journals, May 12, 1917, YCAL.

194 "filthy publication"—Beatrice Wood, *I Shock Myself,* p. 31.

194 "Friday was a scorcher . . ."—Ettie Stettheimer Journals, July 30, 1917, YCAL.

195 "It seemed very real, French, and classical . . ."—Parker Tyler, *Florine Stettheimer: A Life in Art,* p. 69.

195 "Because I feared the roller coasters . . ."—Beatrice Wood, *I Shock Myself,* p. 37.

195 "It just happened in the most natural way . . ."—Beatrice Wood, interview with author.

195 "With Roché," she said—Ibid.

197 "Here summer is just like winter . . ."—MD to Louise Arensberg, August 25, 1917, PMA. In Marcel Duchamp, "Marcel Duchamp's Letters to Walter and Louise Arensberg, 1917–1921."

198 "Picabia could not live . . ."—William A. Camfield, *Francis Picabia,* pp. 101–2.

199 In the first of Roché's many journal entries . . .—Roché papers, HRC.

199 "Varèse and Picabia would lie around . . ."—Louise Varèse, *A Looking Glass Diary,* p. 132.

199 Duchamp told Roché that he was thinking about leaving New York—Jennifer Gough-Cooper and Jacques Caumont, *Ephemerides,* September 29, 1917.

199 "going to be useful to my country after all . . ."—MD to Ettie Stettheimer, October 8, 1917, YCAL.

200 Dreier had studied art . . .—Francis M. Naumann, *New York Dada,* edited by Rudolf E. Kuenzli, p. 153ff.

200 "I feel so conscious of Duchamp's brilliancy . . ."—Katherine Dreier to William Glackens, April 6, 1917, YCAL.

200 Dreier also wrote to Duchamp—letter dated April 13, 1917, YCAL.

201 "It is $1.50 a person . . ."—Katherine Dreier to Mary Dreier, January 13, 1918, YCAL.

Page

202 "I had found a sort of projector . . ."—Pierre Cabanne, *Dialogues with Marcel Duchamp,* p. 60.

202 "The painting was a form of résumé . . ."—Interview with author.

203 "*Tu m'emmerdes* . . ."—H. P. Roché, *Victor,* p. 20.

204 "a sort of multicolored cobweb"—MD to Jean Crotti, July 8, 1918, AAA. (See also Marcel Duchamp, "Affectueusement, Marcel.")

204 "the shape could be changed at will"—Interview with author.

204 "Duche expects to leave for Buenos Aires next month . . ."—Ettie Stettheimer Journals, July 24, 1918, YCAL.

205 "Are you coming to N.Y. this week? . . ."—MD to Stettheimer sisters, July 29, 1918, YCAL.

205 Carrie Stettheimer's dollhouse—This amazing artifact, with Duchamp's *Nude* and many other replicas of art works contributed by artist friends, can be seen today in the Museum of the City of New York.

206 "Good bye dear . . ."—MD to H. P. Roché, August 11, 1918, HRC.

206 "I would very much like to play chess with you again . . ."—Jennifer Gough-Cooper and Jacques Caumont, *Ephemerides,* August 13, 1918.

206 The French film director Léonce Perret—Ibid., August 11, 1918.

206 "I have a very vague intention of staying down there a long time . . ."—MD to Jean Crotti, July 8, 1918, AAA. (See also Marcel Duchamp, "Affectueusement, Marcel.")

Buenos Aires

207 The curious thing about that moustache and goatee . . . —Herbert Crehan, "Dada," excerpts from a radio interview with Duchamp, published in *Evidence* (Toronto), no. 3 (fall 1961), pp. 36–38.

207 "I only have light in the evening . . ."—MD to Arensbergs, postmarked August 26, 1918, PMA. (Reprinted in Marcel Duchamp, "Marcel Duchamp's Letters to Walter and Louise Arensberg, 1917–1921."

207 "Delightful voyage . . ."—MD to Stettheimer sisters, August 24, 1919, YCAL.

207 ran a brothel in Buenos Aires—See Otto Hahn, "Passport No. G25300," *Art and Artists.*

208 "Tell Suzanne my despair . . ."—MD to Jean Crotti, October 26, 1918, AAA. (See also Marcel Duchamp, "Affectueusement, Marcel.")

208 "deep friendship and admiration . . ."—MD to Walter Pach, November 15, 1918, AAA. (See also Marcel Duchamp, "Amicalement, Marcel.")

209 "Yvonne finds herself deprived of her night life"—MD to Jean Crotti, October 26, 1918, AAA. (See also Marcel Duchamp, "Affectueusement, Marcel.")

209 Dreier had come to write a series of articles—Her book, *Five Months in the Argentine: From a Woman's Point of View,* was privately published in 1920.

209 "Buenos Aires does not admit women on their own . . ."—MD to Walter Arensberg, November 8, 1918, PMA. (Reprinted in Marcel Duchamp, "Marcel Duchamp's Letters to Walter and Louise Arensberg, 1917–1921.")

Page

209 "I have started a small glass . . ."—MD to Jean Crotti, October 26, 1918, AAA.
 (See also Marcel Duchamp, "Affectueusement, Marcel.")

209 "awaken these sleepy dark faces"—Ibid.

209 He wrote to a French friend Henri-Martin Barzun—MD to Walter Arensberg,
 November 8, 1918, PMA. (Reprinted in Marcel Duchamp, "Marcel Duchamp's
 Letters to Walter and Louise Arensberg, 1917–1921.")

209 told Crotti in Paris to mail him some literature—MD to Jean Crotti, October 26,
 1918, AAA. (See also Marcel Duchamp, "Affectueusement, Marcel.")

209 "I myself will exhibit nothing . . ."—MD to Walter Arensberg, November 8,
 1918, PMA. (Reprinted in Marcel Duchamp, "Marcel Duchamp's Letters to Wal-
 ter and Louise Arensberg, 1917–1921.")

210 "Buenos Aires does not exist . . ."—MD to Ettie Stettheimer, November 12, 1918,
 YCAL.

210 "It was down near Washington Square then . . ."—Interview with author.

210 "I play chess all the time . . ."—MD to Walter Arensberg, end of March, 1919,
 PMA. (Reprinted in Marcel Duchamp, "Marcel Duchamp's Letters to Walter
 and Louise Arensberg, 1917–1921.")

210 "I play [chess] day and night . . ."—MD to Stettheimer sisters, May 3, 1919, YCAL.

211 "never read Descartes, to speak of"—Dore Ashton, "An Interview with Marcel
 Duchamp," *Studio International,* pp. 244–47.

211 "very much of a Cartesian"—Unpublished interview by G. and R. Hamilton for
 BBC program "Art, Anti-Art," 1959.

211 "doubting everything, I had to find . . ."—Marcel Duchamp, interview with
 author.

211 "Chess is a marvelous piece of Cartesianism . . ."—Marcel Duchamp, interview
 with author.

211 "From my close contact with artists and chess players . . ."—AAA, Duchamp
 papers, August 30, 1952.

211 "I insisted that she not leave . . ."—MD to Jean Crotti, March 9, 1919, AAA.
 (Reprinted in Marcel Duchamp, "Affectueusement, Marcel.")

211 "My mother didn't talk about him much . . ."—Interview with author.

212 "go through the book, choose its own problems . . ."—Pierre Cabanne, *Dialogues
 with Marcel Duchamp,* p. 61.

213 "It amused me to bring the idea of happy and unhappy into readymades . . ."—
 Ibid.

214 "the seriousness of a book full of principles"—Otto Hahn, "Passport No.
 G255300," *Art and Artists.*

214 "the treatise seriously got the facts of life"—Harriet and Sidney Janis, "Marcel
 Duchamp, Anti-Artist," in *The Dada Poets and Painters,* edited by Robert Moth-
 erwell, p. 313.

214 "I feel I am quite ready to become a chess maniac . . ."—MD to Walter Arens-
 berg, June 15, 1919, PMA. (Reprinted in Marcel Duchamp, "Marcel Duchamp's
 Letters to Walter and Louise Arensberg, 1917–1921.")

214 Arthur Cravan's disappearance—See Carolyn Burke, *Becoming Modern: The
 Life of Mina Loy,* pp. 258–67.

Page

214 "I dread very much my return to Puteaux . . ."—MD to Walter and Magda Pach, June 6, 1919, AAA. (See also Marcel Duchamp, "Amicalement, Marcel.")

215 "with the same dust"—MD to Walter and Magda Pach, September 3, 1919, AAA. (See also Marcel Duchamp, "Amicalement, Marcel.")

216 "La Jolie Rousse"—Guillaume Apollinaire, *Calligrammes: Poems of Peace and War, 1913–1916,* p. 342.

217 an incendiary article that vilified Matisse . . .—William A. Camfield, *Francis Picabia,* p. 129.

217 "It's a projectile"—Walter Pach, *Queer Thing, Painting,* pp. 144–45.

218 "I have a clearer and surer vision of the road passed over . . ."—Raymond Duchamp-Villon to John Quinn, April 8, 1916, NYPL.

218 "a little tubercular"—Roché journals, October 27, 1919, HRC.

219 "the shock of two heavy masses . . ."—Roché journals, November 28, 1919, HRC.

219 "I've been to Germany . . ."—Ibid.

219 a memorable dinner party at Brancusi's studio—Roché journals, November 29, 1919, HRC.

219 "They were all kindness themselves . . ."—Jennifer Gough-Cooper and Jacques Caumont, *Ephemerides,* November 16, 1919.

219 "tremendously alive at 71"—Ibid.

219 Roché noticed that Dreier kept taking Duchamp's arm—Roché journals, November 21, 1919, HRC.

220 were both sleeping with Yvonne Chastel in Paris—See Jennifer Gough-Cooper and Jacques Caumont, *Ephemerides,* December 17, 1919.

220 They met by chance on the steps of a Métro station—Alexina Duchamp to author.

221 Duchamp bought the check back from him for 1,000 francs—Sidney and Harriet Janis, unpublished interviews with Duchamp, 1953.

221 Duchamp bought, on the rue de Rivoli, a cheap postcard reproduction of the *Mona Lisa*—Ibid.

221 "no other human being, historical or imaginary . . ."—Roger Shattuck, "The Tortoise and the Hare: A Study of Valéry, Freud, and Leonardo da Vinci," in *Leonardo da Vinci: Aspects of the Renaissance Genius,* edited by Morris Philipson, p. 374.

222 "It was using what they do on posters . . ."—Interview with author.

222 "The curious thing about that moustache and goatee . . ."—Herbert Crehan, "Dada," excerpts from a radio interview with Duchamp, published in *Evidence* (Toronto), no. 3 (fall 1961), pp. 36–38.

223 Since they had everything else—Hans Richter, *Dada: Art and Anti-Art,* p. 99.

Enter Rose Sélavy

224 Much better than to change religion would be to change sex.—Interview with author.

224 "In spite of the few changes . . ."—MD to John Quinn, February 16, 1920, NYPL.

224 "One doesn't drink here any more . . ."—MD to Yvonne Chastel, February 26, 1920, Getty Center Archives, Malibu, Calif.

Page

225 her husband had managed . . . to borrow four thousand dollars from the Arens-
 bergs—Beatrice Wood, *I Shock Myself,* p. 41.

225 Gabrielle Buffet-Picabia came to New York toward the end of February—Jen-
 nifer Gough-Cooper and Jacques Caumont, *Ephemerides,* February 26, 1920.

225 Gabrielle indicated that they did—In an interview with Malitte Matta, who
 reported it to the author.

226 "People took modern art very seriously . . ."—Jennifer Gough-Cooper and
 Jacques Caumont, *Ephemerides,* May 6, 1920.

226 Duchamp had suggested making it fifty cents for critics—MD to Jean Crotti and
 Suzanne Duchamp, circa October 2, 1920, AAA. (See also Marcel Duchamp,
 "Affectueusement, Marcel.")

227 One of the advantages of this new life, he wrote to Yvonne Chastel—MD to
 Yvonne Chastel, July 15, 1920, Getty Center Archives, Malibu, Calif.

227 "We chatted happily . . ."—Beatrice Wood, *I Shock Myself,* p. 46.

229 "Duchamp switched on the motor . . ."—Man Ray, *Self-Portrait,* p. 62.

230 He intimated to Man Ray that he might stop painting altogether—Ibid., p. 73.

230 "I've made enormous progress . . ."—MD to Jean Crotti and Suzanne
 Duchamp, circa October 1920, AAA. (See also Marcel Duchamp, "Affectueuse-
 ment, Marcel.")

231 "It was not to change my identity . . ."—Interview with author.

231 a castration symbol in the "widow"—Arturo Schwarz, *The Complete Works of
 Marcel Duchamp,* p. 480.

232 "Dada belongs to everybody . . ."—*The Dada Painters and Poets,* edited by Robert
 Motherwell, p. 216.

234 "I kept hoping to have a better time . . ."—Quoted in Wayne Andrews, *The Sur-
 realist Parade,* p. 40.

235 "if you read André Gide aloud for ten minutes . . ."—*The Dada Painters and
 Poets,* edited by Robert Motherwell, p. 176.

235 "TO THE PUBLIC . . ."—Ibid., p. 109.

236 Duchamp wrote back that he had nothing to exhibit—MD to Jean Crotti and
 Suzanne Duchamp, May 19, 1921, AAA. (See also Marcel Duchamp,
 "Affectueusement, Marcel.")

236 "exquisite smile, subtle and gay"—Roché journals, June 25, 1921, HRC.

236 "an immediate exchange and correspondence"—Jennifer Gough-Cooper and
 Jacques Caumont, *Ephemerides,* September 1, 1921.

237 "Someone came in by the window . . ."—Pierre de Massot, "Sketch for a Future
 Portrait of Marcel Duchamp," *Journal des Poètes* (Brussels), March 1948.

237 "From afar," he wrote to Ettie Stettheimer—MD to Ettie Stettheimer, July 6,
 1921, YCAL.

238 "The whole of Greenwich Village is walking up and down Montparnasse"—
 MD to Stettheimer sisters, September 1, 1921, YCAL.

238 "the interrogation of shop windows . . . the coition through a glass pane . . ."—
 Marcel Duchamp, *Salt Seller,* p. 74. This note, which is dated 1913, was not
 included in *The Green Box.* It was first published in 1966, in the collection entitled
 A l'infinitif.

Page

239 "I could have made twenty windows . . ."—Unpublished interview with Harriet Janis, quoted in *Marcel Duchamp,* edited by Anne d'Harnoncourt and Kynaston McShine, p. 295.

239 Paris was "deadly dull"—MD to Stettheimer sisters, September 1, 1921, YCAL.

239 "What could you be doing for 24 hours a day in California . . ."—MD to Arensbergs, November 15, 1921, PMA. (Reprinted in Marcel Duchamp, "Marcel Duchamp's Letters to Walter and Louise Arensberg, 1917–1921.")

Bedbugs Are Required

240 The only thing which could interest me now . . .—MD to H. P. Roché, February 15, 1922, HRC.

240 "You had the feeling that the bluenoses were in the saddle . . ."—Calvin Tomkins, *Living Well Is the Best Revenge,* p. 21.

240 "the place where the twentieth century was"—Gertrude Stein, *Paris, France,* p. 21.

240 "I work a little on it . . ."—MD to Man Ray, no date, probably spring 1922, HRC.

241 "something that absolutely didn't need . . . to be compared with other works of art of the time"—Arts Council of Great Britain, interview in Richard Hamilton's studio, June 19, 1966, unpublished.

241 "I became bored with it . . ."—Interview with author.

241 "fed up with the idea of being a painter or a filmmaker . . ."—MD to H. P. Roché, February 15, 1922, HRC.

241 "I don't remember seeing anyone else at the party . . ."—Georgia O'Keeffe, in *Marcel Duchamp,* edited by Anne d'Harnoncourt and Kynaston McShine, p. 212.

241 "the charm of his physical fineness"—In Henri Waste, *Love Days,* p. 115.

241 "where you and I have spent such good times . . ."—MD to Ettie Stettheimer, July 6, 1920, YCAL.

242 "left with tears in my eyes . . ."—MD to Ettie Stettheimer, July 9, 1922, YCAL.

242 "does more credit to his thoughtfulness . . ."—Ettie Stettheimer Journals, July 31, 1922, YCAL.

242 *Pensée-Cadeau*—Ettie Stettheimer to MD, no date, 1922, YCAL.

243 "He never was hurried or flurried . . ."—This and the following quotations are from *Love Days* by "Henri Waste."

245 "universal panacea, or fetish . . ."—MD to Tristan Tzara, no date, BLJD.

245 "take care of the United States"—Ibid.

245 "I am a businessman . . ."—MD to Man Ray, no date. HRC.

245 "The room looked as though it had never been swept . . ."—Georgia O'Keeffe, in *Marcel Duchamp,* edited by Anne d'Harnoncourt and Kynaston McShine, pp. 213–14.

246 "You know exactly how I feel about photography . . ."—Marcel Duchamp, *Salt Seller,* p. 165.

246 "It is by rallying around this name . . ."—*Littérature,* October 1922, as cited in Jennifer Gough-Cooper and Jacques Caumont, *Ephemerides,* October 1, 1922.

Page

247 "Breton did not smile . . ."—Quoted in Anna Balakian, *André Breton: Magus of Surrealism,* p. 9.

248 *"Rrose Sélavy trouve qu'un incesticide . . ."*—Marcel Duchamp, *Salt Seller,* p. 105.

248 he suggested that Desnos and Rrose Sélavy become engaged—MD to André Breton, November 25, 1922, BLJD: "Why doesn't he ask for the hand of Rrose? She would be delighted."

248 "words have stopped playing . . ."—*Littérature,* December 1922, as cited in Jennifer Gough-Cooper and Jacques Caumont, *Ephemerides,* December 1, 1922.

248 "To my mind, nothing more remarkable has happened in poetry in many years"—Ibid.

248 "For me," he said once, "words are not merely a means of communication . . ."—Katharine Kuh, "Marcel Duchamp," in *The Artist's Voice,* pp. 88–89.

250 "definitively unfinished"—Interview with author.

250 "It may be that subconsciously I never intended to finish it . . ."—Katharine Kuh, "Marcel Duchamp," in *The Artist's Voice,* p. 81.

251 "I was really trying to invent . . ."—Ibid.

Drawing On Chance

252 *Question d'hygiène intime . . .* —One of the sayings of Rrose Sélavy, freely translated by Elmer Peterson. Marcel Duchamp, *Salt Seller,* p. 106.

252 "My ambition is to be a professional chess player"—MD to Francis Picabia, February 8, 1921, BLJD.

253 "I am starting with the small nations . . ."—MD to Ettie Stettheimer, July 26, 1923, YCAL.

253 "the man from whom I would be the most inclined to expect something . . ."—André Breton to Jacques Doucet, August 12, 1922, BLJD. (Cited in François Chapon, *Mystère et splendeurs de Jacques Doucet, 1853–1929,* p. 291.)

255 "an exchange and not a payment"—MD to Jacques Doucet, February 28, 1924, BLJD.

255 "All expositions of painting and sculpture make me ill . . ."—MD to Jacques Doucet, October 19, 1925, BLJD.

256 "You'd better come along . . ."—Quoted by Lincoln Kirstein in his preface to Henry McBride, *The Flow of Art.*

257 "Dinner at Brancusi's . . ."—Roché journals, January 28, 1922, HRC.

257 According to Kiki's friend Thérèse Treize—See Billy Klüver and Julie Martin, *Kiki's Paris,* p. 124.

257 "a beautiful, tall dancer, calm and noble"—Roché journals, May 19, 1924, HRC.

257 "a handsome spectacle . . ."—Roché journals, June 9, 1924, HRC.

258 "He's had lots of my mistresses"—Roché journals, July 3, 1924, HRC.

258 "She suffers, Marcel is debauched . . ."—Ibid.

259 "with eyes of fire . . ."—Roché journals, June 13, 1924, HRC.

259 "bouquet of three flowers"—Roché journals, July 31, 1924, HRC.

Page

259 "She has no hope . . ."—Roché journals, August 16, 1924, HRC.

259 "The climate suits me perfectly . . ."—MD to Jacques Doucet, May 31, 1924, BLJD.

259 "You see, . . . I have not ceased to be a painter . . ."—MD to Francis Picabia, April 20, 1924, BLJD.

260 "M. Duchamp thoroughly earned his title . . ."—Quoted in *New Chess,* April 1989, p. 37.

261 "If anyone is in the business of buying art . . ."—*Little Review* 10, no. 2 (fall–winter 1924–25): p. 18.

261 Katherine Dreier thought it was a terrible idea—Jennifer Gough-Cooper and Jacques Caumont, *Ephemerides,* December 8, 1924.

262 *The Wonderful Book*—see Arturo Schwarz, *The Complete Works of Marcel Duchamp,* p. 588.

263 "a poor imitation of Dada . . ."—William A. Camfield, *Picabia,* pp. 207–8.

263 "Art is not fabricated . . ."—Ibid.

264 *Relâche* "is perpetual movement . . ."—Ibid., p. 210.

264 "a little scenario of nothing at all . . ."; "limited to realizing technically the aims of Francis Picabia"—Ibid., p. 212.

267 "I myself have never had a part . . ."—André Parinaud, interview with Duchamp, in catalog to "Omaggio a André Breton" (Milan: Galleria Schwarz, June 1967).

Duchamp Married!!!

268 My life hasn't changed in any way . . . —MD to Walter and Magda Pach, June 24, 1927, AAA.

269 "My statistics give me full confidence . . ."—MD to Ettie Stettheimer, March 27, 1925, YCAL.

269 "to force roulette to become a game of chess"—MD to Jacques Doucet, January 16, 1925, BLJD.

269 He very nearly won his seventh-round match—Jennifer Gough-Cooper and Jacques Caumont, *Ephemerides,* September 8, 1925.

272 "You will see me from 2 October . . ."—MD to Ettie Stettheimer, August 23, 1926, YCAL.

273 "Understand nothing about this 'town' . . ."—MD to Jacques Doucet, May 3, 1926, BLJD.

273 one of the grandest works of art of all time—Herbert J. Seligmann, *Alfred Stieglitz Talking,* p. 110.

274 "I go to the opera every night . . ."—MD to Ettie Stettheimer, January 13, 1927, YCAL.

274 "M. Duchamp—what is he doing? . . ."—Jennifer Gough-Cooper and Jacques Caumont, *Ephemerides,* January 11, 1927.

275 "On that first voyage with Duchamp . . ."—Julien Levy, *Memoir of an Art Gallery,* p. 20.

277 "handsome, nice, elegant"—"Le Récit de Lydie," *Rrosopopées,* nos. 19–20 (March 1989): 475.

Page

277 Brancusi soon began calling her "Morice"—*Brancusi,* edited by Pontus Hulten et al., p. 267, note 21. See also Ann Temkin, "Brancusi and His American Collectors," in Friedrich Teja Bach et al., *Constantin Brancusi,* p. 64: "Agnes Meyer's daughter Elizabeth recalls Brancusi's explication of this usage: 'Morices,' he explained quite seriously, 'are a certain kind of person. You don't describe them. They exist in the world and they recognize each other when they meet.' Who invented them, I wanted to know. 'Duchamp invented them,' he replied."

277 "desastrous"—Roché journals, May 27, 1927, HRC.

277 "If he had known that we had tried it out!"—"Le Récit de Lydie," *Rrosopopées,* p. 480.

278 "An important news . . ."—MD to Katherine Dreier, May 25, 1927, YCAL.

278 the sum Lydie's father was prepared to settle on her—Jennifer Gough-Cooper and Jacques Caumont, *Ephemerides,* June 4, 1927.

278 "annihilated"—"Le Récit de Lydie," *Rrosopopées,* p. 482.

279 Man Ray brought along his movie camera—Man Ray's film of the wedding, which has never been shown publicly, is in the archives of Jennifer Gough-Cooper and Jacques Caumont.

280 "a very fat girl"—Carrie Stettheimer to her sisters, June 10, 1927, YCAL.

280 "I rather expected just about this to happen . . ."—Ettie Stettheimer to Alfred Stieglitz, June 24, 1927, YCAL.

280 "Duchamp married!!!"—Alfred Stieglitz to Ettie Stettheimer, June 27, 1927, YCAL.

280 "a very fat girl . . . very, very fat"—Florine Stettheimer to Henry McBride, June 27, 1927, AAA.

280 "Why didn't he then, since he likes 'em fat . . ."—Henry McBride to Florine Stettheimer, July 13, 1927, AAA.

280 "adopted son"; "very powerful . . ."—Katherine Dreier to MD, August 5, 1927, YCAL.

281 "gastronomic" honeymoon—"Le Récit de Lydie," *Rrosopopées,* p. 486.

281 "a real epicure . . ."—Ibid., p. 488.

281 "owned nothing"—Ibid.

281 "he had an almost morbid horror of all hair . . ."—Ibid., p. 489.

281 "Why not, if it pleased him?"—Ibid.

281 Until the end of June . . .—Ibid., p. 490.

281 "A charming experience so far . . ."—MD to Walter and Magda Pach, June 24, 1927, AAA.

281 "As I said in my first letter . . ."—MD to Katherine Dreier, June 27, 1927, YCAL.

281 The trouble had started, according to Lydie—"Le Récit de Lydie," *Rrosopopées,* p. 491.

281 Lydie finally met the American clients—Ibid., pp. 491–92.

282 "What could they do with them?"—Ibid., p. 493.

282 Crotti asked Lydie to pose—Ibid., p. 496.

282 She got up and glued the pieces to the board—Man Ray, *Self-Portrait,* p. 190.

282 "amorous excesses"—"Le Récit de Lydie," *Rrosopopées,* p. 499.

283 "That extra night was one night too many"—Ibid., p. 500.

Page

283 He explained . . . that he could no longer support . . ."—Ibid., p. 503.

283 "Haven't you understood yet?"—Ibid., p. 505.

The Most Singular Man Alive

284 Don't see any pessimism in my decisions . . .—MD to Katherine Dreier, September 11, 1929, YCAL.

284 "I enjoy every minute of my old self again . . ."—MD to Katherine Dreier, March 12, 1928, YCAL.

284 Kay Boyle . . . remembered her going "on a sort of wild thing afterward . . ."—Kay Boyle, interview with author.

285 "the old art dealer Knoedler . . ."—Man Ray, *Self-Portrait,* p. 187.

285 "almost ready" to accept the position—MD to Katherine Dreier, July 2, 1928, YCAL.

285 "The feeling of the market here is so disgusting . . ."—MD to Alfred Stieglitz, July 2, 1928, YCAL.

285 "The more I live among artists . . ."—MD to Katherine Dreier, November 5, 1928, YCAL.

287 "England loved my beauty . . ."—Katherine Dreier to MD, May 28, 1930, YCAL.

288 "Do you think that I am terrible . . ."—Katherine Dreier to Duchamp, September 11, 1929, YCAL.

288 "You must understand . . ."—MD to Katherine Dreier, September 11, 1929, YCAL.

288 "Well are you going to meet me in Paris . . ."—Katherine Dreier to MD, January 20, 1931, YCAL.

288 "That's too bad. Too bad."—Jennifer Gough-Cooper and Jacques Caumont, *Ephemerides,* March 18, 1936.

288 "I was a little sorry . . ."—Interview with author.

289 nor was he a particularly innovative tactician—See Robert Lebel, "Marcel Duchamp as a Chess Player and One or Two Related Matters," *Studio International,* January–February 1975.

289 "a very strong player"—Edward Lasker, in Calvin Tomkins, *The Bride and the Bachelors,* p. 51.

289 "Of course you want to become champion of the world . . ."—Interview with author.

290 "arranged like a boat"—Roché journals, April 26, 1930, HRC.

290 "with his pipe . . ."—H. P. Roché, "Souvenirs of Marcel Duchamp," in Robert Lebel, *Marcel Duchamp,* p. 85.

291 "the man from whom we persist in expecting more . . ."—André Breton, *Le Surréalisme et la peinture.*

291 "the most singular man alive . . ."—André Breton, *Nadja,* p. 31.

292 "Totor is nicely installed . . ."—Roché journals, September 25, 1932, HRC.

292 "Often there would be people for dinner . . ."—Marjorie Watkins, interview with author.

Page

293 "Ideal weather and charming peseta"—MD to Man Ray, August 21, 1933, YCAL.

294 "It is still the great lacuna . . ."—Walter Arensberg to MD, May 23, 1930, PMA.

294 "are simply trying to play us for suckers"—Louise Arensberg to Beatrice Wood, July 15, 1930, AAA.

295 Barnes was "very kind"—Jennifer Gough-Cooper and Jacques Caumont, *Ephemerides,* December 3, 1933.

296 "tried in that big Glass to find a completely personal and new means of expression . . ."—"Marcel Duchamp Speaks," unpublished interview broadcast by the BBC in the series "Art, Anti-Art," 1959.

296 "I wanted to reproduce them as accurately as possible . . ."—Michel Sanouillet, "Dans l'atelier de Marcel Duchamp," *Les Nouvelles littéraires,* p. 5.

298 "Well dear your amazing book . . ."—Katherine Dreier to MD, October 16, 1934, YCAL. What Dreier meant by "the glass was broken" is unclear. There was no glass in *The Green Box.* Perhaps she was referring to *The Large Glass* itself.

298 "a capital event"—This and subsequent quotations from Breton's essay are from the English version that appeared first in *View* 5, no. 1 (1945); it was subsequently reprinted in Robert Lebel's *Marcel Duchamp,* pp. 88–94.

Vacation in Past Time

300 Every picture has to exist in the mind . . .—Marcel Duchamp, in Walter Pach, *Queer Thing, Painting,* p. 155.

300 "Mais que voulez-vous . . ."—Cleve Gray, "The Great Spectator," *Art in America.*

300 "an album of approximately all the things I have produced"—MD to Katherine Dreier, March 5, 1935, YCAL.

301 "playtoy"—Ibid.

302 "This second project . . ."—Ibid.

302 "All the discs were turning . . ."—H. P. Roché, "Souvenirs of Marcel Duchamp," in Robert Lebel, *Marcel Duchamp,* pp. 84–85.

302 "If people find it too cheap . . ."—MD to Katherine Dreier, December 7, 1935, YCAL.

303 "an amazing detail"—MD to Katherine Dreier, January 1, 1936, YCAL.

303 Dreier urged Alfred H. Barr, Jr.—Letter of February 11, 1936, YCAL.

303 Duchamp tried in several letters—MD to Katherine Dreier, May 3, May 12, and May 20, 1935, YCAL.

303 "I hope you will find it again"—MD to Katherine Dreier, May 20, 1935, YCAL.

303 "Dee, am I getting old?"—Katherine Dreier to MD, February 4, 1936, YCAL.

304 "with a tame excuse"—MD to Walter Pach, October 17, 1934, AAA. (See also Marcel Duchamp, "Amicalement, Marcel.")

304 "neither love nor intelligence regarding art"—Katherine Dreier to Duchamp, April 4, 1936, YCAL.

Page

304 "lack of confidence in Barr . . ."—Duchamp to Walter Pach, October 17, 1934, AAA. (See also Marcel Duchamp, "Amicalement, Marcel.")

304 "there would not be any more expenses . . ."—MD to Katherine Dreier, March 18, 1936, YCAL.

305 "This is my first summer in America for *years! . . .*"—MD to Katherine Dreier, May 11, 1936, YCAL.

306 "I have become a glazier . . ."—MD to H. P. Roché, July 12, 1936, HRC.

306 "an organization of time and space . . ."—Daniel MacMorris, "Marcel Duchamp's Frankenstein," *Art Digest,* January 1938, p. 22.

307 "The air is delicious . . ."—MD to Katherine Dreier, August 6, 1936, YCAL.

308 absurd inaccuracies—For example, the article states that when Duchamp exhibited a shovel at the Bourgeois Gallery in 1917, he also provided "an elaborate essay on its artistic worth."

308 "morose, poker faced painter . . ."—*Time,* August 31, 1936.

308 "The more I look at it . . ."—James Johnson Sweeney, "A Conversation with Marcel Duchamp," in *Wisdom,* edited by James Nelson, p. 92.

308 "a wonderful vacation . . ."—MD to Katherine Dreier, September 4, 1936, YCAL.

308 The process required Duchamp's direct involvement—For details of the collotype process and Duchamp's part in it, I have relied on Ecke Bonk's comprehensive study, *Marcel Duchamp: The Box in a Valise,* pp. 153–54.

309 "I have always been so much impressed by it . . ."—Alfred H. Barr, Jr., to MD, May 8, 1936, Museum of Modern Art archives.

310 "I was operating on a very low margin then . . ."—Interview with author.

311 "I am convinced that my production . . ."—MD to Walter Pach, September 28, 1937, AAA. (See also Marcel Duchamp, "Amicalement, Marcel.")

311 "Duchamp had the lightest touch of all the Cubists . . ."—C. J. Bulliet, *Chicago Daily News,* February 5, 1937.

312 "anything that could bring about the meeting . . ."—Interview with author.

313 Marcel Jean saw him in the main gallery—Marcel Jean, *The History of Surrealist Painting,* p. 282.

Box-in-a-Suitcase

314 You have invented a new kind of autobiography . . . —Walter Arensberg to MD, May 21, 1943, PMA. This letter was marked "not sent," so Duchamp probably never received it.

315 "Marcel was a handsome Norman . . ."—Peggy Guggenheim, *Out of This Century: Confessions of an Art Addict* (hereafter cited as *Out of This Century*), p. 50.

315 "I could not distinguish one modern work from another . . ."—Peggy Guggenheim, *Confessions of an Art Addict,* p. 47.

315 At one point she wrote to tell Duchamp that Sidney Janis—Katherine Dreier to MD, January 13, 1938, YCAL.

315 "very exciting idea"—Katherine Dreier to MD, August 1, 1939, YCAL.

Page

315 he suggested that she lend, rather than give—MD to Katherine Dreier, August 8, 1939, YCAL.

316 In a letter to Kiesler—Jennifer Gough-Cooper and Jacques Caumont, *Ephemerides,* June 25, 1937.

317 the printer scratched them into the celluloid—Ecke Bonk, *Marcel Duchamp: The Box in a Valise,* p. 155.

317 "Well, it had to come . . ."—MD to Katherine Dreier, September 24, 1939, YCAL.

318 "I didn't know anything about the prices of things . . ."—Jacqueline Bograd Weld, *Peggy: The Wayward Guggenheim,* p. 197.

318 "Lingerie is on the next floor"—Ibid., p. 198.

319 "the organization of the country is not as disagreeable . . ."—MD to Arensbergs, July 16, 1940, PMA.

319 "the 'dramatic' is over"—MD to Beatrice Wood, July 17, 1940, AAA.

319 he offered to send Arensberg two "small things"—MD to Arensbergs, July 16, 1940, PMA.

323 "I am reserving one for you . . ."—MD to H. P. Roché, January 7, 1941, HRC.

323 "I sell them for 4,000 francs each . . ."—MD to H. P. Roché, January 17, 1941, HRC.

323 "stubborn as a horse"—MD to Alice Roullier, October 26, 1942, Roullier papers, Newberry Library, Chicago.

323 "One never goes out in the evening . . ."—MD to H. P. Roché, January 17, 1941, HRC.

323 "I thought of a scheme . . ."—Interview with author.

325 "When, where, and why shall I meet you?"—Jacqueline Bograd Weld, *Peggy: The Wayward Guggenheim,* p. 229.

325 He had his own refuge in Sanary—For several years, Sanary had been a haven for German writers in exile (Thomas and Heinrich Mann, Lion Feuchtwanger, Bertolt Brecht, Arthur Koestler, Julius Meier-Graefe, and Franz Werfel, among others). By the time Duchamp got there, most of the German literary figures had emigrated to the United States.

326 "like her books . . ."—Varian Fry, *Surrender on Demand,* p. 185.

326 "Of course . . . I was very fond of Marcel . . ."—Interview with author.

327 "I remember arriving in Grenoble . . ."—H. P. Roché, "Souvenirs of Marcel Duchamp," in Robert Lebel, *Marcel Duchamp,* pp. 83–84.

327 "It is the first time I have seen him a little down . . ."—Roché journals, July 14, 1941, HRC.

327 "Work—it's horribly difficult to put my hand on a 'tangible' idea . . ."—MD to H. P. Roché, January 26, 1942, HRC.

328 "a production which is no longer manual . . ."—Ibid.

328 "Why not watercolors of the Riviera?"—Roché journals, December 30, 1941, HRC.

328 "a little masterpiece of humoristic sculpture . . ."—Roché journals, March 1942, HRC.

328 "It's a new turning point in his life"—Ibid.

Page

328 "very pleasant holiday"—Jennifer Gough-Cooper and Jacques Caumont, *Ephemerides,* June 7, 1942.

328 "alone in a bathroom . . ."—MD to H. P. Roché, May 27, 1942, HRC.

328 "the best trip of all"—Jennifer Gough-Cooper and Jacques Caumont, *Ephemerides,* June 25, 1942.

New York, 1942

329 I am dumbfounded . . .—MD to Katherine Dreier, November 4, 1942, YCAL.

329 In Paris, as Max Ernst said—Jacqueline Bograd Weld, *Peggy: The Wayward Guggenheim,* p. 260.

329 "smiling composure . . ."—Robert Allerton Parker, "America Discovers Marcel," in *View,* p. 32.

330 "people whose names were written in gold . . ."—John Cage, interview with author.

331 "It was Duchamp"—Ibid.

331 as Arensberg put it in a letter to Robert Parker—Walter Arensberg to R. A. Parker, June 1, 1942, PMA.

331 did the Arensbergs know anyone in Hollywood—MD to Arensbergs, July 21, 1942, PMA.

331 He also told the Arensbergs . . .—MD to Arensbergs, July 5, 1942, PMA.

331 "one of the most delightful and strangest experiences . . ."—Joseph Cornell, *Theater of the Mind: Selected Diaries, Letters and Files,* p. 98.

333 "Mr. Duchamp told us we could play here"—Arturo Schwarz, *The Complete Works of Marcel Duchamp,* p. 515.

335 Spring Salon for Young Artists—In addition to Pollock, this show included works by William Baziotes, Ilya Bolotowsky, Peter Busa, Jimmy Ernst (Max's son), Morris Graves, Matta, Robert Motherwell, Ad Reinhardt, Sonia Sekula, and Hedda Sterne.

335 "Pretty awful, isn't it? . . ."—Jacqueline Bograd Weld, *Peggy: The Wayward Guggenheim,* p. 305.

335 "You can't be serious . . ."—Ibid.

335 "among the strongest abstract paintings I have yet seen by an American"—Clement Greenberg, *The Nation,* November 27, 1943.

337 "poor art for poor people"—See Harold Rosenberg, *The De-definition of Art,* p. 35.

337 "a number of relatively obscure American artists . . ."—Clement Greenberg, *Art News,* Summer 1957.

337 "I am particularly impressed . . ."—"Jackson Pollock," *Arts and Architecture,* February 1944, p. 14. (Answer to questionnaire.)

339 "I have sold 7 . . ."—MD to Alice Roullier, December 4, 1942, Roullier papers, Newberry Library, Chicago.

339 "fingertips touching . . ."—*VVV: Almanac for 1943,* nos. 2–3 (March 1943).

340 "What the hell is this?"—Enrico Donati, interview with author.

Page

340 "I am dumbfounded . . ."—MD to Katherine Dreier, November 4, 1942, YCAL.

341 "not for *Vogue*"—Alexander Liberman, interview with author.

341 "which had been hanging fire for twenty years"—Peggy Guggenheim, *Out of This Century,* p. 272.

341 "or be deprived of any life"—Roché journals, March 1, 1940, HRC.

342 an evening at Hale House . . . —Peggy Guggenheim, *Out of This Century,* p. 271.

342 he "behaved more like a nurse than a lover"—Ibid., p. 283.

342 Mary Reynolds's work for the Resistance—Author's interview with F. B. Hubachek. See also Deirdre Bair, *Samuel Beckett,* pp. 308–15.

342 one of them was the painter Jean Hélion—Katharine Kuh, interview with author.

343 "statuesque, unmelodramatic . . ."—Janet Flanner, the Paris correspondent of the *New Yorker,* preserved Mary Reynolds's privacy by calling her "Mrs. Jeffries" in a series of three articles on "The Escape of Mrs. Jeffries," which appeared in the *New Yorker* issues of May 22, May 29, and June 5, 1943.

343 "I thought she was trapped . . ."—MD to Walter Pach, January 3, 1943, AAA. (See also Marcel Duchamp, "Amicalement, Marcel.")

Silence, Slowness, Solitude

344 Marcel Duchamp [is] the only one of all his contemporaries who is in no way inclined to grow older"—André Breton, "Testimony 45," *View,* p. 5.

345 "It was a medium-sized room . . ."—Calvin Tomkins, *The Bride and the Bachelors,* p. 61.

345 "What would I do with the money? . . ."—Beatrice Wood, *I Shock Myself,* p. 119.

345 "Duchamp always had the same lunch . . ."—Robert Motherwell, interview with author.

346 "as the huge panel moved . . ."—James Thrall Soby, *Saturday Review,* November 6, 1954.

347 "startling the commuters . . ."—George Heard Hamilton, "In Advance of Whose Broken Arm?" in Joseph Masheck, *Marcel Duchamp in Perspective,* pp. 73–76.

347 "unshakeable fidelity to the sole principle . . ."—André Breton, "Testimony 45," *View,* p. 5.

348 "Besides my personal admiration . . ."—MD to Monroe Wheeler, September 1944, Museum of Modern Art archives.

349 "The most insignificant thing you do . . ."—Neil Baldwin, *Man Ray: American Artist,* p. 252.

350 "the human animal is so stupid . . ."—MD to Yvonne Lyon, September 21, 1944, Getty Center Archives, Malibu, Calif.

350 de Rougemont's diary—Denis de Rougemont, *Journal d'une époque,* pp. 562–71.

350 "Marriage, for example . . ."—Ibid., p. 565.

354 "ejaculated seminal fluid"—See Ecke Bonk, *The Box in a Valise,* p. 282. The chemical analysis was performed by a Federal Bureau of Investigation laboratory

Page

in Houston, at the request of Walter Hopps, who was then the director of the Menil Collection. Calling in the FBI would have amused Duchamp no end.

355 "My mother could seduce anybody . . ."—This and the following statements by Nora Martins Lobo were made in interviews with the author.

Maria

358 ". . . this cage outside the world"—MD to Maria Martins, PMA.

358 Unlike his fellow passenger Virgil Thomson—Jennifer Gough-Cooper and Jacques Caumont, *Ephemerides,* May 9, 1946.

359 "the dreariest structures . . ."—Mary Reynolds to Hélène Hoppenot, January 8, 1947, BLJD.

359 "if the retirement fever still burns"—Ibid.

360 "Farewell, dear Yvonne . . ."—MD to Yvonne Lyon, January 13, 1947, Getty Center Archives, Malibu, Calif.

361 "We painted every nipple ourselves . . ."—Enrico Donati, interview with author.

362 Harold Rosenberg's famous phrase—In "The American Action Painters," *Art News,* September 1952.

362 "a way of living today . . ."—William de Kooning, "What Abstract Art Means to Me," *Museum of Modern Art Bulletin* 17, no. 3 (spring 1951).

362 "Duchamp said that in this type of painting . . ."—Jacqueline Bograd Weld, *Peggy: The Wayward Guggenheim,* p. 326.

362 "I saw at once . . ."—Roberto Matta Echaurren, interview with author.

363 "the most energetic, poetic, charming, brilliant young artist . . ."—S. Simon, "An Interview with Robert Motherwell," *Art International* 2 (summer 1967): 21.

364 Matta's private theory—Interview with author.

364 "the most profound painter of his generation"—Marcel Duchamp, *Salt Seller,* p. 154.

364 "moral turpitude"—André Breton's phrase in French was *"ignominie morale."*

366 Duchamp's letters to Maria Martins—Copies of the correspondence are in the archives of PMA. Access is restricted.

366 "She created him again . . ."—Nora Martins Lobo, interview with author.

367 "thinner than ever . . ."—Mary Reynolds to Hélène Hoppenot, August 26, 1948, BLJD.

367 "debacle in painting"—MD to Yvonne Lyon, January 8, 1949, Getty Center Archives, Malibu, Calif.

368 "so-called modern art is merely the vaporings of half-baked, lazy people"—Harry S. Truman to William Benton, April 2, 1947. This letter was quoted in the *Chicago Daily Tribune,* June 4, 1947, and in a number of other newspapers at the time.

368 "esthetic echo . . . some analogy with a religious faith . . ."—This and other excerpts from "The Western Round Table on Modern Art" are reprinted in *West Coast Duchamp,* edited by Bonnie Clearwater, pp. 106–14.

370 "very, very beautiful . . ."—Katharine Kuh, "Walter and Louise Arensberg," *Archives of American Art Journal,* p. 27.

Page

370 "He walked around and looked at all his own works"—Ibid.
370 "He changed his mind not from day to day . . ."—Katharine Kuh, interview with author.
371 The future of the Arensberg collection—This information is drawn largely from "The Art Institute of Chicago and the Arensberg Collection" by Naomi Sawelson-Gorse, in *One Hundred Years at the Art Institute.*
371 "the core of our collection . . ."—Walter Arensberg to MD, January 11, 1945, PMA.
373 "opening great success . . ."—MD to Arensbergs, October 20, 1949, PMA.
373 "the point I insist on . . ."—MD to Arensbergs, October 21, 1949, PMA.
373 "flimsey [sic] and inappropriate ply-wood decor"—Walter Arensberg to MD, April 8, 1950, PMA.
373 "saddest, saddest episode"—Katharine Kuh, "Walter and Louise Arensberg," *Archives of American Art Journal,* p. 27.

Teeny

374 My capital is time, not money—Marcel Duchamp, quoted in *Life,* April 28, 1952.
374 *Paris Air* was accidentally broken—See *West Coast Duchamp,* edited by Bonnie Clearwater, p. 45, note 54.
374 "I don't think there will be great demand . . ."—MD to H. P. Roché, November 14, 1949, HRC.
375 "I have never uttered the word cancer . . ."—MD to H. P. Roché, July 17, 1950, HRC.
375 "The main thing is to die . . ."—Ibid.
375 "Her brain is so lucid . . ."—MD to H. P. Roché, September 23, 1950, HRC.
376 "had undergone a kind of miraculous revival . . ."—Janet Flanner to Kay Boyle, October 3, 1950. Kay Boyle Collection, Morris Library, Southern Illinois University at Carbondale.
376 "Elizabeth said . . ."—Ibid.
376 "He insisted that I be unfaithful to him . . ."—H. P. Roché, *Victor,* pp. 90–91.
376 "the Parisian crocodiles"—MD to Arensbergs, September 7, 1950, PMA.
377 "Deep down I'm enormously lazy"—Pierre Cabanne, *Dialogues with Marcel Duchamp,* p. 72.
377 "a one-man movement . . ."—Willem de Kooning, "What Abstract Art Means to Me," *Museum of Modern Art Bulletin* 17, no. 3 (June 1951), p. 7.
378 according to Motherwell they rarely . . . mentioned him—Robert Motherwell, interview with author.
378 "Marcel had that inner confidence . . ."—Sidney Janis, interview with author.
379 "Marcel's attitude was to let them do it . . ."—Ibid.
379 "Dada's Daddy"—*Life,* April 28, 1952.
380 "She would browbeat him unmercifully . . ."—George Heard Hamilton, interview with author.
380 "Some facts may be wrong . . ."—Ibid.

Page

380 "too short and inadequate"—MD to Robert Lebel, October 21, 1953, cited in Jennifer Gough-Cooper and Jacques Caumont, *Ephemerides,* entry of that date.

380 "Miss Dreier always had it in mind . . ."—MD to Fiske Kimball, May 6, 1952, PMA archives.

381 "My capital is time, not money"—*Life,* April 28, 1952.

382 "some electric element floating around . . ."—Dorothea Tanning, interview with author.

382 Teeny, who had acquired her nickname—Biographical information about the Sattler family, Teeny's youth, etc., is from author's interviews with Alexina Duchamp.

384 "developed parasitism to a fine art"—William Copley, interview with author.

384 "She really had little property . . ."—Brookes Hubachek to Duchamp, December 16, 1950, Hubachek family papers.

385 "They were real soul mates . . ."—Marjorie Hubachek Watkins, interview with author.

385 "He neither retreated nor sidestepped . . ."—Brookes Hubachek to Anne d'Harnoncourt, July 18, 1969, PMA archives.

385 "With him, there was never this concern . . ."—Paul Matisse, interview with author.

387 "Marcel, what are you doing here?"—Alexina Duchamp, interview with author.

The Artist and the Spectator

388 All in all, the creative act is not performed by the artist alone—Marcel Duchamp, "The Creative Act" (see appendix, p. 509).

388 "I never expected [Walter] to die . . ."—MD to Fiske Kimball, February 7, 1954, PMA.

388 "Francis, à bientôt" ("Francis, see you soon")—Robert Lebel, *Marcel Duchamp,* p. 55, note 2.

388 "a new and immense pleasure . . ."—MD to H. P. Roché, July 5, 1954, HRC.

388 "even sex exercises are completely normal"—MD to H. P. Roché, August 6, 1954, HRC.

389 "Another mere piece of news . . ."—MD to Walter Arensberg, January 23, 1954, PMA.

389 "Marcel enjoyed every minute of it . . ."—Enrico Donati, quoted by Alan Jones in *Arts,* April 1991.

390 "Who is he?"—Jennifer Gough-Cooper and Jacques Caumont, *Ephemerides,* November 24, 1954.

391 "While nobody dares to butt into . . ."—Alain Jouffroy, *Arts et spectacles,* November 24, 1954.

391 "For me there is something other than *yes, no,* and *indifferent*"—MD to André Breton, October 4, 1954, BLJD.

392 "I realize that there are factors in Marcel's past . . ."—Alfred H. Barr, Jr., to Nelson Rockefeller, November 22, 1955. Alfred H. Barr Papers, Museum of Modern Art.

392 Congressman George A. Dondero . . . had delivered a speech—*Congressional Record* (81st Congress), 95, pt. 9, p. 11584.

Page

393 There were two kinds of artists, he said . . .—James Johnson Sweeney, "A Conversation with Marcel Duchamp," in *Wisdom,* edited by James Nelson, p. 93.

394 "I do not believe in language . . ."—MD to Jehan Mayoux, March 8, 1956, Archives of Alexina Duchamp.

395 "I didn't make a vow . . ."—Michel Sanouillet, "Dans l'atelier de Marcel Duchamp," *Les Nouvelles littéraires,* December 16, 1954.

396 "The Creative Act"—See the appendix for the full text of Duchamp's essay.

396 "the whole of posterity . . ."—Marcel Duchamp, radio interview by Georges Charbonnier on France Culture, January 13, 1961. Reprinted as *Entretiens avec Marcel Duchamp* (Marseilles: André Dimanche, 1994), p. 82.

Nothing Else but an Artist

399 There is no solution because there is no problem—Marcel Duchamp, in Harriet and Sidney Janis, "Marcel Duchamp: Anti-Artist," *View*, p. 24.

399 "the Mexican phantasmagoria"—MD to H. P. Roché, April 18, 1957, HRC.

399 "It feels like a happy marriage"—Beatrice Wood to H. P. Roché, October 21, 1956, AAA.

399 "He would always appear . . ."—Alexina Duchamp, interview with author.

400 "Chess was such a part . . ."—Ibid.

400 "Marcel didn't like caves . . ."—Ibid.

400 "Artists of all times are like Monte Carlo gamblers . . ."—Duchamp to Jean Crotti, April 17, 1952, AAA.

401 "We are having the most heavenly time . . ."—Alexina Duchamp to Jacqueline Matisse Monnier, August 7, 1958, Jacqueline Matisse Monnier papers.

402 "Sweet. Enchanting . . ."—H. P. Roché to Beatrice Wood, November 22, 1958, AAA.

402 Richard Hamilton . . . had seen Duchamp's work . . .—Richard Hamilton, interview with author.

403 "*arbre-type* . . ."—MD to Richard Hamilton, January 29, 1959, Richard Hamilton papers.

403 "feeble" to "weak"—Ibid.

403 "There is no solution . . . because there is no problem"—Calvin Tomkins, *The Bride and the Bachelors,* p. 57.

403 "profound indifference"—Jennifer Gough-Cooper and Jacques Caumont, *Ephemerides,* October 21, 1958.

404 "having foretold Freudianism . . ."—Robert Lebel, *Marcel Duchamp,* p. 30.

405 "His finest work is his use of time"—H. P. Roché, "Souvenirs of Marcel Duchamp," in Robert Lebel, *Marcel Duchamp,* p. 87.

405 "Otherwise, I will send you . . ."—Jennifer Gough-Cooper and Jacques Caumont, *Ephemerides,* October 21, 1958.

405 "a form of denying the possibility of defining art"—Marcel Duchamp, unpublished interview with G. and R. Hamilton for BBC series "Art, Anti-Art," November 1959.

Page

406 "You have to choose . . ."—H. P. Roché, *Victor,* p. 92.

406 "Yes, he was great . . ."—François Truffaut, "Henri-Pierre Roché Revisited," in H. P. Roché, *Jules et Jim,* p. 251.

407 "I became a non-artist . . ."—*Newsweek,* November 9, 1959, pp. 118–19.

409 "purposeless play . . ."—John Cage, *Silence,* p. 12.

410 "collaboration with materials"—Robert Rauschenberg, interview with author.

410 "the mind already knows"—Leo Steinberg, "Jasper Johns: The First Seven Years of His Art," in *Other Criteria,* p. 31.

411 "Marcel's quiet way . . ."—John Cage, interview with author.

411 Teeny had bought it from Roché—The sale of *9 Malic Moulds* was arranged by Duchamp in 1956, when the fragile, once-broken glass was shipped to New York for the "Three Brothers" show at the Guggenheim Museum. Teeny paid $14,000 for it, which she raised by selling a Rouault and a Miró from her collection.

411 "I was living in the country then . . ."—John Cage, interview with author.

411 "Don't you know you're not supposed to touch that crap?"—Robert Rauschenberg, interview with the author.

411 "It's very much in the present tense . . ."—Jasper Johns, interview with author.

413 "He was the first to see . . ."—Jasper Johns, "Thoughts on Duchamp," *Art in America,* July–August 1969.

414 "an easy way out"—Hans Richter, *Dada: Art and Anti-Art,* pp. 207–8.

414 "When I discovered readymades . . ."—Ibid.

415 "If you take a Campbell soup can . . ."—Rosalind Constable, "New York's Avant Garde," *New York Herald Tribune,* May 17, 1964.

415 "We are *crazy* about the book . . ."—MD to Richard Hamilton, November 26, 1960, Richard Hamilton papers.

416 "the great artist of tomorrow will go underground"—Statement at the Philadelphia Museum of Art, March 20, 1961.

416 "I'm nothing else but an artist . . ."—Unpublished interview with Duchamp, by Katharine Kuh and Richard Hamilton, for BBC television, September 27, 1961. Duchamp expressed the same sentiment, in almost the same words, in a 1963 interview with Francis Roberts; this interview appeared, belatedly, in the December 1968 issue of *Art News.*

416 "I don't want to destroy art . . ."—Jennifer Gough-Cooper and Jacques Caumont, *Ephemerides,* October 19, 1961.

417 "He was the same at eighty . . ."—Pierre Cabanne, *The Brothers Duchamp,* p. 229.

417 "I tell them I don't know any more than they do . . ."—Ibid., p. 237.

417 Duchamp was somewhat resentful—Ibid., pp. 207, 252.

417 "He is like Father . . ."—Jennifer Gough-Cooper and Jacques Caumont, *Ephemerides,* June 12, 1963.

Wanted

418 I am entering my sex maniac phase . . .—Marcel Duchamp, quoted by Walter Hopps, in interview with author.

Page

418 "Marcel was such a good patient . . ."—Alexina Duchamp to Jacqueline Matisse Monnier, January 19, 1963, Duchamp family papers.

418 "The entire art scene . . ."—Francis Steegmuller, "Duchamp Fifty Years Later," *Show,* pp. 28–29.

419 "the idea of an esthetic 'smell' . . ."—William Seitz, "What's Happened to Art?" *Vogue,* pp. 110ff.

419 "a bridge to take me . . ."—Ibid.

419 "I have forced myself to contradict myself . . ."—Marcel Duchamp, in Harriet and Sidney Janis, "Marcel Duchamp, Anti-Artist," *View,* p. 18.

420 "He seemed pleased . . ."—Walter Hopps, interview with author.

420 "the only Duchamp expert . . ."—*West Coast Duchamp,* edited by Bonnie Clearwater, p. 68.

420 "He never tried to control things"—Walter Hopps, interview with author.

421 "If that were the case . . ."—Ibid.

421 "the metamorphic quality . . ."—Ibid.

422 "It is a shock . . ."—Richard Hamilton, "Duchamp," *Art International,* p. 22.

423 "sex maniac phase . . ."—Marcel Duchamp, quoted by Walter Hopps, in interview with author.

424 "One way or another . . ."—Walter Hopps, "Duchamp in Vegas," in Yves Arman, *Marcel Duchamp Plays and Wins,* p. 43.

424 "like two pink footballs"—Eve Babitz, "I Was a Naked Pawn for Art," *Esquire,* September 1991, pp. 164–74.

424 "There was no person in the world . . ."—Arturo Schwarz, interview with author.

425 Schwarz had a vivid dream about Duchamp—Ibid.

426 "the value of the gesture . . ."—Max Ernst, "A Collaborative Portrait of Marcel Duchamp," in *Marcel Duchamp,* edited by Anne d'Harnoncourt and Kynaston McShine, p. 198.

426 "The idea was to find . . ."—Francis Roberts, "I Propose to Strain the Laws of Physics," *Art News,* December 1968.

426 "As for recognizing a motivating idea . . ."—Otto Hahn, "Passport No. G255300," *Art and Artists.*

426 The art historian William Camfield—See William A. Camfield, *Marcel Duchamp/Fountain,* pp. 40ff.

427 "But, oh, Marcel . . ."—The quote comes from an article by Robert Morris in *Art in America,* November 1989.

427 "Manufactured objects had the advantage . . ."—Interview with author.

427 "I'm getting something out of it . . ."—Ibid.

429 "a cuddly little actress . . ."—Otto Hahn, "Passport No. G255300," *Art and Artists.*

429 "Very seldom do I like any piece of theater . . ."—Ibid.

429 "Marcel really pushed us . . ."—David Hare, interview with author.

430 "there was a lot of looking up words . . ."—Denise Hare, interview with author.

430 "Bonjour, Marcel"—Franco Bombelli, interview with author.

431 Mary Callery . . . did not approve of Duchamp—Mimi Brown Cohane, interview with author.

Page

433 "He said he had something to show me . . ."—William Copley, interview with author.

433 "The whole thing went very smoothly . . ."—Ibid.

Not Seen and/or Less Seen

435 There won't be any difference . . .—Marcel Duchamp, in *Vogue,* February 15, 1963.

436 "She had no real interest in or feeling for the work"—Arne Ekstrom, interview with author.

436 "Hamilton felt that Ulf Linde's *Glass* . . ."—Richard Hamilton, interview with author.

437 "Where did you get that?"—Ibid.

437 "He was clearly angry . . ."—Ibid.

437 "a pasticheur of refined taste . . ."—Hilton Kramer, "Duchamp: Resplendent Triviality," *New York Times,* Sunday, July 10, 1966.

437 "to attack Duchamp . . ."—Thomas B. Hess, "J'Accuse Marcel Duchamp," *Art News,* p. 44ff.

438 "I'm afraid I'm an agnostic in art . . ."—Interview with author.

438 "few men could better exemplify . . ."—Clyfford Still, *Artforum,* Letter to the Editor, February 1964.

438 it "was on the same train as Marcel Duchamp"—See Thomas B. Hess, "J'Accuse Marcel Duchamp," *Art News,* p. 44ff.

438 "Duchamp is not responsible . . ."—Ibid.

439 "a loathsome crime . . ."—Jennifer Gough-Cooper and Jacques Caumont, *Ephemerides,* October 6, 1965.

439 "the only thing to do is ignore it . . ."—Pierre Cabanne, *The Brothers Duchamp,* p. 253.

439 "a lovely person, so dignified"—Alexina Duchamp, interview with author.

440 "You see, it has been a vivid thing . . ."—Yvonne Savy, interview with author.

441 Duchamp stunned William Copley—William Copley, interview with author.

441 "He came often to my show . . ."—Yvonne Savy, interview with author.

442 Olga Popovitch had gone to see—Olga Popovitch, interview with author.

443 "There is more freedom here . . ."—Interview with author.

443 "I have not known a man . . ."—*Arts et Loisirs,* October 5, 1966.

443 "I have had an absolutely marvelous life . . ."—*Arts et Loisirs,* May 5, 1966.

444 "quite simply waiting for death"—Jennifer Gough-Cooper and Jacques Caumont, *Ephemerides,* June 21, 1967.

444 "Do you think this is all right . . ."—Cleve Gray, "The Great Spectator," *Art in America,* p. 21.

444 "in order to discredit it . . ."—Pierre Cabanne, *Dialogues with Marcel Duchamp,* p. 39.

444 "In spite of Einstein . . ."—O. B. Hardison, Jr., *Disappearing Through the Skylight: Culture and Technology in the Twentieth Century,* p. 49.

445 "We have to accept those so-called laws of science . . ."—Interview with author.

Page

446 "with a look of horror on his face"—Jasper Johns, interview with author.

446 "Aren't you coming?"—Ibid.

446 "I remember seeing Marcel Duchamp . . ."—"A Collective Portrait of Marcel Duchamp," in *Marcel Duchamp,* edited by Anne d'Harnoncourt and Kynaston McShine, p. 194.

446 "I am too old to meddle . . ."—MD to Raymond Dumouchel, in Jennifer Gough-Cooper and Jacques Caumont, *Ephemerides,* July 2, 1968.

447 "Capital! . . ."—Jennifer Gough-Cooper and Jacques Caumont, *Ephemerides,* June 5, 1960.

447 "All right, Teeny . . ."—Richard Hamilton, interview with author.

447 "rubbish"—Alexina Duchamp, interview with author.

447 the book was not *about* him—Alexina Duchamp, interview with author.

448 "So let us not try . . ."—Arturo Schwarz, *The Complete Works of Marcel Duchamp,* p. 562.

449 Duchamp wrote to Brookes Hubachek—Letter dated September 22, 1968, Hubachek family papers.

450 "He had the most calm, pleased expression . . ."—Alexina Duchamp, interview with author.

450 "much as I miss him . . ."—Alexina Duchamp to Beatrice Wood, November 20, 1968, AAA.

450 possibly the most destructive artist—*New York Times,* October 3, 1968, p. 51.

Etant Donnés

451 I have forced myself to contradict myself . . . —Marcel Duchamp in Harriet and Sidney Janis, "Marcel Duchamp, Anti-Artist," *View,* p. 18.

451 *Etant donnés*—Although the titles of Duchamp's other works in the Philadelphia Museum of Art are in English, this one retains (and seems to require) its French title.

451 "the strangest work of art in any museum"—Jasper Johns, in conversation with the author.

454 like a vertical, speaking mouth—See Jean Clair, *Marcel Duchamp: Colloque de clerisy,* pp. 130–31: ". . . in the midst of a 'Da Vinci' style landscape as mysterious as the one in which the Mona Lisa sits, is the enigma of another smile, but this time vertical, and unshadowed by any hair from the otherwise anonymous offerer."

454 No wonder Duchamp has become . . . —See, for example, Amelia Jones, *Post-modernism and the En-gendering of Marcel Duchamp.*

454 "to grasp things . . ."—Lawrence D. Steefel, Jr., *The Position of Duchamp's "Glass" in the Development of His Art,* p. 312.

454 "a banal affair . . . a peephole tableau"—Anthony Hill, "The Spectacle of Duchamp," *Studio International,* January–February 1975.

455 "If earlier works by Duchamp . . ."—Joseph Masheck, ed., *Marcel Duchamp in Perspective,* p. 23.

Page

455 "It has, rather, the most exact separation"—John Cage, interview with author.

456 Although the French scholar Jean Clair was able to prove—See the catalogue raisonné to the 1977 Duchamp exhibition at the Centre Georges Pompidou, pp. 107–13.

456 "alchemy was in the air"—Lawrence D. Steefel, Jr., *The Position of Duchamp's "Glass" in the Development of His Art,* p. 366, note.

457 "If I have practiced alchemy . . ."—Robert Lebel, *Marcel Duchamp,* p. 73.

457 "entirely unconscious"—Arturo Schwarz, "Rrose Sélavy alias Marchand du Sel alias Belle Haleine," unpublished lecture at the Museum of Modern Art, 1974.

457 The American art writer Jack Burnham—See Jack Burnham, "Unveiling the Consort," *Artforum,* March and April 1971. The two articles were republished, in somewhat different form, in Burnham, *Great Western Salt Works.*

458 "After Duchamp . . . it is no longer possible . . ."—Roger Shattuck, "The Dada-Surrealist Expedition: Part II," *The New York Review of Books,* June 1, 1972, p. 20.

458 "All the environmental pieces . . ."—Allan Kaprow, "A Collective Portrait of Marcel Duchamp," in *Marcel Duchamp,* edited by Anne d'Harnoncourt and Kynaston McShine, p. 205.

459 "With the unassisted readymade . . ."—Joseph Kosuth, "Art After Philosophy," in Gregory Battcock's *Idea Art,* p. 80.

459 "yearning for relaxation"—Clement Greenberg, "Modern and Post-Modern," *Arts Magazine,* February 1980.

459 "Certainly the whole fabric of current American art . . ."—Max Kozloff, "Duchamp," in *Renderings: Critical Essays on a Century of Modern Art,* pp. 119–27.

459 "The Futurists discovered avant-gardeness . . ."—Clement Greenberg, "Counter-Avant-Garde," pp. 16–19. Reprinted in *Marcel Duchamp in Perspective,* edited by Joseph Masheck.

462 the nude was far more beautiful before . . .—Alexina Duchamp, interview with author.

463 "joyful chaos"—"The Opening Doors of *Etant Donnés,*" SITES, no. 19, pp. 5–6.

463 "One thing that really struck me . . ."—Paul Matisse, interview with author.

465 "I am nothing else but an artist . . ."—Francis Roberts, "I Propose to Strain the Laws of Physics," *Art News,* December 1968, p. 64.

465 *It's merely a way of succeeding in no longer thinking . . .* —Marcel Duchamp, *Salt Seller,* p. 26.

Appendix

THE CREATIVE ACT

by Marcel Duchamp

Session on the Creative Act,
Convention of the American Federation of Arts,
Houston, Texas, April 1957

Professor Seitz, Princeton University
Professor Arnheim, Sarah Lawrence College
Gregory Bateson, anthropologist
Marcel Duchamp, mere artist

Let us consider two important factors, the two poles of the creation of art: the artist on the one hand, and on the other the spectator who later becomes the posterity.

To all appearances, the artist acts like a mediumistic being who, from the labyrinth beyond time and space, seeks his way out to a clearing.

If we give the attributes of a medium to the artist, we must then deny him the state of consciousness on the esthetic plane about what he is doing or why he is doing it. All his decisions in the artistic execution of the work rest with pure intuition and cannot be translated into a self-analysis, spoken or written, or even thought out.

T. S. Eliot, in his essay on 'Tradition and Individual Talent,' writes: 'The more perfect the artist, the more completely separate in him will be the man who suffers and the mind which creates; the more perfectly will the mind digest and transmute the passions which are its material.'

Millions of artists create; only a few thousands are discussed or accepted by the spectator and many less again are consecrated by posterity.

In the last analysis, the artist may shout from all the rooftops that he is a genius; he will have to wait for the verdict of the spectator in order that his declarations take a social value and that, finally, posterity includes him in the primers of Art History.

I know that this statement will not meet with the approval of many artists who refuse this mediumistic role and insist on the validity of their awareness in the creative act—yet, art history has consistently decided upon the virtues of a work of art through considerations completely divorced from the rationalized explanations of the artist.

If the artist, as a human being, full of the best intentions toward himself and the whole world, plays no role at all in the judgment of his own work, how can one describe the

phenomenon which prompts the spectator to react critically to the work of art? In other words, how does this reaction come about?

This phenomenon is comparable to a transference from the artist to the spectator in the form of an esthetic osmosis taking place through the inert matter, such as pigment, piano or marble.

But before we go further, I want to clarify our understanding of the word 'art'—to be sure, without any attempt at a definition.

What I have in mind is that art may be bad, good or indifferent, but, whatever adjective is used, we must call it art, and bad art is still art in the same way that a bad emotion is still an emotion.

Therefore, when I refer to 'art coefficient,' it will be understood that I refer not only to great art, but I am trying to describe the subjective mechanism which produces art in the raw state—*à l'état brut*—bad, good or indifferent.

In the creative act, the artist goes from intention to realization through a chain of totally subjective reactions. His struggle toward the realization is a series of efforts, pains, satisfactions, refusals, decisions, which also cannot and must not be fully self-conscious, at least on the esthetic plane.

The result of this struggle is a difference between the intention and its realization, a difference which the artist is not aware of.

Consequently, in the chain of reactions accompanying the creative act, a link is missing. This gap, representing the inability of the artist to express fully his intention, this difference between what he intended to realize and did realize, is the personal 'art coefficient' contained in the work.

In other words, the personal 'art coefficient' is like an arithmetical relation between the unexpressed but intended and the unintentionally expressed.

To avoid a misunderstanding, we must remember that this 'art coefficient' is a personal expression of art *à l'état brut,* that is, still in a raw state, which must be 'refined' as pure sugar from molasses by the spectator; the digit of this coefficient has no bearing whatsoever on his verdict. The creative act takes another aspect when the spectator experiences the phenomenon of transmutation: through the change from inert matter into a work of art, an actual transubstantiation has taken place, and the role of the spectator is to determine the weight of the work on the esthetic scale.

All in all, the creative act is not performed by the artist alone; the spectator brings the work in contact with the external world by deciphering and interpreting its inner qualifications and thus adds his contribution to the creative act. This becomes even more obvious when posterity gives its final verdict and sometimes rehabilitates forgotten artists.

Selected Bibliography

Adcock, Craig. *Marcel Duchamp's Notes from the "Large Glass": An N-Dimensional Analysis.* Ann Arbor: UMI Research Press, 1983.

Andrews, Wayne. *The Surrealist Parade.* New York: New Directions, 1990.

Antin, David. "Duchamp and Language." In *Marcel Duchamp,* edited by Anne d'Harnoncourt and Kynaston McShine. New York: Museum of Modern Art and Philadelphia: Philadelphia Museum of Art, 1973, pp. 95–115.

Antliff, Mark. *Inventing Bergson: Cultural Politics and the Parisian Avant-Garde.* Princeton, N.J.: Princeton University Press, 1993.

Apollinaire, Guillaume. *Alcools.* Paris: Gallimard, 1920.

———. *Calligrammes: Poems of Peace and War, 1913–1916.* Edited and translated by Anne Hyde Greet. Berkeley and Los Angeles: University of California Press, 1991.

———. *Les Peintres cubistes.* Paris: Eugène Figuière, 1913. Reprint. Paris: Hermann, 1965. English translation of essay on Duchamp printed in *Marcel Duchamp in Perspective,* edited by Joseph Masheck.

Arman, Yves. *Marcel Duchamp Plays and Wins.* New York: Galerie Yves Arman, 1984.

Armory Show 50th Anniversary Exhibition Catalogue. New York: Henry Street Settlement, and Utica, N.Y.: Munson-Williams-Proctor Institute, 1963.

Arp, Jean. "Looking." In *Arp,* edited and with an introduction by James Thrall Soby. New York: Museum of Modern Art, 1958.

———. *On My Way.* New York: Wittenborn, Schultz, 1948.

Art and Artists 1, no. 4 (July 1966). Special Duchamp issue.

Ashton, Dore. "An Interview with Marcel Duchamp," *Studio International* (London) 171, no. 878 (June 1966): 244–47.

Assouline, Pierre. *An Artful Life: A Biography of D. H. Kahnweiler.* Translated by Charles Ruas. New York: Grove Weidenfeld, 1988.

Bach, Friedrich Teja, Margit Rowell, and Ann Temkin. *Constantin Brancusi, 1876–1957.* Cambridge: MIT Press, 1995. Exhibition catalog.

Bailly, Jean-Christophe. *Duchamp.* Translated by Jane Brenton. New York: Universe Books, 1986.

Bair, Deirdre. *Samuel Beckett.* New York: Simon & Schuster, 1978.

Balakian, Anna. *André Breton: Magus of Surrealism.* New York: Oxford, 1971.

Baldwin, Neil. *Man Ray: American Artist.* New York: Clarkson N. Potter, 1988.

Barr, Alfred H., Jr. *Cubism and Abstract Art.* New York: Museum of Modern Art, 1936.

———. *Fantastic Art, Dada, Surrealism.* New York: Museum of Modern Art, 1936.

Baruchello, Gianfranco, and Henry Martin. *Why Duchamp: An Essay on Aesthetic Impact.* New Paltz, N.Y.: McPherson, 1983.

Battcock, Gregory. *Idea Art.* New York: E. P. Dutton, 1973.

Baudelaire, Charles. *Oeuvres complètes.* Paris: Gallimard, 1956.

———. *The Painter of Modern Life and Other Essays.* Edited and translated by Jonathan Mayne. London: Phaidon, 1964.

Bergson, Henri. *Creative Evolution.* Translated by Arthur Mitchell, foreword by Irwin Edman. New York: Modern Library, 1944.

Blesh, Rudi. *Modern Art USA: Men, Rebellion, Conquest, 1900–1956.* New York: Alfred A. Knopf, 1956.

Bloemink, Barbara J. *The Life and Art of Florine Stettheimer.* New Haven, Conn.: Yale University Press, 1995.

Bonk, Ecke. *Marcel Duchamp: The Box in a Valise.* New York: Rizzoli, 1989.

Breton, André. *André Breton: La Beauté convulsive.* Paris: Centre National d'Art et de Culture Georges Pompidou, 1991. Exhibition catalog.

———. *Anthologie de l'humour noir.* Paris: Editions du Sagittaire, 1940. Duchamp's puns and word games, pp. 329–35.

———. *Conversations: The Autobiography of Surrealism.* Translated by Mark Polizzotti. New York: Paragon House, 1993.

———. "Marcel Duchamp." *Littérature* (Paris), no. 5 (October 1, 1922): 7–10. English translation in *The Dada Painters and Poets,* edited by Robert Motherwell.

———. *Nadja.* Translated by Richard Howard. New York: Grove Press, 1960.

———. "Phare de la mariée," *Minotaure* (Paris) 2, no. 6 (winter 1935): pp. 45–49. English translation in *View* (New York) 5, no. 1 (March 1945): 6–9, 13.

———. *Le Surréalisme et la peinture.* New York: Brentano's, 1945.

Brown, Milton W. *The Story of the Armory Show.* New York: Abbeville Press, 1988.

Buffet-Picabia, Gabrielle. "Arthur Cravan and American Dada." In *The Dada Painters and Poets,* edited by Robert Motherwell.

———. *Rencontres.* Paris: Pierre Belfond, 1977.

———. "Some Memories of Pre-Dada: Picabia and Duchamp." In *The Dada Painters and Poets.* Edited by Robert Motherwell.

———. "Un peu d'histoire." In *Paris–New York.* Paris: Editions du Centre Pompidou, 1991.

Burke, Carolyn. *Becoming Modern: The Life of Mina Loy.* New York: Farrar, Straus and Giroux, 1996.

Burnham, Jack. *Great Western Salt Works: Essays on the Meaning of Post-Formalist Art.* New York: George Braziller, 1974.

Cabanne, Pierre. *The Brothers Duchamp*. Translated by Helga and Dinah Harrison. Boston: New York Graphic Society, 1976.

———. *Entretiens avec Marcel Duchamp*. Paris: Pierre Belfond, 1967. U.S. edition: *Dialogues with Marcel Duchamp*, translated by Ron Padgett. New York: Viking Press, 1971.

Cage, John. *Silence*. Middletown, Conn.: Wesleyan University Press, 1961.

———. *A Year from Monday*. Middletown, Conn.: Wesleyan University Press, 1967. Includes Cage's "26 Statements Re Duchamp," pp. 70–72.

Camfield, William A. *Francis Picabia: His Art, Life, and Times*. Princeton, N.J.: Princeton University Press, 1979.

———. *Marcel Duchamp/Fountain*. Houston: Menil Collection, Houston Fine Art Press, 1989.

Camfield, William A., and Jean-Hubert Martin, eds. *Tabu Dada: Jean Crotti and Suzanne Duchamp, 1915–1922*. Bern: Kunsthalle Bern, 1983.

Carrouges, Michel. *Les Machines célibataires*. Paris: Arcanes, 1954.

Chadwick, Whitney. *Women Artists and the Surrealist Movement*. Boston: Little, Brown, 1985.

Chapon, François. *Mystère et splendeurs de Jacques Doucet, 1853–1929*. Paris: Jean-Claude Lattès, 1984.

Charbonnier, Georges. *Entretiens avec Marcel Duchamp*. Marseilles: André Dimanche, 1994.

Clair, Jean. "Duchamp and the Classical Perspectivists." *Artforum* 16 (March 1978): 40–49.

———. *Duchamp et la photographie: Essai d'analyse d'un primat technique sur le developpement d'un oeuvre*. Paris: Chêne, 1977.

———. *Marcel Duchamp: Catalogue raisonné*. Paris: Centre National d'Art et de Culture Georges Pompidou, 1977. Published in connection with the 1977 exhibition.

———. *Marcel Duchamp, ou Le Grand Fictif: Essai de mythanalyse du "Grand Verre."* Paris: Galilée, 1975.

———, ed. *Marcel Duchamp: Abécédaire: Approches critiques*. Paris: Centre National d'Art et de Culture Georges Pompidou, 1977. Published in connection with the 1977 exhibition.

———, ed. *Marcel Duchamp: Colloque de clerisy*. Paris: Union Générale d'Editions, 1979.

Clearwater, Bonnie, ed. *West Coast Duchamp*. Miami Beach: Grassfield Press, Inc., 1991.

Cordier & Ekstrom Gallery, New York, *Not Seen and/or Less Seen of/by Marcel Duchamp/Rrose Sélavy 1904–1964*. Catalog for exhibition January 14–February 13, 1965; introduction and notes by Richard Hamilton.

Cornell, Joseph. *Theater of the Mind: Selected Diaries, Letters and Files*. Edited by Mary Ann Caws. New York: Thames and Hudson, 1993.

Dalí, Salvador. "The King and Queen Traversed by Swift Nudes." *Art News* 58 (April 1959): 22–25.

———. "Why They Attack the 'Mona Lisa.'" *Art News* 62 (March 1963): 36, 63–64.

Danto, Arthur C. *Embodied Meanings: Critical Essays and Aesthetic Meditations*. New York: Farrar, Straus and Giroux, 1994.

———. *The Philosophical Disenfranchisement of Art*. New York: Columbia University Press, 1986.

———. *The State of the Art*. New York: Prentice-Hall Press, 1987.

Desnos, Robert. "Rrose Sélavy," *Littérature* (Paris), no. 7 (December 1, 1922): 14–22. Reprinted in *View* 5, no. 1 (March 1945): 17.

d'Harnoncourt, Anne, and Kynaston McShine, eds. *Marcel Duchamp.* New York: Museum of Modern Art and Philadelphia: Philadelphia Museum of Art, 1973.

d'Harnoncourt, Anne, and Walter Hopps. *"Etant Donnés: 1. La Chute d'eau, 2. Le Gaz d'eclairage": Reflections on a New Work by Marcel Duchamp.* Philadelphia: Philadelphia Museum of Art, 1987.

Dreier, Katherine S. *Five Months in the Argentine: From a Woman's Point of View, 1918–1919.* New York: Frederic Fairfield Sherman, 1920.

Dreier, Katherine S., and R. Matta Echaurren. *Duchamp's Glass/La Mariée mise à nu par ses célibataires, même: An Analytical Reflection.* New York: Société Anonyme, Museum of Modern Art, 1944.

Drot, Jean-Marie. "Jeu d'échecs avec Marcel Duchamp." Unpublished interview, from sound track of a film made for ORTF, 1963.

Duchamp, Marcel. "Affectueusement, Marcel: Ten Letters from Marcel Duchamp to Suzanne Duchamp and Jean Crotti." Edited by Francis M. Naumann. *Archives of American Art Journal* 22, no. 4 (1982): 2–19.

————. *A l'infinitif.* Translated by Cleve Gray. New York: Cordier & Ekstrom Gallery, 1966. Also known as "The White Box."

————. "Amicalement, Marcel: Fourteen Letters from Marcel Duchamp to Walter Pach." Edited by Francis M. Naumann. *Archives of American Art Journal* 29, nos. 3 & 4 (1989): 36–50.

————. "Apropos of Readymades." A talk delivered at the Museum of Modern Art, New York, 1961. First draft published in *Art and Artists* (London) 1, no. 4 (July 1966): 47.

————. *The Bride Stripped Bare by Her Bachelors, Even: A Typographic Version by Richard Hamilton of Marcel Duchamp's "Green Box."* New York: Wittenborn, 1960.

————. *Collection of the Société Anonyme: Museum of Modern Art 1920.* New Haven, Conn.: Yale University Art Gallery, 1950. Includes 33 critical notes by Duchamp on artists in the collection.

————. "The Creative Act." Duchamp's 1957 lecture at the Convention of the American Federation of Arts in Houston, published in *Art News* 56, no. 4 (summer 1957): 28–29.

————. *Duchamp du signe: Ecrits.* Edited by Michel Sanouillet. Paris: Flammarion, 1976. Revised edition of *Marchand du sel,* with English texts translated into French.

————. *Manual of Instructions for "Etant Donnés."* Philadelphia: Philadelphia Museum of Art, 1987. Facsimile reproduction of Duchamp's loose-leaf notebook showing how to assemble the last work.

————. *Marcel Duchamp: Letters to Marcel Jean.* Munich: Silke Schreiber, 1987.

————. *Marcel Duchamp: Notes.* Edited by Paul Matisse. Paris: Centre National d'Art et de Culture Georges Pompidou, 1980. U.S. edition. New York: G. K. Hall, 1983 (includes new preface by Anne d'Harnoncourt).

————. "Marcel Duchamp's Letters to Walter and Louise Arensberg, 1917–1921." Edited, translated, and notes by Francis M. Naumann. In *Marcel Duchamp: Artist of the Century.* Edited by Rudolf E. Kuenzli and Francis M. Naumann. Cambridge: MIT Press, 1990, pp. 203–27.

————. *Marchand du sel: Ecrits de Marcel Duchamp.* Edited by Michel Sanouillet. Paris: Terrain Vague, 1959. Collected writings, presented in the original language, French or English.

————. *La Mariée mise à nu par ses célibataires, même.* Paris: Editions Rrose Sélavy, 1934. (*The Green Box.*)

————. *Notes and Projects for the Large Glass.* Edited by Arturo Schwarz. New York: Harry N. Abrams, 1969.

————. "Notes for a Lecture, 1964." Unpublished typescript.

————. *Rrose Sélavy.* Paris: GLM, 1939.

————. *Salt Seller: The Writings of Marcel Duchamp.* Edited by Michel Sanouillet and Elmer Peterson. New York: Oxford University Press, 1973. English-language edition of *Marchand du sel.* A paperback edition of *Salt Seller* was also published in 1973 by Da Capo Press (New York), entitled *The Writings of Marcel Duchamp.*

————. "Where Do We Go from Here?" *Studio International* 189 (January–February 1975): 28. Text from a symposium at Philadelphia Museum College of Art, March 1961.

Duchamp, Marcel, and Vitaly Halberstadt. *L'Opposition et les cases conjugées sont reconcilées.* Paris: L'Echiquier, 1932.

Duve, Thierry de. *Kant After Duchamp.* Cambridge: MIT Press, 1996.

————. *Nominalisme picturale: Marcel Duchamp, la peinture et la modernité.* Paris: Editions de Minuit, 1984.

————. *Pictorial Nominalism: On Marcel Duchamp's Passage from Painting to the Ready-made.* Translated by Dana Polan with the author. Foreword by John Rajchman. Minneapolis: University of Minnesota Press, 1991. English version of *Nominalisme picturale . . .*

————, ed. *The Definitively Unfinished Marcel Duchamp.* Cambridge: MIT Press, 1991. Eleven essays presented at colloquium at Nova Scotia College of Art and Design.

Edwards, Hugh. *Surrealism & Its Affinities: The Mary Reynolds Collection.* Introduction by Marcel Duchamp. Chicago: Art Institute of Chicago, 1956.

Eksteins, Modris. *Rites of Spring: The Great War and the Birth of the Modern Age.* Boston: Houghton Mifflin, 1989.

"Eleven Europeans in America." In *Museum of Modern Art Bulletin* 13, nos. 4–5 (1946): 19–21. Interview with Duchamp.

Ernst, Jimmy. *A Not-So-Still Life.* New York: St. Martin's, 1984.

Etherington-Smith, Meredith. *The Persistence of Memory: A Biography of Dali.* New York: Random House, 1992.

Flanner, Janet. *Paris Was Yesterday.* New York: Viking Press, 1972.

Fowlie, Wallace. *Mallarmé.* Chicago: University of Chicago Press, 1953.

————, trans. *The Complete Works of Arthur Rimbaud.* Introduction and notes by Wallace Fowlie. Chicago: University of Chicago Press, 1966.

Fry, Varian. *Surrender on Demand.* New York: Random House, 1945.

Gervais, André. *La Raie alitée d'effets: Apropos of Marcel Duchamp.* Ville la Salle, Québec: Editions Hurtubise, 1984.

Gibson, Michael. *Duchamp Dada.* Paris: Casterman, 1991.

Glackens, Ira. *William Glackens and the Ashcan Group.* New York: Crown, 1957.

Gold, Laurence S. "A Discussion of Marcel Duchamp's Views on the Nature of Reality and Their Relation to the Course of His Artistic Career." Unpublished senior thesis, Princeton University, 1958. Includes interview with Duchamp as an appendix.

Golding, John. *Cubism: A History and an Analysis, 1907–1914.* 3d ed. Cambridge: Belknap Press of Harvard University Press, 1988.

————. *Marcel Duchamp: "The Bride Stripped Bare by Her Bachelors, Even."* New York: Viking Press, 1973.

Gough-Cooper, Jennifer, and Jacques Caumont. *Ephemerides on and About Marcel Duchamp and Rrose Sélavy, 1887–1968.* Milan: Bompiani, 1993.

————. *La Vie illustrée de Marcel Duchamp.* Paris: Centre National d'Art et de Culture Georges Pompidou, 1977. With twelve illustrations by André Raffray.

————. "Le Récit de Lydie." *Rrosopopées* (Yvetot, France), nos. 19–20 (1989).

————. *Plan pour écrire une vie de Marcel Duchamp.* Paris: Centre National d'Art et de Culture Georges Pompidou, 1977. Published in connection with the 1977 exhibition.

Gray, Cleve. "The Great Spectator." *Art in America* 57, no. 4 (July–August 1968): 20–27.

————. "Retrospective for Marcel Duchamp." *Art in America* 53, no. 1 (January 1965): 102–5.

Green, Martin. *New York 1913: The Armory Show and the Paterson Strike Pageant.* New York: Scribner's, 1988.

Greenberg, Clement. "Counter-Avant-garde." *Art International* 15, no. 5 (May 20, 1971): 16–19. Reprinted in *Marcel Duchamp in Perspective,* edited by Joseph Masheck.

Guggenheim, Peggy. *Confessions of an Art Addict.* New York: Macmillan, 1960.

————. *Out of This Century: Confessions of an Art Addict.* New York: Universe Books, 1979.

Hahn, Otto. "Entretien: Marcel Duchamp." *Express* (Paris), no. 684 (July 23, 1964): 22–23.

————. "Passport No. G255300." Translated by Andrew Rabeneck. *Art and Artists* 1, no. 4 (July 1966): 7–11.

Hamilton, George. "In Advance of Whose Broken Arm?" *Art and Artists* 1, no. 4 (July 1966): 29–31. Reprinted in *Marcel Duchamp in Perspective,* edited by Joseph Masheck.

Hamilton, George, and William C. Agee. *Raymond Duchamp-Villon, 1876–1918.* New York: M. Knoedler, Walker and Company, 1967.

Hamilton, George, and Richard Hamilton. "Marcel Duchamp Speaks." Unpublished interview broadcast by the BBC in the series "Art, Anti-Art," 1959.

Hamilton, Richard. *The Almost Complete Works of Marcel Duchamp.* Catalog for exhibition at the Tate Gallery, London, June 18–July 31, 1966.

————. "Duchamp," *Art International* (Lugano) 7, no. 10 (December 1963–January 1964).

————. *Richard Hamilton: Collected Works, 1953–1982.* New York: Thames and Hudson, n.d.

Hardison, O. B., Jr. *Disappearing Through the Skylight: Culture and Technology in the Twentieth Century.* New York: Viking Penguin, 1990.

Hellman, Geoffrey. "Marcel Duchamp." *The New Yorker,* April 6, 1957, pp. 25–27.

Henderson, Linda Dalrymple. *Duchamp in Context: Science and Technology in the "Large Glass" and Related Works.* Princeton, N.J.: Princeton University Press, 1997.

————. *The Fourth Dimension and Non-Euclidian Geometry in Modern Art.* Princeton, N.J.: Princeton University Press, 1983.

Hess, Thomas B. "J'Accuse Marcel Duchamp." *Art News* 63, no. 10 (February 1965): 44–45, 52–54. Reprinted in *Marcel Duchamp in Perspective,* edited by Joseph Masheck.

Hill, Anthony, ed. *Duchamp: Passim. A Marcel Duchamp Anthology.* New York: G+B Arts International Limited, 1994.

Hommage à Marcel Duchamp. Alès: PAB, 1969. Texts by Man Ray, Gabrielle Buffet-Picabia, Pierre de Massot, Robert Lebel, and Alexander Calder.

Hopps, Walter. *By or of Marcel Duchamp or Rrose Sélavy.* Catalog for the retrospective exhibition at the Pasadena Art Museum, October 8–November 3, 1963.

Hopps, Walter, Ulf Linde, and Arturo Schwarz. *Marcel Duchamp: Ready-mades, etc. (1913–1964)*. Paris: Terrain Vague, 1964.

Huelsenbeck, Richard. *Memoirs of a Dada Drummer*. Translated by Joachim Neugroschel, edited by Hans J. Kleinschmidt. Berkeley and Los Angeles: University of California Press, 1969.

Hulten, Pontus. *Futurismo & Futurism*. Milan: Bompiani, 1986. Exhibition catalog.

———. *The Machine as Seen at the End of the Mechanical Age*. New York: Museum of Modern Art, 1968. Exhibition catalog.

Hulten, Pontus, Natalia Dumitresco, and Alexandre Istrati. *Brancusi*. New York: Harry N. Abrams, 1987.

Janis, Harriet and Sidney. "Marcel Duchamp, Anti-Artist," *View* (New York) 5, no. 1 (March 1945). Reprinted in *The Dada Painters and Poets,* edited by Robert Motherwell.

———. "Thoughts on Duchamp." *Art in America* 57 (July–August 1969): 31.

Jarry, Alfred. *Ubu Roi*. New York: New Directions, 1961.

Jean, Marcel. *The History of Surrealist Painting*. Translated by Simon Watson Taylor. London: Weidenfeld & Nicolson and New York: Grove Press, 1960.

Johnson, Ronald W. "Poetic Pathways to Dada: Marcel Duchamp and Jules Laforgue." *Arts Magazine* 50, no. 9 (May 1976): 82–89.

Jones, Amelia. *Postmodernism and the En-gendering of Marcel Duchamp*. Cambridge: Cambridge University Press, 1994.

Josephson, Matthew. *Life Among the Surrealists: A Memoir*. New York: Holt, Rinehart and Winston, 1962.

Judovitz, Dalia. *Unpacking Duchamp: Art in Transit*. Berkeley and Los Angeles: University of California Press, 1995.

Kiesler, Frederick J. "Design Correlation," *Architectural Record,* May 1937. Essay on *The Large Glass.*

Klüver, Billy, and Julie Martin. *Kiki's Paris: Artists and Lovers 1900–1930*. New York: Harry N. Abrams, 1989.

Kozloff, Max. *Renderings: Critical Essays on a Century of Modern Art*. New York: Simon and Schuster, 1968.

Kramer, Hilton. "Duchamp & His Legacy." *The New Criterion* 14, no. 2 (October 1995): 4–8.

Kubota, Shigeko. *Marcel Duchamp and John Cage*. N.p.: Takeyoshi Miyazawa, 1968. Documentation of an event at the Ryerson Theater, Toronto, March 5, 1968.

Kuenzli, Rudolf E., ed. *New York Dada*. New York: Willis Locker & Owens, 1986.

Kuenzli, Rudolf E., and Francis M. Naumann, eds. *Marcel Duchamp: Artist of the Century*. Cambridge: MIT Press, 1990.

Kuh, Katharine. "Marcel Duchamp." In *20th Century Art: From the Louise and Walter Arensberg Collection*. Chicago: Art Institute of Chicago, 1949.

———. "Marcel Duchamp." Interview in *The Artist's Voice: Talks with Seventeen Artists*. New York and Evanston: Harper & Row, 1962, pp. 81–93.

———. "Walter and Louise Arensberg." *Archives of American Art Journal* 27, no. 3 (1987): 25–29.

Laforgue, Jules. *Selected Writings of Jules Laforgue*. Edited and translated by William Jay Smith. New York: Grove Press, 1956.

Lake, Carlton, and Linda Ashton. *Henri-Pierre Roché: An Introduction*. Austin: Harry Ransom Humanities Research Center, University of Texas, 1991.

Lebel, Robert. *Marcel Duchamp*. English translation of *Sur Marcel Duchamp,* by George Heard Hamilton. New York: Grove Press, 1959.

————. "Marcel Duchamp as a Chess Player and One or Two Related Matters." In *Studio International,* January–February 1975.

————. "Marcel Duchamp hier et demain." *L'Oeil* (Paris), no. 112 (April 1964): 12–19.

————. *Sur Marcel Duchamp*. With additional texts by André Breton and Henri-Pierre Roché. Paris: Trianon, 1959. Reprinted with revisions and additions, but without the texts by Breton and Roché, as *Marcel Duchamp*. Paris: Belfond, 1985.

Le Lionnais, François. "Echecs et maths." In *Marcel Duchamp: Abécédaire: Approches critiques*. Paris: Centre National d'Art et de Culture Georges Pompidou, 1977, pp. 42–51.

Levy, Julien. *Memoir of an Art Gallery*. New York: G. P. Putnam's Sons, 1977.

Linde, Ulf. *Marcel Duchamp*. Stockholm: Galerie Buren, 1963.

Lippy, Thomas Edward, Jr. "The Influence of Max Stirner's Philosophy on the Art and Thought of Marcel Duchamp." Unpublished master's thesis, Yale University, 1987.

Loughery, John. *John Sloan: Painter and Rebel*. New York: Henry Holt and Company, 1995.

Loy, Mina. *The Lost Lunar Baedecker*. Edited by Roger L. Conover. New York: Farrar, Straus and Giroux, 1996.

Lyotard, Jean-François. *Les Transformateurs Duchamp*. Paris: Editions Galilée, 1977.

MacLeod, Glen G. *Wallace Stevens and Company: The Harmonium Years, 1915–1923*. Ann Arbor: UMI Research Press, 1983.

Mallarmé, Stéphane. *Selected Poetry and Prose*. Edited by Mary Ann Caws. New York: New Directions, 1982.

"Marcel Duchamp." *L'Arc,* no. 59 (1974). Special Duchamp issue.

"Marcel Duchamp, 1887–1968." *Art in America* 57, no. 4 (July–August 1969). Special Duchamp issue.

"Marcel Duchamp Number." *View* 5, no. 1 (March 1945).

Marquis, Alice Goldfarb. *Marcel Duchamp: Eros, c'est la vie: A Biography*. Troy, N.Y.: Whitston, 1981.

Martin, Jean-Hubert. *Voice: "Peinture d'Ameublement" de Yo Savy (alias Yo Sermayer)*. Bern: Kunsthalle Bern, 1983. Exhibition catalog.

Masheck, Joseph, ed. *Marcel Duchamp in Perspective*. Englewood Cliffs, N.J.: Prentice-Hall, 1975.

Massot, Pierre de. *The Wonderful Book: Reflections on Rrose Sélavy*. Paris: Privately printed, 1924.

Matisse, Paul. "Some More Nonsense About Duchamp." *Art in America* 68, no. 4 (April 1980): 76–83.

Matthews, J. H. *An Introduction to Surrealism*. University Park: Pennsylvania State University Press, 1965.

McBride, Henry. *The Flow of Art: Essays and Criticisms of Henry McBride*. Selected and with an introduction by Daniel Catton Rich. Prefatory essay by Lincoln Kirstein. New York: Atheneum, 1975.

McEvilley, Thomas. "Empyrrhical Thinking (And Why Kant Can't)." *Artforum,* October 1988, pp. 120–27.

McShine, Kynaston. "La Vie en Rrose." In *Marcel Duchamp,* edited by Anne d'Harnoncourt and Kynaston McShine.

Millan, Gordon. *A Throw of the Dice: The Life of Stéphane Mallarmé*. New York: Farrar, Straus and Giroux, 1994.

Moholy-Nagy, Lászlo. *Vision in Motion.* Chicago: Paul Theobald, 1956.

Molderings, Herbert. *Marcel Duchamp: Parawissenschaft, das Ephemere und der Skeptizismus.* 1983. Revised edition. Frankfurt am Main: Qumram, 1987.

Motherwell, Robert, ed. *The Dada Painters and Poets.* New York: Wittenborn, Schultz, 1951.

Moure, Gloria. *Duchamp.* Madrid, 1984. Catalog for an exhibition organized by the Fundacion Caja de Pensiones, Barcelona, and the Fundacio Joan Miró.

Nadeau, Maurice. *The History of Surrealism.* Translated by Richard Howard, with an introduction by Roger Shattuck. New York: Macmillan, 1965.

Naumann, Francis M. "The Bachelor's Quest." *Art in America* 81, no. 9 (September 1993): 72–81.

———. "The Big Show: The First Exhibition of the Society of Independent Artists." *Artforum* 17, no. 6 (February 1979): 34–37, and no. 8 (April 1979): 49–53.

———. "Marcel Duchamp: A Reconciliation of Opposites." In *Marcel Duchamp: Artist of the Century.* Edited by Rudolf Kuenzli and Francis M. Naumann. Cambridge: MIT Press, 1990, pp. 20–37.

———. *The Mary and William Sisler Collection.* New York: Museum of Modern Art, 1984.

———. *New York Dada, 1915–23.* New York: Harry N. Abrams, 1994.

O'Doherty, Brian. *Inside the White Cube: The Ideology of the Gallery Space.* San Francisco: Lapis Press, 1986.

Pach, Walter. *Queer Thing, Painting: Forty Years in the World of Art.* New York: Harper, 1938.

Parry, Albert. *Garrets and Pretenders: A History of Bohemianism in America.* New York: Covici-Friede, 1933.

Paz, Octavio. *Marcel Duchamp: Appearance Stripped Bare.* Translated by Rachel Phillips. New York: Viking Press, 1978.

———. *Marcel Duchamp; or, The Castle of Purity.* Translated by Donald Gardner. London: Cape Goliard, 1970.

Philadelphia Museum of Art. *The Arensberg Collection.* Introduction by Henry Clifford. 1954.

Philipson, Morris, ed. *Leonardo da Vinci: Aspects of the Renaissance Genius.* New York: George Braziller, 1966.

Poggioli, Renato. *The Theory of the Avant-Garde.* Cambridge: Belknap Press of Harvard University Press, 1968.

Polizzotti, Mark. *Revolution of the Mind: The Life of André Breton.* New York: Farrar, Straus and Giroux, 1995.

Ray, Man. *Self-Portrait.* Boston: Little, Brown, 1963.

Raymond, Marcel. *From Baudelaire to Surrealism.* The Documents of Modern Art, vol. 10. New York: Wittenborn, Schultz, 1950.

Reff, Theodore. "Duchamp and Leonardo: L.H.O.O.Q.-Alikes." *Art in America* 65 (January 1977): 83–93.

Reid, B. L. *The Man from New York: John Quinn and His Friends.* New York: Oxford University Press, 1968.

Richardson, John. *A Life of Picasso, Vol. 1, 1881–1906.* New York: Random House, 1991.

Richter, Hans. *Dada: Art and Anti-Art.* New York and Toronto: McGraw-Hill, 1977.

Robbins, Daniel. *The Formation and Maturity of Albert Gleizes: A Biographical and Critical Study, 1881–1920.* Ann Arbor: UMI Press, 1993.

Roberts, Colette. "Interview by Colette Roberts." *Art in America* 57 (July–August 1969): 39.

Roché, Henri-Pierre. *Carnets: Première Partie, 1920–1921.* Preface by Jacques Truffaut. Marseilles: André Dimanche, 1990. First volume of a projected series, published in collaboration with the Harry Ransom Humanities Research Center.

———. *Jules et Jim.* Translated by Katherine C. Foster, with an afterword by François Truffaut. London and Boston: Marion Boyars, 1981.

———. *Victor (Marcel Duchamp).* Prefaces and notes by Jean Clair. Paris: Centre National d'Art et de Culture Georges Pompidou, 1977. Roché's unfinished novel, issued in connection with the 1977 exhibition.

Rosenberg, Harold. *The De-definition of Art.* New York: Horizon Press, 1973.

———. "Duchamp: Public and Private." *The New Yorker,* February 18, 1974.

Rosenblum, Robert. "The Duchamp Family." *Arts* 31, no. 7 (April 1975): 20–23.

———. *Marcel Duchamp 11, Rue Larrey 1927.* Rome: L'Attico Editore, 1988.

Roth, Moira. "Marcel Duchamp and America, 1913–1974: A Self Ready-Made." *Arts Magazine* 51, no. 9 (May 1977): 92–96.

Roth, Moira and William. "John Cage on Marcel Duchamp: An Interview." *Art in America* 61 (November–December 1973): 72–79. Reprinted in *Marcel Duchamp in Perspective,* edited by Joseph Masheck.

Rougemont, Denis de. *Journal d'une époque, 1926–1946.* Paris: Gallimard, 1968.

Roussel, Raymond. *Comment j'ai écrit certains de mes livres.* Paris: Lemerre, 1935.

———. *Impressions d'Afrique.* Paris: Jean-Jacques Pauvert, 1963.

Rubin, William S. *Dada, Surrealism, and Their Heritage.* New York: Museum of Modern Art, 1968. Exhibition catalog.

———. "Reflexions on Marcel Duchamp," *Art International* (Lugano) 4, no. 9 (December 1960): 49–53. Reprinted in *Marcel Duchamp in Perspective,* edited by Joseph Masheck.

Russell, John. "Exile at Large: Interview." *Sunday Times* (London), June 9, 1968, p. 54.

Saarinen, Aline B. *The Proud Possessors.* New York: Random House, 1958.

Samaltanos, Katia. *Apollinaire, Catalyst for Primitivism, Picabia, and Duchamp.* Ann Arbor: UMI Research Press, 1984.

Sanouillet, Michel. *Dada à Paris.* Paris: Jean-Jacques Pauvert, 1965.

———. "Dans l'Atelier de Marcel Duchamp." Interview in *Les Nouvelles littéraires* (Paris), no. 1424 (December 16, 1954): 5.

Sawelson-Gorse, Naomi. "The Art Institute of Chicago and the Arensberg Collection." In *One Hundred Years at the Art Institute: A Centennial Celebration.* The Art Institute of Chicago Museum Studies, vol. 19, no. 1, pp. 80–101. Includes interview with Duchamp.

———. " 'For the want of a nail': The Disposition of the Louise and Walter Arensberg Collection." Unpublished master's thesis, University of California at Riverside, 1987.

Schuster, Jean. "Marcel Duchamp, vite." Interview in *Le Surréalisme, même* (Paris), no. 2 (Spring 1957): 143–45.

Schwarz, Arturo. *The Complete Works of Marcel Duchamp.* New York: Harry N. Abrams, 1969. Revised edition, 1996.

———. *The Large Glass and Related Works.* Milan: Galleria Schwarz, 1967. Etchings by Duchamp, text by Schwarz.

———. *Marcel Duchamp.* New York: Harry N. Abrams, 1970.

———. *Marcel Duchamp, la Sposa . . . e i Readymade.* Brera: Accademia di Belli Arti di Brera, 1988. Exhibition catalog.

————, ed. *Marcel Duchamp: Notes and Projects for "The Large Glass."* London: Thames and Hudson, 1969. Companion volume to *The Complete Works of Marcel Duchamp.*

Seigel, Jerrold. *The Private Worlds of Marcel Duchamp: Desire, Liberation, and the Self in Modern Culture.* Berkeley and Los Angeles: University of California Press, 1995.

Seitz, William C. *The Art of Assemblage.* New York: Museum of Modern Art, 1961. Exhibition catalog.

————. "What's Happened to Art?" *Vogue,* February 15, 1963, pp. 110–13, 129–31. Interview with Duchamp.

Seligmann, Herbert J. *Alfred Stieglitz Talking.* New Haven, Conn.: Yale University Library, 1966.

Siegel, Jeanne. "Some Late Thoughts of Marcel Duchamp, from an interview with Jeanne Siegel." *Arts Magazine* 43 (December 1968–January 1969): 21–22.

Soby, James Thrall, ed. *Arp.* New York: Museum of Modern Art, 1958. Exhibition catalog.

Stauffer, Serge. *Marcel Duchamp: Die Schriften.* Zurich: Regenbogen-Verlag, 1981. Includes more than 100 questions by Stauffer and Duchamp's written replies, translated and edited by Stauffer. In French.

Steefel, Lawrence D., Jr. "The Art of Marcel Duchamp." *Art Journal* 22, no. 2 (winter 1962–63): 72–80.

————. *The Position of Duchamp's "Glass" in the Development of His Art.* New York: Garland, 1979.

Steegmuller, Francis. *Apollinaire: Poet Among the Painters.* New York: Penguin Books, 1986.

————. "Duchamp: Fifty Years Later." *Show* 3, no. 2 (February 1963): 28–29. Interview with Duchamp.

Stein, Gertrude. *Paris, France.* 1940. Reprint. New York: Liveright, 1970.

Steinberg, Leo. *Other Criteria: Confrontations with Twentieth Century Art.* New York: Oxford University Press, 1972.

Stevens, Wallace. *Letters of Wallace Stevens.* Edited by Holly Stevens. New York: Knopf, 1966.

Stirner, Max. *The Ego and His Own.* New York: Boni and Liveright, 1918.

Stuckey, Charles. "Duchamp's Acephalic Symbolism." *Art in America* 65 (January 1977): 94–99.

Suquet, Jean. *Miroir de la mariée: Essai.* Paris: Flammarion, 1975.

Sweeney, James Johnson. "A Conversation with Marcel Duchamp . . ." Interview at the Philadelphia Museum of Art, filmed by NBC-TV in 1955, broadcast in January 1956. Text published in James Nelson, ed., *Wisdom: Conversations with the Elder Wise Men of Our Day.* New York: W. W. Norton, 1958.

————. "Eleven Europeans in America," *Museum of Modern Art Bulletin* 13, nos. 4–5 (1946): 19–21. Interview with Duchamp.

Tancock, John. "The Influence of Marcel Duchamp." In *Marcel Duchamp,* edited by Anne d'Harnoncourt and Kynaston McShine.

Tanning, Dorothea. *Birthday.* San Francisco: Lapis Press, 1986.

Tashjian, Dickran. "Henry Adams and Marcel Duchamp: Liminal Views of the Dynamo and the Virgin." *Arts Magazine* 51, no. 9 (May 1977): 102–7.

————. *Skyscraper Primitives: Dada and the American Avant-Garde.* Middletown, Conn.: Wesleyan University Press, 1975.

Taylor, Joshua C. *Futurism.* New York: Museum of Modern Art, 1961. Exhibition catalog.

Tharrats, Joan-Josep. *Cent anys de pintura a Cadaqués.* Barcelona: Edicions del Cotal, 1981.

————. "Marcel Duchamp." *Art Actuel International* (Lausanne), no. 6 (1958): 1. Interview with Duchamp.

Tomkins, Calvin. *The Bride and the Bachelors: The Heretical Courtship in Modern Art.* New York: Viking Press, 1965. Revised and expanded edition. New York: Viking Compass, 1968.

————. *Living Well Is the Best Revenge.* New York: Viking Press, 1971.

————. *The World of Marcel Duchamp.* New York: Time-Life Books, 1966.

Tyler, Parker. *Florine Stettheimer: A Life in Art.* New York: Farrar, Straus, 1963.

Van de Velde, Ronny. *Marcel Duchamp Rrose Sélavy.* Antwerp, 1991. Exhibition catalog.

Varèse, Louise. *A Looking Glass Diary.* New York: W. W. Norton, 1972.

Varia, Radu. *Brancusi.* New York: Rizzoli, 1986.

Waste, Henri [Ettie Stettheimer]. *Love Days.* New York: Knopf, 1923.

Watson, Steven. *Strange Bedfellows: The First American Avant-Garde.* New York: Abbeville Press, 1991.

Weld, Jacqueline Bograd. *Peggy: The Wayward Guggenheim.* New York: E. P. Dutton, 1986.

Wohl, Hellmut. "Beyond the 'Large Glass': Notes on a Landscape Drawing by Marcel Duchamp." *Burlington* 119 (November 1977): 763–72.

Wood, Beatrice. *I Shock Myself: The Autobiography of Beatrice Wood.* Ojai, Calif.: Dillingham Press, 1985.

————. "Marcel." In *Marcel Duchamp: Artist of the Century,* edited by Rudolf Kuenzli and Francis M. Naumann. Cambridge: MIT Press, 1990, pp. 12–17.

Yale University Art Gallery. *The Société Anonyme and the Dreier Bequest: A Catalogue Raisonné.* Edited by Robert L. Herbert, Eleanor S. Apter, and Elise K. Kenney. New Haven, Conn.: Yale University Press, 1984.

Zilczer, Judith. *"The Noble Buyer": John Quinn, Patron of the Avant-Garde.* Washington, D.C.: Smithsonian Institution Press, 1978.

Acknowledgments

I met Marcel Duchamp for the first time in 1959, when I was assigned to interview him for *Newsweek* magazine. It was the start of a continuing investigation that has lasted more than three decades and has brought me into contact with more Duchampians—artists, scholars, friends, addicts—than I could possibly list here. What follows is a partial roll call of those to whom my debt is the greatest, starting with Duchamp himself, whose affirmative irony, I firmly believe, is still the soundest guide to an understanding of twentieth-century art.

Jacqueline Matisse, the artist's stepdaughter, has been extraordinarily generous, guiding my research at every turn, helping me gain access to elusive sources, and bringing her knowledge and insight to bear on a close reading of the completed manuscript. Paul Matisse, who translated an important group of Duchamp's notes and was responsible for taking apart Duchamp's *Etant donnés* and reassembling it in the Philadelphia Museum of Art, provided invaluable perspectives on his stepfather's unique and inimitable processes of working and thinking.

Anne d'Harnoncourt, the director of the Philadelphia Museum of Art, is the *fons et origo* of all Duchamp studies. She and her expert staff have answered a thousand questions and assisted in every possible way, and her scholarly imagination has been one of the primary sources for my own effort to penetrate the mystery of Duchamp. My thanks also to Ann Temkin, the Philadelphia Museum's curator of twentieth-century art, for her unflagging and good-humored assistance over many years, and for her careful reading of the manuscript, which helped me avoid a number of errors that I wouldn't dream of disclosing.

Francis M. Naumann, whose interest in Duchamp is as obsessive as my own, has shared his encyclopedic knowledge, his research material, and his thoughts with me in countless discussions. Jennifer Gough-Cooper, Jacques Caumont, Richard Hamilton,

George Heard Hamilton, Arturo Schwarz, Walter Hopps, and Pontus Hulten have all contributed substantially to this book, through their writings and through personal interviews, letters, and conversations. Alexander Liberman, friend and mentor, has provided subtle guidance and constant encouragement.

In addition, I would like to thank William Agee; Lili Auchincloss; Arman; Richard Avedon; Timothy Baum; Franco Bombelli; Ecke Bonk; Kay Boyle; John Cage; Nicolas Calas; William A. Camfield; Mikki Carpenter; Leo Castelli; François Chapon; Bonnie Clearwater; Mimi Brown Cohane; Noma Copley; William Copley; Xavier Corbero; Crosby Coughlin; Merce Cunningham; Jeffrey Deitch; Caroline Demaree; Enrico Donati; Thierry de Duve; Arne Ekstrom; Walter Faixó; Patricia Faure; Mimi Fogt; Monique Fong; Hugh Ford; Martin Friedman; André Gervais; Lucien Goldschmidt; Adam Gopnik; Cleve Gray; Samuel Adams Green; Sue Guinness; Rita Hamilton; David Hare; Denise Hare; David Hayes; Shirley Hazzard; Linda Dalrymple Henderson; Hayden Herrera; Thomas B. Hess; Frank Brookes Hubachek; Richard Huelsenbeck; Carroll Janis; Sidney Janis; Jasper Johns; Daniel-Henri Kahnweiler; Frederick Kiesler; Lillian Kiesler; Rachel Klauber-Speiden; Billy Klüver; David V. Koch; Katharine Kuh; Carlton Lake; George Lang; Edward Lasker; Jean-Jacques Lebel; Xavier Le Bertre; Julien Levy; Thomas E. Lippy, Jr.; Nora Martins Lobo; John Loughery; and Peter Lyon.

Also Judith Young Mallin; Jean-Hubert Martin; Julie Martin; Roberto Matta Echaurren; Malitte Matta; Pierre de Massot; Harry Mathews; Peter Matisse; Kynaston McShine; Bernard Monnier; Robert Motherwell; Natalia Murray; Hector Obalk; Brian O'Doherty; Anne Poor; Olga Popovitch; Yves Poupard-Lieussou; Emilio Puignau; Man Ray; Juliet Man Ray; Robert Rauschenberg; Rona Roob; William Rubin; John Russell; Niki de Saint-Phalle; Michel Sanouillet; Naomi Sawelson-Gorse; Julian Schnabel; Yvonne Sermayer; Katherine Shannon; Thomas Shannon; Deborah Solomon; Joseph Solomon; George Staempfli; Francis Steegmuller; James Johnson Sweeney; Dorothea Tanning; Alain Tarica; Jean Tinguely; Lucien Treillard; Evan Turner; Dolores Vanetti; Kirk Varnedoe; Cynthia Wall; Julian Wasser; Marjorie Watkins; Brenda Wineapple; Beatrice Wood; Charles Rue Woods; and Virginia Zabriskie.

Andrew Wylie, my literary agent, urged me to undertake a biography of Duchamp in the first place. Jack Macrae, my editor, stuck with it (and with me) when the gestation period stretched from three years to nine. Without their support, the book would not have been written.

Above all, I am indebted to the late Alexina (Teeny) Duchamp, the artist's widow, whose friendship and encouragement over the years meant more to me than I can possibly express. By some miracle, Teeny got through the entire manuscript of the book during the last weeks of her life—it was read to her by her daughter, Jackie Matisse—and she was able to make helpful corrections and suggestions. What a gift.

Index

Italic page numbers refer to illustrations.

Photography Credits

The Museum of Modern Art, New York. Anonymous Extended Loan. Photograph © 1996 The Museum of Modern Art, New York. Torn and pasted paper on velvet, 13⅛ × 9¾″ (33.3 × 24.8 cm): *p. vi*. Philadelphia Museum of Art. Bequest of Katherine S. Dreier. Oil, varnish, lead foil, lead wire, and dust on two glass panels: *p. 2*. Philadelphia Museum of Art. Lent by Mme Marcel Duchamp: *p. 20*. Dr. Pierre Jullien: *p. 19*. Académie de Muséologie Evocatoire: *p. 21*. Académie de Muséologie Evocatoire: *p. 23*. Duchamp estate: *p. 26*. Private collection: *p. 27*. Philadelphia Museum of Art: Louise and Walter Arensberg Collection. Oil on canvas: *p. 28*. The Metropolitan Museum of Art. Gift of Mrs. William Sisler, 1975. Brush drawing and "splatter" on paper: *p. 36*. Académie de Muséologie Evocatoire: *p. 37*. Collection of Mme Ferdinand Tribout, Rouen. Dry point: p. 38. Académie de Muséologie Evocatoire: *p. 41*. The Museum of Modern Art. Mary Sisler Bequest. Conté pencil, brush, and "splatter." 23¾ × 19⅛″ (60.3 × 48.6 cm): *p. 42*. Philadelphia Museum of Art: Louise and Walter Arensberg Collection. Oil on canvas: *p. 43*. Philadelphia Museum of Art: Louise and Walter Arensberg Collection. Oil on canvas: *p. 44*. Philadelphia Museum of Art: Louise and Walter Arensberg Collection. Oil on canvas: *p. 45*. Philadelphia Museum of Art: Louise and Walter Arensberg Collection. Oil on canvas: *p. 48*. Philadelphia Museum of Art: Louise and Walter Arensberg Collection. Oil on canvas: *p. 50*. The Israel Museum, Jerusalem. Gift of Arturo Schwartz. Oil on canvas: *p. 52*. Philadelphia Museum of Art: Louise and Walter Arensberg Collection. Oil on canvas: *p. 55*. Philadelphia Museum of Art: *p. 61*. Philadelphia Museum of Art: Louise and Walter Arensberg Collection. Charcoal and ink on paper: *p. 63*. Philadelphia Museum of Art: Louise and Walter Arensberg Collection. Oil on canvas: *p. 63*. Peggy Guggenheim Collection, Venice. Photograph by David Heald © The Solomon R. Guggenheim Foundation, New York. Oil on canvas: *p. 77*. Philadelphia Museum of Art: Louise and Walter Arensberg Collection. Pencil on paper: *p. 81*. Philadelphia Museum of Art: Louise and Walter Arensberg Collection. Oil on canvas: *p. 82*. Private collection. Pencil and chalk on paper with collaged stamp: *p. 83*. Tate Gallery, London. Oil on cardboard: *p. 84*. Philadelphia Museum of Art: Louise and Walter Arensberg Collection. Oil on canvas: *p. 86*. Philadelphia Museum of Art. Lent by Mme Marcel Duchamp: *p. 95*. Centre National d'Art et de Culture Georges Pompidou, Paris. Pencil and wash on paper: *p. 96*. Philadelphia Museum of Art: A. E. Gallatin Collection. Graphite on paper: *p. 97, top left*. Philadelphia Museum of Art: Louise and Walter Arensberg Collection. Watercolor and pencil on paper: *p. 97, top right*. The Museum of Modern Art, New York. Purchase. Photograph © 1996 The Museum of Modern Art, New York. Oil on canvas, 23⅜ × 21¼″ (59.4 × 54 cm): *p. 97, bottom*. Philadelphia Museum of Art: Louise and Walter Arensberg Collection. Oil on canvas: *p. 100*. Philadelphia Museum of Art: Louise and Walter Arensberg Collection. Oil on canvas: *p. 126*. The Museum of Modern Art, New York. Abby Aldrich Rockefeller Fund and Gift of Mrs. William Sisler. Photograph © 1996 The Museum of Modern Art, New York. Oil and pencil on canvas, 58⅝ × 77⅝″ (148.9 × 197.2 cm): *p. 133*. Philadelphia Museum of Art: Given by the Schwarz Galleria d'Arte. Readymade: *p. 134*. Philadelphia Museum of Art: Louise and Walter Arensberg Collection. Readymade (the first to be known as one): *p. 135*. Philadelphia Museum of Art: Louise and Walter Arensberg Collection. Oil, thread, and pencil on canvas: *p. 136*. Estate of Mme Marcel Duchamp. Oil, lead wire, and sheet lead on glass (broken): *p. 139*. Francis M. Naumann: *p. 145, top and bottom*. Philadelphia Museum of Art: Louise and Walter Arensberg Collection. Readymade: *p. 160*. The Beinecke Rare Book and Manuscript Library, Yale University: *p. 172*. Philadelphia Museum of Art: Louise and Walter Arensberg Collection: *p. 176*. Philadelphia Museum of Art: Louise and Walter Arensberg Collection. Readymade, from painted tin advertisement: *p. 177*. Philadelphia Museum of Art: Louise and Walter Arensberg Collection. Readymade: *p. 183*. Collection of Timothy Baum, New York: *p. 186*. Private collection. Oil on canvas: *p. 194*. Philadelphia Museum of Art. Lent by Mme Marcel Duchamp: *p. 196*. Philadelphia Museum of Art: *p. 197, top*. Carlton Lake Collection, Harry Ransom Humanities Research Center, The University of Texas at Austin: *p. 197, bottom*. Collection of Peter Lyon, Paris: *p. 201*. Yale University Art Gallery. Gift from the estate of Katherine S. Dreier. Oil and pencil on canvas, with bottle brush, three safety pins, and a bolt: *p. 203*.

Philadelphia Museum of Art. Lent by Mme Marcel Duchamp. Watercolor, ink, and colored pencil on paper: *p. 206*. The Museum of Modern Art, New York. Katherine S. Dreier Bequest. Photograph © 1996 The Museum of Modern Art, New York. Oil paint, silver leaf, lead wire, and magnifying lens on glass (cracked), $19\frac{1}{2} \times 15\frac{5}{8}''$ (49.5×39.7 cm), mounted between two panes of glass in standing metal frame: *p. 213*. The Museum of Modern Art, New York. Van Gogh Purchase Fund. Photograph © 1995 The Museum of Modern Art, New York. Bronze (cast c. 1930–31), $40 \times 39\frac{1}{2} \times 22\frac{3}{8}''$ ($101.6 \times 100.3 \times 56.8$ cm): *p. 218*. Collection of Alain Tarica. Rectified readymade—pencil on a reproduction: p. 221. Philadelphia Museum of Art: Louise and Walter Arensberg Collection. Readymade—glass ampule: *p. 222*. Philadelphia Museum of Art: Archives of The Louise and Walter Arensberg Collection. Photograph: *p. 228*. Philadelphia Museum of Art: Samuel S. White III and Vera White Collection: *p. 232*. Philadelphia Museum of Art: Louise and Walter Arensberg Collection. Assisted readymade—marble blocks, thermometer, wood, and cuttlebone in small birdcage: *p. 233*. Present location unknown. Rectified readymade: *p. 249*. The Museum of Modern Art, New York. Gift of Mrs. William Sisler and Edward James Fund. Photograph © 1996 The Museum of Modern Art, New York. Motor-driven construction—painted wood demisphere fitted on black velvet disc, copper collar with Plexiglas dome, motor, pulley, and metal stand, $48\frac{1}{2} \times 25\frac{1}{4} \times 24''$ ($123.2 \times 64.1 \times 61$ cm): *p. 254*. Philadelphia Museum of Art. Lent by Mme Marcel Duchamp. Oil on canvas: *p. 255*. Alain Tarica: *p. 260*. Film Stills Archive, The Museum of Modern Art, New York: *p. 265*. Philadelphia Museum of Art. Lent by Mme Marcel Duchamp: *p. 266*. Philadelphia Museum of Art. Lent by Mme Marcel Duchamp: *p. 275*. Académie de Muséologie Evocatoire: *p. 279*. The Beinecke Rare Book and Manuscript Library, Yale University: *p. 283*. Philadelphia Museum of Art. Lent by Mme Marcel Duchamp: *p. 293*. The Beinecke Rare Book and Manuscript Library, Yale University: *p. 305*. Philadelphia Museum of Art: Louise and Walter Arensberg Collection. Leather suitcase containing miniature replicas, photographs, and color reproductions of works by Duchamp: *p. 320*. Philadelphia Museum of Art: Duchamp Archives: *p. 333*. Philadelphia Museum of Art: Duchamp Archives: *p. 336*. Centre National d'Art et de Culture Georges Pompidou. Assemblage—cardboard, gauze, nails, iodine, and gilt stars: *p. 340*. Philadelphia Museum of Art. Lent by Mme Marcel Duchamp: *p. 349*. The Beinecke Rare Book and Manuscript Library, Yale University: *p. 352*. Photograph by John Rawlings. Courtesy *Vogue*. Copyright © 1944 (renewed 1972) by the Condé Nast Publications, Inc: *p. 353*. Courtesy of Ecke Bonk: *p. 354*. The National Swedish Art Museums: *p. 356*. Photograph by Man Ray. Collage of foam rubber and velvet on cardboard: *p. 361*. Philadelphia Museum of Art. Lent by Mme Marcel Duchamp: *p. 365*. Collection of Jacqueline Matisse Monnier: *p. 386*. Philadelphia Museum of Art: Gift of Mme Marcel Duchamp. Bronze: *p. 386, top*. Philadelphia Museum of Art: Gift of Arne Ekstrom. Bronze: *p. 386, middle*. Philadelphia Museum of Art: Duchamp Archives. Galvanized plaster and dental plastic: *p. 386, bottom*. Private collection: *p. 390*. Private collection: *p. 404*. Centre National d'Art et de Culture Georges Pompidou, Paris. Photo Philippe Migeat © Centre G. Pompidou. Plaster, pencil, and paper mounted on wood: *p. 406*. Calvin Tomkins: *p. 409*. *The Time-Life Library of Art: The World of Marcel Duchamp*. Photograph by Mark Kauffman © 1966 Time-Life Books, Inc. *p. 412*. Patricia Faure Gallery, Santa Monica: *p. 423*. Julian Wasser: *p. 425*. Philadelphia Museum of Art. Lent by Mme Marcel Duchamp: *p. 430*. Denise Hare: *p. 432*. Photograph by Marc Lavrillier for *L'Oeil*, no. 149 (May 1967): *p. 441*. Private collection: *p. 445*. Philadelphia Museum of Art: Gift of the Cassandra Foundation: *p. 452*. Philadelphia Museum of Art: Gift of the Cassandra Foundation. Mixed media assemblage: *p. 453*. Réunion des Musées Nationaux, France. Photograph © Réunion des Musées Nationaux, France. Oil on canvas: *p. 461*. Alexander Liberman: *p. 464*.

Works by Miró, Man Ray, and Marcel Duchamp © 1996 Artists Rights Society (ARS), New York/ADAGP, Paris.